More praise for Generation Ecstasy:

- "Generation Ecstasy serves as an important cultural critique, a detailed record that brings us up-to-date on a dynamic social experiment in progress."
 - -STEPHEN SANDE, San Francisco Chronicle Book Review
- "An extended megamix of postmodern theory and rockcrit gone 'mental' (as the ravers say), **Generation Ecstasy** is social history at two hundred beats per minute."
 - -MARK DERY, author of Escape Velocity
- "Reynolds offers a revved-up, detailed, and passionate history and analysis of the throbbing transcontinental set of musics and cultures known as rave..."
 - -Publishers Weekly
- "Generation Ecstasy is a sparkling inside view of a colorful underground youth subculture, and a testimony to kids' capacity to create joy."
 - -DONNA GAINES, author of Teenage Wasteland

generation ecstasy

into the world of techno and rave culture

simon reynolds

Published in 1999 by Routledge 29 West 35th Street New York, NY 10001

This edition published by arrangement with Little, Brown and Company, (Inc.). All rights reserved.

Copyright © Simon Reynolds, 1998

Printed in the United States of America on acid-free paper

All rights reserved. No part of this book may be reprinted or reproduced or utilized in any form or by any electronic, mechanical, or other means, now known or hereafter invented, including photocopying and recording, or in any information storage or retrieval system, without permission in writing from the publisher.

1098

Library of Congress Cataloging-in-Publication Data

Reynolds, Simon, 1963-

Generation ecstasy: into the world of techno and rave culture / Simon Reynolds.

p. cm.

Originally published: Boston: Little, Brown, and Company, 1998.
Includes bibliographical references (p.), discography (p.), and index. ISBN 0-415-92373-5 (pb.)

1. Techno music—History and criticism. 2. Rave culture.

I. Title.

ML3540.R49 1999 781.64—dc21

> 99-22695 CIP

CONTENTS

introduction | 003 detroit techno, chicago house, and new york garage, 1980-90 | 012 a tale of three cities digital psychedelia sampling and the soundscape | 040 living a dream acid house and uk rave, 1987-89 | 056 everything starts with an e ecstasy and rave music | 080 twenty-four-hour party people "madchester," positivity, and the rave 'n' roll crossover, 1988–91 | 092 'ardkore, you know the score the second wave of rave, 1990-92 | 112 us rave culture, 1990-92 | 142 america the rave spiral tribe and the crusty-raver movement, 1991–97 | 162 fight for your right to party feed your head intelligent techno, ambient, and trance, 1990-94 | 180 slipping into darkness the uk rave dream turns to nightmare, 1992–93 | 206 the future sound of detroit underground resistance, +8, and carl craig, 1990–96 | 218 rave as counterculture and spiritual revolution | 236 in our angelhood (:::::: roots 'n' future jungle takes over london, 1993–94 | 250 in the mix [:] dj culture and remixology, 1993-97 | 270 marching into madness gabba and happy hardcore, 1992-97 | 282 crashing the party american rave's descent into the darkside, 1993-97 | 298 sounds of paranoia trip-hop, tricky, and pre-millennium tension, 1990–97 | 318 intelligent drum and bass versus techstep, 1994-97 | 334 war in the jungle the post-rave experimental fringe, 1994-97 | 358 fuck dance, let's art outro: nineties house, speed garage, and big beat | 375 bibliography | 391 discography | 397 acknowledgments | 437

index | 439

The second of th

ado - vila monera de timo

the state of the s

and the second s

the second secon

So English and the second of t

The second secon

1970 No.

GENERATION ECSTASY

.

I'm lucky enough to have gotten into music at the precise moment — punk's immediate aftermath — when it was generally believed that "the way forward" for rock involved borrowing ideas from dance music. "Lucky" in that I arrived too late to get brainwashed by the "disco sucks" worldview. My first albums were all postpunk forays into funk and dub terrain: Public Image Limited's *Metal Box*, the Slits' *Cut*, the Talking Heads' *Remain in Light*. Any mercifully brief fantasies of playing in a band involved being a bassist, like Jah Wobble; I learned to play air guitar only much later.

In the early eighties it didn't seem aberrant to be as excited by the electro-funk coming out of New York on labels like Prelude as I was by the Fall or the Birthday Party. As much time and money went into huntergathering secondhand disco singles and Donna Summer LPs as sixties garage punk compilations or Byrds albums. Starting out as a music journalist in the late eighties, I devoted most of my rhetorical energy to crusading for a resurgent neopsychedelic rock. But I still had plenty of spare passion for hip-hop and proto-house artists like Schoolly D, Mantronix, Public Enemy, Arthur Russell, and Nitro Deluxe. In early 1988 I even wrote one of the first features on acid house.

That said, my take on dance music was fundamentally rockist, insofar as I had never really engaged with the music's original milieu — clubs. This was perhaps forgivable, given that eighties "style culture" dominated London clubland. Its posing and door policies, go-go imports, and vintage funk obscurities were anathema to my vision of a resurrected psychedelia, a Dionysian cult of oblivion. Little did I realize that just around the corner loomed a *psychedelic dance* culture, that the instruments and time-space coordinates of the neopsychedelic resurgence would not be wah-wah pedals and Detroit 1969, but Roland 303 bass machines and Detroit/Chicago 1987.

My take on dance was rockist because, barely acquainted with how the

music functioned in its "proper" context, I tended to fixate on singular artists. This is how rock critics still tend to approach dance music: they look for the auteur-geniuses who seem most promising in terms of long-term, album-based careers. But dance scenes don't really work like this: the 12-inch single is what counts, there's little brand loyalty to artists, and DJs are more of a focal point for fans than the faceless, anonymous producers. In the three years before I experienced rave culture on its own terrain and terms, I accordingly celebrated groups like 808 State, the Orb, and the Shamen on the grounds that their music made sense at home and at album length. Today I cringe when I recall that, reviewing the second Bomb the Bass LP, I proposed the term "progressive dance" to describe this new breed of album-oriented artist. This divide between so-called progressive electronica and mere "rave fodder" has since become for me the very definition of "getting it completely wrong."

I finally got it "right" in 1991, as one drop in the demographic deluge that was 1991–92's Second Wave of Rave, carried along by the tide of formerly indie-rock friends who'd turned on, tuned in, and freaked out. It was some revelation to experience this music in its proper context — as a component in a system. It was an entirely different and un-rock way of using music: the anthemic track rather than the album, the total flow of the DJ's mix, the alternative media of pirate radio and specialist record stores, music as a synergistic partner with drugs, and the whole magic/tragic cycle of living for the weekend and paying for it with the midweek comedown. There was a liberating joy in surrendering to the radical anonymity of the music, in not caring about the names of tracks or artists. The "meaning" of the music pertained to the macro level of the entire culture, and it was much larger than the sum of its parts.

"What we must lose now is this insidious, corrosive knowingness, this need to collect and contain. We must open our brains that have been stopped and plugged with random information, and once again must our limbs carve in air the patterns of their desire — not the calibrated measures and slick syncopation of jazz-funk but a carnal music of total release. We must make of joy once more a crime against the state." This paragraph by *New Musical Express* writer Barney Hoskyns, written in 1981, changed all my ideas about music, setting me on a quest for the kind of Dionysian spirit that Hoskyns

here located in the Birthday Party. As a fan I found it in Hendrix and the Stooges, as a critic in bands like the Young Gods, the Pixies, My Bloody Valentine. But apart from the odd bare-chested maniac or bloody-shirted mosher, I'd never witnessed the kind of physical abandon imagined by Hoskyns on any mass level.

The last place I'd expected to find a modern bacchanalia was in the cool-crippled context of dance music. But that's what I saw in 1991 at Progeny, one of a series of DJ-and-multiband extravaganzas organized by the Shamen. The latter were pretty good, and Orbital's live improvisation around their spine-tingling classic "Chime" was thrilling. But what really blew my mind were the DJs whipping up a Sturm und Drang with the *Carmina-Burana*-gone-Cubist bombast of hardcore techno, the light beams intersecting to conjure frescoes in the air, and, above all, the crowd: nubile boys, stripped to the waist and iridescent with sweat, bobbing and weaving as though practicing some arcane martial art; blissed girls, eyes closed, carving strange hieroglyphic patterns in the air. This was the Dionysian paroxysm programmed and looped for eternity.

My second, fatally addictive rave-alation occurred a few months later at a quadruple bill of top 1991 rave acts: N-Joi, K-Klass, Bassheads, and M People. This time, fully E'd up, I finally grasped viscerally why the music was made the way it was; how certain tingly textures goosepimpled your skin and particular oscillator riffs triggered the E-rush; the way the gaseous diva vocals mirrored your own gushing emotions. Finally, I understood ecstasy as a *sonic* science. And it became even clearer that the audience was the star: that guy over there doing fishy-finger dancing was as much a part of the entertainment — the tableau — as were the DJs or bands. Dance moves spread through the crowd like superfast viruses. I was instantly entrained in a new kind of dancing tics and spasms, twitches and jerks, the agitation of bodies broken down into separate components, then reintegrated at the level of the dance floor as a whole. Each subindividual part (a limb, a hand cocked like a pistol) was a cog in a collective "desiring machine," interlocking with the sound system's bass throbs and sequencer riffs. Unity and self-expression fused in a force field of pulsating, undulating euphoria.

^ ^ ^

Getting into the raving aspect of house and techno somewhat late had a peculiar effect: I found myself, as fan and critic, on the wrong side of the tracks. In terms of class and age (as a middle-class twenty-eight-year-old), I should logically have gravitated toward "progressive house" and "intelligent techno," then being vaunted as the only alternative to the degenerate excesses of hardcore rave. But, partly because I was a neophyte still in the honeymoon phase of raving, and partly because of a bias toward extremity in music, I found myself drawn ever deeper into hardcore. Confronted by the condescension of the cognoscenti, I developed my own counterprejudice, which informs this entire book: the conviction that hardcore scenes in dance culture are the real creative motor of the music, and that self-proclaimed progressive initiatives usually involve a backing away from the edge, a reversion to more traditional ideas of "musicality." Hardcore is that nexus where a number of attitudes and energies mesh: druggy hedonism, an instinctively avant-garde surrender to the "will" of technology, a "fuck art, let's dance" DJ-oriented funktionalism, and a smidgen of underclass rage. Hardcore refers to different sounds in different countries at different times, but the word generally guarantees a stance of subcultural intransigence, a refusal to be coopted or to cop out.

In London, circa 1991–92, hardcore referred to ultrafast, breakbeat-driven drug-noise, and it was abhorred by all right-thinking techno hipsters. To me it was patently the most exhilaratingly strange and deranged music of the nineties, a mad end-of-millennium channeling of the spirit of punk (in the sixties garage and seventies Stooges/Pistols senses) into the body of hip-hop (breakbeats and bass). I've found no small glee in watching hardcore evolve into jungle and drum and bass, thereby winning universal acclaim as the leading edge of contemporary music.

But the experience of being in the "wrong" place at the right time has instilled in me a useful Pavlovian response: whenever I hear the word "hardcore" (or synonyms like "dark," "cheesy") used to malign a scene or sound, my ears prick up. Conversely, terms like "progressive" or "intelligent" trigger alarm bells; when an underground scene starts talking this talk, it's usually a sign that it's gearing up to play the media game as a prequel to buying into the traditional music industry structure of auteur-stars, concept albums, and long-term

careers. Above all, it's a sign of impending musical debility, creeping self-importance, and the hemorrhaging away of fun. Hardcore scenes are strongest when they remain remote from all of that and thrive instead as anonymous collectives, subcultural machines in which ideas circulate back and forth between DJs and producers, the genre evolving incrementally, week by week.

For the newcomer to electronic dance music, the profusion of scenes and subgenres can seem at best bewildering, at worst willful obfuscation. Partly, this is a trick of perspective: kids who've grown up with techno feel it's *rock* that "all sounds the same." The urgent distinctions rock fans take for granted — that Pantera, Pearl Jam, and Pavement operate in separate aesthetic universes — makes sense only if you're already a participant in the ongoing rock discourse. The same applies to dance music: step inside, and the genre-itis begins to make sense. Like sections in a record store, the categories are useful. But they're also a way of talking about the music, of arguing about what it's for and where it should go.

In the late eighties, "house" was the all-encompassing general term for rave music; Detroit techno was originally treated as a subset of, and adjunct to, Chicago house. But by the early nineties, not only was house's primacy challenged by "techno" — now a distinct genre with its own agenda — but house itself started to splinter as a seemingly endless array of prefixes — "tribal," "progressive," "handbag" — interposed themselves in order to define precise stylistic strands and taste markets. What had once been a unified subculture based on a mix of musics began to fragment along class, race, and regional lines, as different groups began to adapt the music to fit their particular needs and worldviews.

When I first started going to raves in 1991, you could still hear a broad range of styles within a single DJ's set, and wildly different DJ sets on the same bill. But within a year, rave culture had stratified into increasingly narrower scenes. It became all too easy to avoid hearing music you weren't already into and mixing with people who weren't your "own kind." To say "I like techno" became a meaningless claim by 1993, since the original black American sound had mutated, under pressure from various British and European subcultures,

into three main genres: hardcore and its ultrafast Dutch variant, gabba; jungle, a bass-heavy hybrid of hip-hop, reggae, and techno; and Teutonic trance, with its metronomic beats and cosmic imagery. Each of these soon began to fracture into numerous subgenres and sub-subgenres.

Despite this proliferation, one might generalize and say that there are really only three types of electronic dance music, determined by how and where the music is used. There's music for clubs: sophisticated, adult-oriented sounds like house, garage, and the more purist, Detroit-affiliated forms of techno. There are hardcore sounds designed for one-shot raves and for clubs that cater to rave-style teenage bacchanalia as opposed to more "mature" nightclub behavior: jungle, gabba, trance, happy hardcore. And finally, there's music for the home: album-oriented ambient techno and atmospheric electronica that appeals both to people who've grown tired of the rave lifestyle and to many who've never been into dance culture at all. Although *Generation Ecstasy* covers all three of these "types," my bias is toward the hardcore rave genres and the more functionalist, drug-oriented forms of club music.

What I'm proposing here is that music shaped by and for drug experiences (even "bad" drug experiences) can go further precisely because it's not made with enduring "art" status or avant-garde cachet as a goal. Hardcore rave's dance floor functionalism and druggy hedonism actually make it more wildly warped than the output of most self-conscious experimentalists. In *Generation Ecstasy*, I trace a continuum of hardcore that runs from the most machinic forms of house (jack tracks and acid tracks) through British and European rave styles like bleep-and-bass, breakbeat house, Belgian hardcore, jungle, gabba, speed garage, and big beat. A lot of exquisite music was made outside this continuum and is also covered in this book. But I still believe that the essence of rave resides with "hardcore pressure," the rave audience's demand for a soundtrack to going mental and getting fucked up.

This begs the question of whether the meaning of rave music is reducible to drugs, or even a single drug, Ecstasy. Does this music make sense only when the listener is under the influence? I don't believe that for a second; some of the most tripped-out dance music has been made by straight-edge types who rarely if ever touch an illegal substance (4 Hero, Dave Clarke, and Josh Wink being only three of the most famous abstainers). At the same time, rave cul-

ture as a whole is barely conceivable without drugs, or at least without drug metaphors: by itself, the music *drugs* the listener.

Rave is more than music plus drugs; it's a matrix of lifestyle, ritualized behavior, and beliefs. To the participant, it feels like a religion; to the mainstream observer, it looks more like a sinister cult. I think again of that declaration: "We must make of joy a crime against the state." In 1992 the two aspects of underground rave that particularly enthralled me were *literally* crimes against the state: pirate radio and the resurgence of illegal raves, instigated by renegade sound systems like Spiral Tribe.

What the London pirate stations and the free parties conjured up was the sense of rave as a vision quest. Both transformed mundane Britain, with its dreary metropolitan thoroughfares and placid country lanes, into a cartography of adventure and forbidden pleasures. A huge part of the excitement of the rave lifestyle is the nocturnal itineraries that connect favorite clubs. Anyone who's ever been involved in rave has his own enchanted pathways; for my gang, one such was the pilgrimage between two profane shrines, Labrynth and Trade. It was a journey between worlds — Labrynth's ultraviolet catacombs thronged with working-class East End teenagers, and Trade's gay pleasure dome in the center of London — but both, in their different ways, were hardcore. It's in these clubs that I experienced raving in its purest and most deranged form, blissfully ignorant of the DJs' identities or the tracks' names, lost in music, out of time.

These kinds of experiences, shared by millions, can't really be documented, although the post—Irvine Welsh mania for "rave fiction" has made an attempt. Most of this writing consists of thinly disguised drug memoirs, and as everybody knows, other people's drug anecdotes are as boring as their dreams. So how do you write the history of a culture that is fundamentally amnesiac and nonverbal? Unlike rock music, rave isn't built around lyrics. For the critic this requires a shift of emphasis, so that you no longer ask what the music "means" but how it works. What is the affective charge of a certain kind of bass sound, of a particular rhythm? Rave music represents a fundamental break with rock, or at least the dominant English Lit and socialist realist paradigms of rock criticism, which focus on songs and storytelling. Where rock relates an experience (autobiographical or imaginary), rave constructs an experience. Bypassing in-

terpretation, the listener is hurled into a vortex of heightened sensations, abstract emotions, and artificial energies.

For some, this makes the idea of "rave culture" a contradiction in terms. One might define "culture" as something that tells you where you came from and where you're going, something that nourishes the spirit and generally makes life habitable. Rave provokes this question: is it possible to base a culture around sensations rather than truths, fascination rather than meaning?

For all my believer's ardor, a thread of doubt runs through this book. As an adult with left-liberal allegiances, I worry sometimes whether recreational drug use is any kind of adequate basis for a culture, let alone a counterculture. Is rave simply about the dissipation of utopian energies into the void, or does the idealism it catalyzes spill over into and transform ordinary life? Can the oceanic, "only connect!" feelings experienced on the dance floor be integrated into everyday struggles to be "better at being human"? Learning to "lose your self" can be an enlightenment, but it can also be quite selfish, involving a sort of greed for intense, ravishing experiences.

Dance culture has long been home to two radically opposed versions of what rave is "all about." On one side, the transcendentalist, neopsychedelic discourse of higher planes of consciousness and oceanic merger with Humanity/Gaia/the Cosmos. On the other, Ecstasy and rave music slot into an emergent "rush culture" of teenage kicks and cheap thrills: video games; skateboarding, snowboarding, bunjee jumping, and other "extreme sports"; blockbuster movies whose narratives are merely flimsy frameworks for the display of spectacular special effects.

For all my reservations about the spiritually corrupting and politically retreatist ramifications of rave culture, my own experience is different. Even as I cherish its power to empty my head, I've found this "mindless" music endlessly thought-provoking. And despite its ostensibly escapist nature, rave has actually politicized me, made me think harder about questions of class, race, gender, technology. Mostly devoid of lyrics and almost never overtly political, rave music — like dub reggae and hip-hop — uses sound and rhythm to construct psychic landscapes of exile and utopia. One of this book's themes is the utopian/dystopian dialectic running through Ecstasy culture, the way the hunger for heaven on earth almost always leads to a "darkside" phase of drug excess and paranoia.

Generation Ecstasy strives to combine the thoughtless immediacy of my experiences in the thick of the scene with the "thinking around the subject" that ensued after the heat of the moment. As a history, it's an attempt to chronicle how this extraordinary culture coalesced into being, and to track how those strands have subsequently unraveled to form the current post-rave diaspora. But pulsing inside the text, its raison d'être, is the incandescent memory of amnesiac moments, dance floor frenzies that propelled me outside time and history. Bliss on

detroit techno, c

a tale of three cities

detroit techno, chicago house, and new york garage, 1980-90

Kraftwerk was always very culty, but it was very Detroit too because of the industry in Detroit, and because of the mentality. That music automatically appeals to the people like a tribal calling.... It sounded like somebody making music with hammers and nails." DERRICK MAY, 1992

To promote Kraftwerk's 1991 remixed "greatest hits" compilation *The Mix*, the group's American label, Elektra, came up with an amusing ad: a simulation of the famous one-and-only photo of blues pioneer Robert Johnson, but with his suit filled by a robot's body. The visual pun was witty and eye-catching, but most important, it was *accurate*. Just as Johnson was the godfather of rock's gritty authenticity and wracked catharsis, Kraftwerk invented the pristine, posthuman pop phuture we now inhabit. The story of techno begins not in early-eighties Detroit, as is so often claimed, but in early-seventies Düsseldorf, where Kraftwerk built their KlingKlang sound factory and churned out pioneering synth-and-drum-machine tracks like "Autobahn," "Trans-Europe Express," and "The Man-Machine."

In one of those weird pop-historical loops, Kraftwerk were themselves influenced by Detroit — by the adrenalized insurgency of the MC5 and the Stooges (whose noise, Iggy Pop has said, was partly inspired by the pounding clangor of the Motor City's auto factories). Like the other Krautrock bands — Can, Faust, Neu! — Kraftwerk were also inspired by the mantric minimalism and non-R & B rhythms of the Velvet Underground (whose John Cale produced the first Stooges album). Replacing guitars and drums with synthesizer pulses and programmed beats, Kraftwerk sublimated the Velvets' white light/white heat speed rush into the cruise-control serenity of *motorik*, a metronomic, regular-as-carburetor rhythm that was at once post-rock and proto-techno. "Autobahn" — a twenty-four-minute hymn to the exhilaration of gliding down the freeway that sounded like a cyborg Beach Boys — was (in abbreviated form) a chart smash throughout the world in 1975. Two years later on the *Trans-Europe Express* album, the title track — all indefatigable girder beats and arching, Doppler effect synths — segues into "Metal on Metal," a funky iron

foundry that sounded like a Luigi Russolo Art of Noises megamix for a futurist discotheque.

"They were so stiff, they were funky," techno pioneer Carl Craig has said of Kraftwerk. This paradox — which effectively translates as "they were so white, they were black" — is as close as anyone has got to explaining the mystery of why Kraftwerk's music had such a massive impact on black American youth. In New York, the German band almost single-handedly sired the electro movement: Afrika Bambaataa and Soulsonic Force's 1982 smash "Planet Rock" stole its doomy melody from "Trans-Europe Express" and its beatbox rhythm from Kraftwerk's 1981 track "Numbers." But while New York hip-hop soon abandoned electro's drum machines for seventies funk breakbeats, Kraftwerk had a more enduring impact in Detroit. Their music's Teutonic rigor and glacial grandeur plugged into the Europhile tastes of arty middle-class black youth and fired the imaginations of three high school friends — Juan Atkins, Derrick May, and Kevin Saunderson — who together invented Detroit techno. From Cybotron's 1982 "Cosmic Cars" to Carl Craig's 1995 Autobahn homage Landcruising, the Detroit sound still fits May's famous description: "like George Clinton and Kraftwerk stuck in an elevator with only a sequencer to keep them company".

"When I first heard synthesizers dropped on records it was great... like UFOs landing on records, so I got one," Juan Atkins has said. "It wasn't any one particular group that turned me on to synthesizers, but 'Flashlight' [Parliament's number one R & B hit from early 1978] was the first record I heard where maybe 75 percent of the production was electronic."

Atkins was then a sixteen-year-old living in Belleville, a small town thirty miles from Detroit, and playing bass, drums, and "a little bit of lead guitar" in various garage funk bands. He had befriended Derrick May and Kevin Saunderson three years earlier. "In Belleville," remembers Saunderson, "it was pretty racial still at that time, there wasn't a lot of black people there. So we three kind of gelled right away." Atkins became May's musical mentor, hipping him to all kinds of weird shit — Parliament-Funkadelic, Kraftwerk, Gary Numan, Giorgio Moroder, even quirky American New Wave like the B-52's.

Although the music they were into was all dance floor oriented, the "Belleville Three" — as Atkins, May, and Saunderson were later to be mythol-

ogized — brought an art-rock seriousness to bear on what rock fans then dissed as mere "disco." "For us, it was always a dedication," says May. "We used to sit back and philosophize on what these people thought about when they made their music, and how they felt the next phase of the music would go. And you know, half the shit we thought about the artist never even fucking thought about! . . . Because Belleville was a rural town, we perceived the music differently than you would if you encountered it in dance clubs. We'd sit back with the lights off and listen to records by Bootsy and Yellow Magic Orchestra. We never just took it as entertainment, we took it as a serious philosophy."

The Belleville Three belonged to a new generation of Detroit-area black youth who grew up accustomed to affluence, thanks in part to the racially integrated United Auto Workers union. "My grandfather worked at Ford for twenty years, he was like a career auto worker," says Atkins. "A lot of the kids that came up after this integration, they got used to a better way of living. If you had a job at the plant at this time, you were making bucks. And it wasn't like the white guy standing next to you is getting five or ten dollars an hour more than you. Everybody was equal. So what happened is that you've got this environment with kids that come up somewhat snobby, 'cos hey, their parents are making money working at Ford or GM or Chrysler, been elevated to a foreman, maybe even to a white-collar job." The Europhilia of these middle-class black youths, says Atkins, was part of their attempt "to distance themselves from the kids that were coming up in the projects, the ghetto."

Eddie Fowlkes — soon to become the fourth member of the Belleville clique, despite being from a rougher area of Detroit — remembers that kids from the posher West Side of Detroit "were more into slick clothes and cars. They were into stuff like Cartier and wearing all the shit they read about in *GQ*. And it all kind of snowballed into a scene, a culture." According to Jeff Mills — a ruling DJ/producer in the nineties but then in his last year of high school — *American Gigolo* was a hugely influential movie on these Euro-fashion-obsessed black youth, just for the chic lifestyle and massive wardrobe of Richard Gere's lead character.

One expression of this upwardly mobile subculture was clubs and dance music. These weren't nightclubs but high school social clubs with names like Snobs, Brats, Ciabattino, Rafael, and Charivari, who would hire spaces and throw parties. Charivari was named after a New York clothing store and is said to have recorded the first Detroit techno track, titled "Shari Vari," just to play at its own parties. The social club kids were "obsessed with Italian 'progressive' music — Italian disco, basically," says Carl Craig, another early acolyte of May and Atkins. Dubbed "progressive" because their music stemmed from Giorgio Moroder's synth-and-drum-machine-based Eurodisco, rather than the symphonic Philly sound, Italian artists like Alexander Robotnik, Klein and MBO and Capricorn filled the gap left by the death of disco in America. On the Detroit dance party circuit, you would also hear electro-funk from New York labels like West End and Prelude, English New Romantic and Euro-synthpop artists like Visage, Yello, and Telex, and American New Wave from Devo and Talking Heads. "Man, I don't know if this could happen nowhere else in the country but Detroit," laughs Atkins. "Can you imagine three or four hundred black kids dancing to the B-52's' 'Rock Lobster'?"

Another factor that shaped Detroit youth's Europhile tastes was the influential radio DJ Charles Johnson, "the Electrifyin' Mojo," whose show "The Midnight Funk Association" aired every night on WGPR through the late seventies and early eighties. Alongside synth-driven funk by Prince, Mojo would play Kraftwerk's "Tour De France" and other Euro electro-pop. Every night, Mojo would do his Mothership spiel, encouraging listeners to flash their headlights or bedroom lamp so that the intergalactic craft would know where to touch down. "He had the most magnanimous voice you ever heard," remembers Derrick May. "This guy would just overpower you with his imagination. You became entranced by the radio."

Around 1980, Atkins and May started making tentative steps toward becoming DJs themselves. "Juan and I started messing around with the idea of doing our own personal remixes, as a joke, using a pause button, a tape deck, and a basic turntable. Just taking a record and pausing it up, doing edits with the pause button. We got damn good at it. That led to constant experimentation, constantly freaking out, trying all kinds of crazy shit. And Juan thought, 'damn, man, let's go to the next level, start up our own DJ company.' We found a guy who owned a music studio, a sort of rental place, hiring out gear. And he was nice enough to give us a room in back and set up a pair of turntables and speakers, and let us just have hours. Didn't charge us a dime! In that room, Juan would teach me how to mix. I remember the two records I learned how

to mix with: David Bowie's 'Fashion' and Edwin Birdsong's 'Rapper Dapper Snapper.' I had to mix those records for weeks, with Juan, like, *in my ass*, every time I fucked up!"

Calling themselves Deep Space Soundworks, Atkins and May played their first DJ engagement in 1981, at a party thrown by a friend of Derrick's, as warm-up for Detroit's most famous DJ, Ken Collier. "It was *packed*, but nobody was dancing," remembers May. "We were spinning 45s [7-inches] and we didn't even have slipmats on the turntable. Collier took over, and man, the dance floor filled in 2.2 seconds. It was the most embarrassing, humbling experience of our lives!"

In the early eighties Detroit had a huge circuit of parties, and the competition among the fifty or so DJs in town was fierce. Every weekend there were several parties, often organized around concepts (for instance, everyone wearing the same color). "Everywhere you went you had to be on your shit, because Detroit crowds were so particular, and if you really weren't throwing down or you had a fucked-up mix, people would look at you and just walk off the dance floor. And that's how we developed our skills, 'cos we had no room for error. These people wouldn't accept it." May and Atkins applied the same kind of theoretical intensity to the art of mixing and set building that they'd once invested in listening to records. "We built a philosophy behind spinning records. We'd sit and think what the guy who made the record was thinking about, and find a record that would fit with it, so that the people on the dance floor would comprehend the concept. When I think about all the brainpower that went into it! We'd sit up the whole night before the party, think about what we'd play the following night, the people who'd be at the party, the concept of the clientele. It was insane!"

Eventually, the social club party scene got so successful that the *GQ* kids found that an undesirable element began to turn up: the very ghetto youth from the projects that they'd put so much energy into defining themselves against. That was when the clubs started putting the phrase "no jits" on the flyers — "jit" being short for "jitterbug," Detroit slang for gangsta.

"They would put 'no jits allowed,' "says May, "but how you gonna tell some 250-pound ruffneck, standing about six foot four, 'you're not coming to my party' — when you're some little five foot two pretty boy? I don't think so! He's coming in! It was a *hope* that they wouldn't come! It was to make them

feel unwanted. . . . West Side kids and the whole elite high school scene just wanted to keep this shit to themselves. . . . It was the beginning of the end. That's when the guns started popping up at the parties, and fights started happening. By '86, it was over."

Prior to forming Deep Space, Juan Atkins had already started making music as one half of Cybotron. Studying music and media courses at Washtenaw Community College in Ypsilanti, Michigan, he befriended fellow student Rick Davis. Older than Atkins, Davis was an eccentric figure with a past: in 1968, he'd been shipped out to Vietnam just in time to experience the Tet offensive. Davis and Atkins discovered they had interests in common — science fiction, futurologists like Alvin Toffler, and electronic music. Prior to Cybotron, Davis had done experimental electronic tracks on his own, but like a lot of Viet vets he also had a heavy acid rock background. He was a huge fan of Hendrix.

Although both Atkins and Davis shared instrumental duties and contributed lyrics and concepts, Atkins's focus was on "putting the records together," making Cybotron tracks work as dance music. Davis handled a lot of the "philosophical aspects" of what was a highly conceptual project. He'd cobbled together a strange personal creed out of Alvin Toffler's *The Third Wave* and the Zohar (the "Bible" of classical Jewish Kabbalah). The gist of it was that, through "interfacing the spirituality of human beings into the cybernetic matrix," you could transform yourself into a suprahuman entity. In line with Zoharian numerology, Davis changed his name to 3070. Atkins and Davis also devised their own technospeak dictionary, the Grid, inspired by video game terminology. "We conceived of the environment as being like the Game Grid," says Atkins. "Certain images in a video program are referred to as 'sprites,' and Cybotron was considered a 'super-sprite' with extra powers."

Independently influenced by the same Euro sounds, Cybotron's cold, synth-dominated sound and drum machine rhythms paralleled the electro then emerging from New York. Their first single, "Alleys of Your Mind" — released on their own Deep Space label in 1981 — became a big hit in Detroit, selling around fifteen thousand copies. The next two singles, "Cosmic Cars" and

"Clear," did even better, resulting in Cybotron being signed by the Berkeley, California, label Fantasy, which released the *Clear* album.

In Detroit, everybody assumed Cybotron were white guys from Europe. And indeed, apart from a subliminal funk pulsing amid the crisp-and-dry programmed beats, there was scant evidence to suggest otherwise. Davis's vocals had the Angloid/android neurosis of a John Foxx or Gary Numan, making Cybotron the missing link between the New Romantics and William Gibson's Neuromancer. But for all their futuristic mise-en-scène, the vision underlying Cybotron songs was Detroit-specific, capturing a city in transition: from industrial boomtown to post-Fordist wasteland, from US capital of auto manufacturing to US capital of homicide. Following the late-sixties and early-seventies syndrome of "white flight" to the suburbs, the decline of the auto industry, and the degentrification of once securely middle-class black districts, Detroit's city center had become a ghost town.

With its dominant mood of paranoia and desolation, Cybotron's tech-noir should have been the soundtrack to *Robocop*, the sci-fi movie set in a grim near-future Detroit. Songs like "Alleys of Your Mind" and "Techno City" were "just social commentary, more or less," says Atkins, citing "thought control" and the "double-edged sword" of technology as Cybotron major preoccupations. Lyrics like "don't you let them robotize your behind" — from the gloomfunk epic "Enter" — testify to an ambivalent investment in technology. As Atkins puts it, "With technology, there's a lot of good things, but by the same token, it enables the powers that be to have more control."

"Techno City" was inspired by Fritz Lang's vision in *Metropolis* of a future megalopolis divided into privileged sectors high up in the sky and subterranean prole zones. According to Davis, Techno City was equivalent to Detroit's Woodward Avenue ghetto; its denizens dreamed of working their way up to the cybodrome, where the artists and intellectuals lived. Again, this was a thinly veiled allegory of the unofficial apartheid taking shape in urban America, with the emergence of privately policed fortress communities and township-like ethnic ghettos.

Perhaps the most extreme expression of Cybotron's ambivalent attitude to the future — half anticipation, half dread — was "R9," a track inspired by a chapter in the Bible's Book of Revelation. "What you have on the record is the War of Armageddon," laughs Atkins. But despite the track's jagged gouts of

dissonance, hideously warped textures, and background screams for "Help!," this is no nightmare vision of the future, says Atkins. "For the people who don't have anything, any kind of change is good. There's two ways of looking at it."

After recording the apocalyptic "Vision," Cybotron split. Davis — "the Jimi Hendrix of the synthesizer," according to Atkins — wanted to go in a rock direction. So Atkins started working on his own material as Model 500. Setting up his own label, Metroplex, he put out "No UFO's"; the sound, Motor City motorik, was harder and faster than Cybotron, streamlined and austere, with ciphered vocals demoted low in the mix. Then Eddie Fowlkes — now calling himself Eddie "Flashin'" Fowlkes — decided he wanted to make a record too; his "Goodbye Kiss" was the second Metroplex release. Derrick May had conceived of himself primarily as a DJ: he'd enjoyed some success outside Deep Space, spinning at a club called Liedernacht and on the radio. But he too pitched in with "Let's Go," Metroplex's third release. Finally, Kevin Saunderson joined the fray with "Triangle of Love," recorded under the name Kreem.

Although the clique was tight, pooling its limited equipment and helping out on each other's records, there was friction. Soon, each member of the Belleville Three was running his own record label. May's Transmat began as a sublabel imprint of Metroplex. Saunderson started his own label, KMS, which stood for Kevin Maurice Saunderson. "I was working a security job at a hospital and running my business from telephone booths and hospital phones," he remembers. Eventually, all three labels settled in close vicinity to each other in Detroit's Eastern Market district.

With their cottage-industry independence and futuristic output created via low-level technology, the Belleville Three fit the model of "Techno Rebels" proposed by Alvin Toffler in *The Third Wave*. Rejecting Luddite strategies, these renegades embraced technology as a means of empowerment and resistance against the very corporate plutocracy that invented and mass-produced these new machines. And so Juan Atkins described himself as "a warrior for the technological revolution." But songs like "Off to Battle" were aimed as much at rival cottage industrialists as against the larger powers — the track was "a battle cry to 'keep the standards high,' " says Atkins, addressed to "amateur electronic artists."

Where Model 500 records were icy and eerie, Derrick May's music—as Mayday and Rythim Is Rythim—added a plangent, heart-tugging poignancy to the distinctively dry minimalism of the Detroit sound. On tracks like the elegantly elegiac "It Is What It Is" he pioneered the use of quasi-symphonic string sounds. In one case, they were genuinely symphonic: "Strings of Life" was based on samples from the Detroit Symphony Orchestra. May reworked these orchestral stabs into a sort of cyber-Salsa groove. His own phrase was "twenty-third-century ballroom music."

Atkins and May both attribute the dreaminess of Detroit techno to the desolation of the city, which May describes in terms of a sensory and cultural deprivation. "It's the emptiness in the city that puts the wholeness in the music. It's like a blind person can smell and touch and sense things that a person with eyes would never notice. And I tend to think a lot of us here in Detroit have been blind to what was happening around us. And we sort of took those other senses and enhanced them, and that's how the music developed." Hence the oddly indefinable emotions in May tracks like "Nude Photo" and "Beyond the Dance," the weird mix of euphoria and anxiety.

Having grown up in New York until he moved to the Detroit area in his early teens, Kevin Saunderson was the most disco-influenced of the Belleville Three. His tracks — released under a plethora of aliases, including Reese, Reese and Santonio, Inter City, Keynotes, and E-Dancer — had titles as baldly self-descriptive as the music was stripped down: "The Sound," "Rock to the Beat," "Bassline," "Funky, Funk, Funk." Of the three, Saunderson had the sharpest commercial instincts and the greatest commercial success. But he also produced the darkest avant-funk of the early Detroit era, with Reese's "Just Want Another Chance."

Recorded in 1986, the track was inspired by Manhattan's celebrated proto-house club Paradise Garage, which Saunderson would visit when he returned to New York to see his older brothers. "I used to imagine what kind of sound I would like to have coming out of a system like that," he remembers, referring to the infamously low-end intensive, tectonic plate—shaking sound system. "It made me vibe that kind of vibe." Over a baleful black-hole bass line running at about half the speed of the drum program, Saunderson intones the guttural monologue of some kind of stalker or love addict. "I just started thinking about this cat in a relationship, how this person was deep with this other

person, really wanted to be with them, and kind of screwed up." The "Reese bass" has since been resurrected and mutated by a number of artists in the nineties, most notably by darkside jungle producers Trace and Ed Rush.

Displaying the kind of canny, market-conscious versatility that would characterize his whole career, Kevin Saunderson also turned out tracks as light and upful as Inner City's "Big Fun" and "Good Life" — to date, Detroit techno's biggest hits. "Big Fun" was spawned almost accidentally out of the collaborative symbiosis that characterized Detroit's incestuous and interdependent scene. James Pennington — soon to release tracks for Transmat under the name Suburban Knight — made a bass-line round at Kevin's apartment, left it on tape, and went to work. "Kevin said, 'Let me use this, man,' " remembers Eddie Fowlkes. "James said, 'Okay, just put my name on it.' Next thing you know, you got Inner City." With Art Forest cowriting, Chicago-based diva Paris Grey singing the melody, and Juan Atkins mixing the track down, the result was "Big Fun."

"It was real tight," Fowlkes fondly recalls of this golden age of Detroit. "Everyone was helping each other out, there was no egos, and nobody could compete with Juan because he had already done stuff as Cybotron and knew where he wanted to go. We were just like kids following the Pied Piper."

Detroit techno came to the world's attention indirectly, as an adjunct to Chicago's house scene. When British A & R scouts came to Chicago to investigate house music in 1986–87, they discovered that many of the top-selling tracks were actually from Detroit. "We would sell ten to fifteen thousand records in Chicago alone," says Juan Atkins. "We were selling more records in Chicago than even Chicago artists. We kind of went hand in hand with the house movement.

"Chicago was one of a couple of cities in America where disco never died," Atkins continues. "The DJs kept playing it on radio and in the clubs. And since there were no new disco records coming through they were looking to fill the gap with whatever they could find." This meant Euro synth pop, Italian "progressive," and eventually the early Detroit tracks. The Belleville Three quickly got to know everybody in the Chicago scene. And they started to make the four-hour drive to Chicago every weekend to hear the Hot Mix Five — Farley

Jackmaster Funk, Steve Silk Hurley, Ralphi Rosario, Mickey Oliver, and Kenny Jason — spin on local radio station WBMX.

Bar the odd session that May would do for Electrifyin' Mojo, you couldn't hear this kind of DJ cut 'n' mix on the radio in Detroit. Despite its Europhile tendencies, Detroit was always more of a funk city than a disco town. This difference came through in the music: the rhythm programming in Detroit techno was more syncopated, had more of a groove. House was propelled by a metronomic, four-to-the-floor beat, what Eddie Fowlkes calls "a straight straight foot" — a reference to the mechanical kick drum that Chicago DJs like Farley "Jackmaster" Funk and Frankie Knuckles would superimpose over their disco mixes. Where Chicago house tended to feature disco-style diva vocals, Detroit tracks were almost always instrumentals. The final difference was that Detroit techno, while arty and upwardly mobile, was a straight black scene. Chicago house was a gay black scene.

Disco music is a disease. I call it Disco Dystrophy. The people victimized by this killer disease walk around like zombies. We must do everything possible to stop the spread of this plague. DJ STEVE DAHL, 1979

At the height of "disco sucks" fever in 1979, Chicago's Comiskey Park baseball stadium was the site of a "Disco Demolition Derby," organized by Detroit DJ Steve Dahl, which took place halfway through a doubleheader between the Chicago White Sox and the Detroit Tigers. When the 100,000 plus records were dynamited, discophobic mobs stormed the field. The rioting and postexplosion debris resulted in the game being forfeited to the Tigers.

The "Disco Sucks" phenomenon recalls Nazi book burnings or exhibitions of Degenerate Art. Modern-day spectacles of Kulturkampf like Comiskey were impelled by a similar disgust: the belief that disco was rootless, inauthentic, decadent, a betrayal of the virile principles of the true American *volk* music, rock 'n' roll. Hence T-shirts like "Death Before Disco" and organizations like

DREAD (Detroit Rockers Engaged in the Abolition of Disco) and Dahl's own "Insane Coho Lips Antidisco Army."

Discophobia wasn't limited to white rockers, though; many blacks despised it as a soulless, mechanistic travesty of da funk. And so the sleeve of Funkadelic's 1979 album *Uncle Jam Wants You* bore the slogan "it's the rescue dance music 'from the blahs' band." Funkateer critic Greg Tate coined the term "DisCOINTELPRO" — a pun on the FBI's campaign to infiltrate black radical organizations like the Panthers — to denigrate disco as "a form of record industry sabotage ... [which] destroyed the self-supporting black band movement out of which P-Funk ... grew." In 1987, Public Enemy's Chuck D articulated hip-hop's antipathy to house, disco's descendant, declaring: "it's sophisticated, anti-black, anti-feel, the most *artificial* shit I ever heard. It represents the gay scene, it's separating blacks from their past and their culture, it's upwardly mobile."

Chicago house music was born of a double exclusion, then: not just black, but gay and black. Its cultural dissidence involved embracing a music that the majority culture deemed dead and buried. House didn't just resurrect disco, it intensified the very aspects that most offended the discophobes: the mechanistic repetition, the synthetic and electronic textures, the rootlessness, the "depraved" hypersexuality and "decadent" drugginess. Stylistically, house assembled itself from disregarded and degraded pop-culture detritus that the mainstream considered passé, disposable, un-American: the proto-disco of the Salsoul and Philadelphia International labels, English synth-pop, and Moroder's Eurodisco.

If Düsseldorf was the ultimate source for Detroit techno, you could perhaps argue that the prehistory of house begins in Munich, where Giorgio Moroder invented Eurodisco. Setting up Say Yes Productions with British guitarist Pete Bellote, Moroder recruited Donna Summer, then singing in rock musicals like Hair and Godspell, and transformed her into a disco ice queen. Moroder can claim three innovations that laid the foundations for house. First, the dramatically extended megamix: 1975's seventeen-minute-long orgasmotronic epic "Love to Love You Baby." Second, the four-to-the-floor disco pulse rhythm: Moroder used a drum machine to simplify funk rhythms in order to make them easier for whites to dance to. Third and most crucial was Moroder's creation of purely electronic dance music. One of his earliest songs — "Son of My Fa-

ther," a 1972 UK number one for Chicory Tip — was one of the very first synth-pop hits. But it was Donna Summer's 1977 global smash "I Feel Love" that was the real revolution. Constructed almost entirely out of synthesized sounds, "I Feel Love" had no verse or chorus laid out in advance; Summer improvised her gaseous, eroto-mystic vocals over Moroder and Bellote's gridlike juggernaut of percussive pulses and clockwork clicks. The result, at once pornotopian and curiously unbodied, was acid house and trance techno avant la lettre.

In the absence of fresh disco product, Chicago DJs had to rework the existing material into new shapes. House — a term that originally referred to the kind of music you'd hear at the Warehouse, a gay nightclub in Chicago — was born not as a distinct genre but as an approach to making "dead" music come alive, by cut 'n' mix, segue, montage, and other DJ tricks. Just as the term disco derived from the discotheque (a place where you heard recorded music, not live performances), house began as a disc jockey culture. In fact, it was an imported DJ culture, transplanted from New York by Frankie Knuckles, who DJ-ed at the Warehouse from 1979 until 1983.

Born in 1955, Knuckles grew up in the South Bronx. At Nicky Siano's underground dance club, the Gallery, Knuckles helped out by, among other things, spiking the punch with LSD and even going so far as to inject the drug into the free fruit. Knuckles DJ-ed for several years in the early seventies alongside another future "deep house" legend, Larry Levan - at the Continental Baths, a gay "pleasure palace," and then at the club SoHo. Levan was originally the first choice of the Chicago entrepreneurs who set up the Warehouse. But when Levan decided to stay on in New York, Knuckles moved to Chicago to take up the DJ spot in early 1977. A three-story former factory in West Central Chicago, the Warehouse drew around two thousand hedonists, mostly gay and black, to dance from midnight Saturday to midday Sunday. It was here that Knuckles began to experiment with editing disco breaks on a reel-to-reel tape recorder, reworking and recombining the raw material -Philadelphia International classics, underground club hits on the Salsoul label by the likes of Loleatta Holloway and First Choice, Moroder-beat — that would soon evolve into house.

In 1983, the Warehouse's promoters doubled the four-dollar entrance fee, prompting Knuckles to quit and set up his own Friday-night club, the Power Plant. The Warehouse retaliated by opening another Saturday club, the Music

Box, DJ-ed by a young kid from California called Ron Hardy. Playing in a rawer style than Knuckles, Hardy created an even more intense and disorienting atmosphere. Using two copies of the same record, he'd stretch a track out into a Tantric eternity, teasing the audience by endlessly delaying the breakdown. Unlike the Detroit scene, where drug taking was the exception, Chicago house went hand in hand with stimulants and hallucinogens. People smoked pot, sniffed poppers (also known as "rush"), and snorted cocaine. Acid was popular because it was cheap and long-lasting and the blotters were easily concealed. And some clubbers smoked "happy sticks," reefers dipped in angel dust (the deliriant hallucinogen PCP). At the rougher and more hardcore hedonist Music Box, where it got so hot people tore their shirts off, the vibe was dark.

With other regular parties emerging, competition between DJs grew fierce. To get an edge over their rivals, DJs would devise more complicated mixing tricks and employ special effects, like Frankie Knuckles's steam locomotive sound. Both Farley and Knuckles started to use a live drum machine to bolster their mixes and make the experience more hypnotic. The stomping four-to-the-floor kick drum would become the defining mark of house music. Other elements — hissing hi-hat patterns, synthetic hand-claps, synth vamps, chiming bass loops, drumrolls that pushed the track to the next plateau of preorgasmic intensity — emerged when Chicagoans started making records to slake the DJs' insatiable demand for fresh material. Called "tracks" as opposed to songs, because they consisted of little more than a drum track, this protohouse music was initially played by DJs on reel-to-reel tape and cassette.

Although many have claimed the title of "first house track," most agree that the first vinyl release was Jesse Saunders and Vince Lawrence's "On and On" (a raw, ultraminimal version of the Salsoul classic by First Choice), which the duo put out in 1983. Saunders and Lawrence approached Larry Sherman, a local entrepreneur who had bought out Chicago's only record-pressing plant, and asked him to press up five hundred 12-inches for them on trust. They promised to return within twenty minutes and pay him \$4 per disc. Not only did they come back and pay him in full, they also asked him to press another thousand copies.

Stunned by the demand for this new music in Chicago, Sherman started the Trax label and debuted with another Jesse Saunders track, "Wanna Dance," released under the name Le Noiz. Sherman's role in the genesis of house is much disputed. Some regard him as a visionary entrepreneur who fostered the

scene and provided work for the musicians in the day-to-day operations of Trax.

Others accuse Sherman of pursuing short-term profit and neglecting the long-term career prospects of their artists, thereby contributing to the premature demise of the Chicago scene in the late eighties.

In the mid-eighties, though, Trax and the other leading Chicago house label, DJ International, played a major role not just in developing a local market for house tracks, but also in getting the records distributed to other cities in America and to Europe. It was a DJ International track — Farley "Jackmaster" Funk and Jesse Saunders's "Love Can't Turn Around," a cover of an Isaac Hayes song — that became the first international house hit, making the UK top ten in September 1986. Propelled by a bass line made out of what sounds like a sampled tuba motif and by almost boogie-woogie piano vamps, "Love Can't Turn Around" features the fabulously overwrought histrionics of Darryl Pandy, whose hypermelismatic vocals are the missing link between gospel and gender-bending male diva Sylvester, the disco star responsible for "You Make Me Feel (Mighty Real)."

Other hits followed in early 1987: "Jack the Groove" by the DC-based Raze made it to number twenty in the UK, and Steve Silk Hurley's "Jack Your Body" was a number one smash in January. But by the middle of that year, house seemed to be petering out like any other clubland fad. The self-reflexive song titles, which usually included the words "house" and "jack" (the Chicago style of palsied dancing), seemed to place house in the pop tradition of dance crazes like the Twist and the Mashed Potato, novelties with built-in obsolescence. House's depthless doggerel (catchphrases like "work your body," "move your body") and sonic gimmicks (the stutter effect often put on vocals) were impressively posthuman and depersonalized, but quickly became irritating. At the time I thought that house, compared with hip-hop, didn't have much of a future. I was dead wrong, of course, for what we'd heard so far was only the tip of the iceberg. House was the future.

"Love Can't Turn Around" and "Jack Your Body," early house's two biggest hits, represented the two sides of house: songs versus tracks, an R & B-derived tradition of soulful expression versus depersonalized functionalism. For me, it's the "tracks" that ultimately proved to be the most interesting side of

house culture. The songful style of "deep" house rapidly collapsed into an affirmation of traditional musicianly values and uplifting humanist sentiments. But "jack tracks," and the "acid tracks" that followed them, honed in on a different potential latent within disco: jettisoning all the residues of soul and humanity, this was machine music without apology, machine-made music that turned you into a machine. Its mind-nullifying repetition offered liberation through trance-dance.

In many ways, the trippy, track-oriented side of house was a flashback to the white avant-funk and experimental electronic music of the early eighties, when post-punks in England and New York turned to black dance styles. Many of the avant-funksters enjoyed substantial success when they reinvented themselves as key members of the first wave of British homegrown house later in the eighties. A Certain Ratio's Simon Topping teamed up with another Mancunian avant-disco veteran, Quando Quango's Mike Pickering, to record the Brit-house favorite "Carino" as T-Coy; Pickering went on to lead the hugely popular but more songful M People. Cabaret Voltaire's Richard Kirk reappeared as Sweet Exorcist; 400 Blow's Tony Thorpe purveyed UK acid house as Moody Boys; Biting Tongues' Graham Massey became the musical brains behind 808 State.

Perhaps the most prophetic of the early-eighties avant-funk outfits was Düsseldorf's D.A.F., who began as an experimental industrial unit, then stripped down their chaotic sound to a harsh, homoerotic avant-disco influenced by the New Savagery ideas of artist Joseph Beuys. On their three Virgin albums, the inelastic synth pulses and frigid frenzy of the beats uncannily anticipate acid house. D.A.F. and the similar group Liaisons Dangereuses actually had some currency in the early Chicago scene. Their sinewy sound embodied an idea — the dance floor as a gymnasium of desire, liberation achieved through submission to a regime of strenuous bliss — that was latent in gay disco's erotics. From the Village People's "In the Navy" to D.A.F.'s "Der Mussolini" ("dance der Mussolini/dance der Adolf Hitler"), disco often used "the language of recruitment and evangelism" (Walter Hughes) to bring out both the homoerotics of discipline and the ecstasy of being enthralled by the beat.

As house music evolved, this idea — achieving freedom by abandoning subjectivity and self-will — became more explicit. Gradually, the hypersexual imagery was supplanted by a postsexual delirium, reflected in the Chicago

dancing style known as "jacking." In disco, dance had gradually shed its role as courtship ritual and opened up into unpaired freestyle self-expression. Jacking took this to the next stage, replacing pelvic thrust and booty shake with a whole-body frenzy of polymorphously perverse tics and convulsive pogo-ing.

Etymologically, "jack" seems to be a corruption of "jerk" but also may have some link to "jacking off." The house dance floor suggests the circle jerk, a spectacle of collective autoeroticism, sterile *jouissance*. "Jacking" also suggests jacking into an electrical circuit and recalls the "console cowboys" in William Gibson's *Neuromancer* who jack into cyberspace via direct neurological interface. Plugged into the sound system, the house jacker looks a bit like a robot with epilepsy. In jack tracks like Fast Eddie Smith's "Jack to the Sound," lyrics are restricted to terse work-that-body commands. Eventually acid house bypassed verbals altogether and proceeded to what felt like direct possession of the nervous system via the bass-biology interface.

Robotnik vacancy, voodoo delirium, whirling dervishes, zombiedom, marionettes, slaves to the rhythm: the metaphors that house music and "jacking" irresistibly invite all contain the notion of becoming less than human. Other aspects of the music exacerbate the sense of attenuated selfhood. With a few exceptions, house singers tend to be ciphers, their vocals merely plastic material to be manipulated by the producer. In early house, the vocals were often garbled, sped-up and slowed down, pulverized into syllable- or phoneme-size particles, and above all subjected to the ubiquitous, debasing stutter effect, whereby a phrase was transformed on the sampling keyboard into a staccato riff. In Ralphi Rosario's "You Used to Hold Me," diva Xavier Gold is initially in the spotlight, playing the role of gold-digging, vengeful lover. But then producer Rosario takes control, vivisecting Gold's vocal so that stray vowels and sibilants bounce like jumping beans over the groove, and transforming one syllable of passion into a spasmic Morse code riff.

House makes the producer, not the singer, the star. It's the culmination of an unwritten (because unwritable) history of black dance pop, a history determined not by sacred cow auteurs but by producers, session musicians, and engineers — backroom boys. House music takes this depersonalization further: it gets rid of human musicians (the house band that gave Motown or Stax or Studio One its distinctive sound), leaving just the producer and his machines. Operating as a cottage factory churning out a high turnover of tracks,

the house producer replaces the artist's signature with the industrialist's trademark. Closer to an architect or draftsman, the house auteur is absent from his own creation; house tracks are less like artworks, in the expressive sense, than vehicles, rhythmic engines that take the dancer on a ride.

As well as being post-biographical, house is post-geographical pop. If Chicago is the origin, it's because it happens to be a junction point in the international trade routes of disco. Breaking with the traditional horticultural language we use to describe the evolution of pop — cross-pollination, hybridization — house's "roots" lie in deracination. The music sounds inorganic: machines talking to each other in an unreal acoustic space. When sounds from real-world acoustic sources enter house's pleasuredome, they tend to be processed and disembodied — as with the distortion and manipulation inflicted on the human voice, evacuating its soul and reducing it to a shallow effect.

But this is only one side of house culture. Just as important was the humanist, uplifting strain of "deep house" that affiliated itself with the R & B tradition, combining Philly's silky symphonic strings and mellifluous vocals with gospel's imagery of salvation: songs like Sterling Void's "It's Alright", and Joe Smooth's "Promised Land" and album *Rejoice*. In house, there's a divide between finding yourself (through becoming a member of the house) and losing yourself (in solipsistic hallucinatory bliss). This split could be compared to the tension in gay culture between the politics of pride, unity, and collective resilience, and the more hardcore "erotic politics" of impersonal sexual encounters, "deviant" practices, and drugs.

House offered a sense of communion and community to those whose sexuality might have alienated them from organized religion. Frankie Knuckles described the Warehouse as "church for people who have fallen from grace," while another house pioneer, Marshall Jefferson, likened house to "old-time religion in the way that people just get happy and screamin'." Male divas like Daryl Pandy and Robert Owens had trained in church choirs. In "deep house" the inspirational lyrics often echo the civil rights movement of the sixties — Joe Smooth's "Promised Land" and Db's "I Have a Dream" explicitly evoke Martin Luther King — conflating the quest for black civic dignity with the struggle for gay pride. In the Children's "Freedom," a spoken-word monologue beseeches "don't oppress me" and "don't judge me," and asks, bewildered and vulnerable: "can't you accept me for what I am?" The name the Children

itself comes from Chicago house slang: to be a "child" was to be gay, a member of house's surrogate family.

In other house tracks, spiritual redemption and sexual rapture are fused in a kind of eroto-mystic delirium. Jamie Principle's "Baby Wants to Ride" begins with a prayer, then the Voice of God declares that it's time to relate "the Revelation of my Second Coming." But the "coming" is decidedly profane: an encounter with a dominatrix, who strips Principle, makes him beg, then rides him through a porno-copia of sexual positions. Principle revels in the passivity of being a sexual object, feyly gasping: "She took me . . . She made me scream." Not content with blasphemously conflating S/M with the Book of Revelation, "Baby Wants to Ride" adds politics to liberation theology: Principle exhorts the South African government to set his people free, disses AmeriKKKa as a "bullshit land," and complains that it's hard to ride "when you're living in a fascist dream."

In Fingers Inc's "Distant Planet," this longing for sanctuary from racial and sexual oppression takes the form of cosmic mysticism, à la Sun Ra. The distant planet is a place "where anyone can walk without fear"; if you're treated like an alien, you wanna go where the aliens feel at home. This eerie track has a mood of desolate utopianism. Larry Heard, the musical brain behind Fingers Inc, is an interestingly conflicted house auteur. With its nimble-fingered fluency and overmelismatic Robert Owens vocals, most Fingers Inc output reflects Heard's background as a jazz/R & B drummer and keyboardist reared on jazz-fusion and progressive rock. Songs like "Mysteries of Love," "Another Side," and "A Path" are the electro-blues of a spiritual seeker. Yet Heard's most thrilling music took the form of the brutally dehumanized and mechanistic tracks he released under the alias Mr. Fingers. "Washing Machine" — an interminable brain-wash cycle of burbling bass loops and jarringly off-kilter hihats — is a mantra for a state of mindlessness.

The machinic, trance-inducing side of house exemplified by "Washing Machine" took another turn in 1987, when jack tracks evolved into "acid tracks": a style defined by a mind-warping, wibbly bass sound that originated from a specific piece of equipment, the Roland TB 303 Bassline. The Roland 303 was originally put on the market in 1983 as a bass-line synthesizer designed to partner the Roland 606 drum machine, and targeted at guitarists who wanted

bass lines to jam off. It was singularly unsuited for this purpose, and by 1985 Roland ceased manufacturing the machine. But a few Italian disco producers discovered the 303's potential for weird Moroder-esque sounds: Alexander Robotnik's "Les Problèmes d'Amour," released in 1983, was a huge "progressive" hit in Chicago, selling around twelve thousand import copies. A few years later, house producers — already enamored of Roland drum machines and synths — started messing around with the 303, discovering applications that the manufacturers had never imagined.

The 303 is a slim silver box with a one-octave keyboard (but a four-octave range) and six knobs that control such parameters as "decay," "accent," "resonance," "tuning," "envelope modulation," and "cut-off frequency." Having programmed a bass riff on the keyboard, you tweak the knobs to modulate the pitch, accent, "slide," and other parameters of each individual note in the bass line. The result is bass patterns as polytendrilled and trippy as a computer fractal, riddled with wriggly nuances, smeary glissandi, curlicues, and whorls. Precisely because programming the machine is so complicated, the 303 tends to generate inspired errors and happy accidents, in much the same way that chaos theory generates complex phenomena out of simple iterated processes.

The first Chicago 303 track, Phuture's "Acid Tracks," was released in 1987. DJ Pierre, Spanky, Marshall Jefferson, and Herb Jackson were messing around with a 303, hoping to get a conventional bass line for a Spanky rhythm track. "The acid squiggle was there to start with," Pierre has said. "The machine already had that crazy acid sound in it that you were supposed to erase and put your own in, because it was just some MIDI gerbil. But we liked it." Eleven minutes and seventeen seconds long, "Acid Tracks" is just a drum track and endless involuted variations on that bass sound: somewhere between a fecal squelch and a neurotic whinny, between the bubbling of volcanic mud and the primordial low-end drone of a didgeridoo. The 303 bass line is a paradox. It's an amnesiac hook: totally compelling as you listen, but hard to memorize or reproduce after the event.

Pierre, Jefferson, and Co gave a tape of the session to DJ Ron Hardy. The track became such a sensation at the Music Box that it was known as Ron Hardy's Acid Trax, a reference to the rumor that the club's intense, flipped-out vibe was caused by the promoters' putting LSD in the water supply. Subsequently, acid producers strove to distance the music from hallucinogenics,

claiming that the name was chosen because the 303's weird 'n' wired sound reminded them of acid rock. Another story circulating by mid-1988 was that "acid" came from "acid burn," Chicago slang for sampling somebody else's sound — not really plausible, since sampling didn't play a major role in early house, which was based on analog synths rather than digital technology.

Wary of appearing to condone drug use, Phuture liked to point to the anticocaine song on the flipside of "Acid Tracks." In some ways even more eerily brilliant than "Acid Tracks," "Your Only Friend" personifies the drug as a robot-voiced Slavemaster, who introduces himself at the start with the words "this is Cocaine speaking," then proceeds to relate just how far he'll debase you: "I'll make you lie for me/I'll make you die for me/In the end, I'll be your only friend," "Your Only Friend" is one of a number of tracks of this era that have the disorientation and sinister, fixated quality of acid house, without actually employing a Roland 303. The It's "Donnie," a Larry Heard production, is the fever dream of a love-junkie abandoned by a gold-digging girlfriend; Harry Dennis's stuttering vocals sound like he's wracked by spasms and deep-body shudders. Sleezy D's "I've Lost Control" consists of nothing but simmering percussion, stray smears of flanged sound, and deranged screams, groans, and madman's laughter from the reverberant recesses of the mix-scape. According to its creator, Marshall Jefferson, "I've Lost Control" was inspired by the dark vibe of Black Sabbath and Led Zeppelin. Recalling the disorienting "ambient" midsection of "Whole Lotta Love," "Control" sounds like the Sleezy D persona is literally disintegrating in an acid maelstrom.

"I've Lost Control" got carried along by the *après* Phuture deluge of 303-based acid tracks: Laurent X's "Machines," Armando's "Land of Confusion," Mike Dunn's "Magic Feet," Bam Bam's "Where's Your Child?," Adonis and the Endless Poker's "Poke It," and hundreds more. Ironically, it was the genre's pioneer, DJ Pierre who — after recording a few more acid anthems — was one of the first to abandon the sound. Explaining his shift away from "tracks" to songs, he said "it's kinda soulless. . . . There's no emotion that goes with it apart from jumping up and down and making you want to dance." In fact there is an emotion to acid house, one that seems to emanate from some infrahuman domain: the passion of subatomic particles, the siren song of entropy.

Although the acid fad petered out by 1989, the Roland 303 has endured, securing a permanent place in the arsenal of house and techno producers. It's

like the wah-wah guitar: instantly recognizable, yet capable of infinite variations and adaptations, and forever drifting in and out of fashion.

In the early days of the Garage ... they'd do things like spike the punch.... You took a glass of electric punch and you were going, boy. It was never enough to actually make you trip, just enough to make you have a fantastic time and not know why. I mean, we knew what was in it, so we'd drink 12 or 13 cups of punch and we'd be flying.

DAVID DEPINO

warm-up DJ for the legendary Larry Levan, on New York club the Paradise Garage

By 1988 house music was having a massive impact in Britain and Europe, but Chicago itself was in decline. The previous year, the authorities had begun to crack down on the house scene, with the police banning after-hours parties and withholding late-night licenses from clubs. WBMX went off the air in 1988, and sales of house records slowed in Chicago, eventually dwindling to an average of fifteen hundred copies, a mere tenth of peak sales. Many of the scene's prime movers became inactive, disillusioned by bad deals. Others went to Europe, where financial prospects were better. Frankie Knuckles moved back to New York. DJ Pierre moved to New Jersey in 1990 and became a major exponent of house's next phase, the New York—based song-oriented deep-house sound known as "garage."

Garage's roots go back to New York's early-seventies disco underground. Mostly gay (black and Hispanic), this scene was characterized by a bacchanalian fervor fueled by acid, amphetamine, and the Ecstasy-like downer Quaalude. It was in this milieu — clubs like the Gallery, Salvation, Sanctuary, the Loft, the Ginza, and with DJs like Francis Grosso, David Rodriguez, Steve D'Aquisto, Michael Cappello, Walter Gibbons, David Mancuso — that Frankie

Knuckles and his colleague Larry Levan learned the art of mixing. Garage is named in homage to the sonic sensibility and sensurround ambiance Levan developed at his legendary club, the Paradise Garage. As a distinct genre, though, it only really took shape after the club shut its doors in late 1987.

Opened in January 1977, the Paradise Garage was named after its location: an indoor truck parking lot in SoHo. Like Chicago's Warehouse, the Saturday-night clientele was gay (Friday night was mixed straight and gay). Philly and Salsoul were the soundtrack, with the songs' gospel-derived exhortations to freedom and fraternity creating a sort of pleasure-principled religious atmosphere. John Iozia described the Garage as both pagan ("an anthropologist's wet dream . . . tribal and totally anti-Western") and ecclesiastical (the dance floor was a fervent congregation of "space-age Baptists"). Just as regulars used to call the Gallery "Saturday Mass," and Salvation was styled a cathedral, Garage veterans regarded the club as "their church." The young Levan had in fact been an altar boy at an Episcopalian church, while the Bozak DJ-mixer he used at the Garage was modeled on an audio mixer originally developed for church sound systems.

Levan was one of the very first examples of the DJ-as-shaman, a technomystic who developed a science of total sound in order to create spiritual experiences for his followers. Working in tandem with engineer Richard Long, he custom-built the Garage's sound system, developing his own speakers and a special low-end-intensive subwoofer known as Larry's Horn. Later, during his all-night DJ-ing stints he would progressively upgrade the cartridges on his three turntables so that the sensory experience would peak around 5 AM. During the week, he would spend hours adjusting the positioning of speakers and making sure the sound was physically overwhelming yet crystal clear. Garage veterans testify that the sheer sonic impact of the system seemed to wreak submolecular changes in the body.

Alongside pioneering the DJ-as-shaman's "technologies of ecstasy," Levan was also an early DJ/producer. He remixed classics like Taana Gardner's "Heartbeat" and Class Action's "Weekend," and cofounded the Peech Boys with synth player Michael deBenedictus and singer Bernard Fowler. The band's ambient-tinged post-disco epics like "Don't Make Me Wait" and "Life Is Something Special" are notable for their cavernous reverberance and dub-deep bass. Peech Boys were on the cutting edge of the early-eighties New York

electro-funk sound, alongside acts like D-Train, Vicky D, Rocker's Revenge, Frances Joli, and Sharon Redd, labels like West End and Prelude, and producers such as Arthur Baker, François Kevorkian, and John "Jellybean" Benitez.

Another figure who played a key role in building a bridge between electrofunk and garage was Arthur Russell. An avant-garde composer and cellist who once drummed for Laurie Anderson and nearly became a member of the Talking Heads, Russell experienced an epiphany at Nicky Siano's club the Gallery, where he was struck by the parallels between disco's repetition and the New York downtown minimalism of Philip Glass, Steve Reich, et al. Thereafter his career straddled two sides of New York's downtown: avant-garde minimalism and disco-funk. Russell's 1980 Loose Joints track "Is It All Over My Face" was a Paradise Garage favorite. In 1982 he cofounded the Sleeping Bag label with Will Socolov and released the surrealistic and dub-spacious "Go Bang #5" as Dinosaur L. Infatuated with the ocean (as Indian Ocean, he released brilliant proto-house tracks like "Schoolbells" and "Treehouse"), Russell was obsessed with echo. His major complaint about most dance floor fodder was its "dryness" (or lack of reverb). Russell recorded an album of cello and slurred-vocal ballads called The World of Echo, but his masterpiece of oceanic mysticism was the polyrhythmically perverse "Let's Go Swimming."

If one word sums up the garage aesthetic, it's "deep" (hence tracks like Hardrive's "Deep Inside" and band names like Deep Dish). "Deep" captures the most progressive aspect of garage, its immersive, dub-inflected production, but also its traditionalism — a fetish for songs and classy diva vocals, an allegiance to soul and R & B, and an aura of adult-oriented maturity. Of all the post-house, post-techno styles, garage places the highest premium on conventional notions of musicality. Garage has little truck with the rhetoric of futurism; samplers and synthesizers are used for economic reasons, as a cut-rate way of emulating the opulent production values and sumptuous orchestral arrangements of classic disco like Philly and Salsoul.

After the Paradise Garage's demise in late 1987, the spirit of garage was preserved at clubs like the Sound Factory, Better Days, and Zanzibar, by DJs like Junior Vasquez, Bruce Forrest, and Tony Humphries. In the nineties, DJ/producers like Masters at Work, Roger Sanchez, David Morales, Benji Candelario, and Erick Morillo kept the flame alive. In Britain, garage thrived as a kind of back-to-basics scene for sophisticates who'd either outgrown rave or

had always recoiled from its juvenile raucousness. In South London, the Ministry of Sound modeled itself on the Paradise Garage, creating an ambiance of upwardly mobile exclusivity and priding itself on having the best sound system in the world (a claim that has not gone undisputed).

In the late eighties, the two labels that did the most to define the nascent garage sound were Nu Groove and Strictly Rhythm. Started in August 1988 by Frank and Karen Mendez, Nu Groove's slinky, jazz-inflected house was infused with a subtle artiness and an absurdist sense of humor, reflected in the band names and song titles: NY Housin' Authority's "The Projects" and its sequel, "The Apartments," Lake Eerie's "Sex 4 Daze." Many important New York house producers recorded for Nu Groove: Lenny Dee and Victor Simonelli (as Critical Rhythm), Ronnie and Rheji Burrell, Kenny Gonzalez.

Strictly Rhythm was where DJ Pierre ended up working as an A & R director and developed his "fractal" Wild Pitch production style — based on tweaking EQ levels, using filtering effects, and constantly adjusting levels in the mix — as heard on classics like Photon Inc's "Generate Power" and Phuture's "Rise from Your Grave." With its bumpin' bass lines, sultry percussion, and skipping, syncopated snares, the Strictly Rhythm sound — as shaped by producers like Roger Sanchez and Kenny "Dope" Gonzalez and "Little" Louie Vega — was more hard driving and feverish than Nu Groove's *pent*-house refinement. Strictly Rhythm is also notable for the brimming, aqueous production on tracks like House 2 House's "Hypnotize Me (Trance Mix)," all gulf-stream synth currents and bubble trails of mermaid-diva vocal. The atmosphere on "Hypnotize Me" and similar tracks like After Hours' "Waterfalls (3-AM Mix)" is condensation-stippled postcoital langour, a balmy plateau of serene sensuality.

Working together as Masters at Work and Sole Fusion, and separately under a plethora of pseudonyms, Kenny "Dope" Gonzalez and "Little" Louie Vega went on to become arguably the most famous of the New York house production teams. The Masters at Work name was a gift from Todd Terry, who'd used it for his early tracks "Alright Alright" and "Dum Dum Cry." Terry is most famous for developing a strain of New York "hard house" that was tougher and rawer than garage. Instead of symphonic disco, this sound was rooted in electro, old skool hip-hop, and the brash, crashing electro-funk style known as Latin Freestyle.

Alongside Terry, the pioneers of this New York hardcore house were Nitro Deluxe. Their glassy and glacial 1987 track "This Brutal House" had a huge impact in Britain and made the top thirty in early 1988 as a remix, "Let's Get Brutal." The track is a vast drumscape of seething Latin percussion and distant snare crashes on the horizon of the mix, underpinned by sub-bass that has the floor-juddering impact of dub reggae. The only element that connects "This Brutal House" to the sounds coming out of Chicago is the eerie vocal effects: a human cry is played on the sampling keyboard like a jittery trumpet ostinato. then arpeggiated into what sounds like Tweety Bird singing scat. Nitro Deluxe's follow-up, "On a Mission," is even more despotic in its vivisection of the human voice. The "Say Your Love" mix puts the word "say" through a digital mangler, shattering it into a pandemonium of pitch-bent whimpers, hiccups, bleats, and oinks; the "Closet Mission" mix multitracks and varispeeds the syllable into a cyclonic vortex of phoneme particles that sounds like an aviary on fire, then rapid-fires a stream of 94 rpm microsyllables like electrons from a cathode-ray tube.

Todd Terry's own style was a bridge between the cut-up collage tracks of New York's Mantronix and the sample-heavy house soon to emerge from Britain. Terry is a no-nonsense, whack-'em-out, I-wanna-get-paid-in-full kind of guy; he's described himself as "more of a trackmaster . . . I'm not a writer of songs, they're too much trouble. Plus you make twice the money off of tracks [because] they're quicker." Lacking both the artistic pretensions of the Detroit aesthetes and the soul-affiliated spirituality of the garage producers, Terry proved that mercenary motives can result in great popular art like Royal House's "Can You Party," Orange Lemon's "Dreams of Santa Anna," and CLS's "Can You Feel It?"

Terry's roots in hip-hop block parties come through in early tracks like Black Riot's "A Day in the Life" and the pre-Vega/Gonzalez Masters at Work outings "Dum Dum Cry" and "Alright Alright": the sound is all jagged edits and stabs, scratch FX, toytown melody-riffs, sampler-vocal riffs à la the Art of Noise, blaring bursts of abstract sound, depth-charge bass, and breakbeats. That rough-and-ready, thrown-together quality also characterizes Royal House's "Can You Party," a UK number fourteen hit in October 1988, with its "can you feel it?" invocations, sirens, and bursts of mob uproar (cunningly designed to trigger a feedback loop of excitement in the crowd). Basically a rewrite of "Can You

Party," "Party People" intensifies the palsied atmosphere until the very air seems to be trembling with an intangible fever. The track turns around a Morse code riff seemingly made out of heavily reverbed piano or audience hubbub, a riff that seems to possess your nervous system like digital epilepsy, inducing strangely geometric convulsions. Like much of Terry's work, the track is jarring because it's like a series of crescendos and detonations, a frenzy of contextless intensities without rhyme or reason.

With their jagged edges and lo-fi grit, Terry's cut-and-paste tracks were a world away from garage's polished production and smooth plateaus of pleasure. Adding funky breakbeats to house's four-to-the-floor kick drum, Terry's sound was hip house, a hybrid subgenre that was simultaneously being reached by Chicago producers Tyree and DJ Fast Eddie. Some hip house tracks simply layered rather feeble rapping over a four-to-the-floor beat. Others, like Fast Eddie's "Hip House" and "Yo Yo Get Funky," combined house rhythms and 303 acid pulses with James Brown samples, sound effects, and breakbeats. Perhaps the best of the bunch was Tyree's "Hardcore Hip House," with its weird blend of funky drummer shuffle beats, house piano vamps, and Tyree rapping about how "hip house is soon to be/the giant in the industry." It wasn't, but the hybrid sound and the chant "I'm comin' hardcore" were prophetic of the hardcore sound that would become the staple of the British rave scene in the early nineties.

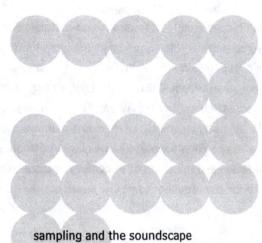

digital psychedelia

"Sampladelia" is an umbrella term covering a vast range of contemporary hallucinogenres — techno, hip-hop, house, jungle, electronica, swingbeat, post-rock, and more. "Sampladelic" refers to disorienting, perception-warping music created using the sampler and other forms of digital technology.

The sampler is a computer that converts sound into numbers, the zeros and ones of digital code. In its early days, the sampler was used primarily as a quote machine, a device for copying a segment of prerecorded music and replaying it on a keyboard at any pitch or tempo. But because the sound has been converted into digital data, the information can be easily rearranged. This means the source can be disguised to the point of unrecognizability, and it opens up a near-infinite realm of sound-morphing possibilities.

At its most advanced, sampladelia drastically expands on the recording methods developed by late-sixties psychedelia. Acid rock groups departed from the "naturalistic" model of recording (documenting the band in performance) and used multitracking, overdubbing, reversing, echo, and other sonic processes to create sounds that could never be achieved by a band playing in real time. This antinaturalistic aspect of sampling has been intensified by recent music technology developments like "hard disk editing," which is like having a recording studio with a mixing board and an array of effects *inside* your computer. With hard disk editing (aka digital multitrack recording), sound sources can be chopped up, stretched, treated, looped, and recombined, all within the "virtual" space of the computer.

The sampler is not necessarily the most important instrument in the techno producer's arsenal. While some producers enthuse about the sampler as the ultimate creative tool ("the new electric guitar"), others prefer synthesizers (particularly old-fashioned analog synths, with their knobs and sliders) for their hands-on, real-time element, which requires traditional dexterous musicianship. Sampling breaks with traditional ideas of "musicality," though, and so I'm using "sampladelia" as a general rubric for electronic dance music's revolutionary implications: its radical break with the ideals of real-time interactive playing and natural acoustic space that still govern most music making.

Although the first people to use the technique — via the expensive Fairlight Computer Musical Instrument — were art rockers like Peter Gabriel and Kate Bush, the age of sampladelia really began when cheaper machines like the Emulator and Ensoniq Mirage fell into the hands of rap producers.

Sampling was the logical extension of the hip-hop DJ's cut-'n'-mix vinyl bricolage. Shifting from the block party model of the DJ-and-MC, hip-hop became a studio-based art centered on the producer-as-auteur and rapper-as-poet. Meanwhile, in the UK, the new cut-rate samplers catalyzed the "DJ record" fad of 1987–88. Influenced by the Art of Noise, Mantronix, and Steinski, such artists as Coldcut, Bomb the Bass, M/A/R/S, and S'Express created breakbeat-driven sample collages that had hip-hop's funky feel but were uptempo enough to slot into a set of house music.

Critiques of sampling focused on the regurgitative, referential nature of the practice, the gleeful disregard for conventional musical skill, and the fact that these records were brazen extravaganzas of sonic larceny. Enthusiasts promptly seized these accusations and turned them around into proof of sampling's subversiveness: its transgression of copyright, its punk-style democratization of music making. Coldcut's "Beats + Pieces" preempted and mocked the anti-sampling fogies with the sleeve slogan "Sorry, but this just isn't music."

By 1990, sampladelia had blossomed into a more subtle and covert aesthetic. Hip-hop and house producers increasingly eschewed blatant lifts in favor of microscopic fragments from obscure sources — partly out of a desire to be more creative and partly because music publishers had their hawk-eyes trained on the extra royalties they could glean by prosecuting unauthorized use of their clients' compositions. Once the sampling-as-theft notion dropped off the agenda, attitudes to the instrument split between postmodernist and modernist. For some, the sampler is still a tool for collage, for elaborate games of Pop Art referentiality. For others, the sampler represents an easy-as-pie update of musique concrète's tricky and time-consuming tape-splicing techniques. Here, digital technology functions as a crucible for sonic alchemy the transmutation of source material into something "new," sounds that seemingly originate from imaginary or even unimaginable instruments. The guiding ethos is a fierce conviction that all samples must be masked, all sources unrecognizable. Yet there's a sense in which this approach reduces the sampler to a synthesizer and thereby misses what is truly idiomatic to the machine: taking the known and making it strange, yet still retaining an uncanny, justrecognizable trace of the original's aura.

In late-nineties dance music, sampladelia mostly falls somewhere between

these two poles of postmodern referentiality and musique concrète re-creation. The texture of these tracks still has a human, real-time feel, but the lifts are sufficiently brief or arcane as to preclude triggering specific popcultural associations in the listener. The model of creativity here is seventies jazz fusion; not only is the ideology borrowed from that period, but so are most of the samples. A lot of trip-hop and jungle is basically fusion on the cheap: instead of a band jamming together, the producer is like a bandleader deftly arranging the expert playing of musicians from different genres and eras.

Trip-hopper Howie B, for instance, described his track "Martian Economics" as a "collaboration . . . like me doing a tune with [keyboard legend] Jimmy Smith, even though he wasn't there." For Howie B and similar artists like Beck and DJ Shadow, part of the creative process is the preproduction research of going on record-buying sprees, then sifting through hundreds of hours of music for suitable samples. "I'll take anything, it can be as small as a triangle hit, and I'll spread it across a [sampling] keyboard and turn it into a tuned piano," says Howie. "I'll take a Latin timbale recorded in 1932 and make it into a percussion pattern, or snatch some vocal and take it four octaves down until it's a lion's roar."

Although it can be performed live, techno is seldom *born* in real time. Rather, electronic music is programmed and assembled sequence by sequence, layer by layer. Even the separate constituents of a track, like keyboard riffs and arpeggios, don't necessarily come into being as discrete musical events. Stepwriting, a technique whereby a rhythmic or melodic pattern is programmed into the sequencer note by note or written on the computer screen, allows for the construction of complicated riffs that are often beyond the real-time capabilities of even the most dexterous keyboardist. Not only does this make it easy to correct errors and add nuances, but sequences can be rearranged, edited, run backward, and generally messed around with on a trial-and-error basis. Furthermore, the same basic riff-pattern can be played in any "color," with the musician free to choose from a vast sonic palette of synthesized "instruments" and self-invented sampladelic timbres.

On the surface, all this would appear to constitute a radical break with the spontaneity of rock 'n' roll. In truth, from very early on in the music's history,

rock bands used studio technology to correct mistakes and overdub extra instrumental parts, if only to make the records sound as densely vibrant as the live band. In *Rhythm and Noise: An Aesthetics of Rock*, Theodore Gracyk argues that it is precisely rock's interest in phonography (the art of recording) that separates it from folk and jazz, where records are usually documents of a performance. In folk and jazz, it is respectively the song and the improvisation that count; in rock, the record is the basic unit of musical meaning. In this respect, hip-hop and techno represent the apotheosis of rock's interest in sound in itself (timbre, effects) and virtual space (unrealistic acoustics).

Gracyk points out that even at the primal origin of rock 'n' roll — the Sun Sessions — studio artifice was involved, in the famous echo that Sam Philips slapped on Presley's voice. The brilliance of late-sixties psychedelia derives from the way artists like the Beatles, Jimi Hendrix, and Pink Floyd combined a gritty "feel" (live, interactive playing among seasoned band members) and the fantastical (hallucinatory effects, ultravivid timbres, an artificial sense of space conjured using echo and reverb). Digital music abandons all the elements of "feel": the inflections and supple rhythmic interplay that communicate the fact that flesh-and-blood humans physically shaped this sound together in a real acoustic space. But by way of recompense, it dramatically intensifies the trompe l'oreille side of psychedelia: its fictitious psycho-acoustic space, its timbres and textures and sound shapes to which no ready real-world referents attach themselves. At its most inventive, sampladelia lures the listener into a sound world honeycombed with chambers that each have their own acoustics. This music is "like walking through a maze whose walls rearrange themselves with every step you take" (James Gleick's description of chaos theory's nonlinear equations).

If rock phonography uses multiple takes and overdubs to create a quasievent, something that never "happened," what you hear on record usually sounds *plausible* as a real-time occurrence. Sampladelia goes further: it layers and concatenates musical fragments from different eras, genres, and places to create a time-warping pseudo-event, something that could never possibly have happened. Different acoustic spaces and recording "auras" are forced into uncanny adjacency. You could call it "deconstruction of the metaphysics of presence." You could also call it "magic." It's a kind of time travel, or seance, a conference call colloquy between ghosts in the sampling machine. Sampladelia is zombie music: dead sound reanimated like the *zombi* — a Haitian corpse brought back to robotlike half-life by a voodoo sorcerer, then used as a slave. Disembodied beats, licks, cries, and riffs — born of human breath and sweat — are vivisected from their original musical context and then literally *galvanized*, in its original meaning. (When electricity was first discovered, physicians would electrocute cadavers to make their limbs and facial muscles twitch, for the public's ghoulish delectation.) Early hip-hop sampling was like Frankenstein's monster, funk-limbs crudely bolted together, the stitching clearly audible. With its quasi-organic seamlessness, today's sampladelia is more like the *chimera*, that mythical monster composed of the parts of different animals. Its chimerical quality parallels digital video effects like morphing, where faces blend into each other imperceptibly and human bodies distend and mutate like Hanna-Barbera animations.

In their jeremiad *Data Trash: The Theory of the Virtual Class*, Arthur Kroker and Michael Weinstein warn that the "archivalism" of cyber-culture is hatching "monstrous hybrids," that "archived body parts are disguised in the binary functionality of data and pooled into larger circulatory flows." This could be a description of the process of converting the vinyl-encoded musical energy of flesh-and-blood musicians into the zeros and ones of binary code, which is then disseminated as currency throughout contemporary pop culture. This is the *fin de millennium* sampladelic supernova, where the last eighty years of pan-global recorded sound is decontextualized, deracinated, and utterly etherealized.

In *The Third Wave*, Alvin Toffler wrote of a "blip culture" where "we are all besieged and blitzed by fragments of imagery, contradictory or unrelated, that shake up our old ideas and come shooting at us in the form of broken or disembodied 'blips.' "Sampladelia can be seen as a new kind of realism that reflects the fact that the late-twentieth-century mediascape has become our new Nature; it can be diagnosed as a symptom of, but also an attempt to master and reintegrate the promiscuous chaos and babbling heteroglossia of the information society.

But sampladelia may also be prophetic, offering hints of future forms of human identity and social organization. Cyber-theorist Arthur Kroker confronts

the prospect of "digital recombinant" culture with a weird mix of manic glee and dystopian gloom, hailing sample-based music as the cutting edge of consciousness, a preview of posthuman life in the age of virtual reality. "Just like virtual sound-objects in sampler music technology, subjectivity today is a gaseous element, expanding and contracting, time-stretched, cross-faded, and sound-accelerated."

Kroker's belief in music as *portent* is shared by Jacques Attali, who traces a history in which each stage of music making is a "foretoken" of future social transformations. Music begins as sacred noise, the accompaniment to sacrificial ritual, a bacchanalian clamor in whose creation everybody participates. The next stage is the age of "representation," where music making is the preserve of specialists (composers, professional musicians), and takes place at special events that have a symbolic, socially stabilizing function. The modern age is characterized by "repetition": the mass-mediated circulation of musical commodities (records). Reified as product, tarnished by everyday currency, and "stockpiled" by isolated collectors, music loses its magical aura. Individuals in the twentieth century are exposed to more music in a month than someone in the seventeenth century heard in a lifetime, but its meaning is increasingly impoverished.

The fourth era of music is the age of "composition": "a music produced by each individual for himself, for pleasure outside of meaning, usage and exchange." Attali is vague about what this music would sound like. Subsequent commentators have argued that punk's do-it-yourself creed fits Attali's criteria, while others have suggested free jazz. The karaoke craze, where the consumer displaces the star vocalist, could be seen as an industry-sponsored, top-down attempt to involve the listener; other future half-measures will involve playback equipment that allows you to remix tracks (a form of music customization already approached by some CD-ROMs).

Lo-fi rock and electronic dance are the two contemporary genres that come closest to Attali's notion of "composition." Both are usually created in home studios and are either self-released or put out by tiny independent labels, in small pressings sometimes as low as two hundred; both reach the public via marginal distribution networks and specialist retailers. And both are marginal scenes appealing to audiences that pride themselves on being more than "mere" consumers. In lo-fi, a high proportion of the audience is in bands, while

in dance music there's a high percentage of DJs, professional and amateur.

DJ culture represents that threshold stage at which repetition morphs into composition. DJs are chronic consumerists and collectors, who nonetheless use their stockpiling expertise as the basis for composition in its literal etymological sense, "putting together." They create a metamusical flow by juxtaposition and segue. As an extension of DJ cut 'n' mix, sample-based music at its best is fully fledged composition: the creation of new music out of shards of reified sound, an alchemical liberation of the magic trapped inside dead commodities. Attali claims that the age of composition will be characterized by a return to music's ancient sacred function. DJ cultures fit the bill; surrounded by ritualized festivity, they emphasize participation and the democratization of noise (ravers blowing their whistles and horns rhythmically).

If music *is* prophecy, as Attali argues, what kind of social organization or disorganization is heralded by dance music? The transformation of music into a mass-marketed commodity (records, as opposed to sheet music) anticipated the late-twentieth-century triumph of what the Situationists called "the spectacular-commodity society," with its passive, alienated consumers/ spectators. Rave culture's decentered networks — cottage industries, micromedia, temporary one-shot gatherings — may herald some postcorporate heterotopia of the late twenty-first century. Then again, sampladelia may equally be a component of a Krokerite dystopia of "cold seduction": "a cool hallucinatory culture of special effects personalities moving at warp speed to nowhere," a virtual-reality pleasuredome where the self is a will-o'-the-wisp buffeted by "ceaseless movement in the eddies of cultural matter."

Critiques of digital music usually focus on the fact that, despite the rhetoric of "infinite possibilities" that surrounds it, most music made on computers sounds awfully homogeneous. Some of the most acute criticisms have come from Brian Eno. Although he pioneered many of the techniques taken up by sampladelia — loops, found sounds, the obsession with timbre, the creation of "fictional psycho-acoustic space" — Eno is disenchanted with almost all the music currently made using computer technology. Speaking to *Wired* magazine, he complained that digital, sequenced music had merely resurrected many of the inherent limitations of classical orchestral music, with its hierar-

chical ranking of instruments in the mix, its rigid sense of pitch, and its locked rhythms tied to the conductor/timekeeper. "Classical music is music without Africa," he complained, later adding, "the problem with computers is that there is not enough Africa in them.... A nerd is a human being without enough Africa in him or her."

Eno's model of musical liberation is African percussion ensembles, which are based not just on polyrhythm, as is much rock and dance music, but on multitiered meters that coexist in a sort of loose interdependence, locking together at certain dramatic moments and then drifting apart again. Africa's polymetric perversity has a utopian, democratic charge for Eno. By comparison, house and techno producers are "slaves to their machines, just as most of us are slaves to [the machines we use]. . . . This is a music that's particularly enslaved."

This politically charged analogy — Africa versus slavery — is ironic, since it is part of the terminology of computer-based music, where instruments are "slaved" to MIDI (Musical Instrument Digital Interface), the timekeeper machine that triggers all the different sequences and keeps them in synch. As Andrew Goodwin has pointed out, this sort of critique of musical standardization echoes the notions of anticapitalist thinkers like Theodor Adorno, who characterized the products of the pop culture industry in terms of "partinterchangeability" and "pseudo-individuation": superficial novelty within rigid formats (in pop terms, 4/4 meter and verse/chorus/middle-eight structure). MIDI and other digital technologies promise infinite potential for individual expression, but only within the rigid parameters of a gridlike matrix for organizing sound.

"Part-interchangeability" certainly applies to the bulk of dance music, insofar as most producers operate rather like the car freaks who cannibalize auto parts, hot-rod their engines, and customize the vehicle's body in order to personalize the mass-produced. They build souped-up rhythm engines using an often rather restricted repertoire of components, derived from sample CDs or sound modules containing hundreds of breakbeats, diva a capellas, synth patches, etc. Although the sampler does indeed offer "infinite possibilities" for resequencing and warping these samples, most dance producers are constrained by the funktionalist criteria of their specific genre. Tracks are designed as material for the DJ to work into a set and so must conform in tempo and

mood. Creativity in dance music involves a balancing act between making your tracks both "music and mixable" (as Goldie put it). Simon Frith points out that one of the defining qualities of digital music is the sense that this music "is never finished and . . . never really integrated" as a composition. It is precisely this "unfinished" aspect — the sockets, as it were — that enable the DJ to plug tracks into the mixscape.

More than in any other genre, electronic musicians articulate what they do in terms of their tools. Ironically, despite this technophile rhetoric, the most radical electronic dance music is often made with relatively low-level equipment and outmoded machinery. The Roland TB 303, source of the acid house bass, and Roland's 808 and 909 drum machines are prime examples of the way in which techno musicians find new possibilities in obsolete and discontinued gear. State-of-the-art, top-of-the-range equipment is more likely to be found in expensive recording studios, where it's used in the production of conventional-sounding pop and rock. Indeed, the most widespread use of sampling is pretty prosaic: it's a means of cutting corners and costs, a way of procuring "authentic" instrumental colors without hiring session musicians or of "saving" a good sound without having to go through the bother of, say, repeatedly miking up the drums in a particular way. Generally, there's more space-age technology involved in the making of MOR shlock like Celine Dion than in tracks by avowed futurists like Juan Atkins.

The picture is further complicated by the fact that techno artists sometimes have a confused idea of what constitutes "progress" for electronic music. Too often, this is conceived in terms of "musicality." Within the terms of genres like house and jungle, "innovation" or "maturity" for the genre can involve steps that, from an external avant-garde perspective, seem regressive: a move away from noise-and-rhythm minimalism toward greater harmonic/melodic complexity; "organic," quasi-acoustic textures; highly finessed arrangements and the incorporation of "live" vocals or "real" musicianship.

Self-consciously "progressive" dance music has an unfortunate tendency to repeat the mistakes of progressive rockers like ELP, Genesis, Jethro Tull, et al, who sought to legitimate rock by aping the grandiosity of nineteenthcentury classical music. The results, in both prog rock and prog dance, are bloated song cycles and concept albums, ostentatious musicianship, a prissy obsession with production values. Just as the truly "progressive" bands of the late sixties and early seventies had more in common with twentieth-century avant-classical composers (electro-acoustic, musique concrète, the New York school of drone-minimalism), similarly the truly radical sampladelic artists are engaged in *expanding* our notions of what "music" can be. This involves the exploration of timbre, chromatics, and "noise-sound," the prioritizing of rhythm and repetition over melodic/harmonic development, and the elaboration of virtual space using the studio as instrument.

How does this project relate to technology? First, it's about finding out what a new piece of equipment facilitates that wasn't previously possible or even thinkable. This involves locating and exploiting potentials in the new machines that the manufacturers never intended. A frequent claim heard from techno producers is that the first thing they do when they've acquired a new machine is to throw away the manual and start messing around, in blithe indifference to the manufacturer's helpful hints. Above all, the truly progressive edge in electronic music involves doing things that can't be physically achieved by human beings manipulating instruments in real time. Rather than using techniques like step writing to mimic traditional ideas of musicianship (frilly arpeggios, solo-istic meanderings), it's about inventing a new kind of posthuman virtuosity. A prime example is the way jungle producers use sampling and sequencing software to create fantastically complex breakbeat rhythms that are too fast and convoluted for a human drummer to achieve, yet still retain an eerie "feel."

Technophobes often argue that electronic dance music rapidly becomes dated because it is so tied to the state-of-the-art technology of the day, making "timeless art" an impossible goal. But rock and pop are equally susceptible to being trapped in time, because of the vogues for particular production styles and effects. These "period sounds" are often alluring precisely for their nostalgic charm or the way they capture a specific pop zeitgeist. At various points in rock history, the leading edge of music involves a strategic retreat from the state of the art toward more limited technological setups. Examples include 1968's retreat from 1967's psychedelic studio excesses to a more gritty, blues-and-country—influenced sound; grunge's rejection of eighties

rock's crystal-clear production in favor of the muddy naturalism of early-seventies heavy rock; and lo-fi's fetish for four-track recording and distortion. As techno has become more self-conscious about its own history, it too has staged periodic returns to period sounds, like the Roland 303 acid bass, or early-eighties electro's gauchely futuristic textures and stiff, drum-machine beats.

Just as they are sometimes overdeferential toward conventional notions of musicality, techno artists often talk about what they do in the seemingly inappropriate language of traditional humanist art — "expression," "soul," "authenticity," "depth."This "false consciousness" can be attributed partly to time lag (rhetoric failing to keep pace with technology), partly to the industry and media's need for singular auteur-geniuses (as opposed to the collective creativity of scenes), and partly to an attempt to contradict those critics who denigrate techno as cold, inhuman machine music.

The truth lies somewhere between the two poles of expressive subjectivity and objective functionalism. Even when he is trying to express feelings, rather than simply make something (some *thing*) that works on the dance floor, the techno auteur is not present in the artwork in the way that the singer/songwriter is present in rock. For rock critics, the song is a mini-novel, a story (either personal confession or character study). As instrumental music, techno is closer to the plastic arts or architecture than literature, in that it involves the creation of an imaginary environment or kinesthetic terrain.

The materials with which the techno auteur works — timbre/texture, rhythm, and space — are precisely those elements that rock criticism ignores in favor of meaning, which is extracted almost exclusively from close study of lyrics and persona. Rock critics use techniques borrowed from literary criticism or sociology to *interpret* rock in terms of the singer's biography/neurosis or the music's social relevance. Devoid of text, dance music and ambient are better understood through metaphors from the visual arts: "the soundscape," "aural decor," "a soundtrack for an imaginary movie," "audio-sculpture."

But these metaphors aren't really satisfactory either, since they tend toward the static, which is fine for ambient, but not that helpful when it comes to

dance music. Even when it attempts to abolish a sense of temporality by trancing you out, dance music happens over time (it *moves*) and it's kinesthetic (it makes *you* move). Dance tracks are less about "communication" in the rock sense and more like engines for "the programming of sensations" (Susan Sontag). Triggering motor/muscular reflexes and recalibrating your body, the rhythms and textures of jungle, trance, garage, etc., each make you move through the world in a different way.

Of course, rock is also rich in nonverbal elements, a hefty proportion of its pleasure and power residing in the sound, the groove. Nonetheless, critics continue to discuss rock as a series of stories or statements. Because it isn't figurative (it gets rid of both the singer and the persona/character in the song), dance music intensifies the nonreferential but deeply evocative/provocative aspects at work in all forms of music — the very stuff that criticism can't handle (in both senses of the word). From the text-biased vantage of rock criticism, dance music is troubling precisely because it seems to be all materiality and no meaning. Entirely an appeal to the body and the senses, mere "ear candy" that gives you an empty sugar-rush, it offers no food for thought.

In this respect, techno and house exacerbate the original sins of disco, scorned by rock fans and crits as superficial and lyrically trite. Rave music completes the trajectory begun by disco when it depersonalized the vocal mannerisms of funk and soul. In techno and house, vocals are either eliminated or survive mostly as soul-diva samples, which are diced, processed, and molded like some ectoplasmic substance. Rave music doesn't so much abolish "soul" as disperse it across the entire field of sound. This is music that's all erogenous surface and no depth, "skin" without "heart."

Sampladelic dance music also confounds standard notions about creativity and authorship in pop music. Not only is the romantic figure of the creator displaced by the less glamorous curator (the DJ-turned-producer), but the lines between art and craft, inspiration and technique, are blurred. Once, it was possible to distinguish between music and its production, between the song and the recording tricks with which it's embellished. But with dance tracks, the music *is* the production. Increasingly, the figure of the producer blurs with the engineer, traditionally regarded as a mere technician who facilitates the sonic

ideas and aspirations of band and producer. In most dance music, though, it's the timbre and penetration of a bass tone, the sensuous feel of a sample texture, the gait of a drum loop, that's the real hook, not the sequence of notes that constitutes "the melody."

All this has ignited a hotbed of fiercely contested questions about publishing credits and payment. Where do you draw the line between producer/engineer and composer? The rise of figures like Rob Playford (Goldie's partner), Howie B, and Nico Sykes of the No U Turn label is proof that we need to start thinking of the engineer as poet, as weaver of dreams. Once "creativity" and "composition" have been reconceptualized in this way, the history of rock suddenly looks different. Why does the law say that you can't copyright a beat or a sound? Why did Mick Jagger and Keith Richards get the publishing credit and royalties for "Satisfaction," when it's Charlie Watts's drum part that provides the song's killer hook? We might start to rethink James Brown as simultaneously the CEO and the public trademark of a funk corporation, an early-seventies polyrhythm factory churning out breakbeats, B-lines, horn stabs, and rhythm-guitar tics — quality components of such machine-tooled durability that they're still being cannibalized by engineer/producers in rap and jungle today. Instead of JB's ponderous ballads and portentous Soul Statesmanship, we might consider his greatest contribution to this legacy to be his sex-machine repertoire of hypersyncopated vocal grunts and gasps.

The problems that rock critics have with dance music are reminiscent of the hostile incomprehension with which highbrow cineastes greet certain sorts of genre movie like science fiction and horror. They vainly search these movies for what they valorize: acting, sparkling dialogue, character development, a non-corny plot, and meaning (insight into the human condition, social resonance). Ironically, these are values that pertain more to literary or theatrical drama than to the cinematic per se.

But these elements of narrative and character are present in genre movies as a mere formality, a structural framework for the purely cinematic: the *retinal intensities* of ultraviolent action, special effects, and, in sci-fi movies, futuristic mise-en-scène and decor. Here, the true filmic poets are set designers like H. R. Giger (*Alien*) and effects engineers like Douglas Trumbull (*2001: A Space Odyssey, Close Encounters, Blade Runner*). With their emphasis on the sheerly spectacular and sensational, science-fiction and horror flicks simply

take after their literary sources. In William Gibson's novels, what you read for are his prose-poem evocations of cyberspace as a *techno-sublime*, not the hackneyed dialogue.

If techno can be thought of in this way — the track as a framework for the display of special effects and processing — what, then, constitutes the "sublime" in techno? The answer is sound in itself. "If I can't create a sound that I like, I find it very hard to create a song," Kevin Saunderson told Music Technology magazine in 1988. "I get inspired by a good sound . . . it gives me a feeling for a rhythm or a melody. The sound's the most important thing." In most music, timbre and "chromatics" are the medium, the pigment as it were, through which the important thing — the melody, the emotional meaning is expressed. In techno, melody is merely an implement or ruse for the displaying of texture/timbre/sound matter. This is why most rave music shuns complicated melody lines in favor of riffs, vamps, and ostinatos (short motifs repeated persistently at the same pitch throughout the composition). In the ultraminimalist "tech-house" of the Basic Channel and Chain Reaction labels, simple riffs serve to twist and crinkle the sound fabric in order to best show off its properties; what you thrill to is the scintillating play of "light" as it creases and folds, crumples and kinks.

Basic Channel and Chain Reaction tracks have a curious quality: listening to them is sublime, but afterward it's hard to retain anything but the faintest flavor of the experience. Bar the odd bass line, there's nothing you can hum to yourself. This is because the tracks are all percussion and timbre, the two elements of music that are hardest to remember. Gracyk points out that our memory of chromatics (timbre/texture in music, color in painting) fades faster than our memory of pitch and line. Similarly, timbre and space cannot be notated on a score. Yet it's these ineffable, untranscribable elements in music that are the most intensely pleasurable.

Timbre, rhythm, space: these elements in music are all related to sensuously overwhelming immediacy. They are the *now-intensive* elements in rock and in techno. Rock began the work that techno completed: accentuating rhythm, elevating timbre (distortion, effects, grain of the voice), opening up dub space. Structurally, rock and techno both fit Andrew Chester's notion of *intensional* music (complexity achieved through modulation and inflection of simple melodic units, as in African music), as opposed to the *extensional* structures of Western classical music (theme and variations, crisis and resolution).

Techno and house create a subtly different form of heightened immediacy than African music — a sort of *future-now*. (This is an effect of the music's reliance on the vamp — originally a brief introductory passage repeated several times before a solo or verse in order to whip up anticipation, but in techno sometimes making up the whole body of the track). Timbre-saturated, repetitive but tilted always toward the *next now*, techno is an immediacy machine, stretching time into a continuous present. Which is where the drug-technology interface comes into play. Not just because techno works well with substances like MDMA, marijuana, LSD, speed, etc., all of which amplify the sensory intensity of the present moment. But because the music itself *drugs* the listener, looping consciousness then derailing it, stranding it in a nowhere/nowhen, where there is only sensation, "where now lasts longer."

By 1988 black America had generated three distinct and full-formed genres of electronic dance music: Detroit techno, the deep house/garage sound of Chicago and New York, and acid house and minimal jack tracks. Transplanted to the other side of the Atlantic, each of these sounds would mutate beyond all recognition, and *through* a kind of creative misrecognition on the part of the British.

Yet at the start of 1988, house music seemed to be a fad that had been and gone, at least as far as British clubland was concerned. "House never kicked off the way we thought," remembers Mark Moore, one of the few London DJs who played Chicago and Detroit tracks. "I remember spinning Derrick May's 'Strings of Life' at the Mud Club and clearing the entire floor." House did have a toehold in the gay scene, at clubs like Jungle and Pyramid. But most gay clubbers still preferred Eurobeat and Hi-NRG, says Moore, and saw the arty Pyramid crowd as "weirdoes." The only straight club that regularly played house in late '87 was Delirium, modeled on New York's Paradise Garage. But most of the club's following were hip-hop kids who, according to Moore, "hated it when it went into house. They had to have a cage built around the DJ box so they wouldn't get bottled by hip-hop kids when they played house!"

All through 1987, the dominant clubland sound in London had been rare groove: early-seventies, sub—James Brown funk. Rare groove represented the fag end of eighties-style culture, what with its elitist obscurantism (DJs covered up the labels with White Out to prevent their rivals from identifying the tracks) and its deference to a bygone, outdated notion of "blackness." But there were signs of life in the vogue for "DJ records" — breakbeat-and-sample collages that eschewed rapping in favor of absurdist sound bites and that tempo-wise were closer to house than hip-hop. Made possible by the arrival of cheap samplers and usually recorded for next to nothing, these DJ records stormed the pop charts, starting with M/A/R/R/S's number one smash "Pump Up the Volume" in late '87 and continuing into early '88 with Bomb the Bass's number two hit "Beat Dis" and S'Express's chart-topping "Theme from S'Express."

S'Express was Mark Moore. With its campy "I've got the hots for you" hook and "suck me off" samples courtesy of performance artist Karen Finley, "Theme" was the vinyl expression of Moore's irreverent and eclectic DJ sensibility. Although it was closer to a postmodern update of disco than the

Chicago sound, "Theme" was received as one of the first British house records. More important, the track's kitschy euphoria chimed in with the anti-cool ethos of new "Balearic" clubs like Shoom and the Project.

"Balearic" referred to the DJ-ing approach of Alfredo Fiorillo, a former journalist who'd fled the fascist rigors of his native Argentina for the laid-back bohemian idyll of Ibiza, a popular Mediterranean island vacation destination for English youth. DJ Alfredo's long sets at Amnesia — which, like most Ibizan nightclubs, had no roof, so you danced under the stars — encompassed the indie hypno-grooves of the Woodentops, the mystic rock of the Waterboys, early house, Europop, and oddities from the likes of Peter Gabriel.

"It was the best of all kinds of music, and really refreshing, because in London you were just hearing the same old sound," remembers Paul Oakenfold. In the mid-eighties, Oakenfold was involved in London's hip-hop scene as a DJ, club promoter, and agent for Profile and Def Jam acts like Run DMC and the Beastie Boys. After his first visit to Ibiza in 1985, where he encountered clubs like Amnesia, Pasha, and Ku, Oakenfold and his friend Trevor Fung tried to start a Balearic-style club called the Funhouse in South London. "It was exactly the same as what we did in '87 with the Project, but we did it in '85 and it didn't work. People couldn't understand the concept of playing all kinds of music together. . . . It was something that we tried six months and lost a lot of money, so we just shelved it."

The other element missing in 1985 was Ecstasy — which was readily available in Ibiza and helped open up dancers' minds to diverse, "uncool" sounds. The turning point came in the summer of 1987, when Oakenfold rented a villa in Ibiza and brought over a bunch of DJ friends — Danny Rampling, Johnny Walker, Nicky Holloway — to celebrate his twenty-sixth birthday. When Oakenfold returned to London after a summer of dancing all night on Ecstasy, he reactivated the "Balearic" concept at a South London venue called the Project Club. He and partner Ian St. Paul persuaded the owner to let him start an illegal after-hours event. When the regular night's crowd had been ushered out at 2 AM, the exit door would be opened to admit about 150 Ibiza veterans. Oakenfold flew in Alfredo to play and "invited all the main heads, the key people in London, from fashion to film to music to clubland."

What these prime movers encountered was a complete subcultural package of slang, behavior, and clothing, hatched during the summer in Ibiza. The

look was a weird mix of Mediterranean beach bum, hippy, and soccer hooligan — baggy trousers and T-shirts, paisley bandannas, dungarees, ponchos, Converse All-Stars sneakers — loose-fitting, because the Ecstasy and nonstop trance dancing made you sweat buckets. Recalls Oakenfold, "London clubs had always been about people drinking, trying to chat up girls, looking good but not dancing. All of a sudden we completely changed that — you'd come down and you'd dance for six hours. The idea was 'if you're not into dancing, then don't come down.'"

The Project all-nighters got so popular that the club was soon raided by the police. So St. Paul and Oakenfold started Future at the Sanctuary, around the back of the huge gay club Heaven in central London. Future was members only; the card bore the commandment "dance you fuckers!" On his first visit to Future, says Mark Moore, "I remember thinking 'this is it, this is the crowd for this kind of music.' It was exactly the same mix — early house, plus all that indie stuff — I'd been playing to the gay crowd, except this was a straight crowd." He took Philip Salon, doyen of eighties "style culture" and the impresario behind the Mud Club, down to Future. "I told him 'this *is* the future, this is what it's going to be like,' and he was saying 'no, no, they're all suburban *norms.*' And I'm like, 'yeah, but this music and this energy, this is the next thing that's gonna happen.'"

Around this time — November '87 — Danny Rampling and his wife, Jenni, started Shoom, a tiny club located in a South London gym called the Fitness Centre, just a few hundred yards south of the Thames. Although Danny supplied the club's musical vision (pure Balearic), the powerhouse behind Shoom is generally reputed to have been Jenni Rampling. She maintained the club's membership scheme and newsletter, kept the press at arm's length, and controlled the door with a ruthlessness that became infamous. "We used to say that Jenni had the Battle of Britain spirit," recalls Mark Moore. "The Ramplings were a very ordinary, upwardly mobile working-class couple from Bermondsey," remembers journalist Louise Gray, an early Shoom convert. "Suddenly they were thrown into this fantastically trendy set where they had luminaries pounding on their doors, and they were being taken up by people like Boy George — queeny, nightlife sophisticates."

The first time Gray actually managed to get inside Shoom, "we arrived terribly early, about 10:30, and we couldn't really figure out what the fuss was

about. There were about twenty people, dancing wildly. I was sitting talking, and then this girl just appeared absolutely out of nowhere, plonked herself down on my knee, grabbed the corners of my mouth, and pulled them up into a smile. She said 'Be happy!' and then jumped off. I'd never experienced behavior like that, and thought it quite crazed."

Suddenly the club filled up — not just with people, but with "peasoupey, strawberry-flavored smoke, lit only by strobes. If you went onto the dance floor, you could only see a few inches ahead. It was just exciting, there was a real contact high. I didn't have any drugs that night, but that was when I realized that drugs had something to do with it." Drugs had everything to do with it: the name "Shoom" was freshly coined slang for rushing, for the surging, heart-in-mouth sensation of coming up on Ecstasy. The imagery on the flyers, membership cards, and newsletters was blatantly druggy: pills with Smiley faces on them, exhortations to "Get Right On One, Matey!!!"

Unlike the typical West End club, the Shoom scene was not about being seen, but about losing it — your cool, your self-consciousness, your *self*. Quoting T. S. Eliot, Gray describes the fruit-flavored smoke as "the fog that both connects and separates. You'd have these faces looming at you out of the fog. It was like a sea of connected alienation." Says Mark Moore: "Often it was so chaotic you couldn't really see in front of you, you couldn't really talk to anyone. So a lot of the time you just spent on your own dancing. . . . You'd have people in their own world, doing that mad trance dancing, oblivious to everything else. But then you also had blokes coming up who were, like, 'yeah, all right mate!! smile! smile!,' and hugging you." Coming from the arty end of the gay scene, Moore was used to this kind of demonstrativeness. But at Shoom he encountered "this whole new mentality. . . . It was all these suburbanites who'd taken Ecstasy and it was as if they were releasing themselves for the first time." Gay behavioral codes and modes of expression were entering the body-consciousness of straight working-class boys, via Ecstasy.

Oriented around communal frenzy rather than cooler-than-thou posing, Shoom was the chrysalis for rave culture, insofar as *rave* in its pure populist form is the antithesis of *club*. At the same time, Shoom *was* a club, more so than most Soho nightspots in fact, because it had a membership scheme. Jenni Rampling's door policy was as strict as Studio 54; as word of Shoom spread and people flocked down to find out what the fuss was all about, she rapidly

acquired a reputation for being a "queen bitch" who'd turn away people who only weeks earlier had managed to get in.

The Shoom ethos was love, peace and unity, universal tolerance, and weare-all-the-same. It was supposed to be the death knell of clubland's snobbish
exclusivity, but there was an essential contradiction in the way that the Shoom
experience was restricted to the original clique and their guests, plus a few minor celebrities like Patsy Kensit and Paul Rutherford of Frankie Goes to Hollywood. Then again, Shoom's close-knit, we-are-family atmosphere depended
on keeping at bay the influx of intrigued neophytes, not to mention the hooligan element. Those who did belong were treated to ice pops, fruit, and other
giveaways. Members also received a rough-and-ready newsletter, largely composed of blissed-out testimonials from Shoom converts: "Let your pure inner
self manifest and only then will you be shooming!"; "I Felt As If I Was Living
A Dream."

But the democratic promise of the Balearic ethos could not remain the preserve of a chosen few for long. In the spring of 1988, Oakenfold took it to another level when he launched Spectrum as a Monday-night club in the two-thousand-capacity gay club Heaven. Spectrum billed itself as a "Theatre of Madness" and this was no idle boast.

"I was quite shocked, almost appalled, actually," remembers Nick Philip, a hip-hop fan who was intrigued enough to check out Spectrum at its height. "Just the hedonism, and how out of line everyone was getting. Back in the late eighties, the club scene was quite uptight, you had to wear exactly the right clothes to get in. You might see the odd person there who was really out of it, but it was not the general rule. But at Spectrum, everyone looked like they were from fucking Mars. Drenched in sweat, wearing baggy shit, and all just looking at the DJ with their arms in the air, like it was some really weird religious ceremony. I was quite freaked out by it."

The atmosphere was even more deranged at the Trip, a club started by Nicky Holloway in June 1988. Instead of the laid-back, sunkissed Balearic vibe, the music was full-on acid house. The location — the Astoria, in the heart of London's West End — signaled the scene's emergence into public consciousness. When the Trip closed at 3 AM, the dancers would pour out into Charing Cross

Road, stopping the traffic and partying in the street. "Then the police would come," remembers Mark Moore, "and the sirens would get turned on. Everyone would crowd around the police van and chant 'acieed!' "— the war cry of 1988— "and dance to the siren. The police didn't know what to make of it." Then everyone would troop en masse to the municipal multistory parking lot near the YMCA in Bedford Street, where they'd dance around to house music pumping out of their car stereos.

Because of Britain's antiquated club licensing laws, the night's mayhem ended prematurely. If you wanted to carry on dancing through the night, you had to turn to the illegal warehouse parties or after-hours, unlicensed clubs like the legendary RIP, brainchild of creative and romantic partners Paul Stone and Lu Vukovic. In April 1988, Stone recruited the DJ team of Kid Batchelor, "Evil" Eddie Richards, and Mr. C (who'd been running Fantasy, one of the first straight house clubs in London) for the first RIP party in a tiny underground location near Euston Station. A couple of months later, RIP started up again as a regular club at Clink Street, a dingy building in South East London that had once been a jail.

"It was used as an illegal drinking den before we got our hands on it," says Mr. C, who later became the rapper in the Shamen. "And there was a recording studio in there, which we used as the DJ booth." In one room Eddie Richards and Kid Batchelor played; in the other Mr. C spun, followed by the Shock Sound System, another bunch of early house crusaders. "We started off RIP every Saturday night, and within a month it was choc-a-bloc. Then we started the Friday night as well, which was called A Transmission — for Acid Transmission. Then we did Zoo on Sundays, so we'd have all weekend at it." The parties would go until nine or ten in the morning.

Many people thought RIP was an acronym for Rave In Peace. It actually stood for Revolution In Progress. The phrase captures the near-militant underground attitude of the music policy (acid and hard house, rather than Balearic pick 'n' mix) and the slightly sinister atmosphere of the club, a world away from Shoom's teddy bears and ice pops. "If Shoom was 'underground' and 'edgy,' Clink Street was dark as fuck, sound-in-Hell!," laughs Mr. C. "It was pretty heavy in there — there were a lot of soccer thugs and villains. But there were also some of the most beautiful people you ever saw in your life. All types of people from all walks of life just came together to get completely *nutted*. It

was complete madness. Everybody was on something. And back then, it wasn't just about E. LSD was just as popular. Often it was E and acid taken together as a synergy thing — what used to be called 'candy flips.' "

Ecstasy had been available in London since the early eighties, but the supply was highly restricted. You had to know someone who brought it over from America, where it was legal until 1985. There was something of an Ecstasy scene at Taboo, Leigh Bowery's club for fashion freaks, but nobody had discovered its application as a trance-dance drug. Instead, small groups of friends were using it for private bonding sessions.

In 1988, Ecstasy became much easier to get hold of, though it was still rather pricey at around twenty pounds a tab. Nobody really knew much about how it worked or the best way to take it. People quickly discovered that alcohol dulled the E buzz; at Shoom, the glucose-rich soft drink Lucozade became the beverage of choice, partly because it replenished energy and partly because it was the only drink available at the Fitness Centre. Myths sprang up around the new drug, like the notion that vitamin C killed the buzz, which ruled out orange juice. There was also considerable confusion over Ecstasy's legal status, and nobody knew if it was addictive or not.

The other big Ecstasy myth concerned the drug's aphrodisiac powers. "All these strange reports were coming through that it turned you into a sex fiend," says Louise Gray. "But if anything it was the complete opposite. Very little sex happened that year. People were very cuddly, and that was very nice: you could be cuddled by complete strangers in a totally nonthreatening way, 'cos you knew nothing was going to happen. If you got upset about something, this crowd of strangers' hands would descend on you. It was touchy-feely, an amorphous sensuality — but it wasn't a *sexuality*. I think that was one of the reasons why you could have such an extraordinary mix of people — male gays, but also working-class boys who hadn't had any contact with the trendy culture. Suddenly they were thrown into this environment where everyone was kissy-kissy, but it didn't matter, they weren't threatened in any way."

Thanks to Ecstasy, all the class and race and sex-preference barriers were getting fluxed up. One of the most striking changes was the way that the territorial rivalry between areas of London — largely expressed through following

different soccer teams — was dissipated. Almost overnight, the box cutter-wielding troublemaker metamorphosed into the "love thug," or as Brit rapper Gary Clail later put it, "the emotional hooligan." "Football firms" (warring gangs who supported rival teams) were going to the same clubs, but to everyone's surprise, there was never any trouble. They were so loved-up on E they spent the night hugging each other rather than fighting.

This interface between soccer fanaticism — with its ritualized inebriation and hand-to-hand combat — and acid house — with its anti-alcohol bias and hippy-dippy pacifism — seems extremely unlikely. But there are actually quite a few parallels between soccer and raving. In the eighties, with mass unemployment and Thatcher's defeat of the unions, the soccer match and the warehouse party offered rare opportunities for the working class to experience a sense of collective identity, to belong to a "we" rather than an atomized impotent "I."

The experience of going to the Trip and Spectrum, or to the bigger-scale warehouse parties like Apocalypse Now, was not unlike that of a soccer match: collective fervor, bodies pressed together, the liberation of losing oneself in the crowd. Forming an avant-garde of soccer fandom, the football firms had evolved ways of intensifying the game's sensations of tribal unity. Like Viking berserkers, the hooligans used alcohol, chanting, and sprinting en masse to generate a collective adrenaline surge that propelled them over the brink between normality and running amok. In Bill Buford's Among the Thugs, the soccer hooligans talk of these exalted moments of frenzied ultraviolence using the language of drugs ("the crack, the buzz, and the fix") or spirituality ("it's a religion, really"). In 1988-89, the thugs discovered that E offered an even better high than the adrenaline and endorphin rush of hand-to-hand combat, and they temporarily gave up their carefully strategized confrontations. But when the Ecstasy buzz inevitably faded through tolerance to the drug's effect, the early nineties saw many hooligans reverting to their old, tried-and-true techniques of getting a rush.

Back in '88 the LoveThug was a crucial element of the myth in progress that was popularly dubbed the Second Summer of Love: the heartless hooligan turned loved-up nutter was proof that Ecstasy really was a wonder drug, the agent of a

spiritual and social revolution. Flooded with idealism, some members of the first Ecstasy generation were latching onto ideas about spirituality and the New Age, struggling to articulate the overwhelming Ecstasy-induced feelings coursing through their nervous systems. "A lot of people were born again," marvels Mark Moore. "They gave up their relatively normal lives, 'cos they thought 'why am I doing this shitty job?' You got all these people suddenly deciding to go off and travel. People I'd known for years were suddenly dressing all ethnic and getting spiritual. The whole New Age thing surged forward."

For most, the back-to-the-sixties/Age of Aquarius imagery was tongue-incheek, a smokescreen for pure hedonism. But many felt utterly transformed. "I remember getting prophet books myself, the Bhagavad-Gita," says Barry Ashworth, an Ibiza veteran who went on to run clubs like Deja Vu, Monkey Drum, and Naked Lunch. "All kinds of things that I certainly wouldn't have bothered with, coming from a macho working-class background where nobody expresses their emotions. All of sudden, you started saying things to people you would never ever have said: 'I *loooove* you!' And it wasn't just about telling your friends you loved them, it was about telling people who weren't your friends you loved them!"

Ecstasy was a miracle cure for the English disease of emotional constipation, reserve, inhibition. Because of the mingling and fraternization the drug catalyzed, the living death of the eighties — characterized by social atomization and the Thatcher-inculcated work ethic — seemed to be coming to an abrupt end. "Everyone was vitalized," says Gray. And yet, for all the self-conscious counterculture echoes — the Smiley-face T-shirts, the garish psychedelic clothing — acid house was a curiously apolitical phenomenon, at least in terms of activism and protest. While the tenor of the peace-and-unity rhetoric ran against the Thatcherite grain, in other respects — the prohibitive cost of Ecstasy, for example — acid house's pleasure-principled euphoria was very much a product of the eighties: a kind of *spiritual materialism*. Tim London of the politicized dance-pop band Soho railed: "Summer of Love? What a load of old bollocks. Summer of Having a Good Time, more like! Just like kids have always done, since the days of *Saturday Night Fever*."

Acid house's biggest impact was in the domain of leisure; it caused a shift from alcohol to Ecstasy and soft drinks, created a mass recreational drug culture, and stoked a craving for all-night dancing that would rub up against

the antedeluvian club licensing laws. The energy liberated by Ecstasy felt revolutionary, but it wasn't directed against the social "stasis quo." Acieed was more like a secession from normality, a subculture based on what Antonio Melechi characterizes as *collective disappearance*. "One of the things I found exhilarating," confirms Louise Gray, "was the idea that there was this whole society of people who lived at night and slept during the day. This carnivalesque idea of turning the ordinary world completely on its head. Like slipping into a parallel universe." By autumn '88, it was possible to live virtually full-time in this parallel universe. There was a party every night. Shoom, the Trip, RIP, and Spectrum were joined by new clubs like Confusion, Rage, Babylon, Love, Loud Noise, Enter the Dragon, Elysium, and on the weekends there were a host of one-shot warehouse events.

Alongside the reinvocations of late-sixties psychedelia, the acid house revelers often compared the feeling in the summer of '88 to punk rock — the same explosion of suppressed energies, the same overnight Year Zero transformation of tastes and values. All that was missing was the mass media's discovery of the new subculture and the inevitable "moral panic" over what the kids of today were up to.

When the press finally discovered the acid house explosion, their coverage was initially quite positive. Tabloid newspaper the *Sun* described the scene as "cool and groovy," printed a guide to the slang, and even ran a special offer for Smiley T-shirts. But a few weeks later, the tabloid abruptly changed its tune with a story entitled "Evil of Ecstasy" that conjured up the prospect of horrendous hallucinations and panic attacks, plus the possibility of being sexually assaulted while under the influence. The *Sun* also alleged that MDMA was often cut with rat poison, heroin, and embalming fluid.

As the tabloid newspapers engaged in a contest to see who could come up with the most luridly distorted reportage, acid's "folk devil" revealed itself not to be the poor deluded youth themselves (as was the case with the mods, punk rockers, skinheads, and soccer casuals) but the sinister figures behind the parties and the pill pushing: the "Acid House baron," a mercenary Pied Piper figure luring the children of England into a world of bad trips and orgiastic delirium.

The Ecstasy-related death of twenty-one-year-old Janet Mayes on October 28 provided the tabloids with the "killer drug" angle they'd been waiting for. On November 2, the *Sun*'s front page pointed the finger at a jailbird/boxer turned bouncer who, it was alleged, was the "Mr. Big of Acid Parties." Inside, the paper announced that it was withdrawing its Smiley T-shirt offer, offering instead free "Say No To Drugs" pins, with a frowning Smiley. In the grand tradition of yellow press scare stories about cocaine and "reefer madness," the tabloids were obsessed with Ecstasy's supposed aphrodisiac powers. Readers were warned that they might end up in bed with someone undesirable or even an entire tangle of nude strangers. At one club, the *Sun*'s reporter hallucinated "OUTRAGEOUS sex romps taking place on a special stage in front of the dance floor."

The fact that the new music was called "acid house" led to considerable confusion on the newspapers' part about exactly which demon drug they were decrying. "The screaming teenager jerked like a demented doll as the LSD he swallowed an hour earlier took its terrible toll," declared one *Sun* report. "The boy . . . had become sucked into the hellish nightmare engulfing thousands of youngsters as the Acid House scourge sweeps Britain. . . . Callous organizers and drug dealers simply looked on and LAUGHED . . . DJs encouraged the frenzied crowd with chants of 'Are you on one? Let's go MENTAL, let's go FATAL." Inflamed by the tabloids, the backlash began in earnest. Smiley T-shirts were withdrawn from all 650 branches of the Top Shop and Top Man retail chain. Pop stars — including a few veterans of early Shoom — reeled off platitudes about how you didn't need to take drugs to have a good time, kids, honest. The police began to crack down on warehouse parties, raiding events by Kaleidoscope and Brainstorm, and using frogmen to assault a pleasure boat rave in Greenwich.

But the scaremongering tabloid and television coverage did not have the intended effect of discouraging the youth of Britain. If anything, "it just helped it grow even bigger," says Mark Moore. The result was an influx of younger kids and suburbanites onto the scene.

Despite their populist rhetoric and antagonism toward traditional clubland elitism, the original Balearic scenesters were horrified by the arrival of the

great unwashed and unhip. Oakenfold blames the tabloids: "They ruined it for us. Before, it was responsible people [taking drugs]. It wasn't silly. It got silly when they made it commercial. And that's when it got worrying 'cos you had young kids doing drugs 'cos they were told by the press that was what everyone was doing. Everyone became sheep. Our club was about individuals, characters. But it became horrible drugs, horrible people."

The backlash against the Johnny-come-lately acieed freaks was led by Boy's Own, a clique of Balearic DJs and tastemakers — Terry Farley, Andy Weatherall, Cymon Eckel, and Steve Mayes — who threw private parties under the railway arches near London Bridge and put out the *Boy's Own* fanzine, an irregular and irreverent publication dedicated to documenting the minutiae of music, clothes, and soccer. *Boy's Own* coined the famous slogan "better dead than acid ted." The "acid ted" was the timewarp kid who wasn't hip enough to change with the times. The idea was that the neophyte ravers in bandannas and Day-Glo T-shirts, shouting "acieed!" and dancing on the tables at the tacky nightclub Camden Palace were the equivalent of forty-year-old teddy boys with fifties-style rockabilly quiffs, drainpipes, and brothel creepers.

The Balearic versus "acid ted" antagonism was grounded in an enduring class divide that runs through British pop history, at least as far back as the mods versus rockers wars of the 1960s: an upper-working-class hipster superiority complex vis-à-vis the undiscriminating unskilled proles. It was also a generational conflict: the fatigued cynicism of Balearic veterans suddenly surrounded by Johnny-come-latelies in the first flush of E'd-up enthusiasm. "Even at that early stage," says journalist Gavin Hills, a 1988 veteran, "you'd get people saying 'Ecstasy isn't as good as it used to be' or complaining that 'clubs are just full of kids now.' All the clichés you've heard every year since!"

All of a sudden acid house was declared vulgar and passé; Chicago deep house and New Jersey garage was the in thing. Not only acieed music but the whole "mental" attitude that the "acid teds" had embraced and exaggerated was deemed unseemly, despite the fact that only a few months earlier the Boy's Own types had been indulging in such antic behavior. One Shoom newsletter beseeched the laddish element not to "take your shirts off." Louise Gray admits, "We were rather snotty about the teenagers who were suddenly coming through, swallowing handfuls of pills and going round pulling faces." As well as "acid ted," another derogatory term used by Shoomers for the new arrivals

was "lilac camels" — lilac being a popular color for sneakers, "camel" referring to E'd-up kids who'd chew gum frenziedly and stick their tongues out of their mouths.

Despite the Summer of Love and Unity rhetoric, less than a year into its existence the scene was stratifying: on one side, the original Balearic crowd; on the other, the hardcore acieed monsters swarming to warehouse parties whose flyers promised "no balearic, just pure psycho-delic shit." The Balearic backlash against the alleged "herd mentality" of the acid teds was understandable, up to a point. Clubs once full of familiar "Faces" (in the mod sense) were suddenly mobbed with rowdy strangers, who inevitably seemed faceless, sheeplike. But the backlash was also a response to a power shift: the Balearics' "subcultural capital" had suddenly gone public, the rituals and apparel they'd invented were common currency, tarnished and tawdry. Panicked, the Balearics began the retreat from the populist premises that had originally defined their revolt against West End clubland, a retreat that would eventually led them back to door policies, expensive designer clothes, and cocaine rather than Ecstasy.

By the end of '88, the scene had lost some of its innocence — ironically, partly because of the fresh-faced teenage newcomers who were taking psychoactive substances they weren't emotionally mature enough to handle. But many of the original, more experienced scenesters were also in a bad way. "You'd see people who were completely abusing it," remembers Mr. C. "Seven or eight pills on a Friday, ten pills on a Saturday, and half a dozen on a Sunday."

Amazingly, given the lack of knowledge about the drug and the need to avoid dehydration, there were almost no E deaths in 1988; physical damage was limited to weight loss and the continual mild flu that for many people lasted the whole summer. Most of the casualties in '88 were *mindwrecks*. As their tolerance to Ecstasy built up and their intake rose, some were experiencing the typical symptoms of long-term and excessive drug use: mood swings, paranoia, even mental breakdown. "There were people that were having nightmares, their nervous systems were completely shot," says Mr. C.

Some just didn't want to stop, despite the early warning signs around them. "That initial phase of taking Ecstasy, the pleasure of it is so unexpected, you just keep doing it," says Jack Barron, a rock journalist swept up in acid house fever. His love affair with the drug reached a climax when he "took thirty-eight

Es in a week. . . . I was completely convinced that there was this parallel universe which came to us in our dreams, and in which we all flew around. . . . The separation between dream time and day time . . . well, there wasn't any. I wouldn't particularly recommend it."

Despite all the idealism and energy triggered by Ecstasy, a surprisingly small amount of artistic expression survives the era. Apart from *Boy's Own*, there was next to no fanzine documentation of the scene as it happened. People were simply too busy having fun. But it was a creative period for short-term artifacts like T-shirts, flyers, and club design.

Homegrown house took a while to come through, too. The early British stabs at this black American music were imitative, and often quite poor imitations. D-Mob's "We Call It Acieed" got to number three in November '88, and was something like the acid house counterpart of Bill Haley's "Rock Around the Clock": a self-reflexive title, a thin-sounding pastiche of the real underground black music. It didn't even feature a proper Roland 303 and, worse, came with a rap that disingenuously claimed that "acid" wasn't about a drug. The other early homegrown acid smash, "Acid Man" by Jolly Roger, was a bit better, featuring genuine 303 squelch-a-rama and a prim matronly voice that commanded, "Stop that infernal racket, I mean NOW!" Better still, Humanoid's "Stakker Humanoid" — number seventeen in December '88 — was a terrific surge of acieed-meets-techno, as lithe and deadly as a bionic cheetah.

As a British pop cultural explosion, acid house was unique insofar as it was based almost entirely on nonindigenous music. During 1988–89, the scene had three years' worth of American house and techno classics to draw on, as well as all the new tracks streaming out of Chicago, New York, and Detroit each week. Faced with this deluge of music made by black American artists, it took UK producers a while to find their own distinctively British voice.

In its dependence on imports, acid house resembled Northern Soul, the strange seventies North of England cult based around sixties sub-Motown dance singles from the Detroit area. Like acid house, Northern Soul was all about uptempo black American music and popping pills so you could dance 'til dawn; it revolved around name DJs, obscure tracks, and long-distance journeys to clubs that were worshipped as temples. In both cases, the raw material of a black American music was transformed into a British way of life.

It was a Northern Soul connection that led to the domestic release of De-

troit techno in Britain. Dance music entrepreneur Neil Rushton had been a "Northern Soul freak, into Motown." Intrigued by the Detroit tracks simply because of where they came from, he contacted the Belleville Three and licensed their tracks for UK release through his labels, Kool Kat and Network. Rushton then sold the idea of doing a Detroit compilation to Virgin subsidiary Ten Records. Detroit's music had hitherto reached British ears as a subset of Chicago house; Rushton and the Belleville Three decided to fasten on the word "techno" — a term that had been bandied about but never stressed — in order to define Detroit as a distinct genre. The single from the compilation — Kevin Saunderson's Inner City track "Big Fun" — was a huge hit; the follow-up, the crystalline shimmer-funk of "Good Life," was even bigger. Worldwide, both tracks sold over two million. While Saunderson and singer Paris Grey were being treated like pop stars, Juan Atkins's Model 500 tracks and Derrick May's "Strings of Life" and "Nude Photo" ruled the underground.

For the Belleville Three, it was something of a revelation to be embraced by a white European audience. "If you're a kid in Detroit, you might never even have to *see* a white person, unless they're on TV," says Atkins, describing Detroit's unofficial apartheid of different neighborhoods, different schools, different radio stations. "The first time I went to the UK, man, I played for *five thousand white kids.*" The revelation was tempered by certain reservations about how these crazy English kids had taken techno and made it a component of a totally different subculture. There was virtually no drug element to the Detroit party circuit. For the DJ/philosopher Derrick May, in particular, the deranged and debauched atmosphere of the British scene was a world away from his vision of the ideal techno audience of urbane aesthetes. Compare the druggy names of British clubs and warehouse parties (Brainstorm, Trip City, Hedonism) with the sober, lofty-sounding moniker of the Detroit club where May was then realizing his vision: the Detroit Musical Institution, aka the Music Institute.

By the early nineties, May's distaste for Brit-rave excesses had hardened into bitter contempt: "I don't even like to use the word 'techno' because it's been bastardized and prostituted in every form you can possibly imagine. . . . To me, the form and philosophy of it has nothing to do with what we originally intended it to be." Eddie Fowlkes shares May's resentment. "Techno was a musical thing," he says. "There wasn't no culture — no whistles, no Es or

throwing parties at old warehouses. A warehouse party in Detroit — it was swept clean, painted, mirrors on the wall, a nice sound system. It wasn't dirty and raunchy."

Although Fowlkes clearly means to indict, this comment could equally serve as a tribute to the British youth who took this imported music and built a *culture* around it, an entire apparatus of clothes and rituals, dance moves and drug lore. Eventually the cultural framework they built actually changed the music itself, mutated and mutilated the Detroit blueprint, adding new inputs and intensifying certain elements that enhanced the drug sensations. And these transformations would be spawned above all in the "dirty, raunchy" milieu of warehouse parties and the massive one-shot raves and rave-style clubs that followed in their wake.

Warehouse parties dated back to the late seventies, to the reggae "blues," shebeens, and illegal after-hours drinking dens. In the eighties, the scene stretched from funk, soul, and hip-hop parties like the Dirtbox and Westworld to the legendary events thrown in abandoned British Rail depots and derelict schools by the Mutoid Waste Company, an anarcho-punk collective that lived in caravans and constructed postapocalyptic sculptures out of scrap machinery and salvage from skips.

Acid house mania incited an explosion of warehouse parties, as ravers looked to circumvent the restricted hours of licensed clubs. Besides their regular weekend parties at Clink Street, the RIP crew went peripatetic in late 1988, organizing a series of Brainstorm events. Film studios and disused industrial hangars were typical locations. There was also a spate of riverboat parties, often kicking off in the Docklands area of East London.

In the East End, a number of warehouse parties were controlled by the ICF, one of several soccer "firms" turned criminal syndicates that had realized the scope for profit in the new dance-and-drug culture — not just from admissions to events, but from controlling the drug supply. As well as running their own parties, these gangs would also latch onto successful promoters with an established following, then apply the pressure.

One East London party promoter who narrowly escaped the hoodlums' clutches was Joe Wieczorek, the Dickensian figure behind Labrynth, the

world's longest-running rave club. In the eighties Wieczorek — an avid supporter of the soccer team Tottenham Hotspur — had links to the football hooligan scene, running a pub that served as a meeting point for Tottenham fans when they had matches with Millwall or West Ham (the team supported by the ICF). Having retired from the pub game, sick of alcohol culture and the East End hard man ethos, Wieczorek was impressed when he encountered a former soccer enemy loved-up on E at an acid house party. "The last time we met, he was sticking a great big blade in my back."

From late 1988 on, warehouse parties were rife throughout the East End, thanks to the abundance of derelict, disused buildings. In October 1988 Wieczorek decided to have a crack at it himself. The more cunning warehouse promoters had become adept at fooling the police into believing their events were fully licensed, using falsified leases and paperwork. Wieczorek made an appointment with his local fire station to discuss safety at house parties. "The guy left me in his office for five minutes, and I picked up a piece of headed notepaper, folded it up and put it in my pocket." One of the Labrynth crew used his computer skills to forge "a fire certificate." No such thing existed, but it looked official, and it worked. "The moment the police saw the certificate, and the odd fire extinguisher, they were just not interested in stopping the party."

After this, there was no stopping Wieczorek & Co, and they launched themselves on an astounding run of weekly parties, pulling off around 120 illegal warehouse events at some 47 different venues. Like other rising 1989 promoters, Labrynth stuck with the previous year's "Second Summer of Love" spirit, even as the original Balearic crew were reneging on its premise of universal brotherhood. A picture of a mustachioed and mystic-looking George Harrison with an eye in his palm became the Labrynth logo. Grainy black-and-white snapshots of the crowd appeared on the flyers for their "Every Picture Tells a Story" events, spelling out the fact that the audience was the star. The E of "Every" was emphasized with a circle — a hint that "only the happiest of people need apply" (the Labrynth slogan).

All through '89, Labrynth was the number two East End party organization, just behind an outfit called Genesis. Despite its reputation for throwing the most spectacular parties, Genesis eventually threw in the towel, Wieczorek believes, because of an attempted takeover by gangsters. Wieczorek faced the same pressure. After attempting to sweet-talk Labrynth into their fold, the

soccer-thugs-turned-protection-racketeers tried intimidation. The ugly climax came at a Labrynth party in Silvertown on April 29, 1989. A gang of thugs rushed the dance floor wielding machetes. Wieczorek believes it was a reprisal for his having refused a protection arrangement in which he would have had to hire security men "at 185 pounds a man per night, and we had to have ten men." One Labrynth associate lost an eye.

This incident convinced Wieczorek that the illegal party game was too much of a hassle: it was time to go legitimate. Further incentive came from the police, who had formed a special "acid squad" to wipe out the warehouse scene and later unsuccessfully prosecuted the East End pirate station Centre Force for allegedly operating a drug-peddling ring. After a threatening visit from the acid squad, Labrynth took up residency at Dalston's Four Aces club — a suitably labyrinthine warren of corridors and caverns — where it remained until it moved to bigger premises next door in 1997.

The involvement of the criminal football gangs in the warehouse scene was a sign of the times. The characters who took acid house to the next stage — massive raves in aircraft hangars, grain silos, and open fields, mostly at sites near the M25 orbital highway that encircles London — weren't subcultural movers and shakers. They were underworld figures or entrepreneurs who weren't averse to breaking a few laws. Unlike the original Balearic and acieed figures — DJs and scenemakers — the new breed of promoters wasn't motivated by musical concerns. For sure, they might have developed a taste for E, genuinely getting into the music and the vibe. But the primary impetus to make the events bigger and more spectacular was profit. Transforming an underground scene into a mass movement had the happy combined effect of amplifying the atmosphere of loved-up communion and raking in tax-free income.

The spirit underlying this next phase of the acid house revolution was anarcho-capitalist. If the Summer of Love rhetoric ran against the Thatcherite grain (the prime minister had infamously proclaimed, "There is no such thing as society, just collections of individuals"), the spirit behind emergent organizations like Sunrise, Energy, World Dance, and Biology was an entrepreneurial audacity utterly in tune with the quick-killing spirit that fueled the economic boom of the late eighties. Sunrise's Tony Colston-Hayter turned Tory ideology

against Tory family values, protesting "surely this ridiculous three AM curfew on dancing is an anachronism in today's enterprise culture?" Sunrise's PR officer was Paul Staines, a Libertarian Conservative whose day job was as assistant to rabid freemarket ideologue David Hart, one of Thatcher's favorite advisors.

Unlike the Oakenfolds and Ramplings, these new promoters tended not to have any background in club promotion. Colston-Hayter's résumé included setting up his own game machine companies while still a schoolboy and stints as a professional blackjack gambler. World Dance's Jay Pender was a foreign exchange broker. "I realized rave was a sort of 'power to the people' thing, where you could just *do it* if you had some contacts and the nerve," he says. Inspired by a Sunrise party at an equestrian center in the Buckinghamshire countryside, Pender used his contacts in the London financial world to find a green field site off the M25. When the local police attempted to thwart the event on the grounds that Pender hadn't applied for permission, he countered with the argument that permission wasn't required because it was a private party, for members only. "To become a member, though, all you had to do was fill in your address and give us fifteen pounds on the day — so it was a bit of a scam!"

The rave-as-private-party concept was Colston-Hayter's idea; in true Thatcherite spirit, he had found a loophole in the law. (Also in that fuck-society spirit, Sunrise's profits would be siphoned to an offshore tax haven). Colston-Hayter's other great stratagem was using the British Telecom Voice Bank system as a method for outwitting the police. Flyers advertised only a phone number, not an address. The Voice Bank allowed for a series of locations to be updated remotely via mobile phone; party-goers would drive to these meeting points and be told where to go next. The convoy would descend upon the site, presenting the police with a de facto rave that couldn't be dispersed for fear of a riot. Only then would the exact location be posted on the answering machine.

Hitherto, warehouse parties had mostly drawn in the neighborhood of three or four thousand; the orbital rave dramatically upped the ante, as organizers competed to throw the biggest and most dazzling events. Sunrise established a new record on June 24, 1989, with its eleven-thousand-strong "Midsummer Night's Dream" event at an aircraft hangar in Berkshire. The parties also

attracted the attention of the tabloids, which had forgotten all about the "Acid House barons." The *Sun's* front-page story painted a lurid picture of "thrill-seeking youngsters in a dance frenzy," complete with absurd details like "ecstasy wrappers" strewn on the floor afterward. Home Secretary Douglas Hurd promised to draft legislation to "stop the menace of acid parties." In response, a news sheet distributed outside London clubs declared that "house parties will rock all summer and the [police], the establishment and the gutter press can go fuck themselves." The stage was set for a summer of fun and trouble.

For many, 1989 was the year things really kicked off. The combined thrills of thumbing your nose at the police and experiencing the sheer scale of the outdoor raves was addictive. The magical routes that had traversed and transformed London the previous summer were now shifted outside the city limits, into the semirural Home Counties. "1989 was the real explosion," says Gavin Hills. "It was still underground, a special club, even though it was a mass movement. It was Us against Them. Going out and trying to get past police roadblocks, having a laugh — it was an adventure." Motorway service stations became the scenes of impromptu parties, before and after raves, with people dancing around their cars with stereos on full blast.

For journalist Helen Mead, dancing with ten thousand people "on Ecstasy" was "completely fucking mind-blowing, compared with doing it in Shoom with two hundred people. . . . And I never remember any sense of worry at those big events. You'd maybe go with five people, and you'd be in these absolutely massive places, and you'd always be wandering off — whether it was 'cos you'd had your eyes closed and then found you'd danced half a mile away, or going to the toilet, navigating your way through these huge places. But I never remember feeling lost or stranded anywhere."

As the big promoters competed to lure the customers, flyers were emblazoned with increasingly extravagant, highly technical, and often fraudulent claims about the raves' spectacular sound systems and lights: 80 K proquadraphonic sound, turbo bass, water-cooled four-color lasers, golden scans, terrastrobes, arc lines, varilights, and robozaps. A lot of the fancy-sounding verbiage was actually made up. As well as brain-frazzling sound-and-visuals, the raves promised sideshows and added attractions like fairground rides, gyroscopes, fireworks, and the soon-to-be-infamous inflatable "bouncy castle."

In 1988 the word "rave" was in common parlance, but mostly only as a

verb, e.g., "I'm going out raving tonight." By 1989 "rave" was a fully fledged noun and "raver" was, for many, a derogatory stereotype, an insult. While "raving" came from black British dance culture, and originally from Jamaica, "raver" plugged into a different etymology. The *Daily Mail* had used the word in 1961 to condemn the boorish antics of "trad jazz" fans at the Beaulieu Jazz Festival. A few years later a TV documentary employed "raver" to evoke the nymphomaniac hysteria of teen girl fans and groupies. There had also been an "All Night Rave" at the Roundhouse in October 1966, a psychotropic spectacular featuring Pink Floyd and the Soft Machine. All these connotations — frenzied behavior, extreme enthusiasm, psychedelic delirium, the black British idea of letting off steam on the weekend — made "raving" the perfect word to describe the acid house scene's out-of-control dancing.

If the original Balearic hipsters had been dismayed by the acid teds, the orbital raves were even more repugnant. Shoom had organized a few excursions to the countryside. At one of these, Down on the Farm, the local fire brigade was hired to come down at the height of the party and pump foam onto the dance floor, turning it into a giant bubblebath. Boy's Own also ventured outside London, throwing a lakeside party at East Grinstead in August '89. But with only eight hundred people in attendance, this was far from a megarave, which was now more like a stadium rock concert than a warehouse jam.

For the Shoom and Boy's Own cognoscenti, the ravers' rowdy rituals of abandon and joyous uniformity of attire signified a "herd mentality," something that clubbers defined themselves against. Orbital raves were "mass, teenage. . . . One didn't do it," says Louise Gray. RIP's Mr. C DJ-ed at a few Sunrise, Biology, and Energy events, but "wasn't generally impressed. It was bit too impersonal." The competition between rave organizations for star lineups meant that "you'd get twelve DJs playing in twelve hours, and each DJ would only get an hour. In an hour, you're only going to fit in ten or fifteen records, and you're gonna play the biggest fifteen records in your box — in order to make the people scream the loudest. So it was no longer about how psychedelic and challenging the music was, it was about how big and loud it was."

Where a club DJ might play a two- or three-hour set, taking the crowd on a journey through peaks and valleys, the structure of raves was transforming the music and the scene, orienting it toward anthems — instantaneous, high-impact, sensation-oriented. In a break with the DJ-dominated club ethos, live

rave performers began to appear: there was a craze for keyboard whizz kids like Adamski, Guru Josh, and Mr. Monday. In response, the Balearic backlash intensified, taking the form of a return not just to clubs, but to clubland in its pre-acieed form: dressing flash, "quality sounds for quality people." The vogue for deep house and New Jersey garage — Turntable Orchestra, Blaze, Phase II, Adeva — strengthened.

Musically, there was still some crossover between the Balearic scene and the rave circuit: tracks like Nightwriters' "Let the Music Use You," Lil Louis's orgasmatronic epic "French Kiss," Ce Ce Rogers's "Someday," and 10 City's "Devotion" were anthems on both sides of the divide. But by late summer, the ruling sound at the big raves was the almost preposterously uplifting Italohouse sound — all oscillating piano vamps and shrieking disco divas — that had been hatched in Adriatic resorts like Rimini and Riccioni. When Black Box's "Ride on Time" — whose vocal was pilfered wholesale from Loleatta Holloway's "Love Sensation" — annexed the number one spot for six whole weeks in September '89, it felt like a victory for the rave nation, the climax of the *second* Second Summer of Love.

By this point, though, the orbital rave scene was beginning to unravel. The police had built up a massive computer database on the major rave organizers. They were setting up phone taps, eavesdropping on pirate radio, and deploying helicopters in the countryside to spot raves being set up. Out in the country lanes, the police were playing cat and mouse with the convoys of ravers. Pressure was applied to landowners to get them to renege on deals struck with the likes of Sunrise and Energy. Gradually, the ravers became disenchanted: not only were there more and more rip-off events with shitty sound systems, no-show DJs, and none of the advertised facilities, but there was a good chance the raves wouldn't happen at all.

"Biology was the one that was a disaster," recalls Helen Mead, referring to an overly ambitious megarave in October 1989. "It was supposed to be the first million-pound party. I just remember driving around all night 'cos they had to change the site three times." The police strategy was attrition: wear down the spirits of the ravers, make them so sick of the wild goose chases and the bitter disappointment when an event was quashed that they'd return to the guaranteed pleasures of licensed clubs. As well as the dangers of inadequate fire and safety precautions and the debauchery of mass teenage drug con-

sumption, the police were concerned by the fact that major criminal organizations were muscling in on the scene, trafficking in narcotics and attempting to extort their slice of the massive takings.

The ravers weren't going to let go of their good thing without a fight. Altercations between frustrated ravers and police forces engaged in roadblocks became frequent. There was also an attempt to take the resistance into the political arena. With the tabloids stoking public concern, Graham Bright, a Conservative MP, drafted a private member's bill to increase the penalties for unlicensed parties, proposing huge fines and six-month prison sentences. In response, Tony Colston-Hayter and his libertarian sidekick Paul Staines attended the Conservative Party's annual conference in November, where they announced the formation of the Freedom To Party campaign. Although all the leading rave promoters were involved, the movement petered out after a few sparsely attended rallies — seemingly yet more proof of the apolitical, unmotivated character of the Ecstasy generation.

With the big rave almost extinct — at least in the South of England — the general feeling was that it was all over, for good. But the living dream of rave was too alluring to fade away even after the passage of Graham Bright's anti-rave legislation. Rave resurged, but with a different inflection. Local authorities began to adopt a more liberal approach to permits for commercial rave promoters. Licensing hours were finally liberalized (although regional variations remained), allowing for the growth of rave-style clubs open until 6 AM, 8 AM, sometimes even noon the next day. Spreading to every provincial corner of the UK, rave culture became a highly organized leisure industry. Still underground, in terms of its atmosphere, it was at the same time the norm: what Everykid did, every weekend.

Webster's defines ecstasy as "a state of being beyond reason or self-control," "a state of overwhelming emotion," "a mystic or prophetic trance," a "swoon." In the early eighties, ecstasy acquired another meaning: the illegal drug MDMA, whose range of effects spans all the definitions above. A "psychedelic amphetamine," MDMA is a remarkable chemical, combining the sensory intensification and auditory enhancement of marijuana and low-dose LSD, the sleep-defying, energy-boosting effects of speed, and the uninhibited conviviality of alcohol. If that wasn't enough, MDMA offers unique effects of empathy and insight.

Depending on expectations and context, the Ecstasy experience ranges from open-hearted tête-à-tête through collective euphoria to full-blown mystical rapture. Used in therapy Ecstasy can facilitate a profound experience of interpersonal communication and self-discovery. In the rave environment, Ecstasy acts as both party-igniting fun-fuel and the catalyst for ego-melting mass communion. What all these different uses of MDMA have in common is *ekstasis*, the Greek etymological root of *ecstasy*, whose literal meaning is "standing outside oneself." MDMA takes you out of yourself and into blissful merger with something larger than the paltry, isolate "I," whether that trans-individual be the couple in love, the dancing crowd, or the cosmos. MDMA is the "we" drug. It's no coincidence that Ecstasy escalated into a pop cultural phenomenon at the end of the go-for-it, go-it-alone eighties (the real Me Decade). For Ecstasy is a remedy for the alienation caused by an atomized society.

MDMA (methylene dioxymethamphetamine) was first synthesized and patented shortly before the First World War by the German company Merck. One version of MDMA's history maintains that the drug was briefly prescribed as a dieting aid, another that it was originally developed as an appetite suppressant for German troops. If the latter is true, MDMA's aggression-diminishing, empathy-inducing effects would have quickly disqualified its use in combat situations. When it was used in the early nineties in experimental therapy sessions for traumatized Nicaraguan soldiers, 75 percent of the subjects expressed a desire for peace and an end to war, with several talking of loving everyone, including the enemy.

The modern story of MDMA begins with its rediscovery in the early 1960s

by Alexander Shulgin, widely regarded as "the stepfather of Ecstasy." Shulgin was then a biochemist working for Dow Chemical and pursuing an interest in psychedelics on the sly. Later in the decade he opened his own government-approved laboratory in San Francisco dedicated to the synthesis of new psychoactive substances, all of which he tested on himself and his wife/coresearcher Ann. Shulgin soon became a prime mover in America's network of neuro-consciousness explorers. By 1976, the first reports on MDMA's therapeutic potential were appearing in medical journals. In the late seventies and early eighties, MDMA — then nicknamed Adam because of the way it facilitated a sort of Edenic rebirth of the trusting and innocent "inner child" — spread throughout a loose-knit circuit of therapists in America. Used in marriage therapy and psychoanalysis, the drug proved highly beneficial. Advocates claimed that a five-hour MDMA trip could help the patient work through emotional blockages that would otherwise have taken five months of weekly sessions.

Similar arguments had been made in favor of LSD, although the accent was on acid as a tool of spiritual discovery. Just like the "serious" psychonauts of the sixties, Adam's evangelists hoped to restrict the use of the drug to clinically supervised sessions, while gradually campaigning for MDMA's medical legitimacy. But the more "frivolous" potential of MDMA — its euphoria-inducing effects — couldn't be kept secret for long. By the early eighties, there was a full-fledged Ecstasy scene in Dallas and Austin nightclubs, and X (as it was nicknamed in America, as opposed to the British slang E) was becoming an increasingly popular "legal high" throughout the USA.

Inevitably the authorities clamped down. On July 1, 1985, MDMA was banned for one year. The Drug Enforcement Administration ignored the judge's recommendation that the drug be put in Schedule 3 and instead put it in its most dangerous category, Schedule 1, an outlaw status sealed by the Federal Court of Appeals in 1988. In the UK, Ecstasy was already a Class A illegal drug alongside heroin and cocaine, because the Misuse of Drugs Act 1971 (Modification) Order of 1977 applied to the whole family of chemicals to which MDMA belonged.

MDMA's therapeutic supporters protest that drug war paranoia outlawed a miracle drug with myriad benign applications. But the truth is that even before its illegalization, Ecstasy had already slipped decisively out of the custodian-

ship of psychotherapy. Instead of being used as Shulgin and his allies had envisioned — in bonding sessions between couples, as a tool of personal discovery — Ecstasy proved to have other, infinitely more alluring applications. When large numbers of people took Ecstasy together, the drug catalyzed a strange and wondrous atmosphere of *collective intimacy*, an electric sense of connection between complete strangers. Even more significantly, MDMA turned out to have a uniquely synergistic/synesthetic interaction with music, especially uptempo, repetitive, electronic dance music.

In a quite literal sense, MDMA is an E-lectrifying experience, charging up the fantastically complex computer that is the human brain. The drug's effect is to dramatically increase the availability of dopamine and serotonin, neurotransmitters that conduct electrochemical impulses between brain cells (aka "neurons"). Excess dopamine stimulates locomotor activity, revs up the metabolism, and creates euphoria. Serotonin usually regulates mood and the sense of well-being, but in excess it intensifies sensory stimuli and makes perceptions more vivid, sometimes to the point of hallucination.

Although MDMA floods the nervous system with dopamine (like speed) and serotonin (like LSD), it's more than just a "psychedelic amphetamine"; when profit-minded dealers try to make pseudo-E cocktails out of speed and acid, their dodgy wares lack MDMA's famous "warm glow." Trying to convey this special attribute of MDMA, the drug's early therapeutic supporters coined new pharmaceutical classifications like *empathogen* (a feeling enhancer) and *entactogen* (literally "touching within," a substance that puts you in touch with yourself and others). Ecstasy has been hailed as "penicillin for the psyche," "a stabilizer" rather than an upper, and as an "artificial sanity" that temporarily quiets the neurotic self, freeing the individual from anxiety and fear.

The Ecstasy trip divides into three distinct phases. Depending on the emptiness of your stomach, it takes approximately an hour to "come up": the senses light up, you start "rushing," and for a short while the experience can be overwhelming, with dizziness and mild nausea. Then there's the plateau stage, which lasts about four hours, followed by a long, gentle comedown and an afterglow phase that can last well into the next day. What you experience during the plateau phase is highly dependent on "set and setting" (the early LSD

evangelists' term for the mind-set of the drug taker and the context in which the drug is taken). In a one-on-one session (lovers, close friends, analyst and analysand) the emphasis is on the breaking down of emotional defenses, the free flow of verbal and tactile affection. The first time I took Ecstasy was in a romantic, private context. The experience was so intense, so special, that I felt it would be sacrilegious to repeat it lest it become routinized, and it was over two years before I did it again.

At a rave the emotional outpouring and huggy demonstrativeness is still a major part of the MDMA experience (which is why ravers use the term "loved-up"), but the intimacy is dispersed into a generalized bonhomie: you bond with the gang you came with, but also with people you've never met. Anyone who's been to a rave knows the electric thrill of catching a stranger's eye, making contact through the shared glee of knowing that you're both buzzing off the same drug/music synergy. Part of what makes the classic rave experience so rewarding and so addictive are the "superficial" but literally touching rituals of sharing water, shaking hands, having someone a tad worse for wear lean on you as if you were bosom buddies.

The blitz of noise and lights at a rave tilts the MDMA experience toward the drug's purely sensuous and sensational effects. With its mildly trippy, prehallucinogenic feel, Ecstasy makes colors, sounds, smells, tastes, and tactile sensations more vivid (a classic indication that you've "come up" is that chewing gum suddenly tastes horribly artificial). The experience combines crisp clarity with a limpid radiance. Ecstasy also has a particular physical sensation that's hard to describe: an oozy yearn, a bliss-ache, a trembly effervescence that makes you feel like you've got champagne for blood.

All music sounds better on E — crisper and more distinct, but also engulfing in its immediacy. House and techno sound especially fabulous. The music's emphasis on texture and timbre enhances the drug's mildly synesthetic effects so that sounds seem to caress the listener's skin. You feel like you're dancing inside the music; sound becomes a fluid medium in which you're immersed. Ecstasy has been celebrated as the *flow drug* for the way it melts bodily and psychological rigidities, enabling the dancer to move with greater fluency and "lock" into the groove. Rave music's hypnotic beats and sequenced loops also make it perfectly suited to interact with another attribute of Ecstasy: recent research suggests that the drug stimulates the

brain's 1b receptor, which encourages repetitive behavior. Organized around the absence of crescendo or narrative progression, rave music instills a pleasurable tension, a rapt suspension that fits perfectly with the sustained preorgasmic plateau of the MDMA high.

These Ecstasy-enhancing aspects latent in house and techno were unintended by their original creators and were discovered accidentally by the first people who mixed the music and the drug. But over the years, rave music has gradually evolved into a self-conscious science of intensifying MDMA's sensations. House and techno producers have developed a drug-determined repertoire of effects, textures, and riffs that are expressly designed to trigger the tingly rushes that traverse the Ecstatic body. Processes like EQ-ing, phasing, panning, and filtering are used to tweak the frequencies, harmonics, and stereo imaging of different sounds, making them leap out of the mix with an eerie three-dimensionality or glisten with a hallucinatory vividness. Today's house track is a forever-fluctuating, fractal mosaic of glow-pulses and flickerriffs, a teasing tapestry whose different strands take turns to move in and out of the sonic spotlight. Experienced under the influence of MDMA, the effect is synesthetic — like tremulous fingertips tantalizing the back of your neck, or the simultaneously aural/tactile equivalent of a shimmer. In a sense, Ecstasy turns the entire body surface into an ear, an ultrasensitized membrane that responds to certain frequencies. Which is why the more funktionalist, drugdetermined forms of rave music arguably are really "understood" (in a physical, nonintellectual sense) only by the drugged and really "audible" only on a big club sound system that realizes the sensurround, immersive potential of the tracks.

Beyond its musical applications, Ecstasy is above all a *social* drug. It's rarely used by a solitary individual, because the feelings it unleashes would have nowhere to go. (A friend of mine, bored, once took some leftover E at home and spent the night kissing the walls and hugging himself.) In the rave context, Ecstasy's urge to merge can spill over into an oceanic mysticism. Rave theorists talk of tribal consciousness, "morphic resonance," an empathy that shades into the telepathic. Writing about his memories of London's most hedonistic gay club, Trade, Richard Smith came up with the brilliant phrase "a . . . communism of the emotions." The closest I've had to a mystical experience occurred, funnily enough, at Trade. Borne aloft in the cradling rush of sound,

swirled up and away into a cloud of unknowing, for the first time I truly *grasped* what it was to be "lost in music." There's a whole hour for which I can't account.

The psychedelic component of the Ecstasy experience is usually gentler than this, though, taking the form not of perceptual distortion but of a numinous glow. There's a sense of hyperreal immediacy, cleansed perceptions, the recovery of a childlike amazement at the here and now. This feeling of gnosis — being in the *know*, living in the *now* — can launch some Ecstasy initiates on a journey of spiritual discovery beyond recreational drug use. Others return again and again to MDMA's enchantments, only to discover that the "magic pill" has a dark side.

In neurochemistry, there's no such thing as a free lunch, and MDMA comes with a plethora of costs and catches. Most of MDMA's physical side effects are merely irritating: dry mouth, jittery nerves, slight nausea (usually during the rush phase, then wearing off quickly). Most notable is jaw tension, which results in "bruxism" (teeth grinding) or, with excessive intake, face pulling. Ravers deal with this by furiously chewing gum or sucking on pacifiers. Although in the short term Ecstasy has the opposite effect of a hangover (a delicious afterglow that lasts into the next day), the major repercussion of the drug is the comedown a few days later, which involves fatigue, emotional burnout, irritability, and mood swings between elation and desolation comparable to heartbreak.

Dopamine (the speedy component of the experience) is more rapidly replaced in the brain than serotonin (the loved-up, euphoric part). It takes about a week for serotonin levels to normalize. Taking Ecstasy is like going on an emotional spree, spending your happiness in advance. With irregular use, such extravagance isn't a problem. But with sustained and excessive use, the brain's serotonin levels become seriously depleted, so that it takes around six weeks of abstinence from MDMA to restore normal levels.

If you take E every day, the blissful, empathetic, serotonin glow wears off within a few days, leaving only the speedy, dopamine buzz. This built-in diminishing returns syndrome is one reason why MDMA isn't considered physi-

cally addictive. The honeymoon period with Ecstasy that most ravers enjoy can, however, create an emotional addiction, insofar as normal life seems dreary compared to the loved-up abandon of the weekend. This is when Ecstasy's potential for abuse enters the picture. Because the original blissed-out intensity of the early experiences never really returns, users are tempted to increase the dose, which only increases the speediness and amplifies the unpleasant side effects. Serious hedonists get locked in a punishing cycle of weekend excess followed by a savage midweek crash. As well as compulsive bingeing on E, many get drawn into compensatory polydrug use — taking other substances to mimic the effects originally achieved by MDMA alone. Alongside the physical attrition wreaked by such a lifestyle (weight loss, frequent illness caused by sleep deprivation in tandem with the virus-fostering nature of hot, sweaty clubs), the long-term abuse of Ecstasy can also result in psychological damage (anxiety disorders, panic attacks, paranoia, and depression).

Although MDMA may actually be far more dangerous for its psychological side effects (some experts worry about a generation that will grow up to face higher rates of depression and suicide), the case against Ecstasy has mostly been pursued in terms of its physical risks. There is some evidence that Ecstasy affects the axons (containers in the brain that hold serotonin), but since no deleterious effects have been detected in long-term users' behavior or neurology, talk of "brain damage" is premature. The truth is that most problems associated with Ecstasy seem to be caused by the *way* it is used. The psychological costs stem from recklessly excessive, long-term intake; the physical dangers are almost all related to its usage in the rave context, where overexertion and dehydration can lead to heatstroke.

Even without physical activity, Ecstasy raises body temperature; dehydration and nonstop dancing can push it as high as 108°F, at which point the blood forms clots. Because this uses up the clotting agent — normally at work sealing the myriad minuscule abrasions that occur inside the body — the result can be internal bleeding, followed by collapse. The solution is to drink plenty of fluids (safe-raving counselors recommend a pint an hour) and take regular chill-out breaks. But the problem is that MDMA affects the subjective awareness of body temperature: those in danger often feel like they're cool. Cashrestricted ravers would often rather spend their money on the "essentials"

(more drugs) than outrageously overpriced soft drinks. Club owners have been known to turn off the cold water taps in order to increase bar takings. Such cynical practices have declined as more clubs adopt the harm-reduction policies devised by safe-raving pressure groups. Ravers also know more about how to take care of themselves. But a little bit of education can also be dangerous. Take the case of Britain's most famous Ecstasy fatality, Leah Betts, who died in 1995 at her own eighteenth birthday party. Feeling unwell and having heard that water was the remedy, she appears to have drunk too much too rapidly; the inquest revealed that she died by drowning. The problem was that the drink-lots-of-fluids advice applies only to intense aerobic activity and wasn't appropriate in her circumstances.

Although there have been a few cases of people dying after taking just one pill because of a statistically remote allergic reaction, most Ecstasy-related fatalities have involved bingeing, overexertion, and mixing of drugs (sometimes the more toxic amphetamine, sometimes alcohol, which dehydrates the body). Because of all these factors, it's hard to ascertain exactly how dangerous MDMA is. Ecstasy apologists often compare the chemical favorably with other drugs, legal and illegal. In the UK there are around 100,000 deaths per year from tobacco-related illnesses, 30,000 to 40,000 from alcohol-related illnesses and accidents. On average, heroin and solvent abuse each claim about 150 lives per annum, while amphetamine's death toll is about 25. In the first ten years of British rave, Ecstasy has been implicated in approximately 70 deaths, an average of seven per year. Given the vast number of people taking the drug during those ten years (conservative estimates put it at half a million per weekend in Britain), Ecstasy appears to be relatively safe — at least compared to such socially sanctioned leisure activities as mountaineering, skiing, and motorbiking. Statistically, you're more at risk driving to the rave than being on E at the rave.

As with liquor in America in the 1920s, prohibition has created a climate in which Ecstasy is more hazardous than it might be if the substance were legal. Prohibition actually made drinkers get drunker (black-market moonshine often had a dangerously high alcohol content) and created a climate of lawlessness. Similarly, because the overwhelming majority of early experiences with Ecstasy are so rewarding, punters become curious about other banned substances and get drawn into the culture of polydrug usage. MDMA's positive aura has rubbed off on other, far less deserving chemicals. This is the flaw in a

drug policy that conflates all "drugs" as a single demon without distinguishing between different levels of risk.

From the consumer's point of view, the worst thing about illegalization is that you don't know what you're buying. The illegal drug market in Britain has given rise to an ever-expanding range of brands of Ecstasy, distinguished by their coloring or by tiny pictograms stamped into the tablets and varying widely in content. Brands like Doves, California Sunrises, Dennis the Menaces, Rhubarb & Custards, Snowballs, Burgers, Flatliners, Swallows, Turbos, Phase Fours, Refreshers, Lovehearts, Riddlers, Elephants, ad infinitum (and in some cases ad nauseam). Ravers become connoisseurs of the pills' differing effects and how they interact with each other or with other drugs.

Although the purity of Ecstasy fluctuates, the general rule today appears to be that you have about a one in ten chance of buying a total dud (usually containing decongestants, antihistamines, or harmless inert substances) and about a 66 percent likelihood of getting a variable dose of pure MDMA. The slack is taken up by pills that contain MDMA-related substances (MDA, MDEA), or amphetamine, or cocktails of drugs designed to simulate MDMA's effects (e.g., amphetamine plus LSD). Instead of making ravers more cautious, the uncertainty of supply seems to have the opposite effect. Ravers eagerly assume that they've been sold an inferior product and take more pills to compensate; hence the perennial mantra "Es are shit these days, you have to take five of them to get a buzz." Often the "weakness" of any given Ecstasy pill is caused by the serotonin depletion effect; the bliss deficit is in the raver's *brain*, not the tablet. If E were legally available in doses of guaranteed purity and fixed levels of MDMA content, it would be easier for users to monitor their intake, to realize when they're overdoing it.

Excessive, routinized use combines with Ecstasy's diminishing-returns syndrome to form a vicious circle, a negative synergy. The individual's experience of Ecstasy is degraded; on the collective level, Ecstasy scenes lose their idyllic luster and become a soul-destroying grind. This utopian/dystopian dialectic intrinsic to rave culture demands the coining of some new quasi-pharmacological terms: *vitalyst* (vitalize + catalyst) and *obliviate* (oblivion + opiate). These terms describe drug *experiences* rather than intrinsic and immutable properties of the drugs themselves; the same drug, abused, can cross the line between positive and negative.

The energy currents that MDMA releases through the body could be compared to theories of a life force that have been promulgated by various "vitalist" philosophers, mystics, poets, and physicians from the eighteenth century to the present: Mesmer's "magnetic fluid," Whitman's "body electric." Reich's orgone. These simultaneously spiritual and materialist theories of an "élan vital" (élan coming from eslan, an archaic French word for "rush") may actually be talking about the same neurological "joy juice" — serotonin. Flooding the nervous system with serotonin and dopamine, Ecstasy starts out as a "vitalyst": you feel more alive, more sensitized, more human. On the macro level, rave scenes in their early days buzz with creativity and we're-gonna-changethe-world idealism. But with regular, rampant use, Ecstasy can become just another "obliviate," like alcohol and narcotics: something that numbs the soul and transforms rave scenes into retreats from reality. This shift from paradise regained to pleasure prison is a recurring narrative experienced by successive Ecstasy Generations across the world. For seemingly programmed into the chemical structure of MDMA is the instruction use me, don't abuse me.

twenty-four-hour party people

"madchester," positivity, and the rave 'n' roll crossover, 1988–91

After London, Manchester has long been Britain's Number Two Pop City. But in the post-punk era the city's musical output was synonymous with the un-pop hue of *gray*: the Buzzcocks' melodic but monochrome punk ditties, the Fall's baleful intransigence, Joy Division's angst rock, New Order's doubt-wracked disco. Dedicated to their own out-of-time sixties notion of pop, the Smiths defined themselves against contemporary, dance-oriented chart fodder. "Panic" was an anthem for disenfranchised discophobes, Morrissey railing "burn down the disco/hang the blessed DJ." The crime? Playing mere good-times music that said "nothing," lyrically, about real life.

Disco and DJ culture had the last laugh, however. Thanks to house clubs like the Haçienda, Thunderdome, and Konspiracy, Manchester transformed itself into "Madchester," the mecca for twenty-four-hour party people and smiley-faced ravers from across Northern England and the Midlands. By 1989, the famously gray and overcast city had gone Day-Glo; Morrissey-style miserabilism was replaced by glad-all-over extroversion, nourished by a diet of "disco biscuits" (Ecstasy).

With its combination of bohemia (a large population of college and art students and the biggest gay community outside London) and demographic reach (around fifteen million people live within a couple hours' drive from the city center), Manchester was well placed to become the focus of a pop cultural explosion. Manchester's ghetto district, Moss Side, is a major drug distribution junction for the Northwest of England. House — which was played as early as 1986 on local station Piccadilly Radio by DJ Stu Allen — chimed in with a long-standing regional preference for up-tempo dance music, as seen in the seventies with the amphetamine-driven Northern Soul scene.

The Haçienda was founded and funded by New Order and the boss of their record label Factory, Anthony H. Wilson (a sort of northern equivalent to the Sex Pistols' Situationist svengali Malcolm McLaren). The nightclub's name was inspired by the Situationists' utopian slogan "The Haçienda Must Be Built." Converted from a yachting warehouse showroom, the Hacienda was initially industrial and dystopian in ambience. The atmosphere perked up when DJs like Mike Pickering started to add house to the mix. Pickering, an ex—Northern Soul fan and member of Factory avant-funk band Quando Quango, had experienced the fervent vibe at the Paradise Garage, thanks to Quando's popularity in New York.

In July 1988, the Haçienda started a Wednesday-night event called Hot with a Balearic Feel; there was a swimming pool and sunlamps, and people danced in beachwear. Then, with Pickering and new DJ Graeme Park on the decks, Friday's long-established Nude became the mental night. As the fervor for acid house swelled, weekday nights at the Hacienda followed, with names like Void and Hallucienda. Rival clubs like Thunderdome and Konspiracy opened, attracting a rougher audience from the more working-class North Manchester. Here the soundtrack was harder: "like punk, almost . . . real Acid stormtrooper stuff," according to Martin Price from local house crew 808 State. Blending subcultural and underworld vibes, there was also an illegal squat club, the Kitchen — a multitiered warren created by knocking through the walls between apartments in a derelict housing block, where ravers mingled with gun-sporting gangsters.

Throughout the Northwest of England, clubs sprang up that modeled themselves on the Manchester vibe. Blackpool had Frenzy, Stoke-on-Trent had Delight, and Liverpool stepped into the fray when its own Hacienda-scale megaclub, the 2,400-capacity Quadrant Park, went house in early 1990. In October that year, "Quaddie" opened Britain's first weekly legal all-nighter, called the Pavilion and located in the basement below the main club. And as with the London house scene, the demand for raves spilled out into the countryside of Lancashire and Cheshire, in the form of illegal parties like Joy and Blastoff, often held in abandoned mills. With its industrial estates, Blackburn became a hotbed for warehouse parties; at its peak, ten thousand kids arrived in cars every weekend in search of the rave.

With the right sound and the right drug in place, all that was needed was a fashion look and some local heroes. The pop media came up with the term "scallydelia" to designate both a laddish breed of Mancunian band — Happy Mondays, the Stone Roses, Inspiral Carpets, Northside, and Paris Angels — and the style of clothes they sported. "Scally" (short for scallywag) was actually a Liverpudlian archetype; the Manchester equivalent was the Perry boy, named after their Fred Perry shirts.

The Scally/Perry look started to coalesce as early as 1984, when "casuals" — soccer hooligans into expensive designer-label fashion — started to

wear flared jeans. By 1989, the scallydelic wardrobe encompassed anything baggy (hooded tops, long-sleeved shirts) and brightly hued (pastel-colored sneakers, garish psychotropic patterns). These "acieed casuals" swapped their designer-logo T-shirts for shirts emblazoned with Madchester-patriot slogans like "And on the Sixth Day God Created Manchester" and "Woodstock '69, Manchester '89."

Thanks to the benign influence of E, violence at soccer matches dropped dramatically. The 1989–90 soccer season became what subcultural theorist Steve Redhead called the "Winter of Love," celebrated in chants like "oh! we're all blissed up and we're gonna win the cup." That summer New Order sneaked the cheeky line "E is for England" into its chart-topping World Cup soccer song "World in Motion." Another expression of the soccer/music interface was the emergence of fanzines that combined both masculine passions. The most famous of these, Liverpool's *The End*, was actually founded in the early eighties and was a big influence on London's *Boy's Own. The End's* editor, Peter Hooton, was also the singer in the Farm, a band that scored Top 10 hits in the early nineties ("Groovy Train," "All Together Now") when it added a house undercarriage to its sixties mod–influenced guitar pop.

Just as mod went from being based on import records from black America to focusing on figurehead bands like the Who and Small Faces, the Manchester house scene went through a similar syndrome. Ecstasy had catalyzed an invincible feeling of change-is-gonna-come positivity, seemingly substantiated by events across the world like the downfall of Communism. Surfing these energy currents of idealism and anticipation, bands like the Stone Roses and Happy Mondays gave the new mood a focus and to varying degrees articulated the Madchester spirit.

"We're Thatcher's children," Shaun Ryder, Happy Mondays' singer, was wont to claim. The Conservative leader's assault on the welfare system and the unions was intended to instill in the working class the bourgeois virtues of providence, initiative, investment, and belt-tightening. But a significant segment of British working-class youth responded to the challenge of "enterprise culture" in a quick-killing, here-and-now way, becoming not opportunity conscious but criminal minded. Eager to participate in the late-eighties Thatcherite boom but excluded by mass unemployment, these kids resorted to all manner of shady money-making schemes: bootlegging (fake designer clothes, pirated

records and computer games), organizing illegal warehouse raves, drug dealing, petty theft, and fraud of all kinds (benefit, credit card). It was from this lumpen-proletarian milieu that Happy Mondays emerged. The truth was that the band and its ilk were Thatcher's *illegitimate* children — unintended, and operating on the wrong side of the law.

By 1989, Happy Mondays had already released two albums on Factory: Squirrel and G-Man Twenty Four Hour Party People Plastic Face Carnt Smile (White Out) and Bummed. Although rough-and-ragged, the Mondays sound — a cross between the Fall and fatback funk — fit fairly well into the Factory tradition of arty, angsty white dance.

There was, however, a distinctively druggy aura to the Mondays' woozy thug-funk. *Bummed* was recorded under the influence of Ecstasy, the band practically shoving it down producer Martin Hannett's throat. Stealing its hook from the Beatles' "Ticket to Ride," "Lazy-Itis" proposed a welfare-age revision of psychedelia: "I think I did the right thing/In slippin' away." A haphazard accretion of hallucinatory images and crooked insights, Ryder's lyrics were like a guttersnipe version of Burroughs-style cut-up: phrases that lodged in his head while stoned in front of the TV, the drivel of acid-casualty friends. Where the Fall's Mark E. Smith penned oblique observations of Northern underclass grotesquerie, Shaun Ryder's drivel was more like the lumpen-proletariat id speaking its bloody mind aloud.

By '89, the Mondays had also picked up a following of Ecstasy-guzzling love thugs. "Everyone in the place was on E and it made us look better and sound better," Ryder told *iD* some time later. "I know they were all on E because we used to go out in the audience selling E like T-shirts." If the "brains" behind the Mondays was Ryder, the focal point and font of the group's anticharisma was Bez — Vicious to Ryder's Rotten. Strictly speaking, his contribution to the group was negligible (on the third album his credit reads "Bez: Bez"!). Onstage, he shook maracas and danced, a listless, moronic traipse that resembled a peasant crushing grapes. Bez's real function was to incarnate the band's debauched spirit, like a Keith Richards relieved of all instrumental duties. For the fans, Bez became both a role model and a stand-in: proof that any one of them could have been up there if they'd lucked out, enjoying all the drugs and ardent groupies.

After a failed attempt at scoring a hit with a Paul Oakenfold house remix of

the brilliant *Bummed* track "Wrote for Luck," Happy Mondays finally got to number nineteen in December 1989 with the "Madchester Rave On" EP. The lead song, "Hallelujah," was a twisted stab at a Christmas single. A queasy merger of rock riffs and studio-programmed beats, "Hallelujah" has Ryder jeeringly defining himself as an Anti-Savior — "ain't here to save ya/just here to . . . play some games." "Rave On" is even more a case of organized confusion. An oozy, ectoplasmic mess of mistreated vocals, effects-wracked guitars, and background hubbub, the track wavers and ripples as if filtered through Bez's E-addled ears. Sounding at his most bleary and smeary, Ryder hollers a party-till-we-drop rallying cry in the chorus: "need a massive boogie 'til we all pack out."

Although they really resembled an English answer to the Butthole Surfers, Happy Mondays were celebrated by the music press as a sort of Acieed Pogues gatecrashing *Top of the Pops*. (Funnily enough, the Pogues' dentally challenged singer Shane McGowan had gotten into rave music in a big way, and around this time was attempting, unsuccessfully, to get his colleagues to record a twenty-minute acid track entitled "You've Got to Connect Yourself"). The other big music press analogy was the Sex Pistols: the Mondays were acclaimed as the first truly working-class band to emerge since punk, "real kids" in possession of the truth that's "only known by guttersnipes" (as the Clash had it).

The Stone Roses — in the Top 10 at the same time as the Mondays with their breakthrough single "Fool's Gold" — were far closer to 1977 punk, or at least the John Lydon version of it: working-class, self-educated, slightly arty, politically aware, and angry. Sonically, the Roses sounded a bit like the Pistols would have if Beatles fan Glen Matlock had managed to prevail over the use of minor chords. But beneath the Byrdsy chimes and Hendrix-like flourishes of their self-titled debut album lurked class-war lyrics that were anything but hippy-dippy. The cuddly-sounding "Bye Bye Badman" was targeted at a riot policeman: "I'm throwing stones at you, man," singer Ian Brown cooed like he was whispering sweet-nothings. They even had their own equivalent to "God Save the Queen" in "Elizabeth, My Dear."

Crucially, the band — Brown, guitarist John Squire, drummer Reni, and bassist Mani — exuded the right Manchester attitude, alternately lippy and laid-back. "We hate tense people," Squire told me in 1989. "The tense people

are the ones who are only interested in making money and who ruin things for everybody else." "Madchester" replaced the workaholic materialism of the eighties with a new spirit, encoded in the slang buzzword "baggy": loose-fitting clothes, a loose-minded, take-it-as-it-comes optimism, a loose-limbed dance beat descended from James Brown's "Funky Drummer." But if there was one factor that sealed the Roses' bond with their following, it was the band's cockiness, proclaimed in anthems like "I Wanna Be Adored" and "I Am the Resurrection" and choruses like "the past is yours/the future's mine": a self-confidence that fit the turn-of-decade positivity like a glove and briefly resurrected a heretical notion — that being young could be fun.

The Stone Roses often spoke of their boredom with eighties rock and claimed that they listened only to seventies funk and contemporary house. With its looped fatback shuffle drums simulating the hypno-groove aesthetic of club music, its bubbling B-line and chickenscratch wah-wah guitar, "Fool's Gold" was the Roses' first nod toward rave. Lurking low in the mix, Ian Brown whispered another baleful lyric of obscure enmity — "I'm standing alone . . . I'm seeing you sinking" — doubtless aimed at the "tense twats" of Thatcherite culture.

By the end of 1989, the Stone Roses' local hero status — a bond forged in Manchester's loved-up Ecstasy atmosphere — had gone nationwide. The Roses took on the mantle of the Great White Hope, plugging into Brit-rock's perennial demand for a four-man trad-guitar combo that Means Something, à la the Jam and the Smiths. But after the triumph of "Fool's Gold," 1990 saw the Roses struggling to articulate the perilously vague creed of "positivity" that Manchester represented. Having already broken with the mold of the traditional rock gig by organizing quasi-raves at Alexandra Palace and Blackpool Empress Ballroom (at which they replaced support bands with DJs like Paul Oakenfold), they convened a twenty-eight thousand—strong outdoor festival at Spike Island on May 27, 1990. But the festival was botched by bad organization and poor sound. Ian Brown came onstage shouting "Time! Time! Time! The time is now." But the Roses' next single, "One Love" — an insipid retread of "Fool's Gold" — failed to sustain the sense of momentum or define what was at stake.

In April, Happy Mondays threw their own pseudo-rave equivalent of Spike Island, with a gig at Wembley Arena timed to coincide with the band and Mad-

chester's biggest hit yet, "Step On," a stomping, house-ified version of Johnny Kongos's 1971 boogie smash "He's Gonna Step on You Again," which stalled at number five. With Anthony Wilson hyping the Mondays as the new Sex Pistols, the next step in the Great Rave 'n' Roll Swindle was the conquest of America. That summer, at the 1990 New Music Seminar in New York, Tony Wilson chaired a panel provocatively titled "Wake Up America, You're Dead." Here, he prophesied that the Manchester groups would export back to white America the revolutionary black American dance music (house and techno) it had ignored, in an echo of what the Stones and the Beatles did with R & B in the sixties. (What really offended the audience of industry insiders, though, was Wilson's gleeful revelation that the Mondays had been drug dealers, and the appearance on the panel of comedian Keith Allen in the guise of a Dr. Feelgood who boasted of having "thousands" of E tablets at his hotel.)

If, as was reported, Manchester had really eclipsed London as the rave capital of the UK, where — you might have been forgiven for asking — were the proper Mancunian house artists? Apart from the Mondays and the Roses, all the other Northwest England bands sounded less like modern *equivalents* of the mod bands than straightforward sixties-beat revivalists. There was only the most tenuous relationship to modern dance music, and an alarming degree of attention to period detail. The Charlatans had the "baggy," shuffle-funk beat, to be sure, but were morbidly obsessed with the milky, Ovalteeny tones of the Hammond organ. Inspiral Carpets exhumed the Farfisa organ, nasal harmonies, and nerdy pageboy haircuts of sixties garage punk. Candy Flip scored a Top 5 hit with a "baggy" version of "Strawberry Fields." Other bands — the High, Ocean Colour Scene, the La's, Mock Turtles — were even more hopelessly classicist.

In truth, there were only two contenders for local house outfits — 808 State and A Guy Called Gerald. Of Caribbean parentage, Gerald Simpson had grown up on a mixture of seventies jazz-fusion, electro, and synth pop (Yellow Magic Orchestra, Numan, Visage). In the late eighties Simpson hooked up with Graham Massey (a refugee from the avant-funk unit Biting Tongues) in a Britrap collective called the Hit Squad. The group practiced in the basement of Manchester's leading import-dance-and-indie-pop record store, Eastern Bloc,

co-owned by Martin Price. With Price supplying "concepts and images," Massey and Simpson then formed an acid-house outfit that evolved into 808 State.

After working on the pure acid LP *New Build*, Simpson quarreled with the rest of the group over money and went solo as A Guy Called Gerald — but not before contributing heavily to a track called "Pacific State." The next thing he knew, his erstwhile partners had recruited two teenage DJs, Andy Barker and Darren Partington, aka the Spinmasters (famous for their sets at the Thunderdome and on Manchester radio), and "Pacific State" was in the Top 10. Rubbing shoulders with "Fool's Gold" and "Rave On," "Pacific" was the third Madchester chart smash at the end of 1989. Simpson tried to get an injunction against the record, eventually settling for royalties and a publishing credit. But he could take solace in the fact that he'd beaten 808 to the punch with "Voodoo Ray," a number twelve hit in July '89 and the first truly great British house anthem.

With its undulant groove and dense percussive foliage (Gerald was trying to get "a sort of samba vibe, I was listening to a lot of Latin stuff"), its glassy, gem-faceted bass pulse and tropical bird synth chatter, "Voodoo Ray" looks ahead to the polyrhythmic luxuriance of Gerald's mid-nineties forays into jungle, as do the tremulous whimpers and blissed-out giggles of the looped and reversed female vocal. The main hook — a sirenlike voice chanting "oooh oo-oooh/aaaah — aa-hahah, yeaahh" — was offset by a sinister male voice intoning "voodoo ray," a mysterious phrase that suggests a shamanic figure or voudun priest, or possibly a mind-controlling beam. In fact, it was a happy accident: originally, "it was meant to be 'Voodoo Rage,' but I didn't have enough memory in the sampler so I had to chop the G off!," says Gerald. "I had this idea of people locking into a beat, this picture of a voodoo ceremony. But instead of it being really aggressive, it ended up something really mysterious."

Gerald followed "Voodoo Ray" with "FX," a track written for the soundtrack to *Trip City* (based on Trevor Miller's experimental novel set in a near-future club scene where everyone is addicted to a hallucinogen called FX), and then, in early 1990, with his major label debut *Automannik*. But the deal with CBS quickly turned sour: the company wanted "ten more versions of 'Voodoo Ray," and Gerald's tougher-sounding, conceptual album *High Life Low Profile* was never released. Disillusioned, Gerald disappeared into the rave underground,

resurfacing in the mid-nineties as one of the most experimental producers in the jungle scene.

808 State fared somewhat better with major-label affiliate ZTT, maintaining a presence in the singles chart while prospering as an album-oriented act. With its cheesy, mellow-yellow saxophone and sampled birdsong, "Pacific State" caught the crest of the vogue for Ambient or New Age house: "coming down music, a sound for when the sun's coming up and the trip's near its end," as Martin Price put it. The original idea behind "Pacific," though, was an attempt at a modern equivalent of 1950s "exotica"; Graham Massey was a big fan of Martin Denny, whose tiki music (quasi-Polynesian mood music for suburban cocktail parties) often featured tropical birdcalls.

On the album 90, "Sunrise" was a far superior take on the same idea; tendrils of flute, mist-swirls of spectral sample-texture, and lambent synth horizons conjure up a Polynesian dawnscape. On this track and the earlier "State Ritual" (which sounded like aborigines trying to make acid house using flutes and wooden gourds), 808 State are denizens of the "Fourth World," Jon Hassell's term for a future fusion that melded Western hi-tech and traditional ethnic musics, as sketched on albums like Dream Theory in Malaya and Aka-Darbari-Java/Magic Realism. Later in 1990, 808 actually remixed "Voiceprint," from Hassell's album City: Works of Fiction, adapting it for the contemporary house dance floor. Primarily a Miles Davis-influenced trumpeter, Hassell was a veteran of the early-seventies, jazz-fusion era. 808 State gave props to Weather Report and Herbie Hancock, fusioneer graduates of Miles's late-sixties and early-seventies ensembles. Darren spoke of "trying to create that big band image, that big sound onstage. We want it so that from every corner of those speakers something's coming out. Those bands were doing it then, and we're doing it now."

On their next album, *Ex-Cel*, 808 State plunged even deeper into the realm of nineties fusion, revealing its pleasures and pitfalls. Tracks like "San Francisco" and "Qmart" offer a pan-global fantasia of reeling vistas and undulating impressionism. Despite its Nubian/Egyptological title, "Nephatiti" is urban to the core, a perfect in-car soundtrack. Like the opening sequence of underpasses and flyovers in Tarkovsky's *Solaris*, it makes you feel like a corpuscle in the city's bloodstream. But elsewhere, there's a tendency toward fusion's cardinal sins: sterile, showboating monumentalism and florid detail verging on the rococo.

Although *Ex-Cel* featured cameos from New Order's Bernard Sumner and Bjork, 808 State's music was for the most part faceless, text-free, *profoundly superficial*. But belying their image as knob-twiddling technicians with nothing to say, 808 State in person were mouthy, vociferous, and in Martin Price's case, almost pathologically opinionated. They had tons of personality — it just wasn't a particularly agreeable one. In person, Price and Massey were quick to define 808 State against the Cabaret Voltaire/A Certain Ratio/On U Sound tradition of avant-funk, despite Massey's own background in that scene. Arguing that rave music had outflanked the egghead experimentalists, Massey declared: "Mainstream clubs are just so out there and futuristic in comparison. At places like Thunderdome, you get beer boys and Sharons 'n' Tracies dancing to the weirdest crap going, stuff that's basically avant-garde."

Price railed against indie-rock/rave crossover bands like the Beloved, the Shamen, Beats International, and Primal Scream as "totally noncredible acts cashing in on the sort of music 808 State have been doing for years." Referring to the widespread argument that the house revolution was "just like punk rock," he snarled: "If somebody says 'techno's like punk' to my face, I'll fucking smash 'em in the teeth. This is about machines, punk was about arm power. Nobody wants to see a load of idiots torturing themselves onstage with guitars anymore. The muscles and sinews in dance music are when you're sweating your bollocks off on the dance floor."

Although the equation of homespun house and punk rock was a little simplistic, the UK dance scene in 1990 was packed with old punks who'd traded in their guitars for the new technology: the Orb's Alex Paterson, Bobby Gillespie of Primal Scream, Bill Drummond and Jimmy Cauty of the KLF. If punk's negativism was really a poisoned romantic utopianism, that blocked idealism flowed free in the 1990s thanks to Ecstasy. Prefigured in Prince's prattle about a New Power Generation and Soul II Soul's community-conscious funky-dredd anthems like "Back to Life" and "Get a Life," positivity emerged as the pop ideology of the new decade. Drawing on diverse sources — American discourses on self-realization and interpersonal therapy, New Age notions of healing music and "abundance consciousness," sixties flower power, deep house's gospel exhortations — positivity heralded the

dawn of a nineties zeitgeist that emphasized caring and sharing, a return to quality of life over standard of living, and green eco-consciousness. The antisocial egotism of the eighties, exemplified in pop terms by rap and Madonna, was eclipsed by a shift from "I" to "we," from materialism to idealism, from attitude to platitude.

Needless to say, the loved-up rave scene was fertile soil for the proliferation of New Agey ideas. Between 1988 and 1990, there was a subtle modulation — from music for losing your mind (acieed) to music for cleansing your mind (ambient house). Alongside 808's "Pacific State" there was S'Express's "Mantra for a State of Mind," Innocence's "Natural Thing," the Grid's "Floatation," the Beloved's "The Sun Rising," the KLF's Chill Out, and the Orb's "A Huge Evergrowing Pulsating Brain That Rules from the Centre of the Ultraworld." This brief fad for dub-tempo house and beat-free chill-out music was accompanied by talk of giving up synthetics like MDMA in favor of "organic highs": guarano, psychoactive cocktails, and "brain machine" goggles whose flickering light patterns induced mildly trippy trance states. On the fashion front, ravers started dressing all in white, signaling their newborn purity of soul. Easy (and highly enjoyable) as it was to mock the nebulous naïveté of the positivity peddlers, the feeling of "something in the air" clearly stemmed from a genuine, if poorly grounded, idealism and hunger for change.

Not all of the positivity punks were old: Adamski, rave's first pinup, was only eleven when he formed a punk rock band called the Stupid Babies in 1979. After performing in the confrontational Diskord Datkord, Adamski became a big draw on the rave scene during the brief vogue for live performances by keyboard whizz kids, and scored a hit with "NRG." "I liked the energy and the visual side of punk, but it was all just saying 'no, no, no, no, whereas now everybody's saying 'yes, yes, yes,' " Adamski said in 1990. "I much prefer the positivity thing we have now."

Ironically, Adamski's biggest hit was the gloomy and harrowed "Killer," an awesome slice of techno-blues that cracked apart the jollity of *Top of the Pops* with its grievous ache of loss and longing. Sung and cowritten by black British singer Seal, "Killer" was rave's very own "What's Goin' On," and in the summer of 1990 it annexed the number one spot for nearly a month. The futuristic frigidity of its sound and the sci-fi imagery of the video suggested Adamski

as a Gary Numan for the twenty-first century: a nubile, Aryan *petit prince*, alone in the world with only his techno toys for company.

Another bunch of "white punks on E," the KLF had made their first forays into dance music during the 1987–88 era of sample-based DJ tracks. Operating as the Justified Ancients of Mu Mu (a name borrowed from Robert Anton Wilson's *Illuminati*, where it belonged to an imaginary anarcho-mystic cult), Bill Drummond and Jimmy Cauty put out tracks like "All You Need Is Love," a crude composite of chunks stolen from the Beatles and MC5. Using another alter ego — the Timelords — the duo scored a number one hit with "Doctorin' the Tardis," cobbled together from the *Dr. Who* theme and Gary Glitter's "Rock 'n' Roll, Part Two." They then wrote a book about the experience, *The Manual: How to Have a Number One the Easy Way.*

Growing sick of their reputation as sub—Malcolm McLaren pop pranksters and convinced that "irony and reference points are the dark destroyers of great music," the pair — now named the KLF — decided rave was the way forward. Dedicating themselves to a sound they called "stadium house," the KLF recorded thrilling pop-techno stampedes like the chart-busting "What Time Is Love," "3 AM Eternal," and "Last Train to Trance-Central." Despite its populist appeal, the KLF's output was still infused with their punk-on-E spirit of "zenarchy." In the video for "3 AM Eternal," the KLF are garbed in ceremonial robes and move in formation as though enacting a religious ceremony, while *The White Room* album featured songs like "Church of the KLF." And in 1991 the band held a pagan rave to celebrate "The Rites of Mu" on the Hebridean island of Jura, burning a sixty-foot-high wicker man.

While the KLF ultimately had too much of a sense of irony to really go the nouveau hippy route, other converts to rave were enthused with a born-again fervor. The Beloved were New Order clones until singer Jon Marsh experienced life-changing rave-alations at Shoom and Spectrum. "The whole of 1988 from March onwards is a complete blur," he told *iD*. "An orgy of parties." Shoom appears to have made mush of his brain, judging by the lyrics of "Up Up and Away" on their breakthrough album *Happiness:* "Hallo new day. . . . Give the world a message and the word is YES." To be fair, the Beloved's first hit, "The Sun Rising," was a rare shock of the sublime in the charts, with its beatific backward guitar and madrigal vocals (sampled from *A Feather on the Breath of God: Sequences and Hymns by the Abbess Hildegard of Bingen*). But the follow-up,

"Hello," was a lazy list song that juxtaposed Jean-Paul Sartre with crap comedians Cannon and Ball, a "Reasons to Be Cheerful, PartThree" for the MDMA generation.

Then there was the Shamen, whose singer/guitarist, Colin Angus, hailed New Age as "the first modern Western spiritual movement." The Shamen began in the mid-eighties as a retro-psychedelic band, complete with phased-andflanged guitars, op art back projections, and melodies that recalled the Electric Prunes' "I Had Too Much to Dream Last Night." Already interested in druginduced altered states. Angus and cofounder Will Sinnot were among the first indie rockers to be drawn into rave culture. Where bands like Primal Scream and Happy Mondays depended on the dance floor savvy of DJ/producers like Andy Weatherall and Paul Oakenfold to overhaul their basically traditional rock songs, Colin Angus painstakingly taught himself to program sampling and sequencer technology. By 1989, the Shamen had broken with the mold of the rock gig and were throwing Synergy raves that combined live techno bands and DJs, stunning video projections, and an array of sideshows ranging from "chill-out" rooms to for-hire virtual reality equipment. Angus's dream was for the Shamen to become a sort of twenty-first-century Grateful Dead, creating a forum for communal freak-outs outside the musical mainstream.

The KLF may have joked about "the Church of the KLF," but the Shamen actually had a distinctly high-minded attitude toward getting high; Colin Angus, with his fastidious, dessicated manner, has something of the aura of a Presbyterian preacher. Tracks like "Move Any Mountain" and "Human NRG" —from the band's breakthrough album En-Tact — are affirmation therapy with a beat. In a UK rave scene organized around "getting off your tits" and "losing the plot," the band talked earnestly of "a spiritual revolution." Angus praised psychedelic-plant prophet Terence McKenna for his "very rational and lucid ideas about how there's been a long-standing human tradition of using psychedelic drugs"; the Shamen then turned the bearded sage into an unlikely pop star when they included snatches of his pro-hallucinogen sermonizing on their Top 20 hit "Re: Evolution."

Other dance-rock crossover bands offered a decidedly less pious and more delinquent take on rave 'n' roll. Touted as London's answer to Happy Mondays,

Flowered Up were inner-city kids from the Regent's Park Estate; their name was a metaphor for youthful idealism struggling up through the cracked paving stones of the urban wasteland. The band had its very own Bez in Barry Mooncult, whose job was to cavort onstage dressed as a giant flower. Like Shaun Ryder, frontman Liam sang about the seedy side of Ecstasy culture in a guttural working-class accent. "It's On" expressed the elation of pulling off "the biggest deal of your life"; "Phobia" evoked the nocturnal paranoia caused by taking one E too many; the Top 20 hit "Weekender" was a heavy-riffing epic about the punishing syndrome of living for the weekend's big blowout, with Liam warning the party-hard hedonist not to get burned out, and samples from *Quadraphenia* underlining the rave-as-mod analogy.

Flowered Up also threw wild parties, like their infamous three-day squatrave at a luxurious mansion block in Blackheath, which climaxed with the place being trashed. On a similar sixties-into-nineties mod tip as Flowered Up, EMF were a gang of West Country reprobates (the name stood for Ecstasy Motherfuckers) who'd started out throwing micro-raves in the Forest of Dean. Their irresistibly swaggering "Unbelievable" got to number three in the winter of 1990.

Of all the post-Manchester crossover bands, Primal Scream were most successful in merging rock's romanticism and rave's drug-tech futurism. Like fellow Scots the Shamen, Primal Scream began in the early eighties as psychedelic resurrectionists attempting to distill the child-man innocence out of the Byrds, Love, and the softer Velvet Underground. By 1988 they had veered off in an unconvincing blues direction, complete with raunchy on-the-road excess. The band and other people from their label, Creation, started going to acid house parties in 1989. "Contemporary rock ceased to excite us," singer Bobby Gillespie said later. "At raves, the music was better, the people were better, the girls were better, and the drugs were better."

The first recorded evidence of these realigned allegiances emerged when Primal Scream asked their DJ friend Andrew Weatherall of the Boy's Own posse to remix the Stonesy "I'm Losing More Than I'll Ever Have." Using rhythm guitar, piano vamps, horn stabs, and other elements from the original, Weatherall built a new track over a chunky-funky, midtempo Soul II Soul—style rhythmic undercarriage. Samples of Peter Fonda from Roger Corman's bikersploitation movie *The Wild Angels*— "We wanna be *free*. We wanna get

loaded and have a good time!" — gave the song its new title: "Loaded." At once sepia-tinted retro and state-of-the-art — imagine a dub version of "Sympathy for the Devil" — "Loaded" got to number sixteen in early 1990, selling over a hundred thousand copies.

For the follow-up "Come Together," Primal Scream recruited both Weather-all and Boy's Own's Terry Farley. The Farley mix puts looped breakbeats under the band's Byrdsy twelve-string song; Gillespie celebrates rave-as-the-swing-ing-sixties-all-over-again, breathlessly panting "kiss me . . . trip me/ride me to the stars/ohhh, it's all too much." But the Weatherall version dispenses with the group's playing entirely and adds churchy organs, a gospel choir, and samples of Jesse Jackson proclaiming "it's a new day," thereby transforming a sex-and-drugs ballad into a redemption anthem of spiritual unity.

Watching Weatherall at work taught Primal Scream all about "rhythm and space. . . . The sampler gave us a whole new palette of colors . . . a whole new world of psychedelic possibilities." The result was the band's masterpiece, "Higher Than the Sun (Dub Symphony)." Here the band, in tandem with Weatherall, brilliantly merged two different traditions of psychedelic experience, acid rock and acid house. Shades of Primal Scream's rock classicist past (Brian Wilson, Love's Forever Changes) mingled and melded with influences from dub, techno, Tim Buckley, and Sun Ra. Never one for hiding his own light under a bushel, Gillespie described "Higher Than the Sun" as the most important record since "Anarchy in the UK." Certainly the lyric (about being your own god) recalled the solipsistic sovereignty of that song (albeit fueled by Ecstasy rather than amphetamine), but what Gillespie really meant was that "Higher" was a rock-historical "cut-off record — it makes everybody else look ancient."

After "Higher" and its sequel, "Don't Fight It, Feel It" — pumping, drug-buzzy techno — Primal Scream released the long-awaited *Screamadelica*. But when they toured the album in the last months of 1991, Primal Scream rediscovered their rock 'n' roll hearts. Drifting away from the dance floor and Ecstasy culture, they devolved toward raunchy rock 'n' soul and harder drugs, signaled by the *Dixie-Narco* EP. During 1992–93 murky reports came through of the band's apparent attempt to replay the misadventures of the Stones at their most wrecked and reckless in the early seventies. What had been so great about Primal Scream circa "Higher" was the interface they'd forged between rock history and the dance present. When the band returned in 1994 with *Give*

Out But Don't Give Up — recorded with R & B producer Tom Dowd and the Muscle Shoals rhythm section — it became horribly apparent that the Primals had removed the dance present, leaving just the rock history. Some wondered if Screamadelica all came down to the mixing-board genius of Andy Weatherall. But the symbiosis/synergy cuts both ways: the truth is, sans Scream, Weatherall never did anything half as good in his Sabres of Paradise guise.

Y'know, two years ago, I'd've said legalize E.... But now ... I don't know....'Cos E... it can make ya nice and mellow but it's also capable of doin' proper naughty things to you as well.... Fuck, if we legalized E, man, we'd probably have a race of fuckin' mutants on our 'ands!

SHAUN RYDER talking to *The Face*, 1990

Hailed by the music press as the album of 1991 and winner of Britain's prestigious music industry award the Mercury Prize, *Screamadelica* was the high point of the rock/rave crossover era initiated by the Manchester bands. But, by then, Madchester was already in its twilight. Frustrated by an invidious contract with their label Silvertone, the Stone Roses went to court only to find themselves in legal limbo, unable to record or release a note. The case dragged on until May 1991, when the Roses were freed and immediately signed to Geffen in a huge deal. But Silvertone appealed the verdict, paralyzing the band for another year.

While the Roses were tangled in litigation, Manchester's funtopia turned to nightmare. In any drug-based pop scene, there comes a point when the collective trip turns bad, when the rush gives way to the crash. Trying to reach a higher high, "too many people take one too many," as Ian Brown put it. Drugs become adulterated as dealers try to maximize profit margins. The clientele

turns to other substances, either to sustain the buzz (freebasing cocaine, injecting speed) or to cushion the comedown (heroin).

Drugs meant money; money meant warfare for market control between rival drug gangs. Once, remembers Brown, "you'd come out of a club at the end of the night feeling like you were going to change the world. Then guns come in, and heroin starts being put in Ecstasy. It took a lot of the love vibe out. . . . Before the Hacienda got metal-detectors on the door, you'd see sixteen-year-old baby gangsters standing at the bar with a gun in a holster, right in view."

Bad memories of this dark period inspired "Begging You," the most thrilling track on the Stone Roses' 1995 *long* -time-a-comin' follow-up album *Second Coming*. A hyperkinetic rock/techno fusion of ballistic blues riffs and looped beats, "Begging You," explained Brown, "is like when you're in a club and everything's beautiful and you're E'd up, and you've got some voice going in your ear saying how they can get you a gun or an ounce of this or that." With its churning centrifugal groove and almighty turbine-roar guitar, the song sounds exactly like the panic rush of an E'd-up raver wondering how and why the rave dream's dying all around him.

There had been intimations of doom as early as July 14, 1989, when sixteen-year-old Claire Leighton collapsed at the Hacienda and later died, reportedly from an allergic reaction to E. In early 1990 new national legislation came into force in the Manchester area, making club licenses easier to revoke; the local police force had already set up Operation Clubwatch to monitor the drug trafficking in the Hacienda and Thunderdome. In December 1990 Konspiracy lost its license. Always a seedy, nefarious place, the club had rapidly become overrun by the drug gangs, who hawked their wares brazenly on the dance floor and stairways and intimidated the staff, demanding huge amounts of free liquor and brutalizing anyone who obstructed them.

In early 1991, the Hacienda closed voluntarily for several months, after an incident in which hoodlums threatened a door manager with a handgun. When the club reopened in May that year, attendance was poor, and violent incidents continued to sour the atmosphere, like the time a Salford gang sneaked into the Hacienda and stabbed several bouncers as a reprisal for being barred entrance. By this point, the city's media image had decisively deteriorated from "Madchester" to "Gunchester" as a result of the ghetto warfare between rival

drug gangs. There were similar problems throughout the Northwest. Liverpool's Quadrant Park closed its famous all-nighter voluntarily, following incidents of stabbing and robbery. Meanwhile, the northern free party scene had disintegrated thanks to the police crackdown. When a series of illegal parties in the Cheshire woodland were stopped by the authorities in early 1991, desperate ravers ventured even further afield, into the wildernesses of the Lake District and Wales.

Hardcore hedonists even before rave, Happy Mondays stuck with it to the bitter end. Released late in 1990, the hit album Pills 'n' Thrills and Bellyaches was a summation of the Madchester era. With its glossy, neat-and-tidy Paul Oakenfold production, the album's contents were tame compared with the disheveled Rave On EP. But there were three Mondays classics. "Loose Fit," slow-burning funk with a shimmering Beatlesy guitar motif, was Ryder's manifesto of baggy bad taste and spiritual laissez-faire: "Doesn't have to be legit/gotta be a loose fit." Starting with the sound of a plane taking off, "Holiday" showed that the Mondays' version of "politics of Ecstasy" had nothing to do with the Tim Leary/Terence McKenna-style "spiritual hedonism" of the Shamen, but was rather modeled on the boorishly orgiastic antics of British youth in Mediterranean sunspots. "Holiday" segued into the guitar-solo epic "Harmony," a debauched and deliriously funny parody of the Coca-Cola vision of world unity, with Ryder hollering that what they really needed was "a big big cooking pot" in which to cook up a broth of "every wonderful beautiful drug."

Happy Mondays' pipe dream of taking a permanent vacation from reality became hellish reality when the band attempted to record their fourth album, *Yes Please!*, in Barbados. Progress on the record was agonizingly slow; Bez trashed several jeeps and broke his arm, while Ryder, fresh from quitting a long-standing heroin habit, succumbed to the cheapness of drugs in the Caribbean and got into crack cocaine. In the drug dens where he spent most of his days acquiring a thirty-to-fifty rock per diem crack habit, the hyped-up natives played dance hall reggae records at an insane 78 rpm. Sadly, none of that mania and derangement made it into the Mondays' new music, which sounded enfeebled by its drugginess rather than galvanized.

Costing over a quarter of a million pounds, Yes Please! helped put Fac-

tory Records out of business, disappointed the fans, and was promptly followed by the band's breakup. But amazingly, Ryder and Bez got their second chance at the big time after hooking up with Mancunian rapper Kermit to form Black Grape. At 1996's Tribal Gathering megarave, the band were greeted as heroic survivors when they headlined the main tent. Despite the rockier sound and ostensibly abstemious title of Black Grape's *It's Great When You're Straight . . . Yeah*, Shaun and Bez were still every raver's favorite drug fiends.

'ardkore, you know the score

As the first acid house generation burned out, by 1990 a second, much larger wave of British youth was tuning in, turning on, and freaking out. Although illegal raves had been largely suppressed, a thriving circuit of commercial raves had emerged. At the same time, the relaxation of licensing laws allowed for the growth of all-night rave-style clubs. Rave spread from the original metropolitan cliques in London and Manchester to become a nationwide suburban/provincial leisure culture.

A distinctively British rave sound, which decisively broke with the mold of Detroit and Chicago and ended the dependence on American imports, was also emerging at the turn of the new decade. The proliferation of cheap computerbased home-studio setups and sampler/sequencer programs like Cubase fomented a do-it-yourself revolution reminiscent of punk and was accompanied by an explosion of independent labels. By 1991 this underground sound — actually a confederacy of hybrid genres and regional styles — was assaulting the mainstream pop charts. Despite virtually no radio play, the rave scene hurled anthem after anthem into the Top 20. With its raw phuturism, coded lingo, and blatant drug references, this hardcore rave music was as shocking and alien(ating) to outsiders as punk had been. But many punk veterans, now in their late twenties and early thirties, decried the new music as soulless, machine-made noise devoid of poetry, mere apolitical escapism for E'd-up zombies. Zapped by a new generation gap, these former rebels now found themselves in the role of fogies who just didn't get what was going on. Those who did rallied to the slogan "hardcore, you know the score."

Throughout the history of dance culture, "hardcore" designates those scenes where druggy hedonism and underclass desperation combine with a commitment to the physicality of dance and a no-nonsense funktionalist approach to making music ("tracks" rather than "songs"). Although the intransigent attitude remains the same, musically "hardcore" means different things at different times and in different parts of the world. Between 1990 and 1993, hardcore in Britain referred by turns to the Northern bleep and bass sound of Warp and Unique 3, to the hip-house and ragga-techno sounds of the Shut Up and Dance label, to the anthemic pop-rave of acts like N-Joi and Shades of Rhythm, to Belgian and German brutalist techno, and, finally, to the breakbeat-driven furor of hardcore jungle.

Weirdly, British hardcore was simultaneously "blacker" and "whiter" than

the original Chicago and Detroit music. Because of unbreachable divisions between rap and disco, the idea of "hip-house" never really took off in America. But in the more integrated UK, hip-hop and house music were part of the same continuum of imported "street beats"; Jamaican sound-system culture had long-established roots. Influenced by reggae and hip-hop, hardcore producers intensified the sub-bass frequencies, used looped breakbeats to funk up house's four-to-the-floor machine beat, and embraced sampling with deranged glee. But as well as gritty, B-boy funk, British hardcore also brought a white rock *attack* to the Detroit blueprint. Following the lead of the bombastic Belgians and Germans, UK producers deployed rifflike "stabs" and bursts of blaring noise.

Detroit techno had begun as a Europhile fantasy of elegance and refinement. So you can imagine the originators' horror when real Europeans transformed techno into a vulgar uproar for E'd-up mobs: anthemic, cheesily sentimental, unabashedly drug-crazed. Shedding Detroit's ethos of cool, the British and Europeans raised the music's temperature to a swelter. English house hipsters and Detroit nostalgics always complained about "sweaty ravers."

During those three years, 1990 through 1992, the British hardcore scene wasn't so much a melting pot as a *mental pot*, an alembic, heated by the flames of drug abuse, that generated new sonic amalgams with every season. All hail the "alchemical generation," to twist Irvine Welsh's famous phrase: half a million British kids who boldly sacrificed their brain cells to spawn some of the maddest music this planet has ever heard.

For all the music's futurism, hardcore was organized around two almost touchingly quaint models: the cottage industry and the local community. Artists — usually DJs with firsthand experience of how to work a crowd's bass-biology reflexes — made their tracks on home-studio setups or at cheap local studios, then pressed up anywhere from five hundred to a few thousand white-label 12-inch singles and sold them direct to specialist dance shops. Steve Beckett, cofounder of Sheffield's Warp label, remembers a golden age when the phrase "white label" was like a magic password. "Shops would take fifty off you for five pounds each, no problem. Dance music was all imports, then people in Britain started doing it for themselves, and their tracks started to get better than the tunes from America."

Warp was a classic example of an enduring hardcore archetype: it was both a label and a specialist record store, with close ties to crucial Sheffield clubs like Jive Turkey, Cuba, and Occasions. Other examples include Bradford's Unique 3, who DJ-ed at the Soundyard and started their own label, Chill, and Romford's Suburban Base, which grew out of owner Dan Donelly's Boogie Times shop. In the typically incestuous scenario, the DJs worked in the store, spun at the club, and made tracks for the label. The shop enabled the music makers to keep in touch with their audience and to service DJs; the club provided opportunities to test out new tracks on the dance floor, then return to the studio to make adjustments. Hardcore rave was fueled by the same vital blend of commerce and aesthetics as the Jamaican record business, with its cowboy labels, self-cobbled studios, and sound-system parties.

If one record can be said to have trailblazed the floor-quaking sub-bass style of Northern house, it's Unique 3's 1989 track "The Theme." Cold and cavernous, "Theme" has only one hook: an ultraminimal percussive/melodic motif that sounds like it's played on a glockenspiel built out of icicles and stalactites. Beneath this shockingly empty soundspace throbs the subliminal pressure of the solar plexus—pummeling bass. The Bradford boys' next release, the ultraspartan "Weight for the Bass," was like a hybrid of electro and dub reggae. On the "Original Soundyard Dubplate Mix," a heart-palpitating B-line jabs and judders in synch with the cardiac arrhythmia—inducing pattern of the programmed drums, and a plangent, ultratrebly piano vamp in the Italo-house style conjures the unlikely vision of dreadlocked roots rockers on E and rude-boys swapping guns for fluorescent glow-sticks.

According to Steve Beckett, this new Yorkshire house sound actually did come out of Jamaica, via North England reggae sound systems: "people like Ital Rockers in Leeds who didn't get as much recognition, but who were doing the *mental*-est records ever. They'd cut just twenty or thirty tracks on acetate, and have sound-system parties underneath this hotel. No lights, two hundred people, and they'd play reggae, then hip-hop, then these bleep-and-bass tunes. And they'd be toasting on top of it."

For Beckett and partner Rob Mitchell, "The Theme" was the impetus to start their own label from the upstairs room of a shared house, using two thousand pounds and money from a welfare enterprise scheme for the unemployed. Having tried and failed to sign Unique 3, Warp debuted with a track by Sheffield

boys Robert Gordon, Shaun Maher, and Winston Hazell, aka Forgemasters. The tune's title, "Track with No Name," stridently affirmed the house scene's radical anonymity (another crucial element of the hardcore ethos). And the band's name, borrowed from the big local steelworks, Forgemasters, chimed in with a lineage of constructivist dance music that ran back through Die Krupps' metal-bashing disco tracks "Steelworks Symphony" and "Wahre Arbeit, Wahre Lohn," through Heaven 17's "Crushed by the Wheels of Industry," all the way to Kraftwerk, whose name is German for power plant.

Sheffield is famous for its stainless steel and its hard-line socialist Labour government. In pop terms, Sheffield also evokes the word "industrial": the bleak avant-funk of Cabaret Voltaire, Clock DVA, and Chakk, the shiny synth pop of the Human League. Not only did these early-eighties bands inaugurate a Sheffield tradition of experimenting with synthesizers, drum machines, and tape loops, they also established a local infrastructure of cheap recording studios, like Cabaret Voltaire's Western Works and Chakk's Fon.

Another resource from Sheffield's industrial past that lent itself to the Northern house explosion was a plethora of ideal venues for illegal parties — warehouses in the city's nonresidential, industrial zones. "You'd have, like, a thousand people in a warehouse," remembers Beckett. "There'd be metal gangways around the side of the walls with people hanging off them. Complete mayhem! It was more like a festival than a party. Always just a few lights, or complete darkness, so you were just dancing in the dark. There was quite a criminal element involved: just a couple of people on the door, no proper security. The reason they were doing it was to make a quick profit. That's what gave the scene an edge — it felt like everybody was doing something dodgy and illegal. Which they were!"

The post-punk industrial outfits had a penchant for using "nonmusical" noises, à la 1950s musique concrète. The Warp artists' version of this was to use a nonmusical function inside samplers and synthesizers: the sine-wave test tones provided so that the frequencies can be set on the recording heads, prior to laying a track down on a master tape. "In a sampler, you'll just have a tone generator," explains Beckett. "It's not supposed to be for making music, just for testing the equipment. You've got a treble tone, a mid tone and a bass tone, which people used to get the biggest bass possible. Then they'd overlay different bass sounds, so there might be three or four bass lines in one track."

This sine-wave sub-bass — as heard on tracks like "Testone" by Sweet Exorcist — drove the Ecstasy-sensitized crowds wild. The bowel-tremor undertow of low-end frequencies impacted the body like an iceberg (90 percent of the devastation took place below the threshold of perception). Test tones were just one strand in what rapidly evolved into a science of bass. Another Warp act, LFO (Mark Bell and Gez Varley, two teenagers from Leeds), would create a bass sound, record it onto cassette with the recording levels right up in the red zone, sample that deliberately distorted sound, and repeat the process: all in search of the heaviest, hurtful-est bass sound.

"A lot of it was in the cut," says Beckett, referring to cutting the lacquer, which is the first stage in the process of pressing vinyl. "Basically, it was about taking off all the filters on the cutting heads, all the compression, and just pushing the levels up as far as you could. The engineer, this guy Kevin, would be sitting there sweating as he watched the temperature gauge go right up—because your cutting heads get really hot if you haven't got the filters on—and he'd be saying 'you're gonna fuckin' destroy me, ya bastards.' If the heads blew, he'd get sacked."

People called the Northern style of house "bleep-and-bass" or just "bleep" (the latter referring to the Kraftwerk/electro-style one-finger synth motifs). But it was the bass pressure that really counted. "I don't remember us ever talking about bleeps," says Beckett, "but there were definitely loads of detailed conversations about how you could get the bass heavier, how Kevin cut it. It became a competition. At this nightclub Kiki's, there was a separate bar made of glass, and the track 'LFO' was actually shaking the bar. That was when we knew we'd got it right."

Nightmares on Wax, the Leeds-based black/white duo of Kevin Harper and George Evelyn, recorded the all-time Warp classic "Aftermath." Over a baleful B-line, a distraught diva intones, "There's something going round inside my head . . . It's something unreal." Echo effects send the last word reeling, like a ghostly/ghastly apparition inside the sensorium of a tripped-out raver; the diva's voice is phased and reversed in a jagged time-lapse effect; a noise loop of eerie metallic scraping sounds like the onset of a migraine. Like many hard-core classics of the 1990–92 era, "Aftermath" is poised on the border between euphoria and delirium; the bliss is shadowed by impending darkness.

"Aftermath" peaked at number thirty-eight on the UK charts in the autumn

of 1990, making it Warp's third hit in a couple of months, alongside LFO's ultraminimal, robot-voiced "LFO" and Tricky Disco's cartoon-techno outing "Tricky Disco." Having scored three national hits and a bunch of club smashes with tracks by Sweet Exorcist, Tuff Little Unit, the Step, and Tomas, Warp found itself at the end of the year in the unlikely position of commanding nearly two percent of Britain's record sales for 1990. But they were also facing financial disaster, having signed a bad distribution deal with the dance indie label Rhythm King.

LFO saved the label by recording the highly successful long-player *Frequencies* — not just the definitive bleep-and-bass record, but one of the dozen or so truly great *albums* the electronic dance genre has yet produced. A precise and rigorous grid of pulses and tics, LFO's sound owed far more to electro than to house or techno. (Indeed, Varley and Bell had originally met as members of rival crews at a 1984 breakdancing contest.)

Frequencies was packed with creaky sonorities like fatigued metal buckling or stressed machinery having a nervous breakdown, and wonderfully sticky, Velcro-like synth textures that tug at your skin-surface and get your goose-bumps rippling in formation. Above, or beneath all, they used myriad shades of bass: SUB-sub-bass, trowel-in-your-ear-hole bass, enema bass, internal injuries bass. On "El Ef Oh," the title's phonemes are drastically filtered to sound like death-rattle gasps or purple gas seeping from a zombie's mouth. "Mentok 1" is a weird surge of oozy, spongy texture goo. "Think A Moment" is a cubist catacomb of wheezing synths, gluey bass, corrugated noises, and glum refrains reminiscent of David Bowie's lugubrious Low. "Groovy Distortion" chugs and puffs like a steam engine on a gradient, with textured percussion that sounds like a cat coughing up a hairball.

Attempting to convey the generation gap created by the bleep-and-bass invasion of the British pop charts, a colleague of mine once likened LFO and their ilk to fifties rockabilly. Rock 'n' roll and bleep-and-bass both seemed like alien musics that came out of nowhere; both flouted then accepted pop notions of melody and meaningfulness and offensively asserted the priority of rhythm and the backbeat. Other commentators cited the twangy guitar instrumentals of the early sixties as a precedent: the Shadows, Duane Eddy, the Tornadoes' "Tel-

star," all of which fascinated teenagers with their gimmicky futurism and otherworldly sheen.

Outside the Warp fraternity, there was a legion of independently released bleep-and-bass classics: Ability II's "Pressure," F-X-U's "The Chase," Hi-Ryze's "Ride the Rhythm," Autonation's "Crosswires," Original Clique's "North of Watford" EP. Even Detroit-aligned Network got on the case, putting out Forgemasters' awesomely inorganic "Stress" (sounds so shiny, sibilant, and serrated they seem to lacerate the eardrum), along with such insidiously catchy yet utterly unmelodic tracks by Rhythmatic as "Frequency" and "Take Me Back."

Greatest of the non-Warp outfits, and one of the few to survive the bleepand-bass era, was Orbital (aka Paul and Phil Hartnoll). Knocked out in their attic studio at the brothers' home in Sevenoaks, a London commuter belt town,
Orbital's debut "Chime" cost virtually nothing to make but got to number seventeen on the UK charts. Appearing on *Top of the Pops* in the spring of 1990,
Orbital infuriated the producers and confirmed all the Luddites' fears about
techno knob-twiddlers' lack of musicianship: the brothers simply pressed a
button (all it took to trigger the track) and stood onstage listlessly, not even
pretending to mime.

The British "Strings of Life," "Chime" sounds at once urgent and serene, capturing the classic Ecstasy sensation of sublime suspension, of being stuck on an endless preorgasmic plateau. It pivots around a tintinnabulating, crystalline sequence of notes that hop and skip down the octave like a shiver shimmying down your spine. This motif is one of the first instances of what would become a defining hardcore device, the melody-riff, a hook that is as percussive as it's melodious. Then a Roland 303 enters, jabbering like a bunch of funky gibbons, while a second sub-bass line quakes beneath it at half tempo. At the breakdown, muzak strings (sweeping, beatific) clash with staccato string stabs (impatient, neurotic), then the melody-riff cascades in again like a downpour of diamonds and pearls. To this day, "Chime" is a rave anthem, guaranteed to trigger uproar; the Hartnolls claim that various elements of the track have reappeared as samples in some fifty other tracks.

In 1990, long before rave culture fragmented into subscenes and the semantics went haywire, there were really only two words for the music — house and

techno — and even these tended to be interchangeable. House could range from soulful and songful ("deep" or "garage") to track-oriented ("hardcore house"). The latter term was vague enough to encompass a multitude of styles that were united less by sound than by context and effect: they all incited frenzy at big raves.

Just as the subliminal influence of the UK's reggae and hip-hop scenes shaped a distinctive Northern style of hardcore, similar factors spawned a quite different sound in the South. There was the same emphasis on sub-bass pressure, but instead of the Warp-style bands' programmed drum-machine rhythms, the South of England producers sampled and looped breakbeats. The break is the percussion-only section of a funk or disco track. House producers got these breakbeats secondhand from hip-hop records or from album compilations of the most highly sought after breaks. American producers like Todd Terry, Fast Eddie and Tyree, and Brooklyn's Lenny Dee and Frankie Bones had already experimented with the idea, but it was in the UK that "breakbeat house" caught on like wildfire. Partly, it was because looping breaks lent itself to the do-it-yourself aspect of the hardcore home-studio boom. It's easier for novices to get a good groove going by using samples of real-time drumming than by painstakingly programming a rhythm track on a drum machine. And it's cheaper too, since the basic setup to make tracks is turntables, a sampler, and a sequencer program, with no need for drum machines or synthesizers. But breaks also appealed to a multiracial London-area population that had grown up on black American imports like jazz-funk, hip-hop, and rare groove. With their raw, "live" feel, breakbeats added extra grit and oomph to house's clinical rhythms.

Although artists like Demon Boyz, Rebel MC, and Blapps Posse all played a part in forging the UK hip-house hybrid, the key figures in the rise of breakbeat house were PJ and Smiley, two black British youths from North East London. Using the name Shut Up and Dance, they operated as a band, a production team, and a label. In the mid-eighties, they'd started out on the sound system Heatwave, where they took Def Jam tracks and sped the breaks up from 100 to 130 bpm, then chanted MC-style over the top. Like Warp, they began Shut Up and Dance (SUAD) in 1989 as a white-label operation, selling tracks direct to dance stores from their car trunk and servicing the burgeoning pirate radio stations. The duo's pro-pirate stance — "once a station goes legal it's shit" —

was given anthem form in a track by the SUAD act Rum & Black, "****The Legal Stations," a grainy slice of breakbeat-and-bass minimalism pivoting around a sound bite that complains "turn off that muthafuckin' radio."

Based on the flagrant theft of highly recognizable chunks from mainstream pop records by the likes of Suzanne Vega, Prince, and the Eurythmics, SUAD's cut-and-paste tracks seemed like sonic documents of hardcore rave's black-market economy: uncleared samples, dodgy warehouse raves, pirate radio, drug dealing, bootleg tracks, and no-permission, no-royalty mix tapes. But Shut Up and Dance saw themselves as young black entrepreneurs engaged in bettering themselves and giving back something to their community. They had a conscience: at heart, they were disenchanted hip-hoppers, inspired by Public Enemy's righteous politics but bored by their increasingly staid production. "We're not a rave group, we're a fast hip-hop group," they told *Melody Maker*. "We've moved hip-hop on in a way that people like Public Enemy haven't dared to." On tracks like "Rest in Peace (Rap Will Never)" and "Here Comes a Different Type of Rap Track Not the Usual 4 Bar Loop Crap," they pledged allegiance to rap even as they berated it for its sonic conservatism.

But SUAD's early output didn't galvanize the moribund Brit-rap scene. Instead their tracks found favor with the hardcore house audience, despite the fact that SUAD specialized in a kind of social realism that foregrounded not just the grim realities that rave aimed to evade, but many of the squalid, exploitative aspects of the rave scene itself. Alongside antiracism polemic ("White White World"), urban vigilante rage ("This Town Needs a Sheriff"), and survivalist determination ("Derek Went Mad," with its ghostly sample of a fragile male voice whispering "but I'll return a stronger man"), there were tracks like "£10 to Get In," a jibe at rip-off raves. The remix sequel, "£20 to Get In," begins with a white Cockney voice phoning for instructions on how to get to a warehouse party, only to be horrified by the extortionate entrance fee: "I thought it was £10!!" "No, mate," says the black promoter in a deadpan, take-it-or-leave-it voice, "it's had a remix."

Shut Up and Dance were at pains to distance themselves from drug culture. They bemoaned London's escalating crack problem on their Top 50 hit "Autobiography of a Crackhead" and its flipside, "The Green Man," a stirring, stringswept instrumental named after a pub notorious for dealers. And their biggest hit, "Raving I'm Raving" — which went straight onto the national pop chart at

number two on its first week of release — wasn't a celebratory anthem but a withering probe into the void at the heart of the Ecstasy dream. The track is based almost entirely on Marc Cohn's AOR ballad hit single of late 1991, "Walking in Memphis." Retaining the song's heartbusting piano chords but tweaking the words slightly, PJ and Smiley created a raver's anthem with a booby-trap lyric. "Bought myself a first-class ticket," gushes singer Peter Bouncer, referring to a tab of Ecstasy, before rapturously evoking his touchdown in a loved-up wonderland. Suddenly there's a fissure of doubt — "But do I really feel the way I feel?" — and a foreboding bass line kicks in, followed by a loop of anguished female vocal.

With their aesthetic of looped breaks and uncleared samples (which led to their being sued by Marc Cohn), their roots in hip-hop and reggae's sound-system culture, and their street survivalist politics (on the cover of their debut album, *Dance Before the Police Comel*, they struck kung fu poses, barechested, oiled, and muscle-bound), Shut Up and Dance laid the groundwork for jungle, the subculture that would evolve out of breakbeat hardcore. SUAD's other big act, the Ragga Twins, mashed up ruff B-boy breaks, uproarious dance hall reggae chatter, and Euro-techno terror riffs — on tracks like "Illegal Gunshot," "Spliffhead," and "Mixed Truth" — with results that uncannily prophesied the ragga-influenced jungle sound of 1994.

Across the Channel, another version of hardcore was hatching: whiter-than-white, based on riffs rather than bleeps and distorted noise rather than clean lines. For about eighteen months *Belgium* ruled the world of techno. Groups as geographically removed as Detroit's Underground Resistance and North London's Manix paid tribute to the mysterious Lowlands nation with "Belgian Resistance" and "Never Been to Belgium," respectively.

The seeds of the new sound, however, germinated somewhere between Belgium and Brooklyn, where DJ/producers like Lenny Dee, Mundo Muzique, and Joey Beltram were pushing rave music in a harder and faster direction. Beltram revolutionized techno twice before reaching the age of twenty-one. First, with 1990's "Energy Flash," which gets my vote as the greatest techno track of all time. With its radioactive bass and pulsing loop-riff, "Energy Flash" sucks the listener into a miasmic maelstrom like nothing since the first acid house

tracks. An insinuating whisper murmurs "acid, ecstasy," like a dealer in the murk or the voice of craving inside an addict's head. The track really does sound like the speed freak's drug "flash," like being plugged into an electric socket (no wonder amphetamine aficionados talk of being "wired").

Like the Stooges' proto-punk classics "Loose" and "Raw Power," Beltram's hardcore techno offered an intransitive surge of objectless aggression. "Raw power got no place to go . . . it don't wanna know," as Iggy sang. Instead of being a form of self-expression, this is music as *force field*, in which subjective consciousness is suspended and erased. "I'm sure the constant exposure to amplifiers and electric guitars . . . has altered my body chemistry," Iggy wrote in his memoir *I Need More*, seemingly anticipating the swarming rush of hardcore. "I was really determined to use the noises on myself, as if I were a scientist experimenting on himself, like Dr. Jekyll."

The title of Beltram's second genre-revolutionizing classic, 1991's "Mentasm," could be a synonym for another Iggy trope: the "O-mind," a paradoxical state of hyperalert oblivion in which self-aggrandizement and self-annihilation fuse. Produced in collaboration with Mundo Muzique and released under the name Second Phase, "Mentasm" was even more influential than "Energy Flash." The monstrous "mentasm" sound — a killer-bee drone derived from the Roland Juno Alpha synthesizer, a seething cyclone hiss that sends ripples of shuddery rapture over your entire body surface — spread through rave culture like a virus, infecting everyone from the Belgian, Dutch, and German hardcore crews to British breakbeat artists like 4 Hero, Doc Scott, and Rufige Cru. The "mentasm stab" — which took the sound and gave it a convulsive riff pattern — was hardcore's great unifier, guaranteed to activate the E-rush.

The "Mentasm" noise has a manic yet dirgelike quality similar to the downtuned guitar sound used by Black Sabbath and their doom-metal ilk. It's no coincidence: Beltram was consciously aiming to re-create the vibe of Sabbath and Led Zeppelin, his teenage faves. On the Beltram/Program 2 collaboration "The Omen (Psycho Mix)," he actually sampled Robert Plant's languishing screams and orgasmic whimpers from the weird "ambient" midsection of "Whole Lotta Love."

Beltram has said that "Energy Flash" and "Mentasm" were deliberate attempts to make the music go faster. Initially, he found his greatest reception in Belgium. Speaking to *iD* in 1991, he enthused: "The Belgians were the first people who could relate to me. Belgium was very, very advanced." Indeed, the first real Euro-hardcore track, Rhythm Device's "Acid Rock," saw producer Frank De Wulf independently hit upon the same techno-as-heavy-metal idea as Beltram: the track imitated Deep Purple's monster-riffing dirge "Smoke on the Water."

Belgium's pop music inferiority complex had ended at the end of the eighties with the New Beat craze, which stormed the country's pop charts and briefly looked like it might be Britain's Next Big Thing after acid house. "Before New Beat, there was no chance for Belgians to break records into our own chart, which was totally dominated by Anglo-American music," said Renaat Van De-Papeliere of R & S, the label that released "Mentasm" and "Energy Flash." New Beat began when DJs started to spin gay Hi-NRG records at 33 rpm rather than the correct 45 rpm, creating an eerie, viscous, trance-dance groove. Groups like Lords of Acid and A Split Second started to make records with the same uncanny, slow-mo feel.

As the nineties progressed, the bpm gradually accelerated as DJs started playing techno with their turntables set to plus 8. A native hardcore was born, with labels like Hithouse, Big Time International, Beat Box, and Music Man, and groups like 80 Aum, Incubus, Holy Noise, and Meng Syndicate. All peddled a distinctively Belgian brand of industrial-tinged techno where melody was displaced by noise. Set Up System's "Fairy Dust" featured a fingernails-on-black-board scree riff that sounded like a brain eraser wiping clean the slate of consciousness. On T99's "Anasthasia," the "Mentasm" stab mutated into what was soon dubbed the "Belgian hoover" effect: bombastic blasts of ungodly dissonance that sounded like *Carmina Burana* sung by a choir of Satan-worshipping cyborgs.

As Belgian hardcore swamped Europe, the techno cognoscenti blanched in horror at the new style's brutalism. With its corrugated, rocklike riffs and stomping beats, tracks like Cubic 22's "Night in Motion" seemed to sever house's familial ties to disco and black R & B. Belgian hardcore was heavily influenced by the late-eighties school of Euro Body Music (groups like Front 242), with its stiff, regimented rhythms and aerobic triumphalism. Something of that muscle-bound, iron-man aura carried through to Euro-hardcore. LA Style's massive hit "James Brown Is Dead" seemed like a gloating celebration of hard-

core's Teutonic funklessness; the track's Sturm und Drang fanfares and cavernous production (geared for massive raves in industrial hangars) imparted an unnervingly Nuremberg-like vibe.

Many anti-hardcore hipsters attributed the new style's megalomaniacal aggression and high tempo to a decline in the quality of Ecstasy, which they believed was heavily cut with amphetamine. House's trippy vibe had degenerated into a manic *power*-trippiness. Hence tracks like "Horsepower" by Ravesignal (R & S producer CJ Bolland), which was like "I Feel Love" might have sounded if Giorgio Moroder had made it for Arnold Schwarzenegger instead of Donna Summer. In the film *Pumping Iron*, Arnie described the autoerotic pleasure of muscle flexing as a sort of endlessly sustained orgasm — a striking parallel with the "arrested orgasm" sensation induced by Ecstasy and amphetamine.

That's very much the vibe exuded by Human Resource's Euro-hardcore classic "Dominator," on which the rapper's boasts of ruffer-than-ruff invincibility climax with the Lacanian epiphany "In other words, sucker, there is no Other/I wanna kiss myself." Taking the mentasmic drone to its nether limit, "Dominator" is simultaneously sluggish and palsied; you feel like your nerve endings have gone dead, but beneath the armature of numbed flesh your heart's beating furiously. And this was a pretty accurate reflection of the insensate, punch-drunk state many hardcore ravers were in by the end of the night, after downing several pills of dubious composition, topped off by a gram of amphetamine sulfate and a couple of acid blotters.

Midway through "Dominator" a startlingly realistic alarm bell lets rip, cuing the Pavlovian response to flight. Hardcore was full of similar sound effects — sirens, church bells — that created a sense of emergency and insurgency. This was the *panic rush*, as celebrated in tracks like Praga Khan's "Rave Alarm," HHFD's "Start the Panic," John + Julie's "Red Alert," and Force Mass Motion's "Feel the Panic," an edgy, jittery exhilaration caused by the metabolic acceleration and paranoiac side effects of too much E and speed. The original Greek panic, the "panic fear" of the horned god Pan, was a transport of ecstasy-beyond-terror. Activating the "flight-or-fight" sector of the brain, amphetamine floods the body with the adrenaline-like neurotransmitters dopamine and noradrenaline. Perceptions are heightened in a panic state. As with a soldier in combat, such a drastic intensification of the immediate present can be a Dionysian thrill. But the side effects of too much speed (hypertension,

paranoia, heart arrhythmia) are unpleasant to say the least, while the attrition wreaked by long-term abuse leads to a kind of physical and spiritual battle fatigue. By 1991 you could see the walking wounded on the dance floor.

For veteran ravers who remembered happier days, clubbing now seemed closer to an assault course than a fun night out. At British hardcore clubs (Rage, Crazy Club, the Eclipse, Wasp Factory, Slime Time — to name just a handful) and their European counterparts (Frankfurt's Omen; Berlin's Tresor, E-Werk, and the Bunker; Ghent's Boccaccio; Amsterdam's Subtopia), the atmosphere on the dance floor was a cross between a soccer match and a neo-Nazi rally. Close-cropped boys danced like they were shadow boxing or molded their hands into the shape of cocked pistols and let rip. Juddering, staccato rhythms enforced a new way of moving — all twitches and jerks, like disciplined epilepsy.

The buzzwords of the era were revealing. Pleasure was expressed in a masochist slang of catatonia and brain damage: on a good night, you'd get "faced" (off your face), "sledged" (sledgehammered into a coma), "cabbaged" or "monged" (turned into a vegetable). Good tracks were "mental," "kickin'," "bangin'," "nosebleed," or "bone" (as in boneheaded). Every European hardcore scene had its own variations: the Belgians called the music "skizzo" (schizophrenic), the Germans used the term "bretter" (as a noun, it means "hard board"; as a verb, "to beat"). The weekender side of rave had always fitted neatly into the traditional working-class "culture of consolation." With hardcore, it had now evolved into a culture of concussion, a regime of punishing bliss "strictly for the headstrong."

Hipsters complained about "cheesy quavers" and "E-monsters" losing it to 140 bpm "nuttercore." And the nutter stereotype really did exist: teenage boys with sunken cheeks, pursed lips, and massively dilated pupils, T-shirts tied round their waists to reveal gaunt adolescent physiques further emaciated by excessive Ecstasy intake. These hardcore youth resorted to "stacking" — taking from three to six tablets per session and sometimes between ten and twenty Es over the course of a three-day weekend without a wink of sleep. Lacking the patience to wait for the E to take effect, they'd eagerly assume that they'd bought a dud pill and "neck" another — a recipe for disaster. Some would grind up three Es and snort them because nasal ingestion was a fasteracting method of administration.

As manufacturers responded to the massive escalation in the demand for

Ecstasy caused by the Second Wave of Rave, police seizures of MDMA and other synthetic drugs rose dramatically. In 1990, the London Metropolitan Police seized 5,500 kilos; in 1991, the figure was more than 66,000 kilos. Reflecting both increased numbers of people using Ecstasy and the rise of a reckless, nihilistic attitude toward drug intake, the number of MDMA-related deaths began to escalate. From 1989 to 1990, there were only two or three deaths linked to MDMA; in the second half of 1991, there were five. During the 1988–90 period, Guy's Hospital in London reported an average of fifteen cases per month of adverse reactions to Ecstasy; by 1991, they were receiving between thirty and forty distressed ravers per month, suffering effects like paranoia, racing heartbeat, and the sometimes fatal condition of heatstroke.

Hardcore crusaders like Renaat of R & S celebrated the way that techno had resurrected the generation gap, supplanting rock as the noise that parents, older brothers, and squares in general just couldn't accept as music. But hardcore also created a generation gap *within* rave culture, as acid house veterans and hipster elitists decried the new brutalism as a barbaric travesty of the original vision of Detroit and Chicago.

People started dissing hardcore as "the new heavy metal." In *DJ* magazine, Claire Morgan Jones argued that rave, "the late 20th century reworking of 60s style peace, love and understanding," had degenerated into "a knee-jerk club ritual" for amphetamine-addled headbangers. Noting the submerged homoeroticism of working-class lads stripped to the waist and sniffing amyl nitrate like gay clubbers, she complained that, in the evolution of house into hardcore, "all the curve and swing [has] been squeezed out. . . . All it seems to be about is boys, bass and bother." Another standard accusation was that hardcore was "just" unpalatable drug-noise if you weren't off your face. Even CJ Bolland, creator of monstrous hardcore anthems like "Horsepower," complained that "most new tracks aren't tunes anymore, just a very hard kick drum and a very mad sound."

While Warp and other bleep-and-bass pioneers like Orbital shifted from hardcore toward supposedly more "intelligent" sounds designed for club play (or even home listening) rather than large-scale raves, a new breed of British indie label emerged to cater to the headstrong. "Hard as fuck! It's the rock

of the future," enthused Caspar Pound, the twenty-one-year-old boss of Rising High. Speaking to *iD* in early 1992, he rebutted his interviewer's suggestion that hardcore was mere aural thuggery, retorting: "It's ridiculous, these are people who in the 1960s were scared of rock 'n' roll and said it was the devil's music. . . . The best thing about hardcore is all the soul's been taken out. We've had 200 years of human element in music and it's about time for a change." He singled out the German scene for praise: "It's stronger, it's darker, it's scarier. . . . I don't like going to a club and seeing 600 people waving their arms about with smiling faces. I like to see 600 people in a dark, hot place; it isn't about happiness, it's more aggressive, more intense."

Alongside labels like Kickin', Vinyl Solution, Rabbit City, and Edge, Rising High took its cue from the Belgians and created a British Brutalist sound. Like the sixties architectural style of the same name, it was all grim slabs of gray noise, harsh angularity, and a doom-laden bleakness. Recording as Industrial High and the Hypnotist, Pound specialized in Nietzschean grandiosity (tracks like "God of the Universe," "A Modern Prometheus") and rabble-rousing anthems ("Hardcore You Know the Score" and "Night of the Living E-heads," which rallied a legion of zombie-warriors with the battle cry "hardcore will never die!"). Of all the Rising High-affiliated artists, the most important was probably the duo of Lee Newman and Michael Wells, who released a torrent of rave anthems via a plethora of pseudonyms and labels: Tricky Disco, John + Julie, GTO, Signs of Chaos, Force Mass Motion, Church of Ecstasy, and Technohead. Wells and Newman's pinnacle was their John + Julie track "Circles (Vicious Mix)." Starting with a madly gyrating carousel melody and a dervishdiva vocal that goes "round and round/turning around," "Circles" lets rip a sub-bass riff, or rift, to make the Warp posse weep: a flatulent eruption of lowend frequencies, a sound like concrete liquefying.

The hardcore as "new heavy metal" or "the rock of the future" analogy had some validity. Sonically, the Belgian and British brutalists restored the midfrequency sounds that dance music had dropped in order to boost the bass, the exact same midfrequencies supplied by distorted electric guitars. "Historically it has been perhaps the bass that people danced to," said German DJ Westbam in 1992. "But at the moment it is the midfrequencies that people scream along to.... In techno music these have been turned up more and more....

They are also the most aggressive sounds, the ones that penetrate the most and make you numb."

There were rock historical parallels too. In the late sixties and early seventies, British groups bastardized the blues, and their American imitators bastardized their bastardizations, and somewhere in all this, heavy metal was spawned. In the late eighties, black producers from Chicago and Detroit took Teutonic electronic music and turned it into acid house and techno. In the early nineties, Belgian and British youth took these elegant, Europhile sounds and spawned a mutant — hardcore. The insults hurled at hardcore by 1988-89 nostalgics bore a striking similarity to the language with which aghast countercultural veterans greeted stadium rock: bombastic, protofascist, a degraded version of a noble tradition. Just as blues purists had harked back to Cream while recoiling from Sabbath and Zep, so too did Detroit connoisseurs pine for Derrick May while flinching at the post-Beltram barbarians. By early 1992, the hipsters were busily erecting bulwarks of "good taste" against the hooligan hordes. Some, in an unfortunate echo of prog rock, rallied to the banner of "progressive house" (labels like Guerrilla and Hard Hands, artists like Leftfield and Spooky); others began to talk of "intelligent techno" (B12, the Black Dog, Future Sound of London).

What the anti-hardcore contingent missed was the crucial historical lesson to be gleaned from the "new heavy metal" analogy: no one today listens to the purist blues boom or prog rock bands of the early seventies. The much despised Sabbath, though, achieved immortality as one of the most crucial sources for alternative music in the eighties and nineties, worshipped by everybody from Black Flag and the Butthole Surfers to the Seattle grungesters Nirvana and Soundgarden. "Maturity" was always only one way forward for the music of the post-acieed/Detroit diaspora. Just as heavy metal distilled blues rock, hardcore took the essence of acid and techno (mind-evacuating repetition, stroboscopic synths, bass-quake frequencies) and coarsened and intensified it. Bad drugs (barbiturates like Mandrax and Quaalude for metalheads in the seventies, dodgy Ecstasy for hardcore ravers) helped these kids focus on and exacerbate that essence. For people who'd grown up on club culture, with its ethos of cool and discrimination, hardcore was a horror story. But for ears reared on rock, hardcore's sonic extremism and insurrectionary fervor were thrilling.

Around the time of the anti-hardcore backlash, some ravers began to deliberately misspell and mispronounce the word as 'ardkore — matching the uncouth, rabble-rousing snarl with which slogans like " 'ardkore, you know the score" were chanted, intensifying the delinquent associations of the sound, and turning the supposedly uneducated taste of the "nutty raver" into a badge of pride. But the misspelled 'ardkore also served to emphasize the fact that this was a distinct and brand-new genre, not a bastardized offshoot. Far from hurtling down a dead end of noise and velocity (as the techno purists alleged), by early '92 hardcore was mutating into a barely imaginable new form of music, light-years beyond Detroit. And the core of that future-sound wasn't bleeps or mentasm riffs, but breakbeats and samples.

While 'ardkore ruled the underground, Britain had already developed a rave overground that fulfilled the KLF's fantasy of "stadium house." Between 1990 and 1992, a circuit of commercial megaraves evolved: Amnesia, Raindance, Kaos, Mayhem, Eclipse, World Dance, Helter Skelter, Elevation, Fantazia, Dreamscape, Vision, and many more. These massive events drew crowds ranging from ten to twenty-five thousand to dance all night inside giant hangars or under circus-size tents in the open countryside. Flyers promised a no-expensespared spectacle ("intelligent lighting," four-color lasers, strobe flowers, skytrackers, data-flash grids, "fully-themed" stage sets), sideshows (bouncy castles, funfairs, bungee jumping, fortune-tellers, face painting), food and merchandise vendors, and above all massive volume (100 K sound systems with "bone-shaking bass"). In order to get a license from the local authorities, they absurdly and disingenuously forbade "illegal substances" and promised stringent searches and "firm but friendly security." The two-hour line, the humiliating body frisk, and the surly bouncer all became part and parcel of the rave experience.

The lineup at these multi-arena events included not just the big-name DJs — Top Buzz, Fabio and Grooverider, Carl Cox, Ellis Dee, Ratpack, Slipmatt — but also artist PAs (personal appearances). These bands — N-Joi, Bizarre Inc, the Prodigy, Shades of Rhythm — had sets chock-a-block with crowd-pleasing anthems, and they put on a show, of sorts (usually a couple of anorexic girl dancers in Lycra and an MC hollering himself hoarse). But cru-

cially, for the first time there was a visual referent for the music, it wasn't just "faceless techno bollocks." ("Faceless techno bollocks" was a derogatory phrase in diehard rockist parlance that got turned into a T-shirt by Rising High and became a defiant slogan/rallying cry for ravers.

As rave became big business, it transformed itself from a lawless zone into a highly organized space programmed for pleasure, and rave culture itself became highly ritualized. There was a uniform — floppy chapeaux, hoods, white gloves, gas masks, woolly hats; loose-fitting or stretchy clothes (baggy jeans and T-shirts for boys, Lycra for girls), along with accessories like whistles, air horns, and fluorescent glow-sticks. Hardcore youth developed a choreography of geometric dance moves and a drug lore of Ecstasy-enhancing tricks; they smeared their naked torsos with Vicks VapoRub or sniffed inhalers because the menthol fumes supposedly increased the buzz and brought on a rush.

On the megarave circuit, a pop hardcore sound gradually emerged, fusing the piano vamps and shrieking divas of 1989-era Italo house with Belgian hardcore's monster riffs and Shut Up and Dance—style breakbeats and rumbling bass. In 1991 this sound stormed the UK charts. For every major-label-distributed crossover act like Shades of Rhythm and N-Joi, there were a dozen underground outfits that operated on shoestring indie labels but nonetheless shared the same sound (affirmative, anthemic) and ambition (to make the charts). Some, like Congress's "40 Miles," cracked the Top 40; many got within spitting distance (Manix's "Oblivion" EP, Rhythm Section's "Midsummer Madness" EP); but most remained underground anthems.

After a year of sustained presence on the charts (some twenty-two Top 40 hits, ten of them in the Top 10), the British rave explosion peaked in the last months of 1991. In November and December 1991, the Top 20 was inundated with a series of anthems — covering the full spectrum from glossy pop-rave to Belgian brutalism to the emergent underground sound of breakbeat 'ard-kore — by Moby, Altern 8, Bassheads, Bizarre Inc, Shades of Rhythm, SL2, Human Resource, Digital Orgasm, and many more. On the outskirts of the Top 40, tracks by T99, the Hypnotist, Quadrophonia, Ravesignal, and many other hard-core artists exacerbated the sense of a barbarian horde waiting to overrun the pop citadel. In terms of hit rate, this "golden age of hardcore" compares with the punk/New Wave period of the late seventies. The record industry responded with a flood of cash-in TV-advertised compilations like *Hardcore*

Uproar, Steamin', and *Kaos Theory*, with words like "slammin' " and "bangin' " liberally scattered on the sleeves.

Hardcore's assault on the pop mainstream continued with slightly less intensity right through to the summer of 1992. Every month the rave audience hurled an anthem or two up into the higher reaches of the charts. The Prodigy's "Everybody in the Place" reached number two in January, kept from the top spot only by the rerelease of Queen's "Bohemian Rhapsody." SL2's protojungle smash "On a Ragga Tip" also got to number two, as did Shut Up and Dance's "Raving I'm Raving." Hits of varying sizes were scored by Kicks Like a Mule, Isotonik, Seduction, Urban Shakedown, Messiah, Utah Saints, Toxic 2, Praga Khan, Liquid, Skin Up, and Altern 8.

Altern 8 were something like the Slade of techno. Like Slade, Altern 8 came from the Midlands, scored a series of rabble-rousing chart hits with deliberately misspelled song titles, and had a wacky image: chemical warfare protection suits, yellow dust masks and gas masks, which cleverly managed to turn techno's "faceless anonymity" into a marketable look. Mark Archer and Chris Peat started out as Nexus 21, using a cheap home studio to make Detroit-influenced techno for Network. When they shifted their sound to boombastic bass, gimmicky samples, and looped breaks, Archer and Peat invented Altern 8 as a jokey alter ego in order to keep Nexus 21's reputation clean of hardcore's taint.

By their own admission, Altern 8 were "a cheapskate KLF." The tabloids lapped up their scams and larks — like Chris Peat running for Parliament on the "Hardcore — U Know the Score" ticket. Altern 8's early tracks "Infiltrate 202" and "Frequency" were crudely exciting. The top three hit "Activ-8" featured a sample of their label boss's five-year-old daughter saying "nice one, top one, get sorted" — a blatant reference to getting E'd up that completely bypassed the BBC censors. Appearing on *Top of the Pops*, Altern 8 got the cameraman to zoom in on the jar of Vicks VapoRub they'd put on top of their sampler, the nudge-nudge, wink-wink equivalent of flaunting a bong or coke spoon on prime-time TV. "E-Vapor-8" cheekily compacted two drug references into a single word. But by the time their debut album/greatest hits package *Full On: Mask Hysteria* came out in the last months of 1992, Altern 8 were already forgotten, like so many teenybopper bands before them.

If Altern 8 were like Slade, the Prodigy were more like the Sweet or T. Rex.

Prodigy 1991 chart smashes "Charly" and "Everybody in the Place" are all teenage rampage and sublimely vacant insurgency. Based in Braintree, Essex, the Prodigy was basically Liam Howlett, a twenty-year-old whiz kid producer blessed with a flair for melody (thanks to classical training in piano) and breakbeat-manipulation skills acquired from his days as a British B-boy. Right from the start, however, the Prodigy was presented as a band: on album sleeves, during live performances, and in the videos, the visual slack was taken up by Howlett's three buddies, Leeroy, Maxim Reality, and Keith Flint, whose job it was to leap about and yell stuff at the audience. It was the music that counted, though, and this was classic pop juvenilia, kiddy-cartoon zany-mania dedicated to sheer sensation and mindless kicks. Howlett's forte was dynamics, bridges, breakdowns, the kinesthetics of tension and release. Years later Flint described the Prodigy as "buzz music." This was music whose only subject was its own sensations; hence self-reflexive titles like "Hyperspeed," "Wind It Up," "Full Throttle," "G-Force."

Following three Top 5 hits in a little over a year, the Prodigy's late-'92 debut album *Experience* was everything that Altern 8's *Full On: Mask Hysteria* failed to be: a commercial success and an album you could listen to all the way through (as opposed to a patchy collection of the hits-so-far). Yet there was no whiff of compromise: *Experience* offered an only slightly more polished and hook-full version of the breakbeat madness percolating in the rave underground.

Despite its exhilarating merger of underground energy and pop appeal, the Prodigy was regarded as hopelessly uncool by tastemakers. Leading dance monthly *Mixmag* accused Liam & Co of destroying the rave scene (which the club-oriented magazine disdained anyway) with its late-'91 hit single "Charly." With its samples from a public safety commercial of a cartoon cat's miaow and a little boy's voice translating the feline's message ("Charly says, 'always tell your mummy before you go off somewhere,' ") this fabulous track spawned a spate of hardcore hit singles that sampled children's TV themes and combined nostalgic infantilism with druggy innuendos: Shaft's "Roobarb and Custard" ("rhubarb and custard" was a popular pink-and-yellow brand of E), Urban Hype's "A Trip to Trumpton," and Smart E's "Sesame's Treet" (E-as-candy puns). By this point, many within the hardcore underground shared *Mixmag*'s disgust, and the leading labels and producers began to push the music in an anticommercial direction.

So maybe the Prodigy *did* kill rave. A number two smash in July 1992, "Sesame's Treet" was the last hardcore hit. In August, Acen's deliriously Ecstatic masterpiece "Trip II the Moon" peaked at number thirty-eight, while 2 Bad Mice's raw-to-the-core "Hold It Down/Waremouse" stumbled outside the Top 40. The Shamen's number one "Ebeneezer Goode" confirmed the sense of an era coming to an end. Treating rave as a gigantic joke, the song anthropomorphized Ecstasy as a Dickensian scoundrel who always livens up the party. Despite a chorus of "'eezer Goode, 'eezer Goode" that sounded suspiciously like advocacy ("Es are good," get it?), the Shamen disingenuously insisted that the song wasn't about drugs at all. What else could they say?

During rave's 1991–92 crossover chart explosion, a new form of hardcore was hatching in the underground. A fusion of hectic breakbeats, dub-reggae bass, and sped-up vocal samples, the new style was a hyperkinetic update of the Shut Up and Dance sound, but with a drug-crazed delirium and polyrhythmic density that SUAD never approached.

Urban Shakedown's "Some Justice," a Top 30 hit in June '92, is a classic example: chopped-up, ricocheting breaks, a seismic undertow of sine-wave bass, and a monster riff pulsating in a Morse code pattern. In 1992 it seemed as if thousands of underground anthems were based around the Morse code oscillator riff: DJs Unite's "DJs Unite," Timelapse's "Sued for a Sample," 2 Bad Mice's "Bombscare," Edge's "Compnded," to name just a few. Fusing the staccato aggression of the "mentasm stab" and the tremulous euphoria of the octave-skipping piano vamp, the oscillator riff electrifies the listener, makes you feel like you're being shocked alive. As 1992 progressed the Morse code riff got ever more jittery and convulsive, matching the spastic intricacy of the semaphore patterns carved in the air by speed-freak ravers.

'Ardkore's oscillator riff is like the aural equivalent of the strobe's stop-gap photography effect. Both zap the raver with a series of ultraintense NOW!s. A staple of the rave lightshow, the strobe's flicker can trigger epileptic fits in the susceptible. In fact, the "disturbed electrical rhythms" and "clouded consciousness" that characterize epilepsy could be a description of 'ardkore itself. Just before an attack epileptics are said to feel "a special state of happiness, a juvenile exhilaration" — which sounds just like the MDMA experience. "Sub-

lime," wrote Dostoyevski, a suffererer. "For that moment you'd give your whole life. . . . At that moment I understood the meaning of that singular expression: there will no longer be time." This is the feeling the KLF captured with the title "3-AM Eternal." Indeed, the Greeks regarded epilepsy as a sacred malady.

But two terms related to epilepsy are probably closer to rave's essence. The first is "nympholepsy," an ecstatic frenzy caused by desire of the unattainable. The second is "picnolepsy," theorist Paul Virilio's term for frequent, incredibly brief ruptures in consciousness, a series of micro-orgasms or "tiny deaths" (as opposed to the "little death" caused by a grand mal seizure). Speed — in the vehicular sense — is the central concept of Virilio's thought. But you could just as easily read "speed" in such books of his as *The Aesthetics of Disappearance* as referring both to amphetamine and to 'ardkore's ever-escalating tempos.

In 1992 'ardkore was just one strand of a picnoleptic "rush culture" based on the cult of velocity, ranging from video games (another hi-tech leisure device known to trigger epileptic attacks) to the nefarious pastime of "joyriding" (stealing cars and burning out the engines by subjecting them to violent acceleration, U-turns, and other forms of stunt driving). Joyriding, Nintendo, roller coasters, bungee jumping, 'ardkore, amphetamine: these hyper-hyper activities all offer a peculiar sexless exhilaration, masculine but distinctly prepubescent.

On the back cover of 4 Hero's EP "The Headhunter" there's a cartoon that testifies to an anxiety about 'ardkore's ever-escalating beats per minute. Three mysterious cloaked figures stare aghast at a gang of grotesque mutants — 4 Hero, it transpires — who "in their race to fuse hip-hop and house . . . overlooked the consequences and side effects of their experiments." Reaching 135 bpm, "their physical structure becomes misshapen, unnatural deformities occur." Dego McFarlane of 4 Hero remembers feeling ambivalent about how hardcore's amphetamine-stoked cult of velocity was "causing deformations in the music." The cartoon was a self-mocking scenario of 4 Hero as "B-movie scientists. . . . The experiments get out of hand, he takes the serum and messes himself up. . . . Even ourselves, we were saying 'bloody hell, it's getting fast.' A lot of people were like 'it's too fast, it's the wrong speed.'"

This was the main complaint of the anti-hardcore contingent: the music was too fast to dance to, it just didn't make sense. At the end of 1991, the average rave tune was around 125 beats per minute; by the last months of 1992,

it was reaching speeds of 150 bpm plus. Not only were DJs crankin' everything up to plus 8, serious speed freaks doctored the pitch-adjust mechanism inside their Technics turntables so that they could go to plus 20 or higher. 'Ardkore was hurtling into the unknown, going faster than anyone had ever gone before, and all because of the malign drug/tech logic of amphetamine and Ecstasy pills cut with speed. Using his alter ego Tek 9, Dego McFarlane released "You Got to Slow Down," a sort of speeding ticket to a scene that was seriously overdoing the stimulants, the song pivoting around a soul-diva sample that leaps up the octaves until it's a helium-shrill shriek.

Such "squeaky vocals" were one of the defining characteristics of '92 'ardkore. Speed grievously unbalanced rave music's frequency spectrum; the midrange dropped right out, leaving just bowel-quaking bass and ultrashrill treble. The female vocals - samples of ethereal singers like Kate Bush, Liz Frazer, Stevie Nicks, even folk-rock maiden Maddie Prior, or soul-diva a capellas lifted from classic house tracks — were high-pitched anyway. In order to get these vocal samples to run in synch with the 140 bpm breakbeats, producers started to play the sound bites on a higher octave on their sampling keyboards; this compressed the time span of the vocal snatch so that it slotted into the frenetic rhythm, but it made the voices sound like cartoon chipmunks. Looped into posthuman swoon machines, these particles of passion hurtled beyond the syntax of desire into a realm of abstract urgency, closer to fireworks than "soul." Molded like plasma, they became a barrage of intensities without pretext or context, shudders and shivers that were not so much inhuman as infrahuman: elf chatter, astral babytalk, Martian doo-wop. And these swoony helium vocals were hugely popular; not only did they mirror the drugged intensities pulsing inside the raver's body, they actively triggered and amplified the E-rush.

Inadvertently avant-garde, the chipmunk voices sounded *hysterical*, in both senses of the word. They brought a cartoony absurdism to techno, puncturing the pompous piety of the Detroit purists. Those who complained that 'ardkore wasn't "proper techno" had a point; while the purists followed Detroit in fixating on the supposedly more "musical" synthesizer, 'ardkore was sampladelic music, based on a collage mess-thetic. You could see the joins, which was so much more postmodern and exciting. Your typical 'ardkore track was a mishmash of incongruous textures (spooky ectoplasm rubbing up against gimmicky

cartoon gibberish) and incompatible moods (mystic, manic, macabre). By 1992 hardcore was a bizarre composite of rush-activating elements — Beltram stabs, Italo piano riffs, breakbeats, melodramatic strings, sped-up ultramelismatic vocals, and dub bass. These stylistic fragments shared only one thing: welded together, they enhanced the senti-mental sensation of buzzing on speed-cut Ecstasy, its oxymoronic blend of aggression and open-hearted tenderness. Fusing the urge to surge and the urge to merge, 'ardkore created a raging oceanic feeling.

'Ardkore was avant-lumpen: the subculture's general impulse toward druggy disorientation required that initially recognizable sound bites be distorted, debased, rendered alien. The sampler worked as an estrangement device, a deracination machine, producing abstract sonorities whose physical origin was increasingly impossible to trace. But unlike the traditional conception of an avant-garde, with its heroic auteurs and lonely pioneers striding out into the unknown, 'ardkore's creativity operated on the collective, macrolevel of the entire genre, a syndrome Brian Eno calls "scenius," as opposed to "genius." When anyone came up with a new idea, it was instantly ripped off a hundred times. Inspired errors and random fucking around produced new riffs and noises, "mutations" that entered the dance floor ecosystem and were then inscribed in the music's DNA.

At the time, 'ardkore really did seem like some monstrous, amorphous creature, sucking in sound and regurgitating great vomit gusts of anonymous, white-label brilliance. Looking back now, it's possible to map out a cartography of creativity, trace the trajectories of key producers, and identify the house style of crucial labels. Some of these prime movers — fledgling labels like Moving Shadow, Suburban Base, Reinforced, Formation; producers like DJ SS, Andy C, DJ Hype, Hyper-On Experience — went on to become recognized and respected auteur figures in the jungle scene. But many more fell by the way-side or drifted off into other genres when the hardcore boom went bust: labels like Ibiza, Third Party, and Big City; outfits like Noise Factory, Bodysnatch, Sub Love, Holy Ghost Inc, and Satin Storm.

The music on Third Party, Big City, and Ibiza — like Bodysnatch's "Revenge of the Punter," a litany of murderous threats against a bouncer synched up to fitful death-funk rhythms — mirrored the subcultural underside of 1992's commercial pop-rave explosion: rip-off raves, dodgy drugs, desperate pleasures,

and bad attitudes (muggings at raves, brutal bouncers). With its rough-cut breakbeats and grainy low-resolution samples, this London-based 'ardkore was a reprise of Shut Up and Dance's urban realism, but stripped of overt politics or hope. It was music for ravers who knew the rave dream was a lie, but carried on taking the bad medicine. Noise Factory's "The Fire" twisted Stevie Nicks's mystical FM-rock classic "Sara" — "said you'd give me light, but you never told me about the fire" — into the plaint of a neophyte raver whose insides blaze with the scalding bliss of an unusually pure Ecstasy pill. Another Noise Factory classic, "Breakage #4," pivoted around a stammering vocal riff: "I bring you the future, the future, the future." This was no idle boast: Ibiza's record sleeves bore the prophetic word — JUNGLIZM.

British hardcore's golden age circa 1990–1992 will one day be remembered as fondly as the American garage punk of the mid-sixties. The parallels are striking. Both genres were the domain of untrained teenagers fixated on gimmicky sonic effects: wah-wah and fuzz-tone with garage, swarming sampler noises with 'ardkore. Both were oriented around the riff: in the sixties, there were a million variations on "Train Kept a Rollin'" or "You Really Got Me"; in the early nineties, myriad takes on the "Mentasm" stab or on the Morse code riff first heard on Todd Terry's CLS classic "Can You Feel It."

Sixties punk was a do-it-yourself movement of bored kids getting together to jam in the garage, just as their nineties 'ardkore equivalents gathered round a computer in the bedroom. Released on indie labels, their rough-and-ready lo-fi recordings might become regional hits, then — if they were really lucky — go nationwide. *Billboard* smashes like Count Five's "Psychotic Reactions" and the Seeds' "Pushing Too Hard" seemed to come out of nowhere, just like Urban Shakedown's "Some Justice" and SL2's "On a Ragga Tip." And in both eras, for every hit, there were a hundred obscure, fleeting bursts of inspiration.

Just as hippy snobs worshipped Cream and sneered at the garage bands for their lack of musicianship, the techno connoisseurs rallied to the art-wank of Future Sound of London while dismissing 'ardkore for its low production values. Years later, garage punk was rehabilitated through the fanatical advocacy of writers like Lester Bangs and musicians like Lenny Kaye. After Kaye's cele-

brated *Nuggets* anthology of lost one-hit wonders, there followed a deluge of compilation series — the most famous being *Pebbles, Mindrocker*, and *Back from the Grave* — dedicated to plucking all the one-miss blunders from history's dustbin. Already, a similar rehabilitation process is under way with 'ard-kore: there's a collector's market for the original 12-inch singles.

Who knows, a future form of techno may reinvoke the sounds and the attitude of 'ardkore in the same way that the seventies punks staged a partial return to the stark riffs and dynamic minimalism of sixties mod and garage punk. 'Ardkore was partly determined by the limited computer memory and 'sample time' producers had at their disposal. But constraints can be energizing; today's better-endowed producers often seem to drown in the mire of options, producing hopelessly cluttered and overnuanced music.

'Ardkore, like garage punk, is one-dimensional music, to be sure. But for my money, it commands that dimension with a single-minded intensity that is as close to the primal essence of rock 'n' roll as you can get. What's the essence? Not sex or drugs or dance, but any or all of these insofar as they're about *intensity*, a heightened sense of the *here and now*. To live in the now, without memory or future-anxiety, is literally childish. For those with an investment in techno's maturation as an art form, the two most offensive aspects of 'ardkore were its regressive, toytown streak and its naked drugginess. Often the two traits were intimately entwined: Bad Girl's "Bad Girl" features a sped-up shesprite chanting a playground paean to "herb an' weed, weed an' ganja, an' weed an' marijuana," while 2 Bad Mice's "Drumscare" starts with a looped entreaty — "E-wanna-E-wanna-E-wanna-E-wanna-E" — that sounds like a spoiled child demanding candy.

Beyond its sniggering puns and coded references, 'ardkore's drugginess was brazenly apparent in its *sound*. Just when it seemed possible to argue for electronic music as more than just the soundtrack to drugging and dancing, along came 'ardkore: not so much music as a science of inducing and enhancing the E-rush. 'Ardkore seemed best understood as a neurological rather than cultural phenomenon. Could you even listen to this music "on the natural," enjoy it in an unaltered state? Well, I did and do, all the time. But whether I'd *feel it* if my nervous system hadn't been reprogrammed by MDMA is another matter. Perhaps you just need to do it once, to become sens-E-tized, and the music will induce memory rushes and body flashbacks.

For many, 'ardkore was a depressing manifestation of rave culture's nihilistic escapism, scantily garbed in the glad rags of a vague and poorly grounded idealism. Yet 'ardkore was in some ways more honest than the would-be countercultural, back-to-the-sixties strands of rave. 'Ardkore simultaneously affirmed rave's utopianism and hinted that its heaven on earth was an illusion sustained by artificial energy and capsules of synthetic happiness. Tracks like Rhythm Section's "Dreamworld" and Desired State's "This Is a Dream" conjure up a poignant vision of paradise even as they remind the listener of its vaporous and transitory unreality.

'Ardkore was really just the latest twist on the traditional contours of working-class leisure, the latest variant on the sulfate-fueled sixty-hour weekend of mod and Northern Soul lore. There's an even earlier precedent: the *Tanzwuth* (dance mania) or St. Vitus Dance, in which medieval youth *jigged* their way out of their constrictions to the raucous soundtrack provided by itinerant minstrels. Helped along by fasting, sleep deprivation, and bingeing on wine, these proto-ravers would get swept up in "fits of wild dancing, leaping, hopping and clapping that ended in syncope [mass fainting]," according to an essay in the *New England Journal of Medicine* that sought a precedent for outbreaks of mass swooning at rock concerts. "Syncope" shares etymological roots with syncopation, the defining rhythmic quality of the 'ardkore breakbeat. Just like raves, *Tanzwuth* carnivals were feared by the authorities as "demoniacal festivals for the rude multitudes," despite the fact that they probably served an ultimately conservative function by dissipating the tensions and frustrations created by the hierarchical, regimented nature of medieval society.

In 1992, a slice of rap circulated through 'ardkore's sample gene pool: "can't beat the system/go with the flow." On one level, it was just a boast about how much damage the sound system can inflict. But perhaps there's a submerged and enduring political resonance there too: amid the socioeconomic deterioration of a Britain well into its second decade of one-party Conservative rule, where alternatives seemed unimaginable and there was no constructive outlet for anger or idealism, what else was left but to zone out, go with the flow, disappear? In their quest to reach escape velocity, 'ardkore youth ended up in the speed trap: a dead-end zone where going nowhere fast becomes a kind of hyperkinetic stasis, strung out between spasm and entropy.

firmative than nihilistic; an urge for total release from constraints, a lust for explosive exhilaration, that incites me like virtually no other music. 'Ardkore seethes with a rage to live, to cram all the intensity absent from a week of drudgery into a few hours of fervor. 'Ardkore frenzy was where the somnambulist youth of Britain snapped out of the living death of the nineties and grasped a few moments of fugitive bliss. As the chorus of Xenophobia's "Rush in the House" put it, "E come alive E come alive E come alive." 'Ardkore's speed freaks were literally *rushing* away from their problems, and who could really blame them?

Since house and techno both originated in America, and MDMA was a popular high throughout much of the USA during the eighties, it's something of a mystery that the Ecstasy/trance-dance connection was first made by the British. Actually, that's not entirely true: back in the early eighties, America *did* have something close to a proto-rave scene, in the bars and nightclubs of Dallas and Austin.

"This was Reagan years, so it was pure hedonism," says Wade Randolph Hampton, then an upper-class Dallas teenager, later a prime mover in the California rave scene. Devoid of countercultural trappings, the Texas Ecstasy scene was about innocent fun — *literally* innocent, since MDMA was legal until the summer of 1985 and you could buy it over the counter in gay clubs like Stark in downtown Dallas. "We were charging it on our parents' credit cards," says Hampton.

Despite the absence of hippy-dippy ideology, Stark and similar clubs anticipated the Balearic anything-goes ethos coined in Ibiza's Amnesia and codified by Shoom in London. The soundtrack mixed proto-techno electronic dance (Section 25's "Looking From a Hilltop," Chris and Cosey) with Wax Trax—style industrial and indie pop like the Smiths' "Girlfriend in a Coma." And as Ecstasy spread from the gay crowd to straights, a Texan equivalent of the loved-up soccer hooligan emerged: fratboys and jocks whose machismo melted under the influence of MDMA. "You'd go into a bathroom and see Southern Methodist University football players wiping the mascara from their eyes. It was the first time [Dallas] men had their testosterone broken down."

But it was these rich college kids who "fucked it up," says Hampton. "If you look back at the cases that were the basis for making Ecstasy illegal, it wasn't the gay crowd, it was SMU students who had enough money to buy twenty hits of Ecstasy. And they'd take *all of it*. The weird thing was that people were going *blind* — temporarily — from taking too much. Those kids' parents had enough money to raise hell — I'm talking the cover of the Dallas *Morning News* every other week, for a year."

Outside the gay discotheques, there was also a yuppie scene of "X parties" that precociously featured one of the defining aspects of rave — the eschewing of alcohol in favor of juice and mineral water. For these respectable professionals, Ecstasy didn't seem like a *drug*. It was cheap, there was no scuzzy paraphernalia like syringes or bongs, it wasn't addictive, and there was no

hangover. Above all, it was legal. "It wasn't unusual to come home with a date and her parents would be higher than you guys," chuckles Hampton.

When the DEA put MDMA on Schedule 1, the worst category of illegal drugs, the yuppies stopped partying and the dance scene went underground. "From the minute it was illegal, there were warehouse events, with DJs involved as organizers." With MDMA outlawed, the drug's price soared even as its quality deteriorated; the cheaper, more dependable methamphetamine infiltrated the clubs, prefiguring the calamity that would strike rave scenes throughout America in the nineties.

In the preprohibition early eighties, MDMA was available in club scenes throughout America. But it was generally used more for bonding sessions among friends than as a trance-dance drug. The first full-fledged rave scene was born in Brooklyn, New York, and was directly modeled on what was happening in Britain in 1989. Already a veteran DJ/producer on New York's "freestyle" scene, twenty-three-year-old Frankie Bones was flown to England for an Energy rave. After the awesome buzz of playing to twenty-five thousand people at 6 AM, Bones wrote the track "Energy Dawn" as a tribute, later telling iD: "England is fantasy land." For the rest of the summer, Bones was a regular on the British rave circuit. "It happened so big and so fast that nobody knew what it was right away; everything was peace, love, and unity," he remembers. "You could basically go on the M25 freeway and find raves back in '89; there'd be carloads of people driving around."

A week after the Energy epiphany, Bones had also enjoyed his own personal "Ecstasy revelation" at Heaven in Charing Cross. "I'm on my first hit of E... and all this shit is going through my head — 'you've *got* to bring this back to America.' "At his first parties in Brooklyn, Bones and his crew actually played videos of English raves on screens, as a sort of training film. These first events were word-of-mouth microraves: "fifteen people in someone's room with a sound system and a strobe." Gradually escalating into the hundreds, the indoor jams turned into "outlaw parties" at warehouses or beaches, advertised with handwritten flyers. After a dozen or so "break-in" parties, Bones and Co — brother Adam X and his girlfriend Heather Heart, DJ Jimmy Crash, and promoter—whizz kid Dennis the Menace — started calling the events STORMrave.

"At first, they were just a place to hang out," says Dennis. "No one could get into clubs; we weren't dressed right. When I got involved, there was an outlaw party in the woods in Queens. You had to go to this famous Carvel ice cream shop on Nostrand Avenue in Brooklyn, where you'd be given the map, which led you to the site in Queens. You followed this path with candles along it into the woods. . . . The early parties were free, but we'd ask for donations to pay for gas for the generator. The less we asked for, the more they gave. That was back when it was *pure*."

One of the most successful early parties took place in a brickyard, with the Storm crew building a DJ booth out of cinder blocks. "Back then, we'd spend the whole week just scouting for buildings like that," says Bones. "In the fence at the back of the brickyard, we cut a hole adjacent to these freight tracks that no trains had been on in years. People parked six blocks away, walked down the tracks, and climbed through the hole." During 1992, there was a STORM-rave every month or so, plus smaller outlaw parties with names like Tina Tripp's Magical Mystery Tour (after Frankie's girlfriend Tina) and a series of "all-nighters" called Cloud Nine. By the summer, events like Brainstorm were pulling crowds in the thousands to hear top DJs like Doc Martin, Caspar Pound, Sven Vath, and Richie Hawtin.

The Brooklyn soundtrack was "hardcore-only 4 the headstrong" (as Bones put it on the flyers), music for the first flush of Ecstasy euphoria — Belgian bombast, Underground Resistance, early English breakbeat 'ardkore. In typical hardcore rave fashion, Storm was part of a subcultural matrix that combined party promotion, DJ-ing, retail, and making tracks. Bones, Adam X, and Heather Heart ran their own Brooklyn record store, Groove. This became the focus of a closeknit alliance of mostly Italian-American DJ/producers — Lennie Dee, Mundo Muzique, Tommy Musto, Ralphie Dee, Joey Beltram, Damon Wild — who traded ideas, collaborated, and engineered each others' tracks. Frankie was at the center of it all: sharing an apartment with Beltram, making music with Lenny Dee as Looney Tunes for England's XL label and with Tommy Musto for Deconstruction/RCA. Then there was his solo stuff as Flowmasters and his famous "Bonesbreaks" series of hip-house EPs, minimal breakbeat tracks designed as mixing material for DJs.

The deals with XL and RCA proved useful in an unexpected way: when the cops came to bust the parties, Bones brandished official-looking documenta-

tion with record company letterheads and claimed "we're shooting my video inside." Eventually, Bones got into serious trouble with the police and fire marshals, who were cracking down on unlicensed events after a hundred people died in a fire at an overcrowded Latin social club. "They set up a police team called the Social Club Task Force to check that clubs had fire exits," says Bones. "When they found out about the rave scene they became the Rave Task Force."

There was also undercover intelligence work to worry about. "On three separate occasions I had people coming to Groove Records asking me for Ecstasy. And I'm, like, 'What's Ecstasy? Is it a record?'There was a track out called 'Ecstasy, Don't Play Me Raw,' so I'd grab a copy and say, 'Is that what you're looking for?,' and then they'd leave. I *knew* people who had Ecstasy, but if you're the DJ and you're the one throwing parties, you don't want to [get involved in] selling pills."

Yet, as Frankie admits, "without Ecstasy, [the scene] would never have happened the way it did. . . . That shit breaks down people's inhibitions." Ecstasy also got rid of the troublemaker element — most of the time. "The one time we did a party where it felt like some kids were going to start robbing people, I set an abandoned car on fire just to get everybody out of there quickly!"

As in Britain, the early "pure" phase of rave was succeeded by a period in which entrepreneurs, legal and illegal, cottoned onto the money-making potential of the scene. In London this involved bringing the music into West End clubs, and the MDMA initiation of working-class nonhipsters. The key figure behind this process in New York was Michael Caruso, aka Lord Michael. "I was friends with Michael," says Frankie Bones. "But he was, like, 'Bones can't do these parties forever; I'm gonna bring it into Manhattan.'"

Surrounded by a thirty-strong ruffneck entourage, Lord Michael started throwing warehouse jams in the outer boroughs, then made the transition to Manhattan in 1991. His working-class following mostly consisted of Italian-American youth from the "bridge and tunnel" areas (Coney Island, Bensonhurst, Staten Island) that surround Manhattan, a self-described "new breed" that had seized on techno's futurism in a violent reaction against their parents and elder brothers' retrograde taste. By early 1992 Caruso was working for

Manhattan clubland mogul Peter Gatien, owner of the Limelight and the Palladium. The "new breed" would gather at Caruso's two hardcore nights, Adrenalin and Future Shock, Thursdays at the Palladium and Fridays at the Limelight.

"Fifty percent of the kids here are just into the music," Lord Michael told me at the time. "They get off on the aggression, 'cos New York's a very aggressive city. The other fifty percent are taking Ecstasy or acid. Some of them smoke PCP. It's wild." The soundtrack was full-on Belgian-British-Brooklyn brutalism, escalating from the voodoo throb of "House of God" by local outfit D.H.S., through djpc's speed-freak anthem "Inssomniak," to the ungodly tintinnabulation of Incubus's awesome "The Spirit." With tempos peaking at a then-outrageous 150 bpm, it seemed the only appropriate response was to headbang or pogo. Clinching the hardcore-as-thrash-or-punk analogy, the brawny boys didn't dance rave-style, they slamdanced. Young bucks with slicked-back hair barged into the fray, stripped to the waist with T-shirts hanging out of their back jeans pockets like Springsteen. Others lurked at the Limelight bar and brazenly snorted cocaine through soda straws. Moby — then DJ-ing at Future Shock and making waves with tracks like "Go" — later likened the experience of spinning for this crowd to "playing in a penitentiary."

As Gatien's right-hand man, Lord Michael became a major clubland power broker. "When Michael met Timothy Leary in the Limelight," says Bones, "he really just flipped the script, he really wanted to be, like, *kingpin*." Bones alleges that the Limelight tipped off fire marshals about a STORMrave because "we were hurting the business in [Gatien's] club. . . . The marshal came with six fire trucks. . . . Conveniently, as everybody's leaving the party, there's people handing out flyers and saying 'now come down to the Limelight!"

By the end of July 1992, STORMrave had an ally in the struggle against the Limelight's commercialized version of hardcore: NASA. Located at Shelter, a club in deepest downtown Manhattan, NASA — short for Nocturnal Audio and Sensory Awakening — was the brainchild of Scotto and DB. Scotto was an indemand lighting director who had toured with Deee-Lite. London-born DB had moved to New York in 1989, where he DJ-ed and ran a peripatetic outlaw party called Deep with a proto-rave vibe, plus smaller events, like Orange, that catered to English expats with a mix of house and Madchester-style indie dance.

Kicking off in July '92, NASA was full-blown rave. The music was a different

version of hardcore than either STORMrave or Future Shock offered — NASA's DJs favored the breakbeat-and-piano-driven tunes that were peaking in England that summer. "The first six weeks, we lost money every week," says DB. "But I knew in my guts that if we stuck with it, the thing was going to pop. After six weeks, there was a line around the block, and these kids were not jaded, they didn't want to get in for free like typical Manhattan clubbers. To this day, I've never seen dance energy like it in New York."

DB and his fellow DJs like Soulslinger and Jason Jinx were pushing the breakbeat hardcore tunes from UK labels like Reinforced, Formation, and Moving Shadow. The first time I went to NASA, I was thrilled to hear tracks I recognized from the London pirate stations. But by this point, the winter of '92, the crowd's vibe was lagging behind the music's madness. The peak "only lasted three or four months," admits DB. "It quickly became way too young, way too druggy, way too cliquey-fashion bullshit." Unlike the dressed-down, jeans-and-sneakers Storm crowd, the NASA kids were inventing the look that was to become the dominant US rave style. "It was the fusion of hip-hop culture into rave," says DB. "Super baggy trousers halfway down their asses, Tommy Hilfiger, Polo — preppy gear that became hip-hop clothing and then entered rave. But back in '92, it wasn't so label-oriented — lots of backpacks, lollipops, flowers in the hair, smiley faces. Very kiddy-innocent looking — nine-teen-year-olds trying to look like they were five-year-olds."

"NASA was where that whole style of East Coast rave dancing was invented," says Scotto. "That dance where there's a little snaky thing going, and little bunny-hop steps — that was created at NASA by this guy Philly Dave. He was an Ecstasy dealer, he wore these big white gloves, and he would come up from Philadelphia every week. One night he was fucked up and mesmerized by his own gloves. He started these moves, and that's how it started. The kids worshipped him; he was an icon. Unfortunately, he OD-ed."

Despite being portrayed in the Gen X-sploitation movie *Kids* as a den of debauchery (chemical *and* sexual), NASA's atmosphere was initially rather freshfaced and idealistic, thanks to the collective MDMA honeymoon. "You could hear it in the conversations," grins DB. "We were going to print a T-shirt with 'I really love you' on the front, and then on the back, 'It's not the drugs talking.' "The same was equally true of the Storm milieu. Heather Heart, then only eighteen, was putting out the fanzine *Under One Sky*, which rapidly progressed

from purely musical coverage to "a very spiritual angle," incorporating poetry, art, and letter pages where kids would testify to life-changing experiences on the scene. Four years after England's 1988 rave-olution, New York was experiencing its own Second Summer of Love. The Storm-NASA axis was bolstered by the arrival of Caffeine, a rave club in Deer Park, Long Island, where party-hard kids from NASA and Storm would end up on Sundays. Here — according to a condescending report in the *New York Times* — the universal refrain on every other teenager's lips was "it's just like the sixties."

For Dennis the Menace, the pinnacle came at a STORMrave in a trucking depot. "At the end of the party, we were winding down, the sun was out, everyone was feeling pure and alive, in that communal unity feeling. Then someone in the middle of the floor started holding hands and putting their hands up in a circle. Kids were jumping from the back to put their hands up to touch the centerpoint where all the hands interlocked. People had tears in their eyes. We were just looking at each other, so happy, so open to everything. At the peak of all of it, with everyone trying to let go as much as they could, the belt drive on the turntable bust. Everyone stopped and looked at Frankie, and he kept trying to keep the record spinning with his finger at the right beats-perminute — just to continue what everyone was feeling."

Although MDMA catalyzed that communion, Dennis insists that "the reason these kids were going out wasn't the ecstasy in the pill, but the feeling you got when everyone was together. Group energy, where one person triggers the next person who triggers the next person.... You could feel it vibrating between everyone. You can't put that in a pill. There's kids I know that were totally straight, who never did drugs, and who were there dancing as hard as anyone 'cos they could feed off that energy."

If New York's rave scene can be traced back to Frankie Bones's experiences in England during the summer of 1989, the West Coast's scene was directly catalyzed, in large part, by British expatriates. In San Francisco a remarkable number of the prime movers were from the UK: Mark Heley, the guru behind the Toon Town raves; most of the Wicked collective; Irish promoters Malachy O'Brien and Martin O'Brien (no relation); Jonah Sharp, founder of the Reflective label and music maker as Space Time Continuum (named after his

pioneering London ambient parties, Space Time); clothes designer Nick Philip.

A particular techno-pagan strand of English rave ideology had a disproportionate influence over what happened in San Francisco. The principal font of this cyberdelic philosophy was Fraser Clark, the original hippie-tuned-zippy (Zen-inspired pagan professional) behind *Evolution* magazine, the *Shamanarchy in the UK* compilation, and (later) London's New Agey trance club Megatripolis. Another influential figure was Psychic TV's Genesis P. Orridge, who actually ended up in SF after exiling himself from England when the authorities threatened to take his children into custody. One SF party organization called Mr. Floppy's was affiliated with Orridge's cult, the Temple Ov Psychick Youth.

P. Orridge was actually a peripheral figure in the UK's acid house scene. But his widely disseminated ideas — psychedelia/sampladelia as the creative abuse of technology; house's 125 bpm as the primordial trance-inducing, alpha-wave-triggering tempo that connects Arab, Indian, and aboriginal music; the manipulation of sonic frequencies to achieve "metabolic engineering," à la Aleister Crowley's dictum "our method is science, our aim is religion" — pretty much defined the San Francisco scene. In the more hyperbolic West Coast versions of rave's history, P. Orridge is credited with actually introducing acid house to the UK in the first place — a total myth-take!

At the same time, there were plenty of local sources for San Francisco's neohippy version of rave: the neuroconsciousness movement's covert research into designer drugs and archaic plant psychedelics; the Internet/Virtual Reality/posthuman/"extropian"/Mondo 2000 scene on the fringes of Silicon Valley; New Age culture; Haight-Ashbury's history of acid rock and psychedelic happenings. And it didn't hurt that much of America's drug supply comes from West Coast labs, making for especially strong Ecstasy in the Bay Area.

Finally, San Francisco was a fertile area for house music because of its indigenous disco scene, a byproduct of the city's allure as a liberal, laid-back Mecca for gays from all over America. The first places to play house were mixed gay/straight clubs like DV8 and Doc Martin's and Pete Avila's clubs Recess and Osmosis. According to Jody Radzik, a key cyberdelic ideologue who helped out at Osmosis, the latter was "one of the main conduits for rave ideas into San Francisco. Then the British rave Mafia took over."

Beginning in the early summer of 1991, Mark Heley hooked up with Diana

Jacobs (who'd been involved in the gay club scene) and her partners Preston Lytton and Craig Valentine to promote a series of parties called Toon Town. "The first, a collaboration with *Mondo 2000*, didn't work out, the second one got busted," says Radzik. "But when they moved it to this strange little club in South of Market — the office/industrial area where most of the clubs are — Toon Town really took off." A Toon Town rave on New Year's Eve 1991 pulled a then-astonishing eight thousand.

If Diana and Preston provided the organizational skills, Mark Heley was the guru who articulated the vision. A Cambridge graduate who'd written about cyberdelic culture for *iD* and had run a "brain gym" in London, Heley is mythologized in Douglas Rushkoff's *Cyberia* as a modern shaman wont to warn his acolytes that "bliss is a rigorous master." "Heley pioneered the whole cyber-rave trip; he brought VR and brain machines into it," says Radzik. Heley also forged contacts with Bay Area neuroconsciousness wizards like Timothy Leary, Terence McKenna, Bruce Eisner, and Allen Cohen, and brought in a character called Earth Girl to set up a Smart Drinks stall. These psychoactive cocktails — briefly popular throughout the US rave scene — were more hype than anything else, although those containing ephedra gave you a sort of sub-MDMA buzz.

Like Heley, Radzik was a bit of a seeker. Enrolled in a Consciousness Studies degree program at John F. Kennedy University, Berkeley, and an adept of bhakti yoga, Radzik had cobbled together a syncretic religion out of "psychedelic, shamanic, and Hindu bhakti practices." Weirdly blending prophet and profit motives, Radzik marketed his knowledge of youth fashions to the sportswear company Gotcha. But this canny business sense was all part of the techno-shamanic role, fashion being a crucial medium for the dissemination of cultural viruses (or in cyberspeak, "memes"). "We thought we were setting up the morphogenetic field for rave," says Radzik. "The idea of rave was alive, it wanted to express itself, and it was using the culture as a medium."

Strip away the posthuman discourse, though, and the nature of the enlightenment offered by rave was actually quite straightforward. "You go to a rave for the first time, take Ecstasy, and you're in this context of bright flashing lights, different sorts of images projected on the walls, crazily dressed people, normally dressed people," says Radzik. "People you don't know are smiling big at you. Everyone else is on E, so there's this huge bath of acceptance. That's a tremendous experience — it changes people."

In the UK, people had these life-changing experiences at raves but didn't necessarily dress them up in cosmic significance; most people enjoyed them as relatively local transformations in their modes of self-expression and the way they related to friends and strangers. But in San Francisco, the Fraser Clark/Genesis P. Orridge-derived anarcho-mysticism went into cosmological overdrive, thanks to booster doses of Terence McKenna's eschatological, drugdetermined theory of human evolution. McKenna argues that human consciousness may have been spawned by primordial man's consumption of magic mushrooms. In this lost Edenic phase of prehistory, psilocybin's effects of "boundary dissolution" worked to sustain an anarcho-utopian tribal society, organized around orgiastic mushroom-eating ceremonies enacted every full moon. Plant-based hallucinogens (psilocybin, DMT, peyote) act as an inoculation against the "tumor" that is the ego, a "cyst" that "keeps wanting to form in the human psyche." Climactic changes led to the disappearance of the mushroom cults and thus to humanity's fall from paradise: the ego formed in tandem with the dominator psychology of territoriality, property, sexism, class, ecocide, and war. But wait, there's hope: "The ego is the pathological portion of the human personality. Like any other pathology, it can be treated with pharmaceutical substances. It can be treated with plant psychedelics and it can be cured." Rave, as a trance-dance drug cult, is part of the "archaic revival," helping to end our alienation from the "Gaian matrix," the womb of Mother Nature.

This doesn't sound *too* farfetched, but McKenna has more outlandish beliefs, like the Mayan notion of End Time. Technological progress is accelerating history toward a "bifurcation point," circa 2012, when human consciousness will abandon its bodily prison and merge into the Overmind. This is basically a cyberdelic rewrite of the biblical notion of the Rapture. If Rushkoff's *Cyberia* can be trusted, Mark Heley seemed to believe that rave was part of this escalating evolutionary thrust toward End Time.

San Francisco's cyber-mystic shtick manifested itself most blatantly through rave fashion and flyers. Nick Philip's clothing company, Anarchic Adjustment, went from purveying skatepunk wear to being "a mouthpiece for loved-up ecstasy consciousness." T-shirts bore slogans like "Open Your Mind" and "Empathize." "We were the first to put aliens and UFOs on shirts," claims Philip. "One of the most popular featured a Buddha with a circuit board and

get right on one, matey

spectrum hosts paul oakenfold(left) and ian st. paul (right) check out their friendly rivals shoom, april 1988

living the dream

shoom dj danny rampling conducts his congregation, july 1988 DAVID SWINDELLS

smiley faces spectrum revelers overcome by balearic bonhomie, july 1988

loved up the famous heart-shaped flyer for shoom

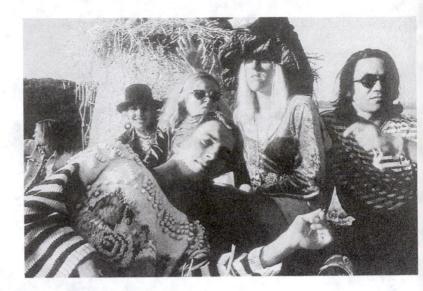

getting your head together in the country

boy's own outdoor party, near east grinstead, surrey, august 1989 DAVID SWINDELLS

rave 'n' roll suicide

the prodigy's liam howlett, overcome by guilt following media accusations that the band killed rave with 1991's toytown techno hit 'charly'
ALEXIS MARYON

the famous 'peanut pete' drug education comics

here illustrating the way the uk's ecstasy culture had become routinized by the early nineties and the effects — from pleasurable to mildly irritating — of the drug

LIFELINE, MANCHESTER

we are e

raver sporting a chemical protection mask, a popular 'ardkore accoutrement. roller express, edmonton, august 1992

blowing your own horn

kids participate in the rave's blitz of sound and visuals using whistles, horns, glowsticks, and mini-lasers. roller express, august 1992

derrick may

as rythim is rythim and mayday, the incarnation of detroit techno's europhile elegance and refinement

larry heard

as fingers inc. and mr. fingers, the creator of a contemplative, spiritual, and serene style of chicago house

richard james

as aphex twin, afx, polygon window, the king of ambient techno and weirdy-beardy electronic experimentation ALEXIS MARYON

licensed to chill

trance heads and hippy ravers recline in the "techno silence suite" at megatripolis, london, late 1993

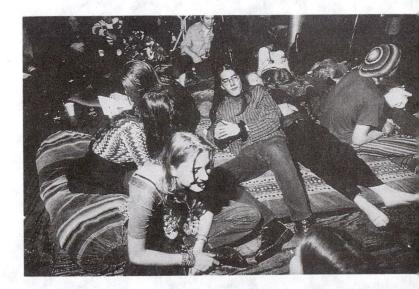

the hypnotic voodoo rhythm, a reckless dance down the Devil's road of sin and self-destruction. leading youth to eternal damnation in the fiery depths of hell!

take a trip

flyer for furthur rave festival in wisconsin, april/may 1994, with haight-ashbury typography and ken kesey's lsd bus paying homage to the original psychedelic counterculture; the micro-flyer hints that the devil has all the best beats

peace and loveism

flyer for new year's eve 1990 rave thrown by labrynth,

the east end hardcore club that stuck with 1988's 'second summer of love' spirit long after the event

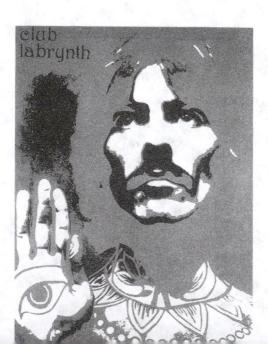

the slogan 'Spirituality Through Technology.' . . . In San Francisco a lot of interesting things collided together because [graphics] technology had developed a lot further than when rave started in England." When Photoshop design software arrived in '89, "half the rave designers didn't know anything about design, but they had all these new tools and they were really experimenting, rather than just using old paradigms. With the people who did rave flyers in early-nineties California, the attitude was just get on the computer and make it as *mental* as you can."

Of course, the results were often cyber-kitsch, riddled with "far out, man!" clichés. "No one understood that we were almost spoofing ourselves for being so high," says Wade Hampton, by this point flitting between LA and San Francisco as a promoter. "We'd put little tag lines at the bottom of flyers like 'Live Fast, Dream Hard' — things the inner core of people would giggle over."

This blend of tongue-in-cheek, retro-hippy references and genuine Ecstatic idealism also informed the first stirrings of San Francisco house music. At the fore were the Hardkiss Brothers, whose brotherhood was spiritual rather than genetic. Gavin Bieber and Scott Friedel had met in college in Philadelphia, become friends through a shared passion for Prince, then swerved from a suitand-tie future to music, inspired by a series of revelatory experiences in Tenerife, at England's Glastonbury Festival, and at a Frankie Bones party in Long Island. The pair followed Scott's old friend Robbie Cameron to San Francisco in 1991, where they threw weekly parties like Sunny Side Up and started the Hardkiss label, Gavin recording as Hawke, Scott as God Within, and Robbie as Little Wing.

Their music's vibe wasn't cyberdelic techno so much as "psychedelic funk," says Scott, "influenced by live, traditional music as much as electronic, futuristic music. A lot of people in this scene are obsessed with the hottest and latest, but personally I have yet to hear a dance record that rivals the Beatles' singles!" One contemporary record that did deeply influence the Hardkiss aesthetic was the Future Sound of London's sublime '92 rave anthem "Papua New Guinea," with its softcore breakbeats, ecstatic wordless vocals (sampled from Dead Can Dance's Lisa Gerrard), and blissed serenity.

Hardkiss's own tracks resemble Prince's psychedelic phase circa "Raspberry Beret" filtered through Balearic house; just dig titles like the Ultraviolet Catastrophe's "The Trip (The Remixes)," God Within's "Raincry (Spiritual Thirst)," Hawke's "3 Nudes (Having Sax on Acid)," the latter being Hardkiss's all-time shimmerfunk classic. The halcyon imagery reflected the honeymoon period that all ravers and rave scenes experience with MDMA. "It was a magical time in San Francisco," says Robbie. "We were going to these outdoor parties, stepping out and creating our own lives after college. We truly believed we were creating our own family — not just us three, but extending to girl-friends, wives, close friends. It was a magic burst, and you can't repeat it. . . . It's like the first time you take Ecstasy, or the first time you fall in love — it never feels like that again."

For all the retro-kitsch knowingness, there was a genuine spiritual yearning behind San Francisco's positivity, expressed through imagery of Gaia and Goddess worship. Take the following leaflet entitled "House Music & Planetary Healing."

When used with positive intention, Group energy has the potential to help restore the plan of Love on Earth. . . . When you open your heart, and trust the whole group you dance with; when you feel love with everyone, and they return it, a higher vibration can be reached. This happens when a crowd is deep into the vibe of House. . . . In the true sense of rhythmic movement, the effect is to align the physical, mental and emotional bodies with the Oneness of All that Is. . . . Don't put out negative energy and feelings. Leave the old ways behind. Throw yourself into the winds of transformation and sow the seeds for a new world — one where the human family is together again. When people respect and care for each other as a community-organism. Spread the Peace!

This leaflet was circulated by Malachy O'Brien, a British expat from County Tyrone, Northern Ireland, who was involved in the weekly club Come-Unity and later worked with Martin O'Brien on the irregular rave the Gathering. The leaflet's idea of house music as biorhythmic synchronization with Gaia was crystallized in Come-Unity's logo: a childlike drawing of a house superimposed over Planet Earth.

The legendary Full Moon outdoor parties were where San Francisco's back-

to-Mother-Nature spirit found its fullest expression. Full Moon was the brain-child of party collective Wicked, which largely consisted of English expatriates — Alan McQueen and his girlfriend Trisha; DJs Jeno, Garth, and Marky Mark — and had links with UK free-party sound system Tonka. McQueen had been friends with Heley in London and was on the same "Terence McKenna techno-shamanism trip," says Nick Philip. But when the increasingly spectacular and successful Toon Town started to inspire "copycat raves with VR and all this shit," people felt the scene was getting too commercial. "So the Wicked crew said 'fuck it, we're just gonna have a sound system and maybe a strobe.'"

As in Brooklyn, most of the underground parties were warehouse break-ins or jams thrown under bridges, beside train tracks, and, in a nice San Francisco—specific touch, in disused tram yards. But the Full Moon parties were held outside the city limits and under the sky. Typical locations included disused military bunkers overlooking the Bay and secluded seashore spots like Baker's Beach. "With the high cliffs, and if the cars were parked well away, you could escape notice and party till noon," says Malachy. "At one Full Moon I was directing people across the sand dunes, and as I got near I was thinking: What the fuck's up with the sound system? I reached the crest of a dune and all I could see was a sea of people, bonfires, dogs running wild, someone juggling with firesticks. Then the sound kicked in and all the people rose to their feet at the same moment. With the moon out there low over the water, it was a pretty awesome sight!"

The Full Moons were free parties. Nobody was benefiting financially, but there was still a competitive spirit of one-upmanship among San Francisco promoters, albeit on a more spiritual level. "It was about how you could take care of people and impress them with something very psychedelic," says Wade Hampton. "In San Francisco, it tended to be much more natural and humandriven — hang gliders, unicycles, anything you could possibly imagine was hauled off to the parties." Ravers competed too — to intensify the vibe by wearing wacky clothes or by freaky dancing. "It might be something like bringing an antique bicycle with a really big front wheel and riding it around on the beach till noon. It was a *Dali scene*."

It was also a drug scene. "Being San Francisco, there was a lot of psychedelics," says Malachy. Not just Ecstasy and LSD, but "San Pedro cactus, ayahuasca, Syrian Rue." The latter is a plant-derived substance rich in a

chemical called harmine, whose MAO inhibitor effect intensifies the visions caused by psychedelics. Amazonian shamans combine harmine-rich plants with the hallucinogenic tree bark DMT to create *ayahuasca*, a potent brew that triggers "extremely rich tapestries of visual hallucination that are particularly susceptible to being 'driven' and directed by sound" (Terence McKenna).

With all these psychoactive substances circulating in the Full Moon milieu, it's hardly surprising that there were incidents of mass hallucination. At one party in late '92, several hundred people "saw the same spaceship come down and land," claims Wade Hampton. "There was this acid floating around called Purple Shield. That party is legendary in San Francisco. After that party, most people walked away as one."

While San Francisco ravers talked about reaching "higher awareness" and celebrated the DJ as a "digital shaman," the house party scene in Los Angeles was more about fashion-conscious fun, rooted in the popular demand for after-hours dancing. In 1989–90, there were parties that mixed a bit of house in with hip-hop and funk, like Solomon Monsieur's Dirtbox, Steve LeClair's OAP (One Almighty Party), and a series of clubs and events like Alice's House, Deep Shag, and Stranger Than Fiction put together by a guy called Randy. After moving down from San Francisco, Doc Martin DJ-ed house at Flammable Liquid. There was also a long-established all-night dance culture among Latino youth on LA's East Side.

Most clubs in Los Angeles had to close by 2 AM. By 1990 "you started seeing flyers for psychedelic after-parties," says Todd C. Roberts, editor of *Urb*, LA's DJ culture magazine. "Normal clubs started kicking people out at about 1:45 AM, so there were lots of drunk, horny guys and gals wandering around." As in San Francisco, the key promoters who spotted the potential for all-night clubs were mostly English. Steve Levy was DJ-ing at his own Santa Monica club, West Go West. After a trip back home to London in 1989, he returned with a stack of acid house 12-inches. Following the warehouse party blueprint he'd witnessed in London — word of mouth, flyers, voice mail, meet-points — Levy founded the illegal after-hours event Moonshine.

"Our first location was a building this guy had been using for an illegal casino," remembers Levy. "The guy was a nut case, dodgy enough that when

he kept our security deposit we didn't argue with him about it!" After a few weeks, the party moved to the Fish Factory, the basement of a fish warehouse in downtown LA. "It stank, but you got used to it after a couple of hours. The people had to go down a freight elevator. Halfway down, we'd turn all the lights out, ask everyone for the money, and search them. In LA, if you search a policeman, they have to give up the gun. Since they aren't allowed to travel without a weapon, we searched everyone to stop undercover cops from getting in." Other locations came through contacts in the real estate business.

After a dozen Moonshines, Levy decided to switch to legal venues. By this point — the summer of '91 — Levy's parties were pulling thousand-strong crowds. But they weren't really raves. The party fuel was still alcohol (hence the prohibition-era name Moonshine) rather than E, and the music was slanted toward hip-hop rather than house. Levy's next venture — Truth, at the Park Plaza Hotel — was closer. Hip-hop and house were in separate rooms, but the funk crowd was getting seduced by the house room's trippy projections and lasers. "Next week they'd be rolling up in their overalls ready to *have it.*"

Promoters in suburban Orange County were already throwing ravey events; following Moonshine's lead, they started breaking into warehouses in downtown LA. If the English club organizers like Levy resembled Paul Oakenfold and Danny Rampling circa 1988, the Orange County impresarios were the equivalent of Sunrise and Energy in 1989: entrepreneurs with the guts and ego to take it to the next level. As with 1989's orbital rave explosion, the result was an escalating spiral of friendly but fierce competition to throw the most spectacular events in the most audaciously outlandish locations.

"For me it was all about the production, the idea of having a vision and then building it up from the ground," says Les Borsai. From his beginnings with Steve Kool-Aid throwing parties like Double Hit Mickey and Mr. Bubble, Borsai progressed to increasingly grandiose raves in downtown LA warehouses. For King Neptune's Underwater Wet Dream, "we painted the whole warehouse fluorescent, using stencils of seahorses and fish and sharks. We put up blue lighting and bubble machines, made the whole club look fuckin' spectacular." Suddenly helicopters and police arrived to arrest Borsai and his team. Managing to wriggle out of the law's clutches by claiming they'd only been hired to paint the place, Borsai faced the challenge of finding a replacement site within twenty-four hours. "We found a massive underground parking structure,

painted it, and brought in a huge water truck and twenty cases of shampoo. We foamed up the whole dance floor." But two hours after the rave kicked off, the police shut it down and arrested Borsai.

Fed up with the precarious nature of unlicensed events, Borsai hooked up with rock promotions company Avalon Attractions. The result was a series of fully legal raves that grew ever more spectacular. For a 1991 rave in a Pomona cow pasture, Borsai rented an entire carnival. Techno Flight One took place in a Disney facility that housed Howard Hughes's wooden airplane the *Spruce Goose*. "The plane sat in a moat, and Disney created dry ice effects so it looked like it was floating on clouds. This plane must have stood fifty feet off the ground, but people were so off their heads, the kids were dancing out on the wings!"

When it came to rave extravaganzas, Borsai's major rival was Daven Michaels, who cultivated a larger-than-life persona — Daven the Mad Hatter — and even hired a personal publicist. Collaborating with early partners Beej and Sparky, Daven threw a rave called LSD (Love Sex Dance) which, he claims, "changed the course of LA." His tale illustrates the flagrant law bending and logistical cunning required to promote raves in LA during the scene's outlaw phase. The location was "an incredible space called the Bingo Building, which the realty management company would rent out for movie shoots. I pretended I was a location scout and kept asking them to hold it for us, saying 'we're going to have a production meeting, I'll get back to you.'That way, we kept the space open right up to the last minute."

But on the day of the rave, Michaels discovered that a rival promoter was advertising a rave in the very same space. "I hopped in my car, threw on a tie, and drove down to the building, where the kids were setting up their event. I said: 'Guys, I'm John Stone from this [realty] company, you've set off a silent alarm, and you have ten minutes to get out before I call the police.' " Having routed the panicked kids, Daven locked the building's entrance, then noticed that the rival promoters were still hanging around. Thinking on his feet, Michaels decided to disguise the rave as an after-concert party for Madonna, performing in LA that very night. After informing his usual security team of the ruse, Michaels hired *another* security company and fed them the Madonna after-party line, so they'd sound convincing if challenged by the police.

Pulling both their own crowd and the people who'd come for the rival rave,

LSD was a huge success, spawning a series of sequels. Like Borsai, Michaels became obsessed with dazzling the kids with spectacular, "fully themed" productions involving up to five separate installations per event. "We worked with a performance artist on huge performance pieces that involved hydraulics. One was modeled on Ancient Rome, with this four-hundred-pound guy called Fat Freddie wearing a toga and sitting on a throne. All of a sudden Rome crumbles, the columns crash down. Then hydraulics lift everything back together. The kids flipped for it."

Eventually going solo, Daven began his Paw Paw Patch series of parties. June 1991's Paw Paw Ranch, in the desert city of Hemet in Riverside County, was LA's first outdoor rave, "the first party where the ravers saw the sun go up." Because the idea of traveling outside the city limits was unusual then, Michaels says "we had to trick people so they didn't realize how far they were really driving. When they finally got off the freeway, they came down onto this long, winding, pitch-black road, where there was a massive billboard onto which we projected: 'The Paw Paw Ranch — You're Almost There.' "A year later, when desert raves were well established, Paw Paw Ranch II took place at Horse Thief Canyon Stables in Orange County. Michaels hired "a ghost town from a company, prefab, which we transported there and erected."

Although the British expats got the LA rave scene off the ground with their clubs ("English weeklies") and medium-scale events, their following was older and relatively sophisticated. Rave ringmasters like Borsai and Daven the Mad Hatter pulled a younger, more suburban crowd who were really there to *rave*. "To an extent we commercialized it," admits Daven. "The English guys never sold out. . . . Whereas we were always outdoing each other. And we really spent a *lot* of money outdoing each other. In the beginning, events cost between five and fifteen grand, but by the end the costs were running to well over a hundred thousand dollars." With tickets selling from \$20 to \$25, and crowds between four and six thousand, "we had to run a pretty tight ship just to keep up with each other and still make a few bucks."

The most extravagant and over-the-top South California rave ever was probably Gilligan's Island, which took place in a Catalina casino-cum-ballroom. Twelve hundred people were ferried over to the island on two ships. "The budget was massive," says Wade Hampton. "There was never even a possibility of recouping what they spent. Eventually they took over the island, 'cos the cops

wanted them to stop but they wouldn't. It was the pinnacle of Los Angeles rave — so outlawish, so brilliant. From then on, people were trying to match that vibe."

Hampton claims that "virtual crime" was rife among LA promoters — hot checks, credit card scams, cellular phone fraud. "A lot of parties were boosted by doing mad things with other people's money. It was the beginning of the end." For the honest promoters, the game was getting too risky: the huge events couldn't evade police notice, and a busted gig could obliterate the profits from several previous triumphs. Inevitably, LA rave began to move toward fully licensed legitimacy. Instead of the flyers/voice-mail/map-point system, promoters started to sell tickets at stores, then graduated to working through Ticketmaster.

By mid-'92, LA rave was losing its outlaw edge, even as the potential profit margins were attracting fly-by-night entrepreneurs and serious criminals. But for about eighteen months, LA had the most full-on rave scene in America. It even had a techno radio station, Mars FM, which broadcast "the new music invasion" all day long, interspersed with the station slogan, "we want our techno." There was also an explosion of rave fashion on LA's streets. According to Hampton, many kids adopted the raver look first, then got into the music. "Fresh Jive, Clobber, all these rave-oriented clothing lines became very influential. If you had flyers designed by Fresh Jive, loads of kids would come to your parties. Through the desktop, computer graphics revolution, the whole culture got very visual."

Fashion and "balls out hedonism" (as Hampton puts it) defined Los Angeles rave. But there was a utopian aspect to Southern California's rave scene — the racial mixing that was going on. "It was the first time in my lifetime I saw people from every neighborhood — San Diego, Riverside, San Bernadino, Long Beach — coming together," says Todd Roberts. "Every weekend you'd see a lot of people you'd never even come into contact with. It was especially nice, being African-American myself, to see black youth involved and not just a bunch of white kids acting weird. Rave allowed me to talk about and see LA as a better community than most people give it credit for. It is a very divided city. But this was the first time those walls were breaking down. . . . Utopian? It was as utopian as LA could get!"

fight for your right to party

It's 11 PM on a Saturday night in May 1992. We're cruising along a country lane somewhere in the English West Country, when the abnormally — one might even say suspiciously — heavy traffic comes to a halt. Someone up ahead has stopped to take a leak. Suddenly, from almost every car, boys emerge to follow suit. It's an image I'll never forget: irradiated in the gleam of a hundred headlights, innumerable arcs of urine spraying into the hedgerow, as far as the eye can see.

An hour earlier we'd been hurtling down the motorway, en route to my first Spiral Tribe outdoor rave. The Spirals are part of the crossover between the rave scene and the "crusty" subculture — crusties being squat-dwelling anarchohippy-punk types named after their matted dreadlocks and postapocalyptic garb. At the bottom of the crusty spectrum are destitute idlers who panhandle for a living; at the top end are more enterprising types who organize illegal parties, deal drugs, or make and sell artifacts and clothes.

My friends have Tribal connections, and one of the clan's DJs has bummed a ride. He tells us about "doets," a new drug that he says is a superpotent cocktail of speed, LSD, E, and ketamine that propels the user on a thirty-hour trip with "amazing visuals, man!" Then he plays a tape of Spiral Tribe's debut EP. The killer track, "Doet," is a juggernaut of noise with a rabble-rousing chorus: "Rush your fucking bollocks off!!!" This is Spiral Tribe's slogan of the summer.

Gradually, our car has become part of a convoy, and the sense of strength in numbers grows almost unbearable, as does the fear that the police will thwart the rave. Our destination is Castlemorton Common, an area of public countryside in Worcestershire where this year's Avon Free Festival — one of the dozen or more summer festivals attended by "New Age travelers" — is taking place.

The traveling lifestyle began in the early seventies, as convoys of hippies spent the summer wandering from site to site on the free festival circuit. Gradually, these proto-crusty remnants of the original counterculture built up a neomedieval economy based on crafts, alternative medicine, and entertainment: jugglers, acrobats, healers, food vendors, candle makers, clothes sellers, tattooists, piercers, jewelers, and drug peddlers. In the mid-eighties, as squatting becoming a less viable option and the government mounted a clampdown on welfare claimants, many urban crusties tired of the squalor of settled life and took to the roving lifestyle. Despite persecution from the

government and local police forces, the traveling movement grew. By the end of the 1980s, some estimates put the number of travelers at forty thousand.

At the 1990 Glastonbury rock festival, crusties and hippies danced to house and techno sound systems like Club Dog and Tonka, while outside the festival bounds there was confrontation as travelers (who'd hitherto been let in for free) railed against the high ticket price and demanded a free campsite. That year also saw ravers — sick of commercialized, rip-off raves — turning up at the free festivals, where techno was gradually eclipsing the hippies' previous staple (cosmic trance-rock of the Hawkwind/Here and Now/Magic Mushroom Band stripe). Sound-system collectives, like Nottingham's DiY, started to throw free parties at abandoned airfields or on hilltops, drawing a mixed crowd of urban ravers and crusty road warriors.

Spiral Tribe started hooking up with the travelers in the summer of '91 and rapidly became prime movers on the scene, luring thousands of urban ravers to party at abandoned quarries. Often the events coincided with traditional free festivals. Gradually, the Spirals — alongside similar sound-system outfits like Bedlam, Circus Warp, Techno Travelers, and Circus Normal — fermented a peculiar symbiosis between the straight rave scene and the anarcho-hippy nomads; the hardcore weekenders brought an infusion of money generated by working in the straight world, while the travelers provided an environment for freaking out. There were tensions, initially: some older travelers, used to folk and acid rock, disliked the harsh new techno soundtrack. Inevitably, there was mutual suspicion based on differences of lifestyle, appearance, and outlook: the travelers with their dreadlocks and shaved patches of scalp, hessian jackets, camouflage fatigues, DM boots, and piercings galore; the fashionconscious middle-class ravers; the baggy-trouser-and-T-shirted 'ardkore proles. But as they discovered common ground in drugs, dance, and the desire to have a dirt cheap wild time, travelers and ravers formed what cultural critic Lawrence Grossberg calls an "affective alliance": the affect in this instance being an exhilarating feeling of freedom combined with the belief that freedom ain't really free if you have to pay for it.

As we wind along the West Country lanes, little do we know that Castlemorton is set to be the high-water mark of this crusty-raver alliance. Previous Spiral-instigated parties have drawn crowds in the region of four or five thousand. But arriving at the darkened Common, it quickly becomes apparent that the event has escalated beyond all expectations. Thanks to Bank Holiday Monday's prolongation of the weekend and exceptionally fine weather, Castlemorton is well on its way to becoming the biggest illegal rave in history—estimates vary from twenty to forty thousand.

Our first surprise is the scarcity of police. We encounter only a pair of genial constables who direct us to a safer parking space, lest "all your paint get scraped off by one of the big buses." The midsummer night scene is somewhere between a medieval encampment and a third world shanty town. The lanes are choked with caravans, buses, ex-military transports, gaudily painted horse-drawn vehicles, and hundreds of cars (in the near pitch black, I keep gouging my hips on jutting wing mirrors). The fields are jammed with a higgledy-piggledy throng of tents, pavilions, and eerie-looking fluorescent sculptures.

The third world/medieval vibe is exacerbated by the bazaar atmosphere. Peddlers hawk their illicit wares, hollering "get your acid!" or "hash cookies for sale," propositioning us with wraps of speed, magic mushroom pies, and innumerable brands of Ecstasy. The most medieval aspect of all, we discover later, is the total absence of sanitation. Venturing out onto the camp's perimeter, we quickly learn to tread gingerly to avoid the excrement in the bracken. A big placard commands "Bury Your Shit," but unlike the seasoned travelers, urban ravers haven't come armed with spades.

After stumbling through the murk for what feels like a small eternity, we finally make it to Spiral Tribe's own enclosure, a Wild West—style wagon circle of vans and trucks circumscribing a grassy dance floor. While the event is free, in accordance with the Spiral credo "no money, no ego," ravers are invited to give donations in order to keep the generators running. Inside the circle, the scene is like a pagan gathering. With their undulating dance moves, it seems like the crowd has evolved into a single, pulsating organism. Faces are contorted by expressions midway between orgasm and sobbing. It's time for us to get "on the vibe," as the Spirals put it, and we quickly score some Tangerine Sunsets at fifteen pounds a shot, sold out of the back of a van.

Dancing with the stars overhead, it's hard not to succumb to the back-tonature romanticism that is part of SpiralTribe's eco-mystical creed, crystallized in the buzzword "terra-technic," using technology to unlock the primal energy of Mother Earth. Tonight, the subsonic bass throb of their sound system certainly feels like it's forging a connection between my bowels and the earth's core.

Around 4:30 AM, the gray predawn light uncovers a scene weirdly poised between idyllic and apocalyptic. The breathtaking Malvern Hills, shrouded in mist, are a sight for sore eyes. But at the Malverns' feet, the festival site is an eyesore. Weary dancers huddle around small bonfires to ward off the clammy, creeping damp. Undernourished dogs roam freely. Bedraggled figures wander around scavenging for cigarette butts to make joints; others panhandle for money to buy more E.

The consensus is that the Tangerine Sunsets were a disappointment. But a spare Rhubarb & Custard left over from a previous rave is shared, and that's all it takes to push us over the edge. On my weakened, sleep-deprived system and empty stomach, the effect is almost instantaneous: I've got that walking-on-air, helium-for-blood feeling. Even though the music sounds harsh and distorted, overdriven at top volume through an inadequate PA, I'm swept up in a frenzy of belligerent euphoria. A friend tells me later that I've actually been growling!

One image sums up Castlemorton for me: a beautiful, androgynous girl—short black bob, virulent red lipstick, Ray-Ban sunglasses, burgundy short-sleeve top—is dancing on top of a van. Her fingers stab and slice, carving cryptograms in the air, and her mouth is puckered in a pout of indescribable, sublime impudence. She's totally, fiercely *on the vibe*, living in the moment and loving it.

By ten in the morning, the sun's breaking through, the temperature's rising, and our rush has dwindled to a buzzy lassitude. We sprawl out on the grass. A photographer friend-of-a-friend, supposedly here to document history in the making, has been dozing for five hours. He wakes, mutters "Wicked sleep!," and we piss ourselves laughing. All around, the exposed flesh of slumped, catatonic bodies is visibly blistering in the baking heat. A couple of well-trained four-year-old crusty kids are wandering around selling outrageously overpriced packets of Rizla rolling papers to desperate ravers, and Spiral personnel are collecting the first night's rubbish in garbage bags. Overhead a police helicopter patrols intermittently (later, a crusty will fire a flare gun at it, much to the public's outrage). By noon, shattered, we decide it's time to go home. Bidding farewells, we wend our way through the revelers and wreckage.

During the next five days of its existence, Castlemorton will inspire questions in Parliament, make the front page of every newspaper in England, and incite nationwide panic about the whereabouts of the next destination on the crusty itinerary. Tabloids like the *Sun* stoke public fear and resentment of "the scum army" of dole-scrounging soap-dodgers having fun on taxpayer money. Back at Castlemorton itself, local residents complain of fences being torn up for firewood, of dogs ravaging sheep, of crusties defecating in their back gardens or trying to sell acid to their kids. Above all, they whine about the incessant barrage of techno, which sends them "all funny." "There's something hypnotic about the continuous pounding beat of the music, and it's driving people living in the front line into a frenzy," one forty-two-year-old villager tells a newspaper. Lambasting the West Mercia police for its failure to thwart the rave and its kid-glove handling of the party-goers, local farmers form a vigilante militia.

On the last day, after inexplicably hanging around rather than attempting to sneak a getaway, thirteen members of the Tribe are arrested and several sound systems are impounded. Police forces across rural Britain start collaborating in Operation Snapshot: the creation of a massive database with names of ringleaders and license numbers of travelers' and ravers' vehicles. An intensive campaign of surveillance and intelligence work is mounted to ensure that any future Castlemortons are nipped in the bud. And the Conservative government begins to hatch the ultimate deathblow to the free party scene: the Criminal Justice and Public Order Act.

I first met Spiral Tribe a few months prior to Castlemorton, at a "legit" club called the Soundshaft with which the Tribe had some vague connection. Within minutes I'm informed that I'm already part of the cosmic "spiral." Synchronicity is at work: my T-shirt, of sampler-wielding cyber-punks the Young Gods, happens to have a luminous spiral in the middle. What's more, there are pictures of bees on the sleeves, which echo a recent Spiral Tribe rave at a farm at which a hive was knocked over. (Nobody got stung.) Even more synchronistically, the farm was in Hertfordshire, a county with which the Tribe claim a "special connection" and where I spent my childhood. The Tribe grin like maniacs, each coincidence confirming their mystical worldview.

The next night I attend my first Spiral Tribe party, at a dilapidated squatters' house in North East London. Five years earlier an equivalent squat party's soundtrack would have been dub reggae or hippy music like Gong. But tonight a thick, tactile web of techno-voodoo rhythms writhes through the murk. Gyrating light beams glance off walls mottled with dry rot and mildew, illuminating cryptic Spiral Tribe insignia and refracting through the curlicues of ganja smoke. Downstairs in the makeshift chill-out room, assorted Spiral folk huddle by a gas fire, rolling joints. Some snort ketamine, an anesthetic drug suddenly in favor with the hardcore psychedelic contingent within rave culture. Slang terms for ketamine are "baby food" (users sink into a blissful, infantile inertia) and "God" (some users are engulfed in a heavenly radiance and, if they're religious, become convinced they've met their Maker).

A week after the squat party, I get the chance to interrogate Spiral Tribe in the aftermath of another event, this time at a derelict pub. Upstairs, survivors lie slumped and glazed on soiled mattresses. On the wall, someone has aerosol-sprayed a pentagram with the number 23 in one corner. The uncanny power and alleged omnipresence of the number 23 is one of a motley array of mystical beliefs to which the Spirals subscribe. It's the sum of paired chromosomes in a DNA helix. All Spiral Tribe information phone lines contain the number. And Castlemorton kicked off on May 23.

Spiral Tribe's spokesman Mark Harrison has the visionary gleam of a prophet in his eyes. After half an hour of his breathless, punctuation-free discourse, I'm mesmerized. I begin to see why he has such a hold over his disciples — and that's what they are, for all the party line about lack of hierarchy. At one point, a Tribesman describes Mark as the Second Coming, only to be swiftly silenced by a reproving glance from the guru himself. Yet despite the cultic aura, a surprising amount of what Mark and his acolytes say makes sense.

"We keep everything illegal because it's only outside the law that there's any real life to be had. The real energy in rave culture comes from illegal dance parties, pirate radio, and white-label 12-inches that bypass the record industry altogether. Rave is about people creating their own reality. Last summer, we did a party that went on for fourteen days nonstop. It's a myth that you need to sleep. Stay awake and you begin to discover the real edges of reality. You stop believing in anything that anyone told you was true, all the false reality that was hammered into you from birth."

"In the old days, rock bands had to go to record companies and sign their souls away just to be able to put out a record," says saucer-eyed Seb Vaughan, the former music student largely responsible for Spiral Tribe's own mindwarping, mutant techno. "But now cheap technology means anyone can do it. Just compare the music released on white labels with the stuff released by major companies — you can taste the freedom. Rock 'n' roll had that freedom once, very briefly, before it was turned into a commodity. The record industry turns energy into money, into dead metal. We want to release the trapped energy."

Although Spiral Tribe recognize that for a lot of hardcore fans raving is just the latest twist on the working-class "living for the weekend" ethos, they claim that people often come to their parties and see the light, then quit their jobs and abandon settled life for traveling. Like a lot of millenarian groups, Spiral Tribe combine paranoid conspiracy theories (the Freemasons, the Illuminati, et al) with fantasies about returning to a lost paradise. "If you compare techno with music from primitive or non-Western cultures," says Seb, "you'll find that those musics, like techno, are based on harmony and rhythm, not melody. That's what's amazing about the house revolution, everyone was waiting for it, and nobody had done it — stripped it all down to the percussive, even the vocals. It's all voodoo pulses, from Africa. With our music and our parties, we're not trying to get into the future, we're trying to get back to where we were before Western Civilization fucked it all up."

In many respects, Spiral Tribe and the free party movement constitute an uncanny fulfillment of the prophecies of Hakim Bey. In his visionary prose poems "Chaos: The Broadsheets of Ontological Anarchism" and "The Temporary Autonomous Zone," the anarcho-mystic writer called for the rebirth of a new "festal culture" based around "spiritual hedonism" and tribalism (he exalts "clans . . . secret or initiatic societies" over the claustrophobia of the nuclear family). The illegal free rave, with its lack of entrance fee or security, is a perfect real-world example of Bey's "temporary autonomous zone," aka TAZ. The TAZ is an advance glimpse of utopia, "a microcosm of that 'anarchist dream' of a free culture," but its success depends on its impermanence. "The 'nomadic war machine' conquers without being noticed," writes Bey; it occupies "cracks and vacancies" left by the state, then disperses only to regroup and attack elsewhere. "Cracks and vacancies" sounds like the abandoned air bases and derelict government buildings taken over by traveler sound systems for a

few days or weeks. Rave culture arguably fulfills Bey's "spiritual project: the creation or discovery of pilgrimages in which the concept 'shrine' has been replaced ... by the concept 'peak experience' "— "a peak experience" that must be "on the social as well as individual scale."

When I interview Spiral Tribe they are already promising that 1992 will be "the maddest summer since 1989," a nonstop conflagration of illegal raves and altercations with the authorities. The ignition point is set to be Sound System City on June 21: a massive convocation of ravers celebrating the summer solstice, at a spot as near as possible to Stonehenge (the traditional site for solstice festivities) as the police's four-mile exclusion zone around the ancient standing stones will allow.

In the event, the subcultural energies fomented by the Tribe slip out of their control: the "maddest summer" peaks too early, at Castlemorton. And Spiral Tribe take all the credit and all the blame. On one hand, thirteen members are charged with a variety of offenses, including causing a public nuisance contrary to common law. But on the other hand, all the music mags and national newspapers want to talk to them, and they get signed to dance label Butterfly, whose owner, Jaz Summers, is convinced that this crusty-raver malarkey is the next punk rock, with Spiral Tribe as its Sex Pistols.

With corporate money at their disposal, the Tribe hire a massive truck and a 23 K sound system for their next and most daring confrontation with the authorities. Given the exclusion zone around Stonehenge they decide to up the stakes and hold the summer solstice megarave right in the heart of the capital. Sound System City will be built at Mudchute Farm — a public park, in the East London area known as the Isle of Dogs, that's rumored to be situated above a ley-line. The rave will be illuminated by the flashing light on top of the ill-fated Canary Wharf tower. Part of the unsuccessful Docklands development scheme, and built to be Britain's new financial center, Canary Wharf is a symbol of Tory hubris, of late-eighties "boom" economics gone bust. But Sound System City itself becomes a symbol of Spiral Tribe's own hubris: it's the first and biggest in a series of defeats that results in the ignominious petering out of the "maddest summer."

Eleven forty-five PM, Saturday, June 21: my posse arrives too early. There's only one other car in the vicinity, its backseat crammed to the roof with bottles of Evian; obviously the owners are budding entrepreneurs looking to slake ravers' thirst. We drift across the eerily calm and deserted field and run into a reconnaissance team from the Tribe on the other side, busy working out how to break the lock on the gate and drive their monster truck onto Mudchute Farm. Brusquely, they order us to disappear, in case local residents get suspicious. We retreat to a friend's house for an hour, then set out again. By this point, the major access roads into the Isle of Dogs are blocked by police, who are turning back anybody who doesn't live in the area. Hundreds of frustrated ravers mill about on the pavement, trying to get up enough courage to rush the barricades. We learn that the rave has kicked off; over a thousand people are already in the area, partying their socks off, but nobody else can get through to Mudchute.

There's one faint hope: the two main roads are sealed, but there's a pedestrian-only tunnel under the Thames that connects the Docklands area to Greenwich and the rest of South East London. We hightail it across the river, but we're too late: the boys in blue have cordoned off the entrance. "Rush 'em," says a crusty, sniggering at the druggy double-entendre, but nobody does. The muffled thud-thud-boom of the Spiral's distant sound system taunts and tantalizes us. Spirits flagging, we cross the Thames again and navigate a circuitous route through the back streets of North East London in an attempt to work our way down to the Isle of Dogs, all the while cursing the poor strategic forethought of the Spirals in choosing a site accessible via only two main roads, both of which are easily sealed. Around daybreak, we get within a half mile of Mudchute. Looking at the map, we realize it might be possible to cross the Docklands Light Railway and get to the rave. Just as we're looking for an egress, a private security firm van drives up. Defeated, we beat a retreat. Later, we learn that the police easily dispersed the rave around 3:30 AM, with no arrests; some hardcore Spiral-types have headed north to a free party in Leicestershire.

Other abortive raves follow throughout the summer of '92; the police intelligence network is too efficient, local farmers spread manure on their fields, and the desperately unhappy travelers are shunted back and forth across county lines. One Spiral rave in Surrey, supposedly on private land and at the owner's invitation, sounds like a good bet, but the local police quash it anyway. The result is a glum convoy of some fifty cars, which — prevented from reaching any of the backup sites — winds up on a picturesque stone quay facing the English Channel. The sense of anticlimax is crushing, and as we drive back to London, I resolve never to go on another Spiral rave. Amazingly, my friend sets out again at 8 AM when she learns that the Spirals have finally pulled off a free party after all, only to find a gaggle of red-eyed crusties crashed out on a beach around a pathetic Tandy hi-fi system.

Actually, I do attend one more Spiral party, in the winter of '92. The location is a derelict Inland Revenue depot in a grim area of North West London. This is the anti-Castlemorton, totally devoid of midsummer-night's dreaminess. The dance hall is basically an industrial hangar, just like at a big commercial rave, but with no facilities: nowhere to sit, nothing to drink, no toilet (people piss on the wooden floorboards in an adjoining room), barely any lights. Five months after Castlemorton, the music seems to have gotten harsher; one Spiral-affiliated outfit plays a set of undanceably fast, stiffly regimented, metallic beats that sounds like ball bearings rattling around in a concrete pipe. As the matte-gray winter dawn filters weak and sickly through the skylight, exposing some seriously haggard E casualties around us, the consensus is that this is the end of an era.

With the Castlemorton trial looming over their heads, Spiral Tribe maintained a high media profile for some time, putting out a series of EPs like "Breach the Peace" and "Forward the Revolution." Stymied in Britain on the free party front, another faction of the Tribe — who bitterly disapproved of the record deal with Butterfly — moved to the Continent, where the police tended to be more tolerant. Like other traveler sound systems, the Spirals roamed throughout Europe, bringing the "teknival" — as they now called it — to Italy, Austria, the Czech Republic, Hungary, and France. Here, the Tribe catalyzed a Gallic free party scene into being, and scored their greatest triumph in August '95 when they instigated a twelve-day *rave gratuite* on an Atlantic beach near Bayonne. Because the site was owned by the military, the local police were powerless to intervene. In Bologna, where squat culture and an-

archism have deep roots, the Spirals hooked up with fellow exiles the Mutoid Waste Company to throw techno fiestas. And in Berlin they acquired a MiG fighter plane and other ex-Soviet military hardware — symbols of the Spirals' "nomadic war machine" approach to throwing raves, but also useful ammunition in their long-term strategy of making the parties more visually "competitive."

Seb and other music-making Spirals eventually settled in Paris, where they founded the Network 23 label and churned out trippy, high-velocity tracks somewhere between gabba and acid house. After struggling to operate their own totally independent pan-European distribution network, Network 23 eventually signed a distribution deal — an ideological lapse that incensed Harrison. By this point, the guru had officially left the Tribe and was running his own Stormcore company, selling clothes and records.

After spending nearly two years and several million pounds on the trial, the Malvern authorities had failed to convict any of the Spirals. But the Conservative government devised a package of new laws to ensure that an event of Castlemorton's scale would never be repeated. Alongside a host of pernicious extensions of police powers (the removal of the right to silence, arbitrary stop-and-search powers), the Criminal Justice and Public Order Bill targeted squatters, travelers, illegal raves, and free festivals. Defining a rave as a mere one hundred people playing amplified music "characterized by the emission of a succession of repetitive beats," the bill gave local police forces the discretionary power to harass gatherings as small as ten. If an officer "reasonably believes" the ten are setting up a rave, or merely waiting for one to start, he can order them to disperse; failure to comply is a crime punishable by a three-month prison sentence or a £2,500 fine. Moreover, the police are granted the power to stop anyone who comes within a one-mile radius of this potential rave and order them to proceed no further.

Few people sympathized with the squatters and travelers, and fewer were prepared to defend them. With the Labour opposition in Parliament avoiding the issue for fear of appearing soft on crime, it fell to civil liberties organizations like Liberty, squatters' rights groups, and the traveling sound systems' own newly formed pressure group, the Advance Party, to fight back with a series of protest marches and rallies in Central London. There were protest records, too: an EP called "Repetitive Beats" by Retribution (a gaggle of dance

floor luminaries including members of the Drum Club, System 7, and Fun-Da-Mental) and Autechre's "Anti" EP, whose lead track "Flutter" was programmed to have deliberately fitful rhythms in order to bypass the CJB's clause about "the emission of a succession of repetitive beats." Both records testified to a widespread misapprehension among ravers that techno itself was about to be made illegal in all circumstances, not just at unlicensed parties. In a similar vein of pot-addled paranoia and delusory self-aggrandizement ("our music is a threat to the powers-that-be!"), conspiracy theorists alleged that the CJB was the government's payback to the major brewers for their handsome contributions to the Conservative Party coffers: an attempt to kill Ecstasy culture (where alcohol is deemed passé) and to arrest the decline in pub profits by driving the youth back to drink.

But all the campaigning, protest records, consciousness raising, and Big Brother Is Coming scaremongering was to no avail. On November 3, 1994, the Criminal Justice and Public Order Act was passed into law, and the crusty-raver "teknival" scene quailed in anticipation of the clampdown.

And yet the scene didn't die. One segment went further underground, throwing smaller, less spectacularly annoying parties, with the tacit tolerance of the police. And another faction of the scene went overground, in the form of licensed "festi-clubs" like Whirl-Y-Gig, Club Dog, and Sativa. Of these, Club Dog was the most significant, creating a milieu in which the original free party revelers mingled with part-time crusties, nonaligned trance fans, and recent converts from rock to techno. Taking place every Friday at the Sir George Robey in Finsbury Park, Club Dog had actually been a focus for London's hippy/punk proto-crustie scene (what organizer Bob Dog called "Warriors of the New Age") as far back as 1988. For the first four years of its existence, the staples of the Dog's soundtrack were acid rock, world music, and dub reggae of the On U Sound ilk (Dub Syndicate, Suns of Arqua). Reflecting the impact of electronic music on the free festival scene, Club Dog gradually began to incorporate "live techno" sets from bands like Orbital, Eat Static, Banco de Gaia, System 7, and Psykick Warriors ov Gaia.

Next came the massively successful monthly Megadog events, whose rockgig-meets-rave-meets-festival vibe offered a paying-but-cheap legal alternative to the outlawed free parties and a haven for the embattled crusty counterculture. Megadog then went on tour in the form of Midi Circus (named after the MIDI technology that allows samplers and sequencers to be coordinated with live playing and nondigital instruments). The Planet Dog label followed, catering to a distinct crusty-techno sound that had emerged: bands like Optic Eye, Children of the Bong, Wizards of Twiddly, Loop Guru, and Transglobal Underground. Despite the use of "ethnodelic" flavorings (didgeridoo pulsations, world-music samples), crusty-techno is ultra-Caucasian, often recalling those original trance-rock-turned-synth-pioneers Tangerine Dream.

Coalescing at roughly the same time as the Megadog scene, Goa Trance was another compromised consolation for the countercultural impulses blocked by the Criminal Justice Act. The scene is named after a style of techno associated with Goa, an area on India's southwest coast about twice the size of London. Goa was a Portuguese colony right up until 1961, but almost as soon as India seized the territory back another wave of European invaders arrived — hippies in search of a drug paradise where one could live like a king for a few dollars a day and hashish was cheaper than cornflakes.

By the late eighties Goa had evolved into a *dance*-and-drug paradise, albeit oriented around LSD rather than Ecstasy. At first, the music at the jungle parties and beach raves wasn't acid house but Euro-beat, electro-pop, and gay Hi-NRG — Front 242, Skinny Puppy, Yello, the vocal-free dub mixes of tracks by New Order and the Pet Shop Boys. In the nineties acid house and trance techno conquered Goa, and the region quickly became commercialized and swamped by raver-tourists looking not for a transcendental experience but for another Ibiza. Aghast, the serious "heads" and spiritual seekers moved on, abandoning Goa's most famous beaches — Anjuna, Vagator, and Arambol — for more remote locations in India, or fleeing to Thailand, where the raves are called "frenzies". At the same time, the Goa "vibe" was filtering back to Europe as a specific post-rave *sound*.

Just as the Balearic craze during the first explosion of UK rave was an attempt to continue the fun had by British ravers in Ibiza after the holiday's end, Goa Trance is an homage to a place that seems like heaven on earth, even to those who've never been there. "Goa" symbolizes the fantasy of taking a permanent vacation from ordinary life. Not coincidentally, Ibiza and Goa were both havens for hippies in the sixties. Even as Goa was being despoiled by

tourism, it was circulating as a viral, "virtual" presence across the Western world. From London to Tel Aviv, Goa trance clubs offered a microcosmic version of the real thing.

By 1996, Goa Trance had exploded into media consciousness, with the rise of labels like Dragonfly, Flying Rhino, TIP, and Blue Room Released, and bands like Man with No Name, Hallucinogen, Green Nuns of the Revolution, and Prana. As with the real Goa, the scene's drug of choice is acid far more than Ecstasy, and the LSD is supposed to be unusually pure and strong. Appropriately, the decor at Goa Trance events like Return to the Source is psychotropic (lots of fluorescent, reflective, and phosphorescent material), and the music is ornate and cinematic, full of arpeggiated synth refrains and mandala-swirls of sound. Imagine New Age music with a metronomic pulse-beat, Giorgio Moroder's Eurodisco infused with Eastern promise and oriented around transcendental surge rather than Donna Summer-style pornotopian rapture. Speaking to DJ magazine, trance decktician Goa Gil talked of giving "youth in Babylon" (the capitalist, consumerist West) "a higher transmission," of dance as "an active meditation." For all its cult of the mystic Orient, Goa Trance is sonically whiter-than-white. All the creativity is in the top level (melody and filigree), with not a lot going on in the rhythm section.

The Goa Trance scene is a sort of deodorized, upmarket version of crusty techno, without the ragged-trousered poverty chic. But both Megadog teknival culture and Goa trance have a similar function — they are an inner-city surrogate for the pre—Criminal Justice Act festivals and free parties, attempts to resurrect a lost golden age, on much reduced premises.

The golden age may be long gone, but free parties continue to take place on a much smaller scale, often in desolate, unlovely inner-city locations as opposed to the pastoral heart of England. Sound systems like Disorganisation, Liberator, Silverfish, Immersion, Virus, Desert Storm, and Turbo Unit persevere despite police harassment.

Perhaps the most persistent sound-system collective, and certainly the most persecuted, is Luton's Exodus. In 1993 the arrest of Exodus leaders in order to thwart a planned rave provoked a three-thousand-strong protest out-

side the police station. The fervent support for Exodus stems as much from their community activism — like their long struggle to create a community center for local youth — as from their parties in abandoned farms. Exodus also established a squatters' commune in a derelict old people's home called HAZ Manor (HAZ being short for Housing Action Zone, and a nod to Hakim Bey's TAZ). The name Exodus itself is an homage to Bob Marley that reactivates the punk dream of a "white ethnicity" equivalent to Rastafarianism: British bohemians as a lost tribe of internal exiles, stranded in a Babylon that's burning with boredom.

The new breed of post-CJA sound systems follow the precept "small is beautiful." By carefully choosing isolated locations and restricting the size of events by keeping them word-of-mouth, collectives like Smokescreen, Krunch, Quadrant, and Elemental can pull off microraves in the countryside, simply because it's too much trouble for local police to break up the party once it's running. Keeping a low profile may not result in mythic victories over "Babylon" like Castlemorton, but it's a sound long-term strategy, ensuring the survival of a free party scene that provides the only alternative to the increasingly costly and commercialized clubbing mainstream.

The one attempt in recent years to score a Castlemorton-scale triumph ended in humiliating disarray. In the summer of 1995, less than a year after the passage of the Criminal Justice and Public Order Act, a group called United Systems attempted to stage the biggest free rave since Castlemorton. A breakaway offshoot of the Advance Party, United Systems believed not in campaigning but in direct action to contest the CJA: "Only free parties can save free parties." The megarave was named Mother, an echo of the terra-technic, Gaian mysticism of the Spirals. The site was a failed theme park called Corby Wonderworld in Northhamptonshire, with a parallel party at Smeatharpe Airfield in Devon. But details of the rave leaked out onto the Internet, and both megaraves were met with roadblocks and policemen wielding their CJA powers to make arrests and impound sound system equipment. Miniraves did take place, however, at Sleaford, on the beach at Steart, and at Grafham Waters, Cambridge.

Defeated but defiant, United Systems declared: "We are unbloodied, unbowed, undaunted and remain totally committed to our cause. They may have

nailed the Mother but she had babies throughout the country that weekend. We live and learn and there's always a next time — we're not going to go away." Later that year, they started the legitimate club DMZ in the heart of London, in order to build a "fighting fund" to defend the eight United Systems members on trial for Mother. From the camouflage decor to the music policy (gabba and hard acid, the militant sounds of post-CJA rage), DMZ was "all about preparedness," an organizer told me. "DMZ stands for Demilitarized Zone. And that implies the rest of the world is a war zone."

feed your head

intelligent techno, ambient, and trance, 1990-94

Are you sitting comfortably? Artificial Intelligence is for long journeys, quiet nights and club drowsy dawns. Listen with an open mind.

sleevenote on Warp's *Artificial Intelligence* compilation, 1992

On the cover of *Artificial Intelligence*, a robot reclines in a comfy armchair, blowing perfect smoke rings in the air and chilling to the atmospheric sounds wafting from a sleek hi-fi unit. In his left hand, there's a fat joint; extralong Rizla rolling papers are strewn on top of an album sleeve on the carpet. Two other LPs are clearly recognizable as classic "head" music: Pink Floyd's *Dark Side of the Moon* and Kraftwerk's *Autobahn*. With no little wit, *Artificial Intelligence*'s cover tableau of domestic bliss-out heralds the birth of a new *post-rave* genre, which Warp Records christened "electronic listening music." Other names followed — armchair techno, ambient techno, intelligent techno, electronica — but all described the same phenomenon: dance music for the sedentary and stay-at-home.

The most striking thing about the album's gatefold sleeve (a deliberate prog rock echo) isn't the robot's sweatless, supine serenity so much as the fact that he's *on his own*. Coinciding with the emergence of a new "chill-out" culture, *Artificial Intelligence* offered a soundtrack for the raved out, for people who'd either given up on or grown out of the rave myth of mass communion and social mixing. And the reason? When the myth became reality, when the plebes turned up en masse for the party in 1991–92, "rave" became a dirty word; Ecstasy was passé, undignified. Musically, battle lines were drawn around the question of breakbeats and samples: they were the stylistic core of 'ardkore, but for the post-rave refugees they signified techno's corruption and commercialization.

Warp's baldly descriptive term "electronic listening music" was rapidly displaced by a more loaded epithet, "intelligent techno." Beneath the rhetoric lurked the perennial bourgeois-bohemian impulse to delineate a firm border between the discerning few and the undiscriminating masses. Hence the not uncommon 1992 slogan of "intelligent" or "pure techno" clubs: the "no breakbeats, no Lycra" promise. On the surface, "no breakbeats" merely indicated

that a particular sound — the breakbeat-driven hardcore that dominated the big raves and the pop charts alike — wasn't on the menu. But by implication, it proposed the purging of the black hip-hop influence that had "polluted" the Detroit-descended genealogy of pure techno. "Lycra" was sheer snobbery: a reference to the clingy, sweat-absorbent clothing in which raver girls shook their funky stuff, code language that summoned the image of the "techno Tracy," the working-class latecomer who wants to join the scene but doesn't really get it. In just four words, "no breakbeats, no Lycra" conflated racism, classism, and sexism into a rallying cry for a mostly male connoisseur elite, self-appointed custodians of the techno canon.

Part of this return to the "original principles" of Detroit and Chicago involved shunning the sampler in favor of analog synthesizers, including acid house's Roland 303 bass machine. Analog sound was often characterized as "warmer" than digital; the "hands-on" nature of these early synths, with their knobs, sliders, and filters, was also felt to be more "musical." When intelligent techno artists did resort to sampling, their use was governed by an ethos of masking and warping sources, in explicit opposition to the recognizable quotes and lifts that characterized 'ardkore's cut-up approach.

For all its rhetoric of "progression," intelligent techno involved a full-scale retreat from the most radically posthuman and hedonistically funktional aspects of rave music toward more traditional ideas about creativity, namely the auteur theory of the solitary genius who humanizes technology rather than subordinating himself to the drug-tech interface. There was even a resurgence of rock notions like the "concept album" and "live musicianship," with bands like Underworld and Orbital developing new forms of onstage improvisation based on the live mixing of prerecorded, sequenced parts.

None of the above means to argue that "electronic listening music" wasn't a necessary initiative in late 1992, when the white-label hardcore boom had saturated the dance scene with derivative, poorly produced tracks composed of nth-generation samples and there was a gap crying out to be filled by contemplative, home-compatible music. Nor is it to deny the fact that a lot of truly beautiful and innovative music was made under the "intelligent" banner. But because it was founded on exclusions (musical and social), electronic listening music ultimately painted itself into a corner. What started as a fresh, innovative idea — techno liberated from the demands of the dance

floor — quickly turned into a new form of myopic orthodoxy. The root of the problem was the retreat from dance itself: resurrecting progressive rock's elevation of head over body, melodic complexity over rhythmic compulsion, the new home-listening electronica set itself on a course that would lead to New Age.

For Warp, "electronic listening music" was simultaneously an aesthetic initiative and a business strategy. Aiming to avoid the fate that befell most independent dance labels — getting burned out by the high turnover of dance floor trends — Warp decided to take measures to foster band and brand loyalty. "We'd seen from running the shop how dance labels had about a year of being on top," says Steve Beckett. "The only way to avoid that fate was to get more artist-oriented and album-oriented."

At hardcore's height in early '92, remembers Beckett, "you started to hear tracks by B12 and Plaid and Speedy J that just didn't fit into any category, B-sides and last tracks on EPs. We realized that they weren't meant for twelve-inches, it was just that this was the only outlet for that kind of music. We realized you could make a really good album out of it. You could sit down and listen to it like you would a Kraftwerk or Pink Floyd album. That's why we put those sleeves on the cover of *Artificial Intelligence* — to get it into people's heads that you weren't *supposed* to dance to it!"

By early 1992 there was a demand among worn-out veteran ravers for music to accompany and enhance the comedown phase after clubbing 'n' raving. "That's still the high point of most people's nights," argues Beckett. "That's when you start hearing the really interesting, mind-blowing stuff. If you're coming down off [drugs], you can get really lost in your own thoughts and concentrate on the music, pay more attention to detail. . . . From our point of view, it also felt like a lot of the white-label dance music had gotten really throwaway. It felt like somebody should start paying attention to the production and the artwork — the whole way the music was presented." Other people shared Warp's frustration. By the end of 1992, a loose international network of anti-rave dissidents had coalesced: artists like the Black Dog, B12, Kirk DeGiorgio, and Mixmaster Morris; labels like GPR, Irdial, Rephlex, Tresor, Beyond, Porky's Productions, and Time.

Although Beckett claims the title *Artificial Intelligence* was "a tongue-incheek reference to the idea that this music is totally made by computers, you just press a button and a tune comes out," the word "intelligent" rapidly took on a dubious life of its own. Many shared the attitude of Mixmaster Morris, who defined "intelligent techno" as "the opposite of stupid hardcore" and declared that "techno got boring when hardcore took all the weirdness and creativity and innovation out of Acid House." Morris's slogan "I Think Therefore I Ambient" recast progressive rock's Cartesian split between head and body as the struggle between atmospheric mind food (ambient) and thoughtless rhythmic compulsion (hardcore). By 1993, with "progressive house" and "trance" set in place as dance floor—oriented adjuncts to electronic listening music, a firm line had been drawn. On one side, still raving after all these sneers, was the moronic inferno of hardcore; on the other, the post-rave cognoscenti, with their intimate clubs and chill-out zones.

Listening to Artificial Intelligence now, it's hard to imagine why the album had such an impact. Speedy J's "De-Orbit" and the two tracks by Musicology (alter ego of Detroit pietists B12) constituted little more than muzak. Electro-Soma, B12's debut long-player that followed as part of Warp's Artificial Intelligence series of single-artist albums, took its name from soma, the Prozac-like tranquilizer in Huxley's Brave New World. Electro-Soma's effect is more akin to a queasy docility, like being forcibly anesthesized with Glade airfreshener. Artificial Intelligence did, however, showcase material from three outfits destined to become major players in the realm of electronica: Autechre, the Black Dog, and the Aphex Twin.

Autechre — the Manchester-based duo of Sean Booth and Rob Brown — followed a typical trajectory for English techno artists. Having grown up on electro, graffiti, and Mantronix, they were dislodged from their B-boy path by the phuture shock of acid house. On albums like *Incunabula, Amber,* and *Tri Repetae*, and EPs like *Garbage* and *Anvil Vapre*, they constructed unlovely but oddly compelling sound sculptures: abstruse and angular concatenations of sonic glyphs, blocs of distortion, and mutilated sample tones. Autechre's music is most redolent of wildstyle graffiti, where typography is convoluted and abstracted to the point of illegibility. The graffiti parallel fits because their mu-

sic is basically avant-garde electro: Man Parrish meets Pierre Henry, or the Art of Noise meets Luigi Russolo's "The Art of Noises." The cryptographic opacity carried through to the song titles: "c/pach," "gnit," "rsdio," "second scepe," "vletrmx21."

Although Artificial Intelligence's sleeve notes had insisted that the new electronica "cannot be described as soulless or machine made," what's most interesting about Autechre's work is the absence of heart and humanity, the way that the listener's impulse to forge an emotional connection simply ricochets off the impenetrable, gnomic surfaces of their sound. At times you can't help wonder if the "aut" in their name stands for autism; listening, the mind's eye conjures up a vision of two small boys surrounded by techno toys, lost in a preverbal world of chromatics, texture, and contour.

The Black Dog — the trio of Ed Handley, Andy Turner, and Ken Downie — were almost as hermetic as Autechre, but more committed to traditional art notions of "expression." They once defined their project as the quest for "a computer soul," while Ken Downie told *Eternity* that the Black Dog started in order to fill "a hole in music. Acid house had been 'squashed' by the police and rinky-dinky Italian house music was getting played everywhere. Emotion had left via the window."

The musical emotions in the Black Dog (and alter egos Plaid and Balil) aren't the straightforward, run-of-the-mill, everyday sort, but rather more elusive: subtle, indefinable shades of mood, ambiguous and evanescent feelings for which even an oxymoron like "bittersweet" seems rather crude. Eschewing live appearances and seldom doing interviews, the Black Dog created a cult aura around their hard-to-find discography. One of their chosen mediums was cyberspace: long before the current craze for techno web sites, the Black Dog established a computer bulletin board called Black Dog Towers. Visitors could gawk at artwork and learn more about the Dog's interest in such arcana as paganism, out-of-body experiences, UFOs, Kabbalah, and "aeonics" (mass shifts in consciousness).

Although far from matching the euphoric fervor of rave, the Black Dogs' early material (1990–92) is remarkably similar to the breakbeat hardcore of the day: incongruous samples, looped breakbeats, and oscillator riffs. But the mood of "Seers + Sale," "Apt," "Chiba," and "Age of Slack" is quirky Dada absurdism rather than Loony Toons zany. The crisp, echoed breakbeat and

keyboard vamp on "Seers + Sale" recalls 2 Bad Mice's classic "Waremouse" except that the riff sounds like it's played on a church organ, so the effect is eldritch rather than E-lated.

Other Black Dog tracks are redolent of the early eighties: the Sinophile phunk of Sylvian and Sakomoto's "Bamboo Music," the phuturistic panache of Thomas Leer. Balil's "Nort Route" daubs synth goo into an exquisite calligraphic melody-shape over an off-kilter breakbeat. The track trembles and brims with a peculiar emotion, a euphoric melancholy that David Toop came closest to capturing with his phrase "nostalgia for the future." What the Black Dog/Balil/Plaid tracks most resembled was a sort of digital update of 1950s exotica. But instead of imitating remote alien cultures, it was as if the Black Dog were somehow offering advance glimpses of the hybrid music of the next millennium: the Hispanic-Polynesian dance crazes of the Pacific Rim or music for discothegues and wine bars in Chiba City and the Sprawl (the megalopolises in William Gibson's Neuromancer and Count Zero). While some of the Dog's later work — on the albums Bytes, Parallel, The Temple of Transparent Balls, and Spanners — crosses the thin line between mood music and muzak, it's still marked by a rhythmic inventiveness that's unusual in the electronic listening field. With its percussive density and discombobulated time signatures, the Black Dog's music often feels like it's designed for the asymmetrical dancing of creatures with an *odd* number of limbs.

If anyone substantiated Warp's concept of electronic listening music it was Richard James, aka Aphex Twin. On *Artificial Intelligence*, he appeared as the Dice Man, just one of a bewildering plethora of pseudonyms — AFX, Caustic Window, Soit P.P., Bluecalx, Polygon Window, and Powerpill. Despite this penchant for alter egos and a professed indifference to publicity, Richard James has been by far the most successful of the new breed of "armchair techno" auteurs at cultivating a cult of personality, painting a picture of an extremely abnormal childhood in the remote coastal county of Cornwall.

James's avant-garde impulses emerged almost as soon as he could walk. As a small child he messed about on the family piano, exploring different tuning scales and hitting the strings inside instead of the keys. Like John Cage and other avant-classical composers, James's interest has always been in sound in

itself, or as he puts it with characteristic down-to-earthness: "I've always been into banging things and making weird noises." Musique concrète—style tape manipulation was swiftly followed by teenage forays into Stockhausen-esque electroacoustic experiments. "I bought a synth when I was twelve, thought it was a load of shit, took it apart and started pissing about with it. I learned about electronics in school until I was quite competent and could build my own circuits from scratch. I started modifying analog synths and junk that I'd bought and got addicted to making noises." This obsession with generating a repertoire of unique timbres eventually led James to study electronics at Kingston University.

Cornwall's geographical/cultural remoteness is another crucial element in the mythos of Aphex as an isolated child prodigy. James claims that when he first heard acid and techno, he was astounded because he'd quite independently been making similar sounds for years. He immediately purchased every techno record he could lay his hands on, and started DJ-ing at clubs and beach raves. Finally his friends persuaded him to put out his own tracks, which he'd been giving them on cassette for years.

James immediately won acclaim with the cosmic jacuzzi swirl of "Analogue Bubblebath," the title track of his 1991 debut EP. With its fluttery, diaphanous riff pattern and hazy production, "Bubblebath" announced a new softcore direction in techno — meditational, melodically intricate, and ambient tinged. But the EP also revealed that James was no slouch when it came to industrial-strength hardcore. With its chemical formula title and astringent sound, "Isoprophlex" suggests a nasty corrosive fluid. James's next track, "Digeridoo," had a huge impact on the hardcore dance floor. Inspired by the traveler-minstrels who played the digeridoo at festival raves in Cornwall, the track is by far the best of a 1992 techno mini-genre based on the strange similarity between the Australian aboriginal pipe and the acieed bass squelch of the Roland 303. But it doesn't actually feature a digeridoo; eschewing samples, James labored for days to concoct an electronic simulacrum of the primordial drone.

"Analogue Bubblebath" and "Digeridoo" mark out the poles of the Aphex sound spectrum: synth-siphoned balm for the soul versus clangorously percussive noise. James's debut album, *Selected Ambient Works*, 85–92 is tilted toward softcore. The opening track, "Xtal," is a shimmer of tremulously translucent synths, hissy hi-hat, and muffled bass. A girl softly intones a

daydreamy, "la-la-la" melody, her slightly off-key voice seemingly diffracted by the gossamer haze of sound. The nine-minute-long "Tha" is twilight-after-rain melancholia worthy of the Eno-produced instrumentals on Bowie's *Low.* Over a pensive bass line and water-drip percussion, a mist of susurrating sound drifts like the whispery hubbub of a railway station concourse or an abbey's cloisters. The voices are so reverb-atomized you catch only the outline of words before they crumble like chalk dust and disperse.

Fusing narcosis and speed rush, "Pulsewidth" is ambient techno; everything is soft focus, the aural equivalent of Vaseline on the lens, yet the fluorescent bass pulse is irresistibly dynamic, propelling you toward a breathtaking breakdown before surging off again. "Heliosphan" is stirring and stately, its cupola-high synth cadence and wistful melody offset by impish twirls of non-chalantly jazzy keyboards. Imagine the theme music for a fifties government film about Britain's new garden cities: serene, symmetrical, euphonious, evoking the socially engineered perfection of a postwar New Order. Selected Ambient Works climaxes with "We Are the Music Makers." The track makes you wait through long stretches of beats and bass fuzz, teasing with intermittent flickers of twinkly synth in the cornermost crevice of the soundscape. Then there's a one-note dapple of reverb-hazy piano, like green-tinted sunlight peeking through a woodland canopy and caressing your half-closed eyelids, before the melody finally blossoms in full spangly-tingly glory.

Almost as striking as the music on *Selected* was the second half of the title: 85-92, which highlights the fact that most of the record was culled from the backlogged output of Richard James's teenage years. In interviews James talked about how he'd amassed a personal archive of around a thousand tracks, enough for a hundred albums. More tantalizing glimpses into his trove of unreleased material came with the two albums that followed swiftly on the heels of *Selected:* Polygon Window's *Surfing on Sine Waves* and AFX's *Analogue Bubblebath 3.* If tracks like "If It Really Is Me" verged on a sort of astral muzak, most of *Surfing* was harder and darker than its ambient predecessor. The standout track, "Quoth," features no melody, no synths, no bass even, just frenzied metallic percussion.

Clad only in bubblewrap, with no track information, *Analogue Bubblebath* 3 also cleaved to the industrial end of the Aphex sound range. Most of the thirteen tracks are undanceably angular anti-grooves, adorned with blurts of noise

and interlaced with the occasional ribbon of minimal melody. One track sounds like a gamelan symphony for glass and rubber percussion; another begins with the sound of a vacuum cleaner, before letting rip with an out-of-tune pianola-like oscillator riff. Like the hair-raisingly forbidding "Hedphelym" on *Selected Ambient Works*, listening to track 11 is like stumbling on a pagan shrine on an alien planet. But there are two lapses back into the outright beauty of *Selected Ambient Works*. Track 4 has a forlorn, Satie-esque melody floating at quarter-tempo over an incongruously strident, unrelenting beat. And track 8 is kosmik *kinder-muzik*, a sublime confection of music-box melody and thunderous dub that always makes me think of an ice cream van doing the rounds on one of Saturn's moons.

Fostering his crackpot genius image, Richard James claimed he could survive on a mere two or three hours of sleep a night. "When I was little I decided sleep was a waste of your life. Not sleeping is sort of nice and not-nice at the same time — your mind starts getting scatty, like you're senile." Sleep deprivation seems to have a lot to do with the spaced-out aura of James's music, most of which is created in a mind state constantly flitting between "hypnagogic" and "hypnopompic." Hypnagogic is the half-awake phase just before you drop off in bed at night, when the mind's eye fills with hyperreal imagery; hypnapompic is that uncanny early morning sensation of being awake but still in a dream.

Released at the end of 1992, *Selected Ambient Works* coincided not just with the electronic listening boom but with a resurgence of interest in "chill-out" music as a supplement or sequel to the rave. The idea had first been broached in 1989 with the short-lived fad for "ambient house." At Land of Oz, Paul Oakenfold's acid house night at Heaven, there was a VIP area called the White Room, where Dr. Alex Paterson — soon to be the main man in the Orb — provided soul-soothing succor for the acieed-frazzled by spinning records by Brian Eno, Pink Floyd, the Eagles, 10CC, and Mike Oldfield, all at very low volume and accompanied by multiscreen video projections. Hippy-rock guru Steve Hillage is said to have dropped by one night, only to hear Paterson playing *Rainbow Dome Musick*, which Hillage had composed for the New Agey Festival for Mind-Body-Spirit in 1979.

In 1989–90, the Spacetime parties were also taking place at Cable Street in the East End of London. Specifically designed to encourage people to talk rather than dance, the events were organized by Jonah Sharpe and featured live music by Mixmaster Morris. Meanwhile, in his magazine *Evolution*, counterculture vet Fraser Clark was expounding his vision of rave as the expression of a new Gaia-worshipping eco-consciousness. Clark coined the term "zippie" to describe a new kind of hippy who rejected sixties Luddite pastoralism and embraced the cyberdelic, mind-expanding potential of technology.

There was music too, dubbed New Age house or ambient house: Sueño Latino's "Sueño Latino" (a dance version of acid-rocker Manuel Gottsching's proto-techno masterpiece *E2–E4*), 808 State's "Pacific State," the Grid's "Floatation," Quadrophonia's "Paradise," Innocence's "Natural Thing" (featuring a sample from Pink Floyd's "Shine On You Crazy Diamond"). Most of this was pretty tepid: slow-mo house grooves overlaid with birdsong samples, serendipitous piano chords, mawkish woodwind solos, plangent acoustic guitars, and breathy female vocals whispering New Age positivity poesy. Two records stood out from the dross: the KLF's *Chill Out* album and the Orb's "A Huge Ever Growing Pulsating Brain That Rules From the Centre of the Ultraworld."

Although it initially seemed like it was going to be just another cheap joke from prankster duo Bill Drummond and Jimmy Cauty, the KLF's *Chill Out* turned out to be an atmospheric trans-American travelogue woven out of samples from sound effect records and MOR songs like Elvis Presley's "In the Ghetto," Acker Bilk's "Stranger on the Shore," and Fleetwood Mac's "Albatross." The sleeve spoofed Pink Floyd's *Atom Heart Mother* (with grazing sheep replacing the Floyd's ruminating cow), and a sticker on the front hinted "File Under Ambient." The Orb's "A Huge Ever Growing Pulsating Brain" came emblazoned with the slogan "Ambient House for the E Generation." Twenty-four minutes long, the track is a shimmerscape of sound effects (crowing roosters, church bells, splashing pebbles), angelic close harmony singing, the helium-high croon of Minnie Ripperton's "Loving You," and a synth pulse as radiant as a nimbus (the luminous vapor that surrounds God). The net effect is sheer nirvana or near-death experience, like your cerebral cortex is being flooded with pain-and-doubt-killing endorphins.

Like the KLF, the Orb consisted of punk rock veterans: Alex Paterson had

been a roadie and drum technician for Killing Joke. Through that connection he got an A & R job at E.G., home to ambient pioneers Brian Eno and Harold Budd, as well as Killing Joke. After appearing uncredited on the KLF's *Chill Out*, Paterson collaborated with Jimmy Cauty on "A Huge Ever Growing Brain." Teaming up with engineer Kris Weston, aka Thrash, Paterson then transformed the Orb into a real band.

"A Huge Ever Growing Brain" was released in December 1989. When the Orb's debut double album *Adventures Beyond the Ultraworld* finally materialized in the spring of 1991, it seemed monumentally tardy: the magnum opus of a clubland fad long past its expiration date. In fact, *Adventures* was the harbinger of an imminent deluge of dub-flavored ambient techno. Following *Chill Out*'s Pink Floyd homage, the sleeve depicted Battersea Power Station, previously seen on the cover of *Animals*; inside, there was a track entitled "Back Side of the Moon." These whimsical acknowledgments of the Floyd connection seemed designed to preempt the carping complaints of punk veterans: THIS is what Sid Vicious died for?

But for all the protective irony and the contemporary house beats, there was no mistaking the fact that Adventures was the unabashed return of cosmic rock. Titles like "Earth (Gaia)" and "Little Fluffy Clouds" (featuring samples of Rickie Lee Jones's blissful reveries of the Arizona skyline of her childhood) harked back to the cosmic pastoralism and nostalgia for lost innocence that characterized late-sixties outfits like the Incredible String Band. The quirkedout humor and over-the-top sound effects recalled seventies space-rockers Hawkwind and Gong; Steve Hillage, a Gong veteran, actually shared production duties on "Supernova at the End of the Universe" and "Back Side of the Moon." On "Supernova," braided wisps of silvery sound were draped incongruously over a kickin' beat. "Back Side" featured crackly samples of astronauts talking about Tranquillity Base, the landing site on the Moon's Sea of Tranquillity. With its beatific, beat-free lassitude and zero-gravity suspension, Adventures was a like a cut-rate aural surrogate for the flotation tank, then in vogue with stressed-out yuppies. The Orb's music lowered one's metabolic rate to the level of a particularly well-adjusted and "centered" sea anemone.

"I've been waiting for music like this all my life" ran a sample in "Back Side." Immodest, perhaps, but it was no idle boast: thousands apparently had been waiting, and next summer, the band's follow-up, u.f. orb, went

straight into the British album charts at number one. It was preceded by a single, "Blue Room," which got to number eight in the hit parade, despite being just under forty minutes long and featuring only one real hook: "ah wah wah a wah wah," the wordless siren song of reggae vocalist Aisha. Paterson and Thrash appeared on the TV chart show *Top of the Pops*, but instead of miming with instruments, they played a *Star Trek*—style 3D chess game in front of back-projected film of dolphins. Named after the room at the Wright Patterson Air Force Base where the remains of crash-landed aliens are allegedly kept by the US government, "Blue Room" alternates between ambient (synth motes like spangly space debris) and aquafunk (an undulant, slow-mo groove that feels like skanking underwater). With Steve Hillage's cirrus streaks of heavily sustained guitar offset by Jah Wobble's thunderquake bass, "Blue Room" was an astonishing reconciliation of hippy and post-punk; imagine Public Image Limited if Johnny Rotten had never scrawled "I Hate" in felt pen over his Pink Floyd T-shirt.

Combining and conflating the studio-as-instrument effects of several forms of "head" music — acid rock, dub reggae, ambient — u.f. orb offered a musiquarium of sound that seemed to have migrated from an alternative pop universe, one where Pink Floyd, Brian Eno, and King Tubby got together to form a seventies supergroup bringing "cosmic ambient dub" to the stadium circuit. By this point, the Orb had built up a formidable reputation as a live band. After "Blue Room" they scored another big hit with "Assassin." an uncharacteristically up-tempo onslaught of tribal house rhythms and guicksilver, scimitar-flashing riffs. The best of the five mixes was recorded live at the 1992 Glastonbury Festival. The following year saw Live 93, a double CD/quadruple LP that recalled the Grateful Dead in the way that the Orb improvised wildly around a core of prerecorded sequences. Catching the Orb tour when it reached New York's Roseland Theater in the autumn of '93, I did spot straggly-bearded Deadhead types headnodding in the audience alongside the sixteen-year-old ravers. And I was struck by how everything about the Orb — from the cloud-castle immensity of the sound to the amazing visuals — was spectacular but impersonal. The band themselves figured as "specks on their own landscape" (as David Stubbs said of the German neopsychedelic group Faust). Throughout the show, Paterson and Thrash remained shrouded, bobble-hatted figures lurking behind their banks of gear,

technicians in the stereo laboratory as opposed to stars. Like a planetarium or a piece of majestic architecture, the Orb's music seemed to invite awe rather than involvement. And yet the grandiosity was veined with Monty Python-esque daftness and post-punk irony, prompting me to wonder: can you really kiss the sky with your tongue in cheek?

The Orb's success spawned a plague of ambient dub, aka digi-dub. While the fad generated a handful of genuinely sublime moments — Higher Intelligence Agency's "Ketamine Entity," Original Rockers' "The Underwater World of Jah Cousteau" — the trouble with the genre was that it was one of those hybrids, like jazz-funk and funk-metal, that only *seem* like a good idea. Too often, instead of Harold Budd meets Prince Far I, the results were more like Vangelis teaming up with Adrian Sherwood on an off-night: celestial synth vapor (ambient) combined with meaninglessly overdone echo FX and stereophonic tomfoolery (dub).

Where seventies roots reggae had a spiritual aura, ambient dub evoked only the geometrically plotted grid space of computer sequencer programs. The pioneering dub producers like Lee Perry and Keith Hudson used self-cobbled effects and four-track lo-fi recording (which meant that several instrumental parts had to be compressed onto one track, a smudging effect that could be the key to classic dub's hazy, halcyon aura). And the Jamaican dubmeisters also used supple and interactive live rhythm sections where their digital dub successors depended on inelastic programmed beats and bass lines. All of which explains why the difference between classic dub and ambient dub resembles that between a stained glass window and a computer graphic.

The ecclesiastical analogy is appropriate insofar as the mystical aura of echo and reverberance is a thread connecting most twentieth-century musics that aspire to timelessness: psychedelia, dub reggae, ambient, and the New Age genre of "resonant music" (recorded in temples, cathedrals, and giant cisterns). Gothic churches were deliberately designed to swaddle the worshipper in a sound bath of low-frequency echoes, while our prehistoric ancestors enacted rites in caves with unusual acoustics. But I'd argue that echo's aura of eternity harks back even further: to our personal prehistory in the amniotic sea

of the womb, where the fetus hears the mother's voice refracted through the fleshly prism of her body. (It's not for nothing that studio engineers talk of a recording being "dry" when it's devoid of reverb.)

With its numinous reverberance and fetus-heartbeat tempo of 70 bpm, dub reggae reinvokes the primordial intimacy of womb time, the lost paradise before individuation and anxiety. Even after birth, sound has primacy over vision for several months; the infant is cocooned in the mother's preverbal vocal caresses, a soothing and cherishing sonorous milieu that some theorists believe is the root of all music. In Civilization and Its Discontents, Freud wrote of the phase of "primary narcissism" in which the infant does not distinguish between itself, the mother, and the world: "Originally the ego includes everything . . . the ego-feeling we are aware of now is . . . only a shrunken vestige of a far more extensive feeling — a feeling which embraced the universe and expressed an inseparable connection of the ego with the external world." Both dub and ambient attempt a magical return to this majestic self-without-contours, the "royal we" of the infant/mother bond or the lost kingdom of the womb. In Rastafarian reggae, though, these longings are identified with Jah, a righteous paternal principle; nostalgia becomes anticipation of returning to the promised land Zion, whereas ambient music tends to be feminine-identified, expressing its homesickness through imagery of pastoral tranquillity, oceanic bliss, childhood, and the celestial.

For all these reasons, the ambient boom of 1992–93 was regarded by many outside the dance scene as a cop-out. Equating contemplation with complacency, nouveau punks like Manic Street Preachers and These Animal Men lambasted ambient-heads as nouveau hippies. For their part, the ambient producers were disarmingly frank about the apolitical nature of their bohemia. Alex Paterson declared: "Our music doesn't reflect the times, it ignores them. . . . Society today is so suppressed, you can only make music that is escapist." And Mixmaster Morris — like Paterson, a thirty-something ex-punk — campaigned for the ambient cause under the slogan "It's Time to Lie Down and Be Counted."

Morris's 1992 debut as the Irresistible Force, *Flying High*, runs the gamut of ambient's sonic and metaphorical tropes: wispy curlicues of crybaby guitar, simulated and sampled bird tweets, tremolo synth ripples, wooshing ascents, spangly texture swathes, and one-note, single-phoneme pulses that recall Lau-

rie Anderson's "O Superman." One of the first and best albums produced during the second wave of nineties chill-out culture, *Flying High* is reminiscent less of the Eno tradition of ambient minimalism than of Spacemen 3's 1989 classic *Playing with Fire*, the album on which the band abandoned Stooges/Velvet Underground mantra rock for an Elysian tranquillity redolent of early Kraftwerk. Like Spacemen 3's music, *Flying High* is based on sounds that are heavily processed verging-on-denatured, mesmerizing loop patterns, stereophonic effects, and drones. The similarity is less surprising when one considers that Spacemen 3 and the Irresistible Force share influences in Kraftwerk, Suicide, and Laurie Anderson, while Morris would doubtless concur with the Spacemen's slogan "taking drugs to make music to take drugs to."

As part of his crusade for floaty softcore, Mixmaster Morris DJ-ed at the first Telepathic Fish, an "ambient tea party" organized by DJ/design collective Open Mind. Kevin Foakes, Chantal Passamonte, David Vallade, and Mario Tracey-Ageura formed Open Mind in the summer of '92, after becoming disillusioned with rave culture's "harder, faster" ethos. The first Telepathic Fish took place in the foursome's South East London house (Morris spun in the kitchen), but was such an unexpected success — attracting five hundred people, with lines round the block — that Open Mind had to locate subsequent tea parties in squatted venues, which they decorated and filled with mattresses. "Basically, what we're trying to create at our events is a massive bedroom," Foakes told me in 1993. "After raves we used to chill out in each other's bedrooms. Now we've turned the bedroom into a party."

Ravers had been having chill-out sessions since 1988, when clubs still closed at 3 AM — long before the Ecstasy glow wore off. "People are doing this at home all round the country," said Passamonte, referring to the rituals that ravers had developed to cushion the comedown. "But we decided to do it for several hundred people, not just ten." After a year of serious raving, the friends "realized that what we *really* enjoyed was that thing of everyone coming back *after* the party. That's when you could really talk to people, and play mellower music." And so they decided to dispense with the sweaty, expensive part of the night out and go straight to the "good bit." The same bright idea had occurred to other outfits across the country; together, they constituted the Second Coming of Chill-Out.

In October 1993, the fifth Telepathic Fish took place at Cooltan, an art

space/gallery/dance hall set up by squatters in an abandoned unemployment benefit office on Brixton's Coldharbour Lane. It was the perfect place for "getting your head together" after a night's raving. In stark contrast to the stressful staccato assault of the average 'ardkore rave (strobes, cut-up beats), Telepathic Fish was a wombadelic sound-and-light bath. The seamless mix of mostly beat-and-vocal-free atmospherics was maintained at just the right volume for conversation. The lights, oil projections, and "deep-sea decor" soothed eyes sore from the previous night's brain blitz. There were tea and cakes and wholesome refreshments available at reasonable prices. Nothing really happened — a few people did a bit of floaty dancing, most just lay down on the grubby mattresses and got stoned — but it was a lovely way to spend a Sunday.

Where rave's buzz phrases often mimicked the language of graft and toil ("get busy," "work it up," "'ardkore pressure"), the chill-out scene staged a quiet revolt against the "work hard, play harder" mentality. "Our parties are as close to getting it together in the country as you can get in London," said Passamonte. With its samples of birdsong and trickling water, ambient techno is a digital update of nineteenth-century program music — the pastoral symphony that imitates nature.

Perhaps the first and best stab at that seeming contradiction in terms, pastoral techno, was Ultramarine's *Every Man and Woman Is a Star*, a soundtrack to an imaginary canoe journey across America. Ultramarine's Paul Hammond declared: "We don't go clubbing. We like techno because of the minimalism and the starkness of its structure. The fact that you can dance to it is irrelevant to us." *Every Man and Woman* seamlessly meshed acoustic instruments (cascades of twelve-string guitar, dolorous violin), real-world samples (owl hoots, babbling brooks), and synthetic sounds like Roland 303 bass lines and programmed beats. The results are like acid house suffused with the folky-jazzy ambiance of Roy Harper, John Martyn, and the Canterbury scene (the Soft Machine, Robert Wyatt, Kevin Ayers). "Weird Gear" is actually based on an Ayers lyric, while "Lights in My Brain" samples a strung-out, unhinged Wyatt incantation and weaves it into an eerie acieed-jazz groovescape.

Every Man and Woman is all sun-ripened, meandering lassitude and undulant dub-sway tempos. "Honey" captures a halcyon "moment in love" and loops it for eternity: a sample of long-lost AOR singer Judy Tzuke murmurs "need you tonight," a flute flickers and darts like a kingfisher, and a violin tugs at the heartstrings. On "Skyclad," jazz-funk slap bass burbles under synth blips that reel and twinkle like a clear night sky, inducing a sublime sensation of "intimate immensity," like being swathed in the Milky Way.

Every Man and Woman is littered with samples testifying to Ultramarine's creed of mystical materialism and feel-good spirituality. "Stella," for instance, pivots around samples from a New Age documentary featuring a woman who explains how dance helped her shed cumbersome mental baggage and live in the fullness of the here and now. Like the Madchester-era positivity bands, the new chill-out music often verged on New Age affirmation therapy. One of the most popular and prolific providers for chill-out DJs, Pete Namlook, had actually started out in the New Age band Romantic Warrior. Through his Frankfurt label Fax, Namlook churned out CDs — solo and in collaboration with the likes of Mixmaster Morris and Dr. Atmo — at the rate of two a week. All lambent horizons of celestial synth, psalmic melodies, and wordless seraphim-on-high harmonies, 1993 albums like Silence and Air transformed one's living room into a sacro-sanctuary of sensuously spiritual sound. At his best, Namlook's project resembled a digital update of "chamber jazz" label ECM and its quest for "the most beautiful sound next to silence." But after a while the hushed solemnity of tracks like "Spiritual Invocation" and "Sweet Angels" starts to feel as piously protracted as a church service, and the "welcome to the temple of sound, please take off your dancing shoes" vibe gives you itchy feet.

Après Namlook came a deluge of pseudo-spiritual sedatives masquerading as ambient techno. But just when chill-out music was getting too flotation-tank cozy, Aphex Twin returned to the fray in early 1994 and took the concept of ambient techno on a sharp bend toward the sinister. Breaking with the dominant notion of the ambient album as a capsule of pastoral tranquillity, *Selected Ambient Works Volume II* returned to Brian Eno's original neutral definition in the sleeve notes of *On Land*, where he envisioned ambient as simply "environmental music."

Probably the best of Eno's ambient series, certainly the most uncanny, *On Land* mostly involved aural re-creations of childhood memories of landscapes. Richard James turned to dreamscapes for inspiration. Around 70 percent of

Selected Ambient Works Volume II (a triple LP/double CD that James originally planned as a *quintuple* album) was created using self-taught "lucid dreaming" techniques. Instead of ambient techno's fatuous and increasingly hackneyed gestures toward the cosmic, Volume II seems to focus on the microcosmos. Its compositions instill a mixture of awe and dread, as though you're peering through a microscope at the impossibly alien yet horribly intimate processes that constitute our biological reality.

Instead of songs, *Volume II* confronts the listener with apparitions, miasmas of ear-confounding ectoplasm that weave an appalling enchantment. Instead of titles, tracks are identified by pictograms: photographs of fabrics, metal surfaces, detritus, and so forth. The music itself is just as cryptic in its materialist focus on timbre and texture. Track 1/Disc 1 is a lattice of single phonemes of female vocal that are looped, echoed, and braided, creating an effect as disorienting as it is graceful, like an acrobat gyrating in a zero-gravity hall of mirrors.

Throughout *Volume II*, overt melody is mostly shunned in favor of percussive/harmonic chimes and amorphous drones. Track 10/Disc 1 has the deadly opalescent allure of the glowworm's web, down whose hollow filaments the luminous larvae glide toward their fatal trysts with trapped insects. There are only a handful of lapses into straightforward beauty, in the form of tracks that recall the devotional music of minimalist neoclassical composers like Arvo Pärt. Most of *Volume II* has more in common with the techniques of late-twentieth-century avant-classical composers like Ligeti, Berio, Xenakis, and Stockhausen. James talked of devising his own tunings and scales, of exploring the "infinite number of notes between C and C sharp" and getting down "to ultrapure frequencies and sine waves."

Needless to say, many Aphex Twin fans were alienated by these subdued and somber sound paintings. As audacious and magnificent as the album is, it simply isn't as hospitable a record as *Selected Ambient Works 85–92*, which seems to infuse everyday life with a perpetual first flush of spring. But Aphex Twin's shift toward ambient noir did win him admirers in the hermetic realm of isolationist music, a loose confederation of experimental outfits like Thomas Koner, :zoviet*france, and post-rockers like Main who'd abandoned riffs and rhythm in favor of drones and dirgescapes. Echoing Main's Robert Hampson, Richard James enthused to *The Face* about hanging out in power stations: "If

you just stand in the middle of a really massive one, you get a really weird presence and you've got that hum. . . . That's totally dreamlike for me . . . just like a right strange dimension."

Selected Ambient Works Volume II represented a particularly focused and uncompromising investigation of an area that had rapidly become the defining obsession of electronic listening music: sound in itself. Sometimes this involved "found sounds" from the environment or drastically processed samples from records, TV, and other media. And sometimes timbres immanent within antiquated analog synthesizers were used. Synesthesia was a common aesthetic goal, with producers striving to generate timbres and textures so tantalizing you wanted to touch or taste them. Hence Beaumont Hannant's series of "Tastes and Textures" EPs and album *Texturology*.

Some of the best of the new breed of texturologists were Aphex Twin associates: Mike Paradinas of μ -Ziq released his early records through Richard James's label Rephlex, while Tom Middleton of Global Communications/Reload had once been the other Twin, having worked on the Analogue Bubble-bath EP. For the Reload album A Collection of Short Stories, he and partner Mark Pritchard visited factories with a DAT recorder in hand, sampling real-world sonorities and then transforming them into percussion. Middleton told The Wire: "It's all about science . . . the science of manipulating eclectic sounds, recycling sounds and bringing them up to date, or taking them into the future." Global Communication's fifteen-minute-long ambient techno classic "Ob-Selon Mi-Nos" is based around a tick-tocking grandfather clock, whose steadfast pulse is interlaced with heartquakes of slow-mo bass, angelic sighs, and a plangent chime melody as idyllic and iridescent as dewdrops on a cobweb.

Texturology alone does not make for music, or at least music that appeals to more than a handful of stern vanguardists. What is required is a mode of organizing disparate timbres into an attractive or compelling arrangement. One model of the textured groovescape was seventies fusion: players like Joe Zawinul and Herbie Hancock had been early synthesizer pioneers. Global Communication named one EP "Maiden Voyage" as a tribute to Hancock, while the best tracks on Bandulu's *Guidance* sounded like jazz-techno, as if Zawinul had

somehow ended up bandleader of Tangerine Dream instead of Weather Report. The fractal synth swirls and cloud-nebula whorls of "Tribal Reign" are like timelapse photography of the Milky Way.

Minimalist and systems-music composers like Steve Reich, Terry Riley, Philip Glass, and Michael Nyman offered another prototype for electronica: the "cellular" construction of complex tapestries of sound by the repetition and interweaving of simple melodic units. On Orbital's second, eponymous album, "Halcyon + On + On" takes the wordless "la di da la di dee" vocal hook from Opus III's New Age House anthem "It's a Fine Day" and modulates it on the sampling keyboard — reversing and chopping it up, then resequencing it into a series of overlapping and intertwined loops. Singer Kirsty Hawkshaw's tremulous gasps and exhalations of euphoria are braided into a nine-minute locked groove of almost unendurable rapture. The sound of a cup of joy overflowing, "Halcyon + On + On" would seem to be an obvious Ecstasy anthem, but it was actually inspired by the Valium-like chemical Halcion, and was far from a celebration. The Hartnolls' mother had taken the tranquilizer for several years and suffered from its manifold side effects.

In "Halcyon" it's the combination of *texture* (the breathy "grain" and seraphic glow of Kirsty's voice) and *textile* (the intricate warp and weft of melody and harmony Orbital achieve by multitracking fragments of the original Opus III chorus) that's so breathtaking. Without patterning skills or a gift for groove, though, texturology is just as capable as any musical methodology of propelling its practitioners on a voyage to the innermost reaches of their own assholes. If any proof is needed, just listen to the work, and words, of the Future Sound of London.

From their immodest moniker to their fervent antidance stance, FSOL represent the unsightly flowering of the "new progressive rock" that was always latent within the concept of electronic listening music. To give credit where credit is due, FSOL's 1992 chart smash "Papua New Guinea" was a gorgeously emotional rave anthem, sampling the sublime arialike tones of mystic-diva Lisa Gerrard from Dead Can Dance and even using a breakbeat. But when they turned their backs on the dance floor ("I see the term 'dance' as really restrictive for us," sniffed member Brian Dougans) and dedicated themselves to concept albums, FSOL's pop instincts withered.

In 1994, FSOL released their second album, Lifeforms, a double CD mag-

num opus. It's a Dali-esque frightmare of liquescent forms, a pseudo-organic samplescape congested with scrofulous sound tentacles and slithery slimeshapes. Lifeforms is texturology run rife: holed up in their studio, venturing out only to forage for found sounds, Dougans and fellow member Garry Cobain bring out all the masturbatory connotations of that techno stereotype "the knob twiddler." Each sampled source is treated, tinted, and morphed until every last drop of "vibe" or "aura" is wrung out of it; the duo appear to have forgotten that the real art of sound painting is knowing when to stop adding another layer or nuance. Like the computer-manipulated photo montages on the sleeve and the globular shapes in FSOL videos, the music on Lifeforms combines the glossy garishness of hyperrealist painting with the varicose convolutions of rococo. As such it recalled the polytendriled excesses of progressive rock. (Indeed ex-King Crimson leader Robert Fripp contributed "guitar textures" to "Flak," while Dougans and Cobain attempted to do a classically scored version of "Eggshell" - an alarming echo of ELP and Deep Purple working with symphony orchestras.) In their determination to avoid recognizable samples, FSOL ended up translating the prog rock ethos of ostentatious virtuosity into sampladelic terms.

One evening in mid-1992 I checked out Knowledge, a "proper techno" night run by DJs Colin Faver and Colin Dale at London's SW1 club. I was immediately struck by the ascetic decor and the curiously sober frenzy of the mostly white male audience (many sporting the shaven-scalp "slaphead" look of the stereotypical techno purist). Of course, nary a breakbeat was heard all night. (Lycra? Forget it.) Speaking to *iD*, Colin Dale explained the anti-hardcore agenda: "That's why we started Knowledge — to show there was better music than the breakbeat stuff around."

At Knowledge and similar clubs like Eurobeat 2000, Lost, and Final Frontier, the sounds — purist techno, nouveau acid, and hard trance from labels like Canada's + 8, Holland's Djax-Up, Germany's Tresor and Labworks — were dance floor—oriented, body-coercive cousins of armchair techno. Despite their fierce physicality, these styles shared the same cerebral cast: the boy's-own aura of anal-retentive expertise, the vague, ill-defined conviction that something radical was at stake in this music. This was rave music purged of cheesy

ravey-ness (the breakbeat, the sample, the riff stab, the anthemic chorus, the E'd-up sentimentality) and retooled for a student sensibility, that perennial class base for the "progressive" since the late sixties.

Although the new purists paid lip service to techno's black American origins, their sound was starkly European, stripped of Detroit's jazzy inflections and Chicago's gay disco sensuality. Instead, the whitest, most Kraftwerk-derived aspects of Detroit techno were layered on top of the least funky element in Chicago house, the four-to-the-floor kick drum. By the end of '92, this whiter-than-white sound had evolved into Teutonic trance, a hybrid of Tangerine Dream's cosmic rock and Giorgio Moroder's Eurodisco, as purveyed by labels like MFS and Harthouse, artists like the Source, Hardfloor, Oliver Lieb, Age of Love, Cosmic Baby, and Speedy J.

Where ambient techno is soundscape painting for immobile contemplation, trance is cinematic and kinetic; producers often describe their music in terms of "taking the listener on a journey." Trance is *trip*py, in both the LSD and *motorik* senses of the word, evoking the frictionless trajectories of video games, virtual reality, or the "console cowboys" hurtling through cyberspace in *Neuromancer*. Along with its cyberdelic futurism, trance also has a mystical streak, expressed in hippy-dippy titles like Paul Van Dyk's "Visions of Shiva" and Trance Induction's "New Age Heartcore." "Trance" evokes whirling dervishes, voodoo dancers, and other ritualized techniques for reaching altered states via hyperventilation, dizziness, and exhaustion.

Harking back to the "purity" of the pre-rave era, trance revived the acid house sound of the late eighties. Presaged by late-1991 tracks like Mundo Muzique's "Acid Pandemonium," the Roland 303 resurgence really exploded a year later with Hardfloor's "Hardtrance Acperience" (which sold thirty thousand in Britain alone). Where the original Chicago acid was ultraminimalist, the new acid was maximalist. "Hardtrance" assembles itself according to an additive logic, gradually layering up at least three 303 bass pulses (writhing like sex-crazed pythons), Moroder-style Doppler effects, sequencer riffs, and tier upon tier of percussion. A terrific tension is built up, but there's no release, no climax.

At its coldly compulsive best — Arpeggiators' "Freedom of Expression," Commander Tom's "Are Am Eye," Trope's "Amphetamine" — trance exhilarates. But it's the form of techno that's most thoroughly in thrall to the se-

quencer's precision-locked logic; tracks are grids rather than grooves. With its programmed drum machine beats and punctual pulses, trance resembles an orchestra of metronomes, all of which are subordinate to the timekeeping of that tyrannical conductor the kick drum. This predictability is what allows the mind to disengage and "trance out."

Inside every trance producer is a prog rocker struggling to express himself. Take Jam & Spoon. Their brilliant early track "Stella" was part of the R & S label's flight from Dionysian rave toward Apollonian softcore. There's literally no hard core to this track, just a muffled kick drum, vapor trails of angel's breath, and a feathery, one-chord pulse riff that ascends from higher to higher plane. "Stella" appeared on a 1992 EP titled "Tales from a Danceographic Ocean" — a tongue-in-cheek nod to Yes's *Tales from Topographic Oceans*, prog rock's noodly nadir. Or perhaps it was simple homage, since Jam & Spoon's debut album was in effect a *quadruple:* two simultaneously released CDs, *Triptomatic Fairy Tales 2001* and *2002*, both crammed with kitschadelic sounds and song titles like "Zen Flash Zen Bones" and "Who Opened the Door to Nowhere."

And then there's Sven Vath — cofounder of Harthouse and its sister label, Eye Q, and the legendary DJ at the Omen in Frankfurt. In the sleeve notes to 1993's *Accident in Paradise*, Vath cites his ancestral spirits as Ryuichi Sakamoto, Harold Budd, and Holger Czukay, but also, more tellingly, Peter Gabriel, Vangelis, Andreas Vollenweider, and Mozart. With its mystic-Orient melodies and DAT-recorded aural snapshots from Nepal and Goa, *Accident in Paradise* is a deodorized ethno-techno travelogue. But in true prog-rock fashion, the album is also steeped in nineteenth-century Euro-classical music, all arpeggiated synth wank and piano trills as frou-frou as Enya, while "Coda" even features a harpsichord. The critics rejoiced (at last! a techno album that "works as a whole" and sounds good on your domestic hi-fi), but even they had no stomach for Vath's next concept album atrocity, *The Harlequin, the Dancer and the Robot*.

The struggle between intelligent techno and hardcore was a bitter contest, waged across class and generational lines, to decide who "owned" electronic dance music and what direction it should pursue. This was a schism between nonstop ecstatic dancing and sedate(d) contemplation, between the 12-inch

and the album, between the demands of the audience and the prerogatives of the auteur. Neither side of this perennial divide had a monopoly on creativity, and the electronic listening music initiative produced some beautiful and innovative sounds. But it has always struck me as odd that so many people involved in dance music seemed to regard the physical response as somehow "lowly." The result was a glut of melodious, middlebrow "mindfood" that neglected dance music's proper priorities, rhythmic complexity and kinetic urgency. Most intelligent techno was hedged on one side by its disdain for the functionalism of "rave fodder" and on the other by its reluctance to really explore the extremities of texturology. By 1995 these self-proclaimed experimentalists could rescue themselves from the disembodied anemia of "intelligence" only by rediscovering the breakbeat. Irony of ironies, they had to relearn the score from the hardcore.

slipping into darkness the uk rave dream turns to nightmare, 1992–93

Just as the electronic listening music initiative was mounting its retreat from the dance floor in late 1992, the hardcore rave scene began to enter a troubled phase. Every drug-based subculture seems to reach a similar point, a threshold at which it crosses over to "the dark side." It happened in late-sixties San Francisco, when heroin, methamphetamine, and the terrifyingly intense hallucinogen STP destroyed Haight-Ashbury's love and peace vibe. But what makes British hardcore unique is the way this shift was reflected in the music. By late 1992, the happy tunes of rave's commercial heyday were being eclipsed by a style called "darkside" or "darkcore." Hardcore became haunted by a collective apprehension that "we've gone too far."

Thematically and sonically, darkside tracks mirrored the long-term costs of sustained use of Ecstasy, marijuana, and amphetamine: side effects such as depression, paranoia, dissociation, auditory hallucinations, and creepy sensations of the uncanny. The titles and sampled sound bites of this era immediately indicate that something is awry. There was imagery of brain damage (Bizzy B's "Total Amnesia," 4 Hero's "Mind Loss (A State of Amnesia)") and disorientation (2 Bad Mice's "Mass Confusion," Satin Storm's "Think I'm Going Out of My Head"). There were tracks about death, like Ed Rush's "Bludclot Artattack," with its "you've got a ticket to hell" sample, and Origin Unknown's "Valley of the Shadows," which pivoted around an unnerving sound bite ("felt that I was in a long dark tunnel") from a BBC documentary about near-death experiences. Another major darkside trope was the idea of drug intensities as a sinister power source, a malign force field in which the raver is suspended and entrapped: DJ Crystl's "Warpdrive," 4 Hero's "The Power," and DJ Hype's "Weird Energy."

Perhaps most disturbing of all was an entire mini-genre of panic-attack songs — Remarc's "Ricky," Johnny Jungle's "Johnny," Subnation's "Scottie" — all of which were based on a sample of someone shouting out a name, as a cry for help or in sheer terror. "Scottie" is the real chiller-killer, both for its superbly rhythmic use of *Star Trek*—derived sound bites and for the way it dramatizes a psychic struggle between hysteria and resilience: the track oscillates giddily between the whimpered "I don't wanna die" and the scared but determined "we're not gonna die, we're gonna get out of here."

Using effects like time stretching, pitchshifting, and reversing, the darkside producers gave their breakbeats a brittle, metallic sound, like scuttling claws; they layered beats to form a dense mesh of convoluted, convulsive

polyrhythms, inducing a febrile feel of in-the-pocket funk and out-of-body delirium. Boogie Times Tribe's "The Dark Stranger (Q Bass Remix)," for instance, pivots around a deeply unsettling, hypersyncopated hi-hat — like a heart skipping a beat then pounding triple time — and hideously voluptuous synth arpeggios like a shudder running up one's spine. 'Ardkore's anthemic choruses and sentimental melodies were stripped away in favor of gloomy, slimy-sounding electronic textures. Vocal samples were sped up, slowed down, reversed, and "ghosted," resulting in grotesque hall-of-mirrors distortions of "the human." Sounds swooped and receded within the stereo field, creating a hair-raising atmosphere of apprehension and persecution, while sustained drones and background hums induced tension.

All these sound-warping effects literalize the old 'ardkore tropes of "madness" and "going mental." Harking back to the heavily treated timbres of fifties musique concrète and post-punk industrial music, darkside's repertoire of noises abducted the listener into the audio-hallucinatory malaise of schizo-phrenia. Darkcore also imitated or sampled the dissonant motifs developed by horror movie and thriller soundtrack composers to evoke derangement, fore-boding, and trauma. (Indeed, Hollywood soundtrack and incidental music is one of the few areas in pop culture where the ideas of avant-garde twentieth-century classical music — serialism, electro-acoustic, concrète — have filtered into mass consciousness.)

Exuding bad-trippy dread and twitchy, jittery paranoia, darkcore seemed to reflect a sort of collective comedown after the E-fueled high of 1991–92. Alienated, ravers deserted in droves to the milder climes of happy house and mellow garage. But a substantial segment of the rave audience mobilized between 1990 and 1992 followed through hardcore's drug-tech logic all the way into the unknown, the twilight zone. Forming a sort of avant-garde within Britain's recreational drug culture, these were ravers who had perversely come to enjoy bad trips and weird vibes. Rather than readjust to normality, it perhaps seemed preferable to stick with rave's "living dream" even after it had turned to living nightmare, if only because any kind of intensity is better than feeling numb.

From my double vantage point as fan and critic, participant and observer, darkside was a pivotal and revelatory moment: the life-affirming, celebratory aspects of rave were turned inside out, the smiley face torn off to reveal the latent nihilism of any drug-based culture. Gradually, the atmosphere at clubs and raves deteriorated. Single-minded fervor became tunnel vision, "getting high" was reduced to "getting out of it." The dance floor was full of dead souls, zombie-eyed and prematurely haggard. Instead of outstretched arms and all-embracing extroversion, you'd see automaton/autistic body moves and vacant self-absorption.

What started off as fun began to acquire the tinge of desperation. The folkloric drug tales got grimmer — stories of people throwing up, then picking the half-digested pills out of the puke and gobbling them down again; rumors of kids using syringes to shoot speed in the toilets. What I remember most of all from the late '92/early '93 era is the number of ravers whose smiles had been replaced by sour, cheated expressions - they hadn't come up on their Es, probably because they'd overindulged so heavily the past few years that the old buzz just couldn't be recovered. That moment of disenchantment is captured in Hyper-On Experience's 1993 anthem "Lords of the Null Lines," a Gothic symphony of skittery rhythms and something-wicked-this-way-comes strings. "There's a void where there should be ecstasy," laments the sampled diva. The line could refer to the desperation of a raver who suspects he's swallowed a dud or "snide" E, but it could equally describe the hollow numbness of veteran ravers whose brains have been emptied of serotonin. Having hammered the E so hard for so long, these ravers find that their synaptic pleasure centers are firing blanks.

Darkcore reflected the complicated pharmacological reality of the rave scene in 1992 and 1993, when a chaos of amateur, untutored neurochemistry and unreliable medicine combined to form an unbeatable recipe for psychic malaise. First, ravers experienced a temporary dip in the quality of Ecstasy. With rave peaking commercially in '92, dealers looked to exploit the influx of gullible, undiscriminating buyers and maximized their profits by cutting MDMA with cheaper drugs, primarily amphetamine and LSD, but also tranquilizers or inert substances. The market was flooded with "cocktail" pills that combined speed and acid in a crude attempt to approximate the Ecstasy feeling. This deterioration in the rave drug's purity didn't last, but it birthed an enduring myth that "Ecstasy isn't as good as it used to be," which in turn provided ravers with an excuse to take more pills to get the same effect. The unreliability of the drug

did not inspire caution or utter disillusionment, as one might have expected, but a spirit of recklessness: take more rather than less; if the first one doesn't come on strong and fast enough, take another.

This headstrong heedlessness was particularly risky given another pharmacological trend at work in this period: the selling of Ecstasy that contained MDA rather than MDMA. MDA is the chemical parent of MDMA and MDEA ("Eve"). Widely available in 1992 in the form of "Snowballs" and "White caps." and reputedly originating from government-controlled factories in Latvia, MDA offers an altogether fiercer, more deranging experience than Ecstasy, devoid of MDMA's empathic warmth. MDA's effects are closer to LSD's hallucinatory disorientation. It lasts much longer than proper Ecstasy, around eight to twelve hours, and the comedown is harsher. Worse still, MDA is more toxic than MDMA: snowballs often contained a high concentration of MDA, around 177 milligrams, so that three pills was within range of a fatal dose. At the very least, it would almost guarantee a psychedelic freak-out or an autistic veg-out. And yet, by 1992 three pills was by no means an unusual number to take during a session. While some blamed snowballs for "killing the scene," mistakenly believing them to be cut with heroin, others actively sought out and savored MDA's manic sensations.

The other syndrome at work in the darkside era was sheer excess. By 1992 many hardcore "veterans," who'd gotten into raving only a few years earlier and were often still in their teens, had increased their intake to three, four, five, or more pills per session. They were locked into a cycle of raving once or twice a week, weekend after weekend. It was at this point that Ecstasy's serotonin depletion effect came into play. Even if you take pure MDMA each and every time, the drug's blissful effects fade fast, leaving only a jittery, amphetamine-like rush. In hardcore, this speed-freak effect was made worse as ravers swallowed more pills in a futile and misguided attempt to recover the long-lost original bliss. The physical side effects — hypertension, racing heart — got worse, and so did the darkside paranoia. Amphetamine and Ecstasy both flood the nervous system with dopamine, and "dopamine overactivity" has been linked to such symptoms of schizophrenia as auditory hallucinations and delusional beliefs.

All of these syndromes — fake Ecstasy "cocktails," MDA masquerading as MDMA, the diminishing returns of long-term use — were exacerbated because

the norm among ravers is "polydrug use." Ecstasy is commonly taken with other illicit substances — amphetamine, LSD, cannabis, "poppers," the barbiturate-like sleeping pill Temazepam — each with its own risks, side effects, and nasty adulterants. Recent research shows that nearly 80 percent of British ravers take amphetamine as a booster to their E. Some chase down Ecstasy with diverse configurations of speed, LSD, and Temazepam. Nearly everybody smokes marijuana, which has its own effects of paranoia and perceptual distortion. MDMA can be the classic gateway to a virtual drug supermarket, insofar as uncertainty of supply can lead to experimentation with other substances as an alternative route to the high.

By 1992 hardcore ravers were veritable connoisseurs of poisons, skilled at mixing and matching drugs to modify their own neurochemistry and achieve the precise degree of oblivion desired. This "street knowledge" often expressed itself in the imagery of science, as with Bizzy B's "Ecstasy Is a Science" and the band Kaotic Chemistry. The latter's self-titled debut EP includes tracks like "Five in One Night," "Strip Search," and "The Comedown," while the sleeve mischievously depicts the ingredients for an average night of mayhem. On the front, a hand simultaneously holds a joint and chops out a line of speed with a credit card; on the back, the table is strewn with a dozen or more white pills. Kaotic Chemistry's "LSD" EP continues the polydrug excess theme with "Space Cakes," "LSD," "Drum Trip II," and "Illegal Subs" (a later remix EP adds "Vitamin K," named after a slang term for ketamine). The title "Illegal Subs" is a knowing pun, referring both to illicit substances and to sub-bass levels so harmful they should be outlawed. The song itself is a sort of tribute to the 'ardkore nation, sampling a Nation of Islam orator who hails her African-American audience as "the people of chemistry . . . of physics . . . of music . . . of civilization . . . of rhythm."

In the utterly blissed hardcore of early 1992, one can hear darkness shadowing the swoony delirium. Take one of the scene's most successful labels, Production House. There's an aura of dangerously overwhelming bliss to tracks like Acen's "Trip to the Moon Part One," with its fizzy electronics and portentous John Barry/You Only Live Twice orchestral fanfares. What sounds like a classic E-rush exultation — "I can't believe these feelings!!!" — could easily be a distraught and distrustful intimation of unreality.

Lurking within the effervescent "hyper-ness" of Production House tracks like DMS's "Love Overdose" and "Mindwreck" is a kind of death wish. Appropriately enough, Acen's other big smash of '92, "Close Your Eyes," samples Jim Morrison, the original death-obsessed Dionysian rock star. Mystic incantations from the Doors' epic "Celebration of the Lizard" — "forget your name . . . go insane" — are sped up into a simultaneously hilarious and grotesque Munchkin squeak. "The Darkside" remix of "Close Your Eyes" adds the line "forget the world, forget the people," fed through a hall-of-mirrors echo effect to conjure a bedlam of Morrison ghosts. Two other samples — "I think I'm gonna" and "OVERDOSE!" — are concatenated to spell out the flirting-with-the-void vibe.

Even Baby D's "Let Me Be Your Fantasy" — Production House's biggest smash, which eventually made number one on the pop charts when rereleased in 1994 — is fraught with ambivalence. With its grand piano trills and bittersweet tenderness, "Fantasy" is that seemingly impossible entity, a rave ballad. Its creator, Dyce, has described the track as a love song to the hardcore scene, to the spirit of loved-up-ness itself. Listen to the lyrics, and it becomes clear that the sirenlike figure is actually Ecstasy herself serenading the listener: "Come and feel my energy/Come take a trip to my wonderland."

"Fantasy" 's maneuver — personifying MDMA as the seductive chanteuse Baby D — was a masterstroke. More common was the hardcore track that took the needy beseeching of the sampled soul diva and separated it from its original flesh-and-blood referent in order to create a love song to the drug. Foul Play's "Finest Illusion," a near-symphonic rush of pizzicato riffs and swoony cascades, is a classic example: if "you're the finest I've ever known" doesn't refer to a particularly pure batch of MDMA pills, why else did the band title the track "Finest Illusion"?

Recording as 4 Horsemen of the Apocalypse, Foul Play took this idea all the way into the twilight zone with "Drowning in Her." The track has all the languorous dejection of a torch song; its tremulous textures and dolorous, dislocated feel conjure a mood of paralysis and enervation. Blurry with reverb, the sampled vocal hook sounds like "drowning in love" but is actually "drowning in her": *jouissance* is associated with an alluring but ultimately asphyxiating femininity. Midtrack, there's a sample of a single word, the horrorstruck cry "how??!?," taken from the spoken-word intro of 4 Hero's 1990 classic

"Mr. Kirk's Nightmare," in which a policemen comes to tell a father that his son has died of an overdose. A classic example of rave music intertextuality, the "how" in "Drowning" triggers memories of all the scare stories and rumors surrounding Ecstasy, reminding ravers that each time they dance with MDMA they risk embracing a femme fatale.

If anyone can claim to have invented darkcore, it's 4 Hero. Two years after "Mr. Kirk's Nightmare," the band returned to the subject of Ecstasy fatalities with 1992's sick-joke concept EP, "Where's the Boy." The funereal black sleeve depicts a coffin with a question mark on it: the tomb of the unknown raver. The four tracks on "Where's the Boy" trace out the theme of death by heatstroke, which in '92 was first entering public consciousness as the explanation for a spate of E-related deaths. "Burning" and "Cooking Up Yah Brain" sound delirious. The sample textures seem to ripple like a heat haze of vaporized sweat, calling to mind a British newspaper's description of one particular Ecstasy fatality as being "boiled alive" in one's "own blood." "Time to Get Ill" samples the Beastie Boys to make a deadly pun that conflates "ill" in the hip-hop sense with the internal bleeding and major organ failure associated with severe heat-stroke. The track sounds literally nauseous, all gastric gurglings and migraine-like squeals.

4 Hero and other artists on their label, Reinforced — Rufige Cru, Doc Scott, Nebula II — pioneered the *sound* of darkness too: metallic beats, murky modulated bass, hideously warped vocals, ectoplasmic smears of sample texture. Holed up in Reinforced's North London loft studio, 4 Hero and Rufige Cru's Goldie embarked on marathons of sampladelic research. "I remember one session which lasted over three days," Goldie told *The Mix* in 1996. "We were sampling from ourselves, and then resampling, twisting sounds around and pushing them into all sorts of places." The resulting audio-grotesquerie, collected on fifteen DAT cassettes, provided a vast palette of sinister textures and mindbending effects for Reinforced artists to draw upon. "We kind of wrote the manual over those three days," Goldie declared.

Perhaps the most crucial component of Reinforced's sonic arsenal were their mutant versions of the searing, snaking terror-riffs originally invented by Joey "Mentasm" Beltram and the Belgians. The Beltram/Belgian sound, says

4 Hero's Dego McFarlane, "was like the punk rock of techno. . . . Back in '92, at clubs like AWOL, it was near enough slam dancing and shit, people got very rowdy in those days." Reinforced's roster took the "mentasm stab" to new intensities of death-ray virulence. On Nasty Habits' "Here Comes the Drumz," the riff morphs like the "liquid metal" plasma-flesh of the robo assassin in *Terminator 2*.

The sound of darkcore is febrile, but it's a cold fever. Take Rufige Cru tracks like "Darkrider" and "Jim Skreech": the staccato string stabs, scuttling breaks, and shivery textures suggest "crank bugs," the speed-freak delusion that insects are crawling under one's skin. These tracks are so infested with fidgety nuance and frenetic detail that's there's never any point of repose or release. So much unrest is programmed into dark-era Reinforced tracks that you can't just trance out, as with house or techno; you're always on edge.

After the "Darkrider" EP, Rufige Cru's Goldie adopted the Metalheads moniker and released "Terminator," a track whose antinaturalistic rhythms constituted a landmark in the evolution of breakbeat hardcore into a *rhythmic psychedelia*. Using pitchshifting so that at the breakdowns the pitch of the drums veers vertiginously upward, Goldie created a jagged time-lapse effect: the drums seem to speed up yet simultaneously stay in tempo. "Terminator" sounds as predatory and remorseless as its movie namesake. In a similarly cyberpunk vein, Nebula II breakbeat-techno classics "Peacemaker" and "X-Plore H-Core" sound as cold-hearted, inorganic, and implacable as a *Robocop*-style cyborg suppressing some twenty-first-century ghetto insurrection.

Nasty Habits' "Here Comes the Drumz" is the sound of inner-city turmoil; the track samples a snatch of Public Enemy rabble-rousing, with Chuck D declaiming the title phrase stagefront and Flavor Flav barging in to blurt "Confusion!!" Produced by Doc Scott and released in late '92, "Drumz" is widely regarded as *the* dark track, the death knell for happy rave. What's striking about "Drumz" is how murky and muddy it sounds. It's as if all the treble frequencies have been stripped away, leaving just low-end turbulence: roiling drums, bass pressure, and ominous industrial drones.

Purging hardcore's sped-up, Minnie Mouse vocals and melodramatic strings (the trebly feminine/gay, pop/disco elements that made hardcore so

euphoric) darkside producers like Scott created masculinist/minimalist drum and bass, the stark sound of compulsion for compulsion's sake. This was a connoisseur's sound: Darkcore's creators were determined to take hardcore back underground by removing all the uplifting elements of crossover rave. Disgusted by 1992's chart-topping spate of squeaky-voiced "toytown techno," the scene's inner circle decided to alienate all the "lightweights" and see who was really down with the program.

That, says Dego McFarlane, was the meaning behind 4 Hero's "Journey from the Light" EP; time to move out of the commercial limelight, away from "all the happy stuff." On this EP, all the effects formerly used to create a heavenly aura in hardcore are subtly bent to the sinister. On "The Elements," an angel choir of varispeeded divas shriek in agony, like they've been demoted to hell. A door opens with an ominous creak, then slams; there's a sample from Don McLean's "American Pie" — "this'll be the day that I die" — sped up to sound horribly fey and enfeebled. "The Power" teems with ghost shivers and maggoty, squirmy sounds.

Later in '93, 4 Hero's "Golden Age" EP and its attendant "Golden Age Remixes" cloaked darker-than-thou themes with a new softcore sensuality, at once mellow and morbid. "Better Place Becomes Reality" jibes against rave's pleasuredome of illusions (amazingly, 4 Hero are all straight-edge nondrug users), with its sound bite of a girl complaining "we need some *reality* reality, not this artificial reality." A worm-holey miasma of stereo panning and disorienting backward sounds, "Students of the Future (Nostradamus: The Revelation — Rufige Cru Mix)" pivots around the sample "Nostradamus tells us the world will finally come to an end." The Nostradamus obsession is part of 4 Hero's interest in prophecy, futurology, science fiction, and the loopier end of speculative science writing. Hip-hop and rave culture (4 Hero are children of both) are rife with millenarianism, a feeling that history is accelerating toward some kind of culmination, whether it's a consummation devoutly to be anticipated or a conflagration desperately to be dreaded.

Drugs loosen the tyrannical grip of the ego, but they also let loose all the predatory phantoms of the id. In the beginning, Ecstasy makes you feel angelic; ultimately, it can turn you into a demon. In darkside, there was a strong vein of what

the philosopher William James called "a diabolical mysticism . . . a religious mysticism turned upside down." It surfaced in superstitious titles like Doc Scott's "Dark Angel," Nebula II's "Seance," Rufige Cru's "Ghosts of My Life," and Megadrive's "Demon" (with its "fury of a demon possessed me" sample). Sometimes the imagery was directly drawn from horror movies, sometimes it was inspired by the residues of a Christian upbringing or by amateur forays into cosmology, angelology, and mysticism. But often the pagan, animist imagery simply seems to have seeped up from the collective unconscious.

The parallels with magic have not been lost on exponents of sampladelia. With his contraptions and arcane, self-invented terminology, the hardcore producer lies somewhere between the mad scientist and the sorcerer with his potions, alembics, and spells. And of course the DJ is often regarded as a shaman or dark magus. Rufige Cru's "Darkrider" is a tribute to Grooverider, worshipped to this day as a "god" for his playing at the legendary darkcore club Rage. Consciously or not, the metaphor of the DJ as "rider" echoes the voodoo notion that the trance-dancer is being "ridden" by the gods, the *loa*. Grooverider's role is equivalent to the *hungan*, or high priest, whose drumming propels the voodoo acolytes into a frenzied state of oblivion. If this seems far-fetched, consider that in Haitian *voudun*, possession by the spirits occurs during the *cassée*, or dissonant percussive break. Darkcore is composed entirely of continuously looped breakbeats; in a sense, the whole music consists of *cassées*.

Darkside's voodoo imagery — 4 Hero's "Make Yah See Spiders on the Wall (Voodoo Beats)," Hyper-On Experience's "Lords of the Null Lines," with its "fucking voodoo magic" sample from *Predator 2* — was just the latest efflorescence of a metaphor with a long history in house music, from A Guy Called Gerald's "Voodoo Ray" to D•H•S's "Holo-Voodoo." This trope of being bewitched, turned into a *zombi*, pervaded acid house and jack tracks — from Phuture's "Your Only Friend" (which personified cocaine as a robot-voiced slave master) to Sleazy D's "I've Lost Control," on which a dehumanized vocal ascends through panic ("I'm *losing* it") to fatalism ("I've lost it"). And in the mid-nineties, Chicago's Green Velvet released a series of brilliant "dark" house tracks with Sleezy D—style spoken-voice monologues like "I Want to Leave My Body," "Help Me," "The Stalker (I'm Losing My Mind)," and "Flash."

The truth is that there has always been a dark side to rave culture; almost from the beginning, the ecstatic experience of dance and drugs was shadowed

by anxiety. "Losing it" is a blissful release from the prison of identity, but there comes a point at which the relief of ceding consciousness and control bleeds into a fear of being *controlled* by a demonic Other. Again and again, the moment of endarkment recurs in rave subcultures. The nihilism latent in the dehumanizing logic of the drug/technology interface is always lurking, waiting to be hatched. Rave's "desiring machine" becomes a machine gone mad, wearing out its flesh-and-blood components. The human nervous system is not built to withstand the attrition that comes from sustained sensory intensification and artificial energy. Ultimately, the rave experience can be literally mind blowing — as in a fuse burning out, rather than psychedelic bliss.

By the autumn of 1993, the pioneers of darkcore were moving on. 4 Hero began their journey back toward the light. Rufige Cru/Metalheads' Goldie disparaged the horde of Reinforced copyists, explaining: "'Dark' came from the feeling of breakdown in society. It was winter, clubs were closing, the country was in decline. As an artist, I had to reflect it. But now all these kids have turned it into a joke, they think 'dark' is about devil worship."

Darkside paved the way for *both* the strands of breakbeat music that displaced it: the roisterous, ruffneck menace of jungle, and the densely textured, ambient-tinged sound of drum and bass. With its premium on headfuck weirdness and disorienting effects, darkcore opened up a vital space for experimentation. In a way, "dark," like the hip-hop term "ill," is a sort of vernacular shorthand for "avant-garde." Many darkside tracks sounded like the improbable return of early-eighties avant-funk: PiL's "Death Disco," 23 Skidoo, Cabaret Voltaire, A Certain Ratio. Darkcore led directly to the artcore explosion of album artists like Goldie. At the same time, darkside's baleful minimalism was a prequel to jungle's gangsta militancy. Just like heavy-metal kids signing up for Satan's army or rappers flirting with psychosis (Cypress Hill's "Insane in the Brain"), aligning yourself with "the dark side" is a way of proclaiming yourself one bad mutha.

the future sound of detroit

The first wave of Detroit techno reached its peak in 1988–89. The city was pumping, thanks to clubs like the Shelter and the legendary Music Institute, where Derrick May, Kevin Saunderson, and Chez Damier spun. At the same time, the Detroit sound was hugely popular on the European rave scene, where "Strings of Life" achieved anthemic status in '89 (several years after it was recorded) and Inner City were veritable pop stars.

Then it all seemed to go wrong. In early 1990, the Music Institute closed; *Techno 2*, the patchy sequel to Virgin's Detroit techno compilation, was badly received; Kevin Saunderson pursued a misguided R & B direction on the second Inner City album. Juan Atkins, frustrated at Network (where the more commercial Inner City had priority), eventually took his album-oriented ambitions for Model 500 to the Belgian label R & S. Disillusioned by bad deals, Derrick May stopped making music altogether. To top it all off, DJ-ing opportunities in Europe took the Belleville Three away from their hometown with increasing frequency, leaving something of a vacuum. Without the first-wave mentor figures to guide and push the scene, younger producers had to seize the initiative. In the vanguard of this "Future Sound of Detroit" were two labels, two DJ/producer squads: Underground Resistance and + 8.

Where the Belleville Three had grown up on Kraftwerk and Parliament-Funkadelic, the new breed had eighties influences: electro, UK synth pop, industrial, and Euro Body Music. The result was a harsh Detroit hardcore that paralleled the brutalism of rave music in Britain, Belgium, Holland, and Germany. The string-swept romanticism of Rhythim Is Rhythim was displaced in favor of riffs and industrial bleakness.

Underground Resistance's attitude was hardcore in another respect: the music embodied a kind of abstract militancy. Presenting themselves as a sort of techno Public Enemy, Underground Resistance were dedicated to "fighting the power" not just through rhetoric but through fostering their own autonomy. For several months before they released anything, Jeff Mills and Mike Banks (aka Mad Mike) planned and theorized their operation. "Most of the conversations were structural — whether we should have employees, what type of rules if any the label would run by," says Mills. "We looked at what other people in Detroit had done and where we thought they'd made mistakes."

Underground Resistance presented themselves as a paramilitary unit, sonic guerrillas engaged in a war with "the programmers" (the mainstream

entertainment industry). According to Mills, this imagery was in large part the result of Banks's "affection for the military. . . . I think his brother and his father were career army." As well as the obvious parallel with Public Enemy and their Security of the First World militia, Underground Resistance's "bacdafucup" militancy also resembles the terrorist chic of Front 242, Belgian pioneers of Euro Body Music. According to Mills, in the late eighties Detroit "went through a techno/industrial phase . . . with bands like Nitzer Ebb, Front 242, Meat Beat Manifesto." The stiff, punish-your-body beats and caustic electronic textures of EBM were also a crucial influence on the Belgian hardcore techno sound of the early nineties, which probably explains why UR's early efforts sound so similar to those of Benelux acts like Meng Syndicate, 80 Aum, and Incubus.

After debuting with a vocal house track featuring chanteuse Yolanda, Underground Resistance released the "Sonic" EP. Tracks like "Predator" and "Elimination" resemble target-seeking missiles, remorseless and implacable killing machines. Etched into the vinyl at the record's center are the first of a series of UR slogans: "to advance sonic is the key"; "the needs of the many outweigh the needs of the few." After the malignant-sounding "Waveform" EP and "Gamma-Ray," Underground Resistance upped the ante with a series of insurrectionary 1991 releases. On the label of the "Riot" EP, the "I" in "RIOT" is a drawing of a masked and sunglasses-wearing UR trooper dressed in black, resembling a PLO hijacker. The music is a kind of sonic pun on the ambiguity of the word "riot" — which can mean both unrestrained revelry or a mob uprising, just as "rave" can mean both wild enthusiasm and maniacal rage. The title track pivots around the looped call to arms "now is the time," background uproar that could be party-goers or a political rally, and a red-alert bleep like a B-movie computer set to self-destruct. "Panic" features a Mayday-signal riff based on a pitch-bent vocal sample that sounds like a mind spasm, a twinge of trepidation, plus a rap that conjures a state of emergency and insurgency. "Rage" is driven by a fuzz-blare riff that's like Deep Purple's "Smoke on the Water" run backward.

Etched into the outer rim of the 12-inch is the mysterious phrase "The Fire in Us All." What Underground Resistance seem to herald on "Riot" and its sister 12-inch "Fuel for the Fire" is a kind of Dionysian politics — orgiastic, unconstructive anger. If this was techno's punk rock, the parallels were less with

the rabble-rousing but ultimately good-hearted Clash than with the appetite for destruction throbbing inside Sex Pistols songs like "Anarchy in the UK," or indeed with songs by Detroit's own proto-punk outfit the Stooges such as "Search and Destroy" and "Raw Power." Paralleling Iggy Pop's obsessions with electricity and amplification, his dream of becoming the conduit for antisocial/inhuman energies that override all the system's circuit breakers, the label of "Riot" declares: "all energy arranged, produced and mixed by Underground Resistance."

After "Fuel for the Fire" (a 12-inch that formed a double pack with "Riot") UR released "Sonic Destroyer" under the alter ego X-101. The flip side, "G-Force," saw UR exploring the nonmusical possibilities of vinyl as a medium. The tracks' grooves are strangely patterned, bunched together normally then separating out into spirals, so that the stylus moves across the record in alarming lunges that parallel the jagged time-lapse effect of "G-Force" (which sounds like tremendous pressures buckling and distorting the human frame). "We thought that if we could physically alter how the record works, it sends out a signal that things aren't always the way they're supposed to be, or appear to be," says Jeff Mills. "That maybe you should pay more attention to what you're buying or what you're listening to."

As well as triggering ideas and confounding expectations, these "gimmicks" also made the records into fetish objects and added to the mystique of the band, which was a cult in Europe by now. Indeed, the music Underground Resistance were making at their 1991–92 peak was very much in synch with the reigning Euro-hardcore sound. "Sonic Destroyer" features a classic ravestyle Morse code oscillator riff, while "Fury" is similar to T99's "Belgian hoover" classic "Anasthasia" — heavy me(n)tal techno with Carmina Burana—like choral stabs. The only difference is that the fuel for UR's (f)ire isn't amphetamine psychosis but their peculiar brand of nonspecific belligerence (hence the vague album title Revolution for Change).

This early, bellicose phase of Underground Resistance peaked with the awesome "Death Star," which sounds like a gigantic, demonic glitterball flashing off death rays in every direction, pulverizing planets and vaporizing interstellar armadas. This time the slogan carved into the vinyl is "Unit Deathstar Mission — Eliminate Anti-Underground Forces," making explicit the *Star Wars* derived allegory of UR as Jedi Knights resisting the Evil Empire of the music industry. Shortly after "Death Star" came "Message to the Majors," an even more blatant fuck-you to the record companies then signing up techno acts in anticipation of rave's breakthrough in America.

In the summer of 1992, UR formed a sublabel called World Power Alliance and issued three one-sided singles, all pertaining to World War II. On the music-free side of each release was etched a lengthy and rather bombastic communiqué to the pan-global techno underground, in which the WPA's mission was defined as resisting "the mediocre audio and visual programming being fed to the inhabitants of Earth." The idea for the World Power Alliance emerged after the three members of UR — Mills, Banks, and Rob Noise (Robert Hood) — had traveled outside Detroit. "We thought it would be interesting for each of us to devote a particular release to a particular country and their armed forces," says Mills. That two of the three "armed forces" chosen belonged to Axis, rather than Allied, powers is striking proof of the curiously apolitical and disinterested admiration UR had for military qualities like discipline, ruthlessness, realpolitik, and subterfuge.

Banks's effort, "Kamikaze," comes with label notes that extravagantly hail the death-bound Japanese dive-bombers for their dedication and self-sacrifice. Jeff Mills's "The Seawolf" is named after the German U-boats that preyed on Allied merchant ships and, breaking with traditional naval chivalry, gave no warning before attacking. "TERROR FROM BELOW" is etched in the vinyl; the track sounds like a stalking subaquatic hunter, with a Roland 303 pulse seeming to home in on its target. Last in the series was Hood's "Belgian Resistance." Probably a tribute to Benelux hardcore, its label notes offered a bizarre fantasy of an "underground legion" of anti-Nazi Belgians "breeding and waiting in the dark, battle scarred caverns, waiting for revenge," decades after German surrender.

Underground Resistance the label wasn't just an outlet for Banks, Mills, and Hood's collective output as UR. It also released tracks by other second-wave Detroit artists, such as Drexciya (the sub-oceanic science fiction electro of EPs like "The Aquatic Invasion" and "The Bubble Metropolis"), Scan 7, and Suburban Knight, aka James Pennington.

Born in 1965, Pennington was actually a first-wave Detroit techno producer;

a roommate of Kevin Saunderson, he'd contributed to Inner City's "Big Fun," and his first two Suburban Knight singles came out on Derrick May's Transmat label. Recorded in the mid-eighties but released only in 1990, Pennington's second release via Transmat — "The Art of Stalking" — launched him on an obsession with nocturnal predators that runs through all his Underground Resistance work.

A pioneering slice of Detroit darkside, "The Art of Stalking" consists of little more than a high-pitched, pizzicato bass line and highly strung drum track. The track twitches with tiptoe-and-tenterhook trepidation, leaving it up to the listener whether to identify with the pursuer or the pursued. The inspiration came from Pennington's fondness for the Discovery channel and, specifically, a wildlife documentary about the plains of Africa that used a night-vision camera to show "lions killing gazelle, tigers walking stealthily through the jungle then disappearing in seconds."

Named after the word for "a creature who hunts by night," Pennington's debut for Underground Resistance was "Nocturbulous Behavior," a twilightzone surge through dread-soaked streets. The credits read "mixed by the Ultimate Survivor," making explicit the political subtext of Pennington's fascination with night vision: social Darwinism, the dog-eat-dog struggle of post-Fordist Detroit, with its apartheid-style ghost-townships and affluent white suburbs. Specifically, Pennington was inspired by the way the bat evolved radar to achieve an evolutionary edge, a topic he returned to with 1996's "Echo Location."

Another inspiration came from a German journalist who hailed Suburban Knight's music as "an advancement of 'metal tank.' "This imaginary genre—"metal tank"— fired Pennington's imagination because he was already obsessed with Germany, partly because of Kraftwerk and partly because of his grandfather's World War II stories. "I thought Germany was like how it's televisioned over here—cold, gray, harsh, a black-and-white country that's been bombed to hell. And then Kraftwerk came out of the rubble and made this electronic shit. That fascinated me. All the stuff that my grandfather was telling me, and the music that we were listening to from overseas, really came together as one whole picture."

Taking a tangent away from this Teutonic terrordome, Pennington's next outing for UR was one disc of the 1994 double pack "Dark Energy," an

explicitly Afrocentric statement. Bearing the slogan "escape the chains on your music" and a black-edged silhouette of the Dark Continent, the label revealed that the tracks were recorded in the Black Planet Studios (in homage to Public Enemy's third album, *Fear of a Black Planet*) and that "Strike Leader James (Suburban Night) Pennington" was commander in chief of these "sonic strikes against programming strongholds."

On Pennington's disc, the phosphorescent-sounding "Midnight Sunshine" was inspired by his grandpa's tales of antiaircraft flares and by his own "infatuation with Playstation flight-simulation games." "Mau Mau (The Spirit)" was a tribute to the tribal guerrillas who harried white settlers in 1950s Kenya. With the Black Panthers—inspired "Mind of a Panther" completing the triptych, the "Dark Energy" EP was an attempt to draw spiritual sustenance from this mind's eye Motherland, in order to survive as an exile in AmeriKKKa.

Where does my fascination with space come from? From wanting to escape from here.

MIKE BANKS talking to *Jockey Slut* magazine, 1994

Underground Resistance's musical evolution chimes in with a dialectic that runs through most "serious" black pop: a tension between militancy and mysticism. On one hand, there's the lineage of consciousness-raising agitprop and righteous rage: the Last Poets, Gil Scott Heron, Public Enemy, KRS1. On the other, there's the "black science fiction" tradition of esoterrorists (hermetic renegades from consensus reality) and otherworldly dreamers: Sun Ra, Lee Perry, George Clinton, Earth Wind and Fire, A. R. Kane. With its outer-spatial imagery, most Detroit techno falls into the second Afro-futurist camp, transcending terrestrial oppression by traveling "strange celestial roads" of the imagination.

Of course, some artists shift back and forth across the militant/mystic divide; Underground Resistance is a prime example. With the album *X-102 Discovers the Rings of Saturn* (1992), the trio left behind earthly alienation for

alien realms. "X-102 was the first release where it became nonterritorial," says Mills. "It's a planet in the solar system, but it became nonmankind, it exceeded all those barriers and territories." Underground Resistance seemed fascinated by Saturn's inhuman and inhospitable qualities, its hostility to life. Where most techno evocations of outer space are idyllic verging on twee, X-102 is harsh and bleak; tracks like "Enceladus," "Hyperion," and "Titan" offer a kind of astral industrial music.

With tracks for each of Saturn's three rings and nine moons and one for the planet surface itself, X-102 was a concept album. The sleeve notes relate information on the composition and possible origins of Saturn's satellites and rings; on the vinyl version, the grooves are patterned to correspond to the relative width of the rings and the distances between them. For the next installment in the series, X-103, Mills and Co turned from one Sun Ra obsession (Saturn) to another: Atlantis. The group spent over six months researching the X-103 project. "We had to find out the theories and the facts of Atlantis . . . the shape of the city, what was actually in the temples, and relating things like that to vinyl, how we make the label actually significant, the grooves of the record." The inner sleeve depicts a city plan of Atlantis, with its tree ring-like districts orbiting the center, its palaces, horse-racing stadium, gardens, and gymnasia. Although both Rings of Saturn and Atlantis are brilliant albums, the conceptual overkill, with its odd echo of mid-seventies prog rock, was a worrying sign. It set the tone for Mills's solo career, in which — by his own admission — concepts took up more of his energy than making the actual music.

Like Underground Resistance, +8 — the other prime movers in Detroit's second wave — gradually evolved from industrial-tinged hardcore to a trippy but minimal "progressive" techno sound that increasingly came with highfalutin concepts attached. The label was formed by Richie Hawtin and John Aquaviva shortly after the pair met at the Shelter, where the nineteen-year-old Hawtin was DJ-ing. Both lived across the border in Canada. Aquaviva was a successful local DJ in London, Ontario, while Hawtin lived in Windsor, where his British father was a robotic technician at General Motors. Hawtin grew up in an intensely electronic atmosphere, surrounded by computers and the electrical gizmos constructed by his dad, and exposed from an early age to Hawtin Sr.'s

collection of Kraftwerk, Tangerine Dream, and other synth records. As a teenager, Hawtin got into Front 242-style Euro Body Music, then discovered Detroit techno.

Hawtin and Aquaviva named their label + 8 after the pitch-adjust function on turntables that allowed DJs to play tracks at maximum velocity. "At that time, as DJs we were all playing faster, everything was cranked up," says Hawtin. "The whole vibe was 'let's go!" "The second release on + 8 was a white label that bore no artist or track information, just the slogan "The Future Sound of Detroit." This forthright proclamation — not just "we have arrived," but the implication that the old guard was now history — got the fledgling label a lot of attention, but also raised hackles among the first-wave Detroit music makers. When the track became more widely available in late 1990, "Technarchy" by Cybersonik (Hawtin, Aquaviva, and their friend Dan Bell) became a huge anthem in the European rave scene. Its ponderous bumblebee of a bass riff slotted perfectly next to the bruising bombast of Euro hardcore, but there was also a unique + 8 quality, a cold midwestern trippiness.

Over the next eighteen months, + 8 unleashed a series of progressively faster and fiercer tracks, partly fueled by their friendly rivalry with Underground Resistance. Listening to "Vortex" by Final Exposure (a collaboration between Hawtin and Joey Beltram and Mundo Muzique of Second Phase/"Mentasm" fame) really is like being sucked up inside a cyclone. Recording solo as F.U.S.E. (Futuristic Underground Subsonic Experiments), Hawtin revived the acid house Roland 303 sound on mantra-nomic monsters like "Substance Abuse" and "F.U."The latter might be his all-time masterpiece: an audio analog of Vasarely's eye-boggling op art, "F.U." and its sequel, "F.U.2," induce a dark exultation, a sense of locked-on-target propulsion.

+ 8's headlong escalation to harder and faster extremes peaked in early '92 with Circuit Breaker's "Overkill"/"Frenz-E" and Cybersonik's "Thrash." The latter was intended almost as a parody of other rave producers who were equating intensity with hardness and velocity. "It got to the point where we felt, 'whoa, time to put the brakes on!,' "says Hawtin. The final Cybersonik record, "Machine Gun" and its flipside "Jackhammer," was released at the start of 1993. The production was credited to the White Noise Association. "We don't even like that record, it was a statement [to the rest of the rave scene] — kind of, 'we don't know what you guys are doing, but it's not what we're about.'"

Like "progressive"-minded producers across the globe, + 8 were aghast at the drug-fueled dynamic that was driving hardcore techno to new extremes of brain-dead brutalism. Despite having played no small role in this escalation, they were now recoiling from the remorseless acceleration of the tempo, the increasingly regimented and funkless nature of the rhythms. The music was changing not just because of Ecstasy and amphetamine abuse, but because of the context it was designed for — raves, not clubs. "There was a revolution against clubs," remembers Aquaviva. "Kind of 'fuck this tired old shit, we're gonna do our own thing in a warehouse.'"

Because rave promoters booked lots of DJs, sets became shorter. Rather than taking the audience on a journey with highs and lows, like the resident DJ at a club, the rave DJs played full-on for the whole of their hour on the decks — partly to avoid being blown away by the next jock and partly to pander to the drug-fueled requirements of the audience. "Even though the DJs rose in stature, they were handcuffed in what they could do," says Aquaviva. "DJ-ing as an art form took a step back. And instead of going to a couple of clubs every week, the tendency for ravers was to save their pent-up energy for these one-off events. So raves became more like illegal rock 'n' roll concerts."

The turning point for Hawtin and Aquaviva came in early '92 when they found themselves in a Rotterdam club called Parkzicht — the crucible for the Dutch ultrahardcore sound called *gabba*. "Gabba is Dutch for buddy," says Aquaviva. "A lot of the guys are dock workers, they're into harder music, so gabba is basically the sound of the buddies letting off steam." At Parkzicht, the DJs and crowd were very partial to "Thrash Beats," the stripped-down version of Cybersonik's "Thrash" — at 150 bpm, the fastest + 8 release to date. Hawtin and Aquaviva noticed that the Rotterdam ruffneck audience was yelling along to the song. With slowly dawning horror, they realized that what sounded like a soccer chant was actually "joden, joden" ("jews, jews"). In fact, it *was* a soccer chant, used by supporters of Rotterdam's team Feyenoord against Amsterdam's Ajax (whose fans sometimes flew the Israeli flag at games, as a proud nod to the city's Jewish mercantile past). "Our Dutch friends are like, no worries, it's just a football chant," says Aquaviva. "But I'm like, fuck that, that's not who I am. I'm not a Nazi, I can make people rock without making them be hostile."

From that point on, + 8 changed tack. "Intensity = good, hard = bad" was now the label's creed; bringing back the funk and the soul to electronic music

was the quest. Aquaviva started the house-oriented sublabel Definitive, while Hawtin directed his energies toward the fusion of Detroit techno and Chicago acid into a style he called "complex minimalism," via his new alter ego, Plastikman. "It was always the one sound that didn't sound like anything you'd ever heard," he says, trying to explain the Roland TB 303's hypnotic appeal. Plastikman's 1993 debut album, *Sheet One*, was one long paean to the synergy of 303s and LSD. Tracks like "Plasticine" offer a kind of monochrome, sensory-deprivation version of psychedelia. (The cover — a simulation of a perforated sheet of acid blotters — is so convincing that a young man in Texas, pulled over for a traffic violation, was arrested when the cop saw the CD insert lying on his car seat.)

Having helped kickstart gabba in Holland with "Thrash Beats," + 8 also contributed to the emergence of German trance. Hawtin's neo-acid direction was an important influence, but the real catalyst was the streamlined kineticism of + 8 artist Speedy J, aka Dutch producer Jochem Paap. "Along with other Detroit-sounding artists, we were some of the first people to go to Germany," says Aquaviva. "Toward the end of '91, we performed at Berlin Independence Days." At this music festival, Speedy J played live and "blew us and all the Detroit guys away. And that spurred his track 'Pullover' into the huge success that it was. Although he's Dutch, he's one of the foreigners who helped put the second wave of Detroit on the map. Speedy is as much Detroit and Chicago as anyone, and he set the tone in Europe. The Germans had their own scene, but we certainly gave them impetus to become one of the techno powerhouses."

In the mid-nineties Berlin became a haven for Detroit producers. Jeff Mills and Blake Baxter moved there for some time. Underground Resistance released their X-101/X-102/X-103 album series via Tresor, a purist techno label linked to the famous Berlin club of the same name — a strobe-blitzed, sardine-crammed sweatbath based in the vaulted subterranean safe of a 1920s department store on Potsdamer Platz. Juan Atkins and Eddie "Flashin" Fowlkes also recorded for Tresor, solo and in collaboration with 3MB's Thomas Fehlmann and Moritz Von Oswald. Celebrating the mutual admiration pact between the two cities, Tresor subtitled their second compilation Berlin—Detroit: A Techno Alliance. Underground Resistance was also proving equally inspirational in Frankfurt, where its renegade militancy influenced labels like Force Inc. and

PCP. Obsessed with Suburban Knight's "The Art of Stalking," PCP main man The Mover produced creepy, crepuscular tracks like "Nightflight (Non-Stop to Kaos)" and recorded an EP using the UR-like alter ego Spiritual Combat. Meanwhile, Richie Hawtin and Speedy J's tracks for $+\ 8$ helped spawn the 303-fired hard trance of labels like Frankfurt's Harthouse and Berlin's MFS.

That said, + 8 were eventually as perturbed by the evolution of trance as they were by Dutch gabba. "At one hard party in Limburgh in '92, they had these Thorens turntables that could go to plus 25," remembers Aquaviva. "The DJ was playing this really heavy trance and the people were dancing like zombies, arms out and bouncing to the 160 to 180 bpm rhythms. This freaked me out, I called it the Nazi waltz. Later I was DJ-ing, playing classic techno and house, and the DJ came up and said: 'Can't you play anything the crowd likes, and that's y'know, *faster?*' I vowed never to play in Germany, and in fact it took me a year and half to play there again."

Nonetheless, there did seem to be a striking affinity between American midwestern and German ideas of rave. There was an industrial influence, both environmental (in the Ruhr/General Motors sense) and musical (Euro Body Music). There was even a weird racial link, insofar as Michigan, Minnesota, Illinois, and other midwestern states had a high proportion of German and Scandinavian settlers.

As trance got more metronomic and monolithic, Richie Hawtin dedicated himself to bringing back "the groove, the soulfulness, the sexiness" of the Roland 303 acid sound. His response was a drastic drop in tempo on the second Plastikman album, 1994's *Muzik*, resulting in midtempo 303 excursions that took you on a pleasant stroll through the cosmos instead of breaking the speed limit on the Astrobahn. As a DJ, Hawtin was also bucking the hard-trance trend toward full-on velocity by mixing in house and even garage tunes. "That was during the years after the separation of techno into different styles. It was a depressing thing for a lot of us. I've always enjoyed playing longer sets. When I do them, I take things up-down, fast-slow, encompassing different kinds of music."

This anti-rave philosophy informed + 8's parties in the midwest. "It wasn't just about playing all new superhard stuff," says Aquaviva. "It was about two DJs playing the whole night, embracing the old principles of house, when there weren't enough records being made to play only one style all night."

Despite the LSD blotter cover of *Sheet One,* + 8 also began to distance themselves from hallucinogens, as they saw the drug abuse get out of hand on the American rave scene. "People I know just went overboard with Ecstasy," says Hawtin. "So there's a little tag line on the second Plastikman album that says 'just because you like chocolate cake doesn't mean you eat it every day.' That was just a backhanded way of saying, 'cmon guys, figure it out, get a grip.'"

Unlike Chicago acid house, Detroit techno was never a drug-oriented music. The word "rave," with its connotations of frenzy and loss of control, had never been applicable to the elegant aestheticism of Derrick May and Co. By 1993, the more serious-minded producers in Britain and Europe were embarking on a return to Detroit principles as a way of sidestepping what they perceived to be the drug-determined dead ends of hardcore and hard trance. They looked to three figures and three directions for guidance: the "hi-tech jazz" being made by Mad Mike under the aegis of Underground Resistance and Red Planet, the austere minimalism of Jeff Mills, and the softcore romanticism of Carl Craig.

Born in 1969 and brought up in Detroit's middle-class West Side, Craig took Detroit's Europhile tendencies even further than his mentor, Derrick May. As a sensitive teenager, he was into bands like the Cure, Bauhaus, and the Smiths. Alongside his diet of Anglo miserablism and avant-funk like Mark Stewart and Throbbing Gristle, Craig shared the typical Motor City appetite for synth-driven dance music. He dug Prince, Kraftwerk, and Italian "progressive" disco. Falling under May's tutelage, he toured Europe as a member of Rythim Is Rythim, worked on the 1989 remix of "Strings of Life," and in 1991 cowrote the sublime "Kao-Tic Harmony" with May. By this point, Craig was already releasing tracks via his own labels, RetroActive and Planet E, using a plethora of whimsical alter egos: Psyche, BFC, Piece, Six Nine, Shop, Innerzone Orchestra, and Paperclip People.

Psyche's "Elements" was the solitary highlight of *Techno 2*, the disappointing sequel to the Virgin compilation that had first put Detroit on the map. Reflective, in both the "introspective" and "opalescent" senses of the word, "Elements" revealed Craig to be Detroit's most gifted miniaturist. With its open-hearted yearning and twinkling textures, "Elements" conjured up the image of a lonely boy moping in a bedroom studio, mixing his lo-tech palette of

tone colors with his teardrops to paint exquisite audio watercolors. There were shades of the electro-calligraphic brushwork of Thomas Leer, Japan, and Sylvian/Sakomoto. This wasn't party-hard music but the pensive frettings of one of life's wallflowers. Six Nine's "Desire" features a keening synth melody that soars up and slides down the octave in fitful lurches. Released under Carl's own name, "At Les" is even more moistly melancholy, its trickle-down synth pattern sounding like glistening teardrops rolling down a cheek.

Taking the Detroit desolation of May's work toward an almost fey forlornness, Craig became a role model for all those techno artists in Britain, like the Black Dog, who wanted to make album-length, home-oriented electronic mindfood. He was the producer's producer, worshipped for the texturological detail and nuance in his compositions. The guru of softcore, Craig's tracks generally elevate atmospherics over energy. His rhythms are relentlessly, restlessly intelligent, but make your brain itch rather than your feet twitch. Innerzone Orchestra's "Bug in the Bassbin," for instance, has been hailed as a prototype for jungle, but the track's loping double bass line and breakbeat shuffle — while engagingly off-kilter — are neither jungalistic nor particularly danceable.

While Carl Craig became the touchstone for many British producers who wanted to make atmospheric home-listening electronica, those who remained committed to the dance floor looked to Underground Resistance and its former members, Jeff Mills and Robert Hood. With Mills and Hood gone, UR became a Mike Banks solo project in all but name. On the "Galaxy 2 Galaxy" double EP, Banks abandoned juggernaut industrialism for fusion-tinged cosmic disco ("Hi-Tech Jazz," as the opening track put it), early hints of which had been heard in the rhapsodic shimmer of UR's classic "Jupiter Jazz." The warrior-priest iconography endured: the labels depicted Bruce Lee and Geronimo, the latter a nod to Banks's half Native American ancestry. But the music sounded pacific rather than militant — all fluttery arpeggiated twirls and nimble-fingered fluency. Titles like "Starsailing" suggested that UR had finally ascended into the mystic.

Any fears that Banks had swapped his rage for space-cadet serenity were partly assuaged by his series of Red Planet EPs. In Mars, the warlike planet, he found an image that perfectly reconciled the militant/mystic dialectic. Although Jeff Mills now denies that there was ever any anger or politics involved in Underground Resistance, Banks — in his rare public utterances — has spoken out

about the twin genocides in his family tree (his mother is Blackfoot Indian, his father black) and how they fuel his struggle against the "forktongue" propaganda of the "programmers." Like the Wu Tang Clan's use of rhymes as "liquid swords," Banks proposes resistance through tribal rhythms, through the war dance. On the "Red Planet VI" EP, the high point of the series, "Ghostdancer" is named after the messianic religion that swept through the reservation-trapped and defeat-traumatized Native American tribes in the 1890s — the desperate belief that by dancing and chanting they could magic the white invaders out of existence and bring the dead tribespeople back to life. Much of the time, however, the sleek sheen of tracks like "Skypainter" and "Windwalker" summons up the spirits of George Benson and Stanley Clarke rather than Crazy Horse and Eldridge Cleaver.

Mills and Hood, meanwhile, were developing their enormously influential brand of minimalist techno with the *Waveform Transmission* album series. Where Hood's 1994 "Minimal Nation" double pack and *Internal Empire* album offered the aural equivalent of a bread and water diet, Jeff Mills's output is at least energizing in its stark ferocity. On *Waveform Transmission Vol. 1* and *Vol. 3*, four-to-the-floor techno is taken as hard and fast as it can go without actually turning into gabba. Chaste and chastening, this is techno as monastic discipline, rigor as mortification of the flesh. The spartan frenzy and flagellating pulses of "The Hacker" and "Wrath of the Punisher" are like a scourge for all of the hedonistic excesses of rave.

Mills's other big influence on Detroit purists is his conceptualism. For the releases on his own Axis label, Mills's music became increasingly concept driven. "Cycle 30," for instance, took the vinyl innovations of UR to the furthest degree: the release consisted of nine locked grooves — five-second riffs and beat loops that were designed for DJs to use as mixing material. "Cycle 30" also referred to Mills's belief in thirty-year cultural cycles and the idea that the era of minimal techno (allegedly an echo of sixties minimalist art) is about to give way to a form of abstract expressionist techno, with producers bringing more of their signature back into the music.

Jeff Mills belongs to a tradition of black scholar-musicians and autodidacts: Sun Ra, Anthony Braxton, Derrick May, DJ Spooky. Instead of inspiring thoughtless, sweaty fun, Mills believes dance music should be the vehicle for lofty intellectualism and weighty concepts. "Let me be very very clear," he says, with the barest hint of annoyance. "Underground Resistance wasn't militant, nor was it angry. . . . I'm not angry now. . . . The music that I make now has absolutely nothing to do with color. It has nothing to do with man/woman, East/West, up/down, but more [to do with] 'the mind.'The mind has no color."

But when race, class, gender, and sexuality are removed from the picture, what exactly remains to fuel the music? Just the "pure" play of ideation. The result is music that appeals to a disinterested and disembodied consciousness. The formalism of minimal techno has some parallels with minimalism in the pictorial arts and in avant-classical composition; both have been criticized as spiritualized evasions of political reality, attempts to transcend the messy and profane realm of history and materiality in the quest for the "timeless" and territorially unbounded.

If the musical legacy of Derrick May and Jeff Mills is largely unimpeachable, the mentality they have fathered throughout the world of "serious" techno is largely pernicious, favoring elegance over energy, serenity over passion, restraint over abandon. It's a value system shared by Detroit purists both within the Motor City and across the globe. In Detroit itself, artists like Alan Oldham, Stacy Pullen, Kenny Larkin, Dan Curtin, Claude Young, Marc Kinchen, and John Beltran uphold the tradition. Many of these producers were corralled onto a 1996 double CD compiled by Eddie "Flashin" Fowlkes and titled *True People* as a stinging rebuke to the rest of the world for its desecration of the Detroit legacy (a crime that Fowlkes has called "cultural rape").

But Detroit is living in denial. Techno has long since slipped out of its custodianship. The evolution-through-mutation of music has thrown up such mongrels as bleep-and-bass, Belgian hardcore, jungle, trance, and gabba, all of which owe as much to other cities (the Bronx, Kingston, Düsseldorf, Sheffield, London) as they do to Detroit. The ancestral lineage of Detroit has been contaminated by "alien" genes; the music has been "bastardized." But lest we forget, illegitimate heirs tend to lead more interesting lives.

If anything, the idea and ideal of "Detroit" is even stronger outside the city, thanks to British Detroit-purists. Leading lights in the realm of neo-Detroit "abstract dance" include the British labels Soma, Ferox, Ifach, and Peacefrog, and producers like Dave Angel, Funk D'Void, Russ Gabriel, Luke Slater, Ian O'Brien

(who titled a track "Mad Mike Disease" as a nod to the endemic influence of the UR/Red Planet maestro), and Mark Broom (whose alter ego Midnight Funk Association is named after the Electrifyin' Mojo's mythic radio show in Detroit). It is a world where people talk not of labels but "imprints" and funk is spelled "phunk" to give it an air of, er, phuturism.

One of the most vocal of the Detroit acolytes is tech-jazzer Kirk deGiorgio. From early efforts like "Dance Intellect" to his late-nineties As One output, de-Giorgio has dedicated himself to the notion that Detroit techno is the successor to the synth-oriented jazz-funk of fusioneers like Herbie Hancock and George Duke. "I never saw techno as anything else but a continuation of black music," he told *Muzik* magazine in 1997. "I didn't think of it as any new kind of music. It was just that the technology and the sounds were different."

This neoconservative attitude — the self-effacing notion that white musicians like deGiorgio himself have nothing to add to black music, the idea that music never undergoes revolution — is reminiscent of the British blues-bore purists of the late sixties and early seventies. Actually, given that Detroit techno was a response to European electro-pop, we should really reverse the analogy: Atkins, May, and Saunderson are equivalent to Clapton, Beck, and Page, virtuoso players worshipped for their purist fidelity to the original music (Kraftwerk for the Belleville Three, Muddy Waters for the ex-Yardbirds). The hip-hop influences (breakbeats, bass, and samples) that revolutionized British rave music are studiously shunned by the Detroit purists, who believe synthesizers are more "musical" than computers. There is literally no future in this traditionalist approach; the notion that the music of Derrick May (or Mad Mike et al.) represents the Way, the Light, and the Truth from which one should never deviate is no more helpful than the early-seventies belief that "Clapton Is God."

This is not to say that Detroit techno has nothing more to offer electronic music. For instance, Kevin Saunderson (the most *im*purist of the Belleville Three) has inspired some exciting records, like Dave Clarke's "Red" series. In the wake of UR outfit Drexciya, the Detroit area has also seen an upsurge of electro-influenced music — artists like Ectomorph, Aux 88, Cronik Tonik, and Dopplereffekt, labels like Interdimensional Transmissions and Direct Beat. Returning to Detroit techno's early-eighties roots as a distant cousin of New York electro, these producers have thrillingly revived Kraftwerk's glacial Germanic geometry and rigid drum machine beats, but — breaking with Detroit's refined

aura — they've also added a booty-shaking boom influenced by Miami bass music's lewd low-frequency oscillations. Meanwhile, in Europe, the Tresoraffiliated labels Basic Channel and Chain Reaction have brilliantly pursued their vision of tech-house abstraction through a million shades of lustrous gray.

But for the most part, European neo-Detroit techno-phunk is music that feels anal and inhibited, crippled by its fear of heterodoxy. Its "radicalism" is defined by its refusals, by what it *denies itself* — overt tunefulness, explicit emotion, vulgar exuberance, breakbeats, intoxication. Detroit purism was born of the impulse to de-*crass*ify techno and restore it to its pre-rave sobriety and subtlety. A cruel irony, then, that Colin Faver's long-running "Abstrakt Dance" show on London's KISS FM was terminated in the spring of 1997 in order to make room for happy hardcore (the cheesy-and-cheerful sound of rave fundamentalism at its most defiantly Ecstatic), while "have you got any Jeff Mills?" has become UK rhyming slang for "have you got any pills?"

By the mid-nineties, the British media had woken up to the fact that the nation contained two societies: the traditional leisure culture of alcohol and entertainment (spectator sports, TV) versus the more participatory, effusive culture of all-night dancing and Ecstasy. The clash between old Britain and young Britain was dramatized to hilarious effect in an episode of *Inspector Morse* entitled "Cherubim and Seraphics." The plot concerns a series of mysterious teenage deaths that appear to be connected to a new drug called Seraphic. Despite its overt "just say no" slant, the episode mostly works as an exhilarating advert for Ecstasy culture. (*Literally*, insofar as Morse's remark to his detective partner — "it's a rave, Lewis!" — was sampled and used by a pirate station.)

This collision of old and new Englands reaches it peak when the detective duo arrive at the stately home where a rave called Cherub is taking place. Morse drones on about the noble history of the building; inside, the kids have transformed it into a future wonderland. Sure, the crooked lab researcher responsible for the Seraphic drug gets his comeuppance. But the episode ends by allowing the sixteen-year-old girlfriend of one Seraphic casualty to utter a paean to Ecstasy: "You love everyone in the world, you want to touch everyone." And it transpires that the teenagers didn't kill themselves because the drug unbalanced their minds; rather, having glimpsed heaven on earth, they decided that returning to reality would be a comedown. Who wouldn't want to give E a try after that? And who would possibly side with decrepit Morse, with his booze and classical music CDs, against the shiny happy people of Generation E?

This episode of *Inspector Morse* signaled a dawning awareness in the media that recreational drug culture had become firmly installed in Britain during the early nineties and was now omnipresent almost to the point of banality. Every weekend, anywhere from half a million to two million people under the age of thirty-five were using psychedelics and stimulants. This geographically dispersed but spiritually connected network of Love-Ins, Freak-Outs, and All-Night Raves constituted a weekly Woodstock (or rather Woodstock and Altamont rolled into one, given that Ecstasy's dark side was starting to reveal itself). The question, then, is this: Has rave proved itself a form of mass bohemia, or is it merely a futuristic update of traditional youth leisure, where the fun-crazed weekend redeems the drudgery of the working week? What are the politics of Ecstasy culture?

Among Ecstasy's social effects, the most obvious is the way it has utterly transformed youth leisure in Britain and Europe. Because alcohol muddies the MDMA high, rave culture rapidly developed an antialcohol taboo. It could be argued that Ecstasy's net effect has actually been to save lives, by reducing the number of alcohol-fueled fights and drunk-driving fatalities.

Like alcohol, Ecstasy removes inhibitions. But because it also diminishes aggression (including sexual aggression), E has had the salutary effect of transforming the nightclub from a "cattle market" and combat zone into a place where women come into their own and men are too busy dancing and bonding with their mates to get into fights. These benign side effects spilled outside clubland: with football fans turning onto E and house, by 1991–92 soccer hooliganism in Britain was at its lowest level in five years.

Generally speaking, Ecstasy seems to promote tolerance. One of the delights of the rave scene at its height was the way it allowed for mingling across lines of class, race, and sexual preference. MDMA rid club culture of its cliqueishness and stylistic sectarianism; hence drug culture researcher Sheila Henderson's phrase "luvdup and de-elited." Rave's explosive impact in the UK, compared to its slower dissemination in America, may have something to do with the fact that Britain remains one of the most rigidly class-stratified counties in the Western world. Perhaps the drug simply wasn't as needed in America as it was in the UK. For in many ways, MDMA is an antidote to the English disease: reserve, inhibition, emotional constipation, class consciousness.

Yet for all the rhetoric of spiritual revolution and counterculture, it remains a moot point whether Ecstasy's effects have spilled outside the domain of leisure. From early on, commentators noted that the controlled hedonism of the MDMA experience is much more compatible with a basically normal, conformist lifestyle than other drugs. Norman Zinberg called it "the yuppie psychedelic"; others have compared it to a "mini-vacation," an intense burst of "quality time." In his essay "The Ecstasy of Disappearance," Antonio Melechi uses the historical origins of rave in Ibiza as the foundation for a theory of rave as a form of *internal tourism:* a holiday from everyday life and from your everyday self. At the big one-shot raves, some kids spend — on drinks, drugs, souvenir merchandise, travel — as much as they would on a short vacation. Rejecting the idea that this is simply escapism, a safety valve for the tensions generated by capitalist work patterns, Melechi argues that rave supersedes the

old model of subcultural activity as resistance through rituals. Where earlier style-terrorist subcultures like mod and punk were exhibitionist, a kick in the eye of straight society, rave is a form of collective disappearance, an investment in pleasure that shouldn't be written off as mere retreat or disengagement.

Melechi's theory of rave — as neither subversive nor conformist but more than both — appeals to the believer in me. From a more dispassionate perspective, though, rave appears more like a new twist on a very old idea. There is actually a striking continuity in the work hard/play hard structure of working-class leisure, from the mods' sixty-hour weekends and Northern Soul's speed-freak stylists, to disco's Saturday-night fever dreams and jazzfunk's All-Dayers and Soul Weekends. When I listen to the Easybeats' 1967 Aussie-mod anthem "Friday on My Mind," I'm stunned by the way the lyrics — a thrilling anatomy of the working-class weekender lifecycle of drudgery, anticipation, and explosive release — still resonate. Thirty years on, we're no nearer to overhauling the work/leisure structures of industrial society. Instead, all that rage and frustration is vented through going mental on the weekend ("Tonight, I'll spend my bread / Tonight, I'll lose my head"), helped along by a capsule or three of instant euphoria.

From the Summer of Love rhetoric of the early UK acid house evangelists to San Francisco's cyberdelic community, from the neopaganism of Spiral Tribe to the transcendentalism of the Megatripolis/GoaTrance scene, rave has also been home to another "politics of Ecstasy," one much closer to the original intent behind Timothy Leary's phrase. Ecstasy has been embraced as one element of a bourgeois-bohemian version of rave, in which the music-drugs-technology nexus is fused with spirituality and vague hippy-punk-anarcho politics to form a nineties would-be counterculture.

The fact that the same drug can be at the core of two different "politics of ecstasy" — raving as safety valve versus raving as opting out — can be traced back to the double nature of MDMA as a *psychedelic amphetamine*. The psychedelic component of the experience lends itself to utopianism and an at least implicit critique of the way things are. Amphetamine, though, does not have a reputation as a consciousness-raising chemical. While they popped as many pills as other strata of society, the hippies regarded amphetamine as a straight person's drug: after all, it was still legal and being prescribed in vast amounts

to tired housewives, overworked businessmen, dieters, and students cramming for exams. Amphetamine's ego-boosting and productivity-raising effects ran totally counter to the psychedelic creed of selfless surrender, indolence, and Zen passivity. So when the spread of methamphetamine poisoned Haight-Ashbury's love-and-peace vibe, the counterculture responded with the "speed kills" campaign. The hippies' hostility toward amphetamine is one reason the punks embraced the chemical.

In their 1975 classic *The Speed Culture: Amphetamine Use and Abuse in America*, Lester Grinspoon and Peter Hedblom draw an invidious comparison between marijuana and amphetamine, arguing that pot smoking instills values that run counter to capitalist norms, while amphetamine amplifies all the competitive, aggressive, and solipsistic tendencies of Western industrial life. Terence McKenna, an evangelist for Gaia-given plant psychedelics like magic mushrooms, classes amphetamine as one of the "dominator drugs," alongside cocaine and caffeine.

Chemically programmed into MDMA is a sort of less-is-more effect: what starts out as an empathy enhancer degenerates, with repeated use, into little more than amphetamine, at least in terms of its effects. When MDMA's warm glow cools through overuse, ravers often turn to the cheaper, more reliable amphetamine. Both these syndromes — excessive intake of E, the use of amphetamine as a substitute — explain the tendency of rave subcultures to mutate into speed-freak scenes after a couple of years.

From all this we might conclude that when the amphetamine component of the MDMA experience comes to the fore, rave culture loses much of its "progressive" edge. At one end of the class spectrum are the working-class weekender scenes, where MDMA is used in tandem with amphetamine and the subcultural raison d'être is limited and ultimately conformist: stimulants are used to provide energy and delay the need for sleep, to intensify and maximize leisure time. At the other, more bohemian end of rave culture, MDMA is used in tandem with LSD and other consciousness-raising hallucinogens, as part of a subcultural project of turning on, tuning in, and dropping out.

But the picture is a bit more complicated than this. LSD is widely used in working-class rave scenes, although arguably in ways that break with the Timothy Leary/Terence McKenna model of enlightenment through altered states. Hallucinogens appeal as another form of teenage kicks, a way of making the

world into a cartoon or video game. (Hence brands of acid blotter like Super Mario and Power Rangers.) And amphetamine, in high doses or with prolonged use, can have its own hallucinatory and delusory effects. Like MDMA, speed makes perceptions more vivid; its effect of hyperacousia can escalate into full-blown auditory hallucinations. The sensory flood can seem visionary, pregnant with portent. Serious speed freaks often have a sense of clairvoyance and gnosis, feel plugged into occult power sources, believe they alone can perceive secret patterns and conspiracies.

Nonetheless, there is a tension in rave culture between consciousness raising and consciousness razing, between middle-class technopagans for whom MDMA is just one chemical in the pharmacopoeia of a spiritual revolution and weekenders for whom E is just another tool for "obliviating" the boredom of workaday life. This class-based divide has quite a history. Witness the snobbish dismay of highbrow hallucinogen fiends like R. Gordon Wasson, who wrote about his psilocybin visions for *Life* magazine in 1957, only to be appalled when thrill-seeking "riff-raff" promptly descended on the magic mushroom fields of Mexico, or worse, turned to its synthetic equivalent, LSD. Wasson refused to use the pop culture term "psychedelic," preferring the more ungainly and overtly transcendentalist "entheogen" (a substance that puts you in touch with the divine). Such linguistic games and terminological niceties often seem like the only way that intellectuals can distinguish their "discriminating" use of drugs from the heedless hedonism of the masses.

Wasson's writings are one of the sources for John Moore's brilliant 1988 monograph *Anarchy & Ecstasy: Visions of Halcyon Days.* Using shreds of historical evidence, Moore imaginatively reconstructs prehistoric pagan rites dedicated to Gaia worship; he argues for the contemporary revival of these "Eversion Mysteries," insisting that a ritualized, mystical encounter with Chaos (what he calls "bewilderness") is an essential component of any truly vital anarchistic politics.

Anarchy & Ecstasy, written in the mid-eighties, reads like a prophecy and program for rave culture. Crucial preparations for the Mystery rites include fasting and sleep deprivation, in order to break down "inner resistances" and facilitate possession by the "sacred wilderness." The rites themselves consist of mass chanting, dancing ("enraptured abandonment to a syncopated musical beat" that "flings aside rigidities, be they postural, behavioral or character-

ological"), and the administering of hallucinogenic drugs in order that "each of the senses and faculties [be] sensitized to fever pitch prior to derangement into a liberatingly integrative synaesthesia." The worshippers are led into murky, mazelike caverns, whose darkness is illuminated only by "mandalas and visual images."

All this sounds very like any number of clubs with their multiple levels and corridors decorated with psychotropic imagery. As for the "hierophants" with their intoxicating poisons, this could be the dealers touting "E's and trips." Moore's description of the peak of Mystery rites also sounds very like the effect of MDMA: "The initiate becomes androgynous, unconcerned with the artificial distinctions of gender. . . . Encountering total saturation, individuals transcend their ego boundaries and their mortality in successive waves of ecstasy."

Hardly surprising, then, that organized religion has noticed the way rave culture provides "the youth of today" with an experience of collective communion and transcendence. Just as the early Church coopted heathen rituals, there have been attempts to *rejuvenate* Christianity by incorporating elements of the rave experience: dancing, lights, mass fervor, demonstrative and emotional behavior. Most (in)famous of these was the Nine O'clock Service in Sheffield, the brainchild of "rave vicar" Chris Brain, whose innovations were greeted with keen interest and approval on the part of the Anglican hierarchy until it was discovered that the reverend was loving some of his female parishioners a little too much. Despite this embarrassment, rave-style worship has spread to other cities in the UK, such as Gloucester and Bradford (where the Cathedral holds services called Eternity). There have also been a number of attempts to lure lost and confused youth into the Christian fold via drug-and-alcohol-free rave nights: Club X in Bath (organized by Billy Graham's Youth for Christ) and Bliss (a Bournemouth night started by the Pioneer Network).

None of these quasi-rave clubs administer Ecstasy as a holy sacrament. But perhaps they should, for if any drug induces a state of soul that approximates the Christian ideal — overflowing with trust and goodwill to all men — then surely it's MDMA. While rave behavior is a little outré for the staid Church of England, it chimes in nicely with the more ecstatic and gesturally demonstrative strains of Christianity. Indeed, Moby, techno's most visible and outspoken Christian, claims that "the first rave was when the Ark of Covenant was brought

into Jerusalem, and King David went out and danced like crazy and tore off all his clothes."

But the rave experience probably has more in common with the goals and techniques of Zen Buddhism: the emptying out of meaning via mantric repetition; nirvana as the paradox of the full void. Nicholas Saunders's *E Is For Ecstasy* quotes a Rinzai Zen monk who approves of raving as a form of active meditation, of being "truly in the moment and not in your head." Later in Saunders's book, there's an extract from an Ecstasy memoir in which the anonymous author describes the peculiar, depthless quality of the MDMA experience: "There's no inside"; "I was empty. I seemed to have become pure presence." At its most intense, the Ecstasy rush resembles the kundalini energy that yoga seeks to awaken: "liquid fire" that infuses the nervous system and leaves the consciousness "aglow with light."

What makes rave culture so ripe for religiosity is the "spirituality" of the Ecstasy experience: its sense of access to a wonderful secret that can be understood only by direct, unmediated experience, and the way it releases an outflow of all-embracing but peculiarly asexual love. Clearly the most interesting and "subversive" attributes of the MDMA experience, these aspects are also what makes rave fraught with a latent nihilism.

If one word crystallizes this ambivalence at the heart of the rave experience, it's "intransitive" — insofar as the music and the culture lack an objective or object. Rave culture has no goal beyond its own propagation; it is about the celebration of celebration, about an intensity without pretext or context. Hence the urgent "nonsense" of MCs at raves and on pirate radio. Witness the following Index FM phone-in session on Christmas Eve 1992, with its strange combination of semantic impoverishment and extreme affective charge.

- MC 1: Sounds of the Dominator, Index FM. And it's getting busy tonight, London. Rrrrrush!!! 'Ello mate?
- CALLER 1 (giggly, very out-of-it): 'Ello, London, I'd like to give a big shout out to the Car Park posse, yeah? There's my friend, my brother, Eli, and there's my friend over there called Anthony, and he's, like, smasher, he's hard —

MC 1: Like you, mate!

CALLER 1: Innit, of course!

MC 1: You sound wrecked -

CALLER 1: Yeah, I'm totally wrecked, mate —

[UPROAR, chants of "Oi, oi! Oi, oi!"]

CALLER 1: My bruvva my bruvva my bruvva my bruvva my bruvva —

MC 1: Make some noise!

CALLER 1: Believe you me, mate, 'ardkore you know the score!

MC 1: Respect, mate! 'Ardkore noise!

CALLER 1: Oi, can you gimme gimme "Confusion," mate? 2 Bad Mice.

MC 1 (getting emotional, close to tears): Yeah, we'll sort that one out for you. Last caller, we're gonna have to go. Respect going out to you, mate! Hold it down, last caller, *rude boy* FOR YEEEEAAARS! Believe me, send this one out to you, last caller! From the Dominator! Send this one out to you, mate. You're *a bad boy*, BELIEF!!! 90–3, the Index, comin' on strong, *belief!!!*

MC 2: Don't forget, people — New Year's Eve, Index FM are going to be throwing a free rave in conjunction with UAC Promotions. *Rrrrrave, rrrrrave!!!!* Three mental floors of mayhem, lasers, lights, all the works — you know the score.

MC 1 (gasping feyly): Oh goshhhh!!! Keep the pagers rushing! Come and go. OOOOOOH goshhhhh!! We're comin' on, we're comin on strong, believe... Deeper! Deeper into the groove.... Yeah, London Town, we've got another caller, wants to go live!

CALLER 2 (sounding rehearsed): Hi, I wanna a big shout to all Gathall Crew, all Brockley crew, Pascal, Bassline, Smasher. . . . We're in the house and we're rocking, *you be shocking*, for '92, mate!!

MC 1: Believe it, mate!

CALLER 2: 'ARD-KORE, you know the score!!!

MC 1: Where you coming from, mate?

CALLER 2: South London, mate.

MC 1: Wicked. Shout to the South London crew. Respect! Index! Yeah, London, you're in tune to the live line, Index FM, *runnin' t'ings in London right 'bout now*. The one and only.

Rapt then and now by phone-in sessions like this one, by the listeners' fervent salutations and the MCs' invocations, I'm struck by the crusading zeal and intransitive nature of the utterances: "Rushing!," "Buzzin' hard!," "Get busy!," "Come alive, London!," "Let's go!," "Time to get hyper, helter-skelter!," "Hardcore's firing!," and, especially prominent in the Index-at-Xmas session, the near-gnostic exhortation "Belief!"

Gnosis is the esoteric knowledge of spiritual truth that various pre-Christian and early Christian cults believed could be apprehended directly only by the initiate, a truth that cannot be mediated or explained in words. In rave, catchphrases like "hardcore, you know the score" or "you know the key" are code for the secret knowledge to which only "the headstrong people" are privy. And this is *drug knowledge*, the physically felt intensities induced by Ecstasy, amphetamine, and the rest of the pharmacopoeia. The MC's role, as master of the sacra-*mental* ceremonies, is ceaselessly to reiterate that secret without ever translating it. The MC is an encryptor; a potent inclusion/exclusion device — for if you're not down with the program, you'll never know what that idiot is raving about.

The transcript of the Index-at-Xmas exchange can't convey the electricity of everyone in the studio coming up on their Es at the same time, of the NRG currents pulsing across the cellular-phone ether from kids buzzing at home. Listening to pirate phone-in sessions like this, I felt there was a feedback loop of ever-escalating exultation switching back and forth between the station and the raving "massive" at home. The whole subculture resembled a giant mechanism designed to generate fervor without aim.

The rave and the pirate radio show (the "rave on the air") are exemplary real-world manifestations of two influential theoretical models, Hakim Bey's "temporary autonomous zone" (TAZ) and Gilles Deleuze and Felix Guattari's "desiring machine." The feedback loop of the phone-in sessions makes me think of Hakim Bey's vision of the TAZ as a temporary "power surge" against normality, as opposed to a doomed attempt at permanent revolution. A power surge is what it feels like — like being plugged into the national electrical grid. The audience is galvanized, shocked out of the living death of normality: "Come alive, London!" The combination of the DJ's interminable metamusic flow and the MC's variations on a small set of themes has the effect of abolishing narrative in favor of a thousand plateaus of crescendo. Again and again,

the DJ and the MC affirm "we're here, we're now, this is the place to be, you and I are we." This radical immediacy fits Hakim Bey's anarcho-mystical creed of "immediatism," so named to indicate its antagonism to all forms of mediated, passivity-inducing leisure and culture.

The rave also corresponds to Deleuze and Guattari's model of the "desiring machine": a decentered, nonhierarchical assemblage of people and technology characterized by flow-without-goal and expression-without-meaning. The rave works as an intensification machine, generating a series of heightened here-and-nows — sonically, by the music's repetitive loops, and visually, by lights, lasers, and above all the strobe (whose freeze-frame effect creates a concatenated sequence of ultravivid tableaux).

Just as a rave can't function without ravers, similarly the "desiring machine" depends on its human components — what Deleuze and Guattari call the "body-without-organs." The opposite of the organism — which is oriented around survival and reproduction — the body-without-organs is composed out of all the potentials in the human nervous system for pleasure and sensation without purpose: the sterile bliss of perverse sexuality, drug experiences, play, dancing, and so forth. In the rave context, the desiring machine and the body-without-organs are fueled by the same energy source: MDMA. Plugged into the sound system, charged up on E, the raver's body-without-organs simply buzzes, bloated with unemployable energy: a feeling of "arrested orgasm" captured in pirate MC ejaculations like "oooooh gosh!"

Described by Deleuze and Guattari as "a continuous, self-vibrating region of intensities whose development avoids any orientation toward a culmination point or external end," the body-without-organs is an update of Freud's notion of polymorphous perversity: a diffuse eroticism that's connected to the nongenital, nonorgasmic sensuality of the pre-Oedipal infant. The body-without-organs also echoes age-old mystical goals: Zen's Uncarved Block, a blissful, inchoate flux preceding individuation and gender; the "translucent" or "subtle body," angelic and androgynous, whose resurrection was sought by the gnostics and alchemists.

In *Omens of Millennium* — a book about the contemporary resurgence of gnostic preoccupations with angels and near-death experiences — Harold Bloom argues: "To be drugged by the embrace of nature into what we call most natural in us, our sleepiness and our sexual desires, is at once a pleasant and

an unhappy fate, since what remains immortal in us is both androgynous and sleepless." MDMA, an "unnatural" designer drug whose effects are antiaphrodisiac and insomniac, might be a synthetic shortcut to recovering our angelhood. I remember one time on E enjoying a radical sensation of being without gender, a feeling of docility and angelic gentleness so novel and exquisite I could only express it clumsily: "I feel really effeminate." The subliminal hormonal "hum" of masculinity was suddenly silenced.

Such sensations of sexual indifference have everything to do with MDMA's removal of aggression, especially sexual aggression. E's reputation as the "love drug" has more to do with cuddles than copulation, sentimentality than secretions. E is notorious for making erection difficult and male orgasm virtually impossible; women fare rather better, although one female therapist suggests that on Ecstasy "the particular organization and particular focusing of the body and the psychic energy necessary to achieve orgasm [is] . . . very difficult." Despite this, MDMA still has a reputation as an aphrodisiac — partly because it enhances touch, and partly because affection, intimacy, and physical tenderness are, for many people, inextricably entangled and conflated with sexual desire.

Unaware of Ecstasy's effects, many early commentators were quick to ascribe the curiously chaste vibe at raves to a post-AIDS retreat from adult sexuality. But one of the most radically novel and arguably subversive aspects of rave culture is precisely that it's the first youth subculture that's not based on the notion that sex is transgressive. Rejecting all that tired sixties rhetoric of sexual liberation, and recoiling from our sex-saturated pop culture, rave locates bliss in prepubescent childhood. Hence the garish colors and baggy clothing, the backpacks and satchels, the lollipops and pacifiers and teddy bears — even the fairground sideshows. It's intriguing that a drug originally designed as an appetite suppressant should have this effect. Anorexia has long been diagnosed as a refusal of adult sexual maturity and all its accompanying hassles. Ecstasy doesn't negate the body, it intensifies the pleasure of physical expression while completely emptying out the sexual content of dance. For men, the drug/music interface acts to de-phallicize the body and open it up to enraptured, abandoned, "effeminate" gestures. But removing the heterosexist impulse can mean that women are rendered dispensable. As with that earlier speed-freak scene, the mods (who dressed sharp and posed to impress their mates, not to lure a mate), there's a homosocial aura to many rave and club scenes. Hence the autoerotic/autistic quality to rave dance. Recent converts to raving often express the sentiment "it's better than sex."

The samples that feature in much rave music — orgasmic whimpers and sighs, soul diva beseechings — induce a feverish state of *intransitive amorousness*. The ecstatic female vocals don't signify a desirable/desirous woman, but (as in gay disco) a hypergasmic rapture that the male identifies with and aspires toward. The "you" or "it" in vocal samples refers not to a person but a sensation. With E, the full-on raver lifestyle means literally falling in love every weekend, then (with the inevitable midweek crash) having your heart broken. Millions of kids across the globe are riding this emotional roller coaster. Always looking ahead to their next tryst with E, addicted to love, in love with . . . nothing?

In her memoir *Nobody Nowhere*, the autistic Donna Williams describes how as a child she would withdraw from a threatening reality into a private preverbal dream-space of ultravivid color and rhythmic pulsations; she could be transfixed for hours by iridescent motes in the air that only she could perceive. With its dazzling psychotropic lights, its sonic pulses, rave culture is arguably a form of *collective autism*. The rave is utopia in its original etymological sense: a nowhere/nowhen wonderland.

So perhaps the best classification for Ecstasy is "utopiate," R. Blum's term for LSD. The Ecstasy experience can be like heaven on Earth. Because it's not a hallucinogen but a sensation intensifier, MDMA actually makes the world seem *realer*; the drug also feels like it's bringing out the "real you," freed from all the neurosis instilled by a sick society. But "utopiate" contains the word "opiate," as in "religion is the opium of the people." A sacrament in that secular religion called "rave," Ecstasy can just as easily be a counterrevolutionary force as it can fuel a hunger for change. For it's too tempting to take the easy option: simply repeating the experience, installing yourself permanently in rave's virtual reality pleasuredome.

NOTTING HILL CARNIVAL | AUGUST 1993

Black sheep of the post-rave diaspora, jungle is banished to a small public park called Horniman's Pleasance on the outskirts of the carnival zone. Adverts on pirate radio had raved breathlessly about the park's twenty-five thousand capacity, but the event hasn't quite lived up to the hype. In fact, only twenty-five people have turned up. A few try to dance, in a desultory fashion; most stand around looking confused. After half an hour, my posse's patience runs out, and we head back to the center of the carnival, where the pumping house and garage systems have packed the side streets off Portobello Road. A believer, I can't reconcile the awesome vitality of the music seething out of the pirate airwaves with this seeming proof that jungle just ain't runnin'.

NOTTING HILL CARNIVAL | AUGUST 1994

What a difference a year makes. It seems like every other sound system is blasting jungle, deafening and distorted through overdriven speakers. UK Apachi, man of the moment with his Top 40 cracking "Original Nuttah," seems to be doing PAs at most of them; we see him perform at least three times. And wherever there's a jungle system, the streets are choked with a crush of mostly young black bodies. It's 1994, and jungle is *running 'tings in London town right 'bout now.*

Out of the fluxed-up chaos of 'ardkore evolved an entirely new sound, a new subculture: jungle. Between 1992 and 1994, jungle shed the chrysalis of hardcore, and with it every last vestige of the rave ethos. The only element of hardcore rave to survive was the sheer velocity of the music; it was as though Ecstasy culture had permanently hyped up the metabolism of a generation.

The speed aspect is crucial. Scene insiders offer platitudes like "jungle is a feeling." But if you need a definition, then the music's core is the accelerated, chopped-up breakbeat rhythms that create that feeling — what Bjork crystallized as "fierce, fierce joy . . . sort of 'I'm just too happy, I want to explode.'" Happy isn't quite the word: jungle's militant euphoria is fueled by the desperation of the early nineties. Composed literally out of fracture ("breaks"), jungle paints a sound picture of social disintegration and instability. But the anxiety in the music is mastered and transformed into a kind of nonchalance; the disruptive breakbeats are looped into a rolling flow. In this way, jungle

contains a nonverbal response to troubled times, a kind of warrior stance. The "resistance" is in the rhythms. Jungle is the metabolic pulse of a body reprogrammed and rewired to cope with an era of unimaginably intense information overload. As such, its rhythmic innovations will pervade popular music well into the twenty-first century, as insidiously and insinuatingly as rock 'n' roll, funk, and disco have done in the past.

A breakbeat is the percussion-only section of a funk or disco track, the peak moment at which dancers cut loose and do their most impressive steps. In mid-seventies Bronx, DJ Kool Herc invented the hip-hop technique of looping these breaks into a continuous, hypnotic groove by using two turntables and two copies of the same record. By the mid-eighties, rap producers were using sampling and sequencing technology to loop beats with greater precision.

Prized for their gritty, live feel, breakbeats come from James Brown and his band the JBs, from the Meters, Kool & the Gang, and the Jimmy Castor Bunch, from fusion artists like Bob James and Herbie Hancock, and from a legion of obscure funk and disco artists of the seventies. As hip-hop culture burgeoned in the early eighties, the choicest breakbeats - like "Apache" by the Incredible Bongo Band — were collated on "Breaks and Beats" compilations. The most famous break in all of jungle is "Amen," a hard-driving snare-andcymbal sequence from "Amen, My Brother," by the soul group the Winstons. Chopped up, processed through effects, resequenced, "Amen" has been used in thousands of tracks and is still being reworked. How would the drummer in the Winstons react if you told him that a stray moment of casual funkiness, thrown down in a studio in 1969, had gone on to underpin an entire genre of music? Close behind "Amen" there's the classic break from Lyn Collins's "Think," in which James Brown yells "you're bad, sister" to Collins. Sped up so that JB sounds like a funky elf with a chronic case of hiccups, "Think" became a feverish, percussive tic almost as ubiquitous in jungle as "Amen."

In the early nineties, many house and techno producers had started to use breakbeats in tracks, either to add extra polyrhythmic "feel" or simply because it was easier to loop and accelerate a segment of "real" drums than to program a drum machine. As breakbeat house and hardcore grew popular, this shortcut was transformed into a positive aesthetic by younger producers,

many of whom had been original British B-boys. Living up to the root meaning of that term (the B refers to "breaks"), producers like Gavin King and Micky Finn of Urban Shakedown, DJ Hype, and Danny Breaks of Sonz of a Loop Da Loop Era layered multiple breakbeats to form an exhilarating bedlam of clashing and meshing polyrhythms.

This hypersyncopated hardcore drew more black British kids into rave culture, catalyzing the feedback loop of black influence that resulted in jungle. But the breakbeat mess-thetic alienated as many as it seduced. While jungle, like most pop music, is in 4/4 time, it lacks the stomping, metronomic four-tothe-floor kick drum that runs through techno, house, and disco. Eurodisco pioneer Giorgio Moroder had deliberately simplified funk rhythms to make it easier for white dancers; the "jungalistic hardcore" that emerged in 1992 reversed this process, and for many ravers it was simply too funky to dance to. That year, Josh Lawford of Ravescene magazine prophesied that the breakbeat was "the death-knell of rave," and in a sense, he was correct. But it was more than just the disappearance of the four-to-the-floor kick that alienated ravers. Jungle's dense percussive web destabilizes the beat, traditionally the steady pulse of pop music. Breakbeats make the music feel treacherous. The safety factor intrinsic to most machine-made dance music, the predictability that allows the listener to trance out, was replaced by a palpable danger. Jungle makes you step in a different way, wary and en garde. It was this edginess that drove many ravers out of the hardcore scene and back to house.

Through 1993 these rhythmic innovations matured into a veritable *breakbeat science*. Sampled and fed into the computer, beats were chopped up, resequenced, and processed with ever-increasing degrees of complexity. Effects like "time stretching/compression," pitch shifting, "ghosting," and psychedeliastyle reverse gave the percussion an eerie, chromatic quality that blurred the line between rhythm, melody, and timbre. Separate drum "hits" within a single breakbeat could be subjected to different degrees of echo and reverb, so that each percussive accent seems to occur in a different acoustic space. Eventually, producers started building their own breakbeats from scratch, using "single shot" samples — isolated snare hits, hi-hat flutters, et cetera. The term breakbeat science fits because the process of building up jungle rhythm tracks is incredibly time-consuming and tricky, involving a near-surgical precision.

Breakbeat science transformed jungle into a rhythmic psychedelia. Unlike

sixties psychedelic rock, which was "head" music, jungle's disorientation is as much physical as mental. Triggering different muscular reflexes, jungle's multitiered polyrhythms are body-baffling and discombobulating unless you fixate on and follow one strand of the groove. Lagging behind technology, the human body simply can't do full justice to the complex of rhythms. The ideal jungle dancer would be a cross between a virtuoso drummer (someone able to keep separate time with different limbs), a body-popping breakdancer, and a contortionist.

Alongside its kinesthetic/psychedelic effects, jungle's radicalism resides in the way it overturns Western music's hierarchy of melody/harmony over rhythm/timbre. In jungle, the rhythm is the melody; the drum patterns are as hooky as the vocal samples or keyboard refrains. In Omni Trio's classic "Renegade Snares," the snare tattoo is the mnemonic, even more than the threenote, one-finger piano motif. The original versions of "Renegade" focus on a bustling, ants-in-your-pants snare-and-rimshot figure, like a cross between James Brown's "Funky Drummer" and an Uzi. The subsequent remix and reremix by Omni's allies Foul Play make the snares snake and flash across the stereofield like a streak of funky lightning. On all four versions, Omni and Foul Play make the drums sing inside your flesh.

This rhythm-as-melody aesthetic recalls West African music. It also parallels the preoccupations of avant-classical composers like John Cage and Steve Reich, who drew inspiration from the treasure trove of chiming timbres generated by Indonesian gamelan percussion orchestras. Jungle fulfills the prophecy in Cage's "Goal: New Music, New Dance" of a future form of electronic "percussion music" made by and for dancers. "What we can't do ourselves will be done by machines and electrical instruments which we will invent," wrote Cage, seemingly predicting the sampler and sequencer.

Alongside breakbeat science, the other half of jungle's musical core is its radically mutational approach to bass. Until 1992, the bass line in hardcore generally followed the 140 bpm tempo; on tracks like Xenophobia's "Rush in the House," the effect was as jittery as a raver's heartbeat after downing three Es. Gradually, a slower bass line sound came in: at first, a seismic, sine-wave ooze of low-end frequencies; later a dub reggae bass line that ran at about 70 bpm beneath the hectic breaks. The half-speed bass line transformed jungle into two-lane music, tempowise. Like driving on the motorway, you could groove in the slow lane to the skanking B-line, then shift to the fast lane and flail to the drums.

As the beats grew ever more complicated, the bass took on a sophisticated melodic and texture a role that broke with the metronomic, pulsating bass lines in techno. Making a parallel with 1940s bebop, David Toop described this role: "Bass is returned to its function as a physically felt harmonic/rhythmic component rather than a stun-gun which punches home the chord changes." Physically felt is the key phrase: jungle's sub-bass frequencies operate almost below the threshold of hearing, impacting the viscera like shock waves from a bomb. "Rumblizm" is how DJ Nicky Blackmarket designated jungle's low-end seismology. New effects and new kinds of riffs emerged every month: stabbing Blines that updated the "sonic boom" effect that rap producers had got from detuning the Roland 808 drum machine; reversed B-lines emitting a sinister, radioactive glow, a sound dubbed "dread bass" after the Dead Dred track that made it famous; shuddering tremolo effects like a spastic colon; metallic pings and sproings like syncopated robot farts. Just as they had meshed together multiple strands of percussion, producers eventually deployed two or more bass lines simultaneously. In jungle, bass — hitherto dance music's reliable pulse — became a plasmalike substance forever morphing and mutating. Like the jittery breakbeats, this new dangerbass put you on edge — like dancing over a minefield.

How did this martial music emerge out of rave culture, with its loved-up, peacedelic spirit? Where did all the junglists come from, anyway? Some were original British B-boys who'd gotten swept up in the hardcore rave scene; others came from the reggae sound-system subculture of the eighties, whose music policy ran the spectrum of imported "street sounds" from dub and dance hall to electro and rap.

Take the trajectory followed by Danny Breaks, the white whizz kid from Essex behind Sonz of a Loop Da Loop Era and later Droppin' Science. As a schoolboy, Danny was into electro, break dancing, and "cutting up breaks on the turntables." By the late eighties Danny had decided that UK rap wasn't "really runnin.' Even when the UK crews were rapping about everyday English life, it didn't come 'cross, 'cos so much of the flavor of rap is the American voice." Rap also never developed the political role (what Chuck D called "black folks' CNN") that it did in America, because, Danny argued, "black and white are

more integrated in Britain, at least amongst the young." Because of this, British youth were always more interested in hip-hop's sampladelic sorcery and breakbeat manipulation, rather than the verbal, protest side of rap.

Like other 'ardkore junglists with roots in the electro/body-popping/graffiti era — Aphrodite, DJ Crystl, 4 Hero, DJ SS — Danny's desire to "do instrumental stuff with breaks and weird sounds" drew him gradually into the rave scene. When acid house hit in 1988, this first generation of British B-boys was swept up in rave fervor; acieed's phuturism eclipsed an American hip-hop sound already retreating to trad funk 'n' soul grooviness. This rave-lation coincided, for many, with their final alienation from American rap, which had taken a turn toward the grimly serious — from the "niggativity" of gangsta rappers like NWA and the Geto Boys to the righteous "edutainment" of KRS 1 and X-Clan.

Infiltrating the hardcore rave scene, these lapsed B-boys came up with their own hyperkinetic mutant of hip-hop. Suppressing the storytelling and rhyming skills side of rap, they reactivated a neglected legacy: the frigid futurism of electro, the cut-'n'-mix collages and jarring edits of Davy DMX, Steinski, and Mantronix. Sampladelia taken to the dizzy limit, 'ardkore was basically hip-hop on E rather than a debased form of techno, as its critics supposed. But consider the fact that MDMA is not exactly a B-boy drug and you'll have some idea of how strange a hip-hop mutant 'ardkore was. On tracks like Hyper-On Experience's "Thunder Grip" and DJ Trax's "We Rock the Most," breakbeats swerve and skid, melody shrapnel whizzes hither and thither, and every cranny of the mix is infested with hiccuping vocal shards and rap chants sped up to sound like pixies. The vibe is sheer Hanna-Barbera zany-mania, but beneath the smiley-faced "hyper-ness" the breaks and bass lines are ruff B-boy bizness.

'Ardkore producers like Hype and 2 Bad Mice even revived scratching, an old skool technique that had virtually disappeared from US hip-hop as it evolved from its DJ-and-MC-oriented street party origins into a studio-based art oriented around the producer and the rapper-as-poet. Danny Breaks christened this 'ardkore subgenre "scratchadelic." A classic example is 2 Bad Mice's remix of Blame's "Music Takes You," where a squelchy scratch riff slots right next to the Morse code keyboard stab, piano vamps, and staccato blasts of hypergasmic diva.

Although it started as a breakbeat-fueled offshoot of techno, 'ardkore jungle had devolved by late 1992 into a speed-freak cousin of old skool hip-

hop. 'Ardkore was the messy birth pangs of Britain's very own equivalent to (as opposed to imitation of) US hip-hop: jungle. That said, you could equally make the case that jungle is a raved-up, digitized offshoot of Jamaican reggae. Musically, jungle's spatialized production, bass-quake pressure, and battery of extreme sonic effects make it a sort of postmodern dub on steroids. As a subculture, jungle is riddled with Jamaican ideas - like "dubplates" (exclusive tracks given to DJs far in advance of release) and "rewinds" (when the crowd exhorts the DJ to "wheel and come again," or manually spin a track back to the start at high velocity, producing a violent screech by rubbing the stylus the wrong way). By the end of '92, junglist MCs were adding patois buzzphrases from dance hall reggae — "Big it up!," "Brock out!," "Booyacka!" — to their repertoire of rave rallying cries and B-boy boasts, and exhorting the crowd to raise their lighters in the air, the ragga fan's traditional salute to the DJ. And by early '94, the most popular jungle tracks were those that used vocal licks sampled from raggamuffin stars like Buju Banton, Cutty Ranks, and Spragga Benz, whose rasping, grainy voices and self-aggrandizing insolence fitting perfectly with the rough-cut rhythms.

Even the name "jungle" comes from Jamaica (as does its more baldly descriptive synonym, "drum and bass"). According to MC Navigator from London's ruling pirate station Kool FM, "jungle" comes from "junglist," and was first heard in 1991 as a sample used by Rebel MC (who pioneered British hiphouse in the early nineties, then formed the proto-jungle label X Project). "Rebel got this chant — 'alla the junglists' — from a yard tape," Navigator told me, referring to the sound-system mix tapes imported from Jamaica. (Yard is the slang term for Kingston and the root of 'yardie,' a hustler or hood-lum.) "There's a place in Kingston called Tivoli Gardens, and the people call it the Jungle. When you hear on a yard tape the MC sending a big-up to 'alla the junglists,' they're calling out to a posse from Tivoli. When Rebel sampled that, the people cottoned on, and soon they started to call the music 'jungle.' "

Actually, there's no real conflict between the jungle-as-twenty-first-century-hip-hop and the jungle-as-cyber-dub theses. Jungle completes the circle in that it reconnects hip-hop with one of its multiple sources: Jamaica. Like many Bronx denizens, DJ Kool Herc was a Jamaican immigrant. As well as inventing

breakbeat science, Herc imported reggae's tradition of megabass sound systems. Reconnecting the Bronx to Kingston, jungle is the latest and greatest of the "postslave," postcolonial hybrids hatched within what Paul Gilroy has dubbed "the Black Atlantic." Jungle is where all the different musics of the African-American/Afro-Caribbean diaspora reconverge. In jungle, all the most African elements (polyrhythmic percussion, sub-bass frequencies, repetition) from funk, dub reggae, electro, rap, acieed, and ragga are welded together into the ultimate tribal trance-dance.

Beyond the idea of the en-tranced dancer being possessed by the spirits, "voodoo" has another resonance with jungle, insofar as Haitian *voudun* is a hybrid culture, a mix 'n' blend of black and white. Like Cuban santeria, *voudun* is a syncretic religion combining West African animist beliefs with elements of Catholicism. Even more striking is the centrality of drums in *voudun* ceremonies and rites. Just as African drums were used as signals for slaves to escape or rebel in the Deep South, similarly *voudun* fueled the revolt of the Haitian slaves, leading to the founding of the first black republic in the Western Hemisphere.

Of course, these submerged resonances aren't the reason London youth "cottoned on," as Navigator put it, to the word "jungle." First and foremost, the term just seems to fit the music like a glove. When you're on the dance floor, it feels like you're inside a jungle of seething polyrhythms, a sensation at once thrilling and scary. Then there's the "urban jungle" metaphor that runs through black pop history in a thread that connects the Wailers' Kingston ghetto-inspired "Concrete Jungle," Sly and the Family Stone's "Africa Talks to You (The Asphalt Jungle)" and the prototypical documentary-realist rap and Grandmaster Flash and the Furious Five's "The Message."

There's also an extensive, highly charged history in pop music of "jungle rhythms" as object of both fear and desire. "Jungle" reinvokes the anxieties of the older, white generation confronted by the "primitivistic" repetition and percussive stridency of fifties rock 'n' roll. Some of the more paranoid antirock evangelists hallucinated a Soviet Communist conspiracy to "negrify" the youth, with Elvis the Pelvis as a pied piper leading the kids into the "dark continent" of animalistic sexuality. Jungle returns to rock 'n' roll's original sin—the prioritization of beat over melody—and drastically exacerbates it by stripping it down to just drum and bass.

Underlying the fear of the "jungle beat," of course, was the fear of miscegenation, the loss of racial identity. In the nineties such fears were no longer the preserve of white supremacists. The title of Spike Lee's anti-mixed marriage movie *Jungle Fever* comes from Nation of Islam supremo Louis Farrakhan, who uses it as a derogatory term for interracial relationships. In Britain, "jungle fever" has sometimes been shouted by black youth at mixed-race couples.

The question of jungle's musical "color" bedevils outside commentators and insiders alike. Jungle is often hailed as the first significant and truly indigenous black British music. This notion obscures the fact that alongside hiphop and reggae, the third crucial constituent of jungle is whiter-than-white: the brutal bombast of the Euro-hardcore sound spawned in Belgium. But even if one concedes jungle's musical "blackness" as self-evident, this only makes it all the more striking that from day one more than half of the leading DJs and producers have been white. Some of the "blackest-sounding," most hip-hop-and-ragga-influenced tracks come from pasty-faced producers like Andy C, Aphrodite, Doc Scott, Dead Dred, Hype, and Pascal.

For the most part, junglists deemphasize the word "black" and stress "British"; there's a weird patriotism, in part a proud response to years of having to look to black America or Jamaica for beats, but also evidence that these second- or third-generation immigrants feel that the UK is their home. Even Nation of Islam—influenced militants like Kemet Crew stress that jungle has always been an integrated scene, while Kool FM's credo is "no matter your class, color or creed, you're welcome in the house of jungle." Far from being racist (as Shut Up and Dance alleged) the term "jungle" actually codifies the multiracial nature of the scene as compared with the mostly white audience for trance and "intelligent" techno. The true meaning of "junglist" is defined not by color, but by class, insofar as all working-class urban youth are "niggas" in the eyes of authority. Junglist youth constitute a kind of internal colony within the United Kingdom: a ghetto of surplus labor and potential criminals under surveillance by the police.

In many ways, jungle is outlaw music: the scene's three staples are pirate radio, drugs, and uncleared samples. From late 1992 onward, the nascent

jungle scene rapidly developed an overtly criminal-minded attitude. Tuning into the newer pirate stations like Don FM, you'd hear MCs sending out "big shouts" to "all the wrong'uns" and "liberty-takers." The nefarious vibe filtered into the music too, in the form of samples of sirens and bloodcurdling gunshots, and sound bites from blacksploitation thrillers and gangsta movies like *Goodfellas*. Ragga-influenced gun-talk pervaded the music with track titles like "Hitman" and "Sound Murderer."

Jungle's ghettocentric vibe reflected the state of the nation in 1993. The recession had hit Britain hard, and inner-city youth faced unemployment and a welfare system that had been systematically dismantled by the Conservative government during its fourteen years of one-party tyranny. "American" problems like guns and crack were taking root. Desperate music for desperate times, jungle's two preoccupations were oblivion and crime. Inner-city kids wanted to get out of "it" (dead-end post-Thatcherite reality), either by taking drugs or by selling them. All this made the emergence of "gangsta rave" — seemingly a contradiction in terms — a logical upshot of systemic failure.

As the music changed, so did the mood of the scene. In 1992 the received image of the 'ardkore raver was a sweaty, shirtless white teenager, grinning and asking for a sip of your Evian. By 1994 the stereotypical junglist was a head-nodding, stylishly dressed black twenty-something with hooded eyes, a joint in one hand, and a bottle of champagne in the other. Out went all the trappings of rave — the woolly hats and baggy T-shirts, the white gloves and fluorescent light sticks. Despite the saunalike humidity of clubs and raves like Telepathy, Innersense, and Sunday Roast, junglists came encased in black flight jackets. For a while it was the fashion among the more chic black junglists to carry handkerchiefs, in order to dab away perspiration and literally keep their cool. The new taboo on sweat and the rowdy communion it symbolizes signaled that the scene's emotional temperature had dropped. By 1993 eye contact was disappearing from the London hardcore scene; bonhomie gave way to a surly vigilance. Smiling (often considered a signifier of servility in black hip-hop culture) was replaced by the skrewface, a pinched sneer expressing disgust and derision.

As hardcore evolved into jungle, it shed rave's emotional demonstrativeness and gestural abandon, which had originated in gay disco and entered white working-class body consciousness via Ecstasy. In its place, a "black" ethos of self-control and masklike inscrutability was embraced by white and black alike. Paralleling and/or catalyzing this shift were changing patterns of drug use. 'Ardkore's knowing references to "rushing" and E-based innuendos were replaced by roots reggae sound bites about sinsemilla, ganja, and herb. To an extent, the disappearance of the Ecstasy vibe allowed young black Britons to enter the rave scene en masse and begin the transformation of hardcore into jungle. MDMA's effects of defenseless candor are probably too risky a cultural leap for the young black male, who can't afford to jeopardize the psychic armor necessitated by the very different black experience of urban life.

As marijuana displaced E, dancing lost its mania, became less ravey and out of control. The half-speed bass-line allowed dancers the option of grooving to the dub-sway bass rather than going berserk to the 160 bpm breaks. At a 1992 rave you'd see lots of open-body gestures. At climactic moments or cosmic interludes in the music, arms were held aloft, outstretched to the heavens in a universal gesture of mystic surrender. Jungle replaced this splayed vulnerability with more controlled movements, closer to shadow boxing or martial arts. As the dance hall reggae influence kicked in, ragga clothing and body moves infiltrated the scene. Girls appeared wearing skin-tight hot pants, bustiers, and microskirts; they'd drop to a panther-style half-crouch and flex their abdomens with the kind of risqué, confrontational sexuality patented by ragga chanteuse Patra. The effect — imagine a Zulu go-go girl — was sexy but menacing, seducing the male gaze only to stab it in the eye with every pelvic thrust.

Sounds of the Lucky Spin, believer! Lively business! Shout going out to Rattle, you know the koo. Cooked food, love it to the bone! To the marrow! Normality, believe! L-I-V-E and direct, to the koo. Are you ready, wind-yourwaist crew? And those who's driving

around Don-land North East South and West, we've got you locked!!! Get on the case, for the hardcore, hardcore bass. For ya face — 100 percent bass! all right, red-eye crew, you know the koo. Do-it-like-this, jungalist! Believe me, 'ardkore's firing!

MC OC, Don FM, 1993

Perhaps the most thrilling phase of jungle's history was its birth pangs in 1992–93, when the MC chants celebrated "'ardkore jungle" or "jungalistic 'ardkore": a semantic vacillation that evokes the thrilling immediacy of a sonic/subcultural hybrid hatching before your astonished ears. This moment of miscegenation is audible in the MC-ing itself. Where the hoarse, rabble-rousing rave MC of 1990–91 was like a cross between a Cockney street vendor and an aerobics instructor, the 'ardkore jungle MCs that followed added techniques and flavors from rap and reggae. The patois-rich patter of this era of MC-ing was a genuine creole tongue, a delirious mix of ragga chat ("big it up!," "brock out!," "maximum boost," "big up your chest"), E-monster drivel ("oh-my-gosh!," "buzzin' 'ard"), American hip-hop slang ("madding up the place!" "blasting bizness!"), and Oi!-like Cockney earthiness ("luvvit to the bone!").

Having been strictly supplementary in rave — on a par with the Lycra-clad female dancers — the MC became an increasingly crucial figure in jungle, only a notch below the DJ. MC-ing is harder than it looks. As the spokesperson for the audience, the MC must generate infinite variations on a restricted repertoire of utterances: all-praise-the-DJ exhortations, druggy innuendoes, exclamations of excitement, and testifications of inexhaustible faith in the entire subcultural project. Jungle MCs get around the semantic poverty of their patter by utilizing an arsenal of incantatory techniques that bring spoken language closer to music: intonation, syncopation, alliteration, internal rhyme, slurring, rolling of *r*'s, stuttering of consonants, twisting and stretching of vowels, comic accents, onomatopoeia. By finding rhythmic and timbral twists to the restatement of their simple themes, great MCs — from 'ardkore unknowns like Rhyme Time and MC OC to top-of-the-bill junglist

chatters like GQ, Moose, Dett, and Five-O — create that intangible but crucial jungalistic factor known as "vibe."

Jungle's "creole" culture could have evolved only in London; Paul Gilroy describes the city as "an important junction point or crossroads on the webbed pathways of black Atlantic [political and cultural traffic]." The assertion of African sonic priorities (polyrhythm, low-end bass frequencies) caused breakbeat-based hardcore to contract from a nationwide, chart-topping pop music into a regional underground centered on London and its surrounding counties. This contraction was celebrated by such late-'92 tracks as Code 071's "London Sumtin' Dis" and Bodysnatch's "Just 4 U London." Apart from outposts in multiracial areas like the Midlands and Bristol, the rest of the country shunned jungle. From the rave-will-never-die movement called "happy hardcore" to the club-based house mainstream, the four-to-the-floor kick drum ruled supreme everywhere but the capital.

As jungle bunkered down into a self-sufficient London underground, it developed something of a siege mentality and a persecution complex. Following the spate of cutesy Prodigy-copyist hits in 1992 based on kids'-TV theme tunes ("Trip to Trumpton," "Sesame's Treet," et al.), dance mags like *Mixmag* had proclaimed the death of rave and cold-shouldered hardcore into a long phase of media blackout. During 1993, jungle sustained itself through its infrastructure of pirate radio, small independent labels, dingy, off-the-beaten-track clubs, and specialist record shops like Lucky Spin, Blackmarket, Unity, and De Underground.

The result was a renegade underground economy that flew in the face of all the "commonsense" business notions adhered to by the music industry in the 1990s. In defiance of the hegemony of the CD, jungle was all about vinyl. The 12-inch was an end in itself, not an advert for the album (which barely existed anyway). The 12-inches were bought mostly by DJs, both professional and aspiring. Fans bought DJ mix tapes, available at specialist stores, street markets, or by mail-order, rather than purchase the few shoddy compilations that were available.

The mix tape was so popular because of jungle's other major break with record biz logic: at any given moment, a huge proportion of the music that's hot in the clubs cannot be purchased as commercially available vinyl. This is

because of the thrall of the dubplate. Producers give influential DJs a prerelease version of a track on DAT, recorded straight from their home studio. The DJ presses up a metal acetate at his own expense (around \$50), which lasts about twenty-five to forty plays. The dubplate is a Jamaican idea: seventies sound systems pressed up their own tracks in order to outdo their rivals. Similarly, jungle's top DJs, desperate for exclusive tracks, spend more than two hundred pounds a week on dubplates — either their own productions or tracks by kindred-spirit producers. Dubplates are also a way of testing out a new track on a club sound system, of seeing how the crowd responds and what scope there is for improving the record.

This sounds "democratic," but unfortunately the net effect of the dubplate system is that fans are tantalized for months (sometimes as long as a year!) until the track's official release, by which time DJs have stopped playing the tune. Some dubplates never get issued at all. Hence the appeal of mix tapes. The only other alternative is to tape hours of cost-free DJ cut 'n' mix off the pirate radio stations.

It's impossible to overstate the importance of pirate radio for jungle's survival during its two and a half years of banishment from the media. At any point between 1992 and 1994 you could scan the FM spectrum and find at least a dozen 'ardkore jungle stations disrupting the decorum of the airwaves with their vulgar fervor and rude-boy attitude — stations like Touchdown, Defection, Rush, Format, Pulse, Eruption, Impact, Function, and Kool, to name only the most famous.

Pirate radio got its romantic name not just from its flagrant flouting of government restrictions on the airwaves, but from its early days in the 1960s, when unlicensed pop stations broadcast from ships anchored at sea just outside British territorial waters. This first golden age of pirate radio came to an abrupt end in August 1967 when the Labour government passed a law making it illegal to operate or finance an unlicensed station. But in the early eighties, pirate radio entered its second boom period, with the rise of black music stations — Horizon, Dread Broadcasting Corporation, Kiss, LWR — which specialized in the soul, reggae, and funk marginalized by the BBC's national pop station, Radio One. By this point, the nautical connotations of "pirate" had faded. The new

illegal stations transmitted from "tower blocks" (high-rise apartment buildings) in the heart of London, using "microlinks" (microwave transmitters) to relay their broadcasts to remote aerials on the tops of other buildings. This made it harder for their enemy, the DTI (Department of Trade and Industry), to trace the signal back to the station's studio-HQ. By 1989 there were six hundred stations nationwide and over sixty in the London area alone — including a new breed of rave pirates like Sunrise, Centre Force, and Fantasy.

In the early nineties, piracy briefly declined in response to tougher penalties, an intensified crackdown by the DTI, and the legalization of leading dance pirate Kiss FM (which had taken up the government's offer of amnesty for stations that closed down voluntarily and applied for an official license). But with the increasingly commercialized Kiss FM failing to satisfy the rave audience's craving for raw-to-the-core 'ardkore, the London pirates resurged massively in 1992. Abandoning the last vestiges of mainstream pop radio protocol, the new pirates sounded like "raves on the air": rowdy, chaotic, and with a strong emphasis on audience participation, enabled by the spread of the portable cellular phone. Despite a fresh package of draconian penalties (unlimited fines, prison sentences of up to two years), 1992–93 saw the biggest boom in the history of illegal radio.

Surviving as a pirate involves a mix of graft, skill, and cunning similar to that possessed by their seafaring namesakes of the seventeenth century. Because "microlink" transmitters operate by a line-of-sight, directional beam, the DTI can only trace the signal back to the pirate studio once they've got to the top of the tower block and found the relay transmitter. To thwart this, the pirates attach a cutout switch to the rooftop door, which cuts the power supply and breaks the link — ensuring that all they lose in a raid is a transmitter rig worth a few hundred pounds. Meanwhile, the station will have redirected its microlink beam to a backup transmitter on another building, thereby maintaining broadcast continuity. If the DTI comes down hard on a particular station, it can lose several transmitters each weekend — an expensive business. Revenue comes from advertising for raves and specialist record shops, but also from the DJs, who actually pay a small fee for the privilege of playing.

Despite this idealistic, love-not-money amateur ethos, pirate radio has long been tarnished with a money-grubbing, criminal-minded reputation. In 1989 several Centre Force DJs were prosecuted for Ecstasy dealing, while accusa-

tions of gangster ties and coded, on-air drug transactions have often been leveled at the jungle pirates. But for all their conspiratorial, clandestine aura, the pirates' criminal activities are generally limited to the struggle to stay on the air. Legend has it that one station blocked a stairwell with concrete to prevent access to the upper stories of an abandoned East London apartment block; the DJs had to rappel up the side of the building to reach the studio.

Such paranoid/paramilitary strategies are exceptional. But cutoff switches, booby traps, and alarms are used to protect transmitters — not
just from the DTI, but from other pirates who will steal the equipment if given
the opportunity. Reflecting the dog-eat-dog nature of the nineties lumpenprole life, there appears to be scant solidarity between the pirates. "A transmitter rig is worth about three hundred pounds," says Marcus, an
eighteen-year-old formerly involved with South London pirate Don FM. "If you
see one and take it, it's almost not regarded as thieving. It's part of the game."

The main threat comes from the DTI, though. Which begs the question: Why is the government dedicated to stamping out the pirates? Is it just the innate desire of state power to regulate all media? Strangely, Britain has never seen much in the way of political "free radio." But an Italian pirate, Radio Alice, played a major role in catalyzing the anarcho-syndicalist riots in Bologna in 1977. If the concept of "resistance" can be applied to the jungle pirates, though, it's clearly on the level of symbolic warfare (that old cultural studies notion of "resistance through rituals") as opposed to overt protest. The pirates hijack the mass media, the instrument of consensus, in order to articulate a minority consciousness that's local and tribal. Surfing the DJs' polyrhythmic pandemonium, the pirate MCs speed-rap a druggy, Dada doggerel of party-hard exhortations and renegade war cries: sublime "nonsense" that is purely invocatory, designed to bind its scattered addressees into a community, mobilize it into an army.

But perhaps what's most subversive about the pirates resides not in their crimes of trespass on the airwaves or their renegade worldview, but in the way they transgress the principles of exchange value, commodity fetishism, and personality cult that govern the music industry. Filling the air with an endless, anonymous flow (MCs almost never identify tracks or artists), the pirates affirm that jungle is a community, a collective project in which everybody par-

ticipates and nobody is a star. The Situationist Raoul Vaneigem argued that a new, revolutionary reality "can only be based on the principle of the gift"; with their amateur pay-to-play ethos and the way they supply their audience with free music (you can tape all the new tunes, long before their official release), the jungle pirates have more than a whiff of the utopian about them.

Situated in the fuzzy interzone between the criminal, the anarcho-capitalist, and the anarcho-collectivist, pirate radio perfectly embodies the contradictions that energize jungle music: the speed-rush euphoria and unity vibe of rave harrowed by the dog-eat-dog realism of gangsta rap and dance hall reggae. Like hip-hop, jungle's anticorporate, pro-underground ideology was in no way socialist. Rather, it concerned the struggle of smaller capitalist units (independent labels, often consisting of a crew of DJ/producers surrounding an engineer/producer with a home-studio setup) to prevent their "subcultural capital" from being coopted by large capitalist units (the mainstream record industry). What gave the junglistic producers/labels their edge was their ability to respond with greater speed and flexibility to the fluctuating demands of the dance floor audience than the major labels.

With pirate radio as its media, jungle was well established by early 1994 as a self-sufficient economy, with no need of the outside world's support. So when the outside world started paying attention that summer, the junglist community didn't quite know how to respond. Having built up such an armor of wariness and suspicion, the scene was torn between its desire for recognition and paranoid fears of misrepresentation and cooptation. By June 1994, pirate MCs were railing against "saboteurs and perpetrators" in the media.

A month later, and the MCs were dissing *The Face* for printing General Levy's boast that "I'm runnin' jungle." An opportunist interloper from dance hall reggae, Levy had provided the vocals to "Incredible," a collaboration with jungle producer M-Beat that eventually became jungle's first Top 10 hit. In response to Levy's bragging, a cabal of top junglists banded together as the Committee with the intention of ensuring that jungle was covered "correctly." The first step taken by the Committee was a boycott on "Incredible," which rapidly escalated into further boycotts against DJs who still played the tune,

promoters who booked Levy to perform PAs, DJs who continued to play for those promoters, ad absurdum. General Levy was also "persuaded" to pen an abject apology in the letters page of *The Face*.

For one brief moment, while the media and record industry descended on the scene, every junglist was united in hatred of General Levy. But almost immediately, jungle's musical tangle of roots and futurism (to misquote Phuture Assassins' classic "Roots 'n Future") began to unravel. The scene began to be torn apart by its divided impulses: underground militancy versus crossover seduction, ghettocentricity versus gentrification.

What is a DJ? Someone who plays other people's records — for a living, for love, ideally for both. The majority of DJs — at weddings, parties, bars, rock clubs, and discotheques — "play" records in the most rudimentary sense of the word: slap them on the turntable one after the other. But in hip-hop and house, and in all the rave and club-based hybrids of those two black American musics, the DJ *plays* records in a different sense — one that's closer to improvising on a musical instrument, or playing with a plastic, mutable substance. As this element of "play" has gotten even more re-creative, the DJ has come to be considered an artist.

The ascent of the DJ-auteur began in the mid-seventies. The wind beneath his wings (then and now, it's usually a "he") was technological: the invention of the 12-inch single and the development of turntables and mixers specially designed for the DJ's needs. The first 12-inch singles started to appear in 1975 as DJ-only promos. Not long after came the first commercially available 12-inch, Double Exposure's "10 Percent," on the New York disco label Salsoul. With its deeper grooves spread over a broader span of vinyl than on the 45 rpm 7-inch single, the 12-inch offered better sound quality and made it easier for DJs to locate points in the track, thereby enabling precise mixing. The extended versions on the 12-inch offered a plethora of stripped-down, nonvocal passages and percussion-only breakdowns, which in turn provided entry points for mixing into the next record.

If the 12-inch was the software element of the DJ revolution, its hardware equivalent was the DJ-oriented mixers and turntables developed by companies like Technics, whose SL-1200Mk2 turntable, launched in 1979, rapidly became the professional jock's deck of choice. With the SL-1200Mk2, the key DJ-friendly elements are "pitch adjust" (a slider that allows you to slow down or speed up the revolutions per minute of a disc by a factor of plus or minus 8) and a high-torque direct-drive motor that can take a record from standstill to full speed in less than a second. Pitch adjust helps with the synchronizing of records of different beats-per-minute rates. The quick-start function is useful when bringing in the new track on beat, and is used in tandem with manually rewinding the record in slow motion and listening through headphones until you find the precise drum hit from which you want to kick off.

Synchronizing and seamlessly segueing tracks of different bpm's is called "beat mixing," and it's the basic DJ skill. Beat mixing is comparable to driving

a car: with enough practice, most people can learn to do it. "It's not that hard," says DB, one of America's top jungle DJs. "But it is hard to be good at it, to hold a mix for a minute or more without wavering, without the kick drum and the snare drum falling out of synch and sounding like a drunk guy falling down the stairs."

There are basically two different kinds of mixing: smooth and rough. House and trance techno, says DB, "are pretty much mixed the same way — the long mix. The records are constructed so that they fit very well together. As one track is ending, the bass line will drop out just as the bass line on the next record is about to drop in. The drums will naturally break down — the middle chunk of the record will be the full drum kit, but then gradually the percussion and the hi-hats will stop, and you'll end up with just a kick drum. And the other track will usually start with just a kick drum."

The other major style of mixing is the rough, cut-up mode associated with hip-hop and its descendants like jungle and trip-hop. Here the cross-fader on the mixer (the machine that allows the DJ to fade or cut between two turn-tables) is used to hurl into the mix brief snatches of the coming track, teasing ear-glimpses that whip up anticipation, or to cut violently back and forth between the two tracks. With jungle, the duration of "the mix" — the period when both tracks overlap — is usually much shorter than with house or trance.

If beat mixing is the basic skill that most can master if they persevere, there's a further dimension of turntable trickery that is perhaps comparable to stunt driving. Using two copies of the same record, DJs can set the second disc running a beat behind the first and cross-fade back and forth to create stutter effects, where a beat, lick, or vocal is doubled or even tripled. Keep the cross-fader dead center, and the two copies running slightly out of synch create a woozy effect called "phasing," "flanging," or "swirling." Then there's the array of hands-on tricks that involve the direct manipulation of the disc's speed of rotation. "That's my trademark," says techno DJ Richie Hawtin. "I do a lot of spinning things up faster and then slowing them back down. I'll slow records down to about half their original speed, 'cos when you slow rhythms down, other rhythms start to emerge out of them. In some ways, you're bringing the energy down, but in other ways, at half speed, more notes and sounds become apparent, and it becomes *more* intense." Then there are DJs like Carl Cox and Jeff Mills who use three turntables rather than the standard pair, and whose

strenuous slam-jam sets involve the lightning-fast concatenation and crosshatching of the most explosively exciting sections of a huge number of tracks.

Virtuoso DJs like Hawtin, Cox, and Mills are quite rare, though. Most of the time, what separates top DJs from the rest of the pack isn't so much their technical skills as their sensibility. To continue the driving metaphor, what counts is the DJ's ability to "take you on a journey" (which is how DJs tend to describe their art). And that comes down to taste, combined with an intuitive sense of what the "passengers" (the audience) want to experience. The DJ constructs the raw material of sundry tracks into a metatrack, an abstract emotional narrative with peaks and valleys.

"There's a lot more to DJ-ing than just mixing two records together on beat," says Paul Oakenfold, one of the UK's most popular DJs. "Anyone can learn that, like you can learn to play a guitar. What makes a good DJ stand out is knowing about keys and arrangements, structure and depth." Like a lot of veteran DJs. Oakenfold waxes nostalgic for a bygone golden age of DJ artistry, before the business became so lucrative that soulless artisans entered the field looking for glory and big bucks. Derrick May has a similarly mournful take on the "lost art" of set building and mixing. "Most of that philosophy has been lost. There's very few guys who really follow the art of mixing, the art of blending. Anybody can slash, cut, and do all that fun stuff with the cross-fader. But not many people really know how to blend records and make records speak to each other. Make music out of music. . . . You can elevate people just from the power of a mix, you can make people believe in you, truly believe in you. Nowadays, most people go to a club and the DJ's like a jukebox. Even if he's playing the best records, he's not playing them with any sort of emotion or any sort of personality."

What can it possibly mean to say that a DJ can play someone else's records — music in whose creation he had no part whatsoever — with a *personality* that makes all the difference? Aren't the emotions inherent in the track itself, and if so, where does the DJ's passion come into the sound picture? For DJs, the expressive elements of what they do resides in the juxtaposition of these already finished artworks, the connections made between different tracks, the transitions and contrast between moods, the up-and-down dynamics of a set.

With their juxtaposition of classics, obscure tracks, unjustly neglected

oldies, and new tunes, the best DJs are constructing a sort of argument about the historical roots of the music and where it should head in the future. In this respect, DJs are a lot closer to critics than the traditional conception of the artist. Indeed, DJs love to talk about what they do in terms of "educating the listener." This means exposing the audience to music they might not have encountered, pushing the envelope of a particular scene's collective sensibility, and hipping newcomers to the roots of that scene's sound.

The etymological root of "educate" is "lead." The "good" DJ is shepherd to an audience that is implicitly posited as a flock of dangerously impressionable sheep. The "bad DJ" is, paradoxically, the crowd pleaser, the mercenary who leads the flock astray by giving them only what they already love (anthems). Noting that DJs are notorious for never dancing, subcultural theorist Will Straw argues that being "hip" in dance culture is about being cerebral, in possession of disembodied knowledge, and has nothing to do with the conventional connotations of the word "hip" (hip shaking, sexuality). The DJ in his booth and his head-nodding acolytes are contrasted with the implicitly feminine abandon and hysteria of the dance floor proper. The DJ labors to elicit uncontrolled physical responses that he disdains and denies himself; he is the maestro, seducing and arousing the "feminine" crowd, guiding it through a multiorgasmic frenzy.

Although female DJs like Mrs. Wood and DJ Rap have achieved high profiles in their respective scenes, DJ culture is distinctly masculine. The presence of women on the dance floor is not reflected by the proportion of women in the ranks of professional DJs. The gender imbalance is, if anything, even worse when it comes to the production of techno, despite the "white-collar" nature of electronic music (its reliance on computing skills that aren't physically taxing and that are transferable from information-based professions in which women are strongly represented). This has a lot to do with the homosocial nature of techno: tricks of the trade are passed down from mentors to male acolytes. DJ-ing and sample-based music also go hand in hand with an obsessive "trainspotter" mentality: the amassing of huge collections of records, the accumulation of exhaustive and arcane information about labels, producers, and auteurs, the fetishization of particular models of music-making technology. Collecting goes hand in hand with the music-critical discourses that construct canons and genealogies.

Like criticism itself, DJ-ing depends on a certain arrogance, a propensity for characterizing oneself as an authority, a leader. As well as seeing themselves as educators, DJs often style themselves as crusaders fighting for a cause; Grooverider, for instance, talks of himself as a "soldier." Certain DJs become identified with a particular sound or subgenre — Fabio and jazzy jungle, Jeff Mills and minimal techno — and function as the ambassadors and public figureheads for a whole community of producers. These artists make tracks with that DJ's sensibility in mind, give them special promo versions of the track called "dubplates," and have even been known to dedicate tunes to the DJ (as with Northern Connection's "For Fabio"). Producers like Goldie and Danny Breaks have testified that they got artistic inspiration for specific tracks from the way Fabio and Grooverider mixed up the styles at Rage, or from Randall's "double impact" mixing at AWOL.

This peculiar displacement of creativity from the artist to the turntable selector can sometimes be hard to fathom. Far from dismantling the rock star system in favor of a radically democratic anonymity, dance culture has shifted the impulse to worship onto the DJ-as-virtuoso. The DJ-godstar phenomenon probably has a lot to do with Ecstasy. The drug generates overwhelming emotions and sensations, plus a peculiar will to believe, that must be given a focus. Just as it's possible to fall in love with someone you've only just met while under the influence of E, similarly that hyperemotional charge rubs off on the DJ, who seems to have a lot to do with the feelings coursing through your nervous system. This is not to deny the importance of the intuitive sense of what an audience wants to feel, where it wants to go, that experienced DJs develop. But in the throes of Ecstasy, it can feel like the DJ is reading the crowd's mind, playing the listeners' bodies.

Legendary DJs tend to owe their godlike status to being in the right place at the right time. Most of Britain's ruling DJs — Paul Oakenfold, Sasha, Carl Cox, Fabio, and Grooverider — began their careers right in the loved-up thick of the 1988–90 acid house/Madchester explosion. By the early nineties, the network of commercial megaraves and rave-style clubs had created a "guest DJ circuit"; the leading DJs traveled up and down the country earning fat fees for performing short sets on bills crammed with other stellar DJs.

By the mid-nineties, Britain's first-division DJs — Sasha, Jeremy Healey, Carl Cox, Pete Tong, Judge Jules, Allister Whitehead, John Digweed, Paul

Oakenfold — could charge fees in the range of \$1,500 to \$3,000 for a two- or three-hour set. Increasingly, top DJs played several gigs *per night* on weekends. Factor in midweek gigs, excursions to Europe, the rise of dance music festivals like Tribal Gathering, and the tripling of fees at New Year's Eve, and you're talking about DJs earning huge sums just for playing other people's records. That's before you include the extra income from mix CDs, remixing singles by pop stars and rock bands, playing radio shows, endorsing products, not forgetting the DJ's own record releases. With all the money, adulation, and numerous fringe benefits (free drugs from hangers-on, the "DJ groupie" phenomenon), little wonder that the DJ has become the new rock star, what Every-Boy dreams of becoming. "Turntables are outselling guitars," crows Paul Oakenfold.

The iconic focus of rave culture, DJs are also increasingly being used as a marketing tool by the dance music industry. The phenomenon of the star-DJ mix CD evolved out of the trade in mix tapes. Sold in street markets, specialist record stores, and by mail order, the mix tape is illegal, insofar as the producers of the tracks that the DJ mixes together don't get a cent. The demand for mix tapes is highest in anonymous hardcore dance scenes where artists' profiles are much lower than DJs'. In jungle, for instance, mix tapes are popular because they contain a high proportion of dubplates: tracks to which only certain DJs have access, and which won't be commercially available for several months. You buy the mix tape because you know you'll get a certain sound from a particular DJ, and the tape will contain all the current hot tunes in that style. Mix CDs simply take this idea and make it legal, by paying royalties to the tracks' original producers.

Alongside the mix tape and the mix CD, the other big earner for the DJ is doing remixes. In the early eighties a remix meant an extended, dance-friendly version of a pop song. Remixing involved hiring a famous DJ to apply his specialized knowledge to the task of adjusting a song to dance floor requirements, given that records originally mixed for radio or the domestic hi-fi sound tinny compared to records designed for club sound systems. In the nineties, remixing has evolved way beyond its early modest premises. Partly this was as a result of a business strategy of maximum market penetration: instead of just one

remix on the flipside, dance tracks began to come with a slew of reinterpretations in tow, each designed to appeal to a specific dance scene. These remixes, performed by DJs and producers renowned in those scenes, became increasingly remote from the original in terms of tempo, rhythm, and instrumentation, so that only the key riffs or vocal hooks of the original track might be retained. Gradually, remixing became a creative activity in itself; the original track became the pretext and springboard for the remixer to compose an almost entirely new piece of music that might contain only tiny shards and ghostly traces of its source. Today, it's the norm for remixers to operate with an almost contemptuous disregard for the material they are given; in turn, their clients give the remixers license to deface and dismember.

This adversarial attitude on the part of remixer toward remixee is encapsulated in one of the nineties dance scene's biggest buzzwords: "versus." One of the first examples occurred in 1990 when Mancunian techno crew 808 State transformed avant-garde trumpeter Jon Hassell's "Voiceprint" into a Latintinged house track; the credit ran "Jon Hassell vs 808 State." There were sporadic sightings of the term in years to come, but the versus trend really blew up in 1995 with Massive Attack V Mad Professor's No Protection and μ -Ziq vs the Auteurs. On the former, UK reggae producer Mad Professor created a dub version of Massive's *Protection* that many fans and critics considered superior to the original album. Since Massive's languid trip-hop is deeply informed by reggae and sound-system culture, it wasn't such a huge leap for the band to invite their hero to rework the album. But art-techno boffin Mike Paradinas of μ-Zig and wordy songsmith Luke Haines of the Auteurs came from utterly opposed aesthetic universes. Paradinas wasn't shy about revealing his contempt for the material he had to rework: the result was the merciless mutilation of Haines's finely honed songs. After this came a deluge of "versus" records, which ranged widely in the degree of devastation wrought on the remixee. In some cases — Tricky Vs the Gravediggaz, David Holmes Vs Alter Ego — they weren't even cases of remixing but artistic collaborations, or even (Freaky Chakra Vs Single Cell Orchestra) split albums.

The idea of "versus" comes from the reggae tradition of the "soundclash," an event where two sound systems competed to attract audience members to their end of the hall or enclosure. "In the early days of reggae, you might have Kilimanjaro Vs Jah Love Music," says reggae historian Steve Barrow. The

nineties vogue for "versus" chimes in with the widely held belief that dub pioneers like King Tubby, Joe Gibbs, and Lee Perry are the founding fathers of today's science of "remixology." "King Tubby and Errol Thompson (Joe Gibbs's engineer) were the first remixers," claims Steve Barrow. "At first dubs were just called 'instrumentals,' then they started calling them 'versions.' Gradually, more effects were added — echo, thunderclap, etc. — and dubs got closer to what we now think of as a remix. By 1982 dub had run its course in Jamaica, it had become a formula." But this was just the moment at which dub techniques were being used by New York electro-funk and disco producers, in remixes and vocal-free B-side instrumental versions.

Dub's repertoire of tricks — dropping out the voice and certain instruments; extreme use of echo, reverb, and delay in order to create an illusory spatiality; signal processing; the addition of sound effects — still permeate dance music. They've also become part of the arsenal of "post-rock:" experimental guitar bands who've abandoned the model of recording as a document of live performance and embraced the studio-as-instrument/sound-lab aesthetic of hip-hop and techno. On "remix albums" like God's *Appeal to Human Greed*, Main's *Ligature*, Scorn's *Ellipsis*, and Tortoise's *Rhythms*, *Resolutions & Clusters*, the subtext is always "versus"; the remixers, usually kinsmen from the world of avant-rock, are given license to mutate, mutilate, and even desecrate the originals to the point of utter unrecognizability. When Techno Animal's Kevin Martin hired Spring Heel Jack to rework "Heavy Water," he told the remixers "they could leave *nothing* of the original if they wanted. They were astounded!"

Post-rock's passion for remixology is more than just a knock-on effect of their interest in club-based and electronic musics. "People have lost respect for the song, it's no longer considered sacrosanct," Kevin Martin says. Instead of a finite entity, he argues, the song is treated as a set of resources that can be endlessly adapted and rearranged. This notion of music as process rather than object underlies two of his most successful projects. Martin's compilation series *Macro Dub Infection* tracks dub's spread as a "subcultural virus" throughout nineties music culture, contaminating everything from hip-hop and house to jungle and post-rock. *Techno Animal Versus Reality* is a sort of post-geographical, virtual jam session. Five guest artists (Porter Ricks, Alec Empire, Spectre, Ui, and Tortoise) supplied Techno Animal with "minimal ma-

terial," to which Martin and partner Justin Broadrick added rhythm tracks. The results were then handed back to the guest artist, who transformed it into a finished piece of music; Techno Animal also produced their own version of each track. The subtext of both *Macro Dub* and *Versus Reality*, says Martin, is "just how important the processing and treatments have become in modern music — it's almost like musicians are accessories to the process now."

While remixology has rejuvenated left-field rock, there are times when you have to wonder if the fad hasn't gone too far. Is there a case for the neoconservative notion that it's time to bring back remixes that *enhance* the original or bring out hidden possibilities, rather than dispense with the blueprint altogether?

You also have to wonder sometimes if remixology isn't often just a giant scam. There's a story, which may or may not be apocryphal, concerning Richard "Aphex Twin" James — a highly sought-after remixer, even though he's infamous for obliterative revamps that bear scant resemblance to the original. Hired by a famous band's record company to do an overhaul, James agreed, then promptly forgot all about the assignment. On the appointed day, a courier arrived *chez* Aphex to pick up the DAT of the remix. Initially taken aback, James quickly recovered his composure and scuttled upstairs, rifled through his massive collection of demos and unfinished tracks, picked one at random, and handed it to the messenger. Band and record label both professed themselves highly pleased with his reinterpretation! True or not, most of James's remixes might as well be all-new compositions. The scale of devastation is in proportion to his estimation of the band. He decimated Curve and Jesus Jones. But on Seefeel's "Time to Find Me," James retained most of the track, albeit considerably rearranged, and managed to intensify the luminous lusciousness of the original.

In genres like trip-hop, house, and jungle, the simultaneous release of a bunch of barely recognizable remakes by several different remixers (four, five, six, and more!) is a common occurrence. Dance music has its own "remix albums" — DJ Food's *Refried Food*, Bjork's *Telegram*, and so forth — where one artist's album is reworked by a stellar cast of guest producers. Another notable syndrome is the "remix tribute" album: instead of covers of songs by the original artist (as with the rock tribute album), illustrious ancestors like

Chris and Cosey, Yellow Magic Orchestra, Pierre Henry, and Can are "honored" by having their classics vandalized by their aesthetic progeny. (The Can remix record second-guessed the diehard's knee-jerk response, with the title *Sacrilege*.)

Of all the modern dance genres, jungle has taken remix mania the furthest. As a result, jungle has a fluid, hazy-round-the-edges notion of authorship. Often, a track will be popularly attributed to its remixer; generally, the revamps are so dramatically different from the originals that this seems only fair. One example is Omni Trio's "Renegade Snares" — often identified as a Foul Play track owing to the latter's awesome remix. Eight months later, Foul Play came up with an even more stunning re-remix of "Renegade" for Omni's debut album; the revamp is so extensive and creative that the credits run "remixed & reproduced by Foul Play."

Posing questions about authorship and attribution, remixing also problematizes the notion of copyright. If, in the age of "versus," the remix is tantamount to an all-new track, why should the original artist get all the royalties? At the moment, copyright remains with the original artist, and the remixer gets a flat fee. But Kevin Martin argues that soon it will "get to the point where percentage points are added to the contract, so that the remixer gets royalties." "Then again," suggests Martin, "in jungle particularly, so much of the 'original' music is sample-based that you could argue that neither the artist nor the remixer are 'creators' in the traditional sense. It's more the case that both the artist and the remixer act as 'filters' for a sort of cultural flow." This metaphor of filtering fits Brian Eno's idea of the modern artist as no longer a creator but a *curator*. In the age of information overload and artistic overproduction, argues Eno, "it is perhaps . . . the connection maker who is the new storyteller." As it happens, "telling a story" is the DJ's second favorite job description metaphor after "taking you on a journey."

The gap between remixing and live DJ-ing is narrowing; re-creating other people's tracks in the studio and recombining them in the DJ booth are gradually merging into a single continuum of mixology. Most mixers now come with "kill switches" and EQ-ing, functions that allow the DJ to alter the frequency levels on records, thereby enabling the DJ to engage in live remixing. Kill

switches are switches that cut out entire frequency bands, allowing the DJ to combine, say, the bass of one track with the treble and midrange of another; the resultant mesh is basically a new track that lasts the duration of the mix. EQ-ing (boosting or lowering the frequency levels) can also be used to add extra dynamics to the experience. DJs are also increasingly using effects processors with functions like echo, phasing, and reverb, or deploying drum machines to add an extra tier of polyrhythm, or programming mini-samplers to throw simple beat loops or riffs into the mix.

Turntable manufacturers are continually coming up with new DJ-friendly functions, like a button that makes the turntable go backwards. "If you were just playing records backwards once in a while, that wouldn't be so interesting," says Richie Hawtin. "But as soon as you add the element of EQ-ing and effects on backwards records, you're getting into really uncharted territory." Then there's the CD mixer — long resisted by DJs, because of their attachment to vinyl. The latest CD mixers can mimic most of the hands-on techniques DJs use to manipulate vinyl discs, and have a number of advantages, like looping functions and the ability to adjust a track's speed by a factor of plus or minus 16 without altering the music's pitch, thanks to a time-stretching/time-compression microchip.

With the range of possibilities open to the DJ ever expanding, and the cult of the utterly transformative remix showing no signs of waning, the idea of the dance track as a finished product had been obliterated. Not only is the moment of completion deferred, but the creative process slips back and forth between DJ booth and studio. For his Purpose Maker label, Jeff Mills makes ultraminimal tracks that he describes as "DJ tools." Essentially unfinished work, this music is only fully "com-posed" (put together) when it is meshed with other minimal tracks. Mills has only self-consciously highlighted what is the general rule in rave music: the vast majority of dance tracks don't make sense when heard in isolation, because they are really DJ food, the raw ingredients for cut 'n' mix. The DJ tests the material for its latent capabilities and applications. But in a sense, the material also tests the DJ, challenging his skills and (hopefully) spurring him on to new performance heights. This peculiar feedback loop between studio and DJ booth characterizes all forms of rave music, from house to jungle. There's no definitive version, no moment of completion; everything remains in the mix, always and forever.

Outside a grim hangar on the outskirts of Arnhem, in Holland, God-fearing Calvinists are handing out leaflets to ravers. They're on a mission to save young souls. Inside, it's a hellzone of sound and fury, a Hieronymus Bosch horrorscape of grimacing faces and neomedieval grotesquerie. Every other T-shirt is emblazoned with imagery celebrating death, destruction, and the dark side.

And the music? Imagine death-swarm synthesizers droning ominously like bombers over Dresden. Imagine a jackhammer beat that pounds as hard as a heart overdosing on adrenaline and steroids. This is gabba, an ultrafast, superaggressive form of hardcore techno developed by the Dutch in the early nineties that has since spread throughout the global rave underground. Above all, gabba's berserker frenzy seems to plug into the Viking race memory of ginger-pubed peoples across Northern Europe, from Scotland and Northern Ireland to Germany, the Netherlands, and Austria.

For hipsters and "discerning folk" of all stripes, gabba is a funkless, frenetic frightmare, the ultimate bastardization of techno. But experience has taught that when all right-thinking people agree that something is beyond the pale, that's precisely when you should start paying attention. That's why I'm in Arnhem for Nightmare, Holland's ruffest rave.

The story of gabba begins in 1991–92, with Second Phase's "Mentasm," the "Belgian hoover" tracks by T99, Holy Noise, and 80 Aum, and Mescalinum United's "We Have Arrived." The latter — a stormtrooper stampede with a blaring bass-blast of a riff — was produced by the Mover, the shadowy figure behind Frankfurt's darker-than-thou PCP label.

What the Dutch added to the "Mentasm"/Mescalinum sound was extra stomp: a distorted Roland 909 kick drum running at insanely fast tempos ranging from 180 to 250 bpm. When gabba fans chant "need a bass!" they're really talking about the trampoline-like *boing* of the distorted kick drum, the pile-driving thud-thud-thud that kickstarts the dance. Pure gabba is totally percussive/concussive. Every musical element functions rhythmically, yet the rhythm is simplistic; we're talking multiple tiers of four-to-the-floor, as opposed to polyrhythmic interplay. The closer you listen, though, the more you appreciate the degrees of invention within gabba's almost preposterously narrow sonic and rhythmic spectrum — and the more you thrill to its visceral blast.

Gabba rapidly became a subculture as well as a sound. Pronounced with a guttural, phlegm-rattling "gah," the word was originally Dutch Yiddish for "best friend." But it came to mean "hooligan" or "ruffneck." Rotterdam's proletarian youth flipped the derogatory term around, transforming it into a badge of pride. Regional antagonism and underclass resentment fused in a fierce but tongue-in-cheek rivalry with Amsterdam, R'dam's enemies both in football (Feynoord versus Ajax) and in music (Amsterdam's tasteful house scene versus R'dam's raucous hardcore). The very first gabba anthem, created by DJ Paul Elstak, was Euromasters' "Where the Fuck Is Amsterdam?"

Although gabba sounds like the most Aryan music this side of death metal, in some ways it is Holland's own equivalent to gangsta rap. Many of the top producers — Elstak, Darkraver, Robert Meijer of High Energy, François Prijt of Chosen Few — started as hip-hop DJs. Gabba tracks often use samples from the Def Jam rap/metal crossover era, like Chuck D's boast/threat "my Uzi weighs a ton."

Gabba is music for sensation junkies, for kids reared on Nintendo, *Hell-raiser*, and Manga comics. Raves like Nightmare create a sensory overkill that blurs pleasuredome and terrordome, using lasers, intelligent lighting, and megabass sound systems to create a hallucinogenic blitzkrieg of light and noise. Gabba's militaristic imagery — band names like Search & Destroy, Annihilator, Strontium 9000; track titles like "Iron Man," "Dominator," "The Endzone," "Dark Knight"; compilations like *Battlegrounds* — recalls heavy metal's superspeedy, sadomasochistic subgenres such as thrash, death metal, and grindcore.

How did gabba's militant sounds and aggressive attitudes emerge out of hardcore rave's smiley-faced benevolence and gloriously soppy sentimentality? Regular and excessive usage causes Ecstasy to degenerate into little more than amphetamine in psychological effect. Revving up motor activity, amphetamine mechanizes and motorizes the human body, and leads to "punding": compulsive, repetitive actions and nervous tics. Amphetamine is a cyborgizing drug, hence speed-freak slang like "wired," "crank," "motorhead."

Amphetamine also has historical connections with warfare, where its adrenalizing, insomniac, and hypervigilant "flight-or-fight" effects became extremely useful. Millions of pills were given to troops during the Second World War to fight fatigue, boost morale, and promote aggression. Hitler was given

methamphetamine shots seven times a day, and Japanese kamikaze pilots were speeding out of their heads as they hurtled to their glorious deaths. After WW II, speed was the drug of choice for veterans who couldn't adjust to civilian life (Hell's Angels, truckers) and for kids who were bored senseless (Mods got "blocked" on purple hearts and black bombers before battling the Rockers on the beaches of Brighton).

As Ecstasy's androgynizing powers began to fade, there was a gradual *re*-masculation of rave culture and a militarization of its music and imagery. In England, 'ardkore turned into jungle; in Scotland and Northern Europe, hard-core turned into gabba. In both cases, the tempo rose dramatically to match the overdriven metabolisms of a new generation of speed freaks, peaking at 170 bpm with jungle, and 180, 200, even 300 bpm with gabba.

All this goes some way toward explaining gabba's aura of mass rally and fascistic brotherhood. With its sensations of velocity, fixation, and aimless belligerence, gabba offers all the pleasures of war without the consequences; it's an intransitive war, a "Mindwar" as one track by Annihilator puts it. The drugmusic interface between gabba and amphetamine creates what Arthur Kroker calls "speed-flesh": a sexless euphoria that harks back to the prepubescent boy's fantasy world of explosions and pyromania. Video games like Mortal Kombat and post-rave styles like jungle and gabba are to virtual reality what cocaine is to crack. By stoking an appetite for ever-escalating doses of hyperstimulation, they recalibrate the nervous system in preparation for insertion into the virtual domain.

Not only is gabba exactly the sort of music that really ought to be playing in the background of all those carnographic video games, but at Nightmare I realize that the bombardment of noise and light, the 200 bpm tempos and airscything lasers, are designed to make the gabba kid feel like he's actually *inside* a video game. And like Nintendo, gabba is a mostly male subculture (an early classic of the genre was Sperminator's "No Woman Allowed").

The classic gabba boy has a shaved head with bright pink ears sticking out from the skull, making him look like an alien. His pale, gaunt torso peeks out from an open "Aussie," a gaudily patterned jacket that looks like a tiedye tracksuit top and can cost up to \$750. The classic gabba girl combines

flaxen-haired Dutch cuteness with skinhead menace; a common look is a ponytail dangling over a shaved patch of scalp from the ears right around the back of the head.

As for the gabba dance, it's somewhere between the punk pogo and morris dancing. At Nightmare, I marvel at the kids' incredibly intricate, absurdly fast footwork, which resembles kickboxing. How do they manage to keep their footing on the sweat and soft drink—soaked floor? Other gabbas prefer to simply rage hard, slicing and dicing the air, growling and grinding their teeth. But the vibe isn't intimidating, because these kids are self-absorbed almost to the point of autism, lost in music and mayhem. One guy who's skip-gliding across the floor in a trance collides with me and goes haywire like a spinning coin that's hit a chair leg.

The strange, almost fey grace of the gabba dance owes everything to Ecstasy and amphetamine, which enable dancers to lock into the groove and keep up with gabba's insane tempo. Everywhere at Nightmare, I can see the symptoms of excessive intake of E and whizz — the crazed, blazing impudence in the eyes, facial expressions contorted midway between snarl and smile, tongues jutting out of mouths, and grimacing caused by the jaw tension that's a side effect of Ecstasy. One guy's pulling such monstrous, gargoyle faces that I can almost hear his jawbone cracking.

Gabba has a terrible reputation. For some, it's "kill your mother" music, nasty noise for trainee psychopaths. For others, it's "Nazi techno." When the scene first emerged, many were quick to equate the gabbas' cropped hair with white-power skinheads, a connection encouraged by the Feynoord supporters' unfortunate habit of hurling anti-Semitic chants at their Ajax opponents. In October 1997, Britain's *Daily Star* somewhat belatedly discovered England's tiny gabba scene. Grossly exaggerating the threat it posed to British youth, the tabloid published an exposé bearing headlines and captions like "Bop Till You Drop . . . *Dead*," "Nazi Gabber Hell," and "Jack Boots and Birds: Nazis have adopted sick Gabber."

Gabba's aggression does seem to hold an attraction for the extreme right; I've heard stories of Austrian neofascists doing drill to its regimented rhythms, of jackbooted and swastika-adorned thugs at Italian hardcore events. To counter this, Netherlands labels often print slogans like "United Gabbers Against Racism and Fascism" or "Hardcore Against Hate and Violence" on their record sleeves, while Dutch fans call themselves "bald gabbas" to distinguish themselves from white-power skinheads.

Most of the time, though, gabba ignites a firestorm of belligerence with no specific target. Despite an emotional spectrum ranging from hostility to paranoia (song titles like "I'm the Fuck You Man," "Mad As Hell," "I'll Show You My Gun"), there's rarely any tension or fights at Dutch or Scottish raves. Instead, gabba kids direct their aggression against their own bodies, punishing their nervous systems with noise and drugs. In the early days of gabba, the big buzzword was "hakke" — pronounced "hack-uh," it sounds like "hardcore" but means to strike someone with an ax. Echoing British rave slang like "sledge-hammered" and "caned," "hakke" captures the concussive nature of gabba's quest for oblivion.

What redeems gabba is its playful sense of humor. The logo of the KNOR label is a horned demon in diapers, while Babyboom's mascot is a diaper-clad infant giving you the finger: both images nicely blend rave's regression with heavy metal's puerility. Funniest of all are the series of T-shirts put out by the Forz label: a teddy bear with a sub-machine gun, a teddy wielding the sort of Christmas pudding bomb clutched by nineteenth-century anarchists, and most tasteless of the lot, one where Teddy's blown his head clean off with a pistol. Stuffing, rather than blood, is spattered on the floor, while the slogan reads "Game Over."

But there's a far less amusing side to gabba's sadomasochismo, one that's audible at Nightmare when midway through the night some technical difficulties lead to the bizarre spectacle of Gabba Unplugged. As technicians fiddle beneath the DJ's decks, the burglar-masked MC leads the crowd in a chant: "Happy Is For Homos." This is a reference to the poppy, sentimental strain of "happy gabba" or "funcore" that has recently taken the Dutch charts by storm. The chant also seems like a diss to a DJ who performed earlier tonight, Paul Elstak — the Rotterdam producer who invented gabba but who has recently disgusted the scene's diehards by going cheesy and tuneful with hits like "Rainbow in the Sky" and "Life Is Like a Dance."

Backstage, Elstak shrugs off the anti-happy backlash. The way he explains it, gabba had to mellow out at some point. "By 1994, the music was too hard,

too fast. Fewer girls were dancing, and we lost the party atmosphere. And kids were taking too many drugs to keep up with the speed." Elstak and other producers picked up on the lighter, less frenetic hardcore sound invented by Scotland's Scott Brown, and kickstarted the happy-gabba explosion.

"Happy" was also a bid for respectability after drug-related deaths had thrown the scene into disrepute and led to licenses being canceled for raves. In Rotterdam, says Elstak, "one party was banned, 'cos the authorities saw the flyer for the event and it was very aggressive, lots of blood and guts." And then there's the Church, whose animosity is directed not just at gabba but at all forms of rave music — apparently because young people have turned to rave culture for the meaning and sense of belonging they once derived from religion.

"I lost my religion the day I discovered raving," says Chris, a nineteen-year-old lapsed Catholic and confirmed hardcore disciple. We're hanging out in the chill-out zone of Rezerection, Scotland's biggest rave, and — chiming in with the Christian theme — it's 3 AM on Easter Sunday morning.

Chris, his fair hair cropped in the Caesar cut that UK hardcore boys favor, tells me that rave is "a way of life, a culture." It's a way of life that demands sacrifices: when he was working, he spent the equivalent of \$5,000 in one year on tickets, drugs, and transport, and now that he's on the dole, events like Rez require weeks of scrimping. And drugs are an inseparable part of that way of life. "They help you forget all your problems for one night," says Chris. I've been told that some of the kids at Rez take up to twelve Es in the course of a night; Chris admits he's been on a few benders in the past, but cautions: "That way you end up dancing yourself into an early grave." This idea sometimes surfaces in the music itself, in sick-humorous song titles like "Friday Night Can Kill You," "I Died in My Teens," and "I Just Died in Your Arms Tonight" (which samples the sappy AOR hit of the same title by Cutting Crew). Tonight, though, Chris, with a believer's gleam in his eye, is accentuating the positive, telling me "I class everybody at a rave as a friend."

Although Chris says that "Rotterdam died when Elstak started to go cheesy," Rezerection is full of testaments to the peculiar Scottish cult of all things Dutch. There are T-shirts everywhere bearing the logos of the top Dutch

gabba labels — KNOR, Ruffneck, Mokum, Dwarf, Terror Traxx. A few kids even sport Feynoord team colors. The music, though, is not the kind of "kill-your-mother" gabba played at Nightmare, but the funcore strain that so aggravates the diehards. The big buzzwords in Scotland are "bouncy" and "cheesy" (like "gabba," an insult transformed into a positive term). With its rinky-dink key-board refrains and anthemic choruses, happycore is almost disturbingly fix-ated. A lot of tunes recall oom-pah music or Jewish *klezmer* (there's actually a gabba version of the wedding jig "Havanagila"); others have carousel-like melodies. This sense of kiddy cartoon frolic is completed by the merry-go-round, funhouse hall of mirrors, and fruit machines in the chill-out zone.

In its own way, funcore is just as extreme as the more sadistic kinds of gabba. And the Scottish kids certainly match the Dutch for sheer mania. Stripped to the waist, tattooed and sweaty, the lads grimace like heavy metal bands posing for a photo shoot. Wee lassies twitch 'n' twirl like clockwork toys wound up too fast, their hands inscribing semaphore patterns at hyperspeed. Everywhere the trappings of UK rave's 1991–92 golden era are visible — gas masks, white gloves, floppy hats and jester caps, baby's pacifiers (to ease jaw ache), and fluorescent glow-sticks. And the golden age's infectious bonhomie is still alive and kickin': total strangers come up and shake my hand, and sharing your soft drink or water is de rigueur.

By 5 AM, though, the euphoria is giving way to battle fatigue. It's then that you become alert to the dark side of E culture. In the chill-out room, there's a booth offering Lifeline's drug education leaflets, chirpy comics that try to engage the kids on their own level, with cartoons about Temazepam Tom, a cat with a wooden leg (he got gangrene from melting the sleeping pill, popularly known as "jellies," and injecting it). In the paramedic support room, kids suffering the effects of overindulgence huddle wrapped in blankets with plastic puke pots on their laps. Despite the fig leaf of intensive drug searches on entrance, big-scale raves like Rez are highly organized spaces designed for kids to freak out, with safety nets provided if they take it too far.

As in Holland, Scotland's spate of E-related deaths in 1994 gave hardcore a disreputable image and prompted a clampdown by the authorities. According to Jamie Raeburn of Scottish rave mag *Clubscene*, "hardcore clubbing is now almost dead." Most Scottish clubs are pushing the mellow, upmarket sound of house, associating hardcore with "schemies" — kids from impover-

ished "housing schemes" (projects). And the police Drug Squad has maintained an intimidating presence at raves ever since a series of drug overdoses at Hangar 13. As a result, it's a common paranoid delusion for wired-and-tired Scottish ravers to believe that the guy next to them is an undercover DS agent.

Despite all the Dutch gabba T-shirts at Rez, Scottish hardcore's allegiances are shifting; several of the DJs playing tonight are big names on the English "happy hardcore" scene. The difference between happy hardcore and happy gabba is minimal: basically, the English tracks have sped-up breakbeats running alongside the stomping four-to-the-floor kick drum. But the genealogy of happy hardcore is quite different: the scene began as an offshoot of jungle.

Back in 1993, when hardcore plunged into the "darkside," a breakaway faction of DJ/producers like Seduction, Vibes, and Slipmatt continued to make celebratory, upful tunes based on hectic breakbeats. By the end of '94, happy hardcore had coalesced into a scene that operated in parallel with its estranged cousin, jungle, but had its own network of labels, its own hierarchy of DJs, its own circuit of clubs. Happy hardcore takes all the elements that jungle purged as too "cheesy" — synth stab patterns, Italo-house piano vamps, shrieking divas, anthemic choruses — and cubes their epileptic intensity. The euphoria of the original '92 'ardkore was tinged with bittersweet poignancy; happy hardcore, by comparison, is relentlessly and ruthlessly upful, with every last hint of "darkness" or ambivalence banished from the music.

Ignored by the dance press until 1997, happy hardcore developed its own media. These glossy mags — *Eternity, Dream,* and *To The Core* — have distilled rave ideology down to its populist essence. The bulk of the mags consists of relentlessly positive reports on megaraves like Dreamscape, Hysteria, Helter Skelter, and Pandemonium. As well as praising the DJs, the reviewers compliment the scantily clad girl dancers, the lights 'n' lasers, the security staff, the toilet facilities, and above all, the crowd. More important than the text, though, are the photo spreads of crowd shots: glassy-eyed boys with their shirts off, red-faced and throwing mad-raver shapes for the camera; girls, dazed and sweaty in their unflatteringly clingy Lycra leotards. Where "serious" dance mags like *Mixmag* frame the DJs as auteurs, the rave mags treat the audience as the star.

Happy hardcore is huge pretty much anywhere the white rave audience predominates, i.e., not in junglistic London. In large part, happycore was the result of an exodus of white ravers from the jungle scene, in reaction to the influx of black youth and the attendant mood change from bonhomie to surliness. As well as the racial factor, the other crucial difference is pharmacological: junglists have mostly moved from Ecstasy to marijuana, whereas happy hardcore caters to younger kids still going through the MDMA honeymoon. Because of its defiant cheesiness, most junglists dismiss happy hardcore as juvenilia for timewarp kids who haven't realized that rave's "living dream" is over. With its rictuslike tone of relentless affirmation, its déjà vu piano chords and synth stabs that all appear to be anagrams of some primordial, rush-inducing riff, happy hardcore is indeed a bit like dance music's equivalent of a rockabilly revival: nostalgia for something you never actually lived through.

In other respects, happy hardcore is closer to heavy metal. Both are scenes that just won't die, fulfilling as they do very basic and enduring needs for provincial youth. Like metal, happy hardcore is all about keeping the faith and unity-as-uniformity: The happycore raver's favorite garment — the identikit black flight jacket — is like the metalkid's denim jacket, except that logos for labels like Kniteforce and Slammin' have replaced Iron Maiden and Motorhead patches. Indeed, events like Rezerection, Dreamscape, and Desire are highly reminiscent of heavy metal festivals like Castle Donnington. There's the fetish for video-nasty grotesquerie (skulls, ax-wielding goblins, monsters) and the overpriced merchandising. There's the way hardcore's obsession with "nosebleed"-inducing sub-bass parallels metal's love of "earbleeding" decibellage. And the rising popularity of the stupor-inducing sleeping pill Temazepam (aka "jellies") recalls the Mandrax and quaaludes popular with Black Sabbath fans.

With the English producers restoring the pounding four-beat kick drum and playing down the breakbeat, the stage was set by 1996 for happycore's merger with Scottish "bouncy techno" and Dutch funcore, to form a single rave-will-never-die sound: in effect, the reintegration of the original pan-European hard-core of 1991, only much faster. But this prospect dismayed a faction of diehard gabba fans for whom hardcore is *anti-rave* in spirit. This pan-global network of dissidents includes Nasenbluten (German for nosebleed), a terrorcore trio

from Newcastle, Northern Australia, who are on a crusade to bring back "quality gabba."

"I never, ever saw hardcore as happy E music," sneers the band's Mark Newlands. "The original Rotterdam gabba by Euromasters and Sperminator was cold and unpleasant, and it was great! We called our double EP '100% No Soul Guaranteed' as a riposte to all those people who say gabba is monotonous, inhuman, soulless. Of course it is!" Such was Nasenbluten's sense of betrayal by Paul Elstak's move toward happy gabba that the band recorded the infamous "Rotterdam Takes It Up the Ass."

Nasenbluten deliberately record their own music in mono on a low-level Amiga computer with a puny 8-bit memory. "With the Amiga, it's impossible to get a clean, distortion-free sound," Mark enthuses. Typical song titles include "Feeling Shit," "Cuntface," "Kill More People," and "Cocksucker" (which clocks in at a lethal 300 bpm). So what gives? "I just don't like other people. We let all our aggression out on the computer. Instead of killing people, we do it with sound."

Nasenbluten's anti-rave sentiments are shared by English DJ Loftgroover. A man on a mission, Lofty believes there's "too much niceness in the rave scene." Although he started out during the late-eighties acid house explosion, Loftgroover never tried E and never bought into the rave dream of love, peace, and unity. "Gabba is how I really feel — hard, angry," he says. "I've always had a bleak view of the world."

Loftgroover coined a bunch of evocative terms for Nasenbluten-style extreme noise terror: "punkcore," "scarecore," and "doomtrooper." There are pockets of doomtroopers all over the UK, and when he plays at clubs like the Shire Horse in St. Ives, Judgement Day in Newcastle, Steam in Rhyl, North Wales, and Death Row Techno in Bristol, Loftgroover is treated like a god. Alongside the gabba, Loftgroover mixes in tracks by death metal bands like Morbid Angel, Stormtroopers of Death, and Slayer. When asked about gabba's origins, he claims it's not even techno but "probably something by Anthrax or Sepultura back in 1983. . . . The line between gabba and metal is only that thin, y'know."

Bizarrely, given his obsession with the two most Teutonic forms of music on the planet, Loftgroover is black. Clearly ambivalent about the fact that "seventy percent of the people following this music are skinheads," he stresses that he's never had any trouble, even though "some of them are giving it all that" — he mimes a frenzied Nazi salute. "Most of the time, the look is just a fashion," he insists, adding, "gabba's about controlled violence. You never see people having fisticuffs at a gabba party."

In addition to the sonic affinities between thrash and gabba, both musics share a similar audience: white working-class youth whose hopes have been crushed by the decline of heavy industry and who face unemployment or ignominious, no-security/no-future jobs in the service sector. From Rotterdam to Brooklyn, from Glasgow to Milwaukee, gabba expresses the rage and frustration of White Niggaz With Bad Attitude and No Prospects. And like metal, gabba is despised by middle-class critics who simply don't understand the mentality of those who crave music to *go mental* to.

"It's a working-class scene, there's no pseudo-intellectual element," says Michael Wells, a long-standing hardcore crusader from his early efforts with Lee Newman as GTO and John + Julie to his current gabba activities as Technohead and Signs Ov Chaos. "People respond on a gut level. The apocalyptic, sci-fi and horror-movie imagery in gabba, it's all part of the trash culture these kids are into. And it's very similar to the way heavy metal uses imagery of death, destruction, and antireligion. It's a reaction against the pressure of modern life."

It was almost inevitable that metal and gabba would join forces. Operating as Signs Ov Chaos, Wells recorded the experimental gabba album *Frankenscience* for English metal label Earache, which also put out a compilation of hardest-core gabba from Lenny Dee's Industrial Strength label. At the album's launch party at the Gardening Club in London, the T-shirts are less cuddly than at Rez — "I'm Afraid I'm Going to Have to Kill You," "Nightmares Are Reality" — and the music is even harder than Arnhem: a remorseless onslaught of electro-convulsive riffs, sphincter-bruising bass and satanic synth tones that get your goosebumps doing the goosestep.

The audience is a strange mix of bare-chested skinheads and crustie types with matted dreadlocks and camouflage trousers. The anarcho-crusties belong to an underground London scene in which gabba serves as the militant sound of post—Criminal Justice Act anger. A key player in this London scene is an organization called Praxis, which puts out records, throws monthly Death by Dawn parties, and publishes the magazine *Alien Underground*. Praxis is part of

an international network of ultrasevere "stormcore": labels like Gangstar Toons Industry, Kotzaak, Fischkopf, and Juncalor; artists like Temper Tantrum, the Speedfreak, DJ Scud, Lory D, and Producer.

On this circuit, gabba's perverse identification of libido with the military-industrial complex is taken even further — just check song titles like "At War" by the Leathernecks (a band named after the US Marines), Disintegrator's "Locked On Target," and "Wehrmacht" by Delta 9 (itself the name of a nerve gas!). Fantasies of man-machine interface and cyborg *ubermensch* abound. The ideology ranges from Underground Resistance—style "guerrilla warfare on vinyl" to full-blown techno-mysticism. In one issue of *Alien Underground*, the record reviews featured "samples" from philosopher Paul Virilio's writings on speed and the war machine. One review, actually credited to Virilio, raves about "instantaneous explosions, the sudden flare of assassinations, the paroxysm of speed." Gangstar Toons Industry's 250 bpm "pure Uzi poetry" is hailed as "exercises in the art of disappearing in pure speed to the point of vertigo and standstill." Everything that Virilio reviles and resists as antihumanist, deathwish-driven tendencies in the culture is perversely celebrated by these speed-freak techno-junkies.

Such febrile imagery recalls the aestheticization of war and carnage in the manifestos of the Italian futurists and the writings of the Freikorps (German veterans who formed right-wing militia to beat down the Communists during the strife that followed the First World War). It also demonstrates the extent to which hardcore techno is the culmination of a militaristic strain within the rock imagination. Examples include road warriors Steppenwolf and their exhortation "fire all of your guns at once/explode into space" and Motorhead's iron-fisted, Hell's Angels—influenced Reich 'n' roll. Greatest of all these "rock 'n' roll soldiers" was Iggy Pop and his "heart full of napalm" ballistic death trip. Reflecting on this era of the Stooges, when he fueled himself with drugs like speed and LSD, Iggy declared: "Rather than become a person singing about subjects, I sort of sublimated the person and I became, if you will, a human electronic tool creating this sort of buzzing, throbbing music." Similarly, PCP's the Mover told *Alien Underground:* "Well you know I'm a machine, I'm wired up. . . . I'm roaming the earth and it's nice and doomy here."

Rock's death-wishful tendencies find their culmination in hardcore techno's

kinesthetics of rush and crash. The rush is when your nervous system's circuitry is plugged into the machine, supercharged with artificial energy, turned to *speed-flesh*; the crash is when the all-too-human body can't handle the pace anymore. Back in 1992, the hardcore rave DJ would sometimes abruptly switch the turntable off: the nauseous, vertiginous sound of the record slowing from 150 bpm to zero was a hideously voluptuous preview of the drug comedown, the inevitable crash, only a few hours ahead. Then, whoosh!, the DJ would flick the Technics switch, and the force field would repossess the dancer's body.

For the terrorcore fiend, release takes the form of the Wargasm. Hence a band like Ultraviolence, who fuse thrash metal and gabba, and whose *Psycho Drama* LP is trailed with the promise "10,000 Nagasakis in your head!" For the modern militarized libido, the equivalent of serene postcoital *tristesse* is the aftermath: postapocalyptic wastelands, razed cities, the empty horizon, entropy-as-nirvana. Hence titles like Jack Lucifer's "After All Wars."

"Imagine surveying earth after nuclear destruction and enjoying what you see, that's how it feels when you listen to it," the Mover told *Alien Underground*. PCP has been exploring such post-rave end zones for years, from the Mover's "Frontal Sickness"/"Final Sickness" trilogy to the "gloomcore" output of their sister label Cold Rush (a perfect phrase for the Ecstasy buzz when the empathetic warm glow has burned out). With their glacial, sorrowful synths, down-swooping drones, and trudging beats, these cavernously echoed dirges — Cypher's "Marching into Madness" (on the "Doomed Bunkerloops" EP), Rave Creator's "Thru Eternal Fog," Reign's "Skeletons March" (from "The Zombie-Leader Is Approaching" EP), Renegade Legion's "Torsion" — conjure mind's-eye visions of barren craterscapes or vast ice catacombs carved beneath the Arctic surface. (Cold Rush sleeves bear the legend "created somewhere in the lost zones"). From burn-baby-burn to burnout, hardcore rave's psychic economy fits Bataille's model of sacrificial violence and expenditure without return. The goal is to get *wasted*.

At Nightmare in Arnhem, I hear a track that seems to sum up gabba's weird fusion of will-to-power and impotence. Beneath a piteous melody that seems to waver and wilt in midair, a robot voice chants a fatigued, fatalistic chorus:

"We are slaves/to the rave." Recorded by the Inferno Bros. for PCP offshoot Dance Ecstasy 2001, this withering parody of the hardcore rave mentality had evidently become an irony-free anthem of entrapment and zombiehood.

A few days earlier Loftgroover had told me of going to a gabba club in Paris "where they handed out straitjackets to the audience!" It's a nice joke, the perfect culmination of gabba's imagery of bedlam and psychosis, but it has a sinister undercurrent. A gabba rave *is* an asylum. It's a haven from an intolerable reality, a world that kids find at once numbingly tedious and worryingly unstable. But it's also a place of confinement where the mad rage harmlessly, where kids vent all their anger out of their systems, instead of aiming it against the System.

Techno is the Devil's Music! *Beware* the hypnotic voodoo rhythm, a reckless dance down the Devil's road of sin and self-destruction, leading youth to eternal damnation in the fiery depths of hell!

DROP BASS NETWORK flyer for Even Furthur, May 1996

Despite the ritual burning of a wicker man, it's hard to take Even Furthur seriously as "an epic pagan gathering of the tribes of Evil." The vibe is closer to a scout retreat (which is actually what the site, Eagle Cave in rural Wisconsin, is usually hired out for). After sundown, kids sit around bonfires on the hill slope, toasting marshmallows and barbecuing burgers. The atmosphere is a peculiar blend of innocent outdoor fun and hardcore decadence. For if this is a scout camp, it's one awash with hallucinogens.

Under a disco glitterball suspended from a tree, a gaggle of amateur dealers trade illegal substances. "Are you buying *more acid*, Craig?" asks one kid, incredulous at his buddy's intake. The vendor is offering five doses for \$20. "Weird Pyramids ain't *nuthin'* compared to these," he boasts, then extemporizes to the tune of Johnny Nash's soul smash: "I can see Furthur now the rain has gone / I can see all the mud and freaks at play." Conversation turns to bad trip casualties, like the guy who went berserk, smashed in several windshields with a log, and was carted off by the local sheriff. The LSD dealer rants about "rich kid crybabies" who can't handle their drugs. He's also offering some G (the steroidlike GHB) and "Sweet Tart" XTC. "They're *mushy*," he hard-sells, "but there's a speed buzz, they won't smack you out — there's no heroin in them." Later, we hear rumors of kids injecting Ecstasy — not for its putative heroin content, but out of sheer impatience to feel the rush.

The scary thing is how young these kids are — hardened drug veterans before they're legally able to drink at age twenty-one. I overhear another boy enthusing about how great it is to "hear the *old* music, like Donna Summer," and I realize with a shock that "I Feel Love" came out before this kid was *even born*. In Even Furthur's main tent, Chicago DJ Boo Williams is playing a set of

voluptuous, curvaceous house informed by this golden era of disco, tracks like Gusto's "Disco's Revenge."

Then Scott Hardkiss pumps out feathery, floaty softcore (including his awe-somely eerie remix of Elton John's "Rocket Man") sending silvery rivulets of rapture rippling down every raver's flesh. My wife points out a boy who's dancing with a folding deck chair strapped to his back, a sort of portable chill-out zone. A space-cadet girl sits cross-legged beside the DJ booth, eyes closed, rocking and writhing in X-T-C. Earlier she'd been handing out leaflets about aliens called "The Greys," who she claims are from Zeta Riticuli in the constellation Orion and are in league with US military intelligence. Abduction stories and UFO sightings are common at American raves, doubtless because of the prodigious consumption of hallucinogens. Loads of kids wear T-shirts featuring slant-eyed ET-type humanoids.

There's a certain folksy charm to Wisconsin's small-town ways: when we tell a curious storekeeper we're in town for "a music festival," she quaintly replies "cool beans!" (meaning "good for you!"). But there's also the unnerving underside of traditionalism, like the grotesque graveyard of tiny crosses by the roadside — a memorial to aborted fetuses put up by Pro-Life evangelists. All in all, this agrarian backwater is the last place you'd expect to find a psychedelic freak-out. But the wilds of Wisconsin is where the Furthur series of threeday raves have taken place since 1994. On the rave's flyers, the trippy typography harks back to the posters for acid rock bands in Haight-Ashbury, while the misspelled "Furthur" originates in the destination posted on the front of the bus driven by the Merry Pranksters, Ken Kesey's troupe of acid evangelists.

During the first Furthur "techno campout" — at Hixton, Wisconsin, from April 29 to May 1, 1994 — one of the promoters (David J. Prince, editor of Chicago rave-zine *Reactor*) got so blissed he danced naked on a speaker stack. On the final Sunday, several organizers were arrested by the local sheriff. At the third annual rave, there's no trouble from the law. But Even Furthur *is* a lawless zone. Although you have to pay for admission, the atmosphere is closer to England's illegal free parties than to a commercial rave.

The Even Furthur kids aren't crusty-traveler types, though — they're much

more fashion-conscious and middle-class, as American ravers tend to be. The guys sport sock hats and B-boyish silver chains that dangle in a loop from the waist to the knee. Girls have the Bjork-meets-Princess-Leia space-pixie look of futuristic innocence; their shiny synthetic fabrics, bright kindergarten colors, bunched pigtails, cutesy backpacks, and cuddly toys make them look even younger than they really are (mostly sixteen to twenty-two). Everyone wears absurdly baggy jeans, the flared bottoms soaked in mud because continual downpour has transformed the campsite into a swamp.

Like Castlemorton, Even Furthur is a chaotic sprawl of cars, RV caravans, trailers, and tents. There's no security and no lighting; you have to stumble through the mud by the fitful illumination of other people's flashlights and the glint of bonfires dotting the hill slope. All this gets to be a gas, although it's slightly disturbing that there's no on-site paramedics to deal with acid freakouts, like the shoeless, shirtless, mud-spattered boy who keeps howling single words over and over — "Friends! Friends!," "Worms! Worms! Worms!," "Dead!" — while other kids try to restrain him from fleeing into the woods. In England, the main reason to have paramedics is to help Ecstasy overindulgers. But at Even Furthur, boiling alive in your own blood is not really a hazard. It's cold and wet, and overexertion is difficult, because dancing is a struggle: the second tent is a puddle-strewn marsh (take a wrong step and you'll slide into a sinkhole), while the main tent's floor is slippery and sloping.

Over three days, some hundred DJs and bands perform, spanning a broad spectrum of rave music. There's a surprising amount of jungle on offer: Mixmaster Morris spins crisp-'n'-mellow drum and bass in a small hillside tent, while Phantom 45 rinses out tearin' hardstep in the big marquee. Not everybody's happy about the jungle influx, though. Sitting outside on a car, a gabba fan whines, "Why do breakbeats make me puke?" What really fires the pleasure centers of this mostly midwestern, Minneapolis/Chicago/Milwaukee crowd is the stomping four-to-the-floor kick drums of hard acid, as purveyed by Brooklyn's Frankie Bones and Minnesota's Woody McBride (whose Communiqué label copromoted Furthur in tandem with Drop Bass Network and David Prince). Saturday's big hit, though, is French duo Daft Punk and their sinuous, sine-wavy brand of raw-but-kitschadelic house.

Unlike your regular commercial rave, Even Furthur has hardly any concessions selling food or drink. In search of liquid, we trek up the treacherously

moist slope out of the camp toward the site owner's hut, where there are toilets and a soft drink machine. It's pitch black as we trudge up the dirt road, but every so often we pass a tiny bonfire with a clutch of burned-out kids huddled together on muddy ledges carved into the hillside, chatting and smoking weed. When we return down the hill, the pale roseate dawn is peeking through the trees, caressing our sore eyes. But as we get closer, our sore ears are assaulted by a 200 bpm jackhammer pummel: the DJs aren't chilling out the night's survivors but blasting ten thousand volts of gabba. At 7 AM, gabbaphobe Mixmaster Morris retaliates with an impromptu ambient set in the second tent. At the start, he's playing quite happily to an audience of exactly zero. "I've been here since Wednesday," Morris tells me. "That's why I smell so bad!" He plays on for six more hours.

On Sunday evening, it's stopped raining at last, the mud has dried, and the slightly reduced crowd consists of the hardcore party people who just don't wanna go home. The Drop Bass Network crew pose for a photo like end-of-year college students. I chat to their leader, Kurt Eckes, who tells me over three thousand people turned up, some from as far away as Florida, California, and Arizona.

Thinking of the teenage acid casualty the previous night, I suggest to Kurt that some of the kids here look kinda *young*. Do their parents know what they're up to? "I suspect they *don't*," he says, adding blithely that "a couple of parents called here threatening to phone the police for having fourteen- and fifteen-year-old kids here without parental permission." Eckes's nonchalance stems from Drop Bass Network's militantly underground attitude. "There are no rules here at all," he grins.

DBN is all about representing the rave scene's dark side. "Within the rave scene, there's definitely some things going on which to most people seem wrong," Eckes told *Urb* magazine. "They seem right to us. We're just pushing those things to the limit." DBN's version of rave might be called *psycho*delic rather than psychedelic. Distancing himself from the Second Summer of Love idyllicism of 1988, Eckes once declared: "I don't see myself going to a party, taking E, hugging people, and screaming peace and love. I'm more . . . a person who'd rather go to a party, take a lot of acid, and hug speakers." As Eckes and I chat, the nearest sound system is pumping out Test's "Overdub," a classic Roland 303-meets-gabba blitzkrieg unleashed in 1992 by Dance Ecstasy

2001, sister label of Frankfurt's PCP. As well as a party promoter, DBN is a record label specializing in PCP-style industrial-strength hardcore and mindfucker acid; the label's third release was titled "Bad Acid — No Such Thing." But DBN's most punishing output is released via a sublabel called SixSixtySix. The Satanic allusion is a clue to Eckes's subcultural strategy — turning heavy metal kids onto techno (Milwaukee is a big town for thrash and "black" metal).

As well as the Furthur events, DBN throw regular "techno-pagan ritual parties," often timed for the solstices. One such party — Grave Rave, on Halloween Night 1992 — was treated like a modern-day witches' mass by the authorities. Armed police stormed the building and arrested not just the organizers but the entire audience. After being detained in handcuffs for five hours, 973 people were issued \$325 citations for "aiding and abetting the unlicensed serving of alcohol" (in fact only a few cans of beer were found). Those under seventeen were also given tickets for violating the "teen curfews" that Milwaukee, like many American cities, instituted to "protect the young." But four hundred of those prosecuted pleaded not guilty, ultimately forcing the city to drop the charges because of bad publicity concerning the police's overreaction. Undaunted, DBN threw a sequel "Helloween 93" party called Grave Reverence, trailed with the promise "demons of the darkside taking control of your soul."

Even Furthur is a microcosm of American rave culture in the late nineties. On the upside, Furthur wouldn't exist without the zeal of the promoters (who definitely aren't in it for the meager profits) and the dedication of the kids, who are prepared to drive five to fifteen hours to a rave, and who sustain the geographically dispersed scene via the Internet and fanzines like *Tripp E Tymes*. But on the downside, there's the debauched extremity of the drug use, the tender age of the participants, and the precarious relationship with the law (the reason why Even Furthur had to take place at such a remote, rural location).

Despite regular outcries in regional newspapers, despite police harassment and legislative repression on the state, county, and city level, rave in America never really escalated to a national news phenomenon. Virtually every year since 1991, current affairs TV programs have "discovered" rave and solemnly informed parents it's "the latest craze," despite the fact that rave started in

America as early as 1990. 20/20's 1997 exposé of the Florida rave scene is typical, whipping up parental fears with its references to "blatant, brazen drug taking" and parties situated "anywhere that's far from adult supervision." At these "drug supermarkets" nonusers are an "endangered species" because "peer pressure is profoundly strong." Yet for all its folk-devil/media-panic potential, American rave culture never hit that critical mass of public outrage that really pushed British rave over the top in 1988–89.

Any given rave scene seems to enjoy a honeymoon period of two years, tops, before problems begin to appear — the shift from Ecstasy use to abuse; MDMA burnout and the lure of amphetamine as a cheap, dependable surrogate; polydrug experimentation. The resulting paranoia and mental confusion are aggravated by taking place in a context of drug rip-offs and criminality. First "in" and therefore first to burn out, the scene's prime movers succumb to "lifestyle dysfunction," even mental breakdown.

The hardcore hedonism caught up with STORMrave's Frankie Bones in August 1993. "On the weekend of Labor Day, I had a seventy-two-hour thing where I was eating everything — acid, Ecstasy — and smoking angel dust. . . . Toward the end of my mission, my mother caught up with me, 'cos I'd wrecked my car. I was doing really weird things — the way my uncle described it to me, I didn't care if I lived or died. . . . My uncle had a neighbor who worked in the hospital. I was only supposed to go there for some tests, but they found so much shit in my system, they locked me up and put me on medication." Seven weeks later, Bones was released and went back to live with his mother for the first time in ten years. "All I wanted to do was eat my breakfast, lunch, and dinner, and watch TV. I had no interest in music." By the end of '93, Bones was off the medication, but his career was in tatters. It took him a year to get back into regular DJ-ing.

Bones's misadventures weren't unusual. In Long Island, Caffeine's "just like the sixties" vibe went from 1967 euphoria to a 1969 death-and-madness trip. "If you exceeded your limit five times over, you were probably at Caffeine," says Bones with a wry grin. "Kids couldn't afford Ecstasy, so they did LSD as an alternative. I remember this girl on acid just flipping out and running amok, we had to hold her down."

By late '93, the East Coast was "at the bottom of the US rave scene, we went from totally the best to a bunch of bullshit. . . . The 'poly-' is what fucked

everything up," Bones says, referring to his doctors' original diagnosis of "poly-substance abuse." Finding that E alone wasn't getting them high enough anymore, kids were mixing all manner of drugs into potent, unpredictable cocktails that blew their teenage minds but created an antidance vibe. "Kids were combining Special K, angel dust, Es, acid, and they'd just become a ball of jelly, sitting on the floor."

NASA was also succumbing to the darkside. "People started taking Limelight drugs," says DB, referring to the rampant abuse of drugs like ketamine by more cynical Manhattan club kids. "People were lying in hallways, it wasn't so euphoric." By 1993, says Scotto, "the drug dealers were the heroes of the scene — you were either a promoter, a DJ, or a dealer. Then the dealers were getting paranoid, having these fantasies of being a Mafia guy or a gang member."

At one NASA night in spring '93 — a few months before the club closed down — a girl handed out a photocopied leaflet. Framed with smiley faces, happy goldfish, and handwritten phrases like "group hugs," the sheet was a heartfelt, heartbreaking plea for a return to lost innocence.

Why are you at this event? The rave scene is not just about techno. This scene is not just about drugs. This scene is not just about fashion. It is something special about unity and happiness. It is about being yourself and being loved for it. It should be a harbor from our society. But our scene right now is disintegrating! Old-style ravers — remember when everybody hugged all the time — not just to say hello and goodbye? Remember when people just said hi for no reason except to be your friend? Remember how good it felt? Why don't we do it anymore? Newcomers — you are wanted and you should know that this scene is about openness. We all share a bond — the desire to groove to a good beat all night long. And no man is an island. Everyone needs friends and the outside world is tough enough. We don't need fronts and attitudes in our scene. Open your hearts and let the good feelings flow. . . . Ravers unite and keep our scene alive.

What's truly poignant about this leaflet is that the golden age being lamented had occurred only nine months earlier — an indication of just how swiftly Ecstasy burnout and polydrug mind rot can set in. Over in San Francisco, many

of the major players in the cyberdelic milieu were succumbing to drug-induced malaise. "There's specific people who got into serious drug trips, using speed, heroin, ketamine," says Jody Radzik. "Key people really fucked up." Radzik himself began dropping out of the scene in February '92. "Just through getting involved in raving and Ecstasy I uncovered [personal problems] that I had to deal with. I developed a lot of insecurities, socially, and just had to remove myself." Radzik says he "went through a little psycho drug period too.... Maybe it *helped* in that it made things a lot worse. The ecstasy, the speed, exposed all these huge inner flaws that I had to [deal with]."

In the spring of 1993, a tragedy occurred that cast a pall over the ailing San Francisco scene, but that also, in a weird twist, opened the way for a partial regeneration of idealism. After a Full Moon party, the Wicked crew were driving back in their van. In the back, asleep, was Malachy O'Brien, with the spare sound system he'd brought along in case the event was busted. "We came off the road up at Candlestick Park, ironically near where some of the early Full Moons had happened, and ended up in the Bay," says Malachy. The driver may have nodded off at the wheel after partying too hard (a common cause of postrave accidents); there might also have been a mechanical failure with the car. Whatever the crash's cause, a speaker impacted Malachy's head, bending it so badly his neck was broken. He was left a quadriplegic.

It's a testament to Malachy's character that he's capable of talking of the accident in terms of good fortune: "It was a lucky escape, there was a generator full of gasoline." Despite his personal catastrophe, Malachy also stresses that the tragedy reunited the divided San Francisco scene, with promoters coming together to organize a series of benefit raves to pay for his hospitalization and physical therapy. The flyer for the first benefit — called Come-Unity and held in April 1993 at Richmond Civic Center auditorium — beseeched "Music Is a Healing Force, Dance Is a Healing Energy, Join Together and Dance For the Healing of A Troubled World and the Healing of Malachy." During the rave, the DJ-ing was interrupted by a healing ceremony guided by a shaman and a Zen monk, with Malachy appearing on a video screen and addressing the crowd. Today, Malachy has recovered some movement in his biceps, allowing him to operate his joystick-controlled wheelchair and use the trackball on a computer. After a period of intensive physiotherapy in England, he's back in San Francisco and still involved in the house scene, helping to run Come-Unity.

Although Malachy accentuates the positive, other scenesters responded to the tragedy as an ill omen. "When that happened, it was the beginning of the end for me," says Nick Philip. "I don't think everybody believed anymore that we were going to save the world. It was just so weird that it happened to Malachy — the nicest guy, and the person who really *lived* it. A lot of people spouted the philosophy about saving the planet and global consciousness, but Malachy really lived it, he gave his [proceeds] away to fuckin' charities [like Greenpeace].... It happened to *him*, and that freaked people out.... A number of things happened — drug-related incidents, busts, someone shot at a rave in Santa Cruz — that turned the optimism into something different."

Meanwhile, down the coast in Southern California, the LA rave scene was being killed by its own success. The syndrome was similar to England in 1989: media outcry, police crackdown, rivalry among promoters, gangsterism, bad drugs. The LA riots provided the coup de grâce, destroying the precarious transracial alliances.

There was a symbolic death knell in July 1992, when Mars FM dropped its techno playlist in favor of alternative rock. Protests and petitions by a group calling itself Friends of Techno and Rave Music led to a brief restoration, but by September techno was dropped again, this time for good. It was probably a sound business decision, based on the realization that the record industry was backing grunge, not rave, as the new youth-cultural cash cow. The major labels had signed up a bunch of British and European rave acts; American Records' supremo Rick Rubin seemed briefly captivated by the idea that techno was the new punk. But grunge was a better bet. Guitar riffs, gruff vocals, a little bit of old-fashioned rebellion — this was something the record industry understood, and bands were something that could be marketed, unlike DJs and "faceless techno bollocks."

Mars FM's turnaround was probably also influenced by the tarnishing of rave's image in LA. The local media had discovered that the dance parties, far from being innocent extravaganzas, were bacchanals fueled by Ecstasy. There was also a growing trade in a very different drug: nitrous oxide, sold in balloons at raves for around \$5. The harmless associations of "laughing gas" were shattered in March '92, when three young men were found dead in a pickup

truck on Topanga Canyon Boulevard. The cabin's windows were rolled up; the kids, high as kites, had left the valve open on their nitrous canister and asphyxiated. As drug researcher Dr. Ronald Siegel put it, "They basically crawled inside a balloon."

Nitrous has a surprisingly distinguished history as a psychoactive inhalant. In the nineteenth century, there was a whole discourse dedicated to "The Anesthetic Revelation" offered by nitrous, ether, and chloroform, propagated by clerics, physicians, and scholars like J. A. Symonds and William James. "Sobriety diminishes, discriminates, and says no; [intoxication] expands, unites, and says yes," enthused James in his 1902 classic *The Varieties of Religious Experience*. James claimed that nitrous intoxication was a thousandfold stronger than alcohol, stimulating "the mystical consciousness to an extraordinary degree. Depth beyond depth of truth seems revealed to the inhaler. This truth fades out, however, or escapes, at the moment of coming to; and if any words remain over . . . they prove to be the veriest nonsense."

The descriptions of "nitrous oxide trance" offered by James and other nine-teenth-century inhalers sound remarkably like MDMA. Benjamin Paul Blood wrote of recovering "the primordial Adamic surprise of Life," a gnostic realization that "the Kingdom is within." James described it as a sensation of "reconciliation," in which "the opposites of the world, whose contradictoriness and conflict make all our difficulties and troubles [melt] into unity." This sense of access to an ineffable enlightenment explains the addictive nature of nitrous — as Dr. Siegel put it: "Just a little bit more and I'm going to get the secret of the universe."

It's fairly safe to say, though, that for most ravers, nitrous's minute-long high was just a wicked buzz. "You get warm and fuzzy all over and you feel like you can float — like an astronaut. Everything feels thick and soft" is how one user put it. A slang term for nitrous is "hippy crack": "hippy" being a nod to its popularity with Deadheads, "crack" evoking the way, says Todd Roberts, "people keep going back for more; it becomes that futile attempt to transcend the experience." Taken on its own, nitrous offers a nondancey "head trip." Roberts claims, "It plays well with the strange effects and echo in the music." Inhaled after taking Ecstasy or LSD, nitrous enhances the synesthetic effects of those drugs, synchronizing visual hallucinations to the music.

Whether stolen from dentists or legally obtained from gas stations (it's

used as a fuel additive to soup up race-car engines), nitrous oxide became rife on the West Coast rave scene, eventually spreading throughout America. Because a hundred-dollar tank could fill two hundred balloons at five dollars each, the nitrous peddler could make a huge profit. Dealers started to offer the promoters big money for the exclusive rights to sell nitrous at raves. Newspapers noted in horror the popularity of "Just Say NO"T-shirts, which meant "just say yes to nitrous oxide."

Despite the freak tragedy in Chatsworth, nitrous is not harmful in itself if used with the right mix of oxygen. Because the gas makes you pass out for a few seconds, there's a risk of injury or concussion if inhaled when standing up or in motion. Morons have been known to get frostbite on the lips, tongue, and throat by sucking directly from the subzero cylinder of liquid gas. In the rave scene, the worst side effect of nitrous was to dampen the dance energy. "You sit on your ass and you don't dance," says Wade Hampton. "People get very pale and their lips turn blue, 'cos you're depleting your oxygen supply. . . . If you see people who've been doing it all night, it makes you want to throw up."

Focusing on nitrous and Ecstasy, most LA newspapers missed the scoop on the real killer drug, amphetamine — which, if seldom lethal to people's lives, is often lethal to their souls and to the rave scene's positive vibe. On the West Coast, speed and its more potent relative crystal methamphetamine (aka "chrissie" or "crystal meth") took over because speed was both more reliable than Ecstasy and more competitively priced: \$20 for a sixteenth of a gram, compared to \$28 for an MDMA pill. This was a false economy, however, because tolerance to the drug quickly destroys its edge over E. Users start taking huge amounts; some progress from snorting it to smoking or injecting. Because the comedown is vicious compared to Ecstasy's afterglow, the temptation is to go on "runs" that last several days.

By the end of '92, the burgeoning speed-freak culture in Los Angeles had coined two new slang terms, *tweaking* and *sketching*. Both mean buzzing on crystal, but "sketching" has more of a wired-and-tired, crashing-after-a-long-run connotation. "We called them raver-zombies," says Todd Roberts of the tweakers. "You'd see them stumbling across the floor, not knowing if it was Tuesday or Sunday, and not really caring. Originally, Ecstasy was the catalyst for people reaching out to you. One of the things I noticed when I first started raving was that strangers would actually say hello and smile." But

amphetamine closed down the open-hearted extroversion, replacing eye contact with vacant stares.

The Sketch Pad, a dark and dingy loft space in Venice, was the raver-zombies' crash pad. Originally running from 6 AM Sunday to the early evening, then later right through the small hours of Monday morning, the Sketch Pad's vibe was "like a crack den," says Roberts. "It started as a rent party for the girl who ran it, then it became an excuse for people to buy more drugs or just be together if they were out of their minds."

Crystal's effect on the rave community was to "break down the ties of reality," as Roberts puts it. As in San Francisco, prime movers and well-known scenesters were experiencing "lifestyle breakdowns," partying so hard they forgot about paying the bills or going to work. The crystal-fueled runs could last for weeks. "They weren't awake for weeks, but it could be a rocky road without enough sleep. Maybe work would get done one week — they'd start some projects, make some money, but then spend it on drugs. It's the addict lifestyle. Over a period of a month, if you've only spent four days working, you've got a problem."

The shift to methamphetamine affected the sound of rave music. Roberts attributes the rise of high-tempo trance on the West Coast in 1993 to crystal. "I think it lost its soul, the funk was gone. It had the beat and all the markings of techno, but it lost the irony and the *fun*." Elsewhere in America, tweakers and Ecstasy abusers followed the European trajectory of hardcore into gabba. Lenny Dee started his Industrial Strength label in Brooklyn, Drop Bass Network established their "Midwest Hardcorps" milieu, and Southern California had its own headstrong scene led by DJ Ron D. Core and based around the record store Dr. Freecloud's. The audience was younger, with little knowledge of house's roots or interest in neopsychedelic utopianism. They hadn't grown out of the club scene; all they knew was raves, massive sound systems, and going mental.

At the same time, the megaraves were dying because kids were fed up with driving long distances to desert parties that got busted. Media outcry stoked the police crackdown — not just TV news exposés, but fictionalized warnings about peer pressure and raves as "drug supermarkets." In an infamous episode of *Beverly Hills*, 90210, clean-cut Brandon is spiked with a drug called Euphoria by his girlfriend and makes a fool of himself. The next day, he's ashamed of

all the pseudo-profound emotions he'd thought he was experiencing, which have evaporated, leaving just a ghastly hangover.

Alongside teenage drug abuse, complaints about noise and nuisance, and the danger of events without proper fire and safety measures, the police were also concerned about the arrival of gangsters and gunplay on the rave scene. At 1993's Grape Ape 3, at the Wild Rivers Water Park in Orange County, a series of incidents — fights, guns being pointed at security guards, a van set on fire — led to the rave being shut down at 3 AM. The next summer, two fifteen-year-old boys were shot dead at a rave alongside the railroad track in San Diego's Old Town. Criminals were also applying pressure to the promoters. Daven Michaels had nitrous gangs trying to monopolize the supply at his parties, and "mobsters from NY coming into town trying to squeeze me 'cos I had a cash business." When he refused their offer of "partnership," Michaels received "death threats in the middle of the night. . . . I had to call the police."

Other Los Angeles promoters were calling the cops — but only to snitch on their rivals. "Originally the promoters all knew each other and made sure we weren't stepping on each other's toes," says Steve Levy. "What started killing it in the summer of '92 was that there'd be three different gigs on the same night. Everyone would be calling the cops. Eventually the kids got pissed off with paying \$20 at the map point and rolling up to a gig that immediately got busted." Even without the busts, several raves going off on the same night guaranteed low attendance all round, dissipating the vibe. Many original LA rave promoters dropped out of the business: Levy started his record label Moonshine; Borsai shifted to alternative rock promotion; Daven Michaels started making music. Others persisted: Ron D. Core with his Orange County hardcore scene, Kingfish Entertainment's Philip Blaine with his desert raves. Despite the downturn, Blaine's ally Gary Richards, aka DJ Destructo, pulled off America's biggest rave to date - the seventeen thousand-strong New Year's Eve rave at Knott's Berry Farm amusement park at the end of 1992.

Knott's Berry Farm may be isolated in its immensity, but raves on the west and east coasts of America regularly draw between four and ten thousand. Herein lies the mysterious paradox of US rave culture: it's a massive subculture, but

its momentum seems stalled. Since the end of '92, it's been stuck in a peculiar holding pattern.

On the other side of the Atlantic, the situation is quite different. Despite its fragmentation into subscenes, European rave is bigger than ever. The culture continued to escalate because new recruits arrive with each generation. In Britain, indie-rockers turned on to the new music thanks to rave 'n' roll intermediaries like Happy Mondays and Primal Scream. This never happened in America because rave is regarded as the epitome of fashion-plate Europhile trendiness; the outlandish way American ravers dress, and the goofy way they dance, tweaks the prejudices of indie-rockers and hip-hoppers alike.

The fashion element really took hold in 1993, says Storm's Dennis the Menace. "If you look at videos of the early outlaw parties, everyone's wearing jeans and T-shirts. Then it became whoever could wear the biggest hat, and people going out to be *seen* rather than to dance." Especially on the East Coast, the dancing that *was* going on didn't resemble raving in the original English sense. Instead of trancing out for hours, US teen ravers tend to dance in spasmodic bursts — often surrounded, hip-hop style, by circles of spectators. The dancing is more stylized and ostentatious than in Europe — complex involutions of the limbs, geometric torsions, and shimmying undulations that make the body ripple like computer fractals; kick-boxer skips and spinning-top twirls — all of which hark back to the break-dancing and body-popping battles of old skool rap, but filtered through a post-E polymorphous fluidity. "The pretzel dance," as Dennis calls it.

From NASA to his work as A & R director of Profile's techno sublabel Sm:)e, DB has been a long-time crusader for rave in the USA. But even he bluntly admits that "it's much more of a fad thing in America . . . more social and less about music. It's a place kids can meet their friends, get fucked up, and stay out all night away from their parents. That may sound jaded, but most weekends I DJ around the country, and that's what I see. . . . People grow into it and grow out of it very quickly. People in England burn out on the drugs too, but that doesn't mean they stop liking the music. That seems to be the way in America — once they've fucked themselves on whatever drugs they're doing, they stop liking the music and get into something else."

In US rave, the "whatever drugs they're doing" nowadays is a pharmacopoeia of illegal and semilegal substances. On the West Coast, the vogue is

hippy chick

taking a twirl on the floor at "pure techno" club knowledge, london, 1993

flyer for brainstorm

megarave thrown by brooklyn's stormrave crew, whose promise/threat was "hardcore, only 4 the headstrong"

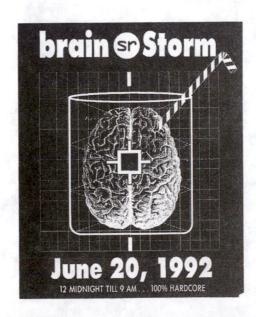

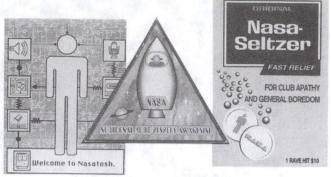

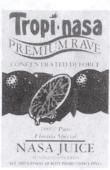

nasa

spin control

dj sneak and a panorama of enthralled ravers watching him at work. tribal massive rave, san francisco, halloween 1997

DAVID J. PRINCE

strike a pose

manhattan club kid shakes her stylized stuff at maskarave, a halloween party thrown by scotto of nasa fame, 1996

space cadet

dego mcfarlane of artcore junglists 4 hero in uncharacteristic wacky mode

jump up jungle

dj hype (right) and pascal (left) play with the ruffneck junglist's favorite lethal weapon

card trickster

trip-hop's dark magus and sonic wizard tricky
ALEXIS MARYON

breakbeat scientists

db (left), crusader for jungle in america, basks in goldie's glow, as the metalhead takes a rare stint at the turntables, mark ballroom, new york, november 1995

smooth operator

fabio, legendary rave dj alongside partner grooverider at hardcore haven rage, lately the doyen of 'jazzstep' drum and bass

ALEXIS MARYON

over the top

los angeles rave promoter daven the mad hatter threw some of the west coast scene's most outlandish and extravagant parties, like lsd and paw paw patch

ALEXIS MARYON

riot sounds produce riots

digital hardcore guerrilla alec empire looks oddly impassive as he battles dj spooky in a soundclash organized by the soundlab in chinatown, manhattan, december 1995

gloved up

archetypal hardcore ravers with white gloves, baggy clothes, and mineral water at the roller express. edmonton, august 1992

DAVID SWINDELLS

alien ninja

fusing rave's obsession with outer space and hip-hop's martial arts fetish, this flyer for a new york drum 'n' bass party captures jungle's "phuture assassin" warrior stance; flyer for SOUNDlab, the peripatetic audio-salon of new york's "illbient" scene, a border-crossing omni-genre pioneered by dj spooky, we, byzar, and subdub

for gamma y-hydroxybutyrate, or GHB, a clear, salty liquid swigged from sports bottles and sometimes fallaciously sold as "liquid ecstasy." Originally favored by bodybuilders because of its steroidlike effects, GHB developed a reputation as an aphrodisiac and a legal alternative to E (although it was actually banned by the FDA in 1990). The problem with GHB is that it may affect breathing. In overdose or combined with alcohol, GHB's respiratory depression effect can lead to coma and death. Because its impact is relative to body weight, "a lot of women pass out," says Todd Roberts. "They gulp GHB like water, and you're only supposed to have a small spoonful."

On the East Coast, another depressant drug is more popular: ketamine, a relative of PCP widely used as a veterinary anesthetic. At raves, kids take regular "bumps" of "Vitamin K" to sustain a plateau state of boneless stupor. They've even started bringing blankets to parties, so they can loll around on the floor. K's popularity with ravers is mysterious: unlike E or acid, it doesn't make music sound fantastic, it's antisocial verging on autistic, and it certainly doesn't make you wanna dance. Then there's the risk of going beyond the dissociative effect of mild doses and falling into a "K-hole," an experience that's been likened to catatonic schizophrenia. A really big dose might transport you into truly *other* realms of consciousness wherein dwell the "ketamine entities," aka "machine elves," who supervise the universe and who may tell you some interesting secrets.

When you've got sixteen-year-old kids dosing themselves with an array of substances of unknown potency and unpredictable interactions — adolescents who often aren't emotionally mature enough to surf the psychedelic maelstrom — then you have the recipe for a freak scene. "I played at LSD in Philadelphia on New Year's Eve, and twenty-five people overdosed at that party," says Heather Heart. "There were ambulances outside all night long. The party was finally shut down 'cos some girl was unconscious and they went to wake her and she was defecating herself. These were kids overdoing it, and doing a mixture of drugs — Ecstasy, ketamine, crystal, acid. None of them were just on one thing." Dennis the Menace argues that the polydrug culture has destroyed the synergy effect that occurs in rave scenes during the honeymoon phase of Ecstasy use: the "rave-gasm" feedback loop between ravers, all relatively fresh to the drug, buzzing on the same pure E. Polydrug abuse shatters that synchronized rush; everyone's on different trips. "The scene got ruined

when the pills got replaced by powders," he claims, referring to K, crystal, PCP, and cocaine. "The raves just splintered into different vibes."

Because it was a transplant — imported by English expats, in many cases rave has had trouble establishing roots in America. It never became a mass working-class movement, and it lacks certain key elements of the UK's selfsustaining subcultural matrix, like pirate radio. America is also a more hostile soil for rave. For rockers who still think "disco sucks" and who hate English "haircut" synth bands, rave is self-evidently inauthentic, a phony fad. This prejudice is not entirely without foundation. Remove from the picture the black house traditions in Chicago, Detroit, and New York (all of which predate rave), and it's striking that the white rave scene in the USA has so far failed to generate a uniquely American mutation of the music. There are isolated pockets of brilliance, for sure: Josh Wink and his Ovum label in Philadelphia, the Hardkiss crew, the Brooklyn milieu in the early nineties, plus a scattering of individual DJ/producers. But white rave America has yet to spawn a creative misrecognition of the music to rival jungle, gabba, or trance. The nearest contender is the "funky breaks" or "breakbeat" style of house that's emerged in Southern California and Florida — a hybrid of hip-hop, electro, and acid house that, while great fun, is historically stuck at the level of UK rave in 1991.

According to Steven Melrose, cofounder of the City of Angels label, the West Coast breakbeat sound has little connection with house apart from its use of "acid builds" (Roland 303 bass riffs) and its 125–135 bpm tempo. The breakbeats are popular because the four-to-the-floor house beat is just too European and disco for most American kids. "Funky breaks stems from the first rave music from the UK that was big in the USA — the '91 breakbeat hardcore of SL2 and Prodigy." This makes West Coast breakbeat the American equivalent of jungle, except that it's not as fast or as polyrhythmically complex; tracks usually feature just one looped break. The West Coast tracks also have a sunny, upful vibe compared with jungle, making the music "better for that 5 AM in the morning, palm trees vibe."

Formed by Scottish expat Melrose and his English partner, Justin King, City of Angels is one of the leading funky breaks labels. Its first release, "Now Is the Time" by the Crystal Method (a Las Vegas outfit named after a technique

for staying up all night, i.e., taking speed), defined the sound. Other West Coast pioneers include the brilliant Uberzone, Bassbin Twins and Bass Kittens; DJs like John Kelley and Simply Jeff; labels like Bassex and Mephisto. In Florida, the regional variant of funky breaks is influenced by Miami Bass — electrodescended, party-oriented rap that consists of little more than frantic drummachine beats and booming Roland 808 bass. The leading lights of Florida breakbeat are Rabbit in the Moon and DJ Icey, whose Zone label is named in homage to UK 1991 breakbeat house labels Ozone and D-Zone.

Florida now rivals California as the USA's number one rave state. These two sunshine states have a lot in common. Geographically and culturally, Florida is not really part of the traditional Dixie South. Just as Los Angeles was imposed on the desert, Florida is a leisure paradise carved out of an inhospitable Jurassic environment. It only really came into its own as a vacation and retirement hotspot after the invention of air conditioning. Like the So-Cal region, Florida is a subtropical suburban sprawl, a car culture of booming bass speakers and rootless anomie. Ostensibly the polar inverse of the state's other big youth culture, death metal, Florida rave puts the morbid metal kids to shame; it is infamous for taking excessive hedonism to the point of near-death experience, and sometimes taking it all the way. "Florida, it's an active place, but the whole state's done too many Es," says Scott Hardkiss. "We've played a lot of parties where three thousand people are there, but no one's dancing. Everyone's off their head on [the downer] Rohypnol and E that's like heroin, sit-down E."

Probably because of its high number of wealthy retirees, Florida is one of the most conservative states in America. It's hardly surprising, then, that its rave scene is under siege from police departments and legislators. As in Los Angeles in 1992, the local news media used a series of rave fatalities to marshal public opposition to the deadly "drug supermarkets." In July 1994, eighteen-year-old Sandra Montessi died from "cardiac dysrhythmia due to MDMA intoxication" after consuming one and a half tablets at Orlando's Edge club. The same year, Ecstasy also killed twenty-year-old Teresa Schwartz at the pioneering Orlando rave club Dekko's. And in 1996 a young woman and her two male friends went into convulsions at a Tampa nightclub after a dealer used an eyedropper to deposit GHB on their tongues. With overdoses a regular

occurrence, Orlando formed a Rave Review Task Force in 1997, while the city legislature passed a bill to prohibit clubs from renting their spaces out for alcohol-free after-hours raves. But the ordinance only shifted the problem elsewhere — to illegal raves outside the city limits.

This kind of repression is not unique to Florida. All across America, police departments, fire marshals, and city councils use teen curfews, ordinances, and license restrictions targeted at notorious clubs. The anti-rave crackdown is nationwide simply because there are very few states in America that don't have a rave scene. According to the Hardkiss brothers, the entire South is kickin' — Texas, Georgia, North Carolina, Virginia, Maryland. "In the Bible Belt, the kids go a little crazy, they need to break loose," says Robbie. Heading up the East Coast, the Washington DC/Baltimore area is a stronghold, thanks to DJs like Scott Henry and promoters like Ultraworld. Washington/Baltimore is really part of an integrated East Coast network that connects Boston, NewYork, New Jersey, and Philadelphia, a circuit of parties to which kids travel by car and even chartered buses. Another burgeoning scene, says Scott Hardkiss, is the Pacific Northwest, from San Francisco right up to Vancouver, via Portland and Seattle.

In the Hardkiss Brothers' hometown of San Francisco, the rave scene is still going strong. Younger kids attend Martin O'Brien's the Gathering. Wicked are still active. The elders of the scene have formed "rave communities," says Jody Radzik, tight cliques who throw small parties: the Rhythm Society of St. John the Divine, Sweet, Friends and Family, Cloud Factory, Gateway Systems. The distinctive Bay Area spirituality endures, often in unusual ways — like the Planetary Masses at Grace Cathedral, religious ceremonies modeled after the Nine O'clock Service in England and organized by the Reverend Matthew Fox, who joined the Episcopalians after having been defrocked as a Dominican priest because of a dispute with the Vatican. On the techno-pagan tip, Dubtribe and other small outfits still throw renegade parties. The Full Moon concept migrated south to Southern California thanks to a crew called Moon Tribe. Along with parties in the desert, many LA raves take place on Native American reservations, where the police have no jurisdiction. Like the post-Spiral Tribe sound systems in Britain, American rave outfits exploit the local terrain, looking for "cracks and vacancies" left by the state.

From illegal free parties through borderline events like Even Furthur to

massive commercial extravaganzas, American rave survives, despite its stylistic fragmentation and regional dispersal. Whether it will benefit from the record industry's enthusiasm for "electronica" is unclear. The major labels are trying to distance the music from drug culture by marketing techno as band music rather than a DJ culture. Where that will leave the "real" American rave scene remains to be seen.

Musicians, bless 'em, hate categories. "Don't pigeonhole us." "It's all music, man." "Is there any kind of music we don't like? Just bad music, really." These are the kind of platitudes the journalist encounters regularly. In recent years, no genre designation has been more resented and rejected by its purported practitioners as a press-concocted figment than "trip-hop."

Personally, I always thought the term was just fine. Not only does "trip-hop" sound good, but it evokes what it supposedly describes: a spacey, down-tempo form of hip-hop that's mostly abstract and instrumental. It's a handy tag for a style that emerged in the early nineties: hip-hop with the rap and the rage removed. While not exclusively UK-based, trip-hop nonetheless remains totally out of step with current American rap, where rhyming skills and charismatic personalities rule.

Designed for headphone listening as opposed to parties, reverie rather than revelry, trip-hop retains the musical essence of hip-hop — breakbeat-based rhythms, looped samples, turntable manipulation effects like scratching — but takes the studio wizardry of pioneering African American producers like Hank Shocklee and Prince Paul even further. When not entirely instrumental, trip-hop is as likely to feature singing as rapping. Widely regarded as the genre's inventors, Massive Attack deployed an array of divas, both female (Shara Nelson, Tracey Thorn, Nicolette) and male (roots reggae legend Horace Andy), alongside rappers 3D and Tricky. The latter's solo work mixes singing and rapping, with Tricky often providing bleary "backing raps" to his partner Martina's dulcet lead vocal. Generally, when trip-hoppers do rap, their style is contemplative, low-key, and low-in-the-mix.

Opponents of the "trip-hop" concept often argue that it's nothing new, citing precedents for abstract impressionist hip-hop like the early collage tracks of Steinski and Mass Media and the 45 King, the sampladelic fantasia of Mantronix, cinematic soundscapes like Erik B and Rakim's "Follow the Leader," obscure one-shots like Red Alert's 'Hip Hop on Wax' or "We Come to Dub" by the Imperial Brothers. True enough, but the fact remains that, with the twin rise in the late eighties of "conscious" rap (Public Enemy, KRS1) and gangsta rap (NWA, Scarface, Dr. Dre), the verbal, storytelling side of hip-hop gradually came to dominate at the expense of aural atmospherics. Just as this was happening Stateside, the idea of instrumental hip-hop was flourishing in Britain (perhaps because of the difficulties involved in rapping convincingly in an

English accent). Some of these early collage-based "DJ records"—M/A/R/S's "Pump Up the Volume," Coldcut's "Beats and Pieces," Bomb the Bass's "Beat Dis" — were sufficiently up-tempo to get swept up into the burgeoning house scene. But others, by the likes of Renegade Soundwave, Meat Beat Manifesto, and Depthcharge, jumbled up elements of hip-hop, dub reggae, and film soundtracks to create a distinctly UK sound — a moody down-tempo funk, high on atmospherics, low on attitude, and a precursor to today's trip-hop.

In America, hip-hop and rave culture are almost totally separate and estranged subcultures. But in Britain, trip-hop can be considered an adjunct to rave culture, just another option on the smorgasbord of sounds available to "the chemical generation." Like rave music, trip-hop is based on samples and loops; like techno, it's the soundtrack to recreational drug use. In trip-hop's case, that drug is marijuana rather than Ecstasy. Funky Porcini's James Bradell went so far as to define trip-hop as "the mixture between computers and dope."

Hip-hop's influence in the UK blossomed in the form of jungle and trip-hop, distinctly British mutants that black Americans barely recognize as relatives of rap. Where hyperkinetic jungle is all about the tension and paranoia of London, trip-hop's mellow motherlode is Bristol. Laid-back verging on supine, Bristol is Slackersville UK, a town where cheap accommodation allows bohemia to ferment; members of Portishead describe it as a place where "people take a while to get out of bed" and "get comatosed" of an evening. Because of its history as a port in the slave trade, Bristol has a large, long-established black population. Combined with a strong student and bohemian presence, this has made the town a fertile environment for genre-blending musical activity. All these factors fostered a distinctive Bristol sound, a languid, lugubrious hybrid of soul, reggae, jazz-fusion, and hip-hop.

The story begins with the Wild Bunch, a mid-eighties sound system/DJ collective renowned for its eclecticism. Members included Nellee Hooper (who later brought a Bristol-ian jazzy fluency to his production work for Soul II Soul, Neneh Cherry, and Bjork) and Daddy G and Mushroom, who went on to form Massive Attack with rapper 3D. Tricky contributed raps to both Massive albums, while Portishead's soundscape creator Geoff Barrow assisted with the programming on Massive's 1991 debut *Blue Lines*.

Blue Lines was a landmark in British club culture, a dance music equivalent to Miles Davis's Kind of Blue, marking a shift toward a more interior, meditational sound. The songs on Blue Lines run at "spliff" tempos — from a mellow, moonwalking 90 beats per minute (exactly midway between reggae and hiphop) down to a positively torpid 67 bpm. Massive Attack make music you nod your head to rather than dance to.

Distancing themselves from the party-minded functionalism of dance culture, Massive Attack cited instead conceptualist, album-oriented artists across the spectrum, from progressive rock (Pink Floyd) to post-punk experimentalism (Public Image Limited), from fusion (Herbie Hancock) to symphonic soul (Isaac Hayes). Hayes's influence came through on string-laden, mournful epics like "Safe from Harm" and "Unfinished Sympathy," both of which were hit singles in Britain. But Massive Attack's real originality lay in more tranquil tracks like "One Love," with its mesmerizing clockwork rhythm and jazzy, electric piano pulsations. On "Daydreaming," 3D and Tricky drift on a stream of consciousness, quoting from *Fiddler on the Roof* and the Beatles and floating "like helium" above the hyperactive "trouble and strife" of everyday life. Expounding a Zen-like philosophy of sublime passivity and disengagement from the "real," they rap of "living in my headphones."

Victims of "Bristol time," Massive Attack took three years to record the sequel to *Blue Lines*. The title track of *Protection* and the album's down-tempo despondency reiterated the basic Massive Attack anti-stance: the longing for refuge and sanctuary from external chaos, music as healing force and balm for the troubled soul. But in 1994, Massive were dramatically upstaged and outshone by two of their protégés, whose different takes on Bristol's "hip-hop blues" were more eerie and experimental (Tricky, about whom more later) and more seductively sepulchral (Portishead).

Throughout Portishead's debut *Dummy*, singer Beth Gibbons sounds like she's buried alive in the blues. *Dummy* is like eavesdropping on the cold-turkey torment of a love-junkie; her lyrics are riddled with imagery of bereavement, betrayal, and disenchantment. "Biscuit" is at once the album's aesthetic high point and emotional abyss. Through one of Geoff Barrow's dankest, most lugubrious palls of hip-hop noir, Gibbons intones a litany of lyric fragments, disconnected shards of anguish. "I'm scared/got hurt a long time ago . . . at last, relief/a mother's son has left me sheer." Compounding the faltering,

fragmentary quality of this abandoned lover's discourse, "Biscuits" pivots around a lurching stuck-needle sample of Johnny Ray singing "never fall in love again," which runs at a grotesquely lachrymose 16 rpm, so that it sounds like the Nabob of Sob is literally drowning in tears.

Throughout *Dummy*, Barrow expertly frames Gibbons's torched songs with somber soundscapes whose jaundiced desolation is steeped in the influence of film noir and sixties spy movies. "I like soundtrack music, 'cos of the kind of sounds they use to create suspense," he says. "Modern soundtracks, they're too digital and synthesizer-based, whereas the stuff I like involves orchestras and acoustic instruments." Perhaps in an attempt to ward off the cliché applied to their kind of impressionistic, evocative music — "a soundtrack to a nonexistent movie" — Portishead went ahead and made a film to accompany the single "Sour Times." Entitled *To Kill a Dead Man*, the ten-minute short aspires to a Cold War feel, in homage to seedy espionage movies like *The Ipcress File*.

The influence of soundtrack music is a common denominator running through trip-hop. DJ Shadow, a white B-boy from Davis, California, who's one of the very few American exponents of the genre, cites film score composers John Williams and Jerry Goldsmith as particular favorites. Shadow's long suites of sample-woven atmospheres and spoken-word sound bites are designed to encourage people to drift off into reverie and generate their own cinematic mind's-eye imagery.

Shadow's music offers the listener what some call "deep time" — the kind of tranquil, spellbound immersion that you experience as a child when you're lost in a book, and which is becoming harder and harder to recover in the age of channel surfing and blip culture. Shadow's music isn't social (he's said many times that he's not making music for the dance floor), nor is it antisocial (as with gangsta rap); it's asocial: an aural sanctuary from the hurly-burly, music that hushes your soul.

After early efforts on his own imprint Solesides, Shadow first grabbed attention when he hooked up with London's Mo Wax label. First, there was the twelve-minute epic "In/Flux," a panoramic early-seventies groovescape whose disconsolate strings, lachrymose wah-wah, and fusion flute recall both

the orchestral soul of the Temptations' "Papa Was a Rollin' Stone" and Miles Davis's elegy for Duke Ellington, "He Loved Him Madly." These two early-seventies classics captured that era's sense of "slippin' into darkness." With its ghostly shards of liberation rhetoric drifting by on the breeze, "In/Flux" is at once an elegy for the lost ideals of the sixties and an evocation of the nineties' own gloom and millennial trepidation.

Throughout "In/Flux" and its sequels, "Lost and Found" and "What Does Your Soul Look Like?," Shadow's mastery of sampling makes him seem like a conductor orchestrating a supergroup of stellar jazz and funk sidemen. Shadow's sources are far broader than the American hip-hop norm: "Lost and Found" offsets tentative dejection (a mournful keyboard figure from Fleetwood Mac's "Brown Eyes," Christine McVie's ballad off 1979's *Tusk*) against resilient determination (a martial drumbeat plucked from U2's "Sunday Bloody Sunday"), in order to dramatize a kind of internal battle for psychic survival in a world gone crazy.

With the release of his 1996 debut *Endtroducing*, Shadow was garlanded with acclaim by American rock critics. But he remains virtually unknown on the US rap scene. What happened to hip-hop in the nineties that it has no place for a visionary like Shadow? For understandable reasons, the American rap community wanted to reaffirm the music's blackness in the face of its commercial breakthrough and subsequent "vanilla" misappropriations. This back-to-black-lash took the form of an obsession with keeping it "real." The emphasis shifted away from production to the verbals — street-life story-telling, rhymin' skills, the rapper's larger-than-life "playa" persona. These elements increased in importance because, by pertaining specifically to African-American experience, they reinforce rap's inclusion/exclusion effect ("it's a black thing, you wouldn't understand"). Simultaneously, some hip-hop producers abandoned samples and loops in favor of live musicianship, because of the legal and financial hassles with sample clearance.

"What sparked me back when I was growing up was the combination of music and lyrics," says Shadow. "But as the lyrics started to get more important, I came to feel they were confining, too specific. I wanted to mess around with breaks, like Steinski or Curtis Mantronik did, and try to do new things with samples. Mantronix albums were about fifty percent instrumentals, and even when they weren't, MC Tee's voice was more like texture. Sometimes I think

what I do is just 'sample music,' an entirely different genre. Like some people aspire to be the best at guitar, I want to be constantly doing new things with the sampler. Prince Paul, Mantronik, and Steinski were doing it — these were guys who had a stack of records behind them and just let their imaginations take over. That's my lineage, that's the tradition I want to contribute to."

The parallel between Jimi Hendrix, who fled R & B constrictions for psychedelic London, and Shadow, a refugee from "hip-hop pressure," is striking. In Britain, hip-hop never assumed the political, countercultural role it did in America, but was just one of many imports (soul, jazz-funk, dub, Chicago house, Detroit techno) to take its place in the spectrum of "street beats." Race is rarely the crucial determinant of unity in British dance scenes (exceptions include swingbeat and dance hall reggae, both of which are based almost entirely on imported African-American and Afro-Caribbean tracks). Instead, what counts is a shared openness to technology and to drugs. And so trip-hop and jungle are full of multiracial crews and black/white duos; all-white practitioners don't have to *justify* themselves like their rare American equivalents do.

From a different vantage point — that of the hip-hop "patriot" — trip-hop's racial politics look less like color-blind utopianism than an evasion of tricky issues. Some have argued that trip-hop simply provides white liberals a chance to experience some of hip-hop's flavor without confronting any of its discomfiting aspects (ghettocentric rage, what KRS1 has called "niggativity"). With their veneration of old skool hip-hop (Grandmaster Flash, electro, Ultramagnetic MCs) and their relative indifference toward contemporary rap and R & B, British labels like Mo Wax and Ninja Tune arguably belong to a tradition of white art-school Brit-bohemians who renovate and adapt black music styles only when their cultural life is over. In the sixties and early seventies it was blues guitar; in the nineties it's scratching and "turntablizm." According to this critique, trip-hop is merely a form of gentrification, a case of middle-class whites moving in when the underclass blacks have moved on or been moved out.

Not "real" rap, not proper jazz, trip-hop is in some ways a nineties update of fusion. But with a crucial difference: despite its fondness for jazzy flavor and blue keys, trip-hop isn't based on real-time improvisation, but rather home-

studio techniques like sampling and sequencing. DJ Krush's "Slow Chase," for instance, is cold-sweat paranoia-funk with an implosive wah-wah trumpet solo that recalls Miles Davis's lost-in-inner-space coked-out delirium circa *On the Corner* and *Dark Magus*. With its psychedelic edge, this era of "electric Miles" deserves the moniker "acid jazz." Unfortunately, that term was invented by an early-nineties London scene — labels like Talkin' Loud and Dorado, bands like the Brand New Heavies and D-Note — to describe a much milder vision of fusion, inspired by the fluency of Lonnie Liston Smith rather than the fever dreams of Miles.

Punning on acid house, acid jazz was a riposte to rave culture, signaling a Luddite retreat to live musicianship and the resurrection of the idea of clubland as a metropolitan elite (as opposed to rave's suburban populism). Triphop has historical links with acid jazz. Mo Wax founder James Lavelle started out writing for the jazz-revival magazine *Straight No Chaser*. And much of the output of Mo Wax, Ninja Tune, and similar labels like Pork and Pussyfoot is basically acid jazz gone digital. Sampling is resorted to not for its radically antinaturalistic potential but as a cut-rate means of making a seamless neo-fusion without actually hiring live musicians. Too often, the result is a tasteful but insipid composite of connoisseur musics like jazz-funk, rare groove, and "conscious" rap (A Tribe Called Quest, The Jungle Brothers).

The guiding ethos of this "good music society" is *cool*. All the energies that galvanize rave music — derangement, submission to technology, underclass desperation, mass hysteria — are shunned in the belief that "mellow" equals "mature," that head-nodding contemplation is superior to sweaty physical abandon. Accompanying this spiritually goateed (sometimes *literally* goateed) hipster ethos is a sort of drug ethic: Ecstasy is unseemly, plebeian, but marijuana is sophisticated, bohemian. The sensibility of labels like Mo Wax and Ninja Tune is what you might call *break-beatnik*.

The problem is that too little of the output of these labels lives up to the psychedelic evocations of the term "trip-hop." Instead, what you get is muzak for pot smokers. Trip-hop rhetoric promises the ultimate in fucked-up, anything-goes, neo-B-boy abstraction, but too often delivers a half-assed sequencing of borrowed bits and bobs and a mood spectrum ranging from pale blue to languid affability. Ninja Tune's brand of "funkjazzticaltricknology" — as purveyed by its roster of DJ Food, Funky Porcini, the Herbaliser, and Up

Bustle & Out — is a prime example of such spot-the-sample whimsy. The label was founded by those late-eighties DJ-record cut 'n' mix pioneers Coldcut, whose Matt Black told *The Wire* in 1996: "I'm interested in the similarities between playing music, playing with toys and playing a game. It's the same word, so at best, we're aiming to be a synthesis of those three things." Drawing on the conventions of EZ listening, soundtrack themes, and incidental music, the Ninja Tune artists take this kitsch and synch it up to looped grooves; the result, on tracks like Funky Porcini's "Venus," is a densely referential melange of motifs and textures — vibes, brush-on-cymbal percussion, "stalking" upright bass — that triggers the listener's received images of "relaxation" and "sophistication."

In British record shops, Mo Wax and Ninja Tune tracks are sometimes filed in a category called "blunted beatz." While all music sounds more vivid when the listener is stoned, trip-hop is explicitly designed to enhance the effects of marijuana. The torpid tempos suit the way marijuana slows down time and expands the present moment. The perception of texture and timbre is intensified so that the rustle and glisten of a hi-hat is endlessly absorbing. With higher doses or stronger weed like "hydroponic," other effects come into play: free association, flights of fancy, synesthetic confusion of the senses ("seeing" the music), mild hallucinations (hearing "voices" in the percussion, say). It's at this point that the free-floating reverie and perceptual distortions induced by the trip-hop/pot combination can tip over into a darker disorientation. You can hear this crepuscular gloom in USSR Repertoire (The Theory of Verticality) by DJ Vadim, by far the best Ninja Tune artist. Minimal to the point of emaciation. Vadim's locked grooves and ultravivid, up-close sample textures create a feeling of entropy and dislocation. Slipping outside the schedules of normal temporal consciousness into an overwhelmingly intensified "now" can instill foreboding rather than bliss. Paranoia is one of marijuana's under-remarked side effects, but it's critical for any understanding of music in the nineties.

If "blunted" literally means without edge (and is therefore a good description of too much trip-hop), in American rap slang it has come to evoke a particular kind of marijuana mind-state in which delusions of grandeur alternate with a mystical apprehension of impending doom. Weed's free-associational effect,

refracted through the dark prism of paranoia, lends itself to a certain kind of conspiracy consciousness: the perception of malign patterns within the chaos, a superstitious belief that history is steered by sinister secret societies. In the nineties, Christian Right militiamen and hardcore rappers found bizarre common ground in what Michael Kelly dubbed "fusion paranoia": a syncretic mishmash of conspiracy theories whose sources range from Nostradamus and the Revelation of Saint John the Divine to science fiction like Robert Shea and Robert Anton Wilson's *The Illuminatus! Trilogy;* from black nationalist sect the Five Percent Nation to white supremacist tracts such as William Cooper's *Behold a Pale Horse* and Ralph Emerson's *The New World Order* and *The Unseen Hand.*

Wu-Tang Clan and its extended family of solo artists (Method Man, Ol' Dirty Bastard, Genius/GZA, Killah Priest, and Raekwon) pioneered the blend of Bboy warrior stance and Doomsday vision that currently dominates East Coast rap. The Clan's 1993 debut album Enter the Wu-Tang (36 Chambers) begins with a sample from a martial arts movie about "Shaolin shadow-boxing and the Wu-Tang sword." Then there's the challenge "En garde!" and the clashing of blades as combat commences. Wu-Tang's Shaolin obsession renders explicit the latent medievalism of hip-hop. Gangsta rap strips away the facade of free enterprise to reveal the war of all against all: a neomedieval paranoiascape of robber barons, pirate corporations, and conspiratorial cabals. In the terrordome of capitalist anarchy, the underclass can survive only by taking on the mobilization techniques and the psychology of warfare - forming blood brotherhoods and warrior clans (like the overtly neomedieval Latin Kings) and, individually, by transforming the self into a fortress, a one-man army on perpetual red alert. (Hence the hip-hop vogue for Machiavelli and Sun Tzu's The Art of War). The medievalism also comes through in the biblical language and superstitious imagery (ghosts, fiends, devils) employed by these rappers. What is conspiracy theory if not twentieth-century demonology, with phantasmic organizations like the Trilateral Commission, the CIA, and the Freemasons standing in for Satan?

Listen to the Wu-Tang's raps, or those of allies like Gravediggaz, Sunz of Man, and Mobb Deep, and you're swept up in a delirium of grandiose delusions and fantastical revenges, a paranoid stream of consciousness whose imagistic bluster seems like your classic defensive formation against the

specter of emasculation. For the Clan, words are "liquid swords" (as Genius's album title put it). The Wu's febrile rhyme schemes are riddled with imagery of preemptive strikes, massive retaliation, and deterrence through overkill: "New recruits, I'm fucking up MC troops"; "Wu Tang's coming through with full metal jackets"; "call me the rap assassinator"; "merciless like a terrorist."

Hallucinatory and cinematic, Wu-style hip-hop — sometimes called "horrorcore" or Gothic rap — is a sonic simulation of the city as combat zone, a treacherous terrain of snipers, mantraps, and ambushes. In Wu Tang producer the RZA's murky mixscapes, it seems like "fiends are lurking," as Raekwon and Ghostface Killer put it on "Verbal Intercourse." Melody is shunned in favor of a frictional mesh of unresolved motifs — a hair-raising horrormovie piano trill, a hair-trigger guitar tic — which interlock to instill suspense and foreboding. Usually, the looped breakbeats don't change, increasing the sense of non-narrative limbo. The selfsame locked-groove repetition that works in British trip-hop as a blissful disengagement from reality becomes, in American horrorcore, a metaphor for the dead ends and death traps of ghetto life.

How is it that a very similar mixture — "computers and dope," basically — has such radically different results on opposite sides of the Atlantic? Freed of American rap's fiercely felt duty to "represent" the "real" through lyrics, British trip-hop can happily evade the questions — of class, race, the crisis of masculinity, the social and psychic costs of drug culture — that literally *bedevil* contemporary hip-hop. Only one English trip-hopper has confronted this dark matter: Tricky.

It's no coincidence that of all the trip-hoppers, Tricky is the most committed to verbal expression (he described Public Enemy's Chuck D as "my Shakespeare"). Moreover, he's made the biggest effort to build bridges between British and American B-boy culture. In 1995, he followed his debut album *Maxinquaye* with the "Hell" EP, credited to Tricky Vs the Gravediggaz and featuring two collaborations with that most Gothic of the RZA's side projects. The best is "Psychosis," a febrile mire of bass-slime that sounds like it's composed of death rattles, groans, and gasps, over which a looped voice intones the doomstruck phrase "falling . . . slowly falling" over and over again. It's an aural depiction of Dante's Inferno, a seething pit of demons. In the lyrics, Tricky notes

that his given name, Adrian, is the same as the Anti-Christ's and concludes, "So it seems I'm the Devil's Son/Out of breath and on the run."

The parallels between Tricky and his East Coast American brethren are striking. Method Man named an album after the local slang term for marijuana, "tical"; Tricky called his sublabel Durban Poison, in homage to a particularly potent breed of weed. Jeru the Damaja recorded "Can't Stop the Prophet"; Tricky wrote "I Be the Prophet." But where Tricky has the edge over the horrorcore rappers is that he lets himself surrender to the psychic disintegration that the American hip-hop ego so zealously fortifies itself against. American rap is all about mobilizing for battle; Tricky's music is all about entropy, dissipation. He's brave enough to stare defeat in the face.

Who is Tricky? A Sly Stone for the post-rave generation (the *Maxinquaye/There's a Riot Goin' On* analogy is a critical commonplace). Public Enemy's Chuck D without the dream of a Black Nation to hold his fragile self together. The greatest poet of England's "political unconscious" since John Lydon circa *Metal Box.* Roxy Music's Brian and Bryan compressed into one wiry body, Enoesque soundscape gardener *and* Ferry-like lizard of love/hate. The "black Bowie."

The latter fits because Tricky's gender-bending imagery is reminiscent of nothing so much as the video for "Boys Keep Swinging," where Bowie impersonated an array of female stereotypes. On the cover of the "Overcome" EP, Tricky's wearing a wedding dress and clutching a pistol in each hand. For the sleeve of "Black Steel" he's a diva, grotesquely caked in mascara and lipstick, mouth contorted somewhere between pucker and screwface. The song itself is Tricky's most confounding gender/genre twist of all, transforming Public Enemy's "Black Steel in the Hour of Chaos" into indie noise-rock, with singer Martina's voice uncaging Chuck D's suppressed "feminine side."

There really aren't too many black artists who cross-dress (it's hard to imagine Ice Cube in a mini-skirt, high heels, and false eyelashes, for instance). This shows the extent to which Tricky belongs as much to a British art-rock tradition (Japan, Kate Bush, Bowie, Gary Numan) as to the more obvious hip-hop lineage. But it's also yet another indication of the compulsive, almost pathological nature of the man's creativity; like Courtney Love's *kinder*-whore

image, Tricky's transvestism proclaims "something's not right here." Especially as cross-dressing isn't a marketing gimmick or joke, but something he's done since he was a fifteen-year-old kid running around town with his ruffneck brethren in the Bristol ghetto Knowle West.

"You say 'what is this?'/Mind ya bizness!" So Tricky taunts the listener two-thirds of the way through *Maxinquaye*. He's actually rubbing your nose in the perplexity aroused by the strange relationship described in "Suffocated Love," but it could serve as an epigraph for the entire album, a statement of malignant intent. Racially, stylistically, sexually, Tricky is one slippery fellow. *Maxinquaye* is an unclassifiable hybrid of club and bedroom music, black and white, rap and melody, song and atmospherics, sampladelic textures and real-time instrumentation. It sucks you into the polysexual, transgeneric, mongrelized mindspace inside Tricky's skull. How did he get into such a state? It's the drugs/technology interface — boundary-blurring, connection-facilitating, but also fucking with stable identity, letting the id come out to play.

Alongside its songs of sexual paranoia and male dread of intimacy ("Suffocated Love," "Overcome"), *Maxinquaye* is an inventory of the psychic costs of Britain's recreational drug culture. Tricky is the conduit for the cloudy, contaminated consciousness of a smashed, blocked generation. "Blocked" because it lacks any constructive outlet for its idealism, "smashed" because it can find temporary utopia only through self-poisoning/self-medication.

Where a lot of groups glamorize drugs, Tricky raps lines — "I roll the blue bills/I snort the cheap thrills"; "brainwashed by the cheapest" — which seem to attest to a healthy quotient of shame. "Cocaine is the cheapest thrill I've ever experienced in my life, the lowest, lowest thing. 'Cause it's totally unreal. You feel so good about yourself, but you've done nothing to deserve it. The times I've took it is with other artists, and you stand there and say loads of bullshit, how you respect them, love their lyrics, and you pat each other on the back all fucking night. E is just as bad: I like loads of nice things being said to me, and you say loads of nice things back, and you get all deep."

Any old stupor will do so long as it blunts an intellect otherwise too sharply conscious of the impasses and dead ends that constitute the present. It's the

revolutionary impulse turned back against the self, imploded — just as Marianne Faithful talked of addiction as an alternative to the explosive release of terrorism, both being forms of perverted utopianism. Damp down those fires; it's better to fade away than go out in a blaze of vainglory. Like *Maxinquaye*'s cover art — metal surfaces mottled with rust, an abandoned car overgrown with brambles, flaking paint — Tricky's music makes cultural entropy picturesque. But this corrosion is costly; rust never sleeps.

Maxinquaye songs like "Ponderosa" and "Strugglin'" are inspired by the slough of despond Tricky sank into after the completion of Massive's Blue Lines. With Massive paying him a weekly wage to do precisely nothing, Tricky embarked upon an alcohol and marijuana—fueled two-year bender that nearly drove him round the bend. In his weed-distorted paranoia, all that wasted time began to assume the grotesque shape of a specter. He started to see demons in his living room.

Hence *Maxinquaye*'s "Hell Is Round the Corner," where the looped lushness of an Isaac Hayes orchestral arrangement is hollowed out by a vocal sample slowed to a languishing 16 rpm basso-profundissimo, impossibly black-and-blue. As with the East Coast horrorcore rappers, Tricky's blunted anxiety detaches itself from the particular and swells into cosmic, millennial dread. "Aftermath" trumps the morbid vision of the Gravediggaz with what Tricky described as an attempt to *see through the eyes of the dead*. Pivoting around a pained flicker of wah-wah guitar and a wraithlike flute, Tricky's postapocalyptic panorama harks back to the orphaned drift of the Temptations' "Papa Was a Rolling Stone."

Where "Aftermath" finds a serene, spectral beauty in the depopulated, devastated cityscape, "Strugglin'" is grimmer because it refuses the lure of entropy, won't succumb to death wish. Sonically, "Strugglin'" sounds like Public Enemy would if they somehow lost a grip on the "black steel" of their ideology and hit rock bottom. Its fitful, stumbling beat — whose sampled components consist of a creaking door and the bloodcurdling click of a clip being loaded into a gun — makes "Strugglin'" the most disorienting track on a relentlessly experimental record. But it's Tricky's words — confessing how he's harried by "mystical shadows, fraught with no meaning" — and his voice, as fatigued and eroded as Sly Stone's on "Thank You for Talking to Me, Africa," that are most disturbing. "They label me insane, but I think I'm more normal

than most," he sniggers at the end, then collapses into mirthless, wheezing laughter.

Although there are rarely any recognizable dub reggae elements in Tricky's music, it's clear that he's been deeply influenced by dub's approach to organizing sound. The way Tricky works — fucking around with sounds on the sampler until his sources are ghosts of their former selves, mixing tracks live as they're recorded, retaining the glitches and inspired errors, the hisses and crackles — is strikingly akin to early-seventies dub wizards like King Tubby.

Tricky's worldview also shares something with Rastafarian roots reggae: the sense that we're living through Armagideon Time, Babylon's last days. The big difference is that, for the natty dread, evil is *out there*. Through their dress and rituals, Rastas exempt themselves as destined for Zion; in a Fallen World, they are "pure." But Tricky doesn't distance himself from Babylon, from the system or shit-stem (as some Rastafarians call it). He admits, "I'm part of this fuckin' psychic pollution." In his words and his music, Tricky lets all this contamination and corruption *speak itself* in its own vernacular, as opposed to the cut-and-dried polarities of the message-mongering "political" songwriter (who also imagines himself "clean").

Lines like "my brain thinks bomb-like/beware of our appetite" implicate Tricky as part of the problem, as someone convulsed by the same voracious will-to-power that's ruining the world. "It's like, I can be as greedy as you. The conditioned part of me says 'yeah, I'm gonna go out and make money, I'm going to rule my own little kingdom." In black music, it sometimes seems that everyone's searching for the kingdom, the kingdom of heaven. Some want it now, and they will not wait: the gangsta tries to build that kingdom on earth, makes a deal with Satan (who himself decided "'tis better to rule in hell than serve in heaven"). Trouble is, there's always a bigger king out there to make you his slave. So the smarter rude boys turn "conscious" and dream of the lost kingdom of the righteous, calling it Zion or the Black Nation — the pot of gold at the end of Time's Rainbow. Other black mystics — Hendrix, Sun Ra, George Clinton — dub this lost paradise Atlantis, or Saturn, or the Mothership Connection.

Tricky has come up with his own proper name for Zion — Maxinquaye. Ever

the slippery trickster, he's presented two versions of the genesis of that evocative title. "Quaye, that's this race of people in Africa, and 'Maxin,' that's my mum's name, Maxine, and I've just taken the E off," he told me. Elsewhere, he's said that Quaye was his mother's surname. I prefer the first version because it makes "Maxinquaye" into a sort of place name: the lost Motherland.

Tricky has described "Aftermath" as a song about "the end of the world" and about his mother. Given her death when he was four, it's easy to see why Tricky might feel like "sorrow's native son" (to steal a line from Morrissey), a stranger in a strange land. It's this primal wound that makes him an aerial tuned to the frequencies of anguish and dread emanating from the culture. Hollowlands, stranded limbos, aftermath zones, desert shores: Tricky's songs are the mindscapes of a generation that has lost the capacity to dream of "a better place." His music's nowhere vastness externalizes the inner void left when the utopian imagination withers and dies. And yet *Maxinquaye*'s last song, the unspeakably beautiful "Feed Me," seems to hold out a cruel glimmer of hope — a dream of the promised land, or lost motherland (Maxinquaye itself?), a place "where we're taught to grow strong/Strongly sensitive." The song is tentative, almost taunting — like a mirage.

"Unreal, yeah," Tricky mutters.

In the summer of '94, the music press, the British record industry, and London's legal dance radio station KISS FM finally woke up to jungle. Initially, the focus was exclusively on the most visible side of the scene, ruffneck raggajungle, and coverage was often sensationalistic, alluding to unsubstantiated rumors of crack abuse.

All this infuriated the self-consciously experimental contingent of the drum and bass community — labels such as Moving Shadow, Reinforced, and Good Looking, artists like Goldie, Omni Trio, Foul Play, 4 Hero, and LTJ Bukem. Together, these artists had forged a sound I dubbed "ambient jungle" because of the way it combined frenetic beats with a soothing overlay of multitextured atmospherics. Within the scene, vaguer and ultimately more problematic modifiers for drum and bass — "deep" and "intelligent" — emerged to designate the new style.

Starting in the summer of '93, there had been the first glimpses of a new direction in breakbeat hardcore: away from the dark side, toward a new optimism, albeit fragile and bittersweet. From Moving Shadow and Reinforced came bliss-drenched releases like Omni Trio's "Mystic Stepper (Feel Better)," Foul Play's "Open Your Mind," and 4 Hero's "Journey into the Light." With "Music" and "Atlantis (I Need You)," LTJ Bukem invented oceanic jungle. "Atlantis" was jungle's equivalent of Hendrix's "1983, a Merman I Should Turn to Be": over a susurrating sea of beats and bongos float scintillating motes and spangle-trails, and the languorous "mmmm's" and soul-caressing sighs of a "quiet storm" diva. If "Atlantis" imagined utopia as a subaqueous paradise, "Music" — a near nine-minute dream-drift of nebulous texture swirls, Milky Way synth clusters, and orgasmic exhalations — was cosmic. Radically uneventful, "Music" and "Atlantis" were heretically at odds with the staccato freneticism of 'ardkore. Bukem had shown it was possible to speed up the breakbeats until the body was bypassed altogether, thereby transforming hardcore into relaxing music. Rhythm itself became a soothing stream of ambience, a fluid medium in which to immerse oneself.

"Angel," by Metalheads (aka Goldie), sounded another death knell for darkside. Fusing Diane Charlemagne's live, jazzy vocal with 150 bpm breaks, eerie samples from Byrne and Eno's *My Life in the Bush of Ghosts*, a bedlam of sampled horns, and Beltram-style terror riffs, "Angel" was an astonishing soundclash of tenderness and terrorism. "Angel" showed that hardcore could become more conventionally "musical" without losing its edge. Time stretching — a process that allows a sample to be sped up or slowed down to fit any tempo of beat without changing its pitch — let producers make the vocal element of their track sound "normal," as opposed to the helium-shrill, chipmunk voices in early hardcore.

As with Warp's electronic listening music initiative in '92, ambient jungle was partly the result of an emerging generation gap within breakbeat. While younger producers still oriented their music toward DJs and dancers, the older hardcore artists were now starting to make music that worked better at home than on the dance floor, as album tracks rather than material for the DJ's relentless cut 'n' mix. As the "intelligent" drum and bass style took shape, its purveyors increasingly defined themselves against the populist fare that ruled the dance floor at the big raves and clubs: on one hand, the "cheesy" E-lation of "happy hardcore," on the other, the rowdy, rude-boy menace of raggajungle. Goldie dismissed the "booyacka" ragga tracks as unimaginative and unoriginal, immature music for immature people. Late in '94, LTJ Bukem founded Speed, a club with an explicit "no ragga" policy. And in '94, the intelligent contingent had a point. Compared with the increasingly formulaic tracks based on dance hall reggae samples, the ambient style was a breath of fresh air.

Omni Trio is not a trio. It's actually just one guy, Rob Haigh, a mid-thirties studio wizard reared on a strictly avant-garde diet: the post-punk experimentalism of Pere Ubu, Pop Group, the Fall, the early-seventies sonic sorcery of Miles Davis and dub pioneers like King Tubby, and above all the Krautrock triumvirate of Can, Neul, and Faust. "I liked the way the German bands abandoned formal song structures and experimented with sounds and textures, the repetitive nature of the music, the shifting layers and patterns," Haigh explained.

After starting out in an avant-funk band called the Truth Club, Haigh turned on to house in '89 — Derrick May, early Warp, Orbital. But he was even more excited by the first hardcore tracks using hip-hop beats. When rave's great parting of the ways occurred (the anti-'ardcore media backlash of late '92), he "couldn't abandon the breakbeats and go back to house's Roland 909 kick drum and hi-hat pattern." Sticking to his hardcore guns, Haigh avoided the culde-sac of trance and ambient that sucked in so many other avant-funk vets.

Bridging the gap between darkside and ambient jungle, Omni Trio's first tracks for Moving Shadow — "Mystic Stepper (Feel Good)" and "Stronger," from the "Vol. 2" EP — sounded at once ecstatic and harrowed. Amid the funereally funky clutter of stumbling, fitful breaks and tolling bells on "Mystic Stepper," the soul diva's exhortation "feel good" sounds strangely wracked and uncertain, capturing the trepidation of a subculture struggling to convince itself it's having fun as Ecstasy's panic-rush kicks in. "Stronger" is even more sorrowful and vulnerable, with its "know I'm not strong enough" sample and heart-tremor B-line.

The 1994 EPs "Vol. 3," "Vol. 4," and "Vol. 5" revealed Haigh to be the John Barry of hardcore. On "Thru the Vibe," harp cascades and deliberate Michel Legrand piano chords lead into a roundelay of hypergasmic female gasps and "yeah!"s, before the track lets rip with a twisting break that rattles like a rivet gun. Despite the lack of lead vocals and conventional verse-chorus-verse structures, Haigh's hook-laden tracks feel like songs, like pop music. "Thru the Vibe," "Living for the Future," and "Soul Freestyle" are epic pop-as-architecture constructions that move expertly through buildup and breakdown, orgasm and afterglow. Haigh orchestrates sampladelic symphonies out of moondust harps, mellotronic strings, seething bongos, and acapella beseechings.

But for all his brilliant arrangements, Haigh's real forte is as a virtuoso orchestrator of rhythm. Throughout his work, Haigh's beats are so nuanced, so full of varied accents, that it's like listening to a real-time, hands-on drummer who's improvising around the groove. "Vol. 5: Soul Promenade" showcased a new development that Haigh called "the soul step": "The first and third beats are emphasized, giving the illusion that the track is running at 80 bpm and 160 bpm at the same time. This gives the music room to breathe and makes it easier to dance to." Hence the ferocious elegance, the murderous panache, of Omni Trio tunes. Like the half-speed reggae bass line, the soul-step transformed jungle into smooth-grooving, sexy music.

What I really love about Omni Trio, though — as best exemplified by Haigh's all-time masterpiece "Renegade Snares" — is the music's sentimentality, the way the tenderness of the voices and the tingly, almost twee piano motifs fit the huggy, open-hearted poignancy of the Ecstasy experience. It's a quality that Kodwo Eshun captured in his plea "open your mind to the kindness of Omni Trio."

Omni Trio allies and "Renegade Snares" remixers par excellence, Foul Play were another Moving Shadow act that played a crucial role in the rise of ambient jungle. Stephen "Brad" Bradshaw, John Morrow, and Steve Gurley first weirded up the pirate radio airwaves in '92 with the ectoplasmic textures and judderquake beats of "Dubbing U" and "Survival," the latter featuring perhaps the most tremulous Morse code oscillator riff of all time.

Then Foul Play really made their mark on the hardcore scene with "Vol. 3" and its attendant remix EPs. "Open Your Mind (Foul Play Remix)" wafts billowing soul harmonies over viciously crisp breaks. The killer hook, though, is a diaphanous ripple of ethereal sample stuff, a succulent squiggle-shimmer that's honey to the ear. It's the closest thing I've ever heard to a shiver down the spine, a shudder of loved-up rapture. Midway, the track veers into the twilight zone, turns morbid and haunted, before letting rip with a veritable St. Valentine's Day Massacre of rapid-fire snares. Finally the girl-diva's voice resurges like a ghost buffeted on the breeze. Probably my favorite hardcore track ever, "Open Your Mind" is as goosepimply as the entire works of My Bloody Valentine liquidized in a blender and injected into your spine.

"Open Your Mind" and the equally ravishing "Finest Illusion" were like the return of 1992-style happy rave, only grown up a bit, the callow euphoria now tinged with poignancy, a bittersweet foretaste of the comedown after the high. Like Bukem's "Music" and "Atlantis," "Open" and "Finest" shined a light at the end of the long tunnel of "darkside." After Steve Gurley left the band, Foul Play lay low for a year, then in November '94 unleashed "Being with You," a soul-harrowing blitz of infrared bass, cluster bombs of phuture-jazz synth chords, and aerobatic vocal samples courtesy of swingbeat-diva Mary J. Blige. The band's own remix of "Being," with its afterimage trailing jitter riffs, still stands as one of the most hallucinatory, positively Martian slices of ambient jungle ever.

As the Moving Shadow roster moved toward a sun-kissed, purely affirmative sound, other drum and bass producers continued to insist on jungle's roots in "darkness." Metalheads' "Angel" and its flipside, "You and Me," typified this meld of soothing and sinister, a style Goldie dubbed "ghetto blues for the '90s."

Offspring of an English mother and an absentee Jamaican father, Goldie

spent most of his childhood flitting between different foster families in the Midlands before becoming a prime mover in the early UK hip-hop scene. His aerosol skills took him to New York, as a participant in a BBC documentary on graffiti and B-boy culture. After a spell of flirting with Rastafarianism and reading Revelation, Goldie moved to Miami, where he worked in a flea market making customized gold teeth (hence his nickname) and got involved in the criminal underworld. Returning to Britain in the late eighties, he hung out with the Nellee Hooper/Soul II Soul/Massive Attack milieu (Massive's 3D had been one of his old graffiti buddies) and made some music with trip-hopper Howie B before getting swept up in rave culture. At hardcore haven Rage, the futuristic breakbeat techno played by resident DJs Grooverider and Fabio blew his mind. Tracking tunes by Nebula II and Manix back to their label, Goldie became part of the Reinforced crew, where he acted as a sort of producer/A & R/spokesman, and, under the name Rufige Cru, released awesome tracks like the gaseous bliss-overdose "Menace."

Just as aerosol-wielding B-boys transformed vandalistic I-am-SOMEBODY rage into signature and style, so Goldie's music turned the delinquent aggression of hardcore into *artcore*. When I first met Goldie in the flesh in February '94, he was working on the intro of his masterwork, a twenty-two-minute-long concept track called "Timeless" about time and the dark side of urban life. Goldie warned me that the track would play funny tricks with my sense of time, that the twenty-two minutes would seem to pass in five, and he was right.

First came "Inner City Life," a yearning reverie of sanctuary from "innercity pressure," sung by Diane Charlemagne. Then the song glides into the ghetto with "Jah," Goldie's cyber-dub riposte to ragga-jungle: pressure-drop bass, a warrior horde of swarming breaks, and an eerie greeting-the-aliens motif à la *Close Encounters*. The track's climactic sequence is a threnody of synapse-searing strings and multitracked Ms. Charlemagnes. Finally, a reprise of "Inner City Life" subsides into the coda's slow resolution.

Listening to Goldie describe the track's construction, it seemed like every cobra-coiled breakbeat, every swathe of morbidly angelic strings, every haunted inflection of Charlemagne's vocal, had some autobiographical referent, some coded significance in his private mythology/demonology. "In New York and Miami, I saw what's happening in Britain now: the first generation of rock stars" — i.e., crack heads, people who smoke rock cocaine. "Kids who are

just going through the paradise state, who are about to become victims. 'Time-less' is Revelation. It's all right taking these kids into euphoria, into a dream state, but you have to come back to reality. What I've tried to provide is that comedown."

"Technically, 'Timeless' is like a Rolex," Goldie continued, never shy to blow his own horn. "Beautiful surface, but the mechanism inside is a mindfuck. The loops, they've been sculpted, they're in 4D." Drawing parallels between the perspectival trickery of Escher and the *trompe l'oreille* effects of the track's production, Goldie claimed that he and his engineer partner Rob Playford of Moving Shadow/2 Bad Mice were so far ahead of the game that they'd had to coin their own private technical terminology for their favorite effects: "igniting a loop," "snaking out a break," "tubing a sound." "We've learned to do magic with the bluntest of instruments," he said, referring to the way jungle producers work with relatively low-level technology. "It's like my graffiti paintings: give a graphic designer an aerosol and he won't be able to do shit with it. Nobody can come in and beat us at our own game."

"Timeless" — the title track of Goldie's major-label debut album — took over a year to come out. In the meantime, two other semiconceptual jungle albums hit the racks, both created by allies of Goldie: 4 Hero's *Parallel Universe* and A Guy Called Gerald's *Black Secret Technology*. The latter's title — inspired by a TV talk show about government mind control via the media — perfectly captured an ambivalence running through the junglist imagination, where technology figures as both orgasmatron (a pleasuredome of artificially induced sensations) and Panopticon (the terrordome in which every individual is constantly under Authority's punitive gaze). Technology promises "total control," but there's a deadly ambiguity: does that phrase refer to empowering individuals and facilitating resistance, or to the secret agendas of corporations and government agencies?

Jungle is a subculture based on abusing technology rather than being abused by it. And so Gerald Simpson takes a boyish delight in the sheer "deviousness" of the ever-escalating technology-mediated struggle between Control and Anarchy. "When we were at school, we'd find ways to get credits on Space Invaders machines. They always came back with some new trick to stop us, but we always got round it. It was, like, *ghetto technology!*"

As with a lot of post-rave producers, there's something vaguely autoerotic

or even autistic about Gerald's techno-fetishism. He frankly admits that working in his studio, "it's like your own world and you become like the god." With its synesthetic textures and three-dimensional, audio-maze spatiality, Gerald's music anticipates virtual reality. His music actually sounds like a datascape that's sensorially intoxicating yet teeming with threat. On tracks like "Gloc" and "Nazinji-Zaka" breakbeats writhe like serpents, samples morph and dematerialize like malarial hallucinations, itchy 'n' scratchy blips of texture/rhythm dart and hover like dragonflies. Like the labyrinthine, multitiered combat zones in video games, jungle offers a drastically intensified aural allegory of the concrete jungle.

Leaving behind the ghetto for the visionary ether, 4 Hero's *Parallel Universe* cleaves to the mystical, utopian side of the Afro-futurist imagination. Space is the place where the race can escape terrestrial oppression. With its astrophysical imagery (titles like "Solar Emissions," "Terraforming," and "Sunspots") and jazzy cadences, *Universe* is basically a digitized update of early-seventies fusion à la Weather Report and Herbie Hancock. This is drum and bass freed of the surly bonds of gravity: quicksilver breakbeats vaporize and deliquesce, succulent keyboards ripple and striate like globules of liquid adrift in Zero-G. On tracks like "Wrinkles in Time" and "Shadow Run" the breaks seem to fluctuate in tempo and pitch, morphing as uncannily as Salvador Dali's melting clocks. Throughout, the percussion is so extremely and exquisitely processed that it's as tactile as it is rhythmic, caressing the skin and kissing the ears.

But Parallel Universe also illustrates some of the perils of "armchair jungle." On the mellow jazz-funk glide of "Universal Love," the creamy "real" vocal and smarmy saxophone seem like a misguided grab for "real music" legitimacy. Similar problems beset Goldie's *Timeless*, finally released to rapturous praise in the summer of 1995. Despite the hosannas, *Timeless* was jungle's *Sgt. Pepper's Lonely Hearts' Club Band:* half genre-bending brilliance, half ill-advised attempts to prove Goldie's versatility.

When he was collaborating with his drum and bass peers — engineer-wizards like Playford, Dillinja, Dego McFarlane from 4 Hero — the results were astonishing: "This Is a Bad," "Jah the Seventh Seal," "Still Life," "Timeless" itself (a sort of nineties "A Day in the Life," with sixties anomie replaced by

nineties millenarian paranoia). But whenever Goldie roped in "luminary" players and vocalists from the jazz world — Steve Williamson, Cleveland Watkiss, Justina Curtis, Lorna Harris — the results were embarrassing: the jazz-rock odyssey of "Sea of Tears," the mushy mystic quiet stormscape of "Adrift" (which David Toop described as "Luther Vandross on acid"). Goldie's motley array of influences — David Sylvian and Japan, Pat Metheny, Byrne and Eno, Visage, the third Stranglers' album — proved both a strength and a liability. On the worst of *Timeless*, two particularly distressing sources — the slickedout, early-eighties Miles Davis of *Decoy* and *Tutu* and the clinical New Age jazzfusion of the Yellowjackets — came perilously close to drum and bass as twenty-first-century progressive rock. Goldie's second album — 1998's *Saturnz Return* — went all the way into prog terrain with "Mother", a sixtyminute-long expressionistic extravaganza of catharsis, inspired by his troubled childhood, and recorded with a forty-piece string orchestra.

Why did so many artcore junglists avidly embrace the most conventional and middlebrow signifiers of "musicality" (sax solos, overmelismatic singing)? Because underneath the bravado and the futurist rhetoric lurked a secret inferiority complex. Jungle is the most digitalized and sampladelic music on the planet. No acoustic sound is involved; nothing is recorded through a microphone. Most jungle is composed entirely from data derived from recordings, video, or sound modules (Pop-Tart-sized encyclopedias of samples and synth tones) and assembled using programs like Cubase VST (virtual studio technology), which presents loops and motifs in visual form on the computer screen. But because jungle relies so heavily on production and effects, many producers secretly believed that "musicality" involved moving away from digital technology. By the end of 1994, some producers in the "intelligent" sector of drum and bass had started to abandon samplers for old-fashioned analog synthesizers and sequencers as used by the early Detroit techno and Chicago house pioneers; these instruments were felt to be more hands-on and "musical" than clicking a mouse. And many began to talk wistfully of working with "real" instruments and vocalists.

When a genre starts to think of itself as "intelligent," this is usually a warning sign that it's on the verge of losing its edge, or at least its sense of fun. Usually, this progressivist discourse masks a class-based or generational struggle

to seize control of a music's direction; look at the schism between prog rock and heavy metal, between the post-punk vanguard and Oi!, between bohemian art-rap and gangsta, between intelligent techno and 'ardkore. The "maturity" and "intelligence" often reside less in the music itself than in the way it's used (for reverent, sedentary contemplation as opposed to sweaty, boisterous physicality). The majority of "intelligent jungle" tracks were no smarter in their construction than the ruff ragga-jungle anthems. "Intelligence" merely indicated a preference for certain sounds — bongos, complicated hi-hat patterns, floaty synth washes, neo-Detroit string sounds — over others that were harsher, more obviously artificial, and digitally processed.

It had always been somewhat ironic that jungle's experimental vanguard resorted to the same rhetoric used in 1992, by evangelists for progressive house and intelligent techno, to dismiss breakbeat hardcore as juvenile and antimusical. By early '95 jungle's upwardly mobile drift became horrendous reality. LTJ Bukem's club Speed — initially founded on the sound premise of playing the tracks that were too experimental for the "jump-up" junglist DJs to play out — quickly became a smug salon for the new smoothcore sound. In 1993 jungle clubs had been banished to the scuzzy margins of London. Speed's central location just off Charing Cross Road symbolized the artcore producers' craving for respectability, their desire to make over their scene into just another West End clique, in the tradition of rare groove, Balearic, and acid jazz. And it worked: everyone from ancient prog-rock bore turned techno bod Steve Hillage to acid-jazz maestro Gilles Peterson to Goldie's future lover Bjork were jostling to be seen there.

Esotericism, elegance, and elitism were now the watchwords. Moving Shadow caught the mood when they coined the ghastly slogan "audio couture"; the label's hitherto peerless output got fatally slick, with almost every release featuring their new house sound of scuttling bongos and what sounded suspiciously like a fretless jazz bass as played by some ponytailed session man. Throughout the intelligent sector, producers studiously shunned anything that smacked of ragga boisterousness or pop catchiness; instead of hefty chunks of melody/lyric, vocal samples were reduced to the merest mood-establishing tint of abstract emotion, while keyboard motifs rarely amounted to anything as memorable as a riff, just timbral washes and jazzy cadences.

The new hegemony of tepid tastefulness coincided neatly with jungle's

rehabilitation by the very people — critics, A & R people, radio programmers, techno producers — who had derided and marginalized hardcore in 1991–93. Desperate to distance themselves from ragga and to disown the ravey-ness of 'ardkore, the intelligent drum and bass contingent seized on "fusion" as a model of progression and maturity. Drum and bass was always a hybrid style. In the early 'ardkore days, this took the form of a collage-based, cut-up aesthetic, but "intelligent" replaced that fissile mess-thetic with a seamless emulsion of influences. There was an explicit reinvocation of seventies jazz-fusion (samples of Lonnie Liston Smith and Roy Ayers licks, Rhodes piano trills, frilly bass parts, horn fanfares, even flute solos) and of subsequent musics influenced by that era, like jazz-funk, Detroit techno, and garage. Too often, the result was a sort of twenty-first-century cocktail music.

For intelligent junglists, "jazz" signified texture, not process; there was no improv-combustion involved, just the use of certain kinds of chords. "Jazz" also related to a specific black British tradition, where plangent chord sequences and a polished fluency connote relaxation, finesse, sophistication, and upward mobility. And so on KISS FM's newly commissioned weekly jungle show, DJ Fabio would hail tracks by artists such as Essence of Aura, Aquasky, and Dead Calm for their "rich, lavish production — real class!" and then exhort breakbeat fans to "open your minds." All this passionate advocacy on behalf of what was basically fuzak draped over unnecessarily fussy breaks!

"Intelligent" producers genuflected at the shrine of Detroit techno, seemingly oblivious to the irony that back in '92 Derrick May, a recent and utterly horrified visitor to Rage, had railed against breakbeat-based hardcore as "a diabolical mutation, a Frankenstein's monster that's out of control." Take rising producer Rupert Parkes, who — as Photek, Studio Pressure, et al — built up a reputation by making jungle sound more like "proper" techno and less like its own superbad self. At every opportunity he would stress his Detroit "roots," telling *iD* that he and his allies (Wax Doctor, Alex Reece, Peshay) had "more in common with Carl Craig's music than we do with the majority of jungle." And this was true: although tracks like "The Water Margin" had a compelling neurotic frenzy, generally Parkes's work infected drum and bass with the funkless frigidity and pseudo-conceptual portentousness of techno — just dig track titles like "Resolution," "Book of Changes," "Form & Function"!

Alex Reece, another jazzy-jungle pioneer, was basically a house fan; in in-

terviews, he never namechecked anyone from jungle or, God forbid, the hard-core era (which he'd detested), but would instead declare of his beloved collection of classic house tracks, "I'd fucking cry if I lost 'em." Like his buddies Wax Doctor and DJ Pulse, Reece's ambition was to seduce house fans into dancing to breakbeat rhythms. And so his tunes, like the Latin-tinged "Basic Principles" and "Feel the Sunshine," downplayed the cut-up, jagged breakbeat-science in favor of a slinky, easy-rolling flow. This disco-fication of jungle paid off massively just once, in the form of the monumental Speed anthem "Pulp Fiction."

Perhaps the most influential icon of jungle's gentrification was LTJ Bukem. In his music and rhetoric, he, more than anyone, helped define "intelligence" as the repudiation of hardcore's drug-fueled energy. In retrospect, the title of his nonanthemic anthem "Music" seems like a poignant plea to "take me seriously, please." More than most computer-in-the-bedroom producers, Bukem had the resources to break with jungle's radical sampladelia; as a child, he'd studied piano, steeped himself in fusioneers like Chick Corea, and played in a jazz-rock band. In his tracks he deliberately muted the wildstyle FX of jungle's breakbeat aesthetic in favor of more naturalistic, less-chopped-up rhythms. "My sound is more realistic if you like. . . . You could imagine [a drummer] drumming it," he told *Mixmag* in 1995. Why such a retreat — from digital antinaturalism toward time-honored musicianship — should be regarded as an advance for jungle was never made clear.

By this point, the aqua-funk serenity of "Atlantis" — once so startling — had become an aesthetic cul-de-sac. Bukem's acolytes on his Good Looking/Looking Good label — PFM, Aquarius, Tayla — followed their guru by expunging all of jungle's most adrenalizing and disruptive elements in favor of a pleasant, placid formula of heartbeat bass lines, smooth-rollin' breaks, and watercolor synths. Bukem's own 1995 offering "Horizons" was closer to jacuzzi than gulf stream; its arpeggiated synths and healing chimes verged on New Age, as did the snatch of Maya Angelou wittering about how "each new hour holds new chances for new beginnings/the horizon leans forward, offering you space to place new steps of change."

Fusion-jungle wasn't an unmitigated calamity; tracks like E-Z Rollers' "Rolled Into One," Hidden Agenda's "Is It Love," PFM's "One and Only," Adam F's "Circles," and Da Intalex's "What Ya Gonna Do" showed it was possible to

incorporate smoother textures from seventies soul and jazz-funk without forsaking jungle's polyrhythmic exuberance. But 1995 saw the second division of drum and bass producers installing a consensus "intelligent" sound — long drawn-out intros, soothing female vocal samples, wafting synth interludes, prissily pristine production — that was just as formulaic as ragga-jungle had been the previous year. Pursuing "depth" but lacking the vision it took to get there, too many intelligent junglists washed up in the middlebrow shallows.

While the doyens of intelligence seemed to have forgotten what had originally made jungle more invigorating than trance or armchair techno, other producers — DJ SS, Asend/Dead Dred, Deep Blue, Aphrodite, DJ Hype, Ray Keith/Renegade — honed in on the genre's essence: breakbeat-science, bassmutation, sampladelia. Their work proved that the true *intellect* in jungle resided in the percussive rather than the melodic. Whether they were white or black, these artists reaffirmed drum and bass's place in an African musical continuum (dub, hip-hop, James Brown, etc.) whose premises constitute a radical break with Western music, classical and pop.

Roni Size and sidekick DJ Die were exemplars. This duo is often regarded as pioneers of jazz-jungle, on account of their early-'94 classic "Music Box" and its sequel, "It's a Jazz Thing." Listen again to "Music Box," though, and you realize that the sublime cascades of fusion-era chimes are only a brief interlude in what's basically a stripped-down percussion workout. Size's late-'94 monster "Timestretch" was even more austere, just escalating drums and a chiming bass line that together resemble a clockwork contraption gone mad. And the Size and Die early-'95 collaboration "11.55" was positively murderous in its minimal-is-maximal starkness. What initially registers as merciless monotony reveals itself, on repeated plays, to be an inexhaustible forest of densely tangled breaks and multiple bass lines (the latter acting both as subliminal, ever-modulating melody and as sustained subaural pressure), relieved only by the sparest shadings of sampled jazz coloration. Forcing you to focus entirely on the rhythm section — which in normal pop is seldom consciously listened to - "11.55" clenches your brain until it feel like a knotted mass of hypertense tendons. Size and Die's fiercely compressed, implosive aesthetic recalled bebop, insofar as it's a strategy of alienation designed to discover who's really

down with the program, by venturing deeper into the heart of "blackness." Articulating this "it's a black thing, you wouldn't understand" subtext, and giving a gangsta twist to the music's glowering malevolence, was the sound bite at the beginning of "11.55" — "you could feel all the tension building up at the convention/as the hustlers began to arrive" — sampled from *Hustlers' Convention*, a solo album by a member of the Last Poets.

Young producer Dillinja was, like Size and Die, renowned for fusion-tinged masterpieces like "Sovereign Melody" and "Deep Love," with their softly glowing electric piano and flickers of lachrymose wah-wah guitar. But this tended to obscure Dillinja's real claim to genius: the viciously disorientating properties of his beats and B-lines, which he convoluted and contorted into grooves of ear-boggling, labyrinthine complexity. "Warrior" places the listener in the center of an unfeasibly expanded drum-kit played by an octopus-limbed cyborg; the bass enters not as a B-line but a one-note detonation, an impacted cluster of different bass-timbres. On these and other Dillinja classics — "You Don't Know," "Deadly Deep Subs," "Lionheart," "Ja Know Ya Big," "Brutal Bass" — the jolting breaks trigger muscular reflexes and motor impulses, so that you find yourself shadowboxing instead of dancing, tensing and sparring in a deadly ballet of feint, jab, and parry.

If Dillinja and Size and Die were developing drum and bass as martial art, Danny Breaks's work as Droppin' Science is more like a virtual adventure playground, where collapsible breakbeats and trampoline bass trigger kinesthetic responses, gradually hot-rodding the human nervous system in readiness for the rapid-fire reaction time required in the info-dense future. On tracks like "Long Time Comin'" and "Step Off," bass fibrillates like muscle with electric current coursing through it, hi-hats incandesce like fireworks in slow-mo, beats seem to run backward. Throughout, melody limits itself to minimal motifs where the real hook is the eerie fluorescent glow of the synth goo.

The year of jungle's mainstream breakthrough in Britain and critical recognition in America, 1995 saw jungle torn every which way in a conflict between two rival models of blackness: elegant urbanity (the opulence and finesse of fusion/garage/jazz-funk/quiet storm) and ruffneck tribalism (the raw, percussive minimalism of dub/ragga/hip-hop/electro). Lurking beneath this smooth/ruff dialectic was a covert class struggle: upwardly mobile gentrification versus ghettocentricity, crossover versus undergroundism.

On one side were artists like Reece, Photek, and Bukem who equated "progression" with making drum and bass sound more like other genres (house, garage, Detroit techno). By the end of '95, most of them had deals with major labels. On the other side were the purists, who wanted jungle to advance by sounding ever more intensely *like itself*, and therefore dedicated themselves to achieving hard-won increments of polyrhythmic intricacy and sub-bass brutalism. This strategy had the beneficial side effect of fending off outsiders, because it involved plunging ever deeper into the antipopulist imperatives of the art's core (that's to say, all the stuff that happens beneath/beyond the noninitiate's perceptual thresholds). Most of these artists stuck with independent labels or put out their own tracks. Meanwhile, caught between intelligent's serenity and the ruff-stuff's moody minimalism, the idea of jungle as frisky funquake seemed to have simply dropped away altogether.

By 1996, "jungle" and "drum and bass" were *the* words to drop. Everybody from thirty-something jazz-pop duo Everything But the Girl to free-form improv guitarist Derek Bailey was dabbling with sped-up breakbeats, as were techno types such as Underworld and Aphex Twin. LTJ Bukem launched a campaign to bring breakbeat rhythms to Britain's mainstream house clubs. Despite having played a big role in the gentrification process with his crusade for "jazzstep," Fabio railed against the reduction of drum and bass to mere "wallpaper fodder" by its use in TV links and commercials. One of the most bizarre examples of this syndrome is Virgin Atlantic's use of Goldie's ghetto-blues ballad "Inner City Life" as tranquilizing muzak to steady passengers' nerves before takeoff!

Just as the commercial success of hardcore in 1992 had prompted the first wave of "darkside" tunes, so the hipster vogue for "intelligent" inspired a defensive, back-to-the-underground initiative on the part of the original junglists. "Intelligent" suddenly became an embarrassing term. Even those who'd most profited from major-label interest in "intelligence," like Goldie and Bukem, renounced the term, erroneously and rather disingenuously decrying it as a "media invention" designed to divide the scene. Meanwhile, other producers started talking again about "darkness" as a desirable attribute.

During 1993's darkside era, when jungle was banished from the media

limelight, AWOL had been *the* hardcore club. Especially after the demise of Rage, AWOL was where the scene's inner circle would gather late on a Saturday night to hear DJs like Randall push the music to new heights of ruff-cut intensity. After being dislodged from its location at Islington's murky Paradise Club, AWOL settled late in 1995 at the SW1 Club in Victoria, reestablishing its former role there. While some of the drum and bass elite had moved on to Goldie's Metalheadz Sunday Sessions at the Blue Note, the core jungle audience were still attending AWOL or similar nights like Club UN and Innersense at the Lazerdrome (later renamed Millennium) — havens for those who refused the lure of "intelligence."

AWOL isn't an acronym for "absent without leave" but for "a way of life." If you're not involved in the scene, this article of faith — that buying records at specialist shops, going to clubs on the weekend, wearing MA2 jackets, and smoking a lot of spliff constitute a set of tribal folkways — can seem a tad overstated. But the frequency and conviction with which the claim "jungle, it's a way of life" is restated suggests that, for the true disciple, something massive has been invested in this music. It was precisely this question — what's at stake for the fans? — that began to haunt my mind when I went to AWOL.

Ethnological research wasn't on my mind; fun was. I'm not sure if I found any, at least in the conventional sense, but the visit was a reaffirmation of flagging faith, a confirmation that jungle was alive and kickin' despite the surfeit of pseudo-jazzy tracks. It was also a reminder that, for all the success of album-length, home-listening drum and bass, jungle's meaning is still made on the dance floor. At massive volume, knowledge is visceral, something your body understands as it's seduced and ensnared by the paradoxes of the music: the way the breaks combine rollin' flow and disruptive instability, thereby instilling a contradictory mix of nonchalance and vigilance; the way the bass is at once wombing and menacing. AWOL is a real Temple of Boom; the low-end frequencies are so thick and enveloping they're swimmable. Inside the bass, you feel safe, and you feel dangerous. Like cruising in a car with a booming system, you're sealed by surround sound while marauding through urban space.

The odd thing is how subdued the atmosphere is. Smiles are rarer than hen's teeth, and even among groups of friends, conversation is minimal. Nobody seems to be having fun. But "fun" doesn't seem to be the reason everyone is here. AWOL's resident crew of DJs — Randall, Mickey Finn, Kenny Ken,

Darren Jay — sustain a mercilessly minimalist and militaristic assault, all ricocheting snares and atonal, metallic B-lines that bounce joylessly like ball bearings in a pinball machine. The night stays at a plateau of punitive intensity, no crescendos or lulls, just steady jungalistic pressure.

By about 4 AM the dancers are jigging about with a kind of listless mania. One girl twitches and bounces mechanically, her limp limbs inscribing repetitious patterns in the air, as if she's animated by some will other than her own. For a Saturday night out, the compensatory climax of a week's drudgery, this seems like hard work. I start to wonder if, like me, she got sucked in by 1991–92 'ardkore's explosive euphoria, its manic, fiery-eyed glee, then got carried along by the music's logical evolution only to wind up at another place altogether. Maybe that stunned, dispirited expression on her face comes from finding herself in the midst of an entirely new cultural formation, a "way of life" that can no longer offer release, let alone a redemptive vision.

At clubs like AWOL, the ruling sound is the gangsta hardstep and "jump up" jungle of labels like Ganja, Dread, and Dope Dragon, made by DJ/producers like Hype, Pascal, Andy C, Swift, Zinc, and Bizzy B. By 1996, jungle had purged almost all of its obvious ragga elements; its ruffneck militancy was now expressed through a conscious alignment with US hip-hop, involving the use of melancholy synth refrains from West Coast G-funk like Dr. Dre and vocal samples from East Coast rap, whether boastful ("raw like Reservoir Dogs") or threatening ("hit the deck, I got the Tek right on your neck").

With its machine-gun snares and landslide/landmine bass, this "ruffneck soldier" style of jungle makes you feel like you're stepping into a war zone; hence rave names like Desert Storm and Wardance. But jungle's militaristic streak actually goes back to the early days of hardcore. The 4 Hero 1991 debut album *In Rough Territory* featured cover images of a commando unit planting a flag on enemy soil. Alongside the idea of urban life as a war zone, there's a fascination with the military as a sort of avant-garde of science: Goldie, one-time Reinforced A & R, talked of his protégés as "prototypes," like they were secret weapons under R & D; 2 Bad Mice's "Bombscare" actually employed the sound of a suspect device detonating as part of its bass line. Moving Shadow continued this idea with ultraminimal 1994 tracks like Renegade's "Terrorist"

and Deep Blue's "Helicopter Tune," whose roiling Latin percussion evoked the sound of the famous dawn-raid copter in *Apocalypse Now*.

By 1996, jungle's militarism had gotten ever more explicit and upfront: artist names like Soul-Jah and Military Police, track titles like "Dark Soldier," "The Battle Frontier," and my favorite, "Homage to Catatonia" by Unknown Soldier. The Terradome's "Soldier" featured the histrionic sample "I'm not a criminal, I'm a soldier, and I deserve to die like a soldier," crystallizing the idea of the gangsta as a one-man army, a rogue unit in capitalism's war of all against all. Listening to gangsta hardstep and jump up — which basically consist of James Brownian funk percussion tightened and toughened into the martial paradiddles and triplets of the parade ground — it was easy to imagine it being used as a training resource by the military; a new kind of drill (with JB barking like a sergeant!) for the new breed of soldier — more improvisatory, less regimented — that will be required for the urban conflicts of the future.

In 1996 a new subgenre of jungle coalesced called "techstep," a dirgelike death-funk characterized by harsh industrial timbres and bludgeoning "butcher's block" beats. The term was coined by DJ/producers Ed Rush and Trace, who shaped the sound in tandem with engineer Nico of the No U Turn label. The "tech" stood not for Detroit techno, dreamy and elegant, but for the brutalist Belgian hardcore of the early nineties. Paying homage to R & S classics like "Dominator" and "Mentasm," to artists like T99 and Frank de Wulf, Trace and Ed Rush deliberately affirmed a crucial white European element that had been written out of jungle's history.

The other important source for techstep was the first era of "darkside," as pioneered by Reinforced artists like Doc Scott and 4 Hero. This was when the teenage DJs Trace and Ed Rush cut their production teeth with sinister classics like "Lost Entity" and "Bludclot Artattack." The name "Ed Rush" sounds like a take on "head rush," early rave slang for a temporary whiteout of consciousness caused by too many Es. There was a big difference between darkside '93 and techstep, though. The original darkcore had still oozed a sinister, sickly bliss on the border between loved-up and fucked-up. In '96, with Ecstasy long out of favor, techstep was shaped by a different mindfuck of choice: hydroponically grown marijuana, aka "skunk," whose near-hallucinogenic levels

of THC induce a sensory intensification without euphoria and a nerve-jangling paranoia perfect for jungle's tension-but-no-release rhythms.

The first stirrings of the return to darkness were heard in late '95 with Trace's seminal remix of T. Power's "Horny Mutant Jazz." Working in tandem with Nico and Ed Rush, Trace tore the fusion-flavored original to shreds, replacing its leisurely glide with slipped-gears breakbeats, spectral synths, and a brooding, bruising bass sound sampled and mutated from Kevin Saunderson's Reese classic "Just Want Another Chance." Meanwhile, Ed Rush's No U Turn tracks "Gangsta Hardstep" and "Guncheck" took the explosive energy of hardcore and imploded it, transforming febrile hyperkinesis into molassesthick malaise. The new sound made you feel like you were caged in a pressure cooker of paroxysmic breaks and plasmic bass.

If Belgian brutalism and early breakbeat 'ardkore resembled sixties garage punk, techstep is like seventies punk rock, insofar as it's not a simple back-tobasics maneuver, but an isolation and intensification of the most aggressive. non-R & B elements in its precursor. As the No U Turn squad honed their sound-and-vision, they accentuated the selfsame "noise annoys" elements that punk exaggerated in garage rock: headbanger riffs and midfrequency blare. Where intelligent drum and bass suffers from an obsessive-compulsive cleanliness, techstep production is deliberately dirty, all dense murk and noxious drones. The defining aspect of the No U Turn sound was its bass — a dense, humming miasma of low-end frequencies, as malignant as a cloud of poison gas — achieved by feeding the bass riffs through a guitar distortion pedal and a battery of effects. Another stylistic trait was the way techstep shunned the nimble fluency of jazzy-jungle's breakbeats in favor of relative simplicity and rigor. Although the breakbeats are still running at jungle's 160and-rising beats-per-minute norm, techstep feels slower — fatiqued, winded. In tracks like Doc Scott's "Drumz 95," the emphasis is on the 80 bpm halfstep, making you want to stomp, not sashay.

Techstep is a sadomasochistic sound. Edrush declared bluntly, "I want to hurt people with my beats," and one No UTurn release had the phrase "hurter's mission" scratched into the vinyl. This terrorist stance is in marked contrast to the rhetoric of intelligent drum and bass artists, with their talk of "educating" the audience, "opening minds," and "easing the pressure" of urban life. Sonically, techstep's dry, clenched sound couldn't have been further from the mas-

saging, muscle-relaxing stream of genteel sound oozed by DJs like Bukem and Fabio, with its soothing synth washes and sax loops alarmingly reminiscent of Kenny G.

While the intelligent and jazz-step producers prided themselves on their "musicality," the techstep producers veered to the opposite extreme: a bracing "antimusicality." Incorporating atonal, unpitched timbres, nonmusical sounds, and horror movie soundtrack dissonance, the new artcore noir was simply far more avant-garde than the likes of Bukem. In an abiding confusion about what constitutes "progression" in electronic music, the intelligent drum and bass producers were too deferential to traditional ideas about melody, arrangement, "nice" textures, the importance of proper songs, and hands-on, real-time instrumentation.

By 1997, producers like Nasty Habits/Doc Scott, Dom and Roland, Boymerang, and Optical had joined No U Turn on their "hurter's mission." Techstep got even more industrial and stiff-jointed, at times verging on gabba or a syncopated, sped-up update of the Swans. Above all, the music got *colder*. The Numanoid synth riff on Nasty Habits' awesome "Shadow Boxing" sears the ear with its glacial grandeur, while the trudging two-step beat suggests a commando jogging under napalm skies with a rocket launcher on his hip. No U Turn themselves reached something of a pinnacle with the dark exultation of Trace/Nico's "Squadron," whose *Carmina Burana*-gone-cyberpunk fanfares slash and scythe like the Grim Reaper.

Where did the apocalyptic glee, the morbid and perverse jouissance in techstep stem from? Nico described the music-making process — all-night, redeye sessions conducted in a ganja fog — as a horrible experience that poisoned his nervous system with tension. Ed Rush talked of deliberately smoking weed to get "dark, evil thoughts," the kind of skunkanoia without which he couldn't achieve the right vibe for his tracks. Like Wu-Tang—style horrorcore rap, techstep seemed based on the active pursuit of phobia and psychosis as entertainment. Which begged the question: what exactly were the social conditions that had created such a big audience for this kind of music?

If rave culture was a displaced form of working-class collectivity, with its "love, peace, and unity" running counter to Thatcherite social atomization, then

jungle is rave music after the death of the rave ethos. Since 1993 and hard-core's slide into the twilight zone, debates about "where did our love go?" have convulsed the UK breakbeat community, with grim tales of muggings outside clubs, of fights and "crack" vibes inside. Disenchanted ravers sloped off to form the happy hardcore scene. Others defended the demise of the euphoric vibe, arguing that jungle's atmosphere wasn't moody, it was "serious."

In the absence of Ecstasy, jungle began to embrace an ideology of *real-ness* that paralleled the worldview of American hardcore rap. In hip-hop, "real" has a double meaning. First, it means authentic, uncompromised music that refuses to sell out to the music industry. "Real" also signifies that the music reflects a "reality" constituted by late-capitalist economic instability, institutionalized racism, and increased surveillance and harassment of youth by the police. Hence tracks like T. Power's "Police State" and Photek's neurotic "The Hidden Camera": lyric-free critiques of a country that conducts the most intense surveillance of its own citizenry in the world (most UK city centers now have spy cameras). "Real" means the death of the social; it means corporations that respond to increased profits not by raising pay or improving benefits but by downsizing.

Gangsta hardstep shares Wu-Tang Clan's neomedieval vision of late capitalism, as influenced by martial arts and Mafia movies whose universe revolves around concepts of righteous violence and blood honor. Techstep is more influenced by dystopian sci-fi movies like *Blade Runner, Robocop, Terminator,* et al, which contain a subliminally anticapitalist message, imagining the future as a return to the Dark Ages, complete with fortress cities and bandit clans. Hence No U Turn tracks like "The Droid" and "Replicants" and Adam F's "Metropolis." "Here is a group trying to accomplish one thing . . . to get into the future" goes the sample in Trace/Nico's "Amtrak." Given the scary millennial soundscape techstep paints, why the hurry to get there? The answer: in a new Dark Age, it's the "dark" that will come into their own. "Darkness" is where primordial energies meet digital technique, where id gets scientific. Identify with this marauding music, and you define yourself as predator, not prey.

What you affiliate yourself to with techstep is the will-to-power of technology itself, the motor behind late capitalism as it rampages over human priorities and tears communities apart. The name No U Turn captures this sense that *there's no turning back*. The pervasive sense of slipping into a new Dark

Age, of an insidious breakdown of the social contract, generates anxieties that are repressed but resurface in unlikely ways and places. Resistance doesn't necessarily take the "logical" form of collective activism (unions, left-wing politics); it can be so distorted and imaginatively impoverished by the conditions of capitalism itself that it expresses itself as, say, the anticorporate nostalgia of America's right-wing militias or as a sort of hyperindividualistic survivalism.

In jungle, the response is a "realism" that accepts a socially constructed reality as "natural." To "get real" is to confront a state of nature where dog eats dog, where you're either a winner or a loser, and where most will be losers. There's a cold rage seething in jungle, but it's expressed within the terms of an anticapitalist yet nonsocialist politics, and expressed defensively: as a determination that the underground will not be coopted by the corporate mainstream. "Underground" can be understood sociologically as a metaphor for the underclass, or psychologically as a metaphor for a fortress psyche: the survivalist self, primed and ready for combat.

Jungle's sound world constitutes a sort of abstract social realism; when I listen to techstep, the beats sound like collapsing (new) buildings and the bass feels like the social fabric shredding. Jungle's treacherous rhythms offer its audience an education in anxiety. "It is defeat that *you* must learn to prepare for" runs the martial arts movie sample in Source Direct's "The Cult," a track that pioneered the post-techstep style "neurofunk" — clinical production, fore-boding ambient drones, blips 'n' blurts of electronic noise, and chugging, curiously inhibited two-step beats that don't even sound like breakbeats anymore. Neurofunk is the fun-free culmination of jungle's strategy of "cultural resistance": the eroticization of anxiety. Immerse yourself in the phobic and you make dread your element.

The battery of sensations offered by a six-hour stint at AWOL, Millennium, or any "nonintelligent" jungle club induces a mixture of shell shock and future shock. Alvin Toffler defined F-shock as what happens when the human adaptive mechanism seizes up in response to an overload of stimuli, novelty, surprise. Triggering neural reflexes and fight-or-flight responses, jungle's rhythmic assault course hypes up the listener's adaptive capability in readiness for the worst the twenty-first century has up its sleeve. If jungle is a martial art form, clubs like AWOL are church for the soul-jah and killah priest, inculcating a kind of spiritual fortitude.

All this is why going to AWOL is serious bizness, not "fun." Jungle is the living death of rave, the sound of living with and living through the dream's demise. Every synapse-shredding snare and cranium-cracking bass bomb is an alarm call saying "wake up, that dream is over. Time to get *real*."

By 1996 a new zone of music making had emerged out of the ruins of "electronic listening music": a sort of post-rave omni-genre wherein techno's purity was "contaminated" by an influx of ideas from jungle, trip-hop, and other scenes. Not particularly danceable, yet too restlessly rhythmic and texturally startling to be ambient chill-out, this music might be dubbed art-techno, since the only appropriate listener response is a sort of fascinated contemplation. Imagine a museum dedicated not to the past but the future, where you marvel at the bizarre audio-sculptures.

One of the earliest events dedicated to this new omni-genre, the Electronic Lounge, was situated in the bar of an art gallery, London's ICA (Institute for Contemporary Arts). Other audio-salons opened in artists' studios (New York's Soundlab) or in pub basements (London's Rumpus Room); some evolved out of the old chill-out side rooms at clubs and raves. Dubbed "freestyle," "eclectro," and, in New York, "illbient," these events were dedicated to the astounding, near-heretical notion that you might get a series of DJs playing different styles of music during one night, or even DJs who mixed up different genres/tempos in a single set (typically, a melange of trip-hop, EZ listening, soundtrack music, mellow drum and bass, and nouveau electro).

These clubs were a response to the emergence of a new post-rave/post-rap/post-rock perimeter zone, where refugees fleeing the shackles of genre and the constraining expectations of scene gathered to trade ideas. This circuit of home-studio, bedroom boffins includes Mike Paradinas (μ-Ziq/Jake Slazenger), Bedouin Ascent, Scanner, David Toop, Patrick Pulsinger, Matthew Herbert (Wishmountain/Dr. Rockit), Mouse on Mars, Squarepusher, Luke Vibert (Wagon Christ/Plug), and former avant-rock musicians like Kevin Martin (Techno Animal/The Sidewinder/The Bug) and Mark Clifford (Seefeel/Disjecta). Alongside eye-catching, exquisitely packaged, collector-fetish singles and EPs — released by labels like Clear, Sahko, Cheap, Sabotage, Leaf — the prime format for art-techno is the compilation, as with Lo Recordings' *Extreme Possibilities* and *United Mutations* series or the Kevin Martin–compiled *Macro Dub Infection* anthologies.

How is this new post-rave/post-everything music different from Warp's electronic listening music? The latter was always limited by its neo-Detroit purism (no breakbeats) and the perennial "progressive" antidance stance. As a result, "intelligent techno was definitely rather anemic on the rhythmic side,"

as Kingsuk Biswas of Bedouin Ascent put it. In 1995, jungle's polyrhythmic exuberance gave techno a hefty and sorely needed kick in the butt, forcing it to liven up its ideas about rhythm. Richard James, for instance, responded with the inspired breakbeat tomfoolery of AFX's "Hangable Auto Bulb" EPs and Aphex Twin's "Girl/Boy" EP.

But this renewed interest in percussive complexity remains oddly cerebral in cast. In freestyle salons, head nodding rather than booty shaking is the order of the day, and there's no drug factor, just beer and an occasional, discreet joint. This is less a hardcore dance scene than a mostly bourgeois-bohemian milieu of rootless cosmopolitans. In the structural, nonpejorative sense of the word, the post-rave experimental fringe is *parasitic* on drugand-dance-driven scenes, hijacking their ideas and giving them an avant-garde twist.

Take the mini-genre of jungle by non-junglists for non-junglists — AFX, Plug, Witchman, Squarepusher — that is sometimes jocularly referred to as "drill and bass" because the breakbeats are so sped up they sound like Woody Woodpecker on PCP. Because these producers don't belong to the drum and bass community, they're free to take the idiomatic features of jungle — fucked-up breakbeats, mutant bass, sampladelic collage — and exacerbate them way beyond any conceivable use-value to DJ or dancer. Not only are the beats so convoluted and body-baffling that they'd clear any dance floor instantly, but the Dada absurdism of the samples creates a mood of whimsy that doesn't fit either of the two moods the jungle community demands: genteel and smooth-rollin' at "intelligent" clubs, menacing 'n' mashed up at jump-up joints.

So AFX's "Children Talking" pivots around nonsensical sound bites of a little kid talking about "mashed potatoes," while on Aphex Twin's "Milk Man," Richard James actually sings a wistful ditty in the persona of a small boy who wishes he could get milk "from the milkman's wife's tits." And on Square-pusher's Feed Me Weird Things and Hard Normal Daddy, Tom Jenkinson replaces jungle's booming low end with twiddly fretless slap-bass, played by himself à la fusioneer Jaco Pastorius. The most quirked-out examples from this quasi-jungle genre are Luke Vibert's first two Plug EPs, Visible Crater Funk and Rebuilt Kev. Here jungle's breakbeat-science gets warped into mad inventor—style mayhem. Their grotesquely contorted polyrhythms will tie your limbs in

knots if you're fool enough to dance. Needless to say, the reaction from the junglist community has been muted.

A stylistic nomad, Luke Vibert is a prime exponent of the post-everything omnigenre. After the glacial ambient techno of his Wagon Christ 1994 debut *Phat Lab Nightmare*, Vibert veered off into cheesy-but-deranged trip-hop with *Throbbing Pouch*. Over moonwalking midtempo breakbeats and bulbous bass, Vibert wafts a pungent fug of samples: keening strings, jazz-fusion woodwinds, EZ listening orchestration, film noir incidental themes, Moog synth, vibes, slap-bass, owl hoots, doo-wop harmonies, android vocals, and so on.

At times, *Throbbing Pouch*'s effect is like you're drowning and the entirety of late-twentieth-century music is flashing before your ears, garbled and grotesquely intermingled. "Phase Everyday" flits from jazz-funk nonchalance to acid-house pulserama to dubbed-up desolation within the space of a minute. Tracks like "Down Under" and "Scrapes" are animated audio mazes, sonic labyrinths whose honeycomb chambers and corridors seem alive with detail. Where most trip-hop demands an attitude of stoned passivity from its listener, Wagon Christ music stones you. This is blunted music with an edge.

One reason Vibert's work is so disorientating is the queasy fluctuation of pitch he often employs, making the Wagon Christ material sound like a cross between Schoenberg and jazz-funk. He uses a feature on his sampler that allows him to modulate pitch and explore fractions of a tone, echoing the "microtonality" of avant-classical composition and much non-Western music, such as Indian raga.

Sometimes the world of post-rave electronica resembles nothing so much as a kindergarten full of little boys daubing texture goo on the walls and molding sample stuff like Play-Doh. Nobody better fits the metaphor of art-techno as an "adventure playground for the imagination" than the German duo Andi Toma and Jan St. Werner, who, as Mouse on Mars, have created some of the most captivating, enchanted-with-itself electronica of the nineties.

The title of Mouse on Mars's 1994 debut *Vulvaland* sounds risqué, but it couldn't be more innocent: it was inspired by an imaginary island called

Lummerland in the German kids' TV marionette show Ausenberger Puppentiste. On Vulvaland and its sequel, Iahora Tahiti, Mouse on Mars build up their music from multiple layers of exquisitely naive music-box melodies. The duo prefer simple melodies because they don't distract from the duo's real priority, "the melody of sound": succulent, strokeable textures, timbres so tantalizing you want to taste or touch them, a whole palette of glow-tones and chime-colors. As much a post-rock band as a post-techno outfit, Mouse on Mars are influenced more by Can, Neu!, and the Beach Boys than by Kraftwerk.

In the late 1990s, the German-speaking world has emerged as a bastion of posteverything experimentalism. In Austria, there's the abstract hip-hop of Patrick Pulsinger and Erdum Tunakan's Cheap label, the Dada-techno of Mause, and the twisted neo-electro of Sabotage (both a label and a sort of art-terrorist collective). In Germany, Cologne and its neighbor Düsseldorf form a close-knit arttechno/post-rock milieu that encompasses Mike Ink, Dr. Walker, Pluramon, To Rococo Rot, Mouse on Mars, and Jan St. Werner's side project Microstoria. On a less avant-garde and more cyberpunk level, Berlin has spawned the anti-rave scene called Digital Hardcore. Finally there's Frankfurt, home to Mille Plateaux and its sister labels, Force Inc, Riot Beats, and Chrome.

Frankfurt is simultaneously Germany's financial capital and a long-standing center of anticapitalist theory, thanks to the famous "Frankfurt School" of Walter Benjamin, Theodor Adorno, Max Horkheimer, et al. Today, the Frankfurt School is mostly remembered for its neo-Marxist/high-Modernist disdain for popular culture as the twentieth century's opiate of the masses. Mille Plateaux share something of this oppositional attitude to pop culture. For label boss Achim Szepanski, Germany's rave industry — which dominates the pop mainstream — is so institutionalized and regulated it verges on totalitarian. Named after Gilles Deleuze and Felix Guattari's *A Thousand Plateaus: Capitalism & Schizophrenia* (a colossal tome that Foucault hailed as "an introduction to the non-fascist life"), Mille Plateaux situate their activity both within and against the genre conventions of post-rave styles like electronica, house, jungle, and trip-hop. Just as deconstructionists unravel texts from within, Mille Plateaux point out these musics' premature closures and seize their missed opportunities.

Szepanski got involved in student politics in the radical climate of the midseventies. He read Marx, flirted with Maoism, and protested conditions in the German prison system. Later in the decade, he immersed himself in the postpunk experimentalist scene alongside the likes of D.A.F., playing in the industrial band P16D4. In the eighties he went back to college, watched the left die, and consoled himself with alcohol and the misanthropic philosophy of E. M. Cioran. Two late-eighties breakthroughs pulled him out of the mire: his encounter with the post-structuralist thought of Foucault, Lyotard, Derrida, et al, and his excitement about hip-hop and house. While still working on a doctoral thesis about Foucault, he started the first DJ-oriented record store in Frankfurt, Boy, and founded the Blackout label.

Influenced by A Thousand Plateaux, Szepanski conceived the strategy of context-based subversion that informs his labels: hard-techno and house with Force Inc, electronica with Mille Plateaux, jungle with Riot Beats, trip-hop with the Electric Ladyland compilations. These interventions are situated somewhere between parody and riposte, demonstrating what these genres could really be like if they lived up to or exceeded their accompanying "progressive" rhetoric.

Founded in 1991, Force Inc was initially influenced by Detroit renegades Underground Resistance — not just sonically, but by "their whole anticorporate, anticommodification of dance stance." In its first year, Force Inc's neo-Detroit/Chicago acid sound and "guerrilla parties" had a big impact in Germany. But as trance tedium took over in 1992, Force Inc "made a radical break" toward an "abstract industrial" version of the breakbeat hardcore then huge in Britain. "Maybe it was just our peculiar warped interpretation, but hardcore's sped-up vocals sounded like a serious attempt to deconstruct pop music," says Szepanski. "Treating sampled voices as instruments or sources of noise destroyed the idea of the voice as an expression of human subjectivity."

In 1993–94, Szepanski watched aghast as rave went overground in Germany, with "the return of melody, New Age elements, insistently kitsch harmonies and timbres." With this degeneration of the underground sound came the consolidation of a German rave establishment, centered around the party organization Mayday and its record label Low Spirit, music channel Viva TV, and Berlin's annual and massive street-rave Love Parade.

For Szepanski, what happened to rave illustrated Deleuze and Guattari's concepts of "deterritorialization" and "reterritorialization." Deterritorialization is when a culture gets all fluxed up — as with punk, early rave, jungle — resulting in a breakthrough into new aesthetic, social, and cognitive spaces. Reterritorialization is the inevitable stabilization of chaos into a new order: the internal emergence of style codes and orthodoxies, the external cooptation of subcultural energy by the leisure industry. Szepanski has a handy German word for what rave, once so liberating, turned into: *freizeitknast*, a pleasure-prison. Regulated experiences, punctual rapture, predictable music. Rave started as anarchy (illegal parties, pirate radio, social/racial/sexual mixing) but, argues Szepanski, it quickly became a form of cultural fascism. "Fascism was mobilizing people for the war-machines, rave is mobilizing people for pleasure-machines."

Mille Plateaux began in 1994 as sort of an answer to "electronic listening music." The label's roster of Steel, Gas, Cristian Vogel, Alec Empire, Christophe Charles, et al, make music that sonically fleshes out Szepanski's dream of a "music without center, radically fractured . . . and conflicting," of "sound-streams" that simulate the cosmic rauschen (a German word whose meanings include "rustle," "roar," and "rush"). The label's greatest achievement to date is In Memoriam Gilles Deleuze, a double CD compiled in tribute to Gilles Deleuze, following his suicide. The best` tracks extend the tradition of electro-acoustic and musique concrète, albeit using sampling and other forms of digital technology rather than the more antiquated and tricky methods of manual tape splicing used by avant-classical composers like Pierre Henry. Mille Plateaux's star act, the Berlin duo Oval, recall Karlheinz Stockhausen — not just with the densely textured disorientation of their music, but with their rarefied discourse and further-out-than-thou hauteur vis-à-vis their contemporaries.

Interviewing Oval is a challenge. Their methods are obscure, their theory fabulously arcane, their utterances marinated in irony. Humble inquiries about backgrounds and influences are met with a rolling of the eyes, sniggers, and "next question!" Tentative characterizations of their activity are treated as a reduction or misrepresentation of the Oval project. Perhaps all that can be safely said is that Oval's "music" offers an uncanny, seductive beauty of treacherous surfaces and labyrinthine recesses. Their two Mille Plateaux albums *Systemich* and *94 Diskont* are the most swoon-inducing records I've heard since My Bloody Valentine's "To Here Knows When." The twenty-minute-long "Do While," for instance, is like Spacemen 3's *Playing with Fire* pulverized into a million fluorescent splinters, then tiled into a "musaic" grotto of impossible acoustics and refractory glints. Lovely, in an insidious, synapse-lacerating way.

Much effort clearly went into making something this endlessly listenable, yet Oval have confused their admirers by insisting that music is *not* one of their interests. It turns out this isn't strictly true: "Our effort constantly oscillates between a very conscious and affirmative use of music technology and an often clueless, 'critical' abuse of that technology," says Markus Popp. "We always wanted to offensively suggest something 'new' from 'outside' or 'before' the digital domain. 'Before,' in that everything we have released so far could easily have been done on a couple of reel-to-reel tape machines."

Yet Oval's activity is dependent on nineties digital technology. According to Popp, the trio's impetus is to expose the "conditions and constraints under which music in the nineties is created" and, by extension, to interrogate the entire technology-mediated nature of today's information society. "Experimentation in music, at least nowadays, is for most people a tame, safely 'guided tour' through MIDI software and hardware," says Popp. "Most of the music produced by using this equipment proved to be no more than a predictable outcome of the hardware or software involved."

Oval resists this deadlock, or exposes it, by having "an audible user interface." In nuts-and-bolts terms, this involves fucking with the hardware and software that organize and enable today's post-rave electronica — like MIDI (Musical Instrument Digital Interface), a machine that allows different pieces of equipment to be coordinated like the players in a band, or instrumental "voices" in an orchestra.

Oval combat the "determinism" within these sequencer programs by erasing the manufacturer's distinction between "features" and "bugs." Just as Hendrix aestheticized feedback (a "bug" or improper effect immanent in the electric guitar but hitherto unexploited) and hip-hoppers abused the stylus and turntable, Oval fuck with digital technology by tampering with MIDI hardware

and, most famously, by deliberately damaging and painting over CDs. Taking the unhappy CD player's anguished noises — glitches, skips, and distressed cyber-muzik generated when the machine tries to calculate and compensate for missing algorithmic information — Oval painstakingly assembled the material into the glistening audio maze that is *Diskont*.

Blindspots and contradictions abound in Oval's rhetoric. They speak in punk-style anyone-can-do-it terms of deliberately keeping their activity at the "lowest entry level," of not wanting "to convey an image of arcane technology and years of expert study," yet their discourse is often absurdly forbidding and user-unfriendly. They reject terms like "sabotage" and "vandalism" to describe how they interfere with digital technology, then use the word "disobedience," which carries its own frisson of subversion. And while they loudly deny any musical intentions, they come close to characterizing their project as an enrichment of music, claiming the invention of a "completely new music paradigm," even "a new kind of perception." The next step for Oval is the realm of the interactive; they are working on a kind of digital authoring system. "It's not exactly CD-ROM or hypertext," explains Popp. "But it will involve guiding the user through some kind of design environment and basically enabling people to make Oval records themselves."

When asked about his relationship to techno, Oval's label-mate Alec Empire declares bluntly: "Rave is dead, it's boring! House is disco and techno is progressive rock." Empire divides his energy between fostering the Berlin-based anti-rave scene called Digital Hardcore and recording as a solo artist for Mille Plateaux and Force Inc, where his output ranges from the edgy eclecticism of Limited Editions 1990–94 and Generation Star Wars to the somber fugue-state electronica of Low On Ice and the psycho-kitsch of Hypermodern Jazz 2000.5 (a sort of twisted riposte to the EZ listening fad).

This two-pronged campaign — rabble-rousing agit-pop versus hermetic experimentalism — reflects an interestingly jumbled background. On one hand, Empire studied music theory and, unusual for a "techno artist," uses notation when composing his own music. On the other hand, he was a breakdancer at the age of ten and playing in a punk band by the time he was twelve. At the end of the eighties, Empire got swept up in Berlin's underground party

scene: clubs like UFO and E-Werk (a derelict electrical power plant), raves in disused government buildings in East Berlin. Despite being a non-druggy type himself, Empire embraced acid's cult of oblivion. "Acid was a political movement for me, it was like stopping being a part of society. At the time it made sense. Politics seemed futile, with the left dead." The German "tekkkno" scene quickly turned dark and nihilistic: "People got into heroin and speed, there were parties in East Berlin with this very hard industrial acid sound, Underground Resistance and $+\ 8$, 150 bpm."

Empire dug the way this aggressive sound reflected the kids' frustration, and, influenced by UR's abstract militancy, he formed the agit-tekkkno band Atari Teenage Riot. Atari signed to a major label, but they were too much trouble and were dropped before releasing an album. By this point — the end of '93 — Alec had already released around fifteen EPs of solo material on Force Inc and other labels, including "Hunt Down the Nazis" and "SuEcide," an ironic/nihilistic "hymn to self-destruction through Ecstasy." Meanwhile, he was experimenting with a Germanic jungle sound for Riot Beats, drawing on the influence of UK darkside tracks by Bizzy B and the Reinforced crews. Darkcore remains an influence on Digital Hardcore, which is both a scene and a label. "Our beats are fast and distorted, but the programming is not as complex as the UK producers'."

Breakbeat appealed as an antidote to Germanic techno's Aryan funklessness and as a multicultural statement. "I did 'Hunt Down the Nazis' at a time when skinheads were attacking immigrants. Then you'd discover, talking about the attacks to people on the rave scene, that a lot of people were quite racist. At the Omen Club, Turkish kids were turned away for no reason. There was quite a nationalistic, 'now we are back on the map' aura to German techno. Mark Spoon from Jam and Spoon made a comment on MTV about how white people had techno and black people had hip-hop, and that's the way it should stay. One neo-Nazi magazine even hailed trance techno as proper German music."

Ironically, Empire now reckons that UK jungle has gotten too funky. "The energy is missing. A whole night of jungle is just too flat. The idea of mixing, of fading tracks into each other smoothly, is overrated. Pirate radio was better before the DJs learned to mix properly. DJ technique is just like a guitarist who knows how to make a really complicated guitar solo. A Stooges riff can mean much more, with just three notes. If the energy's not there, what's the point?"

With its speed-freak tempos and brutalist noise aesthetic, Digital Hardcore has less in common with jungle than it does with that other descendant of the original 1991 pan-European hardcore: the terror-gabba and speedcore sounds of labels like Kotzaak, Fischkopf, Cross Fade Entertainment, and Gangstar Toons Industry. Digital Hardcore Recordings' own acts, like EC80R, Shizuo, and Christoph De Babalon, mash up skittery 200 bpm breakbeats, ultra-gabba riffs, thrash-metal guitar, Riot Grrrl shouting, and loads of midfrequency NOISE. "In techno, in jungle, the middle frequencies are taken out, it's all bass and treble," explains Empire. "But the middle frequencies are the rock guitar frequencies, it's where the aggression comes from."

As well as "boost the midrange, cut the bass," Digital Hardcore's other key precepts are "tempo changes keep it exciting" and "faceless techno PAs are boring." At their parties, DJs favor a crush-collision of mixed-up styles and bpm's, and there are always bands playing. Instead of hypnotizing the listener into a head-nodding stupor, Digital Hardcore's adrenalizingly one-dimensional scree is meant to be a wake-up call. If rave is heavy metal (rowdy, stupefying, a safety valve for adolescent aggression) and electronica is progressive rock (pseudo-spiritual, contemplative), Digital Hardcore is punk rock: angry, speedy, "noise-annoys"-y.

In many ways, Digital Hardcore is the lo-fi underground counterpart to pop groups like the Prodigy and the Chemical Brothers, who mash together hiphop's boombastic breakbeats and techno's insurgent riffs to create a twenty-first-century equivalent of rock aggression, and who've both built up a reputation as thrilling live bands. There's a crucial difference, though. Where Prodigy's "Firestarter" and the Chemicals' "Loops of Fury" are gloriously adolescent tantrums in the plastic punk tradition of the Sweet, Gary Glitter, and Alice Cooper, Digital Hardcore's aural insurrection is targeted; Empire and his comrades really believe that noise can bring down the establishment's walls. Nonetheless, all this music *feels* closer to rock than techno.

It's a few days before New Year's Eve 1995, and downtown Manhattan's "illbient" salon the Soundlab is playing host to Alec Empire vs DJ Spooky: an evenly matched turntable duel between the doyen of digital hardcore and local DJtheorist Spooky. First alternating in ten-minute sequences, then going headto-head, the pair cut up the beats wildstyle, Spooky rocking out in his dreads and B-boy gear, Empire impassive in an incongruously bureaucratic gray suit.

If DJ Spooky tha' Subliminal Kid — aka tha' Tactical Apparition, tha' Ontological Assassin, tha' Renegade Chronomancer, tha' Semiological Terrorist — hadn't existed, it would have been necessary to invent him. There was a gap just waiting to be filled by a figure who's not just hip to the postmodern implications of cut 'n' mix culture, but who goes out of his way to exacerbate them. That's Spooky: the DJ-as-philosopher, someone who can happily flit between the subcult underground of hip-hop jams, raves, ambient parties, and the highbrow overground of *Artforum*, ICA conferences, Semiotexte.

This young African-American — real name, Paul D. Miller — isn't shy of bringing the full might of his education to bear on the humble art of spinning vinyl. And so he calls the mix tape an "electromagnetic canvas," celebrates ambient music as "electroneiric otherspace," exalts the DJ as a "mood sculptor," and lists his occupation as "spatial engineer of the invisible city." The way Spooky describes it, when he's mixing he's pulling down "ill shit" from the vast data cloud of modern media culture; when he makes tracks, his approach is "recombinant," a splicing and dicing of music's genetic code.

"My two big things," Spooky pronounces, "are 'cultural entropy' and 'postrational art.' "By cultural entropy, he means that in the age of sampladelia,
cultural signifiers are becoming deracinated and etherealized, eventually resulting in a state in which all difference has been erased. "Postrational" is art
that isn't about narrative or meaning, but a flux of sensations, "art that's immersive." The supreme example of both syndromes is digitalized dance music,
particularly Spooky's faves, ambient, trip-hop, and jungle. In "illbient" — the
sound and scene that Spooky and a gaggle of downtown New York allies have
conjured — the membranes between these genres have become porous. The
result, depending on your allegiances, is either an exhilarating stylistic freefor-all or a deracinated, diluted mishmash.

In just a few years, Spooky has become both a celebrated and a highly controversial figure. For some, he's a cult, a tightrope walker on the cutting edge; for others, he's a dark magus of auto-hype. Counterculture veteran rockcrits and Marxist academics find Spooky's Baudrillard-meets-B-boy spiel thoroughly decadent, an elaborate postmodern rationalization of political disengagement and surrender to the seductions of late-capitalist hyperreality. Spooky slogans

like "seize the modes of perception" just rub salt in the wounds of these mourners of the death of history and political agency. But the fundamental difference between these sixties nostalgics and "a child of the digital night" like Spooky is temperamental or even psychological; like many of his generation, the Subliminal Kid seems to have a more tenuous but less oppressive sense of superego than people who grew up before the age of McLuhan and the TV-asglass-nipple. Or as he put it himself in a *Village Voice* article entitled "Yet Do I Wonder" — part of a series in which African-American writers pondered questions of identity and community — "I, the Ghostface, the Ripple in the Flux, am a kid who has gotten the picture but lost the frame, and life for me is one big video game."

Spooky's career began in the late eighties with a college radio show called "Dr. Seuss' Eclectic Jungle." "I was playing really mutated dance music — four turntables all going at the same time, turntable feedback, four CD players, two tape decks." Then came a club called Club Retaliation, based in his hometown, Washington, DC. Here Spooky enjoyed an acid revelation while DJ-ing: "Most people dwell on the surface of their records, but with acid and more tactile drugs you feel like you're actually inside a moving text. The immersive quality of music on acid was a revelation."

In New York, Spooky gradually found aesthetic kinsmen in DJs and bands like Olive, Byzar, SubDub, and We. Soon he had a career on his hands, playing at spaces like Chiaroscuro, Jupiter, Abstrakt, and the Soundlab. Unlike the UK's marijuana-infused ambient culture, New York's "illbient" scene is less about wombing sound baths and vegetative bliss, more about creating sonic installations and environmental noisecapes. As such it harks back to a downtown bohemian tradition of multimedia events and Zen-Dada-LSD-inspired happenings: Fluxus, Phil Niblock, John Cage, La Monte Young's Theater of Eternal Music, David Tudor. Illbient's reference points extend even further back (the Italian futurists' Art of Noises, Erik Satie's "furniture music") and further afield (Spooky cites Javanese gamelan and "West African thumb-piano played at ceremonies").

Despite this gamut of illustrious ancestors, "illbient" is mostly defined by its contemporary coordinates: it's an uneasy merger of post-rave ambient and

abstract hip-hop (freed of the figurative role of the rapper). The "ill" indicates an allegiance to B-boy culture (it's basically a vernacular and more flava-full synonym for "avant-garde"), but the music's nonverbal atmospherics (the 'bient) involves cutting loose from the hip-hop street and all its struggles, drifting off into "space." The opposite of "space" is "compression," Spooky's great bugbear. He rails against the "spiritual compression" of hardcore rap, which he attributes to the gangsta cult of "realness" and psychic armature.

Like the British trip-hoppers and nouveau electro outfits, Spooky locates his B-boy roots in the "old skool" era, when hip-hop was oriented toward the DJ-and-turntable rather than the producer-and-studio. Like Mo' Wax's DJ Shadow and Ninja Tune's DJ Vadim, Spooky belongs to a tradition of mostly instrumental collage (Steinski, Davy DMX, the 45 King, Mantronix) that disappeared when rhyming skills, storytelling, and the rapper's charismatic persona took over hip-hop. But whereas the old skool nostalgia of Mo' Wax and Ninja Tune is a product of British B-boys' geographical and cultural distance from rap's so-ciocultural context, Spooky's alienation from hardcore rap is class-based: he's black but from an upper-middle-class, highbrow background. "Illbient" is a bohemian initiative to liberate hip-hop from the thrall of the "real."

This explains why Spooky's own music — tracks like "Journey (Paraspace Mix)" and "Heterotopian Trace" on the compilation *Necropolis: The Dialogic Project* and "Nasty Data Burst (Why Ask Why)" on the Bill Laswell—organized anthology *Valis 1: Destruction of Syntax* — sounds less like contemporary hiphop and more like the neo-Dada collages of British experimental units such as :zoviet*france and Nurse with Wound. "Nasty Data Burst," for instance, is an aleatory haze of deteriorated sound sources, featuring some eighty overlapping beats set up, says Spooky, "to be deliberately randomized and clashing." His debut solo album *Songs of a Dead Dreamer* is marginally more groove-oriented, but it's still hard to imagine any American B-boy recognizing this music.

Spooky's warped and warping relationship with hip-hop stems from the core attitude that he shares with the rest of the international art-techno fraternity: cultural nomadism, a reluctance to be shackled by roots, a commitment to not being committed. "I pass through so many different scenes, each with their different uniforms and dialects. One night I'll be at a dub party, the next in an academic environment. I think people need to be comfortable with

difference. Hip-hop isn't; it says 'you gotta be down with us,' be like us." One of Spooky's most frequent complaints is "I'm stretched real thin at the moment." This is partly the overworked lament of a fin de millennium Renaissance man whose nonmusical fronts of activity include critical journalism, science fiction, painting, sculpture, and academic conferences. But it's also a side effect of his interest in "schizophrenia, the idea of inhabiting all these different personae." Stretching his self to the point of snapping, Spooky is a renegade against identity politics, an (un)real Everywhere-and-Nowhere Man.

The central tenets of the post-everything vanguard are that severing ties to a particular scene or community creates the freedom to drift, and that fusion opens up "infinite possibilities," whereas purism is blinkered tunnel vision. Although a lot of truly remarkable music has been created under the border-crossing banner, it's also important to understand the limitations of this approach: namely, that the dissolution of the boundaries between genres tends to erode precisely what makes them distinct and distinctive, and that it disables the very functionalist elements that make specific styles work for specific audiences. In that respect, Alec Empire's humorously (and accurately) titled "My Funk Is Useless" on Hypermodern Jazz could serve as an art-forart's-sake motto for everyone from Squarepusher to Spooky.

In purist or "hardcore" dance genres — jungle, hip-hop, house, ragga, gabba, Miami bass, swingbeat — sparks fly from the productive friction between innovation and conservatism, between the auteur's impulse to explore and the dance floor's requirements. These genres evolve through the pressure of the audience's apparently contradictory demands: tracks must be "fresh," but they must also reinforce and sustain tradition. To an outsider, the sound-track at hardcore dance events often seems monotonous. But this predictability isn't caused by cowardice so much as a desire to create a *vibe*: a meaningful and *feeling*-full mood that materially embodies a certain kind of worldview and life stance. As you get deeper inside a scene, the apparent homogeneity gradually reveals itself as Amiri Baraka's "changing same"; you begin to appreciate the subtle play of sameness and difference, thrill to the small but significant permutations and divagations of the genre.

Freestyle or "eclectro" events, by comparison, are usually devoid of vibe.

This is partly because of the absence of the drug-and-class energy that makes hardcore scenes so charged (the electricity also can be race- or sexual-preference fueled, as with the gay house scene). Partly, it's because the style-hopping freestyle menu attracts a rather uncommitted consumer: the chin-scratching connoisseur who's more likely to stand at the back head nodding than dance, who'd rather pride himself on being an "individual" than merge with the crowd.

While hardcore underground scenes like jungle, gabba, and East Coast rap are "populist," in a global sense they seldom achieve more than "semipopular" status. If these subcultures constitute the classic "margins around a collapsed center," this makes the post-everything artists marginal even to the margins. In this respect, they belong to a time-honored tradition. Artists like Brian Eno and Miles Davis borrowed ideas from populist genres like dub and funk, which tend to be driven by a vital blend of mercenary and spiritual motives. Sometimes it works the other way around: Byrne and Eno's *My Life in the Bush of Ghosts* was a big influence on Public Enemy producer Hank Shocklee, for instance. But mostly the crosstown traffic is one-way. "Parasitic" is the right word to describe this downwardly mobile dependence on "street sounds" for stylistic rejuvenation; for instance, it's highly unlikely that the idea of accelerating and chopping up breakbeats would ever have independently occurred to Plug/Squarepusher/AFX without jungle's prior example.

If you simply equate radicalism with the ostentatious absence of use-value, then the dys-funk-tional convolutions of Squarepusher et al are conceivably more "advanced" than most jungle. Actually, technically speaking, nothing these weirdy-beardy types have done with breaks has beaten drum and bass insiders like Dillinja and 4 Hero at their own game. What the post-rave artists have done is to hijack the metaphor of "science" from jungle and hip-hop and transform it into a sampladelic-era synonym for old-fashioned "virtuosity." Prog-rock style, they pride themselves on making dance music undanceable. But the trouble with real-world science is that for every Onco-mouse with a human ear grafted into its body or groovy new device for mass destruction, there's a myriad of nonconclusive experiments: fault-ridden machines, test tubes full of useless precipitates and cloudy suspensions. Much the same applies to the output of sound laboratories; simply embarking with an experimental attitude doesn't guarantee results. The constraints inherent in making

music for the dance floor are often more productive than untethered, anythinggoes dilettantism.

The vogue for the word "science" also suggests that a disembodied and dispassionate detachment is the right way to approach music. What the Squarepusher-type drill and bass artists have responded to and exaggerated ad absurdum is only one aspect of jungle: the music's complexity. They've ignored the feelings the music induces and the subcultural struggles that the sound and the scene embody. As a result, no matter how superficially startling the form-and-norm-bending mischief sounds, drill and bass feels pale and purposeless compared with music created by the jungle fundamentalists. It is enfeebled by being divorced from the context that originally imbued those sounds with resonance. Worse, the whiff of stylistic one-upmanship can be offputting, Exhibiting astonishing temerity and arrogance, Squarepusher's Tom Jenkinson described his relationship with jungle in terms of the difference between "people who pioneer and lead and people who form groups." But this is nothing compared with the brinkmanship of Oval, who set themselves above and against all electronic music (yet are dependent on its distribution network and receptive audience).

No amount of willful eccentricity can impart the luster of meaning to music; that comes only when a community takes a sound and makes it part of a way of life. So while I marvel at the art-technocrats' efforts, I often feel curiously unmoved by them, physically or emotionally. Fascinated but uninvolved, I find myself wondering whether anti-purism is just another ghetto, and whether "freedom" is just another word for "nothing much at stake."

Although its technophobe foes still insist that "it all sounds the same," electronic dance music has long since ceased to be a monolith. Rather, it's a fractious confederacy of genres and subgenres, metropolitan cliques and provincial populisms, purisms and hybrids. Post-rave culture encompasses a huge span of divergent and often opposed attitudes to aesthetics, technology and drugs, not to mention wildly different estimations of how much it all matters.

In a sense, you could say that rave culture is a victim of its own success. Like a political party that's won a landslide election, rave could afford to fall out with itself, to succumb to infighting. Just as the Woodstock convergence of the late sixties gave way to the fragmented drift of seventies rock and just as the class of 1977 split into factions over what punk "was all about," rave's Ecstasy-sponsored unity inevitably refractured along class, race, and regional lines. As early as 1990, the divisions that rave once magically dissolved reasserted themselves.

This disunity is partly due to the nature of Ecstasy. One of the secrets of the drug's success is its context-dependent adaptability. MDMA provides a profound but curiously "meaningless" experience — you have to supply the meaning. The overpowering feelings, sensations, and free-floating idealism generated by the drug demand some kind of articulation, but the terms used are conditioned by a complex mesh of parameters — class, race, gender, nationality, and ideology. Hence the huge range of "Ecstasy talk," from the hard-core hedonism of working-class weekenders, to the cyberdelic utopianism of San Francisco, to the neopaganism of the Spiral Tribe. "Mental," "mystical," "avant-garde": these may simply be different ways of exalting the same experience, people using the kind of lingo they're most comfortable with. But the terms used to describe an experience ultimately determine its implications.

On a purely musical level, house and techno mutated as the musics were

adapted to fit the desires and purposes of different social strata, races, and regions. Once started, the process of subdivision appears to be irreversible, so that the "we" that each post-rave fragment addresses can only get smaller and smaller. The cutting edge of each style is often precisely what cuts it off from universal appeal. At the same time, the post-rave turnover of new genres may be a sign of health rather than an affliction — proof that people still care enough to disagree violently about this music, that the stakes are still high.

Although I enjoy the semantic struggles over new genre terms (and have even coined a few — ambient jungle, artcore, post-rock, gloomcore, neurofunk), I do sometimes wonder if the endless subdivision has got out of hand. Nowhere is the turnover of new substyles more rapid than in house music — still the mainstream of Ecstasy culture in Europe, the music most clubbers dance and drug to.

"Handbag house" was initially a disparaging term, coined by condescending cognoscenti vis-à-vis the anthemic, chart-penetrating house tunes that allegedly appealed to women and, above all, to the folk-mythic construct of Sharon and Tracy, stereotypes of the undiscriminating working-class party girl. Inevitably, "handbag" — and its slightly tuffer sequel, "hardbag" — became a rallying cry for populists not afraid of "cheesy" emotionalism. While some of the anti-handbag hipsters affiliated themselves with American deep house and garage from New York and Chicago, another faction came up with the dubious concept of "progressive house." Released by labels like Hard Hands, Cowboy, and Guerrilla, this was homegrown English house music, trippy and trancey, and distinguished by long tracks, big riffs, mild dub inflections, and multitiered percussion. "Progressive" seemed to signify not just its anti-cheese, nongirly credentials but its severing of house's roots in gay black disco. Out of the 1991–93 prog house scene emerged a number of artists who belong to a nongenre that might be dubbed "band house": groups like Leftfield, Lionrock, Underworld, the Aloof, and Faithless who sell albums in large numbers and play live.

Back in America, the equivalents to these big-sellers aren't bands but auteur-producers like Masters at Work, Deep Dish, Armand Van Helden, and Murk. US underground house seems to shift back and forth between songs and tracks, soft and hard, big vocals and depersonalized abstraction. Somewhere between these two poles lies the vogue for disco cut-ups: raw yet camp tracks,

vocal-free but based around looped samples from seventies underground disco classics. Pioneering both the disco cut-up trend and the resurgence of Chicago house were the twin labels Relief and Cajual. Relief is a "trackhead" label: its eerie, unhinged, almost psychotic output, by artists like Green Velvet, Gene Farris, DJ Sneak, and DJ Rush, thrillingly revived the spirit if not the sound of acid house.

From 1996 onward, the proliferation of house subgenres seemed to go into hyperdrive, with terms like nu-NRG (hard, gay, Euro house) and dream house/epic house (lushly melodic, atmospheric house influenced by trance) achieving fleeting currency. Progressive house has returned (now shorn of any pretensions to innovation and signifying no-nonsense pumping house for regular heterosexual blokes), while the purist subgenre of tech-house boasts ultraclean production (sounds so spangly pristine you feel like you've already done an E) and claims to preserve the "lost spirit" of Chicago acid and Detroit techno. Meanwhile, a bastard form of acid emerged from London's underground milieu of squat raves — a screeching, raucous, punk-fierce blare of overdriven Roland 303s. The scene and sound's defiantly impurist attitude was emblazoned in the gloriously titled compilation *It's Not Intelligent . . . It's Not From Detroit . . . But It's F**king 'Avin It,* mixed by crusading free party DJ collective Liberator and released on its label Stay Up Forever.

A world away from the squalor of the squat scene (where ketamine was increasingly the drug of choice), garage — for years the nearest thing to a static entity in the post-rave universe — spawned its own distinctively British mutant called "speed garage." Sometime in late '96/early '97, a segment of London's jungle audience began to wonder why they were listening to such dark, depressing music. Jungle had been shaped by the desperation of the recession-wracked mid-nineties. Now, with "loadsamoney" in their pockets, the junglists didn't feel desperate anymore. Increasingly alienated by the white industrial bombast of techstep, these mostly black junglists began to complain about the surfeit of distortion-drenched and melody-free tracks ("disgusting music, mad music," as DJ Bryan G put it). Searching for a sound that better reflected their affluence and insouciance, the ex-junglists built a brand-new scene based around the "finer things in life" — designer label clothes, champagne, cocaine, and garage music.

As well as attracting upwardly mobile, "mature" white clubbers who reviled

rave culture as juvenile and lumpen, garage's mellow opulence had long appealed to junglists; where a techno club's chill-out room usually offered beat-free ambient, the second room at jungle nights like Thunder & Joy tended to play bumpin' garage. For most of the nineties, homegrown UK garage had slavishly imitated American producers like Masters At Work and Deep Dish. But when the ex-junglists entered the fray, they created a hybrid strain that merged house's slinky panache with jungle's rude-bwoy exuberance.

Like all innovations in dance music — from early eighties house to early nineties hardcore — speed garage began as a DJ-driven sound. Pirate radio DJs pitched up American garage imports — particularly the tougher style of producers like Todd Edwards and Armand Van Helden — to +8 on their Technics turntables, and began to mix in junglistic elements: dubwize effects, rewinds, and dancehall MC chatter. Inevitably, DJs started to cut dubplates that sounded like their mixes; the next step was to release the tracks. A new genre was born: speed garage, aka UK underground garage. Tougher and faster than its US prototype, it's a winning combination of the most crowdpleaser elements from house, jungle circa 1994, and hardcore rave: sultry divas, "dread bass," ragga chants, filtering effects as used by house producers like Daft Punk to make sounds shiver up your spine, 'ardkore's sped-up and helium-squeaky vocals. This back-to-1992 nostalgia — strange, given that "garage" and "rave" were once implacable opposites — extends to speed garage remakes of 'ardkore classics like "Some Justice" and "We Are I.E."

What really defines speed garage, though, is its beat: syncopated, highly textured snares with a curiously organic, wood-block timbre. Unlike house's metronomic four-to-the-floor kick-drum, speed garage is riddled with itchy polyrhythmic tics and micro-breakbeats. And where most rave music is asexual, speed garage is lascivious — the skipping snares tug at your hips, the rumpshaker B-lines wiggle your ass. This sexiness is probably a side effect of British clubbers' shift of allegiance from anti-aphrodisiac Ecstasy to hornymaking cocaine.

The craze for coke ties in with the way the scene resurrects the snobby exclusivity of the pre-rave club culture of the mid-eighties (the last time the economy was booming). Most speed garage clubs ban jeans and sneakers. Speed garage's ethos of "living large" also parallels US "playa" rap's "we-are-the-beautiful people/we be the baddest clique" hedonism — its conspicuous

consumption and luxury-commodity fetishism, its weird blend of chilled languor and latent menace. Hence the garage bootleg version of L'il Kim/Notorious B.I.G's "Crush On You" doing the rounds. If jungle was gangsta rave, speed garage is gangsta house.

Converts hail speed garage as a revolution in British dance culture. Certainly, its victory has been swift and total. In 1997, just about every London pirate radio station switched from jungle to speed garage. Jungle's populist core withered away; hitherto "rammed" jump-up events like the Roast suddenly found their dance floors almost deserted, with the punters going instead to speed garage clubs and raves like Absolute Sundays, Twice as Nice, and Horny. "A lot of the dread side of jungle has gone into the garage", says Phil Aslet from Source Direct, "dread" referring to the dancehall reggae fans originally lured into jungle by its ragga samples back in 1994. Yet because its non-breakbeat rhythms appeal to house fans, speed garage has achieved way more popularity and commercial success than jungle ever managed; genre-defining singles like Double 99's "Ripgroove", 187 Lockdown's "Gunman," and the Fabulous Baker Boys' "Oh Boy" (a brilliant remake of Jonny L's gloriously sentimental '92 anthem "Hurt You So") were propelled into the UK Top 20 only months after the scene's discovery by the media.

Inevitably, speed garage has inspired enmity. From house purists to drum and bass scientists, many argue that speed garage, far from being revolutionary, is merely a crafty collage of the most cheesily effective clichés from the last seven years of UK dance. True enough. Yet it's hard to imagine even the sternest purist managing to resist this pleasure-principled genre's alluring obviousness. And more innovative strains of speed garage are emerging, like the dub-spacious, percussadelic productions of artists such as Baffled Republic and Ramsey & Fen, which recall the eighties avant-disco of Arthur Russell. There's also the fierce, jungle-dominated style that's been called "dangerous garage" or "raggage," exemplified by tracks like Gant's "Sound Bwoy Burial" and Strictly Dubz IV's "Small Step": baleful sub-bass pressure, patois dancehall shouts "timestretched" so that the sample seems to crack apart like it's afflicted with metal fatigue, dub-noise (sonar bleeps, sirens, gunshots, explosions of reverb). Generally, the best version of any given speed garage track is the stripped-down and weirder "dub." As with all hardcore dance scenes, it's the "trackhead," effects-riddled, and ruthlessly sampladelic sector rather than the "we-wanna-move-toward-using-real-instruments," song-oriented school of production that is really shaping any kind of future sound of London.

Still, it's sheer hyperbole to rank speed garage up there with jungle, let alone acid house, as a sonic/subcultural revolution. Colored by the feelgoodism of the late Major/early Blair boom, the politics of speed garage are so much less interesting than jungle's "darkside" paradigm (temporarily outmoded in 1997–98, but not for long, I fear). On a strictly musical level, speed garage is a mere composite (house + jungle) where jungle was a mutant (hip hop × techno). Jungle twisted and morphed its sources; as yet, an equivalent warp factor is barely audible in speed garage. Like most of the sub-generic turnover of the late nineties, speed garage reflects the fact that rave-and-club music seems to have reached an impasse. In every direction, the stylistic extremes have been reached. The only way to advance seems to be through grafting "internal" hybrids (house + trance = "epic house", for instance) or by mounting strategic, one-step-back-two-steps-forward retreats in order to explore a path prematurely abandoned (as techstep did with 1991-era Belgian hardcore). With micro-genres like harsh-step (techstep + gabba) and nu-skool breaks ("intelligent Big Beat"? midtempo jungle?) on the horizon in early 1998, rave music seems to be undergoing two linked but seemingly opposed syndromes: for every new subgenre that breaks off from its parent style, there's also a new hybrid forming that reconnects parts of the shattered whole once called "rave."

All this rampant turnover of subsubgenres and microscenes may smack of hype or hairsplitting to outsiders, but it's actually a sign of house music's continued vitality, proof that it's still evolving. More important, it's still routinely churning out brilliant tracks. But I can't help feeling that in the broader cultural sense house music and the club circuit are fundamentally conservative. At its more populist end, house has reverted back into mere disco, the soundtrack to traditional Saturday Nite fever. As for the more "discriminating" house subscenes, these are simply pre-rave metropolitan clubland elitism back in full, coked-up effect.

Rave was to club culture what punk was to rock: a kind of internal revolt within the broader musical formation. Punk didn't really change the sound of

rock that much, but it changed the attitude and it revived the late sixties' exorbitant expectations that the music could change the world. While rave as music was initially identical to the music played in clubs, rave as a subculture inverted all the guiding principles of clubland: it was anti-elitist, anti-cool, proinclusivity, pro-abandon. Eventually that spirit, that new subcultural context, changed the music itself, resulting in hardcore, jungle, trance, gabba, and all the other mongrel mutations of the Detroit/Chicago genealogy. For me, the idea and ideal of *raving* — mass communion, communal freak-out — seems crucial. When dance subcultures revert from full-on rave madness and "go back to the clubs," my enthusiasm begins to wane.

If Britain's house mainstream has distanced itself from the psychedelic, freakbeat element of rave — noise, aggression, riffs, juvenile dementia, hysteria — it has also reneged on rave's countercultural utopianism. House clubs are now a hi-tech leisure industry, offering the paying customer the opportunity to step inside a drug-conducive, sensorially intensified environment of ultravivid sound and visuals. No sacrifices are required to participate, beyond the financial; no ramifications extend into everyday life, beyond the drug hangover. As the late Gavin Hills put it, "Ecstasy culture is like a video-recorder: an entertainment device. The club structure now is like the pub structure, it has a role in our society."

It also has a role in the economy. The dance record and nightclub industries generate huge amounts of taxable income. Big-capacity "superclubs" like Ministry of Sound, Cream, and Renaissance are closer to corporations than the traditional notion of the club promoter; these are businesses with staffs, payrolls, profit margins, and long-term expand-and-diversify strategies that encompass merchandising, sponsorship deals, club-affiliated CD compilation series, and even the "club tour" to other cities.

Beyond the amount of tax revenue the dance industry creates, club-and-rave culture has contributed — alongside the Britpop explosion of retro guitar bands like Oasis — to the global perception that "England Is Swinging, Again." Despite this, the establishment attitude to rave-and-club culture is deeply conflicted. Both John Major's Conservative government and its Labour successor have maintained the war against recreational drug use. Following the media and public outcry in 1996 about Ecstasy deaths, MP Barry Legg drafted the Public Entertainment Licenses (Drug Misuse) Bill. Passed just

before the downfall of the Tories in May 1997, the law gives local councils and police forces the power to close down nightclubs if it is believed that drug consumption is taking place on the premises. Given the endemic use of Ecstasy, amphetamine, acid, and marijuana (a 1997 Release survey conducted in nightclubs revealed that 97 percent of British clubbers had tried drugs, and that just under 90 percent were planning to take some kind of illicit substance *that evening*), this law ought to mean that every dance venue in the UK should be closed down.

If the political establishment were to take a more realistic and cynical point of view, it might conclude that recreational drug use is not only an established component of British society, it's an essential component. Ecstasy culture is a useful way of dissipating the tensions generated by wage slavery and underemployment; it's an agent of social homeostasis, insofar as the loved-up ambience of clubs and raves offers youth a sort of provisional utopia each and every weekend, thereby channeling idealism and discontent out of the political arena altogether. "I reckon that if it wasn't for Ecstasy, there'd have been a revolution in this country by now," declared the Prodigy's Maxim Reality back in 1992; although he clearly meant to praise MDMA, others might read that remark as an indictment.

Could it be that the entire project of rave and post-rave club culture has amounted to little more than a survival strategy for the generation that grew up under Thatcher? A culture of consolation, where the illusory community of the Ecstatic dance floor compensates for the withering away of the "social" in the outside world, ever more deeply riven by class divisions and economic disparities? The explosion of pent-up social energies that occurred in the late eighties has been channeled and corralled into a highly controlled and controlling leisure system. The rave as temporary autonomous zone has become the club as pleasure-prison, a detention camp for youth.

Nineties house culture in Britain also seems utterly in tune with the apolitical, consumerist spirit of the Thatcher-Major era. House clubs offer their customers the prospect that each and every weekend can be a miniature Ibiza, a vacation from the workaday. One catchphrase seems to sum up house's "work hard/play hard" conservatism: *having it*, or, pronounced authentically, *'avin' it*. Used as an adjective (a havin' it club, a havin' it crowd) or as a hedonist war

cry ("we're 'avin' it LARGE, 'avin' it *major!*"), the buzzphrase captures the voraciousness of house culture, its spirit of pleasure-principled acquisitiveness.

For me, the exhilarating thing about rave was that it was *psychedelic disco*, a mind-blowing merger of rock delinquency and club culture's science of sound. At the time of writing, the most vibrant sound in dance music is the breakbeat-driven rave 'n' roll hybrid called big beat, as purveyed by the Chemical Brothers, the Skint label's Fatboy Slim and Bentley Rhythm Ace, and many others. Resisting the tyranny of good taste and "intelligence," the big beat outfits have brought back a sense of messy, "mindless" fun.

Reared on the neopsychedelic turmoil of My Bloody Valentine and that most riff-driven of rap groups Public Enemy, then radicalized by their experience of acid house during their college days in Madchester, the Chemical Brothers bring a punklike attack to techno by accentuating the same blaring midfrequencies supplied by rock guitar. Take "Loops of Fury," a black-and-white riot of stuttering beats, convulsive fuzzguitar-riffage, and floorquaking electro subbass; when they unleashed this monstertune at New York's Irving Plaza in 1996, I found myself pogoing for the first time in fifteen years!

The Chemicals' second album, *Dig Your Own Hole*, was even more rockist. In interviews, the duo — Ed Simons and Tom Rowlands — testified to the influence of sixties garage punk and freakbeat groups like Tintern Abbey, and even sampled psych-rockers Lothar and the Hand People on the awesomely monolithic mantra-stomp of "It Doesn't Matter." For the breakthrough single that preceded the album, "Setting Sun," they teamed up with the biggest rock star of the day, Oasis's Noel Gallagher, for a track that sounds like a fusion of the Beatles' "Tomorrow Never Knows" and Public Enemy's "Bring The Noise." Unlike those other rock/rave crossover giants Underworld, though, the Chemicals stay true to the most radical aspects of house and techno; they mostly shun songs and vocals, and rarely resort to melody, yet still manage to enthrall through texture, noise, and sheer groove-power alone.

The mentality of the milieu from which the Chemical Brothers emerge — clubs like London's Heavenly Social and Brighton's Big Beat Boutique; labels like Wall of Sound and Bolshi; bands like Monkey Mafia and Death in Vegas —

is decidedly rockist too, but not in a good way. It's all a bit too close to Britpop's boys' own boorishness. Perhaps that's not so strange when you consider that the Chemicals, Fatboy Slim, and Bentley Rhythm Ace all have indie-rock skeletons in their B-boy closets: Fatboy's Norman Cook played bass in janglepop hitmakers the Housemartins, while Bentley's Richard March was in Pop Will Eat Itself.

Then again, these dodgy origins could be big beat's secret strength. At a time when so much electronica suffers from anal-obsessive complexity, the big beat outfits "regress" to those eras when rave music itself was most *rock 'n' roll* in its druggy abandon: Madchester's indie-dance, breakbeat hardcore, acid house, and the late eighties "DJ records" of Coldcut, et al. Big beat simultaneously uses rock 'n' roll's hell-for-leather attitude to show up how too much of today's electronic music is po-faced and purist, while deploying club culture's arsenal of drug/tech effects to make trad guitar bands look terribly dated. Of course, this hasn't stopped dance purists dissing big beat as mere rock music tarted up with ideas ripped off from techno and house, or tradrockers dismissing it as inane party music without the redemptive resonance of your Verves and Radioheads.

Guilty as charged, on both counts, for sure — but so what? Big beat's sole raison d'être is to generate excitement and incite intensity: what could be more rock 'n' roll, more rave, than that? Big beat tracks are crammed with crescendos, builds, drops, explosions, crowd-inciting drum rolls, and whooshing sounds that pan across the stereo-field. These rollercoaster thrills 'n' spills carry over to big-beat DJ-ing, a style-hopping frenzy closer to a jukebox than to the house/techno DJ's seamless mixing. Where the latter's fluidity is designed to accompany MDMA's sustained plateau of bliss, big beat's jagged, epileptic-eclecticism reflects the polydrug consumption of its audience. Where once the E in "Generation E" stood for Ecstasy, now it stands for everything.

And yet big beat could not have emerged without Ecstasy culture; most of its pilfered repertoire of licks and tricks originally evolved specifically for the purpose of tantalizing the Ecstatic body. Combining rush-activating riffs, stabs, and tingle-textures with boombastic breaks 'n' sub-bass, tracks like Fatboy's "Everybody Loves A Filter," Dr. Bone's "I Came Here to Get Ripped," and Environmental Science's "The Day the Zak Stood Still" represent the latest stage in UK rave's longest-running musical narrative: the attempt to fuse house and

hip-hop, a compulsion that runs from the late-eighties DJ records through bleep-and-bass, 'ardkore and jungle, to who knows what future (per)mutations.

Now that the Chemical Brothers' fancy themselves as "mature" album artists, Norman Cook has usurped their role as rave-savior. Truer to Big Beat's immediacy-is-all-that-counts attitude, the debut Fatboy Slim LP Better Living Through Chemistry is more like a "greatest hits" singles collection than an album. It's also a compendium of tried-and-tested devices for triggering the rave 'n' roll rush. "Song For Lindy" features an oscillating piano-vamp melody-riff that flashes back to Brit-rave's euphoric peak circa 1991; "Everybody Needs a 303" rubs seventies slap-bass up against Roland 303 acieed bass-drone, topped with a psychedelic soul chorus courtesy of Edwin Starr; "Going Out of My Head" has the nerve to nick the powerchord riff from The Who's "Can't Explain" and the smarts to make it seem modern rather than mod (none of Britpop's sepia-tinted retro-referentiality). Best of all is "Punk to Funk" - for a small eternity, just chunky breaks and phat-verging-on-obese bass (wobbling like love handles at a Weight-Watchers disco), then an EZ-listening horn section fades up, huffing and puffing and blowing the roof off the sucker. Bentley Rhythm Ace are even more enamored of kitschadelic incongruity: most of what you hear on their self-titled debut album (flutes, Jew's harp solos, cheezylistening orchestration, disco whistles) comes from the dirt-cheap vinyl the duo salvage at tag sales. Like Fatboy's "Going Out of My Head," BRA's killer tune "Return of the Hardcore Jumble Carbootechnodisco Roadshow" pivots around a frenetic chickenscratch-guitar riff that draws a white line between 1966 mod's amphetamine-frenzy freakbeats and 1998 Big Beat's pills-and-Pils fueled pandemonium.

With the Skint sound and its myriad imitators, what I hear is the partial return of the breakbeat 'ardkore of 1992. Take Bolshi's star producer Rasmus — his brilliant "Mass Hysteria" EP is full of old skool rap sliced 'n' diced into locked-groove blurts of glossolalia, 78 rpm squeaky voices, bizarre eighties pop samples, and scratchadelic mayhem that recalls the likes of DJ Hype and Danny Breaks. In a lot of ways, big beat is jungle's retarded cousin — it shares the latter's hectic breaks and heavy bass, and even steals the odd jittery rhythm-programming idea from the breakbeat scientists, but generally favors much more simplistic looped beats. Compared with drum and bass's sophisti-

cation, big beat may seem like a step backward. But at this point in techno's history, "how experimental is it?" is not really the most helpful question to ask of a new music. "Does it work? Does it get me worked up?" may be more telling. (After all, *most* scientific experiments lead to inconclusive results or abject failure; similarly, *most* experimental dance music is seriously dysfunktional when it comes to working as a desiring machine).

Big beat's back-to-1992 tendency parallels the way seventies punk reactivated the adrenalizing minimalism of sixties garage punk. But maybe pub rock is a better analogy, with beery big beat as the necessary back-to-basics initiative before the real revolution, a techno-punk that's hopefully just round the corner. Such a punk-style revolt is sorely needed. Too many post-rave genres bear an uncanny resemblance to progressive rock: conceptualism, auteur-geniuses, producers making music to impress other producers, showboating virtuosity reborn as the "science" of programming finesse. Purist genres like Jeff Mills-style minimalist techno initially defined themselves against the "cheesy"-ness of hardcore rave and happy house ("cheese" standing for the corny-but-effective elements in music) by dedicating themselves to the pursuit of endless subtleties. The thing about cheese, though, is that it creates flava and increases the phat content of any given music. When it comes to cheese, I'll choose a pungent cliché over an insipid subtlety any day. In fact, I'd argue that the entire history of dance music is about the creation of potent clichés — sounds and effects so good that other people couldn't resist copying them. Clichés like disco's snarecrash, acid house's Roland 303 bass, garage's skipping snares, rave's Morse code piano vamps, hardcore's "Mentasm" stabs, jungle's "Amen" breaks, gabba's distorted kick drum, and the goosebump-inducing EQ/filter/phasing effects used by house producers from DJ Pierre to Daft Punk.

To invent a cliché from scratch is a great feat. The Chemicals, Fatboy Slim, and the other big beat acts may not have actually created any *new* clichés, but by inventively crushing together all the golden oldies from rave, house, rap, disco, ad infinitum, they've reminded us that dance music is supposed to be about fun, about *freaky dancing* as opposed to head nodding and train-spotting.

* * *

The rock-like qualities in the Chemical Brothers, Underworld, and the Prodigy are precisely what has enabled them to cross over into the American main-stream. Although the "Electronica Revolution" has been hailed in the US media as the long-overdue arrival of techno to America, it's readily apparent that the British invaders have met the postgrunge audience halfway.

The Prodigy's story is the most bizarre example of this "market repositioning" syndrome. Back in late '92, the Prodigy seemed, for all their hit singles and healthy album sales, like a band without a future: their destiny was surely to go down the drain along with the rave scene that *Mixmag* had accused them of destroying with a single song, "Charly." But over the next two years, the Prodigy sidestepped the decline of the megarave circuit and pulled off an astounding feat of self-reinvention. By 1994, the band was playing rock festivals, selling to *NME* and *Melody Maker* readers, and wowing the crits with *Music for the Jilted Generation*, a vaguely conceptual album that protested the crackdown on rave culture, from local councils refusing licenses for commercial events to the Criminal Justice Act's assault on illicit raves.

After a slew of hits — the rock guitar—propelled "Voodoo People," the awesome slow-mo break-and-bassquake "Poison" — the Prodigy scored their greatest triumph in early 1996 with "Firestarter," a metal-riffin' hymnto-destruction that sampled grunge grrls the Breeders and the Art of Noise. Transforming dancer/MC Keith Flint into star vocalist and videogenic focal point, "Firestarter" went straight to number one in the UK. Appearing at the MTV Europe Awards to pick up a trophy for Best Dance Video, the Prodigy greeted the youth of the EC with a matey "hold it down! — a vintage '92 rave buzzphrase — as if to confirm 'ardkore's historical vindication. It had become what it always secretly had been, for those with ears to hear it: the new rock 'n' roll.

Several months later, "Firestarter" became a heavy-rotation buzz-video in America, igniting a major label bidding war (amazingly, the Prodigy had already been signed and then let go after just one album by *two* substantial American labels, Elektra and Mute). Madonna's Maverick — a Warner Bros. sublabel — won the war, at considerable expense. With corporate heft behind it, the Prodigy's third album *The Fat of the Land* went straight to number one in America (and in another twenty or so countries as well). But by this point — with

almost every Fat track featuring vocals and guitar riffs where once there had only been samples and breaks, and the hectic rave tempos slowed to a big beat pummel — the Prodigy was a rock band, to all intents and purposes. Liam Howlett even declared in interviews that he'd never liked house or Kraftwerk (Detroit techno's sacred source). The Oi!-meets-jungle menace of "Breathe" and a cover of L7's "Fuel My Fire" defined the Prodigy's new sales shtick: an apolitical update of punk offering postgrunge kids an aerobic workout for their frustration and aggression. Onstage and on video, mohican-sporting maniac and self-proclaimed "youth corrupter" Keith Flint pulled grotesque faces and threw twisted shapes like some cartoon cross between Alice Cooper and Vivian from The Young Ones.

For underground techno and house fiends, the American music industry—sponsored buzzword "electronica" — the rubric under which the Chemical Brothers and the Prodigy have been hyped — is already a dirty word. Like "rave" — the milieu in which the Prodigy originally honed its crowd-pleasing stagecraft — the term "electronica" holds out the threat of the music's corruption, as it makes the transition from intimate clubs to stadiums, from discriminating cognoscenti to a mass audience. The house and techno purists want to keep the music contained at the level of the pre-rave, club-oriented scenes in Detroit, Chicago, and New York.

And yet the myth and the reality of rave still haunt this music, even the subscenes that explicitly define themselves against its populism. However much "we" might disagree about the future course of the music, "rave" is what keeps us talking to each other. This can be seen in the success of Tribal Gathering, the UK dance festival. Its very name acknowledges the balkanization of postrave culture, even as it seeks to resurrect the lost unity by shepherding the scattered tribes together.

In 1996, Tribal Gathering was touted as the successor to the Glastonbury rock festival, which didn't happen that year. But at Glastonbury, the sideshows and bazaars are strictly supplementary to the main arena, where fifty thousand plus convene to watch the headlining bands. For the thirty thousand who attend Tribal Gathering, the experience is far more disparate. In 1996, TG offered seven circus-size tents each catering to different tastes: Nexus for jungle and happy hardcore, Planet Cyberpunk for bangin' techno, Astral Nuts for Euro

trance, Tribal Temple for Goa Trance, Planet Erotica for house and garage, Planet Phunk for trip-hop. Each of these tents was approximately the same size. Even the biggest, Starship Universe (at 6,500 capacity), was nowhere close to being the focal point of the event, despite its lineup of crossover acts and genre-blenders, like Leftfield, Black Grape, Carl Cox, and Josh Wink.

Tribal Gathering's decentered structure is the only sensible way to reconcile the megarave ideal of thirty thousand people in a field grooving to the same beat with the postrave reality of shattered consensus, uncommon aims, and different strokes. In years to come, there will doubtless be more and more tents, as subgenres subdivide. (Indeed in 1997 happy hardcore got its own tent, separate from jungle; how long before the happy hardcore substyle "trancecore" gets its own marquee?)

What I wondered as I wandered from tent to tent on that May night in '96 was whether the gathered tribes were fraternizing or simply coexisting. There were a lot of nonaligned types drifting around, but it seemed equally possible that most people gravitated toward their own kind and fixated on their particular drug/technology fix. It was hard to imagine any of the hardcore massive in Nexus stepping out of their particular locked groove in order to check out what was Goa-ing on in Astral Nuts, or vice versa. What was really odd about the event was that the Goa-heads could have enjoyed a similar lineup of DJs at regular Goa events like Return to the Source for about half the price and without having to trek forty miles to the event; the junglists and happycore kids could equally have heard a similarly stellar selection of DJs at events like World Dance. The extra fifteen pounds everyone had paid was basically their homage to the myth of rave, the living dream of unity in diversity. They were subsidizing a ritual reenactment of something that was long lost but that in some obscure way still mattered.

In Britain, on the tenth anniversary of acid house, there's a sense of legacy and achievement, a feeling of "what a long strange trip it's been." Nostalgia abounds, although there's disagreement over when exactly the lost golden age was: 1988–89, or 1991–92, or even 1994, the year jungle broke through. The nostalgia is capitalized on by triple CD compilations of house and hardcore

anthems, "Back to 92" raves and "Old Skool" events. Genealogies, canons, and countercanons are being drawn up, historical knowledge and narratives accumulated.

In America, the feeling is rather different. The rave scene keeps growing steadily, but seems stuck in a holding pattern; the much-vaunted "electronica revolution" may be that scene's long-deferred explosion into mass consciousness, but will more likely be a top-down, corporate-imposed phenomenon, oriented toward bands rather than DJs, and slyly distanced from the taint of drugs.

I have a theory that there is an inverse relationship between the vitality of a pop genre and the number of books written about it. Compared with the thousands of biographies, essay collections, and critical overviews that clog up rock's arteries, only a handful of tomes (academic efforts included) have addressed the dance-and-drug culture — despite the fact that it's been the dominant form of pop music in Europe for nearly a decade. I guess this theory makes my own effort here one of the first nails in the coffin. But we've a long, long way to go before this music is dead and buried, mummified as a museum culture like rock 'n' roll. The Rave Hall of Fame is a couple of decades off. Ten years later, this culture — call it rave, or techno, or electronic dance music — still feels incredibly vital. It's only just hitting its prime, and internal revolutions and reconfigurations along the lines of punk surely lie ahead. If this precise moment feels like a pause for breath, it's only because there's so much yet to come.

SIMON REYNOLDS | APRIL 1998

- ADORNO, THEODOR W. "On the Fetish-Character in Music and the Regression of Listening." In *The Essential Frankfurt School Reader*, ed. E. Arato and E. Gebhardt. Oxford: Basil Blackwell, 1978.
- ———. "Perennial Fashion Jazz." In *Prisms*, trans. Samuel Weber and Shierry Weber. Cambridge, MA: MIT Press, 1981.
- ATTALI, JACQUES. *Noise: The Political Economy of Music.* Trans. Brian Massumi, Manchester: Manchester University Press, 1985.
- BEADLE, JEREMY J. Will Pop Eat Itself? Pop Music in the Soundbite Era. London: Faber and Faber, 1993.
- BECK, JEROME, and MARSHA RONSENBAUM. *Pursuit of Ecstasy: The MDMA Experience*. Albany: State University of New York Press, 1994.
- BENNEY, PAUL. Jeff Mills interview. Jockey Slut, June/July 1996.
- BETTELHEIM, BRUNO. The Empty Fortress: Infantile Autism and the Birth of Self. New York: Free Press, 1967.
- BEY, HAKIM. T.A.Z.: The Temporary Autonomous Zone, Ontological Anarchy, Poetic Terrorism. Brooklyn, NY: Autonomedia, 1991.
- BLOOM, HAROLD. Omens of Millennium: The Gnosis of Angels, Dreams, and Resurrection. New York: Riverhead, 1996.
- BOWIE, MALCOLM. *Lacan*. Cambridge, MA: Harvard University Press, 1991. BROUGHTON, FRANK. "Chicago: Still Rockin' Down the House." *iD*, April 1995. BUFORD, BILL. *Among the Thugs*. New York: W. W. Norton, 1992.
- BUKATMAN, SCOTT. Terminal Identity: The Virtual Subject in Postmodern Science Fiction. Durham, NC, and London: Duke University Press, 1993.
- . "The Artificial Infinite." In *Visual Display: Culture Beyond Appearances*. Ed. Lynne Cooke and Peter Wollen. Seattle: Bay Press, 1995.
- CAGE, JOHN. "Goal: New Music, New Dance." In Cage, John. *Silence: Lectures and Writings*. Middletown: Wesleyan University Press, 1979.
- CHAMPION, SARAH, ed. *Disco Biscuits*. London: Sceptre/Hodder and Stoughton, 1997.
- -----. "Fear and Loathing in Wisconsin" [Further/US rave]. In Redhead, Steve, ed. *The Clubcultures Reader*. Oxford: Blackwell, 1997.
- CHESTER, ANDREW. "Second Thoughts on a Rock Aesthetic: The Band." Originally in *New Left Review* 67 (1970). Reprinted in Simon Frith and Andrew Goodwin, eds. *On Record: Rock, Pop & The Written Word.* New York: Pantheon, 1990.

- COLE, BETHAN. "Trance Tripping" [Goa trance]. In *iD*, The Real Issue, 1996. COLLIN, MATTHEW, with JOHN GODFREY. *Altered State: The Story of Ecstasy Culture and Acid House*. London: Serpent's Tail, 1997.
- DELEUZE, GILLES, and FELIX GUATTARI. A Thousand Plateaus: Capitalism and Schizophrenia. Trans. Brian Massumi. Minneapolis: University of Minnesota Press, 1987.
- ECHLIN, HOBEY. "The History of Detroit Techno Part One" and "Part Two." Detroit Metro Times, May 17–23 and May 24–30, 1995.
- EISENBERG, EVAN. The Recording Angel: Music, Records and Culture from Aristotle to Zappa. London: Picador, 1988.
- ENO, BRIAN. Dialogue with Kevin Kelly. Wired, May 1995.
- ESHUN, KODWO. Carl Craig profile. iD, April 1995.
- FRITH, SIMON. *Performing Rites: On the Value of Popular Music.* Cambridge, MA: Harvard University Press, 1996.
- GIBSON, WILLIAM. Neuromancer. New York: Ace, 1984.
- GILROY, PAUL. The Black Atlantic: Modernity and Double Consciousness. Cambridge, MA: Harvard University Press, 1993.
- GODFREY, JOHN. "The Amnesiacs/Happy Daze Are Here Again" [Balearic and Acid House]. *iD*, The Body Issue, 1988.
- GOODWIN, ANDREW. "Rationalisation and Democratisation in the New Technologies of Popular Music." In *Popular Music and Communication*, ed. James Lull. Thousand Oaks, CA: Sage, 1992.
- GRACYK, THEODORE. *Rhythm and Noise: An Aesthetics of Rock.* Durham, NC: Duke University Press, 1996.
- GRAY, CHRIS HABLES, ed. *The Cyborg Handbook*. New York and London: Routledge, 1995.
- GREENFELD, KARL TARO. Speed Tribes: Days and Nights with Japan's Next Generation. New York: HarperCollins, 1994.
- GRINSPOON, LESTER, and PETER HEDBLOM. *The Speed Culture: Amphetamine Use and Abuse in America*. Cambridge, MA: Harvard University Press, 1975.
- GROSSBERG, LAWRENCE. We Gotta Get Out of This Place: Popular Conservatism and Postmodern Culture. London: Routledge, 1992.
- GUATTARI, FELIX. "Millions and Millions of Potential Alices." In *Molecular Revolution: Psychiatry and Politics*, ed. Felix Guattari and trans. Rosemary Sheed. London: Penguin, 1984.
- HEBDIGE, DICK. Cut 'n' Mix: Culture, Identity and Caribbean Music. London: Comedia, 1987.
- HENDERSON, SHELIA. Ecstasy: Case Unsolved. London: Pandora, 1997.
- HENRY, STUART and MIKE VON JOEL. *Pirate Radio: Then and Now.* Poole, Dorset: Blandford Press, 1984.
- HILLS, GAVIN. "Wonderland U.K." [Drug excess/ennui]. *The Face*, January 1993.

- HUGHES, WALTER. "Feeling Mighty Real: Disco as Discourse and Discipline." Village Voice Rock & Roll Quarterly, Summer 1993.
- JAMES, WILLIAM. The Varieties of Religious Experience. New York: Mentor, 1958.
- ——. "Subjective Effects of Nitrous Oxide." Mind 7 (1882): 186–208. Reprinted in Altered States of Consciousness, ed. Charles T. Tart. New York: HarperCollins, 1990.
- KEIL, CHARLES, and STEVEN FELD. Music Grooves. Chicago: University of Chicago Press, 1994.
- KEMPSTER, CHRIS, ed. History of House. London: Sanctuary, 1996.
- KENT, NICK. "The Mancunian Candidates: Happy Mondays and Stone Roses." In *The Dark Stuff.* London: Penguin, 1994.
- KROKER, ARTHUR. *The Possessed Individual: Technology and the French Post-modern.* New York: St. Martin's Press, 1992.
- ------. Spasm: Virtual Reality, Android Music and Electric Flesh. New York: St. Martin's Press, 1993.
- and MICHAEL A. WEINSTEIN. Data Trash: The Theory of the Virtual Class. New York: St. Martin's Press, 1994.
- LUDLOW, FITZ HUGH. "The Hasheesh Eater: being passages from The Life of a Pythagorean." Extract reprinted in *The Drug User: Documents 1840–1960*, ed. John Strausbaugh and Donald Blaise. New York: Blast Books Inc, 1991.
- MARSHALL, JULES. "Harder Than Hardcore" [Gabba]. iD, The Europe Issue, 1993.
- MCKAY, GEORGE. Senseless Acts of Beauty: Cultures of Resistance Since the Sixties. London: Verso, 1990.
- McKENNA, TERENCE. Food of the Gods: The Search for the Original Tree of Knowledge. A Radical History of Planets, Drugs and Human Evolution. New York: Bantam, 1992.
- MELECHI, ANTONIO. "The Ecstasy of Disappearance." In *Rave Off: Politics and Deviance in Contemporary Youth Culture*, ed. Steve Redhead. Aldershot, Hampshire: Avebury, 1993.
- METCALFE, STUART. "Ecstasy Evangelists and Psychedelic Warriors." In *Psychedelica Britannica: Hallucinogenic Drugs in Britain*, ed. Antonio Melechi. London: Turnaround, 1997.
- METRAUX, ALDRED. *Voodoo in Haiti.* Oxford: Oxford University Press, 1959. MILLER, PAUL D. "Yet Do I Wonder." *Village Voice,* February 8, 1994.
- MOORE, JOHN. *Anarchy & Ecstasy: Visions of Halcyon Days.* London: Aporia Press, 1988.
- NEWCOMBE, DR. RUSSELL. "Raving and Dance Drugs: House Music Clubs and Parties in North-West England." Liverpool: Rave Research Bureau paper, 1991.
- O'HAGAN, ANDREW. "Passing Poison." Observer Life magazine, October 9,

- 1994. Reprinted in *The Faber Book of Pop*, ed. Hanif Kureishi and Jon Savage. London: Faber and Faber, 1995.
- OWEN, FRANK. "Feel the Noise Techno Kids: The Working-Class Avant-Garde" [New York hardcore]. Village Voice, September 24, 1991.
- . "Paradise Lost" [Paradise Garage/Larry Levan]. Vibe, 1993.
- . "The King of Ecstasy" [Lord Michael]. Village Voice, April 1, 1997.
- PENMAN, IAN. "Black Secret Tricknology" [Tricky]. *The Wire*, March 1995. PRINCE, DAVID. Interview with Brian Eno. *Request*, November 1995.
- ——and MATT ADELL. Interview with Terence McKenna. *Reactor*, March 1993.
- ROSE, TRICIA. Black Noise: Rap Music and Black Culture in Contemporary America. Hanover, NH: University Press of New England, 1994.
- REDHEAD, STEVE. Football with Attitude. Manchester: Wordsmith, 1991.
- —— ed. Rave Off: Politics and Deviance in Contemporary Youth Culture. Aldershot, Hampshire: Avebury, 1993.
- RIETVELD, HILLEGONDA. "Living the Dream." In *Rave Off*, ed. Steve Redhead.

 . "The House Sound of Chicago." Working Papers in Popular Cultural Studies No. 8. Manchester: Manchester Institute for Popular Culture, 1993.
- RUSHKOFF, DOUGLAS. Cyberia: Life in the Trenches of Hyperspace. Harper-Collins, 1994.
- SAUNDERS, NICHOLAS. E for Ecstasy. London: Nicholas Saunders, 1993.
- . Ecstasy and the Dance Culture. London: Nicholas Saunders, 1995.
- SCHAFER, R. MURRAY. *The Soundscape: Our Sonic Environment and the Tuning of the World.* Rochester, VT: Destiny Books, 1994.
- SHAPIRO, HARRY. Waiting for the Man. The Story of Drugs and Popular Music. New York: William Morrow, 1988.
- SHAPIRO, PETER and RACHAEL PHILIPPS. "Something for the Blunted" [Coldcut and Ninjatune]. *The Wire*, May 1996.
- SICKO, DAN. "Techno Rebels: Detroit's Agents of Change." *Urb*, no. 50, August/September 1996.
- SILVERMAN, KAJA. The Acoustic Mirror: The Female Voice in Psychoanalysis and Cinema. Bloomington and Indianapolis: Indiana University Press, 1988.
- SMITH, RICHARD. "Us Boys Together Clinging: One Night in a Gay Club." In Seduced and Abandoned: Essays on Gay Men and Popular Music. London: Cassell, 1995.
- SONTAG, SUSAN. "The Basic Unit of Contemporary Art Is Not the Idea, but the Analysis of and Extension of Sensations." In *McLuhan: Hot & Cool*, ed. Gerald Emanuel Stearn. New York: Signet, 1969.
- STRAW, WILL. "The Booth, The Floor and The Wall: Dance Music and the Fear of Falling." *Public*, No. 8, 1993.
- THEBERGE, PAUL. Any Sound You Can Imagine: Making Music/Consuming

- Technology. Hanover, NH: University Press of New England, 1997.
- THORNTON, SARAH. *Club Cultures: Music, Media and Subcultural Capital.* Hanover, NH: Weslyan University Press, 1996.
- TOFFLER, ALVIN. Future Shock. New York: Random House, 1970.
- ----. The Third Wave. New York: Bantam, 1981.
- TOOP, DAVID. Ocean of Sound: Aether Talk, Ambient Sound and Imaginary Worlds. London: Serpent's Tail, 1995.
- -----. "Behind the Groove" [early-eighties New York DJs]. *Collusion*, September 1983. Reprinted in *DJ*, March 11, 1994.
- ———. Giorgio Moroder interview. *The Wire*, April 1992.
- VIRILIO, PAUL. Aesthetics of Disappearance. New York: Semiotext(e), 1991.
- _____, and SYLVERE LOTRINGER. Pure War. New York: Semiotext(e), 1983.
- WELSH, IRVINE. The Acid House. New York: Norton, 1995.
- -----. Marabou Stork Nightmares. New York: Norton, 1996.
- WILLIAMS, DONNA. *Nobody Nowhere: The Extraordinary Autobiography of an Autistic.* New York: Times Books, 1992.

2 - " could be come to the cou

the segment of the segment of the section of the se

Notes:

1/ Just about every record mentioned in the text is included here, plus a good many that weren't but are nonetheless either important or worth hearing. The discography is divided up according to the chapters of the book, and their corresponding genres/eras.

- 2/ Flipside or EP tracks are listed if (a) no A-side was given priority or (b) if the track is especially excellent or notable. Specific mixes are noted if appropriate.
- 3/ Within any individual artist's oeuvre, the releases are listed in chronological order.
- 4/ Single artist albums, including compilations of the artist's work, are listed alongside the single and EP releases; genre anthologies and DJ mix CDs are listed at the end of each chapter or subsection and listed in order of excellence (the best or most useful introduction to that genre comes first).
- 5/ DJ names are alphabetized according to their second, defining name e.g. DJ Hype is under *H*.
- 6/ If the artist's name is a pseudonym or alter ego, the artist's real name or most well known alter ego is listed in parentheses. Exceptions are when an artist is the focus of a subsection: then the whole oeuvre is listed together, with alter egos in alphabetical order.

detroit techno, chicago house, and new york garage,

DETROIT TECHNO

ANCESTORS

Kraftwerk Autobahn (1974; Elektra 1985)

Trans-Europe Express (Capitol 1977) The Man-Machine (Capitol, 1978) Computer World (1981; Elektra 1988)

JUAN ATKINS

Cybotron Interface (Ace anthology)

Model 500 "No UFOs"

"Off to Battle" (both Metroplex)
Classics (R & S anthology)

DERRICK MAY

Rythim Is Rythim "Strings of Life/Move It/Kaos"

"Nude Photo/The Dance"

"The Beginning/Drama/Salsa Life"
"It Is What It Is/Beyond the Dance"

"Beyond the Dance (Cult Mix)/Sinister" (all Transmat)

Innovator (Transmat/Fragile anthology)

KEVIN SAUNDERSON

Inner City "Big Fun"

"Good Life" (both Ten)

Reese "Just Want Another Chance" (Incognito)

Reese & Santonio "The Sound" (KMS)

Kevin Saunderson Faces & Phases: The Kevin Saunderson Collection (Planet E)

COMPILATIONS

Retrotechno/Detroit Definitive (Network)

Techno! The New Dance Sound of Detroit (Network/Ten)

CHICAGO HOUSE

ANCESTORS

Donna Summer/Giorgio Moroder Love to Love You Baby (Oasis 1975)

"I Feel Love" (Casablanca, 1977) Once Upon a Time (Casablanca, 1977)

HOUSE ANTHEMS AND JACKTRACKS

Another Side (Jack Trax) Fingers Inc

Farley "Jackmaster" Funk & Jessie

"Love Can't Turn Around" (DJ International/London) Saunders feat. Darryl Pandy

> The It "Donnie" (DJ International)

"In the City (Devil Mix)" and "(Insane Mix)" (State Street) Master C&J

Mr Fingers [Larry Heard] "Washing Machine/Can You Feel It" (Trax)

> Jamie Principle "Baby Wants to Ride" (Trax)

Ralph Rosario feat, Xavier Gold "You Used to Hold Me" (Hot Mix 5)

COMPILATIONS

The House That Trax Built (Trax) Classic House 1 to 3 (Mastercuts)

The House Sound of Chicago Vol I to III (ffrr)

Jack Trax 1 to 5 (Indigo)

Jackmaster 1 to 5 (DJ International/Westside)

ACID HOUSE

Adonis & The Endless Poker "The Poke" (DJ International)

> Armando "Land of Confusion" (Westbrook)

Bam Bam "Where's Your Child" (Westbrook)

Mike Dunn "Magic Feet" (Westbrook)

Fast Eddie "Acid Thunder" (DJ International)

Laurent X "Machines" (Trax)

Phuture "Acid Tracks/Your Only Friend" (Trax)

Pierre's Pfantasy Club "Dream Girl" (Trax)

Sleezy D [Marshall Jefferson] "I've Lost Control" (Trax)

> Tvree "Acid Over" (DJ International)

COMPILATIONS

Classic Acid: Definitive Acid House Mastercuts Volume 1

(Mastercuts)

A Comprehensive History of Acid House Music (Trax/Mirakkle)

Acid II: Sound of the Underground (DJ International)

Bam Bam: Best of Westbrook Classics (Tresor)

NEW YORK GARAGE

ANCESTORS

Double Exposure "Ten Percent" (Salsoul)

Dinosaur L [Arthur Russell] "Go Bang!" (City Beat/Sleeping Bag)

First Choice "Doctor Love" (Salsoul)

Loose Joints [Russell] "Is It All Over My Face" (West End)

Arthur Russell "Let's Go Swimming" (Rough Trade)

Peech Boys "Don't Make Me Wait" (West End)

Various Artists West End Story (West End)

Salsoul's Greatest 12" Hits Vol. 1 (Salsoul)

STRICTLY RHYTHM

After Hours "Waterfall (3-AM Mix)"

Hardrive "Deep Inside"

House 2 House "Hypnotize Me (Trance Mix)"

Photon Inc [Pierre] "Generate Power"

Phuture [Pierre] "Inside Out"

"Rise from Your Grave"

DJ Pierre DJ Pierre anthology

Various Artists This Is Strictly Rhythm

Strictly Rhythm — The Album

Strictly Rhythm — The Second Album

MISCELLANEOUS

Nitro Deluxe "Let's Get Brutal (Cooltempo)

"This Brutal House" (Cutting/Cooltempo)

"On a Mission" (Cutting Records)

Various Artists Nu Groove — A Compilation (Network)

TODD TERRY

Black Riot "Warlock/A Day in the Life" (Champion)

CLS "Can You Feel It (In House Dub)" (Strictly Rhythm)

Masters at Work "Alright, Alright"

"Dum Dum Cry" (both Fourth Floor)

Orange Lemon "Dreams of Santa Anna" (Bad Boy, 1988)

Royal House "Can You Party"

"Party People"

Can You Party (all Idlers)

Swan Lake "In the Name of Love/The Dream" (Bad Boy)

Todd Terry Project To the Batmobile Let's Go (Sleeping Bag)

Youngbloods "You Got Me Burnin' (UK Deep Mix)" (Strictly Rhythm)

HIP-HOUSE

Fast Eddie "Hip House"

"Yo Yo Get Funky" (both DJ International)

Tyree "Hardcore Hip House" (DJ International)

living a dream

acid house and uk rave, 1987–89

Adamski LIVEANDIRECT (MCA)

Bang the Party "Release Your Body" (Warrior Dance; Transmat)

Baby Ford "Oochy Koochy"

"Chikki Chikki Ahh Ahh" (both Rhythm King)
'Ooo' the World of Baby Ford (Rhythm King/Sire)

Black Box Ride on Time (Deconstruction)

Bomb the Bass "Beat Dis" (Rhythm King)

Ce Ce Rogers "Someday" (ffrr)

Coldcut "Beats + Pieces" (Ahead of Our Time)

What's That Noise (Ahead of Our Time)

D Mob "We Call It Acieed" (ffrr)

E-Zee Possee "Everything Starts with an 'E' " (More Protein)

Humanoid "Stakker Humanoid" (West Side Records)

Jolly Roger "Acid Man" (Ten Records)

Frankie Knuckles "Tears"

"Your Love" (both ffrr)

Landlord "I Like It (Blow Out Dub)" (Debut)

Lil Louis & The World "French Kiss"

From the Mind of Lil Louis (both ffrr)

M/A/R/R/S "Pump Up the Volume" (4AD; 4th & Broadway)

Nightwriters "Let the Music Use You" (fffreedom)

Phase II "Reachin'" (Republic)

Raven Maize "Forever Together" (Z/EMI)

Raze "Break 4 Love" (Champion)

Raze presents Doug Lazy "Let It Roll" (Atlantic)

S'Express "Theme from S'Express"

"Hey Music Lover"

Original Soundtrack (all Rhythm King)

Starlight "Numero Uno" (Citybeat)

Sueno Latino "Sueno Latino" (Expanded Music)

Ten City "That's the Way Love Is"

"Devotion" (both Atlantic)

Turntable Orchestra "You're Gonna Miss Me" (Republic)

COMPILATIONS

A History of Dance Music (Deconstruction)

Classic Balearic: Definitive Balearic Beats Volume 1 (Mastercuts)

twenty-four-hour party people

"madchester," positivity, and the rave 'n' roll crossover, 1988–91

MADCHESTER INDIE-DANCE AND MADCHESTER HOUSE

A Guy Called Gerald "Voodoo Ray" (Rham)

Hot Lemonade (Rham) Automanikk (CBS 1990)

808 State Quadrastate (Creed Records)

"Pacific State" (ZTT)

Ninety (ZTT)/Utd. State 90 (ZTT/Tommy Boy)

Ex:El (ZTT/Tommy Boy)

Happy Mondays Squirrel and G-Man Twenty Four Hour Party People . . .

Bummed (Factory)

"WFL" ["Wrote for Luck" Paul Oakenfold Remix]

"Madchester Rave On" EP

"Step On"

Pills 'n Thrills & Bellyaches Yes Please! (all Factory)

Jon Hassell vs 808 State "Voiceprint" (All Saints)

The Stone Roses

The Stone Roses

"Fools Gold"

"One Love/Something's Burning" (all Silvertone)

Second Coming (Geffen)

T-Cov "Carino" (Deconstruction)

POSITIVITY PUNKS AND RAVE 'N' ROLLERS

Adamski "Killer" (MCA)

The Beloved "The Sun Rising" (WEA)

Happiness (WEA)

EMF "Unbelievable" (EMI)

Flowered Up "Weekender" (Heavenly/Columbia)

The KLF "What Time Is Love?" (KLF Communications)

The White Room (KLF Communications)

Primal Scream "Loaded" (Creation)

"Come Together (Andew Weatherall Remix)" (Creation)

"Higher Than the Sun (A Dub Symphony in Two Parts)"

Screamadelica (Creation; Sire)

The Shamen En-Tact (One Little Indian/Epic)

Boss Drum (One Little Indian/Epic)

'ardkore, you know the score

the second wave of rave, 1990-92

WARP

Coco Steel and Lovebomb "Feel It"

Forgemasters "Track with No Name"

LFO "LFO"

Frequencies (Tommy Boy)

"What Is House" EP

Nightmares on Wax "Dextrous"

"Aftermath"

A Word of Science: The 1st & Final Chapter

Sweet Exorcist "Testone"

C.C.C.D.

Tricky Disco "Tricky Disco"

Tuff Little Unit "Join the Future"

Various Artists Pioneers of the Hypnotic Groove

MISCELLANEOUS BLEEP AND BASS

Ability II "Pressure/Pressure Dub" (Outer Rhythm)

Energise "Report to the Dancefloor" (Network)

Forgemasters "Stress" on "The Black Steel" EP (Network)

Rob Gordon Rob Gordon Projects (Source Records anthology)

Ital Rockers "Ital's Anthem/Science" (Bassic)

"One Day" (Outer Rhythm)

Nexus 21 "Logical Progression" EP (R & S)

Orbital "Chime/Crime" (OhZone/ffrr)

"Satan/Belfast" (ffrr)

Original Clique "North of Watford" EP (Chill)

Rhythmatic "Take Me Back (Robert Gordon Edit — 'With Extra Bass')"

(Network)

"Frequency Remix/Demons" (Network)

Energy on Vinyl (Network)

Unique 3 "The Theme" (Ten Records)

"Weight for the Bass/Musical Melody" (Ten Records)

Jus' Unique (Ten Records)

XON "The Mood Set EP" (Network)

COMPILATIONS

Technorave 2: Trance Atlantic . . . The Wave of the Future

(Network/Next Plateau)

Breaks, Bass and Bleeps Vol 1 (Rumour)

SHUT UP AND DANCE

Nicolette "Waking Up"

Now Is Early

Ragga Twins "Illegal Gunshot/Spliffhead"

"Wipe the Needle/Juggling"

"Hooligan 69"

Reggae Owes Me Money

"Mixed Truth"

Rum & Black Without Ice

Shut Up and Dance "£10 to Get In"

"£20 to Get In"

"Derek Went Mad"

Dance Before the Police Come!

"Autobiography of a Crackhead/The Green Man"

(feat. Peter Bouncer) "Raving I'm Raving"

Death Is Not the End

Various Artists Shut Up and Dance (SUAD)

BELTRAM/BELGIUM

JOEY BELTRAM/SECOND

PHASE

Beltram "Energy Flash" (R & S)

Beltram/Program 2 "The Omen" (R & S/Order to Dance)

Joey Beltram Classics (R & S)

Second Phase "Mentasm" (Outer Rhythm/R & S)

MISCELLANEOUS BELGIAN HARDCORE

Cubic 22 "Night in Motion" (Big Time International)

Frank De Wulf "The Tape" on "The B-Sides Volume Three"

"Magic Orchestra" and "The Tape" on "The B-Sides Remixed"

DJPC "Inssomniak" (Hype)

Holy Noise "The Noise (X-Treme Sounds)" (Hithouse)

Human Resource "The Complete Dominator" (R & S/Order to Dance)

Incubus "The Spirit" (80 Aum/I.M.C.)

LA Style "James Brown Is Dead" (XYZ Records; Arista)

Meng Syndicate "Sonar System" (Hithouse)

Mundo Muzique "Acid Pandemonium" on "Tranztechno EP" (R & S)

Outlander "The Vamp" (R & S)

Praga Khan "Rave Alarm" (Beat Box)

Ravesignal III [CJ Bolland] "Horsepower" (R & S EP)

Rhythm Device (F. De Wulf) "Acid Rock" (Music Man)

Set Up System "Fairy Dust (Centripetal Mix)" (Big Time)

Techno Grooves "Techno Slam" on "Mach 4" (Hotsound EP)

T99 "Anasthasia" (Who's That Beat/XL)

COMPILATIONS

XL Recordings: The Second Chapter (XL)

80 Aum Records: The Diamond Series (80 Aum Records)

Reactivate Volumes 1 to 5 (React) In Order to Dance III and 4 (R & S) The History of Techno 1-3 (Big Time)

CHART BUSTING POP RAVE AND **BRITISH BRUTALIST TEKNO**

"Infiltrate 202" (The Vertigo EP) Altern 8

"Activ-8 (Come with Me)"

"Frequency"

Full On . . . Mask Hysteria (all Network)

"Don't Go" (XL) Awesome 3

"Playing with Knives" (Vinyl Solution) Bizarre Inc

Congress "40 Miles" (Nush)

DJ Carl Cox "I Want You (Forever)" (Perfecto)

> Eon "Spice"

> > "Fear: The Mindkiller"

Void Dweller (all Vinyl Solution)

G.T.O. "Pure" (Go Bang, 1990)

"Listen to the Rhythm Flow" (React)

"The Bullfrog" (React)

"Circles (Vicious Mix)" (XL) John + Julie [G.T.O.]

> "Sweet Harmony" (XL) Liquid

"Feel Real Good" (Reinforced) Manix

N-Joi "Anthem"

"Adrenalin EP"

"Mindflux/Malfunction" (all Deconstruction)

Opus III "It's a Fine Day" (PWL International)

"Android" on "What Evil Lurks EP" The Prodigy

"Charly/Your Love"

"Everybody in the Place" (all XL)

Experience (XL; Elektra)

Music for the Jilted Generation (XL; Mute, 1994)

"Firestarter" (XL; Mute, 1996)

The Fat of the Land (XL; Maverick, 1997)

DJ Seduction "Hardcore Heaven" (Ffrreedom)

Shades of Rhythm

"Homicide/Exorcist" "The Sound of Eden"

"Extacy"

Shades of Rhythm (all ZTT)

Shaft "Roobarb & Custard (Dr Trip & Bob Bolts Mix)" (Great sset/ffrr)

Skin Up "Ivory (Blockbuster)"

"A Juicy Red Apple" (both Love)

The Shamen "Ebeneezer Goode" (One Little Indian/Epic)

SL2 "DJ's Take Control/Way in My Brain"

"On a Ragga Tip" (both XL)

Smart E's "Sesame's Treet" (Suburban Base)

Urban Hype "Trip to Trumpton" (Faze-2 Records)

Utah Saints "Something Good" (ffrr/London)

COMPILATIONS

The Third Chapter: Breakbeat House (XL)

RISING HIGH

A Hippy, a Homeboy and a

Funki Dredd "Total Confusion"

Church of Ecstasy [G.T.O.] "Confess to Acid Remix"

The Hypnotist "The House Is Mine"

"Hardcore You Know the Score" and "Night of the Livin'

E-Heads" on "The Hardcore" EP

The Complete Hypnotist 91-92 "Let Us Pray"

Project One [The Hypnotist] "Cheeba EP"

"Roughneck EP"

Signs of Chaos [G.T.O.] "Crackerjack" EP

Various Artists Techno Classics Volume I

Progressive Hardcore Vol 1

KICKIN

The Scientist [DJ Hype] "The Exorcist"

"The Bee"

Messiah "20,000 Hardcore Members"

"There Is No Law"

Wishdokta "Evil Surrounds Us"

Xenophobia "Rush in the House/The Wobbler"

Various Artists Champion Sound: The Best of Kickin Volume 1

BREAKBEAT 'ARDKORE

Bad Girl "Bad Girl" (Ibiza)

Blame "Music Takes You (2 Bad Mice Remix)"

"Feel the Energy (4 Hero Remix)" (both Moving Shadow)

Bodysnatch "Revenge of the Punter" EP (Big City)

Bolt "Horsepower" (label unknown)

Bug Kann and the Plastic Jam "Made in Two Minutes" (Optimum Dance)

Citadel of Kaos "Vol 3: It's Not Over" (Boombastic Plastic)

The Clepto-Maniacs "Positive Feedback" EP (Fokus U.K.)

Lenny D Ice "We Are I.E." (De Underground)

Dance Conspiracy "Dub War" (XL)

Desired State "Dance the Dream Pts III & IV" (Out of Romford)

Dica & DJ Big Vern "Desire" on "Weekend Rush" EP (Boogie Beat)

DJs Unite "DJ Unite Vol 1/Fourplay" (XL)

"Bass Penetrates" on "DJs Unite Vol 3" (Impact)

The Dragonfly "Hard Like a Criminal" on "The Dragonfly EP #1" (BTB)

Dub 2 "Bad Man (Tuffness Mix)/Sensi Tip" (Big City)

E "I've Got a Little Black Disc with Me Tune on It" (white label)

Edge "Compnded" on "Edge Records #1" EP (Edge)

Energy Zone "Jungle Zone" EP (Rising High; Instinct)

Force Mass Motion "Reach Up" (Rabbit City)

Foul Play "Vol 2: Survival/Dubbing U" (Oblivion)

Genaside II "Narra Mine" (Passion Music)

Goldseal Tribe "Only the Lonely" (Goldseal)

Globe & the Hardcore Massive "Anthem" (White House)

Holy Ghost Inc "Mad Monks on Zinc"

"Nice One Boy/Magnet/Psycho-Missus" (all Holy Ghost)

House Crew "Keep the Fire Burning"

"Maniac (The Final Conflict)/We Are Hardcore

(Magic Fantasy Mix)"

"The Theme (Ozomatli Remix) Euphoria (Nino's Dream)"

(all Production House)

Hyper-On Experience "Fun for All the Family EP"

"Assention" and "Imajicka" on "Keep It in the Family" EP

(both Moving Shadow)

Kicks Like a Mule "The Bouncer (Housequake Mix)" (Sm:)e)

Krome & Time "This Sound Is for the Underground (E5 Remix)/Manic

Stampede (DJ Hype Sandringham Road Mix)"

"The Slammer" (both Suburban Base)

Jonny L "Hurt You So" (Beechwood; R & S)

Manix "You Held My Hand" and "Never Been to Belgium (gotta rush)"

on "Bad Attitude" EP (Reinforced)

Mastersafe "In Your Eyes" on "Aspirations" EP (Formation)

Mixrace "The Future Is Before Your Eyes/Too Bad for You" (Moving

Shadow)

Noise Factory "Set Me Free/Bring Forward the Noise"

"We Have It/Warning Dub" (both Ibiza)
"Set Me Free Remix/The Fire/Skin Teeth"

"My Mind/Be Free"

"Survival," "Futuroid," and "Breakage #4" on "The Capsule EP"

(all 3rd Party)

NRG "I Need Your Lovin' " (Chill)

DJ Phantasy & Gemini "Vol 3: Ruff Beats Producing the Bass" (Han)

"The Hippodrome" (Han)

Nick Power + DJ Ku "Mus Get Dark/Love Survives" (Ruff Tuff & Wicked Stuff)

Powerpill [Aphex Twin] "Pacman" (ffrr)

Psychotropic "Hypnosis" (O2 Records)

Q-Bass "Hardcore Will Never Die"

"Dancin' People" (both Suburban Base)

Ratpack "Searching for My Rizla" (Big Giant Music)

Rhythm Section "Feel the Rhythm (Comin On Strong)"

"Dreamworld" on "Midsummer Madness" EP (both Rhythm

Section Recordings)

Run Tings "Back Again/Something to Dance To" (Suburban Base)

DJ Seduction "Sub Dub" (Impact)

Sly T & Ollie J "Underground Confusion"

Sonz of a Loop Da Loop Era "Far Out (Original Scratchadelic mix)"

"Peace + Loveism (4 Hero RMX)"

"Bust That Groove" on Flowers in My Garden mini-LP (all

Suburban Base)

Sublove "Hyper Active" on "Twisted Techno EP" (Earth Records)

Tek 9 "Del Die Gogo/Just a Dream" and "Del Die Remixes"

"You Got to Slow Down" on "Return of Tek 9" EP (all

Reinforced)

Timelapse "Sued for a Sample/Indian Dream" (Out of Romford)

DJ Trax "Infinite Hype" and "We Rock the Most" on "1 Man 1 DJ"

EP (Moving Shadow)

2 Bad Mice "2 Bad Mice/No Respect" (Moving Shadow)

Urban Shakedown "Assassinator/Do It Now/There is No Other/Quasar"

"Some Justice/Ruff Justice" (both MCG)

Yolk "Music 4 Da People" (Ruffbeat)

WRK "Work It/The Corker Remix" (Great Asset)

COMPILATIONS

Classic to the Core Vol One and Vol Two (Bass Section)
The History of Our World Part One: Breakbeat & Jungle

Ultramix (Sm:)e) Edge Records (Edge)

Rabbit City Compilation (Rabbit City) Base for Your Face (Suburban Base)

A History of Hardcore: Suburban Base and Moving

Shadow (Joint)

america the rave

us rave culture, 1990-92

BROOKLYN AND NEW YORK

Looney Tunes "Volume 1" and "Volume 2" EPs (Nu Groove)

Frankie Bones "Bonesbreaks, Volume 1," "Volume 2" and "Volume 3" EPs

(Under World)

D.H.S. "House of God/Holo Voodoo" double EP (Hangman)

Flowmasters "Energy Dawn" EP (XL)

Moby "Go" (Instinct)

Toxic Two "Rave Generator" (ffrr)

Various Artists Brooklyn Beats (Easy Street)

SAN FRANCISCO/HARDKISS

The Drum Club "Drums Are Dangerous (Drugs Are Dangerous Remix by Robbie

& Gavin Hardkiss)"

Hawke "3 Nudes in a Purple Garden"

"3 Nudes (Having Sax on Acid)"

COMPILATIONS AND DJ MIX CDS

Delusions of Grandeur (Hardkiss/Moonshine)

California Dreaming (ffrr) Weekend: A Gavin Hardkiss Mix

Yes: A Scott Hardkiss Mix (Hardkiss/Moonshine) Mixed Messages: A Robbie Hardkiss Mix (all Hardkiss/

Moonshine)

fight for your right to party

spiral tribe and the crusty-raver movement, 1991-97

SPIRAL TRIBE/MEGADOG CRUSTY-RAVE/GOA TECHNO

Children of the Bong Sirius Sounds (Planet Dog)

The Drum Club "U Make Me Feel So Good" (Guerrilla)

Juno Reactor Beyond the Infinite (Blue Room Released)

Hallucinogen Twisted (Dragonfly)

The Lone Deranger (Twisted)

Loop Guru Duniya (Nation/Waveform)

Spiral Tribe "Breach the Peace" EP

"Forward The Revolution" EP (both Butterfly Records/Big Life)

Various Artists Feed Your Head and Feed Your Head Volume 2

Planet Dub (all Mammoth/Planet Dog)

Return to the Source

Return to the Source: The Chakra Journey Return to the Source: Sacred Sites (all Positiva)

Goa Trance 1 to 6 (Rumour)

feed your head

intelligent techno, ambient, and trance, 1990-94

WARP AND AFFILIATED ARTISTS' RELEASES ON OTHER LABELS

AUTECHRE

Incunabula

Amber "Anti" EP

"Anvil Vapre"

"Garbage"

Tri Repetae (Warp/Wax Trax/TVT)

THE BLACK DOG/PLAID/BALIL

Balil "Nort Route" (Planet E)

The Black Dog "Virtuality" EP

"Age of Slack"

"It Felt Like It/Seers + Sales/Dog Solitude/Apt/Chiba"

(all Black Dog Records)

Parallel (GPR) Bytes

Spanners (both Warp/TVT/Wax Trax)

Plaid "Scoobs in Colombia" (GPR)

APHEX TWIN

AFX "Analogue Bubblebath" (Mighty Force; TVT, 1994)

Analogue Bubblebath 3 (Rephlex)

Aphex Twin "Digeridoo/Analogue Bubblebath 2" (R & S)

Selected Ambient Works 85-92 (R & S) Selected Ambient Works Volume II (Warp; Sire)

Classics (R & S)

I Care Because You Do (Sire; Warp)

Polygon Window Surfing on Sine Waves (Warp/Wax Trax/TVT)

"Quoth" EP (Warp/Wax Trax/TVT)

COMPILATIONS

Artificial Intelligence and Artificial Intelligence II

EARLY CHILL-OUT, AMBIENT TECHNO, AND AMBIENT DUB

The Grid "Floatation" (East West)

The KLF Chill Out (KLF; Wax Trax)

The Irresistible Force Flying High (Rising High)

Pete Namlook Air

Silence (both Fax)

The Orb "A Huge Ever Growing Pulsating Brain That Rules from the

Centre of the Ultraworld"

The Orb's Adventures Beyond the Ultraworld

"Blue Room" u.f.orb

"Assassin" (all Wau! Mr Modo/Big Life)

Live 93 (Island Red Label)

Ultramarine Every Man and Woman Is a Star (Brainiak)

United Kingdoms (Blanco Y Negro/Sire)

COMPILATIONS

Excursions in Ambience 1 to 4 (Astralwerks) Ambient Dub Volumes 1 to 3 (Beyond)

TEXTUROLOGY/INTELLIGENT TECHNO

Bandulu Guidance (Infonet)

Beaumont Hannant "Tastes and Textures Vol-1" to "Vol-3"

Texturology (both GPR)

Future Sound of London "Papua New Guinea" (Jumpin' & Pumpin')

Lifeforms (Virgin)

Global Communications 76:14 (Dedicated)

Orbital "Halcyon" on "Radiccio" EP

Orbital

Snivilisation (all Internal)

Reload/Link [Global Communications] The Theory of Evolution (Evolution/Warp)

TRANCE

Age of Love "Age of Love" (Diki)

Arpeggiators "Freedom of Expression" (Harthouse)

Commander Tom "Volume One: Are Am Eye" (Noom)

Eyes (Noom)

Hardfloor "Hardtrance Acperience"

The Best of Hardfloor (both Harthouse UK)

Illuminatae "Tremorra Del Terra" (XVX Records)

Jam & Spoon "Tales from a Danceographic Ocean" EP (R & S)

Triptomatic Fairytales 2001 and 2002 (Epic)

Mundo Muzique "Andromeda" (R & S)

Sven Vath Accident in Paradise (Eye Q/Warners)

Trope "Amphetamine" (Prolekult)

COMPTLATIONS

Berlin 1992. Der Klang der Familie (Tresor/Novamute)

Harthouse. The Point of No Return Chapter 1 (Eye Q/American)

Novamute: Version 1.1 (Novamute) The Sound of the Hoover (TEC)

Trance Europe Express 1 and 2 (TEE/Volume)

Eclipse (Noom)
Noomrise (Noom)

PRODUCTION HOUSE

Acen "Close Your Eves"

"Close Your Eyes (Optikonfusion)/Close Your Eyes (The Sequel)"

"Trip to the Moon Pt 1"

"Trip II the Moon (The Darkside)"

Baby D "Let Me Be Your Fantasy"

"Vengeance/Love Overdose Remix" D-M-S

"S.O.S./Mindwreck"

DJ Solo "Darkage/Axis"

Various Artists The Best of Production House (Production House)

REINFORCED AND AFFILIATED ARTISTS' RELEASES ON OTHER LABELS

"Mr Kirk's Nightmare" (Reinforced; Sm:)e) 4 Hero

"Headhunter" EP In Rough Territory "Where's the Boy" EP

"Journey from the Light" EP and "Journey Remix" EP

"Golden Age" EP and "Golden Age Remixes"

Metalheads [Goldie] "Terminator/Kemistry/Knowledge/Sinister" (Synthetic

Hardcore Phonography)

"Seance/Anthema" Nebula II

"X-Plore H-Core/Peacemaker"

"Here Comes the Drumz" and "Dark Angel" on "As Nasty As Nasty Habits [Doc Scott]

I Wanna Be" EP

"Darkrider/Believe/Menace/Jim Skreech" Rufige Kru [Goldie]

"Ghosts of My Life/Terminator II"

"NHS" and "NHS EP VOL 2 REMIX" Doc Scott

"Surgery EP" (all Absolute 2)

Sudden Def "Let It Hit/Fall Like Rain (Madness to My Method)"

Various Artists Callin' for Reinforcements

> The Definition of Hardcore "Enforcers" EPs 1 to 5

MISCELLANEOUS DARKCORE

Bay-B-Kane "Hello Darkness" (Ruff Guidance)

"The Dark Stranger/Real Hardcore Pts 1 & 2" **Boogie Times Tribe**

"The Dark Stranger (Q-Bass Remix/Origin Unknown Re-Remix)"

(both Suburban Base)

D'Cruze "Want You Now (DJ SS + EQ Remix)" (Suburban Base)

"Warpdrive" (Dee Jay) DJ Crystl

"The Dark Crystl/Inna Year 3000" (Force Ten)

Edrush "Bludclot Artattack" (No U Turn)

"Ya Buzzin" on "The Subplates Vol 2" EP (Suburban Base) Flex

Foul Play "Finest Illusion" (Section 5)

"Drowning in Her" (Tone Def) 4 Horsemen of the Apocalypse

> "Shot in the Dark (Gunshot Mix)/I Can't Understand It DJ Hype

(Scratch the Fuck out of the Beginning Mix)"

"Shot in the Dark Remixes/Weird Energy"

"The Chopper" on "Subplates Vol 1" Various Artists EP

(all Suburban Base)

Hyper-On Experience "Lords of the Null Lines" on "Deaf in the Family" EP

"Lords of the Null Lines (Foul Play Remix)" 10-inch (Moving

Shadow)

"Johnny Remixes" (Suburban Base) Johnny Jungle [Pascal]

"Kaotic Chemistry EP" Kaotic Chemistry [2 Bad Mice]

"Space Cakes/L.S.D./Illegal Subs/Drum Trip II"

"Space Cakes (2 Bad Mice Remix)/Vitamin K/Illegal Subs

(Krome & Time Remix)" (all Moving Shadow)

"Demon" on "Taking Control" EP (Formation) Megadrive

"Valley of the Shadows" (Ram) Origin Unknown [Andy C/Ant Miles]

> Remarc & Lewi Cifer "Ricky" (Dollar)

> > Satin Storm "I Think I'm Going Out My Head" (white label)

Subnation/Ray Keith "Scottie (Ray Keith Remix)" (Future Vinyl)

> "Lost Entity" (Lucky Spin) Trace

"Underworld/Tribal Revival/Pitch Black/Mass Confusion" 2 Bad Mice

(Moving Shadow)

2 Bad Mice/Kaotic Chemistry Kaotic Chemistry (Sm:)e anthology)

> "X Project (Aled Jones 'Walking in the Air' mix)" (X Project) X Project

COMPILATIONS

The Dark Side and The Dark Side II (React) Suburban Base and Moving Shadow Present:

The Joint LP (Joint)

Hardcore (Leaders of the New School)

Hardleaders III: Enter the Darkside (both Kickin')

UNDERGROUND RESISTANCE AND UR-AFFILIATED ARTISTS' RELEASES ON OTHER LABELS

Drexciva "Deep Sea Dwelic:"

"The Unknown Aquazone" (Hyperspace)

"The Bubble Metropolis"

The Quest (double CD anthology)

"The Art of Stalking (Stalker Mix)/The Worlds" (Transmat) Suburban Knight

"Nocturbulous Behavior"

"Dark Energy" (with Mad Mike)

"By Night"

"Sonic" EP **Underground Resistance**

"Waveform" EP

"Elimination (remix)/Gamma-Ray"

"Riot" EP

"Fuel for the Fire"

"Punisher"

Revolution for Change

"Fury/Cyclone"

"Death Star/The Force/Planet X" "Jupiter Jazz" on "World 2 World" EP

"Galaxy 2 Galaxy" double EP

"Kamikaze" World Power Alliance [UR]

"The Seawolf"

"Belgian Resistance"

X-101 [UR] "Sonic Destroyer/G-Force"

> X-101 X-101 (Tresor)

X-102 X-102 Discovers the Rings of Saturn (Tresor)

X-103 Atlantis (Tresor)

MIKE BANKS, JEFF MILLS, **ROBERT HOOD POST-UR SOLO RELEASES**

> Internal Empire (Tresor) Robert Hood

Jeff Mills Waveform Transmission #1

Waveform Transmission #3 (both Tresor)

"Cycle 30" (Purpose Maker) The Other Day (Axis anthology)

"Red Planet 1" to "7" (Red Planet) Red Planet [Mike Banks]

Waveform Transmission #2 (Tresor) The Vision [Robert Hood]

+8 AND +8-AFFILIATED ARTISTS' RELEASES ON OTHER LABELS

Circuit Breaker "Overkill/Frenz-E"

Cybersonik "Technarchy"

"Thrash"

Final Exposure "Vortex"

F.U.S.E. "FU2"

Dimension Intrusion (+8/Warp)

Plastikman Sheet One (+8/Warp)

Musik (+8/Warp)

Speedy J "Pullover"

Ginger (+8/Warp)

Teste "The Wipe (Sonik Dub)" (Probe/+8)

Vapourspace "Gravitational Arch of 10" EP

(+8/ffrr)

Various Artists From Our Minds to Yours

Blueprints for Modern (Techno)logy Vol 1

CARL CRAIG AND HIS ALTER EGOS

Carl Craig "Wrap Me in Its Arms" (Retroactive)

"At Les" (Planet E/Eevolute)

Landcruising (Blanco Y Negro)

More Songs About Food and Revolutionary Art (Planet E)

Innerzone Orchestra "Bug in the Bass Bin" (Planet E)

Paperclip People "Throw" (Planet E)

Psyche/BFC Elements 1989–1990 (Planet E anthology)

Rythim Is Rythim "Kao-Tic Harmony" (B-side of "Icon") (Transmat/Zomba)

Six Nine Six Nine: The Sound of Music (R & S anthology)

Various Artists Intergalactic Beats (Planet E)

MISCELLANEOUS NINETIES DETROIT ARTISTS AND DETROIT PURISTS

Dave Angel Classics (R & S)

Daniel Bell/DBX "Losing Control" (Peacefrog)

John Beltran Earth & Nightfall (R & S)

Dave Clarke Archive One (Deconstruction)

Dark Comedy "War of the Worlds" (Transmat)

Kenny Larkin Seven Days (Art of Dance/Elypsia)

Model 500 Deep Space

"Sonic Sunset" EP (both R & S)

Tronikhouse [Kevin Saunderson] "Uptempo/Mental Techno/Spark Plug"

"Straight Outta Hell" (both KMS/Network)

COMPILATIONS

Tresor II: Berlin Detroit - A Techno Alliance

Tresor 3: New Directions in Global Techno (both Tresor) The Deepest Shade of Techno I+II (Reinforced/SSR

Crammed Discs)

True People: The Detroit Techno Album (React)

DETROIT NEO-ELECTRO

Dopplereffekt "Fascist State" EP

"Infophysix" EP

"Racial Sterilisation" (all DataPhysix)

Will Webb "Mirrorshades/Cosmic Driveby" (Direct Beat)

COMPILATIONS

From Beyond (Interdimensional Transmissions)

BASIC CHANNEL/CHAIN REACTION AND AFFILIATED ARTISTS RELEASES ON OTHER LABELS

BASIC CHANNEL

Cyrus "Inversion/Presence

Maurizio "M6"

untitled Maurizio CD anthology (both M)

Phylyps "Phylyps Trak/Phylyps Bass"

Various Artists Basic Channel CD

CHAIN REACTION

Monolake "Cyan I/Cyan II"

"Lantau/Macao"

Hongkong

Porter Ricks "Port of Transition/Port of Call"

"Port of Nuba/Nautical Nuba"

Biokinetics

Porter Ricks (Mille Plateaus)

Resilent "1.2/1.1"

Vainqueur Elevations

Various Artists [band name] "No. 8" (Fatcat Records)

Decay Product

roots 'n' future jungle takes over london, 1993-94

DJ Aphrodite "You Take Me Up" (Aphrodite)

A-Zone [Aphrodite] "Callin' All the People" (Whitehouse)

Babylon Timewarp "Durban Poison" (Intense)

Bodysnatch "Just 4 U London" (Big City)

Andy C "Slip 'n Slide" (Ram)

C-Biz "Crowd Says Rewind" (Big City)

Cloud Nine [Nookie] "You Got Me Burnin' (Ray Keith & Nookie Remix)" (Moving

Shadow)

Code 071 "London Sumtin' " (Reinforced)

DJ Crystl "Let It Roll" (Dee Jay)

Dead Dred "Dred Bass" (Moving Shadow)

Deep Blue "The Helicopter Tune" (Moving Shadow)

Desired State [Andy C] "Beyond Bass" (Ram)

D-Force "Original Bad Boy" (Slammin' Vinyl)

DMS & Boneman X "Sweet Vibrations" (Production House)

Dope Style [DJ Hype] "You Must Think First" (Ganja)

Engineers Without Fears "Spiritual Aura" (Dee Jay)

Family Of Intelligence "Champion of Champions" (Kemet)

Ganja Kru [DJ Hype] "Computerised Cops (Pascal Remix)" (Ganja)

Gappa G & Hyper Hyper "The Information Centre Remixes" double 10-inch

(Ruff Kut/Entity)

DJ Hype "Rrrroll da Beats" (Suburban Base)

Hyper-On Experience "Thunder Grip" on "Deaf in the Family" EP (Moving Shadow)

Jo "R Type" (Awesome)

Krome & Time "Ganja Man" (both Tearin' Vinyl)

Leviticus "The Burial" (Philly Blunt/V Recordings)

MA1 "Rollin' with the Punches" (Formation)

Marvellous Cain "Hitman (Asend & Dead Dread Remix)" (Suburban Base)

M-Beat "Shuffle" (Renk)

M-Beat featuring General Levy "Incredible" (ffrr/Payday)

DJ Nut Nut & Pure Science "The Rumble" (Production House)

Phuture Assassins "Roots 'n Future (Make Dem Know Mix)" (Suburban Base)

Q Project "Champion Sound Remix" (Q Project)

Renegade feat. Ray Keith "Terrorist" (Moving Shadow)

Shimon "Predator" (Ram)

Shy FX with Gunsmoke "Gangsta Kid" (SOUR)

Slipmatt "Breakin' Free" (Awesome)

Sonz of a Loop Da Loop Era "What The . . . " and "What The . . . Remix" (Suburban Base)

DJ SS "Breakbeat Pressure" EPs 1 to 3 (Formation)

2 Bad Mice "Hold it Down/Waremouse/Bombscare" and "Remixes"

(Moving Shadow)

UK Apachi with Shy FX "Original Nuttah" (SOUR; Moonshine)

The Untouchables "Vol 2: Take Me Away" (Whitehouse)

COMPILATIONS

Drum & Bass Selection 1 and Selection 2 (Breakdown)

Renegade Selector Series 1 (Re-Animate)

The Best of Jungle (Production House/P.H. Division)

Jungle Massive 3 (Labello Blanco)

in the mix (dj culture and remixology, 1993-97

DJ MIX CDS

Carl Cox F.A.C.T. 2 (Ultimatum/Moonshine)

Jeff Mills Live at the Liquid Room — Tokyo (React)

Sasha and John Digweed Northern Exposure (Ultra Records)

REMIXES AND REMIX CDS (SINGLE ARTIST COLLECTIONS AND TRIBUTES)

Bjork Telegram (Elektra)

Can Sacrilege (Mute)

Pierre Henry/Michel Colombier Metamorphose: Messe Pour le Temps Present (ffrr)

Massive Attack V Mad Professor No Protection (Circa)

 μ -Ziq vs the Auteurs μ -Ziq vs the Auteurs (Hut U.S.A./Astralwerks)

DJ Food Refried Food (Ninjatune)

Seefeel "Time to Find Me (Aphex Twin Remixes)" on Polyfusia (Too

Pure/Astralwerks)

Techno Animal "Heavy Water (Spring Heel Jack Remix)" on "Babylon Seeker"

(Blue Angel Records)

Tortoise Rhythms, Resolutions & Clusters

"Galapagos" (Spring Heel Jack Remix)

"Bubble Economy/Learning Curve" (Markus Popp Remixes) (all

Thrill Jockey)

COMPILATIONS

Macro Dub Infection #1 and Volume 2 (Virgin)

marching into madness

gabba and happy hardcore, 1992-97

GABBA

Annihilator [Scott Brown] "I'll Show You My Gun" (Mokum)

DJ Dano "Fukem All" (Mokum)

Lenny Dee "Blood of an English Muffin" (Industrial Strength)

Dye Witness "Only If I Had One More" (Midtown)

Euromasters "Alles Naar De Klote [Everything Is Bollocks]"

"Amsterdam Waar Lecht Dat Dan?" (both Rotterdam)

The Horrorist EP (Things To Come)

Knightvision "Knight of Visions" (Ruffneck)

The Original Gabber "Pump That Pussy" (Mokum)

Rotterdam Termination Source "Poing" (Rotterdam)

The Speedfreak For You (Shockwave)

5 Years On Speed (Shockwave)

Sperminator "No Woman Allowed" (Rotterdam)

Technohead [G.T.O.] Headsex (Mokum)

Turbulence vs Terrorists "Six Million Ways to Die" (SS/PCP)

COMPILATIONS

Hardcore Terror Vol 1: The Dutch Masters (Rumour)

Technohead: Mix Hard or Die

Technohead II: Harder & Faster (both React) Wakin' Up a Dead Planet Vol 1 to III (Monotone) Battlegrounds: A Collection of Hardcore Cyberpunk

(Mokum/Roadrunner)

 F^{**king} Hardcore Pt 1 to #4 (Mokum) The Ruffneck Collection Part I to V (Ruffneck)

Shock Therapy (Shockwave)

HAPPY GABBA AND SCOTTISH BOUNCY TECHNO

Bass Reaction "Technophobia" (Evolution)

Bass-X "Hardcore Disco" (Evolution)

DJ Paul Elstak "Luv You More" (Stip Records)

Charlie Lownoise & Mental Theo "Wonderful Days" (Master Maximum)

Party Animals "Aquarius"

"Have You Ever Been Mellow"
"Hava Naguila" (all Mokum)

QTEX "Equazion" (Evolution)

The Rhythmic State "Soap on a Rope"

"No DS Allowed" (both Massive Respect)

Search & Destroy [The Speedfreak] "Iron Man" (Mokum)

Stingray & Sonicdriver "As Cold As Ice" (Dwarf)

Technohead "I Wanna Be a Hippy" (Mokum)

COMPILATIONS

Hardcore Cheddar: The Dutch Masters Vol 2 (Rumour)
Make 'Em Mokum Crazy: Popcore (Mokum/Roadrunner)

Rezerection: The Awakening of '95 (Evolution)

Twisted! The Best of Twisted Vinyl Vol 1 (Twisted Vinyl)
Gold: The Best of Evolution Gold (Evolution Gold)

ENGLISH HAPPY HARDCORE

DJ Ham & DJ Poosie "Masterpeace" (Knite Force)

Hixxy & Sharky "Toytown" (Essential Platinum)

Jimmy J & Cru-L-T "Six Days" (Remix Records)

DJ Reno & Eatsum presents The Kidz "I've Got Something in Me (Trancey Mix)" (Happy Trax)

Slipmatt, Sy & Unknown "In Effect the Remixes" (Slammin' Vinyl)

Vibes "Music's So Wonderful" (white label)

COMPILATIONS

Happy Anthems: Volume Four (Rumour)
Bonkers 3: A Journey Into Madness (React)

Speed Limit 140 BPM Plus Seven and Eight (Moonshine)

Happy Anthems Volume One (Rumour) Happy Hardcore (Jumpin' & Pumpin')

TERRORCORE

Aphasic + DJ Scud "Welcome To The Warren" EP

"Snipers At Work" EP (both Ambush)

D.O.A. New York City Speedcore (Industrial Strength/Earache)

Jackal & Hide "Escape from South London" EP (Ambush)

Nasenbluten "100% No Soul Guaranteed" double EP (Bloody Fist/

Industrial Strength)

Signs Ov Chaos [G.T.O.] Frankenscience (urban cyberphunk) (Earache)

COMPILATIONS

Industrial F**king Strength (Industrial Strength/Earache)

Terrordome I to VI (edel)

PCP, ITS SUBLABELS, AND AFFILIATED ARTISTS RELEASES ON OTHER LABELS

PCP

Mescalinum United [The Mover] "Into Mekong Center"

"Symphonies of Steel Part 1"

"Symphonies of Steel: The Second Level"

The Mover "Frontal Sickness" and "Frontal Sickness" Part 2

The Final Sickness

Spiritual Combat [The Mover] "Hellrazor" EP (R & S)

> Superpower "The Future Crusade" EP (Things To Come)

Various Artists Frankfurt Trax: House of Techno Vol 1

> Frankfurt Trax Vol 2: House of Techno Frankfurt Trax Vol 3: The House of Phyture Frankfurt Trax Vol 4: The Hall of Fame Frankfurt Trax Vol 5: Defenders of the Faith

Bigger Bolder Better

DANCE ECSTASY 2001

Inferno Bros. "Slaves to the Rave Remixes"

"Slaves to The Rave (First RaveAge Rough Mix)" on the "Most

Wanted Bootleg"

Reign "Chapter II: The Zombie Leader Is Approachin'"

Renegade Legion "Dark Forces/Torsion"

> "Overdub" Test

Trip Commando "Temple Tunes Vol. 1"

Various Artists A Dance Ecstasy 2001 Compilation

COLD RUSH

Freez-E-Style/Pilldriver "Protectors of Bass"

Mover/Rave Creator "Astral Demons/Rave the Planet"

Pilldriver/Tilt! "Apocalypse Never/Hell-E-Copter"

Rave Creator/Cypher "Lights Sound Action/Doomed Bunkerloops" double EP

Various Artists "Doom Supporters/The Last Judgement Part One" double EP

crashing the party american rave descent into the darkside, 1993–97

FUNKY BREAKS/WEST COAST AND FLORIDA BREAKBEAT HOUSE

The Crystal Method "Now Is the Time" (City of Angels)

Vegas (Outpost/City of Angels)

DJ Icey The Funky Breaks DJ mix CD (ffrr)

Simply Jeff Funk-Da-Fried DJ mix CD (City of Angels)

DJ John Kelley Funky Desert Breaks and Funky Desert Breaks 2 DJ mix

CDs (Moonshine)

Uberzone "The Brain (Braindusted)" on "Space Kadet EP" (City of Angels)

"Botz" EP (City of Angels)

"The Freaks Believe In Beats" (City of Angels)

Tomorrow Land (City of Angels)

Wink "Higher State of Consciousness (Tweekin Acid Funk)"

(Strictly Rhythm)

Left Above the Clouds (XL/Nervous)

COMPILATIONS

U.S. Homegrown (City of Angels)
White Noise (City of Angels)

The American Dream Vol 2 (City of Angels)

Best of House Music: Volume 7: Funky Breaks (Sm:)e) Sunshine State of Mind: A Collection of Florida

Underground Electronic Music (ffrr)

sounds of paranoia

trip-hop, tricky, and pre-millenium tension, 1990-97

ANCESTORS/DJ RECORDS

Depth Charge "Depth Charge"

"Bounty Killers" (both Vinyl Solution)

Meat Beat Manifesto "Radio Babylon" (Play It Again Sam)

Original Fire (Nothing/Interscope anthology)

Renegade Soundwave RSW 1987-1995 (Mute anthology)

BRISTOL

Massive Attack Blue Lines (Wild Bunch/Circa)

Protection (Circa)

Portishead Dummy (Go Beat)

MO WAX

DJ Shadow "In/Flux"

"Lost and Found"

"What Does Your Soul Look Like"

Endtroducing

Various Artists Royalties Overdue: The First Chapter

Headz

Headz 2A and Headz 2B

NINJATUNE AND AFFILIATED ARTISTS' RELEASES ON OTHER LABELS

Coldcut Journeys by DJ mix CD (JDJ)

Coldcut & DJ Food Fight/DJ Krush Cold Krush Cuts/Back in the Base (Ninja Tune double mix CD)

Funki Porcini Love, Pussycats & Carwrecks

DJ Vadim USSR Repertoire (The Theory of Verticality)

COMPILATIONS

Flexistensialism: The Joy of Dex

Funkjazzticaltricknology

If Ya Can't Stand Da Beatz, Git Outta Da Kitchen

Organised Sound (Jazz Fudge Recordings [DJ Vadim's label])

EAST COAST HORRORCORE HIP-HOP

Genius/GZA Liquid Swords (Geffen)

Ghostface Killah Ironman (Razor Sharp Records/Epic Street)

Gravediggaz 6 Feet Deep (Gee Street)

Method Man Tical (Def Jam)

Raekwon Only Built 4 Cuban Linx . . . (RCA)

Sunz of Man "Soldiers of Darkness" (Wu-Tang Records)

Wu-Tang Clan Enter the Wu-Tang (36 Chambers) (Loud/RCA)

Wu-Tang Forever (Loud/RCA)

TRICKY

Nearly God Nearly God (Durban Poison/Island)

Starving Souls "I Be the Prophet" (Durban Poison/4th & Broadway)

Tricky "Aftermath (Hip Hop Blues)"

Maxinquaye (both 4th & Broadway)
Pre-Millenium Tension (Island)

Tricky vs. the Gravediggaz "The Hell" EP (Island)

AMBIENT JUNGLE/ARTCORE

A Guy Called Gerald "Nazinji-Zaka"

"Darker Than I Should Be/Gloc (Remix)"
Black Secret Technology (all Juice Box)

Blame & Justice "Anthemia/Essence" (Moving Shadow)

LTJ Bukem "Music"

LTJ Bukem remix of Apollo Two "Atlantis (I Need You)" (both Good Looking)

E-Z Rollers "Rolled Into One/Believe" (Moving Shadow)

"Believe (Foul Play Remix)" (Moving Shadow)

F.B.D. Project "Gesture Without Motion" on "Enforcers 6" (Reinforced)

4 Hero Parallel Universe (Reinforced)

Earth Pioneers (Talkin' Loud)

Foul Play "Vol 3: Open Your Mind"

"Open Your Mind (Foul Play Remix)"

"Vol 4: Being With You"

"Being With You (Foul Play Remix)" (all Moving Shadow)

Goldie Timeless (ffrr)

Metalheads [Goldie] "Angel" (Synthetic Hardcore Phonography)

Jamie Myerson "Find Yourself" on "Enforcers 6" (Reinforced)

Omni Trio "Vol 2: Mystic Stepper (Feel Good)"

"Mystic Stepper (Feel Better) (Foul Play Remix)"

"Vol 3: Renegade Snares"

"Renegade Snares (Foul Play Remix)"

"Vol 4: Rollin' Heights/Thru the Vibe/Original Soundtrack"

"Vol 5: Soul Promenade"

Vol 1: The Deepest Cut (all Moving Shadow)
Music for the Next Millenium (Sm:)e)

Plasmic Life "Vol 1: Water Baby" (Brain Records)

COMPILATIONS

Routes from the Jungle: Escape Velocity Volume 1 (Circa)

INTELLIGENT DRUM AND BASS, FUSION JUNGLE, AND JAZZSTEP

Adam F "Circles" (Section 5)

Blame & Justice "Nocturnal/Nightvision" (Moving Shadow)

LTJ Bukem "Horizons" (Looking Good)

Da Intalex "What Ya Gonna Do" (Flex)

D'Cruze "Lonely" (Suburban Base)

Hidden Agenda "Is It Love?" (Metalheadz)

Jacob's Optical Stairway [4 Hero] Jacob's Optical Stairway (R & S)

PFM "One & Only" (Looking Good)

Photek "Form & Function Vol 2" (Photek)

"The Water Margin" (Photek)

Alex Reece "Basic Principles/Fresh Jive"

"Pulp Fiction" (both Metalheadz)

Spring Heel Jack "The Sea Lettuce"

There Are Strings (both Rough Trade) 68 Million Shades (Trade 2/Island)

Tek 9 "Slow Down (Nookie Remix)" on "Enforcers 8" (Reinforced)

Dave Wallace "Expressions"

"Waves" (both Moving Shadow)

COMPILATIONS

LTJ Bukem Presents: Logical Progression (Good Looking/

Looking Good/ffrr)

MINIMALIST DRUM AND BASS

Amazon II [Aphrodite] "Big Boo Yaa" (Aphrodite)

Danny Breaks "Droppin' Science Vol 2"

"Droppin' Science Vol 3: Firing Line"

(Breaks remix of Safari Sounds) "Droppin' Science Vol 4: Long Time Comin'"

"Droppin' Science Vol 5: Step Off" (all Droppin' Science)

DJ Die & Roni Size "11.55" (Full Cycle)

Dillinja "Sovereign Melody" (Deadly Vinyl)

"Deep Love Remix"

"You Don't Know/Warrior" (both Logic)
"The Angels Fell" EP (Metalheadz)
"Muthafucka/Sky" (Philly Blunt)

Dillinia with Bert "Lionheart" (Deadly Vinyl)

88-3 feat Lisa May "Wishing on a Star (Urban Shakedown Dub Mix)" (Urban

Gorilla)

DJ Krust "Set Speed" (V)

MA2 [DJ SS] "Hearing Is Believing Remix" (Formation)
NC & Asend "Take Your Soul" (Second Movement)

Northern Connection "The Bounce" (Back 2 Basics)

Roni Size & DJ Die "Music Box" (Full Cycle)

Roni Size "Timestretch/Phizical" (V)

"Dayz" (V)

Roni Size/Reprazent "Share the Fall (Grooverider's jeep-style mix)/New Forms

(Roni Size Remix)" (Mercury)

New Forms (Mercury)

DJ SS "United (Grooverider Remix)/Rollidge" from "The Rollers

Convention EP Part 3" (Formation)

Tek 9 "We Bring Anybody Down" (Reinforced)

COMPILATIONS

DJs Unite Vol 2 (Rogue Trooper/Death Becomes Me)

Music Box (Full Cycle)

Highly Recommended (Formation)

V Classic (V)

JUMP UP/GANGSTA HARDSTEP

B-Jam "Funkula (DJ Hype Remix)" (No Smoking)

Gang Related/Mask "Ready or Not" (Dope Dragon)

H.M.P. [Pascal] "Runnin's" (Frontline)

Joker "Raw Dogs Relik" (Suburban Base)

Keen "The Battle Frontier" on "Keen Remixes" (Formation)

L Double & Shy FX "The Shit" (Flex)

Origin Unknown [Andy C] "Truly One" (Ram)

Remarc "RIP (DJ Hype Remix)" (Suburban Base)

Shy FX "The Wolf" on Shy FX Presents THE FORMULA (Ebony)

Soul Jah "21212" (Hard Leaders)

Splash "Babylon" (Dee Jay Recordings)

Swift "Just Roll (VIP Remix)" (Intalektive)

The Terradome "Soldier" (Dope Dragon)

DJ Zinc "Super Sharp Shooter" (Ganja)

COMPILATIONS

Pure Rollers (Breakdown)
Still Smokin' (Ganja/Frontline)

Drum & Bass Selection 3 and Selection 5 (Breakdown)

The Speed of Sound (Ram)

TECHSTEP AND NEUROFUNK

Boymerang "Still" (Prototype)

Codename John [Grooverider] "The Warning" (Metalheadz)

Dillinja "Violent Killa"

"Acid Trak" (both Valve)

Dom & Roland "The Planets/Dynamics" (Moving Shadow)

Ed Rush "Force Is Electric/Gangsta Hardstep"

"Guncheck/Force Is Electric Remix"

"Mothership/Defect"

Ed Rush/Nico "Sector/Comatone"

Ed Rush/Trace/Nico "Mad Different Methods/The Droid" (all No U Turn)

E-Sassin "The Enemy" (Sound Sphere Recordings)

Adam F "Metropolis" (Metalheadz)

Jonny L "Obedience/Piper (Grooverider Remix)" (XL)

Krust "Genetic Manipulation" EP

"Soul in Motion" (both Full Cycle)

Nasty Habits [Doc Scott] "Shadow Boxing" (31 Records)

Optical "To Shape the Future" (Metalheadz)

Photek "The Hidden Camera" (Science; Astralwerks)

"Ni Ten Ichi Ryu" (Science)

"Still Life" [remix of Goldie track] (Razor's Edge)

Modus Operandi (Science/Astralwerks)

Procedure 769 "Lethal Dosage" (Reinforced)

Rollers Instinct [Trace] "The Mutant Remix" [remix of T-Power's "Horny Mutant

Jazz"] (SOUR)

Doc Scott "Drumz 95 (Nasty Habits Remix)" (Metalheadz)

Source Direct "Snake Style" (Source Direct)

ource Direct "Snake Style" (Source Direct)

"A Made Up Sound/The Cult" (Metalheadz)
Controlled Developments (Science/Astralwerks)

DJ Trace "Lost Entity Remix/Jazz Primitives" (Lucky Spin)

"Mutant Revisited" (Emotif)

Trace/Nico "Amtrak/Squadron" (No U Turn)

COMPILATIONS

Torque (No U Turn)
Techsteppin' (Emotif)

Grooverider Presents: The Prototype Years (Prototype/Sony)

MISCELLANEOUS

AFX "Hangable Auto Bulb EP" and "EP 2" (Warp)

Aphex Twin "Girl/Boy" EP

Richard D. James Album (both Warp)

Bedouin Ascent Science, Art and Ritual (Rising High)

Music for Particles (Rising High)

Burger/Ink "Twelve Miles High" on "Las Vegas" EP (Harvest)

Doctor Rockit "Ready to Rockit" EP

The Music of Sound (Clear)

μ-Ziq Tango n 'Vectif

Bluff Limbo (both Rephlex)

Lunatic Harness (Planet µ-Ziq/Hi-Rise/Astralwerks)

The Sidewinder [Techno Animal] Colonized (Mille Plateaux)

Squarepusher Feed Me Weird Things (Rephlex)

"Port Rhombus"

Hard Normal Daddy (both Warp)

Techno Animal Re-Entry (Virgin)

To Rococo Rot Veiculo (City Slang)

David Toop Screen Ceremonies (The Wire Editions)

Pink Noir (Virgin)

COMPILATIONS

Electro Juice (Sabotage)

Lo Recordings VOL 2: Collaborations (Lo Recordings)

Invisible Soundtracks (Leaf)

LUKE VIBERT AND HIS ALTER EGOS

Plug 1 "Visible Crater Funk

Plug 2 "Rebuilt Kev" (both Rising High)

Plug Drum 'n' Bass for Papa (Blue Angel Records; Nothing)

Luke Vibert Big Soup (Mo Wax/ffrr)

Wagon Christ Throbbing Pouch "Rissalecki" EP

"Redone" EP (all Rising High)

MOUSE ON MARS

Vulvaland

Iahora Tahiti (both Too Pure) Instrumentals (Sonig)

MILLE PLATEAUX AND ITS SISTER LABELS FORCE INC AND RIOT BEATS

Biochip C "Hell's Bells" EP (Force Inc, 1992)

Christophe Charles Undirected 1986-1996

Gas Gas

Microstoria Init Ding (Mille Plateaux/Thrill Jockey)

—snd (Mille Plateaux/Thrill Jockey)

Oval Systemisch (Mille Plateaux/Thrill Jockey)

94 Diskont (Mille Plateaux/Thrill Jockey)

Dok (Thrill Jockey)

Cristian Vogel Beginning to Understand

Specific Momentific

Various Artists In Memoriam Gilles Deleuze

Modulations & Transformation II Rauschen 3 to 10 (Force Inc) Electric Ladyland I to IV

ALEC EMPIRE/DIGITAL HARDCORE

Atari Teenage Riot Burn Berlin Burn (DHR/Grand Royal)

EC80R EC80R (DHR)

All of Us Can Be Rich (DHR/Grand Royal)

Alec Empire Generation Star Wars Limited Editions 1990–94

to The Television

Low on Ice (The Iceland Sessions)

Hypermodern Jazz 2000.5 (all Mille Plateaux)

The Destroyer (DHR)

Shizuo Vs. Shizor Shizor (DHR/Grand Royal)

Various Artists Rough and Fast (Riot Beats)

Harder Than the Rest!!! (DHR)

Chapter 1: Noise and Politics (Capitol Noise)

DJ SPOOKY/ILLBIENT

Byzar Gaiatronyk vs The Cheap Robots

DJ Spooky Songs of a Dead Dreamer

Viral Sonata

Sub Dub Dancehall Malfunction

We As Is (all Asphodel)

Various Artists Valis 1: Destruction of Syntax (Subharmonic)

Incursions in Illbient (Asphodel)

nineties house, speed garage, and big beat

PROGRESSIVE HOUSE/ALBUM-ORIENTED HOUSE

Faithless Reverence (Cheeky)

Jaydee "Plastic Dreams" (R & S)

Leftfield "Not Forgotten" (Outer Rhythm)

"Release the Pressure" (Hard Hands)

Leftism (Hard Hards/Columbia)

Lionrock "A Packet of Peace"

An Instinct for Detection (both Deconstruction/BMG)

The Pied Piper "Kinetic (The Orbital Mixes)" (Absolute 2)

Underworld "Rez"

Dubnobasswithmyheadman (both Junior Boy's Own)

"Born Slippy NUXX" (Wax Trax/TVT)

Second Toughest in the Infants (Wax Trax/TVT)

COMPILATIONS

Guerilla in Dub (Guerrila)

HANDBAG, NU-NRG, EPIC HOUSE, BRIT-HOUSE, TECH-HOUSE, AND ACID TECHNO

Basement Jaxx "Fly Life" (Multiply)

BT Ima (Perfecto/Kinetic/Reprise)

Faze Action Plans & Designs (Nuphonic)

Felix "Don't You Want Me" (Deconstruction)

Robert Miles Children (Deconstruction/Arista)

Way Out West "The Gift" (Deconstruction)

COMPILATIONS

Electronic Warfare (Plink Plonk)

A Compilation (Atlantic Jaxx Recordings)

It's Not Intelligent . . . It's Not From Detroit . . .

But It's F**king 'Avin It' (Stay Up Forever/Truelove)

Junior Boys Own Collection (Junior Boy's Own)

THE FUTURE SOUND OF CHICAGO

Gene Farris "Farris Wheel" (Relief)

The Fruity Green (Force Inc)

Green Velvet "I Want to Leave My Body/Flash" on "Portamento Tracks"

"Flash Remixes" double 12-inch (both Relief)

"The Stalker (I'm Losing My Mind)/Help Me" (Relief/Yeti)

"Destination Unknown" EP (Relief)

DJ Rush Doing It to Death (Force Inc)

COMPILATIONS

The Future Sound of Chicago (Cajual/Relief/Ministry of Sound)

The Many Shades of Cajual (Cajual)

US HOUSE AUTEUR-PRODUCERS
AND MIX CDS

Bucketheads "The Bomb" EP (Strictly Rhythm)

De' Lacy "Hideaway (Deep Dish Remix)" (Deconstruction)

Deep Dish Artists Penetrate Deeper (Deep Dish/Tribal UK)

Funky Green Dogs Get Fired Up (Murk/Twisted)

Masters at Work Masterworks: The Essential Kenlou House Mixes (Harmless)

Murk The Singles Collection (Tribal America/IRS)

Roger Sanchez S-Man Classics (Harmless)

Armand Van Helden "The Funk Phenomena" (Henry Street/ZYX Music)

"Professional Widow" (remix of Tori Amos) (Atlantic)

Greatest Hits (Strictly Rhythm)

COMPTLATIONS.

Collective Sounds of Prescription (Prescription)

Jazz in the House (Slip & Slide)

SPEED GARAGE

"Bad Boys (Move In Silence)" (One Step/Catch) A Baffled Republic

> Da Stylus "Crazy" (Mecca)

Double 99 "Ripgroove" (Ice Cream)

"Jump" (Ice Cream)

"Oh Boy" (Multiply) Fabulous Baker Boys

> "Sound Bwoy Burial (187 Lockdown Dancehall Mix/All Gant

> > Night Long" (Positiva)

"It's A London Thing" (Connected) Scott Garcia feat. MC Styles

> **KMA** "Cape Fear"

> > "Kaotic Madness"

"Recon Mission" (all KMA)

Lady Penelope & Abstrac "Deeper (Part 2)" (Emita Sounds)

> "Gunman" (EastWestDance) 187 Lockdown

"Underground Explosion" on "The Off-Key Experience EP" Ramsey & Fen

> (Very Important Plastic) "Love Bug" (Bug Records)

"Dubplate Culture" (Satellite)

Soundscape

Strictly Dubz IV "Small Step (London Dubz)" (Nice N'Ripe)

"Everything Is Large" (Satellite) **Underground Distortion**

COMPILATIONS

EZ of Freek FM presents: Underground Garage Flavas

(Breakdown)

UK Garage Fever and UK Garage Fever II (Subversive)

187 Lockdown Presents . . . Sunday Flavaz Volume One (Logic)

Tuff Jam Presents Underground Frequencies Volume

One (Satellite)

Uptempo — The Sound of Speed Garage (Death Become Me)

Tuff Jams Vol. 1 (Ultra)

DAFT PUNK

"Da Funk/Musique" (Virgin)

Homework (Virgin)

"Disco Cubizm" (Remix of I: Cube) (Versatile)

BIG BEAT

Bentley Rhythm Ace (Skint; Astralwerks)

Chemical Brothers Exit Planet Dust

"Loops of Fury"
"Setting Sun"

Dig Your Own Hole (all Junior Boy's Own/Astralwerks)

Cornershop "Brimful of Asha (Norman Cook Remix Extended Version)"

(Beggars Banquet)

Environmental Science "The Day The Zak Stood Still (Part 2)/Killa Rooster"

(Fused and Bruised)

Fatboy Slim Better Living Through Chemistry (Skint/Astralwerks)

"Everybody Needs A 303/Everybody Loves A Filter (Skint/

Astralwerks)

"Rockerfeller Skank" (Skint/Astralwerks)

Rasmus "Mass Hysteria" EP (Bolshi)

"Motherfuckin' Beats" (Bolshi)

Req One (Skint)

Frequency Jams (Skint)

Various Artists "Donuts #2 Album Sampler" EP (Bolshi)

Wildchild "Renegade Master 98 (Fatboy Slim Old Skool Mix)" (Hi-Life)

COMPILATIONS

Brassic Beats Volume One and Volume Two (Skint)

Brassic Beats Volume 3 (Skint/Sony)

Donuts (Bolshi)

Live At The Social Volume 1 and Volume 2 (Heavenly)

Used and Abused (Fused and Bruised)

Nu Skool Breakz (Kickin)
Back 2 Mono (Wall of Sound)

Wall of Sound — The Second XI (Wall of Sound)

Massive shout to Sam Batra for getting me into this raving caper in the first place; thanks for all the adventures. Big shouts to the rest of the Batra posse (Claire Brighton, Tom Vaughan, Glenda Richards) and other UK clubbing comrades (Susan Masters, Jane Lyons), not forgetting the original jungle-theory crew (Kodwo Eshun, Rupert Howe).

Thanks to the following for providing information/contacts/clippings, loaning/taping records or radio transmissions, illustrations, general theory-stim, and diverse forms of assistance: Adrian Burns, Jill Mingo, Sarah Champion, Kodwo Eshun, Scotto, Jim Tremayne @ DJ Times, Rupert Howe, Jones, David Pescovits, David J. Prince, Steve Redhead, Denis Catalfumo, Pat Blashill, Rick Salzer, Erik Davis, Chris Scott, Stephanie Smiley @ Domestic, Burhan Tufail, Achim Szepanski, Daniel Gish, Sebastian Vaughan @ Network 23, Tom Vaughan, Mike Rubin, Bat (A. Bhattacharyya), Chris Sharp, Barney Hoskyns, Matt Worley, Dave Howell, and Ian Gittins. Apologies to anyone I forgot.

Special thanks to my brother Jez Reynolds for the music technology lowdown and for taking us to Even Furthur, to my parents, Sydney Reynolds and Jenny Reynolds, for the clippings supply, and to Louise Gray for the archival material.

Extra special thanks to my wife Joy Press for keeping my spirits up, cracking the whip, being the book's first reader, and generally acting as the serotonin in my life.

Gratuitous shout to Foul Play for making (and remixing) some of the rushiest records of all time. Condolences to FP's John Morrow concerning the tragic death of partner Steven Bradshaw in August 1997.

Thanks to those who granted interviews specifically for this book: Juan Atkins, Derrick May, Eddie "Flashin' " Fowlkes, Kevin Saunderson, Carl Craig, James Pennington, Mark Moore, Paul Oakenfold, Barry Ashworth, Louise Gray, Mr C, Jay Pender, Joe Wieczorek, Gavin Hills, Jack Barron, Helen Mead, Steve

Beckett, Doug Baird of Spiral Tribe, Chantal Passamonte, Dego McFarlane, Marcus formerly of Don FM, Jeff Mills, Richie Hawtin, John Aquaviva, Wade Hampton, Frankie Bones, Heather Heart, Dennis "the Menace" Catalfumo, DB, Scotto, Jody Radzik, Nick Philip, Malachy O'Brien, Scott and Robbie Hardkiss, Steve Levy, Todd C. Roberts, Les Borsai, Daven Michaels.

This book contains "samples" from my journalistic output of the last ten years. Thanks to the following editors for giving me the space to explore ideas: Mark Sinker and Tony Herrington at *The Wire*, David Frankel and Jack Bankowsky at *Artforum*, Matthew Slotover at *Frieze*, Ann Powers and Eric Weisbard at *Village Voice*, Matthew Collin and Avril Mair at *iD*, Paul Lester at *Melody Maker*, Nick Terry at *The Lizard*, and Philip Watson at *GQ*. (Parts of Chapter 15, "Marching Into Madness," first appeared as "Gabba Gabba Haze" in *GQ*, October 1996).

Thanks to my agents, Tony Peake and Ira Silverberg, and editors, Michael Pietsch and David Gibbs (USA) and Richard Milner (UK).

index

Ability II, 119	ambient jungle, 335-338, 427
Acen, 134, 211-212	ambient techno, 8, 193-202, 412-413
A Certain Ratio, 28, 217	American Gigolo, 15
acid (LSD), 67, 81, 248, 299, 302	American Records, 307
abuse of, 304, 305, 313	Amnesia club, 58, 143
British use of, 382	Amnesia raves, 130
clubs, use in, 26, 34, 147, 155	amphetamine, 207, 313, 382
Ecstasy used with, 89, 209, 211	abuse of, 109, 306, 309-310
Goa/Goa trance and, 175, 176	Ecstasy compared, 81
music and, 32–33, 55, 176, 202, 240–241	Ecstasy used with, 88, 89, 125, 209, 211,
nitrous oxide and, 308	304
acid house ("acieed"), 3, 8, 28, 49, 113,	music and, 34, 55, 135, 207, 284-285
156, 175, 184, 228, 229, 314, 367,	physical/psychological effects of,
377, 399, 401–402	125-126, 210, 284-285
British, 61–72, 94, 103, 106, 150, 226,	amyl nitrate, 127
256	Anarchy & Ecstasy: Visions of Halcyon Days
development of, 31-34, 129	(Moore), 241-242
Ecstasy use and, 239	Anderson, Laurie, 36, 194–195
nouveau, 201	Andy C, 137, 259, 350. See also Origin
press response to, 66–67	Unknown
acid jazz, 325–326, 343	angel dust. See PCP
acid rock, 174	Angelou, Maya, 345
acid techno, 433–434	Angus, Colin, 105. See also Shamen
Adam F, 345	Annihilator, 284, 285
Adamski, 78, 103–104	Aphex Twin. See James, Richard
Adam X, 144, 145	Aphrodite, 256, 259, 346
Adonis, 33	Apocolypse Now warehouse rave, 64
Adorno, Theodor, 48, 362	Aguaviva, John, 225-229
Adrenalin club, 147	Archer, Mark, 132
Aesthetics of Disappearance (Virilio), 135	'ardkore. See hardcore
African music, 48, 55, 224, 254, 258	A. R. Kane., 224
Afrika Bambaatta, 14	Arpeggiators, 202
AFX. See James, Richard	Artificial Intelligence compilation, 181, 183,
Age of Love, 202	184, 186
alcohol, 81, 88, 143, 157, 238	Art of Noise, 42
Alien Underground magazine, 291, 295	Asend. See Dead Dred
Allen, Keith, 99	Ashworth, Barry, 64
Allen, Stu, 93	Aslet, Phil, 379
Aloof, 376	Atari Teenage Riot, 367
Altern 8, 131-133	Atkins, Juan, 14-22, 71, 219, 228, 234, 398
ambient (ambient house, ambient dub),	Attali, Jacques, 46-47
101, 103, 181, 189–195, 302, 336,	Autechre, 174, 184-185, 411
412-413	Auteurs, 277

Autonation, 119 Bellote, Pete, 24-25 Aux 88, 234 Beloved, 104-105 avant-funk, 26, 28, 93, 94, 102, 116, 230 Beltram, Joey, 122-124, 145, 213-214, Avila, Pete, 150 226, 335, 405 Avon Free Festival, 163 Benitez, John "Jellybean," 36 AWOL club, 349-350, 355-356 Benjamin, Walter, 362 Axis label, 232 Bentley Rhythm Ace, 383, 384, 385 avahuasca, 155 Berlin techno scene, 126, 148-149, 173, Ayers, Kevin, 196 228-229, 362-368 Betts, Leah, 88 B12, 129, 183, 184 Beuys, Joseph, 28 Babyboom, 287 Bey, Hakim, 169-170, 177, 245-246 Baby D, 212 Beyond, 183 Babylon club, 66 Bez, 96-97. See also Happy Mondays Bad Girl, 139 Bieber, Gavin, 153 Baelaric music/scene, 58-59, 61, 67-69, big beat, 8, 383-386, 436 78, 143, 153, 175, 343 Big City label, 137 Baffled Republic, 379 Big Time International label, 124 Bailey, Derek, 348 Biology, 74, 77, 78-79 Baker, Arthur, 36 Birdsong, Edwin, 17 Balil. See Black Dog Birthday Party, 3 Bam Bam, 33 Biswas, Kingsuk, 359 Banco de Gaia, 174 Biting Tongues, 28, 99 Bangs, Lester, 138 Bizarre Inc, 130, 131 Banks, Mike, 219-220, 222, 224, 230, Bizzy B, 207, 211, 350 231-232, 416. See also Red Planet; Bjork, 102, 251, 279, 320, 343 Underground Resistance Black, Matt, 326. See also Coldcut Banton, Buju, 257 Black Box, 78 Baraka, Amiri, 372 Black Dog, 129, 183-186, 231, 412 Barron, Jack, 69-70 Black Grape, 111, 389 Barrow, Geoff, 320-322 Blackmarket, Nicky, 255 Barrow, Steve, 277 Black Riot, 38. See also Terry, Todd Basic Channel label, 54, 235 Black Sabbath, 33, 123, 129 Bassheads, 5, 131 Blaine, Philip, 311 Bass Kittens, 315 Blapps Posse, 120 Batchelor, Kid, 62 Blastoff warehouse party, 94 Baxter, Blake, 228 bleep-and-bass, 8, 113, 115, 117-119, 127, Beastie Boys, 58 233, 403-404 Beatles, 44, 104, 153, 321 Bliss club, 242 beat mixing, 271-272 Blood, Benjamin Paul, 308 Beats International. See Cook, Norman Bloom, Harold, 246-247 Beckett, Steve, 114, 115-118, 183-184 Blum, R., 248 Bedlam sound system, 164 Bodysnatch, 137, 261 Bedouin Ascent, 359 Bolland, CJ, 125, 127. See also Ravesignal Belgian hardcore techno, 8, 113, 128-129, Bolshi, 385 131, 145, 219-220, 222, 233, 352, Bomb the Bass, 4, 42, 57, 320 405-406 Bones, Frankie, 120, 144-146, 147, 153, darkcore and, 213-214 301, 304-305 development of, 122-125 Boogie Times record store, 115 Bell, Dan, 22 Boogie Times Tribe, 208 Bell, Mark, 117, 118 Booth, Sean, 184-185 Belleville Three. See Atkins, Juan; May, Borsai, Les, 157-158, 311 Derrick; Saunderson, Kevin Bouncer, Peter, 122

Charlemagne, Diane, 335, 339 Bowie, David, 17, 118 Charles, Christophe, 364 Boy George, 59 Chemical Brothers, 383-387 Boy's Own fanzine, 68, 70, 77, 95, 107 Chester, Andrew, 55 Brain, Chris, 242 Chicago house, 7, 22-34, 113, 114, 377, Brainstorm, 71, 72 398-399, 434. See also acid house breakbeat hardcore, 113, 120, 131, 134, Children, The, 30-31 137, 138, 145, 214, 251-253, 256, Chill label, 115 335, 344, 352, 360, 367, 408-410 chill-out clubs, 181, 184, 195-196, 289, 359 big beat and, 383, 385 music, 103, 183, 189-190, 196-197, darkside, 207-208, 217 breakbeat house, 8, 39, 120, 314, 345 412-413 Chuck D, 24, 214, 328 breakbeats, 6, 181-182, 201-202, 214, Church of Ecstasy, 128 253-254, 301, 319, 339, 359 Circuit Breaker. See +8 in DJ records, 57 City of Angels label, 314 techno purism and, 201-202, 359 Clail, Gary, 64 Breaks, Danny, 253, 255-256, 275, 347 Clark, Fraser, 150, 152, 190 Bright, Graham, 79 Clarke, Dave, 8, 234 Bristol, 320-322, 425 Clink Street (RIP club), 62-63, 66, 72 Brooklyn rave scene, 144-149, 410 Clinton, George, 14, 224 Brown, Ian, 97, 98, 108-109 Clock DVA, 116 Brown, James, 39, 57, 252, 254 CLS, 38. See also Terry, Todd Brown, Rob, 184-185 Club Dog, 164, 174 Brown, Scott, 288 clubs, 3, 8. See also specific clubs 66, 69, Bryan G (DJ), 377 78, 113, 145-146 B-52's, 14 conservatism of, 380 Buckley, Tim, 107 high school social (Detroit), 15-18 Budd, Harold, 191 licenses, 109, 113 Buford, Bill, 64 rave and, 60-61, 380-382 Bukem, LTJ, 335, 338, 343, 345, 348, 353 Clubscene magazine, 289 Burrell, Ronnie and Rheji, 37 Club X, 242 Bush, Kate, 41, 136 Butterfly label, 170, 172 Cobain, Gary, 201 cocaine, 26, 69, 109, 110, 147 Buzzcocks, 93 in music, 216, 339 Cabaret Voltaire, 28, 116, 216. See also Kirk, speed garage and, 378 Code 071, 261 Richard; Sweet Exorcist Cohen, Allen, 151 Caffeine club, 149, 304 Cohn, Marc, 122 Cage, John, 254 Coldcut, 42, 320, 326 Cajual label, 377 Cold Rush label, 295, 424 Cale, John, 13 Collier, Ken, 17 Cameron, Robbie, 153-154 Collins, Lyn, 252 Candy Flip, 99 Colston-Hayter, Tony, 74-75, 79 Cappello, Michael, 34 Come-Unity club, 154, 306 Caruso, Michael, 146-147 Castlemorton Common megarave, 163-167, Commander Tom, 202 Congress, 131 170, 172, 173 Cook, Norman, 383-386 Catalfumo, Dennis. See Dennis the Menace Cooltan, 195-196 Cauty, Jimmy, 102, 104, 190-191 Core, Ron D., 310, 311 Centre Force pirate station, 74, 265-266 Cowboy label, 376 Chain Reaction label, 54, 235 Cox, Carl, 130, 272-273, 275, 389 Chakk, 116 crack. See cocaine Charivari, 16 Craig, Carl, 14, 16, 230-231, 344 Charlatans, 99

Deleuze, Gilles, 245-246, 362, 364 Crash, Jimmy, 144 Cream, 129, 138 Delight club, 94 Cream club, 381 Delirium club, 57 Creation label, 106 Demon Boyz, 120 Criminal Justice and Public Order Act, 167, Dennis, Harry, 33 173-178, 293 Dennis the Menace (Dennis Catalfumo), Critical Rhythm, 37 144-145, 149, 312, 313 crusty rave, 163-178, 411 Denny, Martin, 101 crystal methamphetamine, 309-310 Depino, David, 34 Crystal Method, 314-315 Depthcharge, 320 Crystl (DJ), 207, 256 Derrida, Jacques, 363 Cubic 22, 124 Desired State, 140. See also Andy C Curtin, Dan, 233 Destructo (DJ), 311 Cybersonik, 226, 227. See also Bell, Dan; Detroit techno, 7, 8, 13-22, 26, 57, 70-71. Hawtin, Richie; +8 113, 114, 129, 143, 219-235 344, 363, Cybotron, 14, 18-20, 398. See also Atkins, 377, 398, 416-418 Juan purists, 136, 182, 202, 233-234, Cypress Hill, 217 417-418 Dett. 263 D.A.F., 28 Devo, 16 Daft Punk, 301, 378, 435 De Wulf, Frank, 124, 351 Dahl, Steve, 23-24 D.H.S., 147 Da Intalex, 345 Die (DJ), 346-347 Dale, Colin, 201 Die Krupps, 116 Damier, Chez, 219 Digital Hardcore, 366-368, 432 Dance Ecstasy 2001, 296, 302-303, 424 Digital Orgasm, 131 Darkraver, 284 Digweed, John, 275 darkside (darkcore), 207-217, 223, 335, Dillinja, 341, 347 338, 348-349, 414-415 Dinosaur L.. See Russell, Arthur NASA, 305 Direct Beat label, 234 techstep and, 351 disco, 15, 16, 21, 28, 34, 36, 52, 93, 114, Data Trash: The Theory of the Virtual Class 150, 239, 278, 300, 366, 380 (Kroker and Weinstein), 45 anti-disco movement, 23-24 Davis, Miles, 101, 325, 336, 342, 373 in Chicago, 22-24, 202 Davis, Rick, 18-20 cut-ups, 376-377 Davy DMX, 256 Diy, 164 DB, 30, 147-148, 272, 305, 312 Djax-Up label, 201 Dead Can Dance, 153 DJ Cool Herc, 252, 257-258 Dead Dred, 255, 259, 346 DJing/DJs, 4, 7, 16-18, 23-26, 32, 47, 49, death metal. See heavy metal 77-78, 105, 114, 225-230, 263-264, deBenedictus, Michael, 35 378, 384, 420-421 Dee, Ellis, 130 culture, 47, 271-281 Dee, Lenny, 37, 120, 122, 145, 310 New York disco underground, 34-35 Dee, Ralphie, 145 DJ International label, 27 Deep Blue, 346, 351 djpc, 147 Deep Dish, 376, 378 DJ records, 42, 57-58, 108. See also Bomb deep house, 28, 30, 57, 69, 78, 102, 120, The Bass; Coldcut; M/A/R/R/S; S'Express Deep Space Soundworks, 17-18 DJs Unite, 134 Definitive label, 227 D-Mob, 70 Def Jam, 58, 120, 284 DMS, 212 De Giorgio, Kirk, 183, 234 DMT, 152, 156 Dekko's club, 315 DMZ club, 177-178

145-146, 148, 150-153, 155, 307, Doc Scott (Nasty Habits), 123, 213, 214, 216, 259, 351, 353 abuse of, 87-90, 126, 215-217, 240, 284, Donelly, Don, 115. See also Suburban Bass 288, 304, 306, 310 Don FM, 260, 262, 266 big beat and, 384-385 Dopplereffekt, 234 brands, 89 Double 99, 379 culture, 65-66, 84-86, 89-90, 149, 152, Dougans, Brian, 200-201 207-217, 237-248, 251, 289, 385-385 Dowd, Tom, 108 deaths, 67, 69, 88, 109, 148, 213, Downie, Ken, 185 288-290, 315-316, 381 Down on the Farm rave, 77 development of drug, 81-82 Dr. Atmo, 197 gabba and, 284-285 Dr. Freecloud's record store, 310 hardcore and, 117, 123, 126-127, 129, Dream magazine, 290 131, 134, 136-139, 141, 256 Dreamscape raves, 130, 290, 291 jungle and, 251-252, 261, 291 Drexciya, 222, 234 legal status, 63, 82, 88-89, 127, Drop Bass Network, 299, 301-303, 310 143-144, 381-382 Droppin' Science. See Breaks, Danny nitrous oxide and, 308 drugs, 129, 130, 237, 288, 312-313. See physical side effects, 83, 86-88, 143, also specific drugs 210 in Britain, 60, 71-76, 78-79, 93, 96, 99, polydrug use and (See polydrug use) 105, 108-111 psychological effects, 69-70, 82, 87, 207, dark side of, 207 209, 304, 351 gabba and, 288 sexuality and, 63-64, 66-67, 238, 243, hardcore and, 113, 207, 227 247-248 house and, 24, 26, 32-33 spirituality and, 65, 149, 152-153, jungle and, 259, 261 241-248, 316 legal/police, 381-382 techno and, 55 New York, 34, 148 Texas Ecstasy scene, 143 polydrug use, 299-317 rave music and, 8-10, 166, 183, 310 Ectomorph, 234 Edge, 128 San Francisco, 151-152, 155-156 Ed Rush, 351-353 techno and, 26, 55, 71, 230 Edwards, Todd, 378 drum and bass, 6, 257, 335-356, 427-431 808 State, 4, 28, 94, 99-102, 103, 277 Drummond, Bill, 102, 104, 190 80 Aum, 124, 220, 283 D-Train, 36 E Is for Ecstasy (Saunders), 243 dubplates, 257, 264 dub reggae (dub), 10, 134, 137, 193, 194, Eisner, Bruce, 151 Electrifyin' Mojo. See Johnson, Charles 258 electro, 51, 118, 219, 255, 314, 315, 359 Dubtribe, 316 electronic listening music, 181-189, 199. Duke, George, 234 See also ambient techno; intelligent Dunn, Mike, 33 techno Dyce, 212 Electronic Lounge, 359 Elektra label, 13 Earth Wind and Fire, 224 Elevation raves, 130 Eastern Bloc record shop, 99-100 Elstak, Paul, 284, 287-288, 292 Eat Static, 174 Elysium club, 66 Eckel, Cymon, 68 EMF, 111 Eckes, Kurt, 302-303 Empire, Alec, 364, 366-367, 372, 432 Eclipse club, 126 End, The fanzine, 95 Eclipse rave, 130 Energy raves, 74, 77, 78, 144 ECM label, 197 Eno, Brian, 47-48, 137, 189, 191, 195, 197, Ecstasy, 8, 10, 58-60, 63-71, 74, 81-90,

93, 95-97, 102, 103, 104, 106-110,

280, 335, 342, 373

Environmental Science, 384 epic house, 433-434 Erik B. 319 Eternity magazine, 290 Euro Body Music (EBM), 124, 219, 220, 226, 229 Eurodisco. See disco Euromasters, 284, 292 Eurythmics, 121 Evelyn, George, 117 Even Furthur rave, 299-303 Evolution magazine, 150, 190 Exodus, 176-177 E-Z Rollers, 345 Fabio (DJ), 130, 275, 339, 344, 348 Fabulous Baker Boys, 379

Factory Records, 93, 96 Fairlight Computer Musical Instrument, 41 Faithless, 376 Fall, The, 3, 93, 96 Fantasy label, 19 Fantazia raves, 130 Farley, Terry, 68, 107. See also Boy's own Farley Jackmaster Funk, 22-23, 26 Farris, Gene, 377 Fast Eddie (DJ). See Smith, Fast Eddie Fatboy Slim. See Cook, Norman Faver, Colin, 201, 235 Fax label, 197 Fehlman, Thomas, 228 Final Exposure, 226 Fingers Inc., 31, 33. See also Heard, Larry Finn, Micky, 253 Fiorillo, Alfredo, 58 First Choice, 25, 26 Five-0, 263 Flavor Flav, 214 Flint, Keith, 133, 387, 388 Floppy, Mr., 150

Florida rave scene, 304, 315–316, 424–425

425 Flowered Up, 106 Flowmasters, 145 Fon label/studio, 116 Food (DJ), 279 Force Inc. label, 228, 362, 365, 366, 432 Force Mass Motion, 125, 128 Forest, Art, 22

Forgemasters, 116, 119 Formation label, 137, 148 Forgest Bruce, 36

Forrest, Bruce, 36 Foucault, Michel, 363 Foul Play, 212-213, 254, 280, 335, 338 400 Blows, 28 4 Hero, 8, 123, 135, 207, 212-213, 215, 217, 256, 335, 340, 341, 350, 351 4 Horsemen of the Apocalypse. See Foul Play Fowler, Bernard, 35 Fowlkes, Eddie Flashin', 15, 20, 22, 23, 71-72, 228, 233 Fox, Reverend Matthew, 316 Foxx, John, 19 France, 172-173 Frankie Goes to Hollywood, 61 Frazer, Liz, 136 Freedom To Party campaign, 79 Frenzy club, 94 Fresh Jive clothing/design company, 160 Friedel, Scott, 153 Fripp, Robert, 201 Frith, Simon, 49 Front 242, 124, 175, 220, 226 Full Moon raves, 154-155, 306, 316 Fung, Trevor, 58 Funhouse club, 58

funk, 156, 157, 186, 227–228, 253, 264, 367
Funkadelic, 15, 24
funky breaks, 314
Funky Porcini, 326
Furthur raves, 299–303
F.U.S.E.. See Hawtin, Richie
Future, 59
Future Shock club, 147–148

Future Sound of London (FSOL), 129, 138, 153, 200–201

F-X-U, 119

gabba, 8, 227–228, 233, 282–295, 310, 314, 421–422
Gabriel, Peter, 41, 58
Gallagher, Noel, 383
Gallery club, 25, 34, 35
gangsta rap, 17, 284, 319, 327, 354, 429–430
Gangstar Toons Industry label, 294, 368
Gant, 379

garage, 8, 34–39, 57, 69, 78, 120, 208, 344,

400–401 speed, 8, 377–380, 435 Gardner, Taana, 35 Garth (DJ), 155 Gathering rave, 154, 316 Gatien, Peter, 147

Geffen label, 108

Hampton, Wade, 143-144, 153, 155, 156, General Levy, 267-268 German rave culture, 126, 128. See also 159-160 Hancock, Herbie, 101, 199, 234, 252, 321, Berlin techno scene 341 German techno, 113 handbag house, 7, 376-377, 433-434 Gerrard, Lisa, 153 GHB (gamma y-hydroxybutyrate), 299, 313 Handley, Ed, 185 Hannant, Beaumont, 199 Gibbons, Beth, 321-322 Hannett, Martin, 96 Gibbons, Walter, 34 happy hardcore, 8, 235, 290-291, 336, 423 Gibbs, Joe, 278 Happy Mondays, 94, 95-97, 98-99, 105, Gibson, William, 19, 54, 186 110-111, 312 Giger, H. R., 53 hardcore, 6-8, 113-141, 145, 147, 182, Gillespie, Bobby, 102, 106-107 184, 336, 343. See also breakbeat Gilroy, Paul, 258, 263 hardcore: darkside (darkcore) Glass, Philip, 36 gabba, 282-295 Gleick, James, 44 Global Communications, 199 intelligent drum and bass and, 335 intelligent techno and, 203-204 Goa trance, 175-176, 239, 411 jungle developed from, 251, 256-257 God, 278 Gold, Xavier, 29 in Scotland, 289-290 hard disk editing, 41 Goldie, 123, 213-214, 217, 275, 335, Hardfloor, 202 338-341, 348, 350. See also Rufige Cru Hard Hands label, 129, 376 Gonzalez, Kenny "Dope," 37 hard house, 37-39, 62 Good Looking/Looking Good label, 345 Hardkiss Brothers, 153, 300, 314, 315, 316, Goodwin, Andrew, 48 410-411 Gordon, Robert, 116 Hardy, Ron, 26, 32-33 Gottsching, Manuel, 190 Harrison, Mark, 168, 173 GQ. 263 Harthouse label, 203, 229 Gracyk, Theodore, 44, 54 Hassell, Jon, 101, 277 Grandmaster Flash, 258 Hawke, 153-154 Grape Ape 3, 311 Grave Rave, 303 Hawkwind, 164, 191 Hawtin, Richie, 145, 225-230, 272-272, 281 Gray, Louise, 59-60, 63, 65, 66, 68-69, 77 Hayes, Isaac, 27, 321 Green Velvet, 216, 377 Healey, Jeremy, 275 Grey, Paris, 22, 71 Grid, 103 Heard, Larry, 31, 33 Heart, Heather, 144, 145, 148-149, 313 Grinspoon, Lester, 240 Heaven club, 59, 61, 144, 189 Groove record store, 145-146 heavy metal, 123, 128-129, 284, 291-292, Grooverider, 130, 216, 275, 339 303, 315 Grossberg, Lawrence, 164 Hedblom, Peter, 240 GTO, 128, 293. See also John + Julie Guattari, Felix, 245-246, 362 Hedonism rave, 71 Heley, Mark, 149-151, 155 Guerilla label, 129, 376 Helter Skelter raves, 130 Gurley, Steve, 338 Henderson, Sheila, 238 Guru Josh, 77 Hendrix, Jimi, 5, 44, 324, 335 Gusto, 300 Guy Called Gerald, A, 99-101, 216, 340-341 Henry, Scott, 316 Herc, Kool (DJ), 257-258 heroin, 109, 207, 210, 306 Hacienda club, 93-94, 109 Heron, Gil Scott, 224 Haigh, Rob, 336-338

HHFD, 125 Haines, Luke, 277 Hidden Agenda, 345 Halcion, 200 Hammond, Paul, 196 Hampson, Robert, 198 INDEX | 445

indie-dance crossover, 105-106, 106, 108 Hills, Gavin, 68, 76, 381 Hi-NRG, 57, 124 Industrial High, 128 hip-hop, 6, 8, 10, 38, 42, 44, 57, 58, 114, Industrial Strength label, 310 Inferno Bros., 296 120, 121, 122, 148, 156, 157, 182, 284, 314, 320, 323-324, 426 Inner City. See Saunderson, Kevin house and, 24 Innerzone Orchestra, 231 jungle and, 256-257 Innocence, 103 hip-house, 39, 113-114, 120 Inspector Morse, 237 Hithouse label, 124 Inspiral Carpets, 94, 99 Holloway, Loleatta, 25, 78 intelligent drum and bass, 335-356, Holloway, Nicky, 58, 61-62 427-428 Holy Ghost Inc. 137 intelligent techno. 6, 127, 129, 181-189. Holy Noise, 124, 283 203-204, 233, 343, 359, 413 Hood, Robert, 222, 231-232, 416 Interdimensional Transmissions label, 234 Hooper, Nellee, 320, 339 Irresistible Force. See Mixmaster Morris Hooton, Peter, 95 It. The. 33 Hoskyns, Barney, 4-5 Italian disco, 32, 230 Hot Mix Five, 22-23 Italo-house, 78, 131, 137, 290 house, 6, 7, 8, 22-34, 37-39, 42, 52, 55, 58, Ital Rockers, 115 59, 62, 70, 85, 93-94, 99, 114, 119-120, 143, 153, 156, 157, 164, Jackson, Herb, 32 208, 216, 272, 289, 314, 363, 366, jack tracks, 8, 28, 29, 31, 57 380, 386, 388. See also acid house; Jacobs, Diana, 150-151 Chicago house; Italo-house; jack Jam and Spoon, 203 tracks James, Richard, 184, 186-189, 197-199. breakbeats in, 252-253 279, 348, 352, 359, 412 Ecstasy and, 85 James, William, 216, 308 subgenres of, 375-380 Japan, 342 House 2 House, 37 Jason, Kenny, 23 Howie B, 43, 53, 339 Jefferson, Marshall, 30, 32, 33 Jenkinson, Tom, 359 Howlett, Liam, 133, 388 Hudson, Keith, 193 Jeno (DJ), 155 Hughes, Walter, 28 John + Julie, 125, 128, 293. See also Human League, 116 Technohead Humanoid, 70. See also Future Sound of Johnson, Charles, 16 London (FSOL) Johnson, Robert, 13 Human Resource, 125, 131 Joli, Frances, 36 Humphries, Tony, 36 Jolly Roger. See Richards, Evil Eddie Hurd, Douglas, 76 Jones, Claire Morgan, 127 Hurley, Steve Silk, 23, 27 Joy Division, 93 Hype (DJ), 137, 207, 253, 256, 259, 346, 350 Joy warehouse party, 94 Hyper-On Experience, 137, 209, 256 Judge Jules, 275 Hypnotist, 128, 131 jump up, 343, 350, 351, 429-430. See also jungle Ibiza, 58-60, 143, 175, 238. See also jump ups, 379 Balearic jungle, 6, 8, 43, 113, 132, 137, 175, 217, Ibiza label, 137-138 233, 251-268, 272, 280, 301, 314, Icey (DJ), 315 319-320, 348, 359, 367, 419-420, ICF (Intercity Firm), 72 427-431 Illbient, 370, 433 happy hardcore and, 290, 291 Illuminati, 104 intelligent, 335-356 Incubus, 124, 147, 220 speed garage and, 377-380 Index FM pirate radio station, 243-245 Jungle, Johnny, 207

Jungle club, 57 Justified Ancients of Mu Mu, 104

Kaotic Chemistry, 211
Kaye, Lenny, 138
Keith, Ray, 346
Kelley, John, 315
Kelly, Michael, 327
Kemet Crew, 259
ketamine, 163, 168, 305, 306, 313, 377
Kevorkian, François, 36
Kickin' Records, 128

Kicks Like A Mule, 132 Kids, 148 Kiki club, 117 Kinchen, Marc, 233 King, Gavin, 253 King, Justin, 314

Kingfish Entertainment, 311 King Tubby, 278, 336

KISS FM, 235, 264, 265, 335, 344 Kitchen club, 94, 109

Kirk, Richard, 28

K-Klass, 5

KLF, 102, 103, 104, 105, 130, 190

KMS label, 20 KNOR label, 287, 289

Knott's Berry Farm rave, 311

Knowledge club, 201

Knuckles, Frankie, 23, 25, 26, 30, 34–35

Konspiracy, 93, 94, 109 Kool-Aid, Steve, 157

Kool FM pirate radio station, 257, 259

Kool Kat label, 71

Kraftwerk, 13–14, 16, 116, 117, 181, 183, 194, 219, 223, 226, 230

Kroker, Arthur, 45-46 KRS1, 224, 319

Krush (DJ), 325

Labrynth club, 9, 72-74 Labworks label, 201 Land of 0z, `89 Lang, Fritz, 19 Larkin, Kenny, 233 Last Poets, 224 LA Style, 124

Lavelle, James, 325

Lawford, Josh, 253 Lawrence, Vince, 26

Leary, Timothy, 110, 147, 151, 239, 240

Led Zeppelin, 33, 123 Leer, Thomas, 186, 231 Leftfield, 129, 376, 389 Legg, Barry, 381 Leighton, Claire, 109 Levan, Larry, 25, 35–36 Levy, Steve, 156–157, 311

LFO, 117, 118

Liaisons Dangereuses, 28 Liberator sound system, 176

Liedernacht club, 20 Lionrock, 376

Liquid, 132 Loft club, 34

Loftgroover, 292-293, 296

London, Tim, 65 Long, Richard, 35 Looney Tunes, 145

Lord Michael. See Caruso, Michael

Lords of Acid, 124 Lo Recordings, 359

Los Angeles rave scene, 156-160, 307-311,

314-315, 424-425

Louis, Lil, 78 Low Spirit label, 364 LSD. See Acid

LSD (Love Sex Dance) rave, 158–159 Lucky Spin record store, 261 Lyotard, Jean-Francois, 363 Lytton, Preston, 151

McBride, Woody, 301

McFarlane, Dego, 135-136, 214, 215

McGowan, Shane, 97 McIntyre, Peter, 202

McKenna, Terence, 105, 110, 151, 152, 155,

156, 240

McQueen, Alan, 155 Madonna, 103 Mad Professor, 277

Maher, Shaun, 116 Manchester rave scene, 93–105, 402

Mancuso, David, 34

Manic Street Preachers, 194

Manix, 122, 131, 339

Man Parrish, 202 Mantronix, 3, 42, 184, 256, 319, 371

marijuana, 26, 81, 211, 168, 240, 326–327,

Ecstasy use replaced by, 261, 351-352

jungle and, 291 music and, 55, 207 Mark, Marky, 155

Marley, Bob, 177 M/A/R/R/S, 42, 57, 320

Mars FM, 160, 307 Marsh, Jon, 104 Martin, Doc, 145, 150, 156 Martin, Kevin, 278-279, 280, 359 Martyn, John, 196 Massey, Graham, 28, 101, 102 Massive Attack, 277, 319, 320, 339 Masters At Work, 36, 37, 38, 376, 378 Maxim Reality, 133, 382 May, Derrick, 14-18, 20-22, 57, 71, 219, 230, 232-234, 273, 336, 344 Mayday party organization, 363 Mayes, Steve, 68 MC5, 13, 104 MCing/MCs, 243-246, 262-263, 266, 267. See also DJing/DJs MDA, 210 MDMA. See Ecstasy Mead, Helen, 76, 78-79 Meat Beat Manifesto, 220, 320 Megadog, 174-175, 411 Megadrive, 216 Megatripolis club, 150, 239 Meijer, Robert, 284 Melechi, Antonio, 66, 238-239 Melrose, Steven, 314. See also City of Angels Meng Syndicate, 124, 220 Mephisto label, 315 Mescalinum United, 283 Messiah, 132 Metalheads. See Goldie Metalheadz club, 349 Metroplex label, 20 Miami Bass, 315 Michaels, Daven, 158-159, 311 Middleton, Tom, 199 Midi Circus, 175 MIDI (Musical Instrument Digital Interface), 48, 365 Mille Plateaux, 362-364, 366, 432 Miller, Paul D., 368-372 Mills, Jeff, 15, 219-222, 225, 228, 230-233. 235, 272-273, 275, 281, 386, 416. See also Underground Resistance Ministry of Sound club, 37, 381 Mitchell, Rob, 115 Mixmag, 133, 261, 290, 387 Mixmaster Morris, 183-184, 190, 194-195, 197, 301, 302 Moby, 131, 147, 242-243 Model 500. See Atkins, Juan Mokum label, 289

Monday, Mr., 78

Mondo 2000, 151 Moody Boys, 28 Mooncult, Barry, 106 Moonshine, 156-157 Moon Tribe, 316 Moore, John, 241-242 Moore, Mark, 2, 57-60, 65, 67 Moose, 263 Moroder, Giorgio, 14, 16, 24-25, 202, 253. 398 Morrison, Jim, 212 Morrissev. 93 Mother rave, 177 Mouse on Mars, 359, 361-362, 432 Mover, 229, 283, 295 Moving Shadow label, 137, 148, 335, 337-338, 340, 343, 350 Mo Wax label, 322, 324, 325, 371, 425 M People, 5, 28. See also Pickering, Mike Mr. C, 62, 69, 109 Mud Club, 57, 59 Murk, 376 Music Box club, 25-26, 32 Music Institute club, 71, 219 Musicology, 184 Musto, Tommy, 145 Mutoid Waste Company, 173 Muzique, Mundo, 122, 123, 145, 202, 226 My Bloody Valentine, 5, 338, 365, 383

Namlook, Pete, 197 NASA club, 147-148, 305 Nasenbluten, 291-292 Nasty Habits. See Doc Scott Navigator (MC), 257 Nebula II, 213, 214, 216, 339 Network label, 71, 119, 219 Network 23 label, 173 New Age, 65, 102–105, 193, 363 house, 101, 190 New Beat, 124 Newman, Lee, 128 New Order, 93, 95, 102, 109, 175 New York rave scene, 144-149, 410 Nexus 21, 131-133 Nicks, Stevie, 136, 138 Nightmare rave, 283-287, 295 Nightmares On Wax, 117-118 Nightwriters, 78 Nine O'Clock Service, 242 Ninja Tune, 324-326, 371 Nitro Deluxe, 3, 38 nitrous oxide, 307-309, 311

N-Joi, 5, 113, 130, 131
Noise Factory, 137–138
Northern Connection, 275
Northern Soul, 70–71, 93, 239
Northside, 94
Notting Hill Carnival, 251
No U Turn label, 53, 352–355
Nu Groove, 37
Numan, Gary, 14, 19
Nu-NRG, 433–434
NY Housin' Authority, 37

Oakenfold, Paul, 58-59, 61, 68, 96, 98, 105, 110, 189, 273, 275-276 Oasis, 381, 383 O'Brien, Malachy, 149, 154, 155, 306-307 O'Brien, Martin, 149, 154, 316 OC (MC), 262 Oldfield, Mike, 189 Oldham, Alan, 233 Oliver, Mickey, 23 Omen club, 126 Omens of Millenium (Bloom), 246-247 Omni Trio, 254, 280, 335-338 Open Mind. See Telepathic Fish Orange Lemon, 38 Orb, 4, 102, 103, 189-193 Orbital, 5, 119, 127, 174, 182, 200, 336 orbital raves, 75-79 Original Clique, 119 Original Rockers, 193 Origin Unknown, 207 Orridge, Genesis P., 150, 152 Osmosis club, 150 Oval, 364-366, 374 Ovum label, 314 Owens, Robert, 30, 31

Paap, Joseph. See Speedy J
Pandy, Darryl, 27, 30
Paradinas, Mike, 199, 277, 359
Paradise Garage, 35–36, 93
Paris Angels, 94
Park, Graeme (DJ), 94
Parkes, Rupert. See Photek
Parkzicht club, 227
Parliament-Funkadelic, 14, 219
Passamonte, Chantal, 195–196
Paterson, Alex, 102, 189, 190–194
Paw Paw Patch raves, 159
PCP (angel dust), 26, 147, 304, 305
PCP label (Planet Core Productions), 229, 295, 296, 303, 423–424

Peat, Chris, 132 Peech Boys, 35-36 Pender, Jay, 75 Pennington, James, 22, 222-224, 229 Perry, Lee, 193, 224, 278 Peterson, Gilles, 343 Pet Shop Boys, 175 Phase II, 78 Philadelphia International label ("Philly"), 24, 25, 36 Philip, Nick, 61, 150, 152-153, 155, 307 Philips, Sam, 44 phonography, 44 Photek, 344, 348, 354 Photon Inc, 37 Phuture, 32-33, 37, 216. See also Pierre (DJ) Pickering, Mike, 28, 93-94 Pierre (DJ), 32, 33, 34, 37 Pink Floyd, 44, 77, 181, 183, 189, 190, 191, 321 pirate radio, 9, 120-121, 245-246, 314, 367 jungle and, 259-260, 264-267 speed garage and, 378 Plaid. See Black Dog Planet Dog, 175 Planet E label, 230. See also Craig, Carl Plant, Robert, 123 Plastikman. See Hawtin, Richie Playford, Rob, 53, 340, 341. See also Kaotic Chemistry; Moving Shadow; 2 Bad Mice Plug. 359 + 8, 201, 219, 225-230, 226, 417 Poques, 97 polydrug use, 210-211, 304-305, 312-314 Polygon Window. See James, Richard Pop, Iggy, 13, 221, 294 Popp, Marcus, 365-366 poppers, 26 positivity, 95, 98, 102-105, 149, 154, 403 Pound, Caspar, 128, 145. See also Hypnotist; Industrial High; Rising High Power, T., 352, 354 Power Plant club, 25 Praga Khan, 125, 132 Praxis, 293-294 Prelude label, 3, 16, 36 Presley, Elvis, 44, 258 Price, Martin, 94, 100, 101, 102 Prijt, Fran‡ois, 284 Primal Scream, 102, 105-108, 312 Prince, 16, 121, 153, 230

Prince, David J., 300, 301 rare groove, 57, 343 Principle, Jamie, 31 Rasmus, 385 Rastafarianism, 177, 339 Pritchard, Mark, 199 Ratpack, 130 Prodigy, 130, 132-134, 261, 368, 382, 387-388 rave, 8, 10, 60-61, 76-79, 113, 120, Production House, 211-212, 414 130-131, 137-138, 146, 275, 312, 383, 388, 401-402 Profile, 58 Progeny rave, 5 derivation of term, 76-77 progressive house, 6, 7, 129, 201, 376, 377, illegal events, 9, 169-170 policing and legislation, 78-79, 109-110, progressive rock, 50, 129, 203, 321, 366, 145-146, 165, 167, 170-178, 386 289-290, 303, 315-316, 383 rave culture, 8-10, 47, 78-79, 107, 110, Project Club, 58-59 psilocybin (magic mushrooms), 152, 240, 119-120, 126, 127, 131, 138, 227-230, 237-248, 285, 299-317, Psyche, See Craig, Carl 312, 374 psychedelia/psychedelic, 41, 44, 66, 105, British, 71-72 club culture and, 380-382 107, 150, 153-155, 193 dark side, 216-217 dance culture, 3 Ecstasy and, 84-90 Psykick Warriors ov Gaia, 174 Public Enemy, 3, 24, 121, 214, 220, 224, fiction, 9 319, 328, 373, 383 Florida, 315-316 Public Entertainment Licenses (Drug Los Angeles, 157-160, 307-311 Misuse) Bill, 381-382 Manchester, 94, 103 Public Image Limited (PIL), 3, 217, 321 New York, 148 Pullen, Stacev, 233 San Francisco, 151-153 Pulse (DJ), 345 traveling, 163-178 punk, 6, 46, 66, 92, 97, 102-105, 113, 194, rave fashion, 131, 148, 160, 260-261, 285-286, 300-301 Ravesignal, 131 Purpose Maker label, 281 Pyramid Club, 57 Raze, 27 Reactor magazine, 300 quaaludes, 34 Rebel MC, 121, 257 Quadrant Park club, 94, 110 Recess club, 150 Quadrophonia, 131, 190 Redd, Sharon, 36 Quando Quango, 28, 93 Redhead, Steve, 95 Red Planet, 230. See also Banks, Mike Rabbit City, 128 Reece, Alex, 344-345, 348 Rabbit in the Moon, 315 Reese. See Saunderson, Kevin Reflective label, 149 Radzik, Jody, 150-151, 306, 316 Raeburn, Jamie, 289 reggae, 8, 134, 114, 115, 120, 122, Rage club, 66, 126, 216, 339, 349 277-278. See also dub reggae Raindance raves, 130 jungle and, 257, 259, 261, 264, 379 Rakim, 319 Reich, Steve, 36, 200, 254 Rampling, Danny, 58, 59 Reinforced, 137, 148, 213-214, 335, 339, 350, 351 Rampling, Jenni, 59-61 Relief label, 377 Ramsey & Fen, 379 Randall (DJ), 349 Remarc, 207 remixing, 276-281 Ranks, Cutty, 257 rap, 39, 41-42, 99, 103, 114, 255-256, 284, Renaissance club, 381 315, 350. See also gangsta rap; hip-hop Renegade Soundwave, 320 trip-hop and, 319-320 Retribution, 174 Rap (DJ), 274 RetroActive label, 230

Sakomoto, Rvuichi, 186, 230 Rezerection raves, 288-289, 291 Salon, Philip, 59 Rhyme Time, 262 Salsoul label, 24-26, 36 Rhythm and Noise: An Aesthetics of Rock Salvation club, 34, 35 (Gracyk), 44 sampling/sampladelia, 40-55, 113, 114, Rhythmatic, 119 136-137, 138, 150, 199, 216, 256, Rhythm Device, 124 259, 377, 379 Rythim Is Rythim, 219, 230, 398. See also Sanchez, Roger, 36, 37 May, Derrick Sanctuary club, 34 Rhythm King Records, 118 San Francisco rave scene, 149-156, 207, Rhythm Section, 131, 140 305-307, 316, 410-411 Richards, "Evil" Eddie, 62, 70 Sasha (DJ), 275 Richards, Gary, 311 Satin Storm, 137, 207 Riley, Terry, 200 Sativa club, 174 Riot Beats, 362 Saunders, Jesse, 26, 27 RIP club. See Clink Street Saunders, Nicholas, 243 Rising High, 128, 131 Saunderson, Kevin, 14-15, 20-22, 71, 219, Roberts, Todd C., 156, 160, 308, 309-310, 223, 234, 352 313 Scan 7, 222 Robocop, 19 Schoolly D. 3 Robotnik, Alexander, 16, 32 Schwartz, Teresa, 315 Rocker's Revenge, 36 Scorn, 278 rock (rock 'n' roll), 3-4, 43, 44, 52, Scottish rave scene, 288-292 107-108, 118-119 Scotto, 147, 305 big beat and, 383-384 Search & Destroy, 284 genres, 7 Second Phase. See Beltram, Joey hard core and, 129 Seduction, 132, 290 lo-fi, 46-47 Seeds, 138 progressive (See progressive music) Set Up System, 124 rave compared, 9-10 Sex Pistols, 6, 97, 221 Rodriguez, David, 34 S'Express, 42, 57-58, 103. See also Moore, Rogers, Ce Ce, 78 Roland drum machines, 32, 49, 255, 283, Shades of Rhythm, 113, 130, 131 315 Roland TB 303 Bassline, 3, 31-34, 49, 51, Shadow (DJ), 43, 322-324, 371 Shamen, 4, 5, 62, 105, 110, 134 69, 119, 202, 228, 302, 314, 377, 385. Sharp, Jonah, 149, 190 See acid house Shelter club, 219 Rosario, Ralphi, 23, 29 Sherman, Larry, 26-27 Rowlands, Tom, 383-385 Shocklee, Hank, 373 Royal House. See Terry, Todd Shoom club, 58-61, 66, 68-69, 76, 77, 104, R & S, 127, 219, 351 143 Rubin, Rick, 307 Shulgin, Alexander, 82 Rufige Cru, 213-214, 216, 217. See also Shut Up and Dance (SUAD), 113, 120-122, Goldie 259, 404-405 Rumpus Room, 359 Siano, Nicky, 25, 36 Run DMC, 58 Siegel, Ronald, 308 Rush, Ed, 22, 207 Signs of Chaos, 128, 293 Rush (DJ), 377 Silvertone label, 108 Rushkoff, Douglas, 151 Simonelli, Victor, 37 Rushton, Neil, 71 Simons, Ed, 383-385 Russell, Arthur, 3, 36, 379 Simply Jeff (DJ), 315 Russolo, Luigi, 202 Simpson, Gerald, 340-341 Rutherford, Paul, 61 Ryder, Shaun, 95-97, 108, 110-111 Six Nine, 231

SixSixtvSix, 303 Spooky (DJ), 129, 232, 368-372, 433 Size, Roni, 346-347 Spring Heel Jack, 278 Sketch Pad club, 310 Squarepusher, 351, 352, 372-374 Skinny Puppy, 175 Squire, John, 97-98 Skint label, 383 SS (DJ), 137, 256, 346 Skin Up, 132 St. Paul, Ian, 58-59 SL2, 131, 132, 138 St. Werner, Jan, 361, 362 Sleeping Bag label, 36 Staines, Paul, 75, 79 Sleezy D, 33, 216 Stark Club, 143 Slime Time, 126 Starr, Edwin, 385 Slipmatt, 130, 290 Steinski, 42, 256, 319, 371 Slits, 3 Steppenwolf, 294 Sly and the Family Stone, 258 Stockhausen, Karlheinz, 364 Smith, Fast Eddie, 29, 39, 120 Stone, Paul, 62 Smith, Lonnie Liston, 344 Stone, Sly, 258 Smith, Mark E., 96 Stone Roses, 94, 97-98, 108-109 Smith, Richard, 85 Stooges, 5, 6, 13, 123, 195, 221, 367 Smiths, 93, 143, 230 Stormcore company, 173 Smooth, Joe, 30 Storm Rave, 144-145, 147-148 Sneak (DJ), 377 STP. 207 soccer fans, 64, 74, 94-95, 227, 284 Straw, Will, 274 Socolov, Will, 36 Strictly Dubz, 379 Soft Machine, 77, 196 Strictly Rhythm, 37 Soho, 65 Strontium 9000, 284 Sonz of a Loop Da Loop Era, 253, 255. See Sub Love, 137 also Breaks, Danny Subnation, 207 soul, 227-228, 264 Suburban Base, 137 Suburban Knight. See Pennington, James Soul II Soul, 102, 111, 320, 339 Soulsonic Force, 14 Sueño Latino, 190 Sound factory club, 36 Summer, Donna, 3, 24-25, 299, 398 Soundlab parties, 359 Summers, Jaz, 170 Soundshaft club, 167 Sumner, Bernard, 102 Sound System City, 170-171 Sun Ra, 31, 107, 224, 232 Soundyard club, 115 Sunrise raves, 74-75, 77, 78 Spacemen 3, 195, 365 Sweet Exorcist, 28, 117, 118. See also Kirk, Space Time Continuum, 149–150 Richard Spacetime parties, 190 Sykes, Nico, 53, 351-354. See also No U Special K. See ketamine Turn; techstep Spectrum club, 61, 64, 66, 104 Sylvester, 27 speed. See amphetamine Sylvian, David, 186, 342 Speed club, 336, 343 Symonds, J. A., 308 Speed Culture: Amphetamine Use and Abuse Synergy raves, 105 in America (Grinspoon and Hedblom), Syrian Rue, 155 240 System 7, 174 Speedfreak, 294 Szepanski, Achem, 362-364 speed garage, 8, 377-380, 435 Speedy J, 183, 184, 202, 228, 229 T99, 124, 131, 221, 283 Sperminator, 284, 292 Talking Heads, 3, 16 Spike Island rave, 98 Tangerine Dream, 175, 202, 226 Spinmasters, 100 Tate, Greg, 24 Spiral Tribe, 9, 163-173, 239, 411 T-Coy, 28 spirituality, and Ecstasy. See Ecstasy tech-house, 377, 433-434 Split Second, A, 124 techno, 6, 7, 8, 13, 44, 52, 54-55, 105, 164,

Goa, 175-176, 239 201-202, 366, 388. See also Detroit Transmat label, 20, 22, 223 techno travelers, 163-178 derivation of term, 71 Trax (DJ), 256 Ecstasy and, 85 Trax label, 26-27 house compared, 120 Tresor club, 126 Manchester, 99 Tresor label, 183, 201, 228, 235 Techno Animals, 278-279 Tribal Gathering rave, 111, 276, 388-389 Technohead, 128, 293. See also GTO; John tribal house, 7 + Julie Tricky, 321, 328-333, 426 techstep, 351-352, 430-431 Tricky Disco, 118, 128. See also GTO; Tek 9. See 4 Hero; Reinforced Technohead Telepathic Fish ambient tea parties, Trip City, 71 195-196 Temazepam, 211 Trip club, 61-62, 64, 66 trip-hop, 43, 272, 319-322, 359 Temple ov Psychick Youth, 150 Tripp, Tina, 145 10 City, 78 Ten Records, 71 Tripp E Tymes magazine, 303 Trope, 202 Terradome, 351 Trumbull, Douglas, 53 terrorcore, 295, 423 Terry, Todd, 37-39, 38, 120 Tuff Little Unit, 118 Turner, Andy, 185 Test, 302 Turntable Orchestra, 78 Texas Ecstasy scene, 143-144 Thatcher, Margaret, 95-96, 260, 382 23 Skidoo, 217 2 Bad Mice, 134, 139, 186, 207, 256, These Animal Men, 194 350 Third Party, 137 Third Wave, The (Toffler), 45 Tyree, 39, 120 Thompson, Errol, 278 Uberzone, 315 Thorpe, Tony, 28 Thousand Plateaus, A (Deleuze and Ultramarine, 196-197 Ultraviolence, 295 Guattari), 362 Ultraworld, 316 Thrash, 191-193 underground garage. See speed garage Thrashing Doves, 58 3MB, 228 Underground Resistance, 122, 145, 219-225, 228-232, 363, 416 Thunderdome club, 93, 94, 109 Under One Sky fanzine, 148-149 Thunder & Joy, 378 Toffler, Alvin, 18, 20, 45, 355 Underworld, 182, 348, 376, 387 Toma, Andi, 361 Unique 3, 113, 115 United Systems, 177-178 Tomas, 118 Tong, Pete, 275 Urban Shakedown, 132, 134, 138, 253 Tonka sound-system, 155, 164 Vadim (DJ), 326, 371 Toon Town raves, 149, 151, 155 Toop, David, 186, 255, 342, 359 Vallade, David, 195 Van De Papeliere, Renaat, 124, 127. See Top Buzz, 130 also R & S Tortoise, 278 Van Dyk, Paul, 202 To The Core magazine, 290 Vaneigem, Raoul, 267 Toxic 2, 132 Van Helden, Armand, 376, 378 Trace, 22, 351, 352, 354 Tracey-Ageura, Mario, 195 Varley, Gez, 117, 118 Vasquez, Junior, 36 Trade club, 9 Vath, Sven, 145, 203 trance, 201-203, 233, 258, 272, 310, 314, 336, 363, 413 Vaughn, Seb, 169, 173 Ecstasy and, 144, 152 Vega, "Little" Louie, 37 Velvet Underground, 13 German, 228-229

Vibert, Luke, 359–360, 431–432. See also
Wagon Christ
Village People, 28
Vinyl Solution, 128
Virilio, Paul, 135, 294
Vision raves, 130
Void, Sterling, 30
Von Oswald, Moritz, 228
voodoo, 216, 258
Vukovic, Lu, 62

Wagon Christ, 359, 360 Wailers, 258 Warehouse club, 25, 30 warehouse parties British, 62, 66, 69, 72-76, 94 Los Angeles, 156-157 San Francisco, 155 Texas, 144 Warp, 113-118, 127, 181-184, 336, 359, 403 Wasson, R. Gordon, 241 Waterboys, 58 Wax Doctor, 344, 345 Wax Trax, 143 **WBMX**, 23 Weatherall, Andrew, 68, 105, 106-108 Weather Report, 101, 341 Weinstein, Michael, 45 Wells, Michael, 128, 293. See also Church of Ecstasy; John + Julie; Tricky Disco Welsh, Irvine, 9 Westbam (DJ), 128-129 West Coast. See Los Angeles; San Francisco West End label, 16, 36 Weston, Kris, 191-193 Whirl-Y-Gig club, 174

Whitehead, Allister, 275 Wicked collective, 149, 155, 306, 316 Wieczorek, Joe, 72-74 Wild Bunch, 320 Williams, Boo, 299-300 Williams, Donna, 248 Wilson, Anthony H., 93, 99 Wilson, Robert Anton, 104 Wink, Josh, 8, 314, 389 Winstons, 252 Witchman, 359 Wobble, Jah, 3 Wood, Mrs. (DJ), 274 Woodentops, 58 World Dance raves, 74-75, 130 World Power Alliance, 222 Wu Tang Clan, 232, 327-329, 354 Wyatt, Robert, 196

X, Laurent, 33 Xenophobia, 141, 254 XL label, 145 X-101/X-102/X-103, 221, 225. See also Underground Resistance

Yello, 16, 175 Yellowjackets, 342 Yellow Magic Orchestra, 15 Young Gods, 5, 167

Zanzibar club, 36 Zawinul, Joe, 199 Zen Buddhism, 243 Zinberg, Norman, 238 Zohar, 18

Zone label, 315